Movement, Manifesto, Melee

Movement, Manifesto, Melee

The Modernist Group 1910–1914

Milton A. Cohen

LEXINGTON BOOKS
Lanham • Boulder • New York • Toronto • Oxford

LEXINGTON BOOKS

Published in the United States of America
by Lexington Books
An imprint of The Rowman & Littlefield Publishing Group, Inc.
4501 Forbes Boulevard, Suite 200, Lanham, Maryland 20706

PO Box 317
Oxford
OX2 9RU, UK

British Library Cataloguing in Publication Information Available

Library of Congress Cataloging-in-Publication Data

Cohen, Milton A.
 Movement, manifesto, melee : the modernist group, 1910–1914 / Milton Cohen.
 p. cm.
 Includes bibliographical references and index.
 ISBN 0-7391-0614-7 (cloth : alk. paper) — ISBN 0-7391-0905-7 (alk. paper)
 1. Arts, Modern—20th century. 2. Modernism (Aesthetics)—Europe—History—20th
 century. 3. Creation (Literary, artistic, etc.)—History—20th century. 4. Reference
 groups. I. Title.

NX456.5.M64C64 2004
700'.4112'09041—dc22 2004049064

Printed in the United States of America

♾™ The paper used in this publication meets the minimum requirements of American
National Standard for Information Sciences—Permanence of Paper for Printed Library
Materials, ANSI/NISO Z39.48–1992.

for Mara, Kendal, and Phillip

Contents

List of Figures

Acknowledgments

Part of this book was written with the assistance of a Special Faculty Development Assignment from the School of Arts and Humanities, the University of Texas at Dallas. I wish to thank Dr. Michael Wilson for reading over the text, Dr. Dannah Edwards for checking the appendices, and my wife, Florence Chasey-Cohen, for her help, her patience, and her unflagging encouragement.

Introduction

1. Précis

The years immediately preceding World War I witnessed two parallel developments in the arts: landmark works and innovative styles appeared in such rich profusion as to make this period (1910-1914) one of the apogees of modernism; and, far more than in preceding years, artists in nearly all media formed and joined groups of fellow artists for a variety of purposes.[1] My thesis in this book is that the two developments are closely intertwined: that the group structure intensified modernist innovation by enabling otherwise isolated artists to develop aesthetic ideas collectively, sometimes even to create the art expressing these ideas collaboratively, and, most important, to *dare* to present their innovative art to a hostile, yet potentially curious public. At the same time, groups facilitated the means of presentation: the exhibitions, the concerts, the publications, the oral readings; organizing such events, in fact, was the primary purpose of many such groups. Thus, although belonging to the group posed problems of identity and freedom for artists, it proved an efficient and effective way to get their work before a public and, equally important, to arouse the public's interest in it, often through highly effective manipulation of publicity and newspaper coverage.

Organizing and leading these groups was a new type of modernist hybrid: part avant-garde artist, part megalomaniacal *duce*, part impresario, part huckster and master of publicity, part aesthetic idealist whose "true Penelope was Flaubert."[2] Many of these leaders were the great innovators of their art: Pound, Kandinsky, Schoenberg, Larionov. Others, like Marinetti, Walden, Burliuk, and Diaghilev, turned leadership itself into an art form and are more remembered today for their service to the artists of their group (or to the medium that sustained the group). All of these leaders were the dynamos that energized the group, gave it vision and purpose, and made its impress felt wherever prewar modernism flourished.

The group did more than provide artists an audience and courage to face its predictable hostility. Urged on by their leaders, inspired by their comrades, artists in groups took the offensive, challenged and provoked the public in belligerent manifestos and outrageous "evenings" as much as in their art. The group thus intensified the agonistic attitude of "*épater le bourgeois*" that the avant-garde had assumed from its origins. So aggressive were these modernist groups, so eager for combat, that fighting spilled over into their competition with each

other for survival and prominence. The art world seethed with artists restlessly splitting off from groups to form more radical ones, then attacking their former groups and other rivals. Curiously, the larger milieus of these battles (both public and interartistic) was remarkably free of rancor and imbued, rather, by the artists' exuberant optimism. But neither their battle-lust nor the optimism underlying it is really surprising when we recall that the artists in these groups were typically in their late teens and early twenties, and that their prewar world, though often veering toward the uncharted cataclysm of a world war and typically the target of their jeers, still spun on its axis. Even apocalyptic artists like Meidner and Marc who painted its destruction envisioned a finer, more spiritual age rising from the ashes. It took the *real* combat of 1914—a destruction more massive, more unrelenting, and ultimately more nihilistic than any these artists could have imagined—to silence their art battles, to collapse that world utterly.

Modernist groups are inevitably recognized in studies of this period and of its artists, and individual groups have received much scholarly attention. But relatively little scholarship has traced the pervasive interactions of these groups across geographical and artistic boundaries to show, for example, how a dynamic group of Italian painters and poets inspired an American poet and an English painter to form their own groups in London; how these same Italians informed the styles of several German painters and poets and showed several Russian groups how to publicize themselves by provoking the public.[3] To provide a coherent structure in which to study these interactions, this book considers the modernist group sui generis, analyzes its essential components and operation, and demonstrates how its dynamics, productions, and confrontations profoundly affected prewar modernism.

II. Some Rationales

Why Groups?

By 1910, there was certainly nothing new about artists—especially avantgarde artists—banding together to exchange ideas, to work together, and to present their art and aesthetic philosophy as a collective enterprise to the public. Every period has had its groups, and the years preceding 1910 had memorable ones. The Impressionists drank together at the Café Guerbois in Paris, painted together at Argenteuil and elsewhere, exhibited together eight times, and most important, shared distinctive aesthetic ideas, working practices, and a clearly recognizable style despite equally recognizable individual differences. The Symbolist poets of Paris held their "Tuesday evenings" at the *Closerie des Lilas* from the 1890s. And the Brücke painters of Dresden, with their collective manifesto of 1906, their shared painting trips to the countryside, their quasi-collective living arrangements, and their stylistic similarities, embodied the group identity more fully than any group preceding the Italian Futurists. Following World War I, groups such as the Dadaists and Surrealists continued to flourish into the 1920s.

But if the group phenomenon was not new in 1910, its proliferation and collective impact had so increased and had become so noticeable in the years just before World War I as to call special attention to this period.[4] Perhaps in no other age did painters, composers, and poets feel that joining together in some collective enterprise—sometimes only to meet and exchange ideas at a café or studio, but usually much more than that—was essential to defining their artistic identity and realizing their professional goals. The poet Henri Martin Barzun, himself an active organizer of such groups, considers them the most distinguishing feature of the age:

> [S]cores of groups of all arts and their reviews [held regular meetings] in their own sphere of cultural interest, practically absorbing the new generation in their folds and making an extinct species of the lone individual artist or writer—a typical aspect of the socio-psychologic[al] change from the past. . . . In fact, it amounted to a youthful declaration of independence from the "Old Century." (*Orpheus* 59)

Critics and journalists, most of them hostile to modernism, agreed that this was, as Alphonse Séché conceded, "the birth of a new age . . . the age of the group."[5] "Not a week goes by that we do not see the birth of another literary school, announcing itself with much commotion and noisy manifestos," complained one critic in December 1909—and in 1909 the resurgence was just beginning.[6] Critics of all stripes agreed with Roger Allard, who recognized that these groups, following the Futurists' lead, had fundamentally changed the public discourse of modernism by appropriating the promotional techniques of modern advertising: "With the aid of articles in the press, shrewdly organized exhibitions, contradictory lectures, polemics, manifestos, proclamations, prospectuses and other futurist publicity, a painter or group of painters is launched." Allard dubbed this new commingling of art and public relations "avant-gardism."[7]

As one might surmise from the forty-five modernist groups listed in appendix 2, their functions, objectives, cohesion, collective self-consciousness, and duration all varied widely. Indeed, if we consider any extended collaboration of two or more artists whose association influenced each other as a "group," such as Picasso and Braque from 1908-1914, then the field is wide indeed, and, as Barzun implies, "loner" artists, such as Modigliani, become rare (if not quite "extinct").

It is not merely that modernist groups were so prevalent in this period that makes the group phenomenon worth studying. Nor is it just that these groups account for so many of the period's major achievements, particularly in collective enterprises: the exhibitions, the little magazines and newspapers, the performances, the evenings. What makes the group phenomenon so important is the ways in which its *particular* nature affected artists, their art, and its public presentation: how it informed the ideas of individual artists regarding their art and their purpose; how it encouraged artists to exchange ideas, emboldened them to experiment with new techniques; and most of all, how it facilitated the artists'

public recognition. A gifted painter like Umberto Boccioni would almost surely have established himself on his own, and his art would doubtless have won recognition. But would recognition have come as quickly without his participation in the most dynamic, controversial, and attention-getting group of the period, the Italian Futurists? More important, would his aesthetic ideas about dynamism, about force lines and about the fusion of objective and subjective "states of mind"—as well as the stylistic techniques he devised to realize these ideas—have acquired their particular cast, intensity, and direction without his active discussions with Marinetti and the Futurist painters and without his direct hand in drafting the Futurist manifestos that articulated these ideas? I believe the answer to both these questions is obviously "no." Boccioni's central participation in Futurism profoundly affected his aesthetics, his art, the recognition of his work, and even his place in art history: For better or worse, he is a *Futurist* painter.

The groups themselves changed the very nature of the art world in this period. The belligerence, promotional hoopla, and esprit with which they intentionally provoked a conservative public and attacked each other in asserting their particular group identities would scarcely be possible if artists had acted only as individuals. Alone, artists simply would not have attracted as much attention, and publicity was crucial to the group's public demeanor. Thus, the group's *public* profile was one of its major achievements—creative productions one is tempted to say—affecting not only the destinies of its members, but the course of modernism itself in the prewar years. The very events that a collective structure facilitated—group presentations and demonstrations—brought the entire modernist enterprise into the public's consciousness far more keenly than ever before. As Wyndham Lewis and many other artists have affirmed in their memoirs, artists became news in those years. More accurately, they *made* themselves news and made good copy for the newspapers, as journalists eagerly reported on the scandals the groups provoked with their exhibitions, concerts, public readings, printed manifestos, and rowdy evenings. In turn, the news stories, often humorously condescending and punctuated with satirical cartoons (for example, fig. 4), intensified public responses to the groups, ranging from outrage to cynical mockery to puzzled curiosity. To be sure, controversy typically expressed itself in hostility (which the groups often courted) and sometimes in censorship (which they obviously did not), but always in greater public interest and better attendance at the group's public events. For all of the mocking reviews, satirical cartoons, and outraged editorials that the Italian Futurists aroused in European cities in 1912, they unquestionably startled large audiences in those cities into confronting radically modernist aesthetics and techniques.

This group-generated public attention raises questions about the way we construe the period historically. Earlier histories of prewar modernism, privileging innovation above all other achievements (and only those stylistic innovations confirmed in historical hindsight), typically focused, for example, on Picasso's and Braque's *development* of Cubist techniques and referred condescendingly to the "Cubist School" painters:

[A]s John Golding has rightly noted, all these [Cubist] works [at the 1911 *Indépendants* Salon] were conceived as so many Salon paintings. Cubism here, instead of a new principle of compositional coherence, was merely a set of formulas for producing effects. It was a mockery of the interiorized exploration of Braque and Picasso, whose lyricism expressed itself in terms of objects and figures without submitting to the outside world. (Daix 75)[8]

True to the origins of Cubism (the Picasso-Braque version of it, at least), such depictions are nonetheless false to the historical moment, when Cubism (for all but the few visiting the studios of Picasso and Braque or Kahnweiler's small gallery) meant the paintings of Le Fauconnier, Gleizes, Metzinger, the Duchamps, Picabia, Léger, the early Delaunay, and others—those who showed their work publicly and collectively. Moreover, the older histories slight the considerable courage the Cubist School painters displayed in *exhibiting* their work before a large public, in standing up to the viewers' mockery, the critics' scathing reviews, the politicians' demands for censorship, the widespread scorn their new styles (however derivative) provoked. Albert Gleizes remembers: "Most of the papers abused us with unusual violence; the critics lost all restraint, and it rained invective."[9] These were the painters who established Cubism publicly, and the group structure was central to their purpose and identity. As Gleizes explains, "It seemed essential to us then that we should form a group, see more of each other and exchange ideas" (*Souvenirs*, qtd. in Cooper 70).

Similarly, the Italian Futurists were the modernist group most talked about at the time (by other artists and the public alike), most influential, and most emulated. But the very techniques that established their contemporaneous prominence—their skillful provocation of the public and manipulation of journalists—typically demeaned their evaluation among historians who, again, privileged the heroic persona of the artist working in semi-isolation over the noisy and undignified self-promoting of the Futurists. Only fairly recently has their contemporaneous importance been given its due and have their publicity techniques been accorded attention as creative activities in their own right—techniques that brought artists out of the garret and into the marketplace by skillfully appropriating the market's own devices.[10] If the Futurists and Cubist School painters gained the public's eye and achieved notoriety largely through collective planning and presentation (as will be shown in subsequent chapters), then the *organizational* mode that enabled their efforts—the modernist group—deserves special attention.

In the chapter that follows, I will examine several aspects of the modernist group. Chapter 1 surveys its diverse types and purposes, the psychological appeals and problems it posed to member artists, particularly regarding questions of identity and allegiance, its combative relations with other modernist groups as competitors, and its demographics. Subsequent chapters will examine the leaders, impresarios, and facilitators of these groups (chapter 2); the group's most distinctive print statement, the manifesto (chapter 3); and (in chapter 4) the dynamics of their public presentations—in exhibitions, concerts, and evenings—

that interlock group provocations and audience upheavals. Through this close study of the modernist group's facets, the distinctive character of the prewar period may emerge in sharper relief.

Why Anatomize the Group?

If groups were central to prewar modernism, they nevertheless remain a relatively unexplored social structure. My premise here is that by anatomizing prototypical groups—examining the ways their central components (leaders, members, aesthetics, artistic productions) interact among themselves, among those of other groups, and vis-à-vis the public—we can gain an understanding of *individual* groups that qualitatively differs from traditional histories of such groups.

A new understanding, of course, depends on the *kind* of discoveries one hopes to make. My book offers no new facts about Alfred Stieglitz's life, for example. Instead, it studies his leadership style against that of analogous leaders, such as the entrepreneurial gallery owner and editor Herwarth Walden, or, more broadly, against dynamic leaders like Filippo Marinetti or Ezra Pound. Stieglitz's "purist" approach to the art he exhibited—in abhorring publicity and in not promoting sales, for example—contrasts sharply with the publicity-loving Walden and with Pound's tireless "booming" of poets he believed in. This rather austere idealism gained Stieglitz an almost universal respect of those who dealt with him, but also frustrated artists like Max Weber who wanted—needed!—to sell their work. Conversely, Walden's pursuit of controversy disgusted artists like August Macke and Franz Marc, but (even if they did not acknowledge it), they benefited from the public exposure and attention he gained for their art. These comparative contexts do not "reveal" Stieglitz's values, but they place them in sharper relief. In short, this study offers new contexts in which to gauge the production of group leaders and artist members and even to redefine those "productions" to give more weight to public performances such as the fractious evenings. As the contexts change, so do the findings.

Why 1910-1914?

Cultural historians have long celebrated what Roger Shattuck called "the fabled, pre-World War I decade that launched the most dazzling feats of modernist art."[11] But why should we single out these particular five years? My answer is twofold: because those modernist feats (as well as the rapid increase of modernist groups) reached a crescendo in these years until the era itself ended; and because a comparative study of several groups in several arts and in many cities across Europe and America requires a fairly limited time frame to treat their interactions comprehensively. Placing temporal brackets around this complex weave is always somewhat arbitrary, but less so for 1914 than for 1910. By virtually all accounts—whether by cultural historians or by the artists themselves—the beginning of the Great War was a watershed in the history of the arts.[12] This juggernaut rolled through all artists' lives, whether or not they donned a uniform, abruptly canceled or radically redirected their artistic projects, closed down scores of little arts magazines and newspapers, squelched

plans for new exhibitions and collective projects, broke up thriving groups, and, except in neutral countries, destroyed the international spirit that distinguished so much of prewar modernism. As the epilogue describes, the war not only disrupted the tempo of modernist projects, and killed or maimed many of the best artists, it profoundly changed the direction, tone, and mood of modernist innovation itself: the art world of 1917-1925 would scarcely have been recognizable in 1910-1914.

The year 1910 is a less obvious choice for a starting date: why not 1909— the year when Marinetti published the Futurist "Foundation Manifesto" in *Le Figaro*; when Picasso synthesized several diverse explorations into his "analytical" Cubist style; and when Stein radically changed her style toward painterly compression in her miniatures of Picasso, Matisse, and Cézanne? (Choosing years *after* 1910, however, is far less justifiable for what they exclude of the rapidly accelerating modernist achievements.) Yet 1910 does have its logic.[13] It was the year Roger Fry introduced modernist styles to London in an exhibition ("Manet and the Post-Impressionists") that prompted Virginia Woolf to declare in a startling hyperbole that "On or about December 1910 human nature changed. . . . All human relations shifted" (*Collected Essays* 321). Other landmark exhibitions occurred that year: the second exhibition of the NKV-Munich, that was aggressively international and highly controversial. The first Futurist exhibitions occurred, accompanied by the famous manifestos on Futurist painting and interspersed with the riotous Futurist evenings in Turin, Trieste, Milan, Venice, and elsewhere. For this most important of modernist groups, 1910 marked the year that Futurism stopped being just a manifesto and became a movement.

1910 was the year of Kandinsky's first completely abstract watercolor and the year he wrote *Concerning the Spiritual in Art*, the same year that Schoenberg completed his equally influential *Theory of Harmony*. Schoenberg's *Three Piano Pieces* (Op. 11), which had its première that year, realized some of *Theory*'s more daring speculations: for virtually the first time, listeners heard a movement lacking a tonal center.

In Russia, Scriabin had also composed a radical work, *Prometheus: Poem of Fire*, which called for a "*clavier à lumières*" to project shifting colors on a screen in sequence with the music. That year witnessed a gathering of Russian groups of avant-garde painters. If Camilla Gray overstates the case a bit by claiming they "came together as a united movement" (114), they nonetheless did exhibit together along with important European modernists at the first Jack of Diamonds exhibition. The year was also significant for Russian poets: "The real appearance of Russian futurists as a group was their publication of . . . [*A Trap for Judges*] . . . in . . . April 1910" (Markov 8)—the same year Velimir Khlebnikov published his "Incantation by Laughter," the prelude to his transrational *zaum* poems.

In Paris, Cubism went "public" in 1910 beyond Picasso's and Braque's small gallery exhibitions at Kahnweiler's and elsewhere,[14] as several painters (Le Fauconnier, Gleizes, Metzinger, Delaunay, and Léger) evolved their post-Cézannesque "affinities" into a group. Albert Gleizes recalls:

> 1910 was the year when, in the last months, there joined together a
> kind of coherent group that represented certain precise tendencies for
> our generation, until then scattered. From the painters who met one
> another, joined by poets, sympathies were created, an ambience was
> formed that was soon going to determine an action the effects of
> which would not be long in being felt outside [the circle]. (*"Souve-
> nirs"*; qtd. in Robbins 16)

That "action"—the first planned collective exhibition of Cubist painters at the
spring *Indépendants* Salon of 1911—exploded Cubism into the public's con-
sciousness.

For modernist poetry, 1910 witnessed a reawakening: T. S. Eliot wrote his
"Preludes" that year and most of "The Love Song of J. Alfred Prufrock"; the
Russian Futurists, as noted above, emerged, albeit separately. Most important,
1910 marked the self-conscious coalescence in Berlin of a major artistic sensi-
bility: literary Expressionism. While earlier works by Strindberg, for example,
certainly fall within the loose stylistic and thematic contours of this movement,
not until 1910 did anything like a shared attitude about what art should be in a
stultifying bourgeois culture unite young artists meeting in Berlin's cafés, stu-
dios, and especially in Herwarth Walden's radical newspaper, *Der Sturm*. As
Roy Allen observes, Berlin was a converging point for Expressionists from all
over Europe (54)—even before this attitude and style had a name—and 1910
was, in Gottfried Benn's phrase, "the year when all the timbers started creaking"
(qtd. in Willet 73).

All these instances, suggesting awakenings, coalescences, major develop-
ments and accelerations, have led me to choose 1910 as my starting point, while
fully recognizing that "new" events seldom occur ex nihilo; that each is the heir
of a long developmental lineage and has important antecedents in the years pre-
ceding.

Why "Modernist"?

In this study, "modernist" and "avant-garde" are relatively interchangeable
terms referring to groups, artists, and styles perceived by the public at the time
as innovative and disturbing, even if, in retrospect, some (for example, some of
the Cubist School painters) now seem derivative of others (for example, Picasso
and Braque). In this usage, I largely reject the categorical distinction between
these terms posited by Peter Bürger and, more recently and lucidly, by Charles
Russell.[15]

Russell distinguishes between modernists like Proust, Eliot, Pound, Woolf,
and Joyce, who retreat from their sense of cultural alienation into "the tradition
of high art," and avant-garde writers (Rimbaud, Tzara, Apollinaire, Marinetti,
Breton, and Brecht), who experience the same alienation, yet strive "to be . . . in
advance of, and the cause of, significant social change . . . [that] would affect the
nature and role of art in society" (15-16). Where modernists enshrine "the [pri-
vate] creative consciousness and the literary work over [and as a refuge from]
the social domain" (13-14), avant-gardists seek "to go beyond the [modernists']
. . . hermetic aesthetic boundaries . . . to act in and on social reality." "At

times," Russell continues, "this activism takes the form of extreme bohemian behavior, at others, it is seen in their identification with the radical politics of the left or the right" (ix). By contrast, "the political positions of many modernist writers have been generally conservative, if not reactionary" (10). Finally, "avant-garde writers are more nihilistic in their rejection of the social values and aesthetic practices of their predecessors and contemporaries" (ix). Russell's distinction between a hermetic "art-for-art's sake" modernism and a socially engaged and culturally subversive avant-garde works moderately well for artists of the late 1910s and 1920s, but even here categorical distinctions blur if we can as easily apply "avant-garde" qualities, such as "strident experimentalism" and "an invocation of the writer's visionary powers" (15) to such "modernist" writers as Joyce and Yeats. Moreover, if (as I believe) cultural subversion results as much from the art as from the politics of the writer, then modernism's innovations can be as culturally transformative as the avant-garde's. Can anyone reasonably claim that *Ulysses* has changed the way we understand the modern world *less* than Tzara's most irreverent poem?

Russell's distinction is even more problematic when applied to prewar artists. They do, indeed, reveal cultural differences among themselves along his primary fault line (art-for-art's sake versus art as social subversion), as will be discussed below. But transcending these differences are shared sensibilities that his categorical distinction does not recognize. For one thing, virtually all modernists before the war, even the most revolutionary groups like the Futurists, made art—*their* art—the center of their concern and took their art extremely seriously. If Italian Futurist manifestos demanded that the museums be blown up, the libraries torn down, Italian Futurist painters devoted themselves to their work—its stylistic development, its aesthetic principles, its exhibition and sale—more than to their social ideology.[16] Similarly, if German Expressionists like Franz Marc believed that art's mission was to lead a spiritual transformation of Wilhelmine materialism, then the spirituality must begin with the paintings themselves. Art, in short, could never be merely a subversive means to a sociopolitical end, a mustache blasphemously drawn on the high-art icon of the *Mona Lisa*.

Perhaps for this reason, very few prewar groups and artists took any direct interest in political reform per se. With the notable exception of a journal like Franz Pfemfert's *Die Aktion*, "politics," as Alfred Döbbin recalls, "had no value then. It was something for the philistines . . . no match for music and literature" (qtd. in Allen 28). Similarly, the nihilism that Russell imputes to the avant-garde scarcely existed before the war. Numerous first-person accounts attest to just the opposite: to what William Rubin called "that mood of prelapsarian optimism which characterized the vanguard in the years just preceding 1914" (*Picasso and Braque* 53). The German Expressionist poet Johannes Becher, for example, eloquently recalls:

> We were passionately dedicated to our cause, only satisfied by it and it alone; yes, were obsessed. In cafés on the sidewalks and squares, in our studios, we were "on the move" day and night. We set out at a fu-

rious pace to fathom the unfathomable, to create—united as poets, painters, composers—the "art of the century," the incomparable art which would tower timelessly above the arts of all previous centuries. We thought we could do it—our age, the twentieth century! We were stepping up to the forum of the centuries, challenging them to a contest. And we thought, "it's a joy to be alive." (qtd. in Allen 30-31)

This optimism informed even the most apocalyptic images in prewar art, such as Ludwig Meidner's.[17] Roy Allen has called this fusion of "intense exhilaration and optimism" and an apocalyptic sensibility a "glaring paradox" (30). But these feelings really weren't paradoxical at all: they reflected the Expressionist generation's supreme, if naive, confidence that their art would transform the world utterly and reinvigorate it with a new spirituality; hence they joined the battle against philistinism with what Klaus Lankheit aptly called "apocalyptic enthusiasm" (*Blaue Reiter Almanac* 36). As the epilogue to this study argues, it took the war to murder this optimism, polarize modernism politically and aesthetically, and realize the more sinister implications of "apocalyptic enthusiasm."

Prewar modernists who did not share the Expressionists' mission of cultural renewal, notably the French, were no less enthusiastic in challenging the bourgeoisie and attacking its aesthetic conservatism. Thus, modernist groups, as the vehicles of these attacks, were as common to Moscow and Paris as to Berlin. As Henri Barzun observed, "By their very existence and constructive effort, these various groups represented the new spirit away from library, ivied [sic] tower or exclusive cenacle which had characterized an earlier period" (60).

In sum, these qualities—artistic seriousness, optimism, enthusiasm, and eagerness to confront the conservative bourgeoisie—were so widely shared among prewar modernists as to blur any categorical division between "modernist" and "avant-garde." A more useful distinction—one I employ in this study—views the avant-garde as the forward-most, innovative edge of the larger modernist movement: the Picasssos and Braques as opposed to the Lhotes and Segonziacs.

III. Prewar Modernism: Consonance and Some Dissonances

If "modernist" and "avant-garde" do not describe separate sensibilities before World War I, it does not follow that this period was entirely homogeneous. It was unified by an intensifying and accelerating pace of artistic innovation, by the artists' awareness of this pace, and most of all by their contacts and collaborations with each other. As table 1.5 of chapter 1 suggests, major exhibitions, premières, and publications of ever more radical works and magazines burgeoned in these years, particularly in 1912-1913, accompanied by a corresponding increase in hostile responses by the public and press.[18] More and more artists formed or joined modernist groups, sometimes battling each other, often visiting each other's studios, giving talks in each other's countries. As these activities spilled across national borders, they seemed to link modernists of all nations into

a self-conscious, loosely coordinate enterprise of artistic innovation and presentation. Nowhere is this collaborative, cosmopolitan spirit better captured than in the philosophy of the Blaue Reiter. Franz Marc proclaims in a prospectus for the *Almanac*: "Everywhere in Europe new forces are sprouting like a beautiful unexpected seed, and we must point out all the places where new things are originating" (rpt. in Lankheit, *Almanac* 252). As nationalism was steadily intensifying in these years and even asserting itself in the art world, the *Almanac*'s editors boldly declared:

> [I]n our case the principle of internationalism is the only one possible. However, in these times we must say that an individual nation is only one of the creators of all art; one alone can never be a whole. As with a personality, the national element is automatically reflected in each great work. But in the last resort, this national coloration is merely incidental. The whole work, called art, knows no borders or nations, only humanity.[19]

The Blaue Reiter's vision of internationalism and cultural renewal was not shared by all prewar modernists, however. The relationship of French painter Robert Delaunay and art critic Guillaume Apollinaire to the German Blaue Reiter group and, secondarily, to the Italian Futurists nicely illustrates both these differences and the larger shared sensibility of prewar modernists.

In October 1912, when the German painters August Macke and Franz Marc visited Paris, the painter they most wanted to see was not Picasso, but Robert Delaunay (fig. 2). Delaunay had sent several canvases, including his semi-abstract *The City No. 2 [study]*, to the first Blue Rider exhibition the previous December; in fact he was the only living French painter to be shown.[20] Enthusiastic about his work, Kandinsky wrote Delaunay to solicit an article on his aesthetics for the *Blaue Reiter Almanac*. When the group's first exhibition traveled to Cologne and Berlin, Delaunay's works went too, thus spreading his influence among the German avant-garde. He participated in the second Blue Rider exhibition in February 1912, as well; so his work was certainly familiar to Marc and Macke when they arrived in Paris. Yet, what they saw there impressed them deeply. Delaunay was well into his nearly abstract *Windows* paintings. With only faint wisps of a subject, the *Windows* canvases were as daring as anything the German painters could see in Paris that fall. For Marc in particular, who was then struggling to collapse his animal forms and colors into essential rhythms, Delaunay's bright colors and semi-transparent planes provided precisely the rhythmic element missing from Picasso's and Braque's analytical Cubism. Coupled with the dynamic, angular lines and intersecting planes of Futurist painting (which Marc had observed at the Sonderbund Exhibition directly before going to Paris and in the Futurist traveling exhibition on his return), Delaunay's work turned Marc away from the sinuous curves of *Cows (red, green and yellow)* toward a more angular style of intersecting color planes (for example, *Rain*), and ultimately toward his completely abstract *Forms* and *Small Composition* series of 1914.

Delaunay's influence on German Expressionism spread dramatically when, in January 1913, the Berlin impresario Herwarth Walden featured him in a three-artist show at *Der Sturm* gallery. As with the Blue Rider and Futurist exhibitions the preceding year, Walden intended this as a major event. Accompanying Delaunay to Berlin was his own publicist, the poet and art critic Guillaume Apollinaire, who had been living with the Delaunays in the preceding months. Both Delaunay and Apollinaire lectured at the gallery (Walden publishing translations in the *Sturm* newspaper),[21] and the two met a number of admiring German painters and writers, such as Meidner and Kirchner. On their way back to Paris, Delaunay and Apollinaire stopped in Bonn to visit August Macke, who felt even closer to Delaunay's sensibility than did Marc (see chapter 2). These interchanges show modernist cosmopolitanism in full bloom. As painters sent their work across Europe and across the Atlantic to international exhibitions, as poets crossed the continent to give lectures and readings, as artists visited each other's studios, national borders—even the idea of a national art—seemed to many artists an increasingly irrelevant concern. The example also demonstrates how these interchanges act more like hubs, sending out spokes in several directions at once, rather than like simple one-directional influences.

Yet these events also had their divisive aspects. Apollinaire, for example, never tired of reminding readers and audiences that Paris took precedence in all modernist innovation. His Berlin talk, "Modern Painting"—a condensed reworking of his soon-to-be-published book, *The Cubist Painters*—was no exception: Although the nineteenth-century modernist movement was really "European," he concedes, "[n]evertheless, this movement first took hold in France, and French artists expressed themselves in this art more felicitously and in greater numbers than the painters of other nations." As he proceeds to group and categorize French modernist painting under a Cubist aegis, the most he could allow German modernists as diverse as Kandinsky and Meidner is a niche in Delaunay's "Orphic" branch: "The most interesting German painters also instinctively belong to this [Orphic] movement: Kandinsky, Marc, Meidner, Macke, Jawlensky, Münter, Otto Freundlich, etc. To orphism likewise belong the Italian futurists, who, originally an outgrowth of fauvism and cubism, considered it wrong to abolish all the conventions of psychology and perspective" (qtd. in *Apollinaire on Art* 267, 270). Despite this distorting, nationalistic bias, the German audience greeted the talk with an "enthusiastic response" (Selz, *Art* 104). By contrast, the intensely nationalistic Italian Futurists were far less willing to become a subdivision of French art, whether Orphic, Cubist, or Fauvist; they counterattacked a few months later when Apollinaire championed Delaunay as having "invented" Simultaneism.

If threads of nationalism run through even the most cosmopolitan of events, Delaunay's reaction to the spirituality that he heard Kandinsky and Marc speak of so confidently reveals another major dissonance in prewar modernism. He writes Marc two months after returning from Berlin: "For progress in art, I find that no mysticism is needed, not Christian nor Jewish nor any other kind of mysticism. What makes my art different from the few things I saw in your country is this enthusiasm or rather mystic daze to which the young Germans, even the

most interesting ones, are subject, and which hampers and paralyzes the vital impulse" (letter of April 1913; qtd. in Vriesen 57-58). The target of Delaunay's rebuff could scarcely have been better chosen, for Marc, as well as his Blaue Reiter collaborator, Kandinsky, was arguably the most enthusiastically "mystical" of modernists,[22] the one most given to the view (which Delaunay identifies as "Germanic") that the "inner truth" of art is not to be confused with the work's material forms and embodies "the first signs of the coming new epoch . . . the signal fires for the pathfinders" ("Two Pictures," *Blaue Reiter Almanac* 69). Essentially, the cultural renewal envisioned by Expressionist artists was, as Roy Allen has observed, a spiritual response to what they perceived as the materialistic philistinism of Wilhelmine Germany. Oskar Kokoschka described it this way:

> German and Russian Expressionism was meant as a moral and cultural awakening of the true nature of man, and as a political commitment. Essentially, Expressionism must be seen as a revolutionary movement, a compulsive need to communicate with the masses. Not only painters and sculptors, but also musicians, architects, writers, and complete non-artists, in their theories and hypotheses, were striving for a transformation of intellectual life. (*My Life* 66)[23]

As noted above, conceptions of this renewal acquired apocalyptic dimensions for a number of German poets and painters. Marc, for instance, writes in a foreword to a planned second volume of the *Blaue Reiter Almanac* (February 1914): "The world is giving birth to a new time; there is only one question: has the time now come to separate ourselves from the old world? Are we ready for the *vita nuova*?" (rpt. in Lankheit, *Almanac* 260). Little wonder, then, that such visionaries greeted World War I as the necessary purge: "The war," Marc writes from the Western Front, "was nothing if not a moral experience . . . a preparation for a breakthrough to a higher spiritual existence; just the kind of event that was needed for sweeping the dirt and decay away to give us the future today" (qtd. in Rosenthal, *Franz Marc* 34).[24]

As Delaunay's acerbic comment suggests, however, this middle-European emphasis on "inner necessity," "spirituality," art as a "moral experience," and a preparation for an impending "higher spiritual existence" was quite foreign to painters like himself who concerned themselves with problems of color and plane. In part, these differences were a matter of individual temperament. For example, August Macke, Marc's friend and fellow member of the Blaue Reiter, shared Delaunay's distrust of mysticism (as chapter 2 will describe). Generally, however, this rift between the "spiritualists" and "formalists" did have a cultural basis. If German and Austrian Expressionists largely shared visions of spiritual renewal through art, the Parisian avant-garde on the whole was more concerned with formal issues. Picasso's 1923 repudiation of abstruse Cubist theories typifies this formalism:

> Many think that Cubism is an art of transition, an experiment which is to bring ulterior results. Those who think that way have not under-

stood it. Cubism is not either a seed or a foetus, but an art dealing primarily with forms, and when a form is realized it is there to live its own life. . . .

Mathematics, trigonometry, chemistry, psychoanalysis, music, and whatnot, have been related to Cubism to give it an easier interpretation. All this has been pure literature, not to say nonsense, which brought bad results, blinding people with theories.

Cubism has kept itself within the limits and limitations of painting, never pretending to go beyond it. (qtd. in Chipp 265)

One reason that French modernists like Delaunay rejected a spiritual conception of art was because in France that conception had been appropriated by a wide spectrum of *anti*modernist poets and novelists, who had fashioned it into a kind of nationalist revival and repudiation of Symbolist ennui and decadence: "[Charles] Péguy, Ernest Psichari, and Romain Rolland were men of the hour in France where 'national revival' stressing discipline, heroism, and national genius was the watchword" (Stromberg 30). The newspaper survey of French university students in 1912, "The Young People of Today," stressed this neo-conservative and neo-Catholic reaction against the "generation of 1885" which young intellectuals saw as "pessimistic, self-doubting, morally flabby, overly intellectual and introspective, relativistic, incapable of action, lacking faith, obsessed with decadence, ready to accept defeat and eclipse of their country. All these traits converged in a debilitating dilettantism" (Wohl 8). The new heroes for this generation, the survey concluded, were writers who, themselves, had repudiated their former ties to Symbolism—Péguy and Maurice Barrès—or who were outspoken chauvinists and political rightists like Charles Maurras of *Action-Française*.[25] Thus, where a spiritual sensibility had become a modernist weapon to attack the conservative status quo (particularly its materialism) in Germanic countries, in France a contrasting nationalist spirit became a conservative weapon to attack modernism.[26]

In sum, the various modernist movements shared a high-spirited optimism and a practical and often philosophical cosmopolitanism as they crisscrossed Europe. But they differed markedly in their nationalism and in the extent to which they saw modernism contributing to a broader cultural revolution. In only a few instances, however, for example, Italian Futurism after 1912 and Franz Pfemfert's influential Berlin newspaper, *Die Aktion*, did this cultural reform acquire specifically political applications. For all groups across Europe and America, art was what mattered most and was the focus of their labors.

As an antidote to this cultural generalizing, let us now consider in some detail a specific group and event to serve as both microcosm and exemplar of the prewar modernist group—the Italian Futurists' traveling exhibition of 1912.

Prologue

The Futurist Traveling Exhibition of 1912

On 5 February 1912, a major exhibition of paintings—"Les Peintres Futuristes Italiens"—opened in Paris at the Bernheim-Jeune Gallery and created the immediate sensation that its organizers had planned. Artistic controversies were nothing new to Paris: just the preceding year, the Cubist School painters had created scandals at the Indépendants and Automne Salons, Stravinsky's tritones in *Petrouchka* had assaulted Parisian ears at the Ballets Russes, and in September, Paris's most prominent modernist art critic and poet, Guillaume Apollinaire, was implicated in the theft of statuettes from the Louvre.

Yet the Futurist controversy was of a different order. For one thing, it was calculated and manufactured. Weeks before the exhibition, the group's leader and impresario, Filippo Tommaso Marinetti, had spread around the city copies of the combative Futurist manifestos on painting and the group's most current views, "The Exhibitors to the Public," which saucily explained why Italian Futurism was superior to French Cubism. During the preceding autumn, the painters themselves had visited Paris to plan the exhibition, make themselves known to the prominent French modernists (including Apollinaire)—in short, act as their own advance agents. In Ester Coen's account: "The young Futurists elbowed their way into the Parisian art scene spoiling for a fight. . . . No weapon was neglected: rhetoric, dialectic, debate, demonstrations, [and Severini's] unmatched socks" (xlv).

Like the military tacticians he admired, Marinetti strategically planned each aspect of Futurism's European debut. Three years had passed since he had stirred Paris with his audacious manifesto in *Le Figaro* announcing the birth and philosophy of an aggressive group of young Italians, in love with everything fast, reckless, violent, and modern; at war with the staid, the safe, and above all, the traditional. In those three years, Marinetti had assembled a mixed group of painters and poets to embody the ideas of his manifesto. (Like Pound, he invented the idea before the group.) With his *Futuristi*, he wrote manifestos on painting and organized across Italy exhibitions of their work and volatile evenings comprised of manifesto and poetry readings, shouted insults to and from the audience, and nearly always, a fistfight. Above all, in those three years, he had perfected the skills of promoter and publicist. Building on the nineteenth-century experience that public scandal heightens artistic subversion (and gains invaluable attention for its perpetrators), Marinetti's genius was to harness the

techniques of modern advertising and publicity to the avant-garde, to guarantee that a sensation within the gallery would become a public controversy outside it. Bad publicity was *much* better than no publicity; and reticence and professional detachment were no longer acceptable standards of artistic behavior. As Alphonse Séché complained in 1914: "Professional conscience [has been] replaced by bluff and audacity."[1] In public or private, Marinetti was characteristically blunt about his motives. He told a Parisian journalist: "Reasonable behavior . . . draws relatively little attention. It is because we want to succeed that we get straight to the point with exhibitionism, that we situate ourselves violently against the grain of good taste and ordinary moderation."[2] To the Futurist composer, Francesco Pratella, he advised:

> To conquer Paris and appear in the eyes of all as an absolute innovator . . . I advise you with all my heart to set to work to be the most daring, most advanced, most unexpected and most eccentric emanation of all that has represented music to date. I advise you to make a real nuisance of yourself and not to stop until all around you have declared you to be mad, incomprehensible, grotesque and so forth.[3]

Most commentators writing on Marinetti deplored his exhibitionism and saw it only as self-serving. Only a few, such as Alexandre Chignac, recognized how central it was to his avant-garde mission: "Marinettism is composed now of buffoonery, now of the heroic-epic; there is above all a curious, original, ultramodern temperament . . . [that expresses the] paroxysm of modern times."[4]

Marinetti had already demonstrated his skills in Paris as a rousing lecturer and writer. The Paris exhibition now marked his group's European première and thus his role as leader and publicist. A succès de scandale was essential, and besides distributing manifestos and giving newspaper interviews, he baited the crowd attending his lecture at the Bernheim-Jeune Gallery. One journalist describes him trading put-downs with French Cubist Albert Gleizes and punches with sculptor Elie Nadelman, "while, in a neighboring corridor, Félix Fénéon . . . shields Van Goghs and Gauguins from the general pandemonium."[5]

Most important, the dynamic Futurist paintings at Berheim-Jeune proved a striking contrast to the more static Cubist works shown the year before. Among the more powerful were: Boccioni's *The Street Enters into the House*, *The City Rises*, and his *States of Mind* trilogy, Carrà's *Funeral of the Anarchist Galli*, Russolo's *The Revolt*, and Severini's *La Danse du Pan-Pan à Monico* and *Travel Memories*. The poet and art critic André Salmon no doubt exaggerated viewers' responses for satiric effect, but he still conveys the potent impact these paintings had on the crowd: "They were overwhelmed before Russolo's *Memories of Night*; they stamped their feet with rage in front of the *Funeral of the Anarchist Galli* by Carrà; they shrieked in front of *Pan-Pan at the Monico* by Severini."[6]

Like their paintings, the Futurists' promotional tactics revealed an essential quality of their collective identity—a quality that profoundly influenced prewar modernism and epitomized its diverse groups. For this was no loose collection of painters who happened to share some aesthetic ideas and to exhibit together

for mutual convenience. The Futurists were a cohesive and well-organized group. Their aesthetic ideas were the unified positions of a group; and the manifestos presenting these ideas were as shrewdly calculated as their paintings to engage and enrage the beholder simultaneously. The "Technical Manifesto of Futurist Painting," for example, explains how the painters saw objects and their surrounding space as interpenetrating each other, but it closes with a list of belligerent declarations, demands, and oppositions: "WE FIGHT . . . AGAINST THE BITUMINOUS TINTS. . . . *We demand, for ten years, the total suppression of the nude in painting*" (rpt. in Chipp 293). "The Exhibitors to the Public" introduces several more aesthetic concepts including "force-lines" that place the viewer in the center of the picture and extend the interaction of masses to all parts of the canvas: "Every object reveals by its lines how it would resolve itself were it to follow the tendencies of its forces. . . . Every object influences its neighbor, not by reflections of light (the foundations of impressionistic primitivism), but by a real competition of lines and by a real conflict of planes, following the emotional law which governs the picture (the foundation of Futurist primitivism)" (rpt. in Chipp 296). "The Exhibitors" also declares in no uncertain terms that the Futurists are "at the head of the European movement in painting" and are "absolutely opposed to [the] art" of the French Cubists. As Marjorie Perloff points out, the *look* of these manifestos reinforces their combative content: the big block letters, subheads like "WE DECLARE" and "WE FIGHT" in boldface, and short paragraphs bristling with exclamations and declarations are both confrontational and easy to read. Even numbering their demands "implies that the authors mean business, that the goals to be achieved are practical and specific" (96).

As the Futurists' manifestos fused all of these objectives into an incendiary document—presenting the group's aesthetics, declaring its primacy over competitors, and assaulting the reader's eye with its aggressive typography—they perfectly complemented the challenging paintings hanging on the gallery walls and were further reinforced by Marinetti's histrionic lectures. The combined effect unmistakably announced calculated provocation, planned controversy, a serious campaign to become the leaders of European modernism. Even their group picture (fig. 3), taken impromptu on a Paris street, exudes collective arrogance: they glower at the camera defiantly, bristling for a fight. Far more than did the Fauves of 1905-1906, and even more than the Symbolists of the 1880s, this group presented itself—and demanded to be received—as a single entity with a coherent aesthetics that guided its style and with tactics calculated to publicize its art and theories with maximum controversy.

These collective actions, "political" stances, and promotional tactics, moreover, set the tone for modernist groups across Europe and America, regardless of medium or country. Critics warily noted this trend; Roger Allard, for example, observed: "With the aid of articles in the press, shrewdly organized exhibitions, contradictory lectures, polemics, manifestos, proclamations, prospectuses and other futurist publicity, a painter or a group of painters is launched."[7] André Salmon, himself not above cutting up, bemoaned "the deplorable intrusion of politics into art."[8] But if some modernists detested their self-aggrandizing showmanship, and many laughed at their machismo swagger, most paid close

showmanship, and many laughed at their machismo swagger, most paid close attention to the Futurists. As Virginia Spate observes, "[They] added an element of competitive publicity, which . . . affected the art-world" (55). In both inspiring and modeling this trend, therefore, the Futurists' 1912 traveling exhibition deserves close attention.

The Futurists had hoped this Paris exhibition would catapult them to the forefront of the modernist avant-garde; they were not to be disappointed. Although they did not quite succeed in creating a succès de scandale of the first order, they did draw big crowds. As Gertrude Stein recounts, the show "made a great deal of noise. Everybody was excited and this show being given in a very well known gallery everybody went" (*Autobiography* 82). The show also attracted a sizable number of reviews, mostly hostile, but a few prominent ones were quite supportive. Apollinaire's two reviews were largely condescending and patronizing, pointing out at every turn the precedence of Paris modernists and the Cubists in particular: "The most original aspect of the futurist school of painting is that it seeks to reproduce movement. This is a perfectly legitimate quest, but the French painters solved the problem long ago."[9] Among the few complimentary reviews, Gustav Kahn wrote in the influential *Mercure de France*: "a movement of such considerable novelty has scarcely been seen since the first pointillists exhibition." To be sure, the Futurists had "found guides in Paris," he continued, "[but] they have added a great deal, which comes from themselves, with much spirit and lustre." Kahn even threw an elaborate banquet for the group.[10] Undoubtedly, the crowds and reviews helped realize the group's immediate aims of gaining prominence; far more important, however, the exhibition offered something significant to three overlapping audiences: artists, publicists, and impresarios of the avant-garde.

For the many painters who attended, the Futurists displayed new stylistic ideas and an example of daring to support their own stylistic experiments. Several art historians concur with Marianne Martin's view that the exhibition "had a profoundly liberating and challenging effect" on the Cubist School painters, who produced "much more vital, synthetic works . . . after they had seen the Futurist works [compared with their weaker 'modern epics' of 1910-11] and evidently had thought and talked at length about the aims of the Italians."[11]

Marcel Duchamp, for example, paid particular attention to the Futurist canvases and to their ideas about capturing on canvas photographic and cinematic depictions of motion, for he was then just finishing his own "static representation of movement," as he later called it, in *Nude Descending a Staircase, No. 2* (Schwarz 202).[12] Delaunay took note of the Futurists' ideas on simultaneity—of intersecting "outside" and "inside" in a work such as Boccioni's *The Street Enters the House* and of filtering "objective" subject matter through subjective "states of mind." Delaunay's quite different interest in color-based simultaneity was just then emerging; and in fact, the pervasiveness of this slippery word, "simultaneity," would soon lead to a merry brouhaha among these artists as to who had "invented" the concept. Fernand Léger was drawn to the Futurists' idea of how fast motion replaces our world of separate stable forms with one of flux and kinesthetic blur. He later wrote in a 1914 essay: "When one crosses a land-

scape in a car or a train, the landscape loses in descriptive value, but gains in synthetic value. . . . All this has influenced the condensation, variety and fragmentation of forms of the modern painting."[13] Virginia Spate points out that both Delaunay and Léger "had learned from their Futuristic experiments that it was *structure* rather than subject which embodies Simultanist experience. This realization was central to development of Orphism" (32).

Finally, the American painter Morgan Russell, then living in Paris, was deeply impressed by the Futurists' "political" identity: their group organization and flamboyant self-promotion. As Gail Levin writes:

> [The exhibition] undoubtedly provoked his own ambition. . . . Russell's interest in Futurism was such that he saved the catalogue, along with numerous other catalogues, manifestoes, and newspaper clippings about the movement. Futurism represented to Russell the kind of group solidarity to which [Robert] Henri had alluded [see epigraph, chapter 1] and suggested that Russell, too, might create a movement capable of influencing others. He set about inventing the new work necessary and finding the means to publicize his discovery. (16)

By June of the following year, he and Stanton MacDonald-Wright had formed both the style and the movement "Synchromism" for its inaugural exhibition in Munich.

For at least one modernist publicist with ambitions similar to Marinetti's, the exhibition—and indeed the whole Futurist movement up to that point— presented a range of subversive "marketing" strategies. Apollinaire the critic may have sniffed at Futurist presumptions; Apollinaire the publicist of the French avant-garde took careful note of the exhibition's political dimension, for what he wrote about Marinetti perfectly described his own ambitions: "He wants to be a reformer of the arts. . . . He has found a number of poets, musicians, and painters to follow him" (200-201). Even before the exhibition, in November 1911, Apollinaire had wryly noted the Futurists' penchant for using their fists to force the "admiration" of their audience (qtd. in Coen xxv) A full paragraph in one of his reviews of the exhibition describes the infamous Futurist evening of 8 March 1910 in Turin: "Together they read their manifesto, which according to their press release, 'is a great cry of revolt against academic art, against museums, against the domination of professors, archaeologists, second-hand merchants, and antique dealers.' At that point, a great uproar broke out in the theater. There were fist fights, duels with canes, the police were called, etc." (*Apollinaire on Art* 201). That Apollinaire understood the strategic value of these demonstrations is clear. He says of one Futurist manifesto: "[It can] by virtue of its violence, be considered a healthy stimulant for the debilitated artistic senses of the Italians" and the exhibition itself "will teach our own young painters to be even more bold than they have been up to now" (202, 204). Even if he could not resist taking the Futurists' bait—he rebukes their claims to leadership as "insolence that might aptly be called ignorance" and "sheer idiocy" (202)—Apollinaire absorbed their tactics and particularly Marinetti's promo-

tional strategies. By the end of 1912 he had moved beyond his semi-detached role of promoting Cubism and various French artists through his journalistic reviews and book, *The Cubist Painters: Aesthetic Meditations*, and had begun to campaign vigorously for a style he himself had named and indeed reified, "Orphism," and for its exponent, Robert Delaunay. Like Marinetti, Apollinaire wrote articles explaining the new style and its concept of Simultaneism; he accompanied Delaunay to Berlin for the latter's 1913 Sturm exhibition and lectured there; and he promoted the movement's expansion until he could claim its dominance of the 1913 *Indépendants* exhibition.

Finally, for a new breed of avant-garde impresarios the Futurist exhibition seemed like a gift-wrapped package of instant controversy that would attract thousands to their galleries. The Paris show produced an invitation from "[a] certain Mr. Meyer-See" to continue the exhibition in London at the Sackville Gallery.[14] Herwarth Walden also saw the show in Paris and felt it would be perfect for the new picture gallery he had opened in Berlin to complement his modernist newspaper, *Der Sturm*. A Brussels showing was also arranged, and one was planned for Amsterdam the following year. A particularly important invitation came late in 1912 from three Americans, Walter Pach, Arthur Davies, and Walt Kuhn, who were planning the first major American exhibition of modern painting for the following spring in New York—an invitation the Futurists declined for somewhat ambiguous reasons.[15] These cultural entrepreneurs, particularly Walden, helped turn the Futurists' one-city exhibition into an artistic juggernaut and a major European event.

Gaining momentum with its next two openings—London in March and Berlin in April—the fame and influence of the Futurist traveling exhibition grew steadily, then leveled off during the Brussels showing in May. Thereafter, it became a completely different show, and its impact and even its itinerary grow hazier. After the Brussels showing (and possibly even earlier), Herwarth Walden and Dr. Wolfgang Borchardt (who had purchased nearly the entire Berlin exhibition) not only took over arrangements for future exhibitions of *their* Futurist paintings, but did not even bother to inform the Futurists of these new showings.[16] Although the itinerary and composition of these showings have never been verified in their entirety, Futurist paintings were definitely exhibited in The Hague, Rotterdam, and Amsterdam over late summer and fall; in Cologne and Munich, and probably in Karlsruhe and Hamburg through late fall; and finally, in Vienna and probably in Zurich, Budapest, and Prague in the winter.[17] Marinetti, who left for the Balkans in October to cover the war as a journalist, no longer masterminded these shows, and as the Futurists themselves complained, the absence of his shock tactics probably weakened the impact of these exhibitions. Equally disturbing, the new impresarios "jumbled together the Futurists with the Expressionists and others who have nothing to do with our movement."[18] In any case, little is known about these later showings, and Paris, London, and Berlin remain the traveling exhibition's most influential locales.

In London, where it opened on 1 March, the exhibition drew large crowds and numerous reviews and articles—over 350, Marinetti boasted—typically

with such titles as "Nightmare Exhibition at the Sackville Gallery." As in Paris, only a few critics voiced hesitant, qualified praise: the painters were "sincere . . . [and] endowed with overabundant imagination," wrote one critic, while another, Max Rothschild, asserted that the Futurists' "song," even though harsh and discordant, showed "youth and originality" and therefore deserved "reasonable attention and criticism" (qtd. in Martin 121 n. 4). Most reviewers howled in outrage and derision, and a few newspapers featured cartoons parodying "The New Terror" (fig. 4). Marinetti skillfully fueled this controversy with provocative statements to reporters that praised London as a "Futurist City" with its illuminated billboards and speedy Underground. He also appealed directly to English painters to expand Futurism into a worldwide movement. As Richard Cork observes, "Marinetti was providing perfect copy for the London press, and the critics had a field day" (27).

Marinetti's lecture at Bechstein Hall on 19 March, "Futurist Art and Poetry," enjoyed a comparable success. In his bombastic style, he again praised London's technological modernity while lambasting English traditionalism. Significantly, he followed this rhetoric with an equally dramatic reading of his poetry. Very likely, these poems reflected the radical poetics Marinetti was then developing and would publish two months later—principles that freed words of their grammatical subservience to enable them to move about the page and recombine in spatial and syntactic freedom, which Marinetti titled "*parole-in-libertà*" and "*l'immaginazione-senza-fili*."[19] The audience reacted strongly: some "begged for mercy" from Marinetti's "impassioned torrent of words" (fig. 5); the *Times* reviewer called his doctrines "a morbid form of destructive revolution"; but others applauded.[20]

These Futurist fireworks gave a decided push to two young London artists, a poet and a painter, who were not only receptive to Futurism's radical aesthetics, but were also learning something from Marinetti about organizing and leading an avant-garde group. Although Ezra Pound probably did not attend Marinetti's lecture, he learned of it directly from Dorothy Shakespear, who did attend (*Letters* 90). Indeed, his omnivorous interest in modernism may well have led him to the exhibition itself, or at least to the newspapers that reviewed it and reproduced its manifestos. Shortly after the Futurist exhibition, Pound decided to do for a few young poets (Richard Aldington and Hilda Doolittle) what Marinetti had done for some young Italian painters: he organized them into a new group with an exotic name (*Les Imagistes*), a somewhat mysterious aesthetic credo ("the doctrine of the image"), and a leader—himself (fig. 6).[21] (Chapter 3 will analyze Pound's clever strategy to publicize the group and write its manifestos.)

In assuming the roles as group organizer, manifesto writer, publicist, and agent, Pound almost certainly followed Marinetti's prominent example. After all, Pound had been experimenting with Imagist techniques since 1909, when he attended meetings of those who had seceded from the Poets' Club. Why had he waited until the spring of 1912 to emerge suddenly as a leader of a new avant-garde group? Moreover, Pound's avant-garde demeanor was remarkably similar to Marinetti's: brash, arrogant, intentionally provocative, swaggering, self-

aggrandizing in his own messianic image, but also sincerely committed to promoting the careers of promising artists and to radically reforming the art.

Futurist aesthetics may also have encouraged Pound to see the image spatially as well as temporally. In the manifestos accompanying their London exhibition, the Futurists asserted that their "style of motion" liberated painting from "the fixed moment" and captured, instead, the unceasing fluidity of life, the intersecting of subjectively perceived impressions of present experience, which Boccioni called "the simultaneousness of states of mind in the work of art" ("Exhibitors," in Chipp 294-95). Pound, too, believed that in fusing objective and subjective experience into a "complex," the verbal image could transcend the temporal linearity of poetry: "It is the presentation of such a 'complex' instantaneously which gives that sense of sudden liberation: that sense of freedom from time limits and space limits; that sense of sudden growth" ("A Few Don'ts by an Imagiste," in *Poetry* 200). In describing the way Imagism operates, Pound's language became increasingly visual and spatial in the next two years. He spoke of the Imagist poem's "two halves" as "diverse planes . . . overlying each other in a certain manner" and the image as "the poem's pigment" (*Gaudier-Brzeska: A Memoir* 121, 86). Undoubtedly, Pound's close ties to the Vorticist artists in 1913-1914 primarily influenced this visual and spatial thinking; but his likely encounter with Marinetti's aesthetics of *parole-in-libertà* in 1912 may well have begun this process.

Like Pound, the young painter Wyndham Lewis (fig. 7) also took a leaf from Marinetti's leadership techniques, but Lewis's painting showed Futurist influence even sooner. *Smiling Woman Ascending a Stair* of 1911-1912 was stylistically as Cubist as any work displayed in the notorious *salle 41* of the 1911 *Indépendants*. Throughout 1912, however, as his figures grew machine-like, his form increasingly stressed dynamic tension along the diagonal as well as planar faceting, for example, *The Courtesan*. While it is certainly true that Lewis "had to reach a synthesis of his own" between the Cubist and Futurist dialectic (Cork 28), by the time he completed *The Vorticist* in 1912, his work "simultaneously escapes from the Parisian obsession with the studio and plunges wholeheartedly into the mainstream of twentieth century dynamism recommended by Futurism" (31).

Futurism's "political" influence on Lewis did not emerge until 1913, but it traces directly back to the 1912 Exhibition. As Richard Cork observes, the two types of influence, aesthetic and political, were really inextricable:

> It would be difficult to exaggerate the impetus which Lewis's yearning for revolt must now have been given by Futurism's first concerted onslaught on London. Until the Exhibition . . . his experience of the European avant-garde had been based almost exclusively upon works of art alone; but the Italians' activities proved to him that controversial new ideas could be effectively disseminated in other ways as well. For Futurist art was, from the outset, so inextricably tied up with a concerted polemical onslaught that the paintings themselves were overshadowed by the [movement's] inflammatory manifestos and public demonstrations. (26)

Not until the following year, however, did Lewis begin to emulate Marinetti's multiple roles and strategies, when he began to style himself as leader of several disaffected young painters in Roger Fry's Omega Workshops. As another member of this group, William Roberts, recalled: "It was the impact of the manifestos of the Italian Futurist poet Marinetti upon him, that made Lewis realize how valuable a manifesto of his own would be" (Cork 98). Lewis led the "rebel artists" out of Omega in 1913 and struggled to organize them into a group like the Futurists. (These efforts, which finally resulted in the English Vorticists, and his tangled relations with Marinetti will be studied in subsequent chapters.) In sum, the Futurists' impact on London painters and writers was unmistakable, indeed "hard to overestimate" (in Peter Nicholls' judgment): "The Futurists introduced London to a full panoply of avant-garde devices, promoting a scornful critique of conventional bourgeois art which outstripped anything that Pound and his associates had so far been able to muster" (172).

While Marinetti could not have known about his influence on Pound and Lewis in 1912, the Futurists were well aware of their artistic impact on Berlin, where the exhibition next opened on 12 April. Theirs was only the second show mounted in Herwarth Walden's new *Sturm* gallery, and the impresario took pains to make their arrival a major event. He had their two exhibition manifestos, as well as the Foundation Manifesto and Marinetti's "Futurist Poetry: Technical Manifesto,"[22] translated and printed in *Der Sturm*, and Marinetti once again distributed copies around the city. Walden also sponsored Marinetti's rousing lectures and reproduced Futurist paintings in his journal and in postcard form. The show was a huge sensation, as Nell Walden recalls: "Sometimes there were a thousand visitors per day. The press could complain as much as they wanted—which they did—but everyone wanted to see the exhibition. It was fashionable to have been there" (qtd. in Eliel 33).

Fashionable—and essential for the German avant-garde. Both in their generous praise of the exhibition, which Walden printed in *Der Sturm*, and in their art, German modernists registered the impact of Futurist ideas and techniques. Franz Marc's article, for example, borrows directly from Boccioni's titles and "The Exhibitors" manifesto: "When a window is opened, the total noise of the street, the movements and materiality of the objects outside enter the room." Like Wyndham Lewis, Marc now found himself drawn to Futurist dynamism to counterbalance the more static abstraction of Cubist analysis: "The connoisseurs speak of 'peinture' like the dog-breeders of pedigrees. This they may still find in Picasso but not in the Futurists. . . . Carrà, Boccioni and Severini will become milestones in the history of modern art. We shall envy Italy her sons and shall hang their works in our galleries" (qtd. in Selz, *German* 259). One can easily see Futurist influence on Marc's *Deer in a Monastery Garden* (1912), for example, where intersecting, straight-edged, diagonal planes and clashing reds and greens create a tense, angular dynamism that replaced the undulating lines and flowing curves of *Red Deer II* (1912).[23] Even at the time, critics noted this influence; Adolf Behne observed in 1913: "Merely the fact that such a sincere and fine artist as Franz Marc took over futurist elements in his paintings must convince

even the greatest skeptic of the stimulative value and the artistic significance of Futurism" (qtd. in Selz, *German* 261).

August Macke, who probably saw Walden's postcard reproductions that spring and the exhibition itself in Cologne the following autumn, also contrasted Futurism favorably to Cubism: "Modern painting can bypass these ideas even less than Picasso['s]" (qtd. in Vriesen 109). Though his work was less prone to Futurist influence than was Marc's, Macke entitled a 1913 pencil sketch of his wife *Futurist Heads (Elisabeth)*: it presents her face in overlapping, planar images (Meseure 48-49). For Ludwig Meidner, who saw the exhibition in Berlin, Futurism's embrace of the urban landscape struck a sympathetic chord. Although he later criticized Futurist painting as "shabby goods," Meidner admired the manifestos, and his 1914 essay, "An Introduction to Painting Big Cities," virtually plagiarizes Marinetti's prose and his famous preference (in the Foundation Manifesto) of a racing car to the *Victory of Samothrace*:

> Let's paint what is close to us, our city world! The wild streets, the elegance of iron suspension bridges, gas tanks which hang in white-cloud mountains, the roaring colors of buses and express locomotives, the rushing telephone wires (aren't they like music?). . . . Wouldn't the drama of a well-painted factory smokestack move us more deeply than all of Raphael's "Borgo Fires" and Battles of Constantine? (Qtd. in Eliel 35-36)

Another passage from Meidner's essay paraphrases an idea repeated often in the Futurists' Berlin manifestos: "A street is composed not of tonal values, but is a bombardment of whizzing rows of windows, of rushing beams of light between vehicles of many kinds, of a thousand leaping spheres, tatters of people, advertisements and droning, formless masses of color" (qtd. in Haxthausen 68). Equally important, the Futurists' sharp-angled dynamism and, in particular, Boccioni's eruptive intersecting of "outside" and "inside" in *The Street Enters the House* strongly influenced Meidner's tilting, collapsing, and exploding buildings in the series of urban apocalypses he began a few months later, in the summer of 1912, for example, *Apocalyptic Landscape*.

A distinctively urban dynamism was precisely what Ernst Ludwig Kirchner was striving for also. Since his move to Berlin six months before the Futurist exhibition, his painting was abandoning the fluid, curvilinear style of his Dresden work, for a tense angularity, with vertical forms crowding the picture plane. These spikey, packed figures gave his Berlin street scenes, particularly those depicting dressed-up ladies looking down at the viewer, a feeling of dense, urban bustle and anomie simultaneously. Essential to this new style, Kirchner later wrote, was a "perception of movement" that could not be captured mimetically: "If we see a modern metropolitan street at night with its thousands of light sources . . . we must realize that any objective construction is futile, since a passing taxi, a bright or dark evening dress transforms the entire . . . construction" (qtd. in Haxthausen 76). If Kirchner's prose (from the mid-1920s) seems Futurist-tinged, an autobiographical note about his stylistic intent in these years

leaves no doubt about his debt to Futurist aesthetics. Referring to himself in third person, Kirchner recalls:

> He discovered the feeling that pervades a city presented itself in the qualities of *lines of force*. In the way in which groups of persons configured themselves in the rush, in the trams, how they moved, this is how he found the means to capture what he experienced. There are pictures and prints in which a purely linear scaffolding with almost schematic figures nevertheless represents the life of the streets in the most vital way. (Qtd. in Haxthausen 76, my emphasis)

Although it would be an exaggeration to credit the Futurists for Kirchner's fascination with urban dynamism, the manifestos and canvases of their Berlin exhibition clearly provided him new ways to construe that dynamism.

Young German poets and writers—for example, August Stramm, Johannes Becher, and Döblin—also caught the Futurist fever. For Döblin, reviewing the show, the exhibition demonstrated that space in painting need not be limited to the canvas's two dimensions, but can have as many dimensions as a painter is capable of imagining (Selz, *German* 259). Futurist poetics were equally potent: in Gottfried Benn's view, Marinetti's manifestos on Futurist poetry had "incredible effects" on the younger poets (qtd. in Grimm and Schmidt 76). Not only did Marinetti urge that his modern gospel of speed and technology replace the "cliché-ridden" styles of the past, but his *parole-in-libertà* showed how the words and sounds themselves could be detached from the linear, progressive logic of the poetic line. August Stramm, on learning somewhat later of Marinetti's theories from Walden, "effected a total break with his previous development as a poet. . . . [and] created a style based on dissecting and reassembling the elements of language." Like Marinetti before him, Stramm felt that "a poet could do away with syntax and enrich his vocabulary, and that the fastest and most concise expression was the best" (Grimm and Schmidt 77). He applied these Futurist-inspired techniques of radical concision and concentration in his plays of 1914, *Kräfte* and *Geschehen*.

Beyond its stylistic influences, the exhibition of Italian modernists in Berlin reaffirmed for Marc, Macke, and Kandinsky a principle they were already practicing in selecting works for the Blaue Reiter and Sonderbund exhibitions and for the *Blaue Reiter Almanac*: that new ideas and styles in the arts paid no heed to national borders. Paradoxically, the Futurists themselves signified for other emerging groups precisely the opposite of this international spirit: a modernist microcosm of nationalism and imperialism. Yet the 1912 exhibition was by its very nature international and focused artists of different locales, media, and interests on this single galvanizing event. Moreover, in daring to act as a lightning rod to critical hostility and ridicule while boldly advancing their radical styles and theories, the Futurists lent considerable moral support to fellow artists embarked on their own avant-garde struggles against a hostile public. Like the Futurists, many of these German artists—Kandinsky, Marc, Macke, Meidner, and Kirchner—had formed their own avant-garde groups to defend, present, and

promulgate their art. The Futurist example of well-planned group events—promotional, confrontational, and artistic—offered much to emulate.

Responses similar to those in Berlin occurred in the other European cities where the exhibition appeared. In Brussels, a local Futurist claimed that it introduced "*un frisson nouveau*," while for August Joly, a Brussels critic, it offered "a more intense communion with . . . primitive forces" (Ray Nyst, Joly, qtd. in Martin, *Futurist Art* 121-22). Joly's own manifesto, "Le futurisme et la philosophie," appeared the same year, as did Futurist writings in several avant-garde Belgian journals (Lawton 5). Even when the exhibition itself did not travel to a capital, its manifestos and reproductions of its paintings often did, along with word-of-mouth descriptions of the events and reactions to them, all having an impact of their own. In Russia, Italian Futurism was known to avant-garde artists from its inception. Both its 1909 Foundation Manifesto and 1910 "Technical Manifesto of Painting" were quickly translated in *Apollon*, an art and literary magazine in St. Petersburg, which also printed a regular "letter from Italy" written by Futurist poet Paolo Buzzi. By the end of 1911, Igor Severyanin had named his new literary group, the "Ego-Futurists," and in April 1912—only two months after the Paris opening of the traveling exhibition—the *Union of Youth* magazine reprinted "The Exhibitors to the Public." Moreover, the artist, poet, and modernist rabble-rouser David Burliuk had almost certainly seen the exhibition while he traveled through Germany that spring, for he brought back photo reproductions of Futurist paintings (Douglas 231-232). Not surprisingly, Futurist influence appears directly in the new name Burliuk and his compatriots gave their group the following year—the "Cubo-Futurists"—and Marinetti's belligerent style and tactics are written all over the title of the first manifesto and almanac they published at the end of 1912: "A Slap in the Face of Public Taste."[24] Complementing Marinetti's manifesto title, "Let's Kill the Moonlight," the Cubo-Futurists entitled their major collaborative opera of 1913 *Victory over the Sun*.

The Italians asserted an even stronger influence on Mikhail Larionov, thoroughly informing his Rayism of 1912-1913. Larionov and Natalia Goncharova laid the groundwork for the movement in the June 1912 manifesto entitled "Luchism" (Dabrowski, "Formation" 200), then introduced the aesthetics of Rayism itself to the important Target exhibition of March 1913 in a manifesto written in Marinetti's exclamatory style and appropriately titled "Rayists and Futurists: A Manifesto." During this same exhibition, Larionov's close friend, the critic Ilya Zdanevich, lectured on "Marinetti's Futurism" and on "Futurism and Rayonism." Besides presenting selections from the Italian group's art, aesthetics, and manifestos, Zdanevich attacked the other Russian artists who had called themselves Futurists, but had failed "to bring art into life": Severyanin (Ego-Futurism) and Khlebnikov (Cubo-Futurism) (Douglas 233). In Larionov's early Rayist works, such as *The Glass* and *Rayist Sausage and Mackerel*, diagonal lines and clashing planes largely obscure the figures and create what the painters describe in their manifesto as "spatial forms arising from the intersection of the reflected rays of various objects" (qtd. in Bowlt, *Russian Art* 90). As Magdalena

Dabrowski notes, this dissolving of objects moved Larionov away from Cézannesque solidity and toward a Futurist-inspired dynamism ("Formation" 202).

Perhaps the strongest evidence of how profoundly the traveling Futurist exhibition affected various artists, and how it provided a militant model for fledgling groups and would-be leaders, is that its influence had to be repudiated almost as soon as these newer groups and leaders established themselves. The more powerfully and directly the groups felt this influence, the more vigorously they disclaimed it. And leaders of the new groups, who modeled their publicity tactics and aggressive styles on Marinetti's example, used those very methods to deny his influence. Inevitably, nationalist pride shaped these conflicts—an echo of the polarizing politics of Europe in 1912 and a partial contradiction to the exhibition's international implications.

Apollinaire, as noted above, needed no lessons from Marinetti in chauvinism and took every opportunity in his reviews of the Futurist exhibition to assert Parisian primacy. But as a would-be leader and publicist, he turned two of Marinetti's best publicity techniques against the master's own group by provoking it into a public quarrel over who had prior claim to Simultaneism and by issuing his own manifesto, "L'Anti-tradition futuriste," in May 1913. In its visual flashiness, categorical absolutism, and aphoristic humor, "L'Anti-tradition futuriste" outdid the Futurists' best efforts.[25] That manifesto, in turn, was plagiarized by the London Vorticists, who, in June 1914, launched an even bolder attack against Marinetti and Futurism in even larger boldface type in the first issue of their journal *BLAST*.

Russian modernists became almost as hostile to the Italian Futurists as they had been susceptible to their influence. Larionov, whose Rayist style, theory, and manifestos owed so much to Italian Futurism, understandably wanted neither his work nor his allegiance confused with the Italians, although he made such confusion possible by using both style names in an important manifesto. His case, in miniature, reflected the problem of Russian modernists who had linked their fledgling movements (at least in name) to the Italian Futurist juggernaut in 1911-1913. By 1914, as Charlotte Douglas observes, such Cubo-Futurists as Khlebnikov saw their work as pursuing aesthetic aims quite different from those of the Italians and greeted Marinetti's recruiting visit in January 1914 with suspicion and hostility. Marinetti, whose ideas had been "a viable force . . . since the middle of 1912 . . . was perceived [in 1914], not as a bearer of news from the West, but as a competitor who was trying to peddle, with great fanfare, ideas already slightly passé" (239). Thus, in less than two years, the Italian Futurists had become victims of their own international success of 1912. The fledgling groups they helped inspire (but also threatened to annex) now turned their own tactics on the Italians in order to assert their separate identities and aesthetics.

In retrospect, the Futurists' 1912 exhibition was a paradigm of the art-politics of prewar modernism. The exhibition's wide-ranging impact went far beyond its daring paintings and owed much to Marinetti's genius for publicity, to the group's provocative gestures, and especially to the controversial ideas and

identity it presented through its manifestos, which, in Peter Nicholls's view, "would constitute a guide to almost every aspect of avant-garde activity to come" (*Modernisms* 84). Through all of these media the Futurists presented themselves as the shock troops of the avant-garde who enjoyed outraging the public, baiting the critics, and challenging fellow modernists. Their multifaceted assault reflected Marinetti's strategic planning, diligent effort, and excellent coordination that enabled all of these tactics to reinforce each other synergistically. The result was not merely a "hullo-bulloo," as the Vorticists claimed, but the international emergence of a well-organized, highly self-conscious avant-garde group, possessed of a clearly articulated program and led by a mastermind of public outrage: "the caffeine of Europe."

The sparks given off by this exhibition started numerous brushfires as new groups, new artist-leaders, and new impresarios adopted Futurist aesthetics and publicity techniques: the Imagists, the Vorticists, the Rayists, and the Cubo-Futurists. Already extant groups like the Blaue Reiter, Die Pathetiker, and the poets affiliated with *Der Sturm* took comfort in the Futurists' confrontational style. For a brief moment the exhibition served to inspire and link separate avant-garde movements all over Europe, as "young artists and intellectuals welcomed the Italians as fellow rebels, or examples" (Martin, *Futurist Art* 121). But as these groups asserted their own identities, they inevitably repudiated Futurist influence and vigorously resisted Futurist efforts to incorporate them. Such internecine combats within modernism, however, only reaffirmed the basic terms of Futurism's political influence: the organized group, the dynamic leader, the provocative media, the combative tactics, the belligerent stance. Beyond its stylistic influence, therefore, the 1912 exhibition stands out as both exemplar and catalyst of the art-politics of prewar modernism.

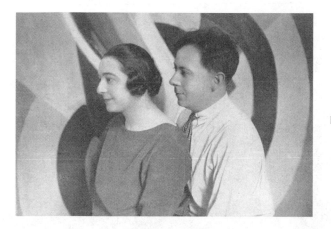

"Orphists" Sonia and Robert Delaunay.

The Italian Futurists outside Bernheim-Jeune Gallery, Paris, February 1912: (from left) Luigi Russoli, Carlo Carrà, Felippo Marinetti, Umberto Boccioni, Gino Severini.

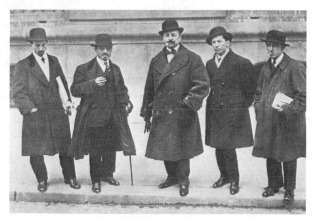

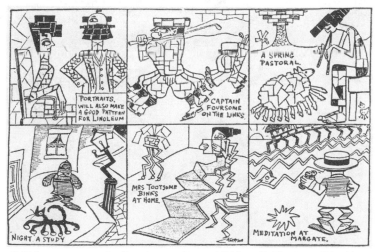

British response to the Futurist traveling exhibition: C. Harrison, "The New Terror." Cartoon in *The Daily Express*, 4 March 1912.

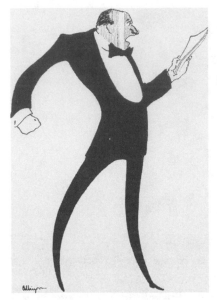

Adrian Allison, "Marinetti Reading One of His Restful Futurist Poems," 1913-14. Ink drawing, 25 x 19 cm., private collection.

Wyndham Lewis. Photo in *Daily News and Leader*, 7 April 1914.

Henri Gaudier-Brzeska, *Study for Bust of Ezra Pound*, 1914. Ink drawing, 49.5 x 37 cm., private collection.

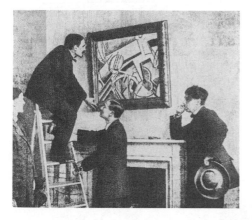

The Vorticists hanging a painting at the Rebel Art Centre: (from left) Cuthbert Hamilton, Edward Wadsworth, Christopher Nevinson, Wyndham Lewis. Photo in *London Daily Mirror*, 30 March 1914.

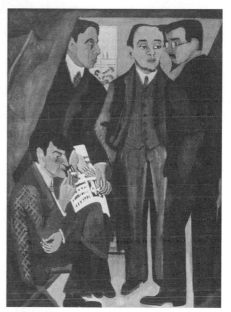

Ernst Ludwig Kirchner, *The Painters of Die Brücke*, 1925-26 (from left: Otto Müller, Kirchner, Erich Heckel, Karl Schmidt-Rottluff). Oil on canvas, Rheinisches Bildarchiv Köln.

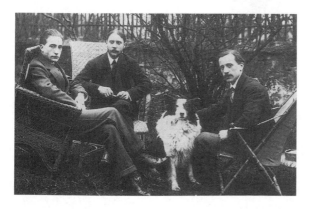

The Puteaux Cubists, 1912: (from left) Marcel Duchamp, Jacques Villon, Raymond Duchamp-Villon.

Chapter 1

The Modernist Group:
A Taxonomy and Rationale

These cults—these "movements" are absolutely necessary or at any
rate their causes are—for somewhere in their centres are the ones
who bear the *Idea*.
　　　　　—Robert Henri, letter to Morgan Russell, 2 May 1910

[W]e discovered each other seriously [at the Autumn Salon], . . .
[and] realized what we had in common. The necessity of forming a
group, of frequenting each other, of exchanging ideas seemed impera-
tive.
　　　　　—Albert Gleizes, on forming Cubist groups (October
　　　　　1910), *Souvenirs*, qtd. in Golding 25

These minor, barely remembered groups . . .
　　　　　—*Oxford Companion to French Literature* 418

If the example of the Italian Futurists suggests that the years immediately pre-
ceding World War I were "the age of the group" for modernist poets, painters,
and composers, then this social phenomenon requires a close examination in its
own right if we are to understand its influence on prewar modernism. Several
questions must be addressed: What constitutes a modernist group? What kinds
existed? How did they function? What were their demographics geographically
and among the different arts? Most important, why did artists form and join
them? What were their particular appeals to artists—and their perceived dan-
gers? And how did their existence not merely parallel, but help facilitate the
astonishing artistic achievements of this period?

I. Defining the Group

First, we need a working definition. What criteria determine a "group" in ways
that are relevant to the historical context of prewar modernism (and, not inciden-
tally, in ways that make an analysis of this kind numerically manageable)?

Clearly, size alone is no criterion.[1] The American painters Morgan Russell and Stanton MacDonald-Wright, then living in Paris, formed a bona fide group, the Synchromists, complete with manifestos, exhibitions of their work, and, most important, a distinct aesthetic philosophy and style to set them apart from their nearest competitors, the Orphists. Less definitively, Picasso and Braque, in their close working relationship between 1908 and 1914, can also be construed as a group. Although he painted alone throughout his career, Picasso worked so closely with Braque in coinventing their Cubist styles between 1908 and 1914, that, as he later acknowledged, at times they could not tell whose paintings were whose. Braque recalled that in these years "We saw each other every day and talked a lot."[2] He continues elsewhere: "We compared our ideas, our paintings, and our techniques. What occasionally set us against each other was always quick to bear fruit for both of us. Our friendship, therefore, always turned a profit. . . . It was a union based on the independence of each."[3] Picasso's description of the friendship to Françoise Gilot corroborates Braque's recollection: "Almost every evening, either I went to Braque's studio or Braque came to mine. Each of us *had* to see what the other had done during the day."[4] Braque provided the perfect image of this interrelated quest, in which each pulled up the other: they were "two mountaineers roped together."[5]

At the other end of the size continuum, Gertrude Stein's salon, through which passed hundreds of artists, was too amorphous to qualify as a group; yet Mabel Dodge's salon could arguably be called one. Why? Three loose criteria help define this elusive and somewhat subjectively perceived phenomenon.

First, belonging to a group, participating in its activities, shaping and sharing its aesthetic philosophy should contribute significantly to the creatively identity and achievement of its members. Reciprocally, what the individual members produce or enact should reflect something of the group's collective philosophy or aesthetics.

Second, the group should have a kind of collective consciousness, a sense of itself as a group. This identity presumes a sense of boundaries, however loosely observed—membership boundaries: such-and-such an artist does (or does not) "belong" to the group with some degree of adherence; aesthetic boundaries: by common consent, the group concerns itself with, even promulgates, these (not those) aesthetic issues or principles; and programmatic boundaries: the group exists to undertake these (not those) activities.

My third criterion frankly arises from the practical exigencies of this study: the group should continue beyond the single event that occasioned it. Innumerable small groups arose in those years to achieve a single goal, for example, to organize one exhibition or to collaborate on one project. Work completed, the union dissolves. The most common of such one-time collaborations typically occurred between individual painters and poets, for example, Picasso creating etchings for Max Jacob's book of poems *Le Siège de Jérusalem* in late 1913. Such collaborations, in which one art responds to or interprets another, not only produced significant works, but also showed how closely entwined painters and poets were in this period. As the Swiss poet Blaise Cendrars describes it: "During this epoch [1910-1914], about 1911, the painters and writers were the same.

They lived mixed up with each other" (qtd. in Arthur Cohen 6). In fact, Cendrars and Sonia Delaunay formed what is arguably the most important of these collaborations in early 1913, producing Cendrars's long poem *La Prose du Transsibérien et de la petite Jehanne de France* alongside and interlocking with the abstract color design that Sonia Delaunay created as an "impression of the poem."[6] Russian Futurist painters too worked closely with their poet counterparts, frequently illustrating their small books of poems with appropriately abstract designs. Malevich designed the covers for Kruchenykh's 1913 *The Word as Such*; Filonov illustrated Khlebnikov's *The Wooden Idols* (1914); and several painters (Malevich, Rozanova, and Kulbin) and even the poet Kruchenykh himself contributed drawings to his booklet *Explodity* (1913). Beyond the individual works they produced, these collaborations sometimes did fulfill my first criterion for a group, by significantly influencing the participants' creative work and identity. Arthur Cohen notes the fruitful results of one such interaction: "The infusion of Apollinaire and Cendrars into the lives of the Delaunays was as significant to the unfolding of Sonia's art as it was to Robert's. The poets provided occasions for the painters; the painters afforded the poets pretexts" (6).

Most such collaborations, however, were ephemeral: two artists come together temporarily to work on a finite project; they maintain their individual identities while collaborating; and, having finished, continue on their separate trajectories. Indeed, with such brief life spans, these collaborations rarely achieve my second criterion of developing a sense of group consciousness, much less a group aesthetics. The performance group Ballets Russes was a major exception. While the collaborators, and particularly the composers, of the various ballets varied, the group's impresario and artistic director, Serge Diaghilev, imposed aesthetic continuity on the ballet's productions with his definite, avant-garde ideas about choreography and scenic design. Thus, at least until May 1912, an audience attending a Ballets Russes production knew pretty much what to expect.

Divided between the artistic truth that ephemeral collaborations in these years often produced significant works well worth studying and the practical reality that to include these collaborations would make a study of modernist groups unmanageable, I have attempted to strike a compromise by excluding such collaborations from my analytical study unless they meet all three of the criteria above, but noting them wherever possible in my time line (appendix 1).

These criteria come into sharper focus if we return to the question of the salon—and locales generally—qualifying for group status. The salon's amorphous nature, with changing visitors and discussion topics, and its predominant purpose of enabling artists and others to socialize, rather than to fashion a shared aesthetics and present resulting works to the public, would seem to disqualify it outright. Certainly, amorphousness fits and thus disqualifies the most famous salon of the period, Gertrude Stein's in Paris. At her "Saturday nights," the guests changed each week and discussion was variable and unstructured. While many visitors' creativity undoubtedly benefited from the lively conversation and even more from Stein's superb collection of avant-garde painting, such benefits were adventitious, dispersed, and difficult to determine.

By contrast, Mabel Dodge's salon in New York during 1913-1914 does qualify as a group.[7] While the cast of characters varied, a core of radical artists, journalists, and political organizers returned regularly. Discussion topics varied, but virtually all addressed relationships among radical aesthetics, leftist politics, new psychological theories, and personal freedom. The discussions were also more structured and focused than those at Stein's salon, reminiscent of some famous nineteenth-century salons. Finally, Dodge's salon did produce a work of its own: the Paterson Strike Pageant of 1913—an embodiment of this salon's characteristic crossing radical politics and art. (Chapter 2 will discuss her salon in more detail.)

A modicum of cohesiveness and consistency of purpose is thus necessary to be designated a "group." Although a group might be identified by its locale, for example, the Puteaux group, locale alone does not make a group. The "Chicago School" (or "Chicago Renaissance"), for example, was far too loosely constructed and disunited to qualify as a locale group.[8] When examined closely, the participants did not form a cohesive group, but rather engaged in several quite separate enterprises (two poetry journals, a literary review in a newspaper, novels, poetry, etc.), which were loosely linked by social relationships and a vaguely shared interest in contemporary theories of art and psychology. By contrast, the "Second Vienna School" was a tightly knit mini- (or "nucleus") group, comprised of pedagogue-leader Arnold Schoenberg and his two student disciples-cum-colleagues, Alban Berg and Anton Webern. All three composers collaborated in developing a major formal innovation—pantonality—and mutually assisted each other in getting their works performed.

Cafés were another locale central to modernism—a home away from home for young artists, as several attested to: "They served as our exchange-offices of ideas and plans, of intellectual interchange, even of ruin. Here we debated and attacked with our critical swords" (Max Krell, qtd. in Allen 24-25). But only discernible groups meeting at cafés to plan or work on their collective projects, such as Franz Pfemfert's *Die Aktion* group, which did much of the journal's writing and editing at Berlin's Café des Westens, will be studied below, not the cafés themselves. Locale provides the venue and perhaps a means of identification, but the group meeting there must do more than socialize.

II. Modernist Groups 1910-1914: A Taxonomy

To facilitate analyzing and comparing modernist groups before the war, we can place them into five broad categories: (1) "full-fledged" groups that were highly organized, genuinely collective, and whose members possessed a distinct group identity; (2) "nucleus" groups comprised of a few key organizers with either no other members or an unstable periphery of affiliates; (3) medium and locale groups organized around either an ongoing medium, typically a journal or gallery, or around a favorite meeting spot like a salon, or both; (4) exhibition and concert groups formed to hold these events and typically continuing on to plan subsequent activities; and (5) performance groups (see table 1.1).[9]

Table 1.1. Types of Modernist Groups 1910-1914

Full-fledged	Nucleus	Medium/Locale	Exhibition/Concert	Performance
Italian Futurists	Blaue Reiter (Munich)	*Der Sturm* (Berlin)	NKV-Munich	Ballets Russes (Paris)
Die Brücke (Berlin)	Second Vienna School	*Die Aktion* (Berlin)	Neue Secession (Berlin)	Neopathet-isches cabaret (Berlin)
Cubo-Futurists (Moscow)	Rayists (Moscow)	Der neue Club (Berlin)	Akademischer Verband (Vienna)	Der literar-isches Club Gnu (Berlin)
	Ego-Futurists (Moscow)	*Pan* (Berlin)	Neukunstgruppe (Vienna)	
	Mezzanine (Moscow)	Das neue Pa-thos (Berlin)	Jack of Diamonds (Moscow)	
	Centrifuge (Moscow)	Meyer Circle (Berlin)	Union of Youth (St. Petersburg)	
	Imagists (London)	Arconauts (Prague)	Donkey's Tail/ Target (Moscow)	
	Vorticists (London)	Mercereau group (Paris)	Triangle group (St. Petersburg)	
	Picasso-Braque (Paris)	Cubist school groups (Paris)	Mánes Union of Artists (Prague)	
	Orphists (Paris)	*Montjoie!* circle (Paris)	Group of Plastic Artists (Prague)	
	Unanimists (Paris)	Stieglitz circle (New York)	Assoc. of American Painters & Sculp-tors (New York)	

Table 1.1—Continued

Full-fledged	Nucleus	Medium/Locale	Exhibition/Concert	Performance
	Simultaneistes (Paris)	Mabel Dodge salon (New York)		
	Dramatistes (Paris)			
	Paroxystes (Paris)			
	Fantaistes (Paris)			
	Synchromists (Paris-New York)			

A. The Full-Fledged Group

The groups one most readily thinks of in this period are those whose members thought of themselves as a group, who worked together, collectively exhibiting their paintings, publishing their poems, getting their compositions performed, and guided their work by aesthetic principles they collectively developed and published. The Italian Futurists embodied these qualities beyond all other prewar groups, but one can also see these criteria in a group that had formed earlier and was already beginning to dissolve in the prewar years: Die Brücke. Each group had a distinctively collective consciousness. Marinetti proposed to the other Futurists various artists for membership; Die Brücke (fig. 8) invited artists like Emil Nolde to join and later "expelled" a member, Max Pechstein, for violating the group's agreement about not exhibiting separately.[10] Both groups evolved an aesthetic philosophy that they published in manifestos. Members in both groups worked together—the Brücke painters even lived communally for a time. And while stylistic differences can always be discerned among the members' works, the artists nonetheless shared stylistic features that marked their painting as being Italian Futurist or from Die Brücke. Developing their aesthetic positions and expressing them publicly intensified their group consciousness. As Marianne Martin says of the Futurists during their formative years: "In Milan the interchange of ideas became so vigorous that by the end of 1911 it was difficult to single out one originator of the artistic vocabulary, though individual modes of expression remained as distinct as before. The

painters' physical proximity and enthusiastic participation in Marinetti's tumul-
tuous campaigns generated and heightened *esprit de corps*" (*Futurist Art* 9).

Merely proclaiming this cohesion, however, does not entitle a group to this
category. Like the Italian Futurists on whom they modeled themselves, the Eng-
lish Vorticists held group exhibitions and wrote manifestos, as well as publish-
ing a memorable magazine, *BLAST*. Coupled with a brilliant publicity campaign,
these achievements made them a prominent avant-garde group in 1914. But their
cohesion as a group was a fiction resulting primarily from Wyndham Lewis's
ambition to become an English Marinetti. The preceding fall, he had led the core
of the group—Edward Wadsworth, Frederick Etchells, and Cuthbert Hamilton—
out of Roger Fry's Omega Workshops, which these "rebel artists," as they now
called themselves, found both too stodgy and, in its collectivist organization, too
anonymous. Driven by purely political ambition, Lewis then tried to build this
core into a highly visible group:

> I assumed . . . [at the time] that artists always formed militant groups.
> I supposed they had to do this, seeing how "bourgeois" all Publics
> were or all Publics of which I had any experience. And I concluded
> that as a matter of course some romantic figure must always emerge,
> to captain the "group." Like myself! How otherwise could a "group"
> get about and above all *talk*? For it had to have a mouthpiece didn't
> it? (*Blasting and Bombardiering* 46)

Together with Ezra Pound and the sculptor Gaudier-Brzeska, Lewis fash-
ioned a vague aesthetics of energy as the group's philosophical basis, symbol-
ized by the vortex, the point of maximum energy in conical motion. But the idea
was too metaphorical to provide a practical aesthetics for unifying these stylisti-
cally diverse artists. Thus, Vorticism produced no distinctive, recognizable style
of its own. Nor was it clear that the artists really wanted to be organized. As
Richard Cork observes: "The English rebels were a heterogeneous collection of
personalities, ambitious and combative enough to make a stand against the exist-
ing art establishment, but neither ready nor willing [in spring 1914] to commit
their separate identities to the kind of group that Lewis tried so energetically to
foster" (vol. 1, 230). Noel Stock, Pound's biographer, is even blunter: "There
were, in fact, no Vorticists except Wyndham Lewis" (165). When these "hetero-
geneous" artists finally did declare themselves a group (fig. 9), it was only to
prevent another leader, Marinetti, from annexing them as Futurists. The group's
questionable authenticity has even led some scholars to underestimate London's
contribution the prewar avant-garde as (in Peter Nicholls's phrase) "moments
rather than movements" (166).

B. The Nucleus Group

The Vorticists were essentially a "nucleus" group, that is, a group having a
central core of organizers—the "ur-group"—and either no other members or a
loose periphery of associates (usually recruited by the organizers) with widely
varying degrees of commitment to and shared interests in the group. The best
example of a nucleus group is the Blaue Reiter. Kandinsky later asserted: "There

never really was a Blue Rider society, not even a group, as is often incorrectly stated."[11] Even today, art historians define it with difficulty: was its identity located in its organizers, Wassily Kandinsky and Franz Marc; in its media, the *Blaue Reiter Almanac* and the two Blaue Reiter exhibitions; or in its rather amorphous philosophy and practice, which, as Peter Selz summarizes, "established connections among artists in all countries working in new directions and broke through periods and genres, searching solely for the inner spirit that motivated the result" (*Art* 84)? Essentially, Kandinsky and Marc *were* the group; affiliate "members" like August Macke, Paul Klee, Arnold Schoenberg, and Gabriele Münter shared the group's philosophy in varying degrees, or its labors, or both.[12] Macke assumed a far less mystical view of the enterprise than did its founders, for example, but provided useful assistance and, not least important, a patron for the almanac and exhibitions, Bernhard Koehler. Schoenberg's philosophical views, on the other hand, were remarkably similar to Kandinsky's; but aside from providing material for the *Almanac* and paintings for the exhibitions, he played no active role in organizing the exhibitions or editing the journal.

Nucleus groups shifted and reformed as often as their founders and core members changed directions or acquired new adherents. Mikhail Larionov, for example, restlessly joined or formed groups, only to leave them abruptly and start new ones. A cofounder of the exhibition group the Jack of Diamonds in 1910, he and Natalia Goncharova left it in a public huff two years later to form their own exhibition group, the Donkey's Tail and (the following year) the Target. At the same time, they called their aesthetic and stylistic alliance first "Ghouls," then "Rayism," the latter naming a definite style and several manifestos of aesthetics. Still unsatisfied, Larionov changed his nucleus group's name to the amorphous "Everythingists" in December 1913, while briefly allying himself with, then opposing, Burliuk's Cubo-Futurists.

Although the nucleus group obviously had fewer resources to draw on (unless it assembled peripheral members for this purpose, as did the Blaue Reiter), its core members often accomplished as much as the full-fledged group. Ideological commitment was typically strong and consistent among these founder-members. Larionov and Goncharova, as noted, published several widely read manifestos from 1911 through 1913; they organized two major exhibitions, "The Donkey's Tail" (1912) and "The Target" (1913), had several large one-artist shows in Moscow and St. Petersburg and a major joint exhibition in Paris (1914); and, most important, they produced a significant style that synthesized Futurist dynamism and Delaunayesque simultaneity of color and light, and that moved Russian modernist painting into complete abstraction.

Similarly, as the nucleus group called the Second Vienna School (comprised of the composer-teacher Arnold Schoenberg and his brilliant student-disciples Anton Webern and Alban Berg) outgrew its pedagogical structure that elevated Schoenberg as *Der Meister*, the three composed major works that developed Schoenberg's pantonal ideas. As will be shown in chapter 2, they also helped each other get their works published and performed. Despite a school's

conservative stereotype, *this* classroom saw both pupils and teacher work closely together to subvert the prevailing tonal system in Western music.[13]

C1. The Medium Group

Nucleus ur-groups tended to be highly unified, but groups were looser ideologically and stylistically when they formed around a medium: a little magazine or newspaper, such as Herwarth Walden's *Der Sturm* or Franz Pfemfert's *Die Aktion* in Berlin, or a gallery, like Alfred Stieglitz's Photo-Secession ("291") Gallery in New York.[14] The founders' names preceding the enterprises suggest that *they* provided the group's unity through the magazine's published platform and contents, the gallery's catalogue statements and selection of artists. Contributors to Franz Pfemfert's *Die Aktion*, like Georg Heym and Jakob van Hoddis and over a dozen others not only met and worked together at the Café des Westens, but subscribed (in varying degrees) to the newspaper's clearly stated position of leftist-anarchist political activism and avant-garde art.[15] Pfemfert was first to publish van Hoddis's "World's End," an apocalyptic poem that describes the doom of bourgeois society in juxtaposed images of foreboding, horror, and humor, and has often been called the first Expressionist poem.[16]

While leaders like Walden and Stieglitz could insure that their medium maintained aesthetic and ideological consistency through their own operational control, they could not (and probably did not wish to) impose comparable consistency on the group that formed around this medium. The core artists that formed Stieglitz's 291 circle from 1909 to 1914—Dove, Marin, Walkowitz, Hartley, and Weber (several of whom meeting daily for lunch with Stieglitz)—obviously shared his commitment to modernism, his openness to abstraction. But each, encouraged by Stieglitz, developed his own unmistakable style, and no "291" style issued from the Stieglitz group. Even so, Stieglitz's visionary commitment to their art and well-being provided these artists a unifying spirit.

C2. The Locale Group

As its name denotes, this group defines itself by the locale where it meets: clubs, cabarets, cafés, salons. But as was asserted above, locale alone is not enough to define a group; participants needed to feel a sense of cohesion and shared purpose. Often the locale provided a venue for artists to present their work, as when Der neue Club sponsored regular "recitals" for poets at its Neopathetisches Cabaret; or it simply provided a comfortable setting for a particular circle of artists to socialize, discuss matters of common interest, and plan some collective action, such as Jacques Villon's studio in Puteaux or Mabel Dodge's salon in Manhattan.

Case Study: Der neue Club of Berlin

Although many cafés and galleries sponsored poetry readings, Der neue Club was special in having a regular circle of members for hosting these events and attracting audiences. Organized in March 1909 by Kurt Hiller and Jakob van Hoddis, the club dedicated itself to providing young poets (particularly its members) the opportunity to read their work before sympathetic and intelligent audi-

ences and to receive encouragement, constructive criticism, and friendship. To that end its leaders organized and advertised recitals at its Neopathetisches Cabaret featuring three or four poets reading their work. Hundreds attended.

Like so many of these modernist enterprises, the Club was not merely a neutral venue for these readings, but had a distinctly social and aesthetic orientation reflected in the poets it sponsored. Socially, the members were "united by their mutual opposition" to the apathy and decadence of the Wilhelmine era; aesthetically, they promulgated in their poetry the *"neues pathos"*—a synthesis of intellect and emotion.[17]

Although the organizers split apart a few years later (Hiller and allies forming another such club), Der neue Club provided a haven to fledgling poets like Georg Heym, Ernst Blass, Ferdinand Hardekopf, Rudolph Blümner, and many others. Its effect on Georg Heym in 1910, in particular, has been noted by several contemporaries and historians:

> Heym, who read poetry very badly . . . would never have been heard in the Berlin of those days if he had not found friends who propelled him almost by force into the limelight. Kurt Hiller and his New Club did just this. They forced Berlin to listen to Heym.
> (Heinrich Jacob, "Prewar Writing and the Atmosphere in Berlin"; rpt. in Raabe, *Era* 20)
>
> Heym was accepted into the club immediately. His quick reflex action changed the content and form of his poetry, and changed him, too. The "mask" of the "robust fellow," with which he entered the club . . . ceased to be merely a mask: his ostentatious robustness, tempered by an air of self-irony, becomes [sic] second nature to him.
> (Erwin Loewenson)[18]

As Roy Allen observes, the support Heym gained from this group enabled him to find his own poetic voice. It also helped place him in the forefront of Berlin Expressionist poets by providing him close ties to the Walden and Pfemfert circles (79-81).

Case Study: The Puteaux Group of the "Cubist School"

Between the locale groups with a distinct mission, like Der neue Club, and those existing entirely for socializing and discussion, the salons, were a wide range of groups that intermingled abstract ideas and practical actions. The Puteaux group is an especially good example, showing the powerful appeal of these locale groups in the prewar years and their ability to bring diverse artists together to discuss a plethora of common interests. Comprised primarily of the "Cubist School" painters and secondarily of sympathetic writers and art critics, this large group met Sunday afternoons at Jacques Villon's studio in the Paris suburb of Puteaux from the winter of 1911 through 1914. Their discussions ranged from the technical—for example, the coloristic and kinetic potential of Cubism—to the abstruse: how fourth-dimensional mathematical theories might be applied to painting.[19]

Structurally, the Puteaux group consolidated several smaller groups of artists and writers interested in Cubism (see appendix 2), and a brief look at these connections reveals how prolifically groups formed and reformed in these years. At the Paris Automne Salon of 1910, several painters (Le Fauconnier, Léger, Metzinger, and Gleizes) discovered that they shared stylistic interests derived from Cézanne's planarism and (for Metzinger) radically developed in the early Cubism of Picasso and Braque. As Albert Gleizes recalled: "It was at this moment . . . that we discovered each other seriously, . . . [and] realized what we had in common. The necessity of forming a group, of frequenting each other, of exchanging ideas seemed imperative" (*Souvenirs*; qtd. in Golding 25).

In fact, they formed several overlapping groups, meeting in different locales. One group met at the studio of Henri le Fauconnier, where Léger, the Delaunays, Gleizes, Metzinger, and the Unanimist poet Jules Romains could observe the progress of Le Fauconnier's large canvas, *Abundance*, which promised to be a major work at the 1911 Indépendants Salon (Spate 17-18). At the same time, these artists and Roger de La Fresnaye had been meeting at the apartment of Alexandre Mercereau, a writer whom Marinetti called "the Central Electric of European letters" (Altshuler 26) because of his uncanny ability to be the energizing nexus of various avant-garde groups. Mercereau, for example, had resided with Gleizes a few years earlier at L'Abbaye de Créteil, a commune of writers and artists. Among the books published by the Abbaye was Romains's influential *La vie unanime* (prompting critics to label the Abbaye's poets as Unanimists). Other Abbaye members and published poets were Henri Martin Barzun and René Arcos. Mercereau interested all these poets in Cubism and brought them on occasion to the painters' gatherings.

A particularly important meeting place during the winter of 1910 was the Closerie des Lilas, where the painters mentioned above (especially Gleizes) met with the art critics Guillaume Apollinaire, Roger Allard, and André Salmon—all keenly interested in how these painters were evolving into a group. Within a year, Apollinaire would dub these loosely connected painters a "school," and thus they are still known today.[20] At the Closerie, the critics discussed with the painters how they could exhibit together at the spring 1911 Indépendants exhibition—the trick was to elect their own slate for the Salon's hanging committee. They solved the problem by stuffing the ballot box.

Another major subgroup of Puteaux comprised the hosts—the Duchamp brothers (painters Marcel Duchamp and Jacques Villon and architect and designer Raymond Duchamp-Villon [fig. 10])—as well as Francis Picabia—all formerly of the Société Normande de Peinture Moderne and all exhibiting at the 1911 Automne Salon. When the Duchamp group discovered the stylistic interests it shared with the Gleizes-Le Fauconnier groups at the Salon, the groups more or less agreed to start meeting together in Puteaux at Jacques Villon's studio. These Sunday afternoons were also joined by Villon's neighbor, the painter František Kupka, the writer and art critic Maurice Raynal, as well as Apollinaire and other critics, and the theoretically oriented actuary, Maurice Princet, whose knowledge of fourth-dimensional mathematical theories the Duchamp brothers and Apollinaire readily applied to Cubist painting. As one participant recalled:

"We would meet on a fixed day, every week, happy to paint, happy to talk about painting, happy with our friendship, happy to live life to the full. For me, the experience began around 1909 and lasted until just before the war."[21] The stage was now set for planning what would become the most important collective showing of Cubist painters before the war, the "Section d'Or" exhibition of October 1912.[22]

As much as these artists shared a practical and theoretical interest in Cubism, a glance at their various styles quickly dispels the notion that they evolved a common style or expressed a unified aesthetics. By the time of the Section d'Or exhibition, for example, Marcel Duchamp had already passed beyond his dynamic Cubist style and was considering withdrawing from the group, even from painting altogether.[23] Kupka, a stylistic iconoclast, had little in common with the others. Léger, too, had already evolved an inimitable style, likewise Delaunay, who soon disaffiliated for that reason. And those still exploring Cubist possibilities—Villon, Gleizes, Metzinger, Le Fauconnier, and de la Fresnaye—pursued markedly different stylistic paths.[24] Thus, the Section d'Or Exhibition "was intended to encompass all [of these] . . . tendencies" and has subsequently been construed to have been as much opposed to the Picasso-Braque version of Cubism as an extension of it: "Duchamp and Picabia wished to express inner subjective experience, while Delaunay and Léger were more interested in embodying sensation" (Spate 36). Not surprisingly, the group did not mount another major exhibition. Nevertheless, it and its subgroups were extremely important not only in the ways their discussions influenced the members' individual styles, their ideas about Cubism, and their concept of themselves *as* Cubists, but also in the way their collective exhibitions established Cubism in the public's consciousness.

D. The Exhibition or Concert Group

Had the Puteaux group formed only to organize the Section d'Or and broken up immediately thereafter, it would fall outside the criteria for this study. Many groups that assembled to mount a single exhibition or concert, however, continued on afterward to stage new events or to expand and diversify their efforts, becoming important facilitators of modernism in their city. Such groups include: the Jack of Diamonds in Moscow, the Union of Youth in St. Petersburg, the Mánes Union of Artists in Prague, the various Secession and Neue Secession groups in Berlin, Vienna, and Munich, the NKV-Munich, and the Akademischer Verband in Vienna, which sponsored concerts of modern music.

These groups made no pretense of asserting a unified aesthetics or style (although the NKV-Munich's aesthetic position, as shaped by Kandinsky and Jawlensky, comes close to achieving this unity); indeed, these groups often sought to present as wide a variety of modernist styles as they could find. For this very reason, they were crucial to the cultural life of their cities, especially in providing opportunities for modernists of all stripes to get their work before the public. For example, the Union of Youth, from its founding in 1909, organized exhibitions, lectures, and debates; published its own journal and its members' books; and attempted, in John Bowlt's words, "to unite talents of young writers,

painters, musicians, and critics under . . . a single cultural organization" (*Russian Modernism* 168). A glance at their productions listed in appendix 2 reveals an impressive string of achievements: five exhibitions of painting; a quarterly magazine that presented in translation such important modernist documents as the manifestos of the Italian Futurists and the NKV-Munich, Gleizes's and Metzinger's *Du Cubisme*, and in 1915 Malevich's *From Cubism to Suprematism*. The Union sponsored Nikolai Kulbin's reading from Kandinsky's *Concerning the Spiritual in Art* to the first All-Russian Congress of Artists the very same month the tract was published; it sponsored Marinetti's visit to St. Petersburg in 1914; and, what was arguably its crowning achievement, it produced the Cubo-Futurist opera *Victory over the Sun* in December 1913, with text by Kruchenykh and Mayakovsky, sets by Malevich, and music by Matyushin. As John Bowlt concludes, the group "served to bridge the aesthetic gap between [St. Petersburg] and Moscow" and was "a valuable refractive medium of Russian Modernist culture."[25]

Beyond local benefits, the internationalism of major exhibitions mounted by these groups connected avant-garde artists across Europe, showed them what their counterparts were doing, and heightened their sense of the accelerating and expanding power of modernist innovation. Artistic regionalism seemed to diminish before the sweep of this cosmopolitan sensibility. As the novelist Karl Otten observed, "we [living in the Rhineland] looked upon Cologne and Bonn as suburbs of Paris, Vienna and Rome" (qtd. in Raabe, *Era* 139).

This internationalism did not go uncontested, however. As the NKV-Munich quickly discovered at its second exhibition, the prominence of "foreign" artists added xenophobes to their already noisy opponents. Nor did such opposition occur only among antimodernist reactionaries. Nationalism and regionalism, especially when linked to a primitivist evocation of cultural roots, infected a number of modernists. Larionov and Goncharova, for example, fed up with what they saw as European domination of the second Jack of Diamonds exhibition in January 1912, staged a much-publicized walkout and organized a competing all-Russian exhibition, the Donkey's Tail, only two months later. Similarly, the well-intentioned ecumenicism of these exhibition and concert groups grated on some members who wanted to promote a single aesthetic philosophy, or who chafed against the uneven quality of work that ecumenicism produced. Such were Franz Marc's reasons for pulling his paintings out of the 1912 Sonderbund exhibition.[26]

III. The Appeal of Groups

What prompts an artist—whom most people think of as an independent sort, if not a loner—to join a group? The answers are surprisingly clear-cut for the aspiring modernists who later recalled their participation in prewar groups. Their motives derive directly from modernism's artistic and social status before the war—a status that has become virtually a cliché of the avant-garde over the preceding century. Challenging accepted styles, as well as the aesthetic and social

norms underlying them, modernism was relentlessly attacked, ridiculed, and scorned by the general public, the public press, and conservative critics. Marginalized professionally, it had to find its own means of support, arrange its own presentations. And since modernists, in turn, scorned the philistine bourgeoisie that reviled their art (the social class from which so many artists themselves emerged), they essentially had only each other—along with a few sympathetic patrons, gallery owners, and journalists—for company, intellectual stimulation, and moral support.[27] The veteran American painter Robert Henri put it very well to the twenty-four-year-old Morgan Russell, who was then struggling alone in Paris to find his style: "Most people like to be *in* a movement. Its [sic] always warm inside and [i]ts quite cool to be out by your self. . . . [M]ost all human beings, be it the commonplace or the minority-advance guard, want company enough to keep warmth and courage up."[28] Although Henri's main point was that true innovation was and always would be reserved for the few individuals "who bear the *Idea*," Russell came to agree with Henri's concession to the psychological comfort of groups and soon formed his own, the Synchromists, with Stanton MacDonald-Wright.

Aspiring young artists, typically having moved to big cities to be closer to the modernist action, thus formed or joined these groups for interrelated reasons: defensively, they found comfort in meeting and socializing with like-minded peers in the friendly environment of the café or studio, especially when the larger societal milieu was distinctly hostile. The group thus becomes a surrogate family; joining it becomes a way for young artists to overcome their sense of isolation, social and aesthetic, in the large, unfamiliar, philistine city. As the American poet Alfred Kreymborg observed about his own artists' colony at Grantwood, New Jersey:

> The desire of congregating in sympathetic groups was a natural development of the craving for solitude[,] for companionship in the wilderness. . . . [This] poignant need of the artist in the days of darkness immediately antedating the war called for some point of contact with his fellows, in protection against the prevailing opinion held by American society that such a man was a wastrel, a pariah, a superfluous blot on an otherwise united democracy. (*Troubadour* 207)

Joining was not merely a defensive act, however; and, far more than being a protective association, the modernist group was a nexus of intellectual stimulation, a goad to artistic growth. As Ezra Pound wrote in 1912: "You must not only subsidize the man with work still in him, but you must gather such dynamic particles together, you must set them where they will interact, and stimulate each other."[29] For young artists still uncertain of their artistic identity, the opportunity to discuss technical problems with talented colleagues, share aesthetic and philosophical ideas with well-read contemporaries, and, not least, receive the encouragement and energy of the group's leader was exhilarating. Even for the more self-sufficient, the group's meeting place, typically a comfortable café or tavern, offered socializing and companionship to relieve the lonely rigors of the studio or writing desk. Little wonder that these cafés became so closely identi-

fied with the groups that habituated them: the Guerbois for the Paris Impression-
ists, the Closerie des Lilas for the Symbolists, the Chat Noir for the Montmartre
Cubists, the Café des Westens and Josty for the Berlin Expressionist groups, and
Stephanie for the Munich modernists, to name only a few. At Berlin's famous
Café des Westens, Wolfgang Goetz recalls: "We learned to see here, to perceive
and to think. We learned, almost in a more penetrating way than at the univer-
sity, that we were not the only fish in the sea and that one should not look at
only one side of a thing but at least at four" (qtd. in Allen 24).

The group milieu gave fledgling artists the encouragement they needed to
get started. Ernst Blass recalls that he did not start to write seriously until he
began associating with poets of Berlin's neue Club, who, in addition to meeting
regularly at the Fledermauszimmer restaurant, gathered often at the Café des
Westens:

> I went there too now, sat with the others [of the neue Club], was in-
> vited by Dr. Hiller to become a member. I accepted gladly, although I
> felt very young and insecure and regarded the others as older, more
> qualified to judge.
> How I came into my own I scarcely know. I was encouraged,
> made to write poems and reviews. Things began to snowball. People
> asked: Have you written anything new this week? Blass poems ap-
> peared, at first playful and imitative, then with more feeling, more
> self-consciousness. . . . I did it timidly, just to see how it would turn
> out. (qtd. in Allen 28)

The milieu of the Café des Westens, where so many other modernist groups
gathered that it (like several other modernist cafés in Europe) was nicknamed
"Café Megalomania," also sharpened Blass's sense of purpose, of participating
in an "us against them" conflict:

> [W]hat I was engaged in, there amid all my personal sufferings, was a
> literary movement, a war on the gigantic philistine of those days
> In the Café, soul was still worth something. Yes, it was an education
> in art, this institution to which I think back as a hard preparatory
> school. . . .
> It was a place of refuge and an unparliamentary parliament.
> Even the timid and the silent learned how to talk and express them-
> selves, learned to recognize what it was they really felt deeply about.
> It was an education in emotional sincerity. ("The old Café des
> Westens," rpt. in Raabe, *Era* 28-29)

Significantly, the group dynamic encouraged members to surpass them-
selves where they might not have working alone. As Lothar-Günther Buchheim
said of the closely knit *Brücke* painters: "They . . . pushed each other to the
heights of inspiration, helped each other with mutual, unvarnished criticism"
(qtd. in Allen 27). This stimulus obtained even in the smallest two-person group,
as Braque described in his metaphor about himself and Picasso as "two moun-
taineers roped together."

Less heroically, groups offered young artists opportunities for getting their work before a public—of having their poems published or at least read aloud, their music and plays performed, their paintings exhibited—and for attracting critical attention to these presentations. Medium and occasion groups existed solely for this purpose, compensating for the predictable dearth of opportunities offered by established publishers and galleries. In Paris, for example, Blaise Cendrars complained that French periodicals of all kinds refused his verse between 1912-1914. In fact, established magazines granted so little space to poetry in these years that, as Kenneth Cornell notes, poets themselves created numerous "little magazines" as a medium for their verse. Henri Martin Barzun's *Poème et Drame* (started 1912), Nicholas Beauduin's *La Vie des lettres* (begun 1913), Ricciotto Canudo's *Montjoie!* (started 1913), and of course Apollinaire's *Les Soirées des Paris* (begun 1912) all arose to fill this void as well as to promulgate their editor's particular aesthetic philosophy or movement: Barzun's Simultanéisme and Dramatisme, Beauduin's Paroxysme, Apollinaire's exegeses of Cubism and Orphism, and others (Cornell 123 ff.).

Groups provided artists greater visibility in another way. Having their work seen as part of a *group*'s style was often a necessary prelude to having it seen and evaluated on its own merits. The Cézanne-inspired artists who recognized their affinities at the Automne Salon of 1910 also realized that each gained from the synergy of being displayed together. Thus, if they should fail to control the hanging committee of the spring Indépendants, Albert Gleizes explains, "in all probability we would be dispersed to the four corners of the salon and the *effect produced on the public by a group movement would be lost. It was necessary that it be produced. We had to be grouped*; that was the opinion of all" (qtd. in Robbins 16; my emphasis).

Finally, aggressive group leaders like Marinetti, Pound, Walden, and Burliuk offered an astonishing array of publicity skills for keeping their group in the public eye. How could a young artist, unknown and often unassertive, gain comparable exposure working independently? Inevitably, the desire to advance oneself motivated many to join. Viewed cynically, professional expedience might even appear a group's sole raison d'être. Thus, Glenn Hughes describes the Imagists' motives in joining:

> None of them was interested in a movement for its own sake; each of them was interested in being a poet. Having certain beliefs, and being faced in common with certain prejudices, they joined forces for a time and marched against the enemy, waving a single banner. That they won their fight is incontestable. And having won it they threw the banner away, broke ranks, and became frankly what they had been all the time: individual artists. (Introduction to *Imagist Anthology: 1930*, xvii)

Commentators of the time, already besieged with modernist styles, regarded this welter of "isms," ideologies, and groups with deep skepticism. As Jeffrey Weiss summarizes, through its "excesses of *réclame* . . . the group or ism was subject to allegations of sinister collectivity—the *cénacle* as a dynamic of lead-

ers and disciples ganging-up to inflict their doctrine on a beleaguered art public" (*Popular Culture of Modern Art* 74). Even modernist devotees of the group could suspect other groups of bad faith. By early 1913, Albert Gleizes, the chief organizer of the various subgroups of the Cubist School, worries in print that "the isms would soon multiply according to the will of artists working more to attract attention to themselves than to realize serious works."[30] Roger Allard was inclined to agree; this critic, who had himself attended the Sunday meetings at Villon's studio in Puteaux, concludes in 1914 that through its posturing and insupportable claims (most egregiously practiced by the Italian Futurists), the modernist group has pushed the avant-garde "from good faith to mystification" (Weiss 102).

This wall of suspicion and distrust inevitably resulted from groups achieving greater public visibility. Collectively, however, artists were far better equipped to deal with ridicule and critical abuse of the "gigantic philistine," not just by defensively retreating into the group for sympathetic support, but by carrying modernist battle directly to the enemy. As Webern wrote to his teacher-colleague, Schoenberg, after the latter's *String Quartet No. 2* was hissed at its première: "Nothing is more important than showing these pigs that we do not allow ourselves to be intimidated" (qtd. in Moldenhauer 105). While the group's antagonistic stance will be discussed below, we note here that the same psychological encouragement a supportive group provided its members to experiment and innovate beyond what they might have done alone also emboldened them to confront—even provoke—a hostile public in collective demonstrations far more eagerly, and with better chances of success, than they could have done as individuals. Their motto was not "safety in numbers," but "strength in numbers."

Typically, these reasons for joining the group merged. In Berlin, for example, where groups formed prolifically beginning in 1910, artists grew bolder as they found others who shared their hostility to Wilhelmine society. They became still more assertive with the appearance of newspapers like *Der Sturm* and *Die Aktion* that provided a public medium for their criticism. Roy Allen summarizes:

> [W]hat had been [for these new groups] at first a retreat from their society was at last reversed now and transformed into stridently critical opposition to it. The activities in the circles were simultaneously growing more intense and more organized, as the circles themselves became more tightly knit and more governed by a common spirit and . . . attitude. . . .
>
> The founding of their own journals . . . [bolstered their] feeling of backing a movement or being united behind a common cause or mission. (18-19)

A reflection of how group identity encouraged this strident opposition appears in the Russian Cubo-Futurists' first manifesto, "Slap in the Face of Public Taste" (December 1912); among the four "rights" of the poet is: "To stand on the rock of the word 'we' amidst the sea of boos and outrage" (qtd. in Lawton 52).

IV. Costs of Belonging

A. Problems of Identity and Allegiance

For all its potential benefits, belonging to a group inevitably raised issues for participants that went right to the core of their professional identity and conduct. In turn, these questions made modernist groups inherently unstable and provisional. Professional independence—that blessing and curse of artists as their status evolved over the past two centuries—meant thinking and acting for themselves. With the decline of the artisan's workshop, artists more often worked alone and came to depend on this isolation (even as they cursed it) to think through problems of their art. Together, these conditions inclined artists toward an iconoclasm that directly contradicts the social nature of groups. In Alfred Kreymborg's view, these needs were precisely why so many groups failed: "The fact that most of these [groups] quickly fell into mutual admiration societies or herds of bickering porcupines did not detract from the genuineness of the original impulse. The failures simply demonstrated that the average artist is an anti-social person, and when he turns sociable it is usually at the expense of some compromise with his inner being"(*Troubadour* 207).

Even artists who saw practical advantages of belonging sometimes demurred. During is brief residence in Berlin in 1910-1911, Oskar Kokoschka reaped multiple benefits from associating with Herwarth Walden, leader of the *Sturm* group: as the newspaper's chief artist and its editor for Austria-Hungary, Kokoschka saw his drawings appear regularly for a large and discerning readership. Associating with the dynamic Walden enabled the shy painter to make numerous contacts in Berlin that he would not likely have made otherwise. Paul Cassirer, for example, gave him his first one-artist show in 1910, which "aroused a great deal of interest among progressive circles in Berlin" and a contract that raised prices of Kokoschka's pictures (*My Life* 63-64). Yet, Kokoschka steered clear of the *Sturm* circle: "I knew few of the artists of the *Sturm* circle personally, and took very little interest in their formal problems or in their moral ideas. I contributed no manifestos, not even a signature. I was not going to submit my hard-won independence to anyone else's control. That is freedom, as I understand it" (67).

Other artists felt no such threat to their autonomy. Giovanni Papini, who joined the Italian Futurists in 1913, claimed that Marinetti, for all his activist leadership, did not pressure members to tow an aesthetic line: "Everyone remains responsible for the ideas he displays and the works he creates: and the tendencies common to all (liberation from the past, the search for novelty and individuality, the use of violence, etc.) are so wide-ranging that they hardly inhibit anyone in what he does."[31]

At what point, then, does membership in a group begin to impinge on this need for independence, for creative "space"? The question can be usefully subdivided into several issues: aesthetic (subscribing to the group's collective philosophy); stylistic (reconciling the desire for personal originality with a collective style and the danger of imitation); practical (accommodating the group's time demands); and personal (getting along with the other members and particu-

larly with a dynamic and demanding leader). Two of these issues—aesthetic ideology and personal relations—will be taken up in chapter 2 in regard to the group leader's actions. Here, we shall consider the other two issues: stylistic originality and practical demands of the group. To flesh out the former, let us consider a fairly extreme case of iconoclasm.

Case Study: František Kupka and the Puteaux Group

A minor mystery in the art history of this period is whether František Kupka participated in the major Section d'Or exhibition organized by the Puteaux group. One art historian devotes three full pages of her monograph to the question.[32] Had Kupka not been such an original and powerful painter, the question would scarcely matter. But its background highlights the issue of the artist's allegiance.

"Never a gregarious person" (as Serge Fauchereau describes him), Kupka was nonetheless attracted to the stimulating discussions of the painters and writers who met regularly next door to his studio in Puteaux (17). As noted above, the group fused several smaller groups of painters and writers, even a mathematician, and reflected their growing excitement about Cubism and, more broadly, the abstract potential of color and line. For Kupka, whose keen interests in biology, astronomy, and theosophy were central to his painterly imagination, the Puteaux group's wide-ranging discussions were well-nigh irresistible. Yet, as Fauchereau observes, he possessed an "almost fanatical desire for independence [that] made it impossible for him to participate fully in a group movement" (18). Thus, the dilemma.

He attended the Puteaux meetings regularly, "was at the centre of discussions concerning orphism and the golden section" (18), exhibited as they did at the yearly Indépendants and Automne salons, and when the group began planning, in the spring of 1912, to exhibit together as the Section d'Or, he apparently decided to join them.[33] Indeed, according to Nicholas Beauduin, who was present, Apollinaire gave his exhibition address, "The Quartering of Cubism," while standing in front of Kupka's paintings. But the talk also realized Kupka's fear of association by lumping his work stylistically with that of Picabia, Duchamp, and Delaunay (who had not exhibited) under the "ism" Apollinaire was just then reifying in his art criticism: Orphism.[34]

Kupka had reason to be disturbed. His *Amorpha: Fugue in Two Colors*, shown at the 1912 Automne Salon, in no way resembled the work of the other "Orphists" and exceeded all but Delaunay's contemporaneous *Windows* series in achieving complete abstraction. Moreover, its origins derived not from a Cézanne-Picasso lineage of planar analysis, but from Kupka's highly eclectic and theosophically tinged interest in organic shapes and their relation to life forces. To be lumped arbitrarily with a style—and a style that existed essentially in Apollinaire's imagination—was galling. As Kupka acknowledged to a friend on a similar occasion: "In the last Salon d'Automne I had a beautiful place of honor, unfortunately in the room with the Cubists with whom I am almost on a parallel. It is with me as it was with Degas, who was classified as an Impressionist."[35]

As several scholars have noted, Kupka's name does not appear in Apollinaire's published version of the talk or elsewhere in *The Cubist Painters: Aesthetic Meditations*, published several months later. Beauduin speculates that Kupka, fuming after the talk, had words with the critic, precipitating a feud and thus Kupka's subsequent exclusion from Apollinaire's criticism.[36] According to Fauchereau, moreover, Kupka removed his works from the exhibition (18).

What especially galled Kupka about being dubbed an Orphist was the fact that the group's putative leader, Robert Delaunay, was then working on a series of abstract *Circular Forms* that showed unmistakable similarities to Kupka's 1911-1912 *Disks of Newton*.[37] Kupka now faced not only public confusion about his artistic identity, but even worse, potential infringement on his claim to artistic innovation and originality: "Certain witnesses state that he even thought that Delaunay with his *disques simultanés*, and Léger, with his *disques dans la ville*, had stolen their ideas from him." Separation from all these groups seemed the only recourse: "Kupka was quick to deny any such links with a specific movement[,] [j]ealously defending his position as a precursor" (Fauchereau 18).

Even then, the issue was not settled. A year later, following the 1913 Automne Salon, at which Kupka exhibited two versions of *Organization of Mobile Graphics*, a journalist for the *New York Times* (19 October 1913) hailed him in a headline as the "creator" of Orphism! Not surprisingly, "it soon became a point of honor for Kupka to lay special emphasis in his art on the absence of any connection with cubism"—and apparently with other groups as well, for "it was around this time that Kupka began to acquire his reputation as a somber, taciturn figure" who, in his own words "live[d] like a hermit" (Fauchereau 18). Not until the 1930s would he venture another group association.

While Kupka's reaction may seem extreme, his case illustrates the tension felt so strongly by modernists between their need for independence and the group's allure. Kupka's example also shows how group membership could lead reductive critics to slap a corporate label on a personal style, on individual innovations, on an artist's identity. Sometimes, it simply seemed like the *wrong* label: "Intellectuals and literati call me an Expressionist," complained the painter Emil Nolde. "I do not like this narrow classification. A German painter, that I am" (*Jahre der Kämpfe*; qtd. in Selz, *German* 120).

B. Practical Demands of Group Membership

The practical demands of group membership could be onerous. Mounting exhibitions, editing and publishing anthologies and magazines, arranging and holding performances and evenings, writing manifestos, giving lectures, promoting group events, discussing strategy and making arrangements for these events—all these took time and effort, time that group members could have spent at their easel or desk. Energetic and thoroughly dedicated group leaders willingly assumed the lion's share of these labors, but they could not do it all and in any case wanted their members to participate so as to make the events more of a collective effort. Those who formed the small nucleus groups often could not even delegate: there was no one else to perform these tasks.

Case Study: Kandinsky and the Blaue Reiter
In the whole history of this prewar period, Wassily Kandinsky's and Franz
Marc's labors may well deserve the foremost place, not just in their devotion to
the Blaue Reiter group that they formed in 1911, but to the modernist sensibility
and achievement that they so profoundly influenced. With their vastly ambitious
program of holding exhibitions and publishing a yearly almanac, they aimed at
nothing less than being "the center of the modern movement."[38] To be sure, arti-
cles for the *Almanac* were assigned to an array of writer-members. Nevertheless,
as both exhibition organizers and *Almanac* editors, their workload was enor-
mous, and their high enthusiasm did not efface the considerable cost of their
labors in lost hours of painting. A letter that Kandinsky writes Schoenberg when
Kandinsky was in the thick of these labors perfectly captures his conflicted sen-
sibility and thus deserves to be quoted at length:

> 13 January 1912
> Dear Mr. Schoenberg,
> I am really very ashamed [to respond so tardily]. But it isn't laziness!
> I will just briefly list for you what I am doing: 1) the Blaue Reiter
> [*Almanac*], that is write, read and correct articles, etc., 2) arrange Ex-
> hibition 1 of the B.R., 3) prepare Exhibition II of the B.R., 4) invite
> Germans, Frenchmen, and Swiss for the exhibition [the second Jack
> of Diamonds] in Moscow (I have unlimited authority, therefore also
> unlimited responsibility), 5) help in the buying and selling of unfa-
> miliar pictures, and as a result 6) read and write letters which are al-
> ways hurried, and often complicated, often very unpleasant (there are
> days when I get letters with each of the five mail deliveries, there are
> days with twenty incoming letters, and there is never a day without
> letters), 7) I owed letters, 8) I don't paint, 9) I neglect my *own* affairs.
> In two weeks I have written over eighty letters. My only hope is that
> it will change when the B. R. is finally printed and the exhibitions are
> arranged. I am already tormented by two pictures which I would like
> to paint—one is finished in my mind, the other I would like to at-
> tempt—So don't be angry with me. (Rpt. in Hahl-Koch 41-42)

In the same letter, Kandinsky engages in the labors he has just bemoaned: he
discusses with Schoenberg the dispositions of several paintings Schoenberg had
submitted to the first Blaue Reiter exhibition and urges him to send in his sub-
missions for the *Almanac*: "P.S. Can you please send me your music *quickly*?
And the article? Must I get along without it? Write something quickly! How
can German music not be represented in an article? There will be two on Rus-
sian music" (43).
Once the *Almanac* was published the following May, Kandinsky demurred
from Marc's wish to forge ahead with a second volume: "I wish we did not need
to rush it at all. Let's quietly receive the material. . . . [(]collect it quietly and then
select more strictly than the first time). I also have a '*selfish*' wish: to have my
own [painting] ideas mature for some time (at least for the summer). I am quite
off track."[39] Although they toyed with the idea of alternating the editing to allow
each other more time to paint, nothing came of it. By March 1914, they were

only able to produce new prefaces for a second edition of the original *Almanac*; Kandinsky, moreover, had convinced himself "that the times were not ready for the *B.R.*" and again proposed delaying the second volume (qtd. in Lankheit 33). The real problem Kandinsky conceded in a letter to Marc (March 1914): "I've noticed that when I awake at night, I very often think not of my work but of the volume. But since my work occupies me at the present time with particular intensity, the consequences for me are bound to be unfortunate, for I would do either one or the other only half-heartedly" (Qtd. in Selz, *GEP* 212).

Before Marc could move ahead with Blaue Reiter projects on his own (and his reply to Kandinsky indicates that he intended to), the war intervened and superceded all such efforts (Lankheit 33). Although Kandinsky later attributed the Blaue Reiter's demise solely to the war and Marc's death,[40] it is clear that both artists had become burned out on the enterprise. Marc reflected from the front: "I shall never again collaborate on anything like that but work as much as possible alone."[41] These burnouts and repudiations were inevitable—and all the more predictable following great enthusiasm and selfless labors. As such, they contributed significantly to the group's instability.

V. Collective Identity: The Battling Group

Thus far, we have looked at the group primarily as an association of individual artists, providing them benefits, costing them time, and raising questions about artistic identity. But it is important to understand that modernist groups assumed collective identities larger than the sum of their parts, based on their objectives, their means of realizing them, and perhaps most important, the personality mix of leader and members. Although these identities varied sharply, a signal quality of virtually all the modernist groups was their high-spirited combativeness, their buoyant, even exuberant eagerness to battle their opponents.

Marinetti had recognized in 1909 that the single most distinguishing—and essential—feature of a modernist group is precisely this aggressiveness, a militant assertion of its aesthetic philosophy, of its members' works, of its eagerness for a public row: "Literature having up to now glorified thoughtful immobility, ecstasy, and slumber, we wish to exalt the aggressive movement . . . the cuff, and the blow" ("Foundation Manifesto"; rpt. in Chipp 286). This will to battle addressed two different opponents. The first enemy was familiar: the defenders and supporters of conventional art. The avant-garde's opposition to the forces of reaction—a complacent public, conservative critics, journalists, academies— was axiomatic, almost a cliché by 1910. The second target, however, was new. As modernist groups proliferated before the war, *inter*group rivalry intensified as groups vied for public attention. The result was often pitched battles between groups.

A. Battling a Hostile Public
The avant-garde's relation to its audience was notoriously ambivalent and problematic—a subject that has been explored so thoroughly that it needs only

mentioning here. If, on the one hand, modernist groups needed and sought public recognition, they nevertheless recognized that their art could not very well ingratiate itself with the general public and still be "avant-garde." Their innate hostility to the public was partly psychological and aesthetic: a fear of being engulfed by—and disappearing into—the bourgeoisie's complacent conventionalism. In Germany and Austria, however, avant-garde hostility was also philosophical and political, expressing young artists' repudiation of a society devoted to the material at the expense of the spiritual. In both cases, modernists recognized that their need to experiment and innovate *must* oppose the bourgeois demand for "safe," conventional art, that their stance toward the public, therefore, must be what Renato Poggioli has called "antagonism" (26). To these high-flown motives must be added the wholly mundane purpose of gaining public attention. In an increasingly competitive art world—and one closely attended by newspapers—attracting the public meant attacking the public, and bad publicity was better than no publicity. [42]

For such public confrontations, a group was far better suited than an individual, not only in psychologically supporting its members as described above, but also in enabling a more organized and efficient assault, allowing for both division of labor and coordination of the numerous and laborious tasks in holding a public event: for example, making the necessary arrangements with gallery, lecture hall, etc.; planning each member's participation; writing, printing, and distributing accompanying material (the group's manifesto, exhibition catalog, program notes, book introductions, etc.). Perhaps most important, the group was publicly more visible and audible than an individual artist, thus better at attracting sufficient "coverage" of the event to make it at least a succès de scandale.

For example, before his lecture in Paris, Marinetti and Co. distributed provocative fliers at strategic locations around town. His London associate, Christopher Nevinson, recalls that before appearing in London in 1914 Marinetti had him not only place their joint manifesto, "Vital English Art," in three London newspapers, but also "go to the galleries of theaters and shower the manifestos on the heads of the unsuspecting people in the stalls and the dress circle" (Nevinson 81). What artist working alone had the energy and time to handle all these chores? Only an organized group could, guided by an energetic leader with a knack for creating a public scandal. Just as the group's support encouraged members to surpass themselves artistically, so a group's *collective* posturing might well embolden its members to sign manifestos and participate in events that they would scarcely dare to consider had they worked in isolation. Finally (and not nearly enough attention has been paid to this factor), group participation often made confrontations more fun for its participants, precisely as comic situations in plays and movies become funnier when shared with an audience.

The prevailing mood of these confrontations—even the fistfights gracing Futurist evenings—was seldom bitter and hateful, but, rather, high-spirited, exuberant, even joyous. As Poggioli observes: "often a movement takes shape and agitates for no other end than its own self, out of sheer joy of dynamism, a taste

for action, a sportive enthusiasm, and the emotional fascination of adventure" (25). Amid the insults and catcalls, the flying fists and tomatoes, modernist groups were having a great time, enjoying the ruckus for its own sake (most of the provocateurs were barely out of their teens),[43] for the intensified public interest in their group and their art, and, in some cases, for the feeling that they were contributing to a cultural revolution.

Finally, if artists had much to gain from these planned scandals, so did the public and press: journalists got good copy, the public titillation and diversion. Journalists flocked to exhibitions, readings, and concerts that promised to be sensational and interviewed group leaders like Marinetti and Walden, who gave them precisely the controversial views that would divert readers. Such published accounts—especially if they ridiculed the group—attracted much larger crowds to modernist events, many attendees looking for a good laugh, others merely curious. Even as they manipulated the journalists to gain their groups more publicity, leaders like Wyndham Lewis recognized that the relationship between modernists and the public was essentially symbiotic:

> The Press in 1914 had no Cinema, no Radio, and no Politics: so the painter could really become a "star." . . . Anybody could become one who did anything funny. And Vorticism was replete with humour, of course: it was acclaimed the best joke ever. Pictures, I mean oil-paintings, were "news." Exhibitions were reviewed in column after column. And no illustrated paper worth its salt but carried a photograph of some picture of mine or of my "school" . . . or one of myself smiling insinuatingly from its pages. To the photograph would be attached some scrap of usually misleading gossip; or there would be an article from my pen, explaining why life had to be changed, and how. "Kill John Bull with Art!" I shouted. And John and Mrs. Bull leapt for joy, in a cynical convulsion. For they felt as safe as houses. So did I. (*Blasting and Bombardiering* 35-36)

Disapproving critics sourly observed that this publicity seeking was altering the very relationship of the artist and public. Groups that loudly reviled a commercial society shamelessly borrowed commercial techniques of advertising and public relations. Camille Mauclair complained that "in their haste to be noticed, artists have transformed perils of yesterday—public mockery or savage criticism—to today's advantages. To shock is to be seen, to attract attention by means of 'bizarrerie, special effects and powder in the eyes' even if the attention takes the form of public scorn. . .'; 'only silence is to be feared.'"[44]

B. Battling Other Groups

As modernist groups competed for the public's attention, more battles broke out, this time between the groups themselves, as they struggled to survive, fend off rival takeovers, and gain attention. Kokoschka recalled: "New 'isms' were springing up everywhere. . . . Each laid claim to consideration as a definitive creative statement and carried on a running battle with all the others (*My Life* 66). Typically, these intergroup conflicts assumed several forms: "split-offs" of

small radical cells from their less-radical parent groups (see table 1.2); rivalries based on conflicting aesthetics, personalities, or both (table 1.3); and survival struggles, as emerging groups maneuvered for attention or fought off older groups (nearly always, the Italian Futurists) attempting to annex them. Not surprisingly, these forms overlap. When Larionov stridently attacked the Burliuk brothers' planning of the 1912 Jack of Diamonds exhibition, his motives were party ideological (opposing their European emphasis, as noted above), and partly political (calling attention to his separatist group, the Donkey's Tail). In turn, the Burliuks nurtured *schadenfreude* toward their former ally. When they saw Alexandra Exter's photographs of recent Cubist work by Picasso, they responded: "This is good. Larionov and Goncharova have had it" (qtd. in Milner 26).

As table 1.2 suggests, split-offs were so numerous as to make the phenomenon almost an essential step in the life cycle of modernist groups, one that also reflects the turbulent art-politics of these years:

Table 1.2 Split-offs of Modernist Groups: 1910-1914

Leaders in parentheses. →forms; —joins

England
Hulme et al. from Poets' Club → "Forgotten School of 1909"
Pound from Imagists (Lowell) → Vorticists
Lewis et al. from Omega Workshops (Fry) → Rebels / Camden Town Group → Vorticists
Nevinson from Camden Town Group (Lewis) → Italian Futurists

France
Apollinaire from Picasso-Braque → Puteaux Cubists → Orphists (Delaunay) → independent

Germany (Munich)
Kandinsky, Marc et al. from NKV-Munich → Blaue Reiter

Germany (Berlin)
Nolde, Pechstein from Berlin Secession → *Neue* Secession
Die Brücke from Neue Secession, 1911
Hiller, van Hoddis from Die frie Wissenshaftliche Vereinigung → Der neue Club
Hiller, Blass, Wasserman from Der neue Club → Der Literarisches Club Gnu
Meidner et al. from Neopathetisches Cabaret → Die Pathetiker
Pfemfert from *Der Democrat* → *Die Aktion*
Hiller from *Die Aktion*
Walden from *Der neue Weg* → *Der Sturm*

Table 1.2—Continued

Russia
Larionov, Goncharova from Jack of Diamonds → Donkey's Tail → Rayism
Severyanin from Ego-Futurists — Cubo-Futurists — Ego-Futurists

Italy
Soffici, Papini from *La Voce* — Futurists and → *Lacerba*
Soffici, Papini from Futurists → "Lacerban Futurism" (sans Marinetti)

Czechoslovakia (Prague)
Group from Mánes Union of Artists → Group of Plastic Artists
Čapek et al. from Group of Plastic Artists → "opposition" to hold Modern Art exhibition, 1914

Split-offs formed chains, as formerly rebellious groups once at the cutting edge now seemed too stodgy for their most radical members. In Berlin and Vienna, avant-garde painters left the Secession groups (which had themselves famously split off from established artist associations in the 1890s) to form the Neue Secession of Berlin (1910) and the Neukunstgruppe in Vienna (1909). In turn, Die Brücke painters grew disenchanted with Berlin's Neue Secession group and collapsed it with their withdrawal in December 1911. In Prague, the Group of Plastic Artists (including painters, sculptors, architects, and writers) seceded from the older Mánes Union of Artists in 1911, only to experience its own secession the following year as several members formed an opposition group.

While conflicting aesthetics—the desire of a few mavericks to pursue or exhibit more radical styles—usually caused these rivalries, ideological and personal differences often played a role. The two most influential Expressionist newspapers in Berlin, for example, Herwarth Walden's *Der Sturm* (fig. 18) and Franz Pfemfert's *Die Aktion* (fig. 11) not only vied for preeminence among readers and contributors (many artists contributing to both newspapers), but represented sharply different editorial philosophies. *Der Sturm* began with "essays on broad cultural and philosophical themes liberally mixed with literature, art criticism and theory" (Allen 106), but it grew increasingly committed to the visual arts, especially after Walden added a picture gallery in 1912 to exhibit the most radically modern art he could find. *Die Aktion*'s agenda, by contrast, emphasized radical social criticism along with interest in the arts. Inevitably, the two journals clashed, but over a proxy issue in 1911—the Kerr-*Pan*-Jagow affair[45]—and the two editors continued to attack each other in their respective journals for several years.

Table 1.3 Rivalries between Modernist Groups, Leaders: 1910-1914
(excluding those mentioned in table 1.2)

England
Imagists/Pound vs. Georgians
Ezra Pound vs. Amy Lowell
Wyndham Lewis vs. Roger Fry
Wyndham Lewis vs. Ford Madox Hueffer
Wyndham Lewis vs. T. E. Hulme
Vorticists vs. "English Futurists" (Marinetti, Nevinson)

Paris
On "simultaneity" claim:
 Apollinaire vs. Italian Futurists
 Delaunay/Orphists vs. Italian Futurists
 Apollinaire vs. Delaunay
 Apollinaire vs. Cendrars
 Yakoulov vs. Delaunay
 Henri Martin Barzun vs. Delaunay, Apollinaire
 Synchromists vs. Orphists

Munich
Macke vs. Kandinsky

Berlin
Walden vs. Pfemfert
Alfred Kerr vs. Paul Cassirer

Moscow
Larionov vs. D. Burliuk, Cubo-Futurists
Khlebnikov, Livshits, et al. vs. Marinetti
Cubo-Futurists (anti-Marinetti) vs. Messanine (pro-Marinetti)

Florence
Soffici, Papini vs. Marinetti, Milanese Futurists

The many conflicts between modernist groups add another slant to the stan-
dard depiction of modernists battling the conservative public. For one thing,
they make artists look less beleaguered, more eager to take on their adversaries
to further their group's fortunes. These internecine conflicts made the art world
noisier, more tumultuous, as Wyndham Lewis describes: "The excitement [in
London of 1914] was intense. *Putsches* took place every month or so" (35). In-
tergroup fights also force us to modify scholarly stereotypes of modernist cama-
raderie: of young artists fighting shoulder to shoulder against the "gigantic phil-

istine," as Ernst Blass put it. Roy Allen's claim, for example, is only partially valid that "in spite of the unavoidable factional disputes" there was a "pervasive spirit of comradeship" among the Berlin groups (71) and that the "Walden-Pfemfert polemic and the schism in Der neue Club are exceptional incidents" (123). True, the German Expressionist groups were less physically contentious than were modernist groups in other locales, but their schisms were scarcely exceptional.[46] Steven Watson's assertion that this infighting did not occur until "the frontiers of modernism began to be colonized . . . [by] the chic galleries . . . [and] mainstream publishers [i.e., about 1914]" (*Strange Bedfellows* 9) is doubly wrong, not only because such battles accompanied *all* stages of prewar modernism, but also because his depiction links infighting to the corruption of worldly success, signaling a loss of the movement's initial idealism. In fact, however, intergroup battles were an essential part of modernism's struggle to establish itself and were fought with the same high spirit that Watson attributes to that larger struggle.[47]

This turmoil among the modernists themselves—and even much of the conflict between the avant-garde and the conservative public—simply could not have occurred without groups. Enabling artists to organize their public presentations—the flashpoints of conflict—and to keep up their morale, the group also emboldened them to take their war against the conservative status quo directly to the enemy. Their success in attracting attention, in turn, intensified competition between rival groups, producing more battles. As both cause and consequence of aggressive conflict, then, modernist groups greatly intensified the confrontational milieu of the prewar art world.

VI. Modernist Groups across Europe: Some Demographic Issues

Before leaving the subject of the modernist group per se, we should look at it macrocosmically and consider its geographical distribution, its comparative appeal among the different arts, its multidisciplinary and international tendencies, and finally, the relation between its proliferation and the accelerating pace of artistic innovation in these years.

A. Geographical Distribution

A glance at the summary page of appendix 2 shows that modernist groups (as I have defined them) proliferated unevenly across Europe and America in the prewar years. Russia and Germany generated the most.[48] Italy produced the least, but only because the Italian Futurists were so dynamic and inclusive in their membership—with a group like the Futurists, Italy needed only one! Paris appears a lively center for groups, as one might have expected from the capital of modernism; but the number is considerably lower if we subtract several movements with only one or two members, typically the editor(s) of a journal.[49] Not surprisingly, group formation was low in America, where modernism was only beginning to take root.

Why were groups so central to modernist activity in Russia and Germany, but less so in Paris? The artistic climate of a locale—specifically, its support or at least tolerance of modernist innovation—helps explain these disparities, but even here the issue is not clear-cut. Paris had long since established itself as *the* center of artistic innovation, which tolerated, if it did not actively encourage, the new. In fact, however, this image was rapidly tarnishing in the prewar years: the Cubist rooms of the spring and autumn salons of 1911-1912 and the Ballets Russes's daring ballets of 1912-1913 were attacked by a hostile and increasingly xenophobic press and public and even became political issues.[50] Nevertheless, those yearly salons were available to young painters and sculptors, as were an infrastructure of small galleries, like Bernheim-Jeune, that were sympathetic to modern art—venues enabling an artist to show without having to resort to the expedient of the group. Parisian poets, however, had fewer established resources. Paul Fort's *Vers et Prose* was there for Symbolist poets, and *Le Figaro* devoted considerable column space to the arts, but not specifically to poetry. Poets thus had to create their own little magazines to see their work into print. For that reason, many of Paris's new movements in these years— Simultanéisme, Dramatisme, Paroxysme—reflected the poetic doctrines of these poet-editors.

By contrast, Germany and Russia offered a milieu most artists thought of as actively hostile to modernism, with newspapers given to scathing attacks, governments that could censor journals and close down exhibitions, and a public that seemed (in Germany's case) complacent, self-satisfied, and indifferent to the arts.[51] Such an environment, offering few resources and considerable intimidation to an artist starting out, made both the protective and assertive functions of groups attractive. The German painter, August Macke, summed up the differing worlds with envious exaggeration: "In France, success follows on the most daring experiments by the young, but for them taking risks derives from a tradition. With us, each risk is a desperate chaotic experiment by a man who cannot master the language" (qtd. in Vezin 104).

These cultural generalizations require qualifying, however. Why, for example, did groups flourish in (and young artists flock to) Berlin, but not Vienna, if both cities fall within the reactionary culture described above? The cities were so different that they prompted no less prominent an artist than Arnold Schoenberg to leave Vienna in 1911 for what he hoped were better prospects in Berlin;[52] and many artists would have concurred with Kupka's comparison of Vienna and Paris in 1897: "Vienna was like the sickness of a man in poor physical health. . . . I have become emotionally ill [living there]. The Viennese air is not good for a painter. . . . It was pure decadence. Here [in Paris] once again I take pleasure in the warmth and light of life. I am cured of my ills and wish to return to my studies of nature."[53] And Berlin, as Kokoschka observed, was

> incapable of enduring boredom. If something is the way it is, why can't it be changed? In this attitude Berlin differs from Paris, London, Rome, and . . . Vienna, where you hear a lot about tradition even

> though the tradition itself is now completely empty. . . . [Berliners] to
> their astonishment, had become cosmopolitans virtually overnight . . .
>
> [They] saw the key to survival in a metaphysical belief, the belief in
> progress . . . the ideology of industrialization. (*My Life* 64)

In such an environment, the arts, too, could change—or at least be left alone by an urban (if not urbane) public.[54] Vienna, on the other hand, prided itself on its reactionary traditionalism and enforced it vigilantly. In Vienna, Kokoschka's incendiary play, *Murderer: Hope of Women*, was closed by police after it provoked an uproar; Stravinsky's *Petrouchka* was insulted by the Philharmonic's musicians; and a concert of Schoenberg's group was broken up by an infamous riot rivaling the one over *Le Sacre du Printemps*.

Clearly, a hostile climate as a negative spur cannot alone account for these differences in group vitality. Artists sought opportunities in a locale, a potential audience to be won, a measure of freedom (or at least benign neglect) enabling them to assemble, experiment, and present their work. Russian modernists experienced both encouragement and resistance in Moscow and St. Petersburg. A conservative and unsophisticated public forced these artists to warm themselves collectively—group activity was more intensive there than anywhere else. But even with censorship and the emigration of many artists to Paris, the milieu was not so repressive as to discourage their efforts—witness the remarkable productivity of the Cubo-Futurists alone—and their antics made good copy. In sum, a locale's artistic climate had to strike a balance for modernist groups to flourish: hostile enough to make groups attractive, but not so hostile as to discourage their activity.

Finally, differences in cultural temperament—specifically how much artists valued iconoclasm versus collaboration—may partly explain the uneven numbers and differing influences of groups across Europe. Parisian poets Georges Duhamel and Charles Vildrac, for example, refused to be grouped under Jules Romains's *Unanimisme*, even though both poets were part of the Abbaye de Créteil commune (with which the Unanimist credo was closely associated) and were sympathetic to the movement's philosophy. Precisely for this reason, as Kenneth Cornell points out, Duhamel and his friends "never made a concerted effort to dominate the *Mercure* [*de France*, where Duhamel wrote a column on poetry]. . . . [T]heir insistence on their individuality precluded such intentions" (120). Had they been Italian Futurists, they would have engineered a coup d'état to control the whole newspaper! This iconoclasm, also evident among the English modernists (despite Lewis's and Pound's best efforts to organize them), splintered French movements and made them far less effectual than their counterparts in Berlin, Moscow, and Milan.

B. *Distribution by Art*
 Another demographic of modernist groups is their distribution according to the arts practiced by their members.

Table 1.4. Group Distribution by Art

Visual Arts	Poetry/Drama	Music	Multidisciplinary
Jack of	Ego-Futurists	2nd Vienna	Cubo-Futurists
Diamonds-e	Mezzanine	School	Union of Youth
Donkey's Tail-e	Centrifuge	Akademischer	Italian Futurists
/Rayists	Imagists	Verband	Vorticists
Picasso-Braque	Dramatistes		Unanimists
Orphists	Simultaneistes		Mercereau salon
Die Pathetiker	Paroxystes		Puteaux group
Neue Secession-e	*Revolution* group		Ballets Russes
Neukunstgruppe-e	*Die Aktion* group		Das neue Pathos
Mánes Union	Der neue Club		*Pan* group
of Artists-e	Neopathetisches		*Der Sturm* group
Assoc. of	Cabaret		NKV-Munich
American	Der literarisches		Blaue Reiter
Painters &	Club Gnu		Group of Plastic
Sculptors-e	Meyer circle		Artists
Synchromists			291 group
			Mabel Dodge
(e=exhibition			salon
group)			*Glebe*

As table 1.4 indicates, nearly all the groups fall into three broad categories: visual artists, poets, or artists from more than one discipline. Significantly, composers are weakly represented (only two groups, both centered around Arnold Schoenberg), and fiction writers are missing entirely. Self-interest vis-à-vis the presentational possibilities of the art form seems the likeliest explanation of these disparities. A poet's opportunities for public exposure were more flexible than a novelist's. While novelists could (and did) have their fiction serialized, they ultimately required publishers to bring it out in book form. For poets, however, publication in a literary magazine or arts newspaper was significant, hence the groups of poets surrounding—or creating—modernist journals like *Glebe* or *Die Aktion*. Poets also seemed more accessible (or perhaps more in demand) than novelists for public readings, thus their gravitation to such locale groups as Der neue Club in Berlin.

Visual artists, needing exhibitions, accordingly formed exhibition groups; the Akademischer Verband served the same purpose for composers. Perhaps the most surprising fact is how many groups intermingled two or more arts. Of course, this list would be much longer if it included one-time collaborations between painters and poets. As it is, the list demonstrates how extensively artists crossed disciplinary boundaries, not only to discuss ideas of mutual interest at a

salon in New York or an artist's studio in Puteaux, but also to work together on interdisciplinary projects (for example, the *Blaue Reiter Almanac*), or because the group's aesthetic philosophy was just as appealing to poets and composers, say, as to painters and sculptors (which was certainly true of the Italian Futurists and the Russian Cubo-Futurists). Consider the alliance between painters and sympathetic poets (doubling as art critics) in the formative years of the Cubist School, 1910-1912. Albert Gleizes recalls their meetings to plan an exhibition or discuss Cubist ideas at the Closerie des Lilas and at artists' studios like Jacques Villon's in Puteaux: "From the painters who met one another, joined by poets, sympathies were created, an ambiance was formed that was soon going to determine an action. . . . Painters and writers went forward shoulder to shoulder, animated by a sense of sharing the same faith" (*Souvenirs*; qtd. in Robbins 16).

C. Group Proliferation

Finally, perhaps the most difficult question: why did the groups themselves proliferate so rapidly in the years just before the war?[55] No single explanation obtains, but the most striking factor is the parallel between the rise of groups in the prewar years and the intensifying and accelerating *pace* of modernist productivity in all the arts. Many historians of the arts—not to mention artists themselves—have observed that avant-garde innovation was most intense in these years, and a list of landmark works and achievements from 1910-1914 confirms these assertions:

Table 1.5. Some Landmark Works and Achievements: 1910-1914

Premières
Scriabin, *Prometheus,* 1910
Stravinsky/Ballets Russes, *Petrouchka*, 1912
Debussy/Ballets Russes, *L'Après-midi d'un faune*, 1912
Schoenberg, *Pierrot Lunaire*, 1912
Schoenberg, *Five Pieces for Orchestra*, 1912
Debussy/Ballets Russes, *Jeux*, 1913
Stravinsky/Ballets Russes, *Le Sacre du Printemps*, 1913

Publications
Italian Futurists, manifestos (over 50) between 1910-1914
Khlebnikov, first *zaum* (transrational poem), 1910
Kandinsky, *Concerning the Spiritual in Art*, 1911
Schoenberg, *Theory of Harmony*, 1911
Hoddis, "World's End" (considered first Expressionist poem), 1911
Marinetti, *Parole-in-Libertà*, 1912, 1913
Sorge, *The Beggar* (considered first Expressionist play), 1912
Kandinsky and Marc, *Blaue Reiter Almanac*, 1912
Pound, *Ripostes*, 1912

Table 1.5—Continued

Pound, Imagist manifestos, 1913, and *Des Imagistes*, 1914
Apollinaire, *The Cubist Painters: Aesthetic Meditations*, 1913
Apollinaire, *Alcools*, 1913, and "Lettre-Ocean," 1914
Cendrar and Sonia Deluanay, *La Prose du Transsibérien . . .* , 1913
Cubo-Futurists, *Victory over the Sun*, 1913
Thomas Mann, "Death in Venice," 1913
Proust, *Swann's Way*, 1913
Marinetti, "Zang Tumb Tumb," 1914
Joyce, *A Portrait of the Artist as a Young Man*, serialized 1914
Vorticists, *BLAST*, 1914
Stein, *Tender Buttons*, 1914

Modernist Newspapers and Little Magazines (Starting Dates)
Walden, *Der Sturm* (Berlin 1910)
Pfemfert, *Die Aktion* (Berlin 1911)
Monroe, *Poetry* (Chicago 1912)
Apollinaire, *Soirées de Paris* (Paris 1912)
Caundo, *Montjoie!* (Paris 1913)
Papini and Soffici, *Lacerba* (Florence 1913)
Marsden and Weaver, *The Egoist* (London 1914)
Anderson, *The Little Review* (Chicago 1914)

Achievements in the Visual Arts
Kandinsky, Kupka, and Delaunay all achieve total abstraction, 1910-1912
Cubism achieves international influence, 1911
Picasso and Braque create first collages and papier collés, 1912
Orphism achieves international influence, 1913

Major Exhibitions
Stieglitz's exhibition of young American modernists, New York 1910
First Post-Impressionist exhibition, London 1910
Cubist "salle 41" at the Salon des Indépendants and "salle 8" at the Salon
 d'Automne, Paris 1911
Blaue Reiter exhibitions, Munich 1911-1912
Italian Futurists' traveling exhibition, 1912
Donkey's Tail, Moscow 1912
Sonderbund exhibition, Cologne 1912
La Section d'Or, Paris 1912
Armory Show, New York 1913
The Target, Moscow 1913
First German Autumn Salon, 1913

As table 1.5 indicates, productivity in these astonishing five years approximates a bell-shaped curve, building to a peak in 1912-1913 and gradually falling off in 1914 *before* the outbreak of the war, which temporarily brings nearly all activity to a screeching halt. Among themselves, artists and historians disagree slightly in locating the pinnacle of creativity. Igor Stravinsky finds in 1912 the "summit" of "originality" and "explosive force" in modernist music—"the years of *Pierrot Lunaire* and *Le Sacre du Printemps*" (*Memories and Comments* 122).[56] Virginia Spate sees 1912 as "the decisive year in the development of Orphism—and, indeed, non-figurative art in general" (29). Mabel Dodge, however, opts for the year of the Armory Show and the Paterson Strike Pageant: "Looking back upon it now, it seems as though everywhere, in that year of 1913, barriers went down and people reached each other who had never been in touch before. . . . The new spirit was abroad and swept us all together" (Luhan, *Movers and Shakers* 39). But by 1914, Apollinaire had noted "signs of lassitude" at the Indépendants Salon, which he attributed to the Salon now attracting conservative painters (Spate 53).

It could be argued, of course, that these two indices of rising energy—group proliferation and modernist productivity and innovation—are merely parallel, not causally connected. But a sizable percentage of the achieving artists did belong to groups, and groups dominated the public, presentational realm of modernism: the exhibitions, concerts, poetry journals and arts newspapers, public readings, and evenings. Moreover, as leaders like Marinetti, Apollinaire, and Burliuk crisscrossed Europe, and as large international exhibitions were mounted, groups contributed significantly to a flowering internationalism in prewar modernism, even as European nations grew increasingly xenophobic. What seems indisputable is that a major aspect of the avant-garde's intensifying energy and productivity expressed itself collectively: As artists dared cross the "acceptable" boundaries of their art, they increasingly felt the need to do so as part of a group, not simply to be protected from the public's hostility, but to further the innovative drive itself through the inspiration of working with like-minded artists and dynamic group leaders. Modernist groups did not simply respond to these conditions: they played a major role in helping to create them.

Chapter 2

Leaders

I concluded that as a matter of course some romantic figure must always emerge, to captain the "group." Like myself! How otherwise could a "group" get about, and above all *talk*. For it had to have a mouthpiece didn't it?

—Wyndham Lewis, *Blasting and Bombardiering* 35

The group's true goal . . . [its] secret and unnamed objective [is] the "Will to Arrive," the single-minded ambition of one man. . . . The *chef* needs a group around him to spread propaganda, but the school functions only as his promotional machine. Even his disciples, the apparent insiders, are dupes to this enterprise. In the end, only the *chef* benefits; followers have been used without ever having achieved anything of their own by practicing the group style.

—Albert Fleury, "*Nouvelles Ecoles et Nouveaux '. . . ismes'" Les Tablettes*, July-September 1912, 29

I. Types

The epigraphs above suggest a relationship of mutual dependency: If leaders needed groups to realize their aesthetic compulsions and megalomaniacal impulses, groups obviously needed leaders, the visionary dynamos who organized the group, gave it a purpose, a program, often a membership; who arranged its exhibitions, publications, and presentations; who publicized it and shaped its public persona; and who led it into verbal and sometimes physical combat at these same events. Most of all, the leader's energy and vision gave the group its identity, its rationale, its momentum. But like subatomic particles that carry their potential dissolution as antimatter, each leadership quality that energized the group could also help dissolve it; in fact, the internal fissures these qualities caused figured prominently in the breakup of several groups.

Who were these modernist leaders whose features so impressed themselves into the group's identity? As table 2.1 suggests, they can be grouped into roughly four overlapping types: (1) leaders like Filippo Marinetti, Ezra Pound, and Wassily Kandinsky, who were themselves serious artists and who typically organized the group around aesthetic principles they were evolving in their own

art; (2) impresarios and gallery owners like Herwarth Walden, Alfred Stieglitz, and Serge Diaghilev who arranged performances, exhibitions, and presentations (often at their own galleries), or were editors and publishers of modernist journals—all of whom attracted a distinct and cohesive "circle" of artists; (3) artist-pedagogues, like Arnold Schoenberg, whose group comprised their students or disciples; and (4) "locale leaders": organizers of clubs (Kurt Hiller), salons (Mabel Dodge, Alexandre Mercereau), and studio discussion groups (Jacques Villon), if the group possessed a fairly distinct and consistent identity and aesthetic orientation, or collectively produced works of its own.

Table 2.1. Modernist Group Leaders by Type

Artist-theoriests	Impresarios, Gallery owners, Editors/Publishers	Artist-pedagogues	Locale providers
F. T. Marinetti	Serge Diaghilev	Arnold Schoenberg	Mabel Dodge
Ezra Pound	Alfred Stieglitz	(Kandinsky)	Alexandre
Wyndham Lewis	Herwarth Walden	(Pound)	Mercereau
Wassily Kandinsky	Franz Pfemfert		Henri
& Franz Marc	Paul Cassirer		Le Fauconnier
David Burliuk	Alfred Kreymborg		Jacques Villon
Mikhail Larionov	Alfred Meyer		Ludwig Meidner
& Natalia Goncharova			Kurt Hiller
Robert Delaunay			
Jules Romains			
Igor Severyanin			
Ludwig Meidner			
Nicholas Beauduin			
Henri Martin Barzun			

Inevitably, as some leaders span more than one category, others fit comfortably into none. Alfred Stieglitz was most certainly an artist and theorist, but it was as a gallery owner and editor that he gathered around him an important circle of artists and writers. Guillaume Apollinaire, on the other hand, was all over the modernist map as a kind of leader-without-portfolio. Through his influential roles as freelance journalist, editor, and lecturer, he positioned himself to be the theorist and promoter of several existing groups and the reifier of one movement, Orphism; but he led none.

Transcending these categories are ambivalent personal qualities shared by a remarkably high percentage of leaders: constructive energy, vision, dynamism, dedication; destructive megalomania, authoritarianism, arrogance, and jealousy of rivals; as well as paradoxical blends (in widely varying proportions) of pub-

licity-seeking showmanship and artistic asceticism. So pervasive are these qualities and in such varying combinations, that, to prevent redundancy, they are best considered in connection with the leader's motives and responsibilities.

II. The Joys of Leadership

To begin, we should consider the leader's typical responsibilities as the group's organizer, chief theorist, publicist, promoter, impresario, and sometime financial backer, and, equally important, the leader's motives for taking on these roles. Although some groups coalesced fairly spontaneously from common interests, such as those organizing exhibitions (for example, The American Association of Painters and Sculptors) or those gathering to discuss matters of common interest (the Puteaux group), the typical modernist group formed through the efforts of one person.

For those leaders who were primarily impresarios, gallery owners, and journal editors—that is, those who presented to the public exciting contemporary artists and ideas—the emergence of a circle of "regulars" around their enterprise was a natural and inevitable outgrowth of their primary desire to promote avant-garde art and ideas that might otherwise lack a venue. In exchange for the impresario's patronage, these regulars often helped him mount the exhibitions (as Max Weber did for Alfred Stieglitz), or edit the newspaper (as the group of writers who met at Café des Westens did for Franz Pfemfert).

Artist-leaders who were not impresarios, however, could expect no such compensation. Why, then, should they divert considerable stores of energy and time from their own art to the labors of forming and nurturing a group? Their motives fall along a continuum, ranging from artistic idealism at one pole to self-promotion at the other. Nearly always, their motives blended something of both extremes. Those whose first devotion was to their art primarily wanted to promulgate their aesthetic ideas and felt that a group was the most effective means by which to do so.[1] For Ezra Pound, Imagist principles and probably even the *notion* of *Les Imagistes* preceded his decision to form the actual group, the latter occurring (as noted in the prologue) only *after* Marinetti and the Futurist traveling exhibition had arrived in London. As one of the original Imagists, Richard Aldington, avers: "My own belief is that the name [*Les Imagistes*] took Ezra's fancy, and that he kept it *in petto* for the right occasion. If there were no Imagists, obviously they would have to be invented. . . . Whenever Ezra has launched a new movement . . . he has never had any difficulty about finding members. He just called on his friends" (*Life for Life's Sake* 135).

Inevitably, as artist-leaders' aesthetic ideas changed, so did the groups they formed to espouse them. In late 1911 Igor Severyanin founded the Ego-Futurists, a group of St. Petersburg poets devoted to expressing the poet's intuitive and even mystical states in a "new poetic rhythm and new orchestration of sounds" (Lawton 20ff.). Although the group programmatically opposed the Cubo-Futurists' idea of transrational poetry (the *zaum*), Serveryanin modified his aesthetics and teamed up with Cubo-Futurists David Burliuk and Vladimir

Mayakovsky to publish *Futurists: Roaring Parnassus. First Revue of Russian Futurists* in early 1914. Together, they also signed the belligerent manifesto "Go to Hell!" But the alliance was brief: Severyanin soon returned to espousing his own aesthetics.

For those who seemed to enjoy leading a group more than working at their art, the pleasures of being at the center of the action, of plotting and executing group campaigns of conquest and scandal, of opining provocatively to journalists and assembled audiences—these appeals to megalomania were reasons enough to leave the studio; and they promised fame, albeit through notoriety, that might otherwise elude a second-rate artist. David Burliuk, for example, was a tireless organizer of modernist exhibitions and groups in Russia;[2] indeed, as Vladimir Markov observes, he was

> a man without whom there probably would have been no Russian futurism. A genius of organization, he inspired the [other Cubo-Futurists] to action, made important decisions, and found new poetic forces at the crucial moments in the history of [Russian] futurism. He was responsible for the publication of such landmarks of futurism as both volumes of . . . *A Trap for Judges*, "A Slap in the Face of Public Taste," *The Croaked Moon*, *The Milk of Mares*, and *The First Journal of the Russian Futurists*. He was the publisher of early books by Khlebnikov, Mayakovsky, and Livshits. To some Futurists, he was also a mentor, especially to Kamensky and Mayakovsky. (Markov 9-10)

As Markov also notes, Burliuk "wanted to appear as radical and experimental as possible" (53-54)—apparently for the attention accorded an enfant terrible (fig. 12). But his poetry, as both Markov and Vahan Barooshian concur, was outdatedly Symbolist and, in Markov's view, "cliché-ridden" (24). His aesthetic ideas were little better: he "cannot be considered a coherent theoretician of Russian Futurism. His theoretical views on poetry are . . . [as] derivative and diverse as his paintings . . . [and] at times contradictory" (Barooshian 70). Such contradictions mattered little to Burliuk who, as fellow Futurist Benedict Livshits recalled, "never took problems of terminology seriously" (qtd. in Markov 118). What he *was* good at was organizing and leading avant-garde movements and inspiring talented artists like Mayakovsky (fig. 13) to join them (Barooshian 69, 78).[3]

Journalists and critics who were disturbed by proliferating groups were all too ready to take this self-promotion as the group's true purpose. In a review of new schools and "isms" in 1912, for example, Albert Fleury dismisses the group's manifestos and aesthetic theories as "nonsense"; only the group's leader knows its true goal—to realize *his* "Will to Arrive"—which he conceals from the disciples. They thus become his dupes, Fleury concludes, necessary agents to spread his propaganda and elevate his importance.[4] For leaders whose talents were more promotional than artistic, such as Burliuk (and, many would argue, Marinetti), this cynical analysis has a grain of truth. But in reducing the group's members to victimized sheep who, in Vauxcelles's words, "do not all know . . .

where they are going, or, better, where they are being taken,"[5] these one-dimensional explanations don't envision the benefits, both aesthetic and practical, that the members realized. Nor do they account for leaders who were serious artists or true believers, or both.

A leader's motives were seldom clear-cut. Even those who seemed idealistic in placing high artistic goals above self-serving ones were not immune to the pleasures of being at the center—or of using their power to maintain that position. No one can accuse Wassily Kandinsky and Franz Marc of indulging in the sensationalism and publicity schemes of a Marinetti. Their public statements and private letters express a sense of a high purpose, a mission to show the public the widest variety of the new art. The brief catalogue note accompanying the first Blaue Reiter exhibition states: "This little exhibition is not seeking to propagate one specific form; our aim is rather to show through a variety of different forms the multiplicity of ways through which the inner wishes of artists take shape" (qtd. in Vezin 178).

But Marc and Kandinsky also conceded privately their pleasure in the centrality and prominence their educational efforts conferred on them. As Marc confided to his brother on the day after Marc and Kandinsky walked out of the NKV-Munich (3 December 1911): "The Editors of the Blaue Reiter will now be the starting point for new exhibitions. . . . *We will try to become the center of the modern movement.* The association may assume there the role of the new *Scholle*" (qtd. in Lankheit, *Almanac* 14, my emphasis). Similarly, one of their announcements for the *Blaue Reiter Almanac* declares: "the publication is a meeting place for all powerful endeavors that can be observed today in all fields of art" (qtd. in Lankheit 38). They could even look forward to posterity's approval of their efforts: As Marc wrote to Kandinsky on the *Almanac*'s publication: "I am sure of one thing: many silent readers and young people full of energy will secretly be grateful to us, will be fired by enthusiasm for this book and will judge the world in accordance with it" (qtd. in Vezin 150).

As both jury for the Blaue Reiter exhibitions and editors of the *Almanac*, the two painters configured these media to their particular tastes: "Marc and I took what we thought was good; and we selected freely without considering certain opinions or wishes. So we decided to run our Blaue Reiter dictatorially."[6] Something of this autocratic attitude emerges in their denominating Karl Hartmann as "Authorized Representative for Russia" for the *Blaue Reiter Almanac*. Kandinsky, moreover, was not above competitive maneuvering to maintain the Blaue Reiter's centrality, nor was he about to let rival groups upstage his pet project. Thus, he resists Marc's wish to feature the Berlin Brücke painters prominently in the *Almanac*:

> [Their] things must be *exhibited*. But I think it is incorrect to immortalize them in the *document* of our modern art (and, this is what our book ought to be) or as a more or less decisive, leading factor. At any rate I am against *large* reproductions [for their paintings]. . . . The small reproduction means: this *too* is being done. The large one: *this* is being done. (letter to Marc, 2 February 1912; qtd. in Lankheit 20)

Similarly, Kandinsky attempted to dissuade Herwarth Walden from energeti-
cally promoting the Italian Futurists in 1912:

> If possible do not give special prominence to Futurist painters. You
> know my attitude toward them and the last manifesto (painting of
> sounds, noises, and smells—with no grey! with no brown!—etc.) is
> even sillier than those preceding it. Don't be offended, Herr Walden .
> . . , but art is, in fact, something sacred that cannot be treated so
> lightly. (Qtd. in Vezin 210)

To be sure, Kandinsky's distaste for the Italians' showmanship and ideas partly
motivated this request, but so did a desire to hinder a competitive group by try-
ing to sour their relationship with this prominent promoter. Walden would have
been right to take offense at this pompous meddling.

III. Organizing the Group

In forming their groups, leaders had to decide how widely to cast their nets:
should they strive for aesthetic purity and exclusivity or political strength in
numbers? The advantages and liabilities of each approach are self-evident: the
nucleus group of a few like-minded (or similarly styled) artists could achieve
relatively easy consensus in aesthetic matters, but would not easily stand out in
an art world of competing groups. Just the opposite obtains for large, loosely
constructed groups: better visibility, but less internal unity. Many small groups
were highly productive artistically and aesthetically—nucleus groups such as the
Picasso-Braque friendship and the Second Vienna School. Groups that made the
biggest splash politically, however, tended to be inclusive: the Italian Futurists,
Imagists (in their various incarnations), Vorticists, and Cubo-Futurists. Inter-
twined always with these strategic issues are personality questions, particularly
the leader's need to control the consistency of the group's aesthetic or philoso-
phical stance.

Case Study: Pound and *Les Imagistes*—Aesthetic Consistency
 Pound's creation of "Les Imagistes" illustrates several sides of the problem.
As noted above, he began with the idea for the movement: its aesthetic princi-
ples (discussed in chapter 3) had been percolating since his participation in the
"forgotten school of 1909." The example of Marinetti leading the Italian Futur-
ists' traveling exhibition of March 1912 sparked those ideas into action. A
French name for the group would lend it the aura of an avant-garde locale where
"isms'" sprang up overnight and became a sensation the next day.[7] (For all of his
confident bluster, Pound in 1912 was still self-conscious enough about London's
provincialism, not to mention his own origins in a "half-savage" country, to re-
sort to this snobbery.) Neither of the two poets he then recruited for the move-
ment were French—Richard Aldington was English; Hilda Doolittle, like
Pound, was an American expatriate. But both were, in relation to Pound's rap-
idly advancing reputation, poetic novices. Pound later claimed that he created

Imagism to launch their careers, but he was also launching his own as a modernist mover and shaker, and, as he put it, establishing "a critical demarcation" in poetics.[8] The members' small number and inferior status as quasi disciples, moreover, seemed to assure no challenge to Pound's authority.

With this nuclear membership, Pound had no problem achieving aesthetic consistency in the movement's poetry, announcements, and manifestos that he sent to Harriet Monroe's *Poetry* magazine in 1912-1913; he alone determined the group's principles and image. Size was a different matter. To make the movement seem larger, he recruited F. S. Flint to sign the group's first manifesto, in which Flint appears to have "discovered" the group. But to fill out a *book*-length anthology of "Imagist" poets—a medium he felt essential to make the group more visible—Pound recruited several other poets whose Imagist credentials (or even knowledge of the movement's aesthetics) were questionable at best: Flint, Skipwith Cannell, John Cournos, Ford Madox Hueffer, Pound's old university friend William Carlos Williams, James Joyce, Amy Lowell, and Allan Upward.

Immediately, he faced resistance in his core group: Aldington recalls that he and Hilda Doolittle "objected to Allen Upward, Skipwith Cannell, and Amy Lowell. . . . [the last of whom] at that time . . . had published only one book. . . . [which was] "the fluid, fruity, facile stuff we most wanted to avoid" (*Life for Life's Sake* 136-37). In addition, Aldington found "nothing very imagistic" in Hueffer's poems, and as for Flint, "the nearest he got to Imagism was reading masses of young French poets and imitating Verlaine" (*Life* 136). Reviewing *Des Imagistes* for *The Little Review*, Charles Ashleigh agreed and felt that these questionable inclusions "have dealt a blow to sectarian Imagism" (July 1914, 15; qtd. in Jones, 19). Years later, Pound himself concurred. Writing to Glenn Hughes in 1927, he conceded that "Flint was . . . really impressionist. He and Ford and one or two others shd. by careful cataloguing have been in another group, but in those far days there weren't enough non-symmetricals to have each a farm to themselves" (26 September 1927; *Selected Letters* 212-13).

Pound addressed the problem by insisting on sole editorial control: since he alone would select the poems for inclusion, they would at least meet his standards of quality, if not of Imagistic purity. But this solution seemed high-handed to the participants. Frank Flint put it bluntly to Pound the following year:

> As to energy, etc. You deserve all credit for what you have done [in developing Imagism]. . . . But where you have failed, my dear Ezra, . . . is in your personal relationships; . . . you might have been generalissimo in a compact onslaught: and you spoiled everything by some native incapacity for walking square with your fellows. You have not been a good comrade, voilà![9]

Not surprisingly, the Imagists—including Pound's "disciples"—quickly gravitated to Amy Lowell's offer of a more egalitarian standard: contributors would choose their own poems for inclusion in *her* Imagist anthologies.[10] Richard Aldington recounts:

> [Amy] proposed a Boston Tea Party for Ezra, the immediate abolition
> of his despotism and the substitution of a pure democracy. There was
> to be no more of the Duce business, with arbitrary inclusions and ex-
> clusions and a capricious censorship. We were to publish quietly and
> modestly as a little group of friends with similar tendencies, rather
> than water-tight dogmatic principles. (*Life* 139)

Pound's response to Lowell's egalitarian standard was predictable. To Har-
riet Monroe he complained bitterly in January 1915, construing the problem as
one of quality versus quantity, rather than of maintaining aesthetic consistency
within a loosely assembled group:

> In the Imagist book [*Des Imagistes*] I made it possible for a few poets
> who were not over-producing to reach an audience. That delicate op-
> eration was managed by the most rigorous suppression of what I con-
> sidered faults.
> Obviously such a method and movement are incompatible with
> effusion, with flooding magazines with all sorts of wish-wash and
> imitation and the near-good. If I had acceded to A.L.'s proposal to
> turn "Imagism" into a democratic beer-garden, I should have undone
> what little good I had managed to do *by setting up a critical standard*
> [my emphasis]. . . .
> A. L. . . . wants to weaken the whole use of the term imagist, by
> making it mean *any* writing of vers libre. . . . And the very discrimi-
> nation, the whole core of significance I've taken twelve years of dis-
> cipline to get at, she expects me to accord to people who have taken
> fifteen minutes' survey of my results. (*Selected Letters* 48)

By this time (1915), however, such complaints were *post facto*: Pound's effort
to head off Lowell's takeover bid had failed dismally.

Case Study: Kandinsky and Der Blaue Reiter—Philosophical Consistency

A major artistic innovator, Kandinsky was also an influential theorist and a
gifted teacher. All three identities, moreover, were integral to his creativity: his
theories directly informed his painting, and he promulgated those theories
through his writing and the productions of the modernist group he helped organ-
ize, the Blaue Reiter.

Artists who knew Kandinsky in these years recognized at once that his char-
ismatic appeal derived from this seamless interweaving of the creative and the
theoretical. Franz Marc spoke of being immediately captivated by his revolu-
tionary ideas when he first met Kandinsky in February 1911.[11] August Macke
was also enchanted—initially. To Marc he wrote: "[Kandinsky] is . . . a roman-
tic, a dreamer, a visionary and teller of fairy tales. . . . There is a boundless vital-
ity in him. . . . It surges up not only in the form of rocks, castles, and seas, but
also in his infinitely tender, pastoral element."[12] Paul Klee observed at their first
meeting that "intellectual rigor in him takes productive forms quite naturally"
(*Die Alpen* 1912; qtd. in Grohmann 69). Hugo Ball wrote of him in 1927, "his
words, his colors, and his tones were alive in a rare harmony" (paraphrased in

Grohmann 70). Perhaps the most thoughtful assessment came from Elisabeth Macke: "Kandinsky himself was a very unusual, original type, uncommonly stimulating to every artist who came in contact with him. There was something uniquely mystical, highly imaginative about him, linked with rare pathos and dogmatism" (qtd. in Grohmann 77).

Kandinsky fully recognized the importance of this synergy between his visionary ideas, innovative practice, and proselytizing fervor. In his important essay "Reminiscences," written in June 1913 to accompany a retrospective album of his work published by Walden's Der Sturm press, he recalled how the ideas in *Concerning the Spiritual in Art* evolved naturally from his painting and returned to it, reinforcing and clarifying his move toward abstraction:

> I derived spiritual experiences from the sensations of colors on the palette. . . . These experiences, moreover, became the starting point for the ideas I started consciously to accumulate as much as ten or twelve years ago, which led to my book *On the Spiritual in Art*. . . . I felt with increasing strength and clarity that it was not the "formal" element in art that matters, but an inner impulse (= content) that peremptorily determines form. One advance in this respect . . . was solving the question of art exclusively on the basis of internal necessity, which was capable at every moment of overturning every known rule and limit.
>
> For me, the province of art and the province of nature thus became more and more widely separated, until I was able [in 1913] to experience both as completely independent realms. (*Complete Writings* 1: 373)

Having experienced and then gradually conceptualized these ideas, Kandinsky goes on to describe how he propagated them:

> My book *On the Spiritual in Art* and the Blaue Reiter [*Almanac*] . . . had as their principal aim to awaken this capacity for experiencing the spiritual in material and in abstract phenomena, which will be indispensable to the future, making unlimited kinds of experiences possible. My desire to conjure up in people who still did not possess it this rewarding talent was the main purpose of both publications.[13]

Retrospectively, he added: "[I] felt obliged to communicate my thoughts not only to the surrounding island [of associates], but also to mankind beyond this island. I considered them seminal, essential."[14]

To "communicate" his ideas understates Kandinsky's mission; ultimately, he aimed for nothing less than changing the thinking of his age. In the Russian edition "Reminiscences," he writes:

> It became clear to me . . . [when writing *Concerning the Spiritual in Art*] that as regards formal questions, even the "spirit of the age" is formed precisely and exclusively by those grandiloquent artists—"personalities," who, by their strength of conviction, dominate not only their contemporaries, possessed of less intensive content or else

of merely external talent (without inner content), but also successive
generations and centuries of artists. (*Collected Writings* 2: 894)

The group Kandinsky formed with the like-minded Franz Marc to propagate
these ideas and to display art representing them was aesthetically unified, but
too small to accomplish their ambitious plans (fig. 14). They recognized from
the outset that they would need help from numerous contributors and assistants
to attain a comprehensive and international range of articles for the *Almanac* and
paintings for the exhibitions. For the *Almanac*, they commissioned well-situated
modernists to represent and report on the arts of various geographical areas:

> From Hartmann I ordered an article on Armenian music and a music
> letter from Russia. . . . Schönberg *must* write on German music. Le
> Fauconnier *must* get a Frenchman [to write for us]. . . . We might also
> ask Pechstein to write a Berlin letter: nothing too definite, just to try
> him out. Miss Worringer on the [Cologne] Gereon Club and its aims.
> Just wait! We will get a real pulse flowing in our dear book.[15]

Complicating this structure, some contributors drew close enough to the
"Editors" through friendship and shared interests to form in effect a second tier
of associate members: August Macke worked closely with Marc and Kandinsky
during the fall of 1911, composing and editing articles for the *Almanac*; he also
provided an all-important guarantor for the *Almanac*, Bernhard Koehler. Elisa-
beth Macke recalls their excitement: "Those were unforgettable times, when all
the men were working on their manuscripts, polishing and revising. . . . [T]hen
the contributions began to come in from elsewhere, as requested, together with
suggestions for works to be reproduced" (qtd. in Grohmann 77).

Alfred Kubin, a fellow member of the NKV-Munich who seceded along
with Marc and Kandinsky, was also in this second tier. Paul Klee, who lived
near Kandinsky, was introduced through the intercession of Macke, Kubin, and
Louis Moilliet; following his favorable review of the first Blaue Reiter exhibi-
tion, one of his works was included in the second exhibition and reproduced in
the *Almanac*. Finally, there was Arnold Schoenberg, who in many ways directly
paralleled Kandinsky as a major innovator and teacher, and whose work was
driven not by an a priori system, but by the composer's subjective feeling of
"inner necessity."[16] Kandinsky had formed an admiring correspondence with
Schoenberg after attending a concert of his music in January 1911 and recogniz-
ing their analogous positions in their respective arts.[17] Once the Blaue Reiter
projects began to take shape, Schoenberg seemed perfect for writing on the aes-
thetics guiding his composition: "Publishing the first issue without Schoenberg's
contribution is unthinkable," Kandinsky declared to Marc in November 1911
(qtd. in Vezin 146). Schoenberg also submitted paintings to the first Blaue
Reiter exhibition.

At this "second tier," Kandinsky's ideological quest created tensions that
intermingled aesthetics and less elevated sentiments. Consider, for example, the
status of his former NKV associates Alexei von Jawlensky and Marianne Weref-
kin, once they sided against Kandinsky and Marc at the "breakup" meeting of

the NKV on 2 December 1911. For Kandinsky, their defection was both a personal betrayal and ideological apostasy: He summarily dropped them from all the Blaue Reiter's events and publications. August Macke's association also conflates personal and ideological tensions. As the quotations above suggest, it began with mutual enthusiasm, Macke contributing an article to the *Almanac* and helping with the exhibitions. The euphoria was short-lived, however. When he learned that one of his paintings in the first exhibition was excluded from the collection that traveled to Cologne and Berlin, Macke was "furious" (Vezin 185).[18] Several months later, the Sonderbund exhibition, on whose "working committee" Macke was an influential member, rejected submissions by Kandinsky and some NKV painters. Marc angrily withdrew his paintings in protest, published an article in *Der Sturm* criticizing the jury system, and, along with Kandinsky, refused to attend the Sonderbund's opening in May 1912.

Although Macke and Marc soon patched up their spat, a deeper divergence between Macke and Kandinsky, did not, indeed could not, resolve itself. Macke simply could not share Kandinsky's emphasis on the spiritual. The sunny sensuousness of Macke's art and his delight in the colors and textures of nature were too deep for him to abandon the physical world; and his sardonic skepticism had little patience with Kandinsky's and Marc's mysticism. Here, too, personal pique may have been a factor: Macke felt that Marc was too much under Kandinsky's sway. But he also believed that the group and its *Almanac* were merely a vehicle for Kandinsky to promote his theories. Still smarting from being excluded from the Blaue Reiter's Cologne exhibition, he writes Marc:

> I have just been thinking that the "Blaue Reiter" does not really represent my work. I have always been convinced that other things of mine are more important. . . . Narcissism, fake heroism and blindness have a lot to answer for in the "Blaue Reiter." All those high-sounding words about the birth of a great spiritual moment still resounding in my ears.[19] Kandinsky can air his personal opinion about that or any other revolution he cares to mention. But I dislike the whole thing. . . . Take my advice—work, and don't spend so much time thinking about blue riders or blue horses. (ca. January 1912; qtd. in Meseure 38)

Once Macke had visited Robert Delaunay's studio in October 1912, any lingering sympathy for the Blaue Reiter died. His *Persiflage on Der Blaue Reiter* (1913) mocks Kandinsky's abstract style and shows Marc's subservient position as coachman, contentedly driving a sainted Kandinsky, while an inflated Herwarth Walden and a diminished Macke look on. Macke's letter to Bernhard Koehler is even more emphatic in rejecting Kandinsky for a newer hero:

> As far as painting is concerned, Kandinsky has quietly faded away. Delaunay has set up shop next door, and there you could see *living* color as opposed to that incredibly complicated but utterly *insipid* color-*patch* composition. One's hopes have been betrayed: it's enough to make one cry. But Delaunay started out with the Eiffel

Tower and Kandinsky with gingerbread. There is more mysticism in
a tabletop than in all his pictures put together. They no longer have
any resonance for me.[20] (Qtd. in Zweite 48)

Although his reaction was more absolute than those of other artists in the
second tier, Macke was not alone in distrusting Kandinsky's ideological extrem-
ity. Paul Klee's feelings toward him were complex. He deeply admired Kandin-
sky's art and intelligence, but was also wary of what he called "a Russian man
without ballast" who "never lived with great fervor in the framework of this
world" (qtd. in Tower 44). At least one associate who knew them both at the
time attributed Klee's ambivalence to tinges of "jealousy and competitive feel-
ings."[21]

In the examples of both Pound and Kandinsky one can see a double dialec-
tic complicating their efforts to organize their groups. One dialectic opposes
idealism and practicality. Both leaders wanted their groups to embody a type of
purity: aesthetic purity in Pound's case, ideological purity (placing the spiritual
over the material) in Kandinsky's. Both, however, needed to expand the group
beyond a core nucleus in order to achieve practical results: filling out a poetry
anthology, expanding the scope of an almanac, mounting exhibitions. Inevitably,
tensions arose from recruiting peripheral members who, in their attitudes or art,
did not fully share the leader's philosophy. Solutions were dubious: Pound
strove for aesthetic unity by imposing absolute control over the group's produc-
tions, leading inevitably to the group's rebellion. Kandinsky, too, acted dictato-
rially, relying only on himself and Marc to select articles and artwork so as to
maintain the group's ideological values; again, the result was rebellion, in
Macke's case, and division.

Another dialectic pits idealism against less attractive personal motives.
Pound's striving for aesthetic purity scarcely conceals his megalomania—the
"Duce business" Aldington refers to; his hostility toward Amy Lowell, likewise,
is mixed with bitterness that she successfully lured his group away from him.
Kandinsky, for all his otherworldly manner, maneuvered to keep other groups—
the Futurists, Die Brücke—from preempting his own from center stage. Simi-
larly, group members do not merely rebel from a noble need for independence:
slights, hurt feelings, and personality conflicts (as between Macke and Kandin-
sky) inevitably enter into these defections.

IV. Expanding the Group: Two Types of Imperialism

Beyond practical necessity, some modernist leaders strove to expand their
groups for the same reasons that their national leaders were colonizing Third
World countries at the same time: for prominence and power. Whether political
or artistic, this imperialism can backfire and prompt the targeted colony to resist,
or encourage rival states to use the same tactics. The resulting empire, moreover,
can prove unwieldy and ungovernable. Among the modernist states, only one
leader, Marinetti, practiced imperialism internationally by attempting to coerce

foreign groups into the Futurist orbit. The same imperializing urge, however, can be applied to the realm of theory in the case of Apollinaire's Cubist and Orphist categorizing—theory that could produce surprisingly similar practical results of empowering the theorist and alienating his subjects.

Case Study: Marinetti as Practical Imperialist

Filippo Marinetti, the most dynamic and visible leader of the period, was also the most aggressive in striving to make *his* group—its art and especially its philosophy—the juggernaut of modernism in all the arts. To that end, he expanded a small core of Italian painters in 1910 into a large group of painters, poets, architects, composers, writers, critics, filmmakers, and photographers by 1913-1914. Within Italy, his success was unparalleled: the Futurists virtually monopolized modernism.[22] Marinetti, however, had greater ambitions and crisscrossed Europe in a whirlwind strategy of provocative lectures and publicity ploys to spread the gospel of Futurism and, ultimately, to recruit new members and even groups. As the prologue shows, the Futurist painters' European début in their traveling exhibition of 1912 was remarkably successful, establishing the group as a major presence, spreading Futurist aesthetics, and influencing artists all across Europe. Here was a group, moreover, that truly seemed to speak and act with one voice, that shared a philosophy it tirelessly articulated and expanded in more than fifty manifestos, and that mastered a new art of publicizing itself. In fact, however, even as Italian Futurism outwardly seemed to flourish between 1910-1914 as the most cohesive of groups, internally it grew increasingly fissured.

Of the Futurist painters who signed the manifestos beginning in 1910, only three—Boccioni, Carrà, and Russolo—could be considered core members, living near each other in Milan, meeting often with Marinetti to exchange ideas, and evolving a coherent aesthetics. Giacomo Balla, much older than the others, lived in Rome and did not actively participate in Futurist events until 1913. Moreover, after 1911 his style often diverged from Futurist aesthetics, sometimes into complete abstraction (for example, *Iridescent Interpenetrations*) influenced by his theosophical beliefs. Gino Severini, the remaining signer, lived in Paris, which he understandably considered the center of modernism, and saw himself as much a Parisian or European as an Italian, as much influenced by Neoimpressionism and Cubism as by Futurist aesthetics of dynamism. Embarrassed by Marinetti's publicity tactics and by the Futurists' crude bravado, he agreed to lend his name to manifestos and paintings to their exhibitions only with considerable reservations. Some of these reservations pertained to the credentials of his fellow Futurists. In his memoir, *Life of a Painter*, he recalls: "It was very difficult for us [the Futurist painters] to stop [Marinetti] from admitting the coarsest idiots into our ranks" (104). Having unsuccessfully appealed for Marinetti's financial support, he opines with understandable jealousy that Marinetti "did often lack discernment about the recipients of his largesse. At times, a person of little worth, as long as he declared himself a Futurist, would obtain more from him than someone truly deserving" (84).

Members who seemed arbitrarily recruited posed obvious problems to the Futurists' internal cohesion. Often feeling least related to the group stylistically or ideologically, they were most likely to leave—or to drive out others. Marinetti's efforts to impose doctrinal unity from above succeeded for a time with the core group, especially since Boccioni translated the broad principles of the Foundation Manifesto (for example, speed and dynamism) into more specific painterly aesthetics (for example, force lines) in their "Technical Manifesto of Painting" (1910) and "From the Exhibitors to the Public" (1912). But as the group expanded, so did problems of unity. For example, Ardegno Soffici and Giovanni Papini, Florentine editors of *La Voce* and formerly vociferous critics of Futurism, were gradually won over to the movement through intensive recruiting following the Milan group's attack on them in the "punchup in Florence." Boccioni facetiously assigned Severini as "plenipotentiary trustee for the Florence Peace Treaty" (Severini 108), but the courting was genuine—and successful. By February 1913, Soffici and Papini had left *La Voce* and started what quickly became the "official" Futurist journal, *Lacerba*, even though their loosely drawn aesthetic philosophy (and Soffici's Cubist style) could never quite accommodate the more programmatic aesthetics articulated in Futurism's numerous manifestos.[23] By February 1914, both artists had severed their Futurist connections. As Marianne Martin summarizes: "They accused [Marinetti and Boccioni] of trying to establish 'an immobile church with an infallible creed,' . . . [of] prescribing 'a precise recipe, a method imposed under pain of heresy, a trademark'" (202).

About the same time, Severini himself and Carrà, a core member, had enough of Marinetti's relentless publicity campaigns. Severini was explicit in his memoirs:

> It was probably Futurism that gave rise to the demons of over-advertising and journalistic demagoguery, which came to plague artists. (80)

> [Marinetti] was [by 1911] beginning to look at things less *from the point of view of art* or *interest in art* than from that of the effect it produced. (84)

> I was sure that all the publicity, and the use Marinetti made of it, tended more and more to distract my friends from the main object of their aspirations.
> Without realizing it, [Marinetti and Boccioni] were treating art as a "means," a "pretext," simply out of vain, materialistic exhibitionism. (93)

Severini finally wrote Marinetti in 1914, asking to be "left to work in peace" (qtd. in Martin, *Fururist Art* 185). Carrà, too, felt "that his artistic interests and those of Futurism were increasingly at odds. . . . Both artists had grown impatient with, in Carrà's words, 'the tireless and not very reflective activity of Marinetti and Boccioni.' Marinetti's social and pedagogical concerns were "of

no value to us who wish to be pure artists" (Martin, *Futurist Art* 184-86). Like the rebellious Imagists, the disaffected Futurists reformed and redefined the movement specifically to exclude their authoritarian leader; their February 1915 article in *Lacerba*, "Futurismo e Marinettismo," asserted a theoretical basis for the separation, but in Martin's view, "the distinctions were extremely arbitrary and on the whole revealed more malice than thought" (202-3).

While these splits were deepening, Marinetti launched two campaigns, in Russia (January 1914) and England (May-June 1914), to persuade extant groups to submerge their separate identities within the collective aegis of a greater Futurism. Both efforts failed, arousing strong resistance from the target groups (the Russian Futurist assembly and the Vorticists) and a reactive nationalism matching Marinetti's own. While Marinetti's ploys and the responses they provoked are examined in other chapters, one conversation that Wyndham Lewis recreated in his memoir, *Blasting and Bombardiering*, shows how direct and unsubtle Marinetti's approach could be:

> "You are a futurist, Lewis!" he shouted at me one day, as we were passing into a lavabo, together, where he wanted to wash after a lecture, where he had drenched himself in sweat.
> "No," I said.
> "Why don't you announce that you are a futurist!" he asked me squarely.
> "Because I am not one," I answered, just as pointblank and to the point.
> "Yes. But what's it matter!" said he with great impatience.
> "It's most important," I replied rather coldly.
> "Not at all!" said he. "Futurism is good. It is all right."
> "Not too bad," said I. "It has its points. But you Wops insist too much on the Machine. You're always on about these driving-belts, you are always exploding about internal combustion. We've had machines here in England for a donkey's years. They're no novelty to *us*."
> "You have never understood your machines! You have never known the *ivresse* of traveling at a kilometer a minute. Have you ever traveled at a kilometer a minute?"
> "Never," I shook my head energetically. "Never. I loathe anything that goes too quickly. If it goes too quickly, it is not there."
> "It is not there!" he thundered for this had touched him on the raw. "It is *only* when it goes quickly that it *is* there!"
> "That's nonsense," I said. "I cannot see a thing that is going too quickly."
> "See it—see it! Why should you want to *see*?" he exclaimed. "But you *do* see it. You see it multiplied a thousand times. You see a thousand things instead of one thing."
> I shrugged my shoulders—this was not the first time I had this argument. . . . "All right. I am not a futurist anyway. *Je hais le mouvement qui déplace les lignes.*"
> At this quotation he broke into a hundred angry pieces.
> "And you 'never weep'—I know, I know. *Ah zut alors!* What a thing to be an Englishman!"[24]

Case Study: Apollinaire as Theoretical Imperialist

The problem of defining and expanding a group could be theoretical as well as actual. Apollinaire (fig. 15) discovered this when he tried to encompass several quite diverse painters within a Cubist rubric. As was described in chapter 1, he had first proposed these categories in his address, "The Quartering of Cubism," at the "Section d'Or" exhibition and likely received Kupka's angry response to being dubbed an "Orphic Cubist." Undeterred, Apollinaire appended the gist of this talk to his book *The Cubist Painters: Aesthetic Meditation*, which came out in March 1913. Privileging Cubism as the central and defining style of modernism, he grouped an array of modernist painters under its domain in four "trends": "Scientific Cubism" (Picasso, Braque, Metzinger, Gleizes, Laurencin, and Gris); "Physical Cubism" (Le Fauconnier); "Orphic Cubism" (Delaunay, Léger, Picabia, and M. Duchamp); and "Instinctive Cubism" (late Cézanne, Derain, and other unnamed European painters).[25] As Herschel Chipp summarizes: "[Apollinaire] forced almost every contemporary artist into one of his categories, even Matisse, Rouault, Boccioni, and Marie Laurencin. In a final note to the book he even aligned most of the critics according to his four categories" (*Theories of Modern Art* 227 n. 1). The categories were immediately controversial and "vigorously condemned from the time they appeared in print" (227 n. 1).

Critics and artists have speculated on Apollinaire's motives for creating such sweeping and dubious categories. Chipp, citing Apollinaire's later remarks that "he did not mean them to be definitive, but . . . was only attempting to evoke the spirit of the new directions in painting," attributes the categorizing to Apollinaire's enthusiasm and informality. Less charitably, Robert Delaunay felt that Apollinaire's poetic sensibility was the culprit. By labeling Delaunay's style "Orphism," "[Apollinaire] assimilated it into the workings of poetry. . . . [A]s a poet [he] could perhaps not comprehend [its] important structural meaning" (qtd. in Vriesen, *Robert Delaunay* 54).[26] But why should a poet whose stock-in-trade is language and who was by then a fairly experienced art critic invent categorical labels so imprecisely?

Several critics see a "strategic" purpose in Apollinaire's labels (Spate 60). Arthur Cohen sees them as self-serving: he "proliferated a language in order to sustain his advocacy [of the modernists]" (11). Gustav Vriesen construes them in military terms as Apollinaire's desire "to create a solid front against the continuing attacks from the press and from the general public. All artists who strove for the new were to be united under the flag of Cubism" (53)[27]—and, by implication, leading this solid front is Guillaume Apollinaire, the commanding general.

Arguably, all of these explanations are valid and, when combined, present a clearer picture of Apollinaire's intentions. In privileging the style he knew best and for which, Adam-like, he now invented an encompassing taxonomy, Apollinaire was positioning himself to be not merely the advocate, but the intellectual leader and speaker for a new movement, which, having "united," he could then lead against its conservative enemies. This synthesis requires two refinements, however. First, as noted above, his Cubist categorizing dates from the Section

d'Or exhibition, and Section d'Or painters figure prominently in *The Cubist Painters*, as they had in his salon reviews over the past two years. As Chipp observes, "It appears that in his mind Cubism was more closely associated with the painters of . . . the Cubist 'school' . . . than with [Picasso and Braque]" (220). Apollinaire, moreover, attended the Puteaux group's Sunday afternoons at Villon's studio. In contrast to the essentially private and practical collaboration between Picasso and Braque, this group was open, fluid, and intellectual—virtually ideal for Apollinaire to assert his credentials as its intellectual leader and public representative. Conceivably, then, "The Quartering of Cubism" and *The Cubist Painters* were his bid to do so. As one critic has observed in another context, "Apollinaire wanted to be the exclusive spokesman for the new art" (Robbins 16).

Moreover, in championing Cubism, Apollinaire chose a style that had emerged in Paris and that he identified as essentially French, Picasso's Spanish origins notwithstanding. Both facts played to Apollinaire's acquired nationalism, which, by fall 1912, he had already asserted against rival pretenders to the Modernist crown—the Italian Futurists—and would soon do again against the German Expressionists. If Cubism was "the most serious and interesting" of all new modernist styles, it validated Paris as the center of the avant-garde, France as its national home, and Apollinaire as its putative leader, spokesperson, and defender.

Whatever personal ambitions prompted Apollinaire's Cubist categorizing, he failed to become the leading spokesman of Parisian painting (or even of the Puteaux group) partly because his totalizing backfired (just as did Marinetti's analogous efforts to imperialize extant groups), and partly because the rapidly changing art world was undergoing yet another major shift at the very time of Apollinaire's lecture and book. "Although artists were glad to have a champion," Virginia Spate writes, "they were frequently embarrassed by the terms he used to characterize their art, and enraged when he incorporated them, willy-nilly, in some grouping of the avant-garde" (60). Moreover, Cubist labels no longer captured the diversifying Parisian art world of 1912-1913, nor even applied to the Puteaux painters, for most of whom Cubism was only a way station en route to their own styles.

Apollinaire, too, had moved on: he was still in the vanguard, but as advocate rather than supreme authority. Shortly after the Section d'Or show, he committed himself to Delaunay's color abstractions and accompanying theories, and his art criticism and lectures of 1913 continue to develop this interest in what he called "pure painting, simultaneity."[28] If promoting a style (which he had reified into a movement simply by naming it) represented Apollinaire's attempt to regain his authority, it too ultimately failed, not only because of his personal falling out with Delaunay, but because by 1914 the Indépendants saw so many "diverse . . . tendencies" that even Apollinaire conceded that categorizing was now—and perhaps had been—pointless: "we shall lay aside the *labels of doubtful validity* that have been used to distinguish [these tendencies] until now" (my emphasis). He settled for categorizing the origins of these styles—with the same dubious reductiveness: "There are two main currents, one of them

issuing from the cubism of Picasso, the other from the cubism of André Derain; both currents stem from Cézanne. This, I believe, is the clearest and simplest thing one can say about modern art."[29] The "signs of weariness" Apollinaire sensed at this exhibition may well have been his own in recognizing that this diversity of styles had gotten beyond him.[30]

V. Leading the Group: Practical Responsibilities

Having organized the group, leaders typically assumed two contrasting types of responsibilities: theoretical, in shaping the group's aesthetic stance (a job often shared with other core members) and relating that stance to what members actually produced; and practical, in publicizing the group, projecting its aesthetic identity (typically through manifestos), promoting its art by arranging for exhibitions, publications, performances, public readings, sales, etc., and sometimes underwriting costs and supporting impoverished members. Theoretical responsibilities have already been mentioned in regard to expanding the group and will be considered further on (regarding the artist-pedagogue). Let us, therefore, turn to the leader's practical responsibilities.

Although leading a group obviously gratified personal needs for power and prominence, leaders were unlikely to keep their groups together for long if the members did not feel that their interests were being served. Roger Fry, for example, suffered a major defection at his Omega Workshops in London in the fall of 1913, when several members (led by Wyndham Lewis) concluded they were disadvantaged by his insistence on the artist's anonymity and by his failure to pass along possible commissions.[31] Amy Lowell, conversely, gained the respect of the Imagists she had won over from Ezra Pound not only by securing a major publisher for their poetry, but by scrupulously tending to mundane, but necessary tasks. Richard Aldington recalls in *Life for Life's Sake*:

> Amy undertook to do all the practical work, to get the books published in Boston and London and to account to us for the royalties. And well and loyally she discharged that task, which involved a good deal of work and correspondence. (139-40)

> [T]he anthologies were widely read; and Amy kept the publicity going with superb generalship. . . . [T]he sales of [Pound's] *Des Imagistes* were only a fraction of the Imagist anthologies after Ezra left. (142)

Aldington concludes that if Pound invented the movement, it was Lowell who "put it across" (133).

Filippo Marinetti, for all his efforts on behalf of Italian Futurism, also rankled fellow Futurists when they felt he was ignoring their personal welfare for the sake of the group's prominence. In Berlin, for example, he allowed nearly all the paintings in the traveling exhibition to be purchased en masse at low prices, and shortly thereafter relinquished control of their future showings to Herwarth

Walden and the purchaser of the paintings, Dr. Wolfgang Borchardt. Boccioni, Carrà, and Severini all complained bitterly among themselves, and Marinetti protested directly to Walden about his not informing the Futurists about the exhibition's future itinerary (see prologue, n. 16). Clearly, however, Marinetti's neglect was culpable: in the fall of 1912, for example, he was off covering Italy's Libyan campaign—another cause for the painters' disgruntlement. Severini's balanced complaint seems to echo the painters' feelings generally by the end of 1912:

> [O]ur paintings were traveling throughout Europe as "curiosities" accompanying Marinetti who used the publicity for the sake of Futurism. In this respect, that is, in subordinating everything to an extrinsic end, to a "given effect," Marinetti was a master and innovator. He would say, "Futurism before everything else; the abilities of the Futurists, their lives, their needs, all secondary things." (104)

This criticism suggests two characteristics about group leaders like Marinetti. First, they may have felt as much devotion to the abstract "movement"—to its aesthetic stance and public image—as to the individual artists who formed it. This was especially true of entrepreneurial and impresario leaders like Walden, Stieglitz, and Diaghilev, who strove to realize their aesthetic philosophy through their medium (newspaper, gallery, ballet) and whose first loyalty was to maintaining its standards. Second, for brash, energetic artist-leaders like Marinetti, Pound, and Burliuk, publicizing the group was a lark, a natural corollary to forming its aesthetic credo. Indeed, these leaders invented (or imitated) crowd-catching ploys in the style of P. T. Barnum, and nowhere does modernism coincide more completely with popular culture, where advertising played a newly prominent role, than in modernism's successful exploitation of publicity devices. Marinetti virtually wrote the book on how to use them. Acting as advance man for Futurist exhibitions, he distributed copies of the Futurist manifestos at strategic places in the city and made contacts with influential local critics (for example, Apollinaire in Paris), artists, and groups. As publicity agent, he gave newspaper interviews (his audacious opinions were always good copy) and ensured coverage of the exhibition. As lecturer, he gave bombastic speeches, read Futurist manifestos, and later performed his *parole-in-libertà* poems, all attracting good crowds and more reviews. And in Italy, he arranged the infamous Futurist evenings that goaded an audience into a fight or riot and thus garnered still more publicity for the movement.

For a few group leaders, and for many artist members, however, this pursuit of publicity was tawdry and uncongenial. Alfred Stieglitz, for example, was driven by the same devotion to the new that energized Herwarth Walden, Serge Diaghilev, and Ezra Pound; but as the following case studies show, his attitude toward promoting was diametrically opposed to the freewheeling practices of these other leaders.

Promoting and Publicizing: Four Case Studies

1. Alfred Stieglitz: Understanding without Promoting

An aesthetic purist who considered himself merely "a trustee for beauty," Alfred Stieglitz (fig. 16) found the practical tasks of publicity seeking and even encouraging sales at his 291 gallery foreign and repellent. To Paul Haviland, he complained in 1916: "The game [of selling art] is being played fast and furious everywhere and to me it is disgusting" (qtd. in Watson 81, 237).[32] True to his beliefs, he refused to sell Max Weber's paintings for prices he felt Weber had set unduly high; and even though the refusal occurred during a one-artist show Stieglitz had arranged for Weber, it was enough to destroy their friendship permanently (Lowe 152). Steven Watson says of Stieglitz: "His commitment [to modernism] was unsullied by commerce: he didn't advertise exhibitions, never locked the gallery's doors, kept no records, accepted no commission from his artists, and sold a work only to those he judged capable of appreciating it. 291 was a laboratory rather than a gallery, Stieglitz insisted" (81).

Contemporary accounts concur: Mabel Dodge, for instance, recalls:

> His belief was that he never gave in to anything except what he be- lieved to be the best; that he never did anything for money or prestige or power, that he cared only for what he called the spirit of life, and that when he found it he fostered it. If, like the rest of us he was in the dark regarding the masks of his colossal egotism, what of it? Only so could he get things done. . . . [We] were drawn together by the purity of Stieglitz's intention. (Luhan 72)

"Purity," however, also has austere, even monastic connotations and can be pur- sued with a monomaniacal devotion. Present in his gallery from 10 A.M. to 7 P.M.,

> the middle-aged Stieglitz wrapped himself in a black cloak that pro- tected him from the cold of the unheated rooms and made his slight frame . . . seem more majestic. He declaimed about the art on the wall, posed Socratic questions, and offered parables and riddles. Visi- tors to the gallery could not see the works on exhibition without in- teracting with Stieglitz. His never-ending sermon was as essential to experiencing the art as the holy words of communion that precede the sip of wine. (Watson 68)

And the sermon could turn acerbic if listeners proved less than sympathetic to the new art, driving away more than a few potential supporters (Lowe 156).

If his priestly devotion discouraged many sales and all salesmanship, Stieglitz's fidelity to the art itself—and his personal support of several artists— gained the lasting respect of his circle. He encouraged John Marin's increasingly bold watercolor style in 1909 by promising to exhibit whatever Marin sent him from Paris. When Max Weber was evicted from his studio in the winter of 1910, Stieglitz enabled Weber to stay briefly in a neighbor's workroom adjoining 291,

often invited him home for dinner, and supported him for a time in exchange for Weber's help at 291. Indeed, several hungry members of Stieglitz's circle could depend on a free lunch at the Holland House and good conversation to go with it. As Stieglitz's assistant, Marie Rapp, recounts:

> Toward noon, "The Men," artists and writers who were regulars, would start drifting into the workroom, having timed their arrival, modestly, for a chance to be taken to lunch. Many were needy; at least two habitually used the black ink on Marie's desk to camouflage bare patches in their frayed overcoats, into which they afterward rubbed cigarette ashes.

At the Holland House "round table," Rapp continues, "opinions circulated without inhibition, arguments were freewheeling and could lead anywhere. When they became too heated, Alfred often intervened to ask: Was that statement honest? and, if honest, was it also true? The fresh air he introduced usually dissipated hard feelings." Back at 291, Stieglitz's took an intense interest in each artist's progress: "What was the artist's aim when he undertook this work? How well had he succeeded? What values underlay his approach? . . . Where was he heading? Had he grown? Above all, Was this new work "an addition?" (qtd. and paraphrased in Lowe 160).

Coming from anyone other than Stieglitz, such questions might well have seemed presumptuous. But from Stieglitz they reflected the same intensity and devotion to the painters' art and growth that produced the one-artist shows he held for them or the patronage (through Agnes Meyer) that he arranged to enable Marsden Hartley, for example, to live in Europe for three crucial years. Hartley's 1934 homage to Stieglitz singles out this devotion:

> [291] did a work that was never done before, and one that is not likely to be done again, for the same degree of integrity and faith in one person will not be so readily found. All that one group was able to do was done by the spirit of 291, for that group was never but a single spirit and a single voice. It was never allowed to be broken in upon by a touch of hypocrisy. . . . we all entered into its trust and were given credence. ("291—and the Brass Bowl," in Frank, *America and Alfred Stieglitz* 241).

Inevitably, Stieglitz's single-minded support deeply affected the members of his circle. Arthur Dove's case is typical; as Ann Morgan observes:

> Initially the contact with Stieglitz must have reinforced his new-found sense of purpose as an artist. Rapidly, through his contact with Stieglitz and the circle of artists and intellectuals at "291," Dove formulated the principles upon which his career as a painter thenceforth depended and began to produce the body of extraordinary work that established his reputation then and sustains it today. . . . Within two years, through Stieglitz and the "291" ambience, Dove had trans-

> formed himself from a competent but derivative painter to a leader in
> international avant-garde developments. (16, 18)

As Dove himself acknowledged, "I could not have existed as a painter without that superencouragement [of Stieglitz's]."[33]

In sum, Stieglitz's disdain for promoting "his" artists and for selling their work was inseparable from his devotion to art, to discovering its potential in a select few, and to getting those artists to realize and transcend that potential. The purity of this devotion, however, could be rather chilly and was not free of less attractive qualities accompanying a monomania: "He was controlling, quarrelsome, contentious, hypochondriacal, and garrulous. His unrelenting devotion to 291 was mixed with self-pitying demands for appreciation, and when he suffered his periodic depressions, he attributed them to the disloyalty of colleagues. . . . His need to control was part of a despotic side that led to severed relations" (Watson 80). Like Weber, a few others found this single-mindedness repellent. One associate, virtually repeating F. S. Flint's charge against another obsessive controller, Ezra Pound, said Stieglitz was "incapable of a relationship of equality" (qtd. in Watson 80). But against these dissenters weighs the fidelity of nearly all his central group, their gratitude for his support, their recognition of his immense achievement.

2. Herwarth Walden: Promoting without Understanding?

As editor of a modernist newspaper and proprietor of an art gallery, Herwarth Walden's vocation in the prewar art world was analogous to Alfred Stieglitz's, but their personalities and concepts of their mission could not have been more different. Walden (fig. 17) was Berlin's equivalent to Marinetti, Pound, Lewis and Burliuk: a tireless impresario who thrived on publicity, controversy, and cultural subversion. Founder of the newspaper *Der Sturm* in 1910, he built it almost overnight into one of the two most influential Expressionist publications in Germany. Two years later, he repeated this achievement in the visual arts with Der Sturm Galerie, where he exhibited the newest and most controversial modernist painters and groups, opening with the Blaue Reiter's first exhibition, followed by the Futurists' traveling exhibition! A consummate impresario, Walden imported not merely the paintings, but the artists themselves to give lectures and read their manifestos, making these exhibitions major events in Berlin's already crowded art world. For his first exhibition of Delaunay (January 1913), for example, he brought Delaunay and Apollinaire to Berlin to lecture on Orphism and distributed Paul Klee's translations of Delaunay's "Sur la lumière" and Apollinaire's poem "Windows." In short order, Walden became a major figure in German Expressionism and arguably the most influential in modernist Berlin. Oskar Kokoschka, *Der Sturm*'s artist and art editor from 1910-1911, summarizes (with some hyperbole): "For a time Herwarth Walden was a dictator in matters of art: he was dynamic and completely disinterested. As the uncompromising spokesman of modernity, he succeeded in establishing his own view of art in Germany to the extent that all the variations, all the 'isms,' of modern art came to be taken seriously" (*My Life* 58-59).

How did Walden achieve so much so quickly? Roy Allen offers one explanation: Walden was

> much more versatile and multitalented . . . than most of his counterparts in the other circles; he was at once editor and publisher, poet, composer and musician, theoretician-polemicist-critic of literature and art, patron of, and dealer in, the arts, and [later] political journalist. . . . For the artists who . . . clustered around him, he became both mentor and patron, critic and spokesman. (97)

Like virtually all dynamic and controversial figures, Walden polarized people. Nell Walden, his second wife, recalls: "[H]e seemed only able to either attract or repulse others, but not to leave them lukewarm." Allen continues: "He thus acquired enemies—even in the Expressionist camp—but the attraction . . . he was able to exercise on many leading Expressionists was . . . like that of a magnet. Many talented writers and painters, especially the young . . . came seeking his counsel and patronage; they all had a great respect for his person and his views on art" (Allen 97). Four qualities, in particular, attracted young artists to Walden: his energy (the common denominator of all these leaders), his talent for discovering talented young artists and radical groups, his eagerness to flail the bourgeoisie with his newspaper and exhibitions, and his talent for publicizing his ventures and the artists connected with them. Again, Nell Walden: "always uncompromising[,] . . . Walden was a fighter . . . in the intellectual sense. He defended his opinions and ideas aggressively and untiringly. Dynamic and full of energy, restless, in a certain sense limitless, he was only interested in the fight. His weapons were polemics and propaganda" (Allen 97). A sample of his fighting spirit appears in *Der Sturm*'s manifesto, which declares that the newspaper's goal is

> to demolish the [reader's spiritually] slothful, sublimely grave world view. . . . [which relies] solely on the intellect, shunning instinctual life; . . .With our most provocative measures, we will flout every manifestation of this culture which aims at the preservation of its conventions instead of [at] the full enjoyment of life. We will pluck out with painstaking care every sign of liberal diffidence, all meaningless customs.[34]

Like Marinetti, Walden enjoyed creating public scandal in the vituperative editorials of *Der Sturm*, in the disturbing woodcuts of Kokoschka and Die Brücke artists that accompanied them (for example, Kokoschka's brutal illustration to his play *Murderer, Hope of Women*, fig. 18), and then in the painting exhibitions and lectures that he sponsored in Der Sturm Galerie. But also like Marinetti, Walden's flair for publicity repulsed some of the most prominent modernists he worked with; in their suspicions of his purpose, they virtually echo Severini's criticism of Marinetti (quoted above). August Macke wrote to Marc in 1912: "The craze he has for advertising and pushing the [Blaue Reiter] association is something terrible. I'm getting disgusted with *Der Sturm* and its

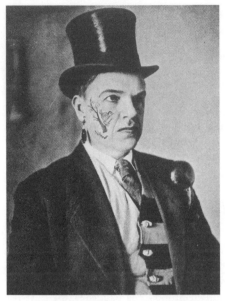

WOCHENSCHRIFT FÜR POLITIK, LITERATUR, KUNST
III. JAHR HERAUSGEGEBEN VON FRANZ PFEMFERT NR.40

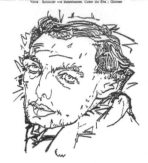

VERLAG / DIE AKTION / BERLIN - WILMERSDORF
HEFT 30 PFG.

Wissenschaftliche Buchgesellschaft, Darmstadt

The Cubo-Futurists: David Burliuk with painted face, top hat, and a spoon in his handkerchief pocket.

Die Aktion front page: Max Oppenheimer ("Mopp"), *Alfred Lichtenstein*, 4 October 1913.

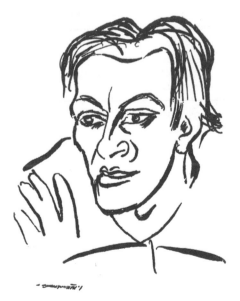

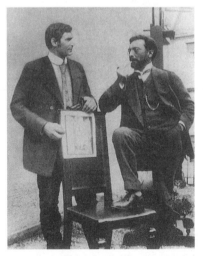

Vladimir Mayakovsky, *Self-Portrait*, 1913.

Franz Marc and Wassily Kandinsky with the cover of their pride and joy: the *Blaue Reiter Almanac,* ca. May 1912, private collection.

Alfred Stieglitz at 291, 1915.

Guillaume Apollinaire, ca. 1914.

Oskar Kokoschka, *Portrait of Herwarth Walden*, 1910. Oil on canvas, 100 x 68 cm., Staatsgalerie, Stuttgart. © 2003 Artists Rights Society (ARS), New York / Pro Litteris, Zurich.

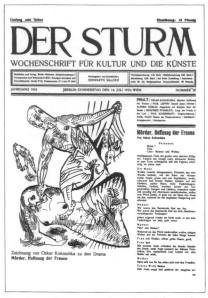

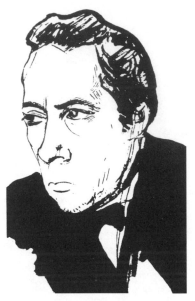

Der Sturm front page, featuring Kokoschka's drawing and play, *Murderer, Hope of Women*, 14 July 1910. © 2003 Artists Rights Society (ARS), New York / Pro Litteris, Zurich.

Vladimir Mayakovsky, *Sketch of Velimir Khlebnikov*, ca. 1912. Ink drawing.

Francesco Cangiullo, *Diaghilev and Stravinsky* (*intonarumori* evening at Marinetti's home in Milan), 1914. Ink drawing. © 2003 Artists Rights Society (ARS), New York / SIAE, Rome.

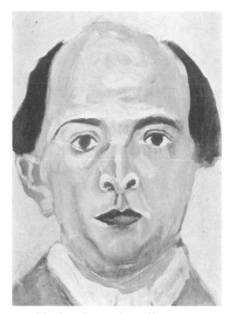

Arnold Schoenberg, *Blue Self-Portrait*, 1910. Oil on paper, 30.7 x 21.7 cm., Arnold Schoenberg Institute, Vienna. © 2003 Artists Rights Society (ARS), New York / VBK, Vienna.

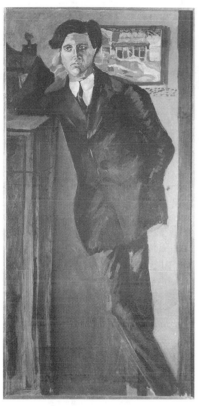

Arnold Schoenberg, *Portrait of Alban Berg*, 1910. Oil on canvas, Museen der Stadt Wien. © 2003 Artists Rights Society (ARS), New York / VBK, Vienna.

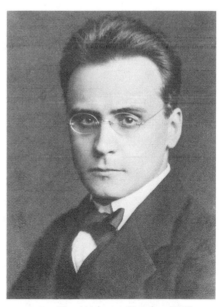

Anton Von Webern, October 1912.

endless manifestoes" (qtd. in Dube, *Expressionists* 66). Paul Klee sketched this vignette of Walden the same year: "little Herwarth Walden was to be seen at the opening of the Futurist show at the Galerie Thannhauser. Lives on cigarettes, gives orders and runs, like a strategist. He is a somebody, but something is lacking. He just doesn't like paintings at all! He just sniffs at them with his good sniffing organ" (*Diaries* 274).

Kokoschka confirms that Walden's "sniffing organ" was acute: "Walden had a special gift for detecting rising talents, artists who were completely unknown even in their native countries, whom he turned into contributors to *Der Sturm*" (59).[35] Yet Klee's suspicion lingers that Walden did not really understand what he promoted. The same has been said of other promoters, impresarios, and salon leaders: about Gertrude Stein,[36] about Marinetti, about Burliuk, (but never about Stieglitz). In all these instances, the promoters are accused of simply exploiting the art of others to promote their movements or themselves.

Walden was liable to these charges. The way that he first spotted, and ultimately took over, the Futurists' traveling exhibition while selling their pictures at half price to a German patron, portrays a less attractive side of his persona: the shrewd "operator" who was not especially devoted to the artists' welfare. And there is something a bit chilling in how quickly he dropped artists and writers who no longer interested him, especially when he shifted *Der Sturm*'s emphasis toward Expressionist visual art. Were the artists and poets, then, merely a means to ego-driven ends of wanting to be the premier mover and shaker of modernism, ever in the spotlight of public controversy?

Kokoschka, who worked closely with him during the newspaper's first two years, saw in Walden the same missionary zeal that Stieglitz and Kandinsky possessed: "He was dynamic and completely disinterested. . . . the uncompromising spokesman of modernity. . . . He was a fanatic in the cause of Expressionism" (*My Life* 58-59, 66). Kokoschka's description of their mutual poverty in those years confirms that if Walden enjoyed being a prime mover, he was not getting rich off of it.[37] His absolutism also links him to Stieglitz and other true believers; Allen describes him as "intractable and intransigent" though capable of great enthusiasm (97). But where he most differed from "purists" like Stieglitz was in his means: Walden, like Marinetti, could yoke a genuine faith in the revolutionary ideals of his group and his enterprises with love of scandal and publicity and with the practical skill of directing them toward his ends. If this "little man" stirred controversy to elevate himself, he also did so for a revolutionary culture in which he believed wholeheartedly.

This question of exploitation haunts many of these leaders. David Burliuk, for example, published poetry manuscripts of Velimir Khlebnikov (fig. 19) without the latter's knowledge, much less permission. Khlebnikov protested this publication in an unpublished open letter of 1914, calling the published poems "worthless and thoroughly garbled to boot." In Markov's view, "Burliuk's praises [of Khlebnikov] seem a tactical exaggeration designed to show rival parties that the [Russian] futurist movement possessed a genius, rather than [being] a sincere tribute to Khlebnikov's greatness" (qtd. in Barooshian 35). Exploiting Khlebnikov's art for propagandistic purposes resulted in a "distorted" presenta-

tion of Khlebnikov's work to the public (Barooshian 34-35). Buliuk, however, was a minor leaguer compared to the exploitive finesse of the Ballets Russes's impresario.

3. Serge Diaghilev: Promoting and Exploiting

Perhaps the strongest case for exploitation appears with the purest example of the impresario: Serge Diaghilev (fig. 20). Unlike the leaders who became impresarios almost by default as they opened a gallery or started an arts magazine, Diaghilev was a professional impresario who had arranged several art exhibitions, orchestral concerts, and an opera (*Boris Godunov*) in Paris before bringing the first Russian ballet there in 1909. As such, Diaghilev fused the incongruous personas of the businessman striving for financial success, the producer seeking artistic success, and eventually the avant-garde radical striving for a revolutionary art. His genius was to merge these identities successfully by bringing to them all a flair for showmanship and artistic provocation. Stravinsky recalls him fondly as being

> the soul . . . of that group of advanced and active artists [the Ballets Russes] which had long attracted me. . . . He had a wonderful flair, a marvelous faculty for seizing at a glance the novelty and freshness of an idea, surrendering himself to it without pausing to reason it out [Yet] his reasoning powers were unerring, and he had a most rational mind." (*An Autobiography* 27-28)

"What struck me most," Stravinsky concludes, "was the degree of endurance and tenacity that he displayed in pursuit of his ends. . . . [E]fficiency and shrewdness were accompanied by a certain childish ingenuousness" (29). Modris Eksteins, however, sees Diaghilev far more critically:

> He was a Nietzschean creation, a supreme egotist out to conquer, and he succeeded in becoming the despot of a cultural empire. . . . His public importance was in his achievement as a manager, as a propagandist, as a *duce*, and less as a creative person. As a theorist he plundered other people's ideas. . . . His creation was his management . . . a brilliant artistic *condottiere*" (58).

Virtually all writers on Diaghilev agree on one point, however: his flair for showmanship and attracting an audience. In *Diaghilev's Ballets Russes*, Lynn Garafola describes how, through the societal connections of impresario Gabriel Astruc, Diaghilev nurtured and catered to a clientele: "an amalgam of financiers, bankers, and diplomats, members of the city's foreign and Franco-Jewish communities, and personalities from the worlds of fashion, music, entertainment, and the press" (279). In addition, "slightly *déclassé* aristocrats turned out in force for *Boris* [*Godunov*], as they would in subsequent years for the ballet" (286). Appealing to this audience's fondness for music and "orientalism," Diaghilev offered a Slavic exoticism that joined the sensuous orchestrations of a Rimsky-Korsakov or a Borodin with Michel Fokine's dynamic and innovative

choreography, realized in the leaping agility of Vaslav Nijinsky, and clothed in
Léon Bakst's brightly colored sets and costumes. The Russian Ballet's successes
turned a long-standing interest in Eastern art and culture into a fad:

> [T]he fashionable craze for "oriental" color and costume . . . dated
> from Diaghilev's first ballet performances. Almost overnight, the
> highly coloristic and sensual vein of orientalism identified with the
> Ballets Russes became decorative and fashion commodities. "The
> taste for oriental art came to Paris as a Russian import, through ballet,
> music, and decoration," commented *Figaro* in 1913. (Garafola 287)

With one eye always on the box office, Diaghilev gave the audience what it
wanted: "The proliferation of orientalia on Diaghilev's stage between 1909 and
1914 . . . betrayed a willingness on [his] part to cater to the tastes of his public
and transform a genre of limited possibilities into a commercially exploitable
formula" (287). Indeed, so exploitable was this fad that *grands couturiers* like
Paul Poiret and even the Ballet's own Léon Bakst designed "oriental" fashions.
The Ballets Russes program carried advertisements for "Parfum Prince Igor,"
and the colorful programs themselves became collectors' items.

But Diaghilev's promotional agility did not end there:

> A master publicist, Diaghilev used every means possible to create an
> artistic and social "splash," pressing salons, newspapers, and embassy
> contacts into service for *Boris* and his early dance seasons. With each
> succeeding year, however, the need to surpass previous successes be-
> came more urgent. With the formation of a permanent company [in
> 1911], it became an economic necessity. Diaghilev now set out to en-
> tice the merely fashionable to grand "celebrity" events. (Garafola
> 292)

Among his "enticements," were charity-gala performances and open dress re-
hearsals to which were invited friendly critics, prominent artists, salonnieres,
and "the most cultured representatives of society" (Stravinsky, *An Autobiogra-
phy* 47). The payoff was immediate: "With their access to salons, these unoffi-
cial publicists sent news of company events rippling among Diaghilev's target
audience" (Garafola 293).

Having three years of successes and now leading a company bearing his
name, Diaghilev was ready to take on more controversial fare. Without in the
least dropping his promotional tactics, he changed the Ballet's choreographer—
and thus its aesthetic emphasis—from Fokine's colorful spectacles to Nijinsky's
far more severe modernism. The shock tactics of Nijinsky and his collaborators,
as well as the audience's polarized responses, will be taken up in chapter 4, but
we should consider here what this aesthetic redirection tells us about Diaghilev's
leadership. First, like virtually all his modernist counterparts, Diaghilev's desire
to innovate was inseparable from his love of creating a controversy. And once
again, the Italian Futurists' manifestos and hijinks seemed to point the way.
Ecksteins writes that Diaghilev "saw himself essentially as a pathfinder and lib-

erator. Vitality, spontaneity, and change were celebrated. Anything was preferable to stultifying conformism, even moral disorder and confusion. . . . [A]rt, or the aesthetic sense, became the issue of extreme importance because it would lead to freedom" (59). Because art "above all . . . was to provoke genuine [intuitive] experience," "shock and provocation became important instruments. . . . [Art] would excite, provoke, inspire. It would unlock experience" (60). Not surprisingly, "[Diaghilev] never succeeded in assembling a clear and consistent philosophy of art" (58)—echoes of Burliuk and Walden! And also like Walden (and the German Expressionists generally), he felt that art was

> a means of deliverance and regeneration. . . . from the social constraints of morality and convention, and from the priorities of a western civilization . . . dominated by a competitive and self-denying ethic. [Thus] regeneration would involve recovery of a spontaneous emotional life, . . . by society as a whole. Art, in this outlook, is a life force . . . a surrogate religion. (Eksteins 58-59)

For Diaghilev, however, this liberationist view of art had distinctly personal sources: it was grounded in his homosexuality and, more specifically, in his affair with Nijinsky, who now, as Diaghilev's lover, choreographer, and chief dancer, literally embodied this fusion of artistic rebellion and sexual tension.[38]

That Diaghilev dismissed Nijinsky just three months after the riot over *Le Sacre du Printemps* and at the same time that Nijinsky had abandoned him for a marriage to dancer Romola de Pulsky again shows how personal, aesthetic, and entrepreneurial motives overlapped for Diaghilev. If sexual jealousy is the most obvious motive, artistic and box office considerations may have superseded it.[39] In brief, Diaghilev recoiled at the outrage of this audience he had worked so hard to cultivate. If Nijinsky had ushered in this new hostility with a severely stylized choreography, and if his competence as a choreographer was criticized by Stravinsky, the natural solution was to replace him and return to the choreographer—and style—that had proven so commercially successful: Michel Fokine.[40] Like the shifting loyalties of so many other modernist leaders, Diaghilev's were not focused on members of his group, but on things impersonal: the commercial viability of his Ballet and, when he could manage it, his self-concept as innovator and agent provocateur.

4. Ezra Pound: "Booming" and Badgering

We have already looked at Ezra Pound's problems in expanding and controlling his Imagist group. Here we should consider a complementary side of his leadership: his relentless promotion of artists he believed in, whether within his group or not, and his relations with editors and patrons, the target of these promotions.

For all of his bluster and megalomania, Pound possessed the same artistic idealism that drove a Stieglitz. His "true Penelope" was artistic excellence; what changed and evolved were his ideas of what constituted it, what conditions enabled or blocked it, and which of his contemporaries possessed it. For those artists he believed in, Pound was a tireless, selfless promoter, and the list of artists

he "boomed," as he put it—and in some cases helped support—reads like a who's who of modernism: T. S. Eliot, James Joyce, Henri Gaudier-Brzeska, Wyndham Lewis, Hilda Doolittle, Richard Aldington, Robert Frost—and these were only in the 1910s! In the same letter in which he complains about Amy Lowell turning the Imagist movement into a "democratic beer-garden," Pound summarizes the role he envisioned for himself. It is not small: "My problem is to keep alive a certain group of advancing poets, to set the arts in their rightful place as the acknowledged guide and lamp of civilization. . . . My propaganda for what some may consider 'novelty in excess' is a necessity. There are plenty to defend the familiar kind of thing." (to Harriet Monroe, January 1915; in *Selected Letters* 48).

Unlike Marinetti's eager showmanship, Pound confined his "propaganda" primarily to writing, partly because of his own awkwardness in public,[41] partly because of the literary medium itself: other than oral readings, poets depended on the print media—newspapers, magazines, and books—to present their work. Thus, Pound's strategy in London was to position himself with modernist journals—typically, as "Poetry Editor" or "Foreign Correspondent"—so as to determine or at least strongly influence the poetry they published without saddling himself with editing the journal. In 1914 he persuaded the coeditors of *The New Freewoman*, Dora Marsden and Harriet Shaw Weaver, to redirect the magazine's feminist agenda toward the arts and change its title to *The Egoist*, for which Pound, of course, would become the literary editor. John Gould Fletcher recounts a typically Poundian approach: "[Pound] persuaded [Marsden and Weaver] that he knew a good deal about the younger and more radical writers of London, and was already engaged in the task of finding literary contributions for them. He now proposed to me that I should put up a small sum every month, to enable him to pay his contributors, and that he should become literary editor of the paper [sic]" (62).

In these multiple capacities, Pound wrote voluminously: articles in these little magazines bemoaning the current decadence of English and American poetry, or presenting Imagist and Vorticist aesthetics to cure this malady; reviews booming his discoveries (he was the first in London and America, for example, to review Frost's first books of poetry); appeals to potential patrons to support a needy artist (but not himself); and most of all, letters to editors of the little magazines—Harriet Monroe, Margaret Anderson, Harriet Shaw Weaver, Alfred Kreymborg, Harold Monro, A. R. Orage—urging, cajoling, and browbeating them to publish *his* artists.[42] The next chapter will examine in detail his clever strategy for exploiting his access to *Poetry* in order to "boom" his group, the Imagists.

One might have expected these editors to bridle against Pound's often arrogant tone and seemingly nonnegotiable demands in these letters. Typically, a poem he submits must be printed immediately and as is. Alfred Kreymborg describes Pound's directions accompanying the astonishing sheaf of Imagist poems he sent to Kreymborg's fledgling magazine, *Glebe*: "A vigorous letter, in a large confident scrawl, warned Krimmie 'that unless you're another American ass, you'll set this up just as it stands!' In a postscript, Pound added promises of

further material provided The Glebe behaved itself and its editors didn't dash his faith by degenerating into some Puritanical policy" (*Troubadour* 204). Kreymborg followed orders and could thus claim the honor of publishing Imagism's first book-length anthology, *Des Imagistes*, as the fifth issue of his journal (February 1914).

What kept these editors—courageous trailblazers in their own right—from dismissing Pound as a crank was not only his indisputable access to the best new work, but also his obvious devotion to finding and promoting it. He writes Harriet Monroe (editor of *Poetry*) at the beginning of their relationship:

> My idea of our policy is this: We must support American poets—preferably the young ones who have a serious determination to produce master-work. . . . [and] [t]he *best* foreign stuff, the stuff well above mediocrity or the experiments that seem serious, and seriously and sanely directed toward the broadening and development of The Art of Poetry.
> And "TO HELL WITH HARPER'S AND THE MAGAZINE TOUCH"! (24 September 1912; *Selected Letters* 10-11)

> I go about this London hunting for the real. . . . But I'm sick to loathing of people who don't care for the master-work, who set out as artists with no intention of producing it, who make no effort toward the best, who are content with publicity and the praise of reviewers. . . . If a man write six good lines he is immortal—isn't that worth trying for? Isn't it worth while having *one* critic left who won't say a thing is *good* until he is ready to stake his whole position on the decision? (22 October 1912; *Selected Letters* 12-13)

Equally impressive was Pound's selflessness. To Monroe: "[D]on't use [my poems] until you've used 'H.D.' and Aldington, s.v.p." (13 October 1912; *Selected Letters* 11). When Pound asked for an advance for Remy de Gourmont in the letter to Kreymborg quoted above, Kreymborg "readily understood why poets attached themselves to Pound. In a world where most people slavishly coddled their own egos, here was a fellow with a heart and intelligence at the service of other contemporaries" (204).[43] Other editors, too, noted Pound's paradoxical blend of avant-garde swagger and selfless idealism. Douglas Goldring, Ford Madox Hueffer's assistant at *The English Review* and then founder of his own magazine, *The Tramp*, captures it perfectly:

> From his room in a lodging house . . . Ezra sallied forth in his sombrero with all the arrogance of a young, revolutionary poet who had complete confidence in his own genius. . . . He struck me as a bit of a charlatan, and I disliked . . . his whole operatic outfit of "stage poet." . . . But one day I happened to see round Ezra's pince-nez, and noticed that he had curiously kind, affectionate eyes. This chance altered my whole conception of him. . . . Ezra could be a friend, and not merely a fair weather one. . . . He was intensely proud of his calling, . . . He was not only fundamentally genial—except, of course, to the objects of his professional scorn . . . —but took a genuine pleas-

> ure in advancing the cause of other poets including those . . . whom
> he might have looked on as dangerous rivals. He was as free from
> petty jealousy as from the least trace of servility to the Established
> and, like Ford, he had a wholly disinterested love of good writing.
> (*South Lodge* 47-48)

Finally, virtually all the editors of these little magazines commented on the
wit and brio of Pound's letters. Thus, Monroe:

> I could go on for many pages with Pound's early letters. They were a
> tonic and an inspiration, for at that time, as I firmly believe, he was
> the best critic living, at least in our specialty, and his acid touch on
> weak spots was as fearsomely enlightening as a clinic. . . .
> During our first year or two, Ezra's pungent and provocative
> letters were falling thick as snowflakes.
> Thus began the rather violent, but on the whole salutary disci-
> pline under the lash of which the editor of the new magazine felt her-
> self being rapidly educated, while all incrustations of habit and preju-
> dice were ruthlessly swept away.[44]

In her autobiography, Margaret Anderson observed that "[h]is letters alone
would have made a good magazine" (*My Thirty Years' War* 159). She then
quotes in full twelve of them!

Pound's letters to potential patrons were more respectful, but no less de-
manding and magisterial. His first letter to John Quinn not only adroitly steers
Quinn's inquiries about purchasing a Gaudier sculpture into a suggestion for
long-term patronage, but lectures this generous supporter of modernism on the
meaning of patronage:

> Speaking of 30,000 dollars for two pictures [which Quinn acknowl-
> edged paying], I "consider it immoral" to pay more than 1,000 dollars
> for any picture NO artist needs more than 2,000 dollars per year,
> and any artist can do two pictures at least in a year. 30,000 dollars
> would feed a whole little art world for five years.
> My whole drive is that if a patron buys from an artist who needs
> money (needs money to buy tools, time and food), the patron then
> makes himself equal to the artist: he is building art into the world; he
> creates.
> If he buys even of living artists who are already famous or al-
> ready making £12,000 per year, he ceases to create. He sinks back to
> the rank of a consumer.
> A great age of painting, a renaissance in the arts, comes when
> there are a few patrons who back their own flair and who buy from
> unrecognized men. . . . [for whom] £10 is a fortune and when £100
> means a year's leisure to work or to travel, or when the knowledge
> that they can make £100 or £200 a year without worry (without
> spending two-thirds of their time running to dealers, or editors)
> means a peace of mind that will let them work and not undermine
> them physically.

> Besides, if a man has any sense, the sport and even the commer-
> cial advantage is so infinitely greater. If you can hammer this into a
> few more collectors you will bring on another Cinquecento. (8 March
> 1915; *Selected Letters* 53-54)

Pound's idealism and dedication shone through so clearly that even prickly pa-
trons like Quinn could overlook his presumption and pedagogical tone.

In marketing himself—accurately—as having the best contacts with new
literary talents, Pound made himself an inevitability in the world of modernist
English poetry. Even if editors despised his arrogant browbeating—and surpris-
ingly few seemed to—they *had* to deal with him if they wanted his discoveries.
Such power, however, could easily build on itself and bring out Pound's "duce"
side in wanting to be a literary dictator of the elite, as these boasts to Harriet
Monroe indicate:

> When you do finally adopt my scale of criticism you will, yes, you
> actually will find a handful of very select readers who will be quite
> delighted, and the aegrum and tiercely accursed groveling vulgus will
> be too scared by the array of delightees to utter more than a very faint
> moan of protest.
> I want the files of this periodical to be prized and vendible in
> 1999. Quixotic of me! and very impractical? (30 March 1913; *Se-
> lected Letters* 18)

> [O]nce they [the popular literary magazines] learn that we do know
> and that we are "in" first, they'll come to us to get all their thinking
> done for them and in the end the greasy vulgus will be directed by us.
> And we will be able to do a deal more for poetry indirectly than we
> could with just our $5000 per annum. (March 1913; *Selected Letters*
> 16)

But such crowing is essentially no different from Marc's and Kandinsky's desire
to be at the controlling center, as they defined it, or from the way that an admir-
ing Kokoschka described Herwarth Walden's "dictatorship." All these cases,
Stieglitz's included, show leaders driven by a paradoxical blend of high ideals,
even selflessness, on the one hand, and on the other a love of personal power: to
be a controller, a wheeler-dealer, a dictator of the arts.

As noted above, Pound fared less well with the members of his Imagist
group who resented his insistence on total editorial control. Initially, however,
they accepted his advice and agreed to his schemes for the same reason the edi-
tors suffered his hectoring. As Richard Aldington explains: "He had the bulge
on us, because it was only through him that we could get our poems into Harriet
Monroe's *Poetry*, and nobody else at that time would look at them. . . . So we
had to give in to his organizing efforts" (*Life* 135). Such expediency has a short
life span, however, lasting only until a better opportunity comes along.[45]

But personal fidelity was shaky on both sides. In fact, Pound later attributed
his accelerating unpopularity among other poets to his fidelity to aesthetic stan-

dards rather than to people. As he explains to Margaret Anderson in August 1917:

> [M]y "personal dislike" of individual contemporaries [that I'm ac-
> cused of] has largely arisen from two causes (also . . . it has arisen
> subjectively in the mind or boozum *of the disliked* and not in my
> own).
> Cause 1. a. My unwillingness to praise what seems to me
> unworthy of praise.
> b. My unwillingness, after having discerned a faint
> gleam of virtue in a young man's work . . . , to be unable to note signs
> of progress in later work, or even to be unable to retain my interest.
> Cause 2. My interest (sudden or gradual) in the work of some
> other artist or writer. (*My Thirty Years' War* 163-64, Pound's empha-
> sis)

Taken together, the great promoter-publicists share qualities that speak to the public nature of prewar modernism. The zest of Marinetti, Walden, and Pound for attracting the audiences and patrons that their groups needed made these leaders, in effect, agents or middlemen, who, despite their antibourgeois rhetoric, were crucial in negotiating the avant-garde's ambivalent relations with the public. Their "descent" into the realm of publicity gambits and promotional schemes entwined modernism with commercial culture—specifically, with marketing, advertising, and public relations—just as several modernist styles themselves were erasing distinctions between "high art" and everyday life: household minutiae occupying Cubist collages and Stein's *Tender Buttons*; cars, street noise, and city crowds filling Romains's poems and Futurist paintings; circus performers, athletes, even lounging soldiers marking the work of Picasso, Delaunay, and Larionov.

But if these tactics proved outwardly successful in gaining modernist groups greater public attention and more patrons, internally they often divided groups, alienating members who found them unseemly and considered their practitioners as self-promoting power brokers. Yet these leaders were also driven by visions of a new, revitalizing art, and to realize this vision, all devoted measures of time and energy that far exceeded practical self-interest. In acting on this aesthetic idealism, they were at one with an Alfred Stieglitz; where they differed from Stieglitz was in the means to this end. Ironically, it was this idealism, rather than pettier motives of power and fame, that most justified group members' suspicions about their leaders' motives. For in striving to establish the more abstract "movement"—to realize the vision—these leaders were often quite willing to abandon artists as quickly as they had taken them up: to use them as means to a larger end.

VI. The Leader as Teacher

To realize their aesthetic principles was often why leaders formed their groups in the first place. Such groups amplified a single aesthetic philosophy that members, attracted by the leader's visionary zeal, would realize in their art. Whether these principles were simply imposed by autocratic leaders, or formed more democratically by the group, determining them was a crucial—and usually the first—activity the group undertook. The results typically took the form of a published declaration of principles—a manifesto—which will be analyzed in the next chapter. Here, we should consider the leader's role as teacher.

The purest examples of this theoretical role appear in leaders who were teachers as well as artists, their pedagogical groups a fusion of studio and classroom, the group's members student-disciples as much as colleagues. Only one modernist group and leader perfectly fits this description: the "Second Vienna School" led by Arnold Schoenberg, with Alban Berg and Anton Webern as both student-disciples and artistic colleagues.[46] Several other leaders, however, had teaching in their blood and backgrounds; some wrote teacherly tracts; and a few organized classes. Kandinsky gave painting classes in Munich from 1901-1903 and published numerous tracts thereafter, including his seminal *Concerning the Spiritual in Art* (1911). Pound, whom Gertrude Stein acidly called "a village explainer," taught for a semester at Wabash College in 1907, before scandal mercifully freed him from this "seventh circle of hell," as he later called it. He never gave up teaching, however, and used almost any means—articles, books, letters, and later even the notorious Rome radio broadcasts—to exhort and admonish his readers, listeners, and acquaintances.[47] With the Vorticists in 1914, he even planned (but did not realize) a College of Arts, and by the 1930s created a half-serious "Ezerversity" in Rapallo that attracted at least one distinguished student, James Laughlin, the future founder and editor of New Directions press. The titles and intents of such books as *How to Read* make Pound's pedagogical intent still clearer. Finally, the *Brücke* painters, Kirchner and Pechstein, founded an institute in Berlin, MUIM, to give courses in several media and to explore relationships between the new art and modern life. The enterprise attracted few students, however (Selz, *German* 131).

Case Study: Arnold Schoenberg: Artist-Pedagogue Par Excellence

The pedagogical group was the most hierarchical of modernist groups: the purer its pedagogical status, the more that leaders treated members as student-disciples, who applied the leader's aesthetic principles to their works and promoted his theories and work as well as their own. The Schoenberg group is the model here, but as Berg and Webern began to produce distinguished work of their own, their group gradually acquired much of the reciprocity and genuinely collective effort that more typified the modernist group.

As a middle-European teacher who happened also to be a startlingly original composer and theorist, Schoenberg (fig. 21) expected—and received—his pupils' complete subservience, respect, and loyalty. Webern (fig. 22) was his student and associate for seven years before he was invited to address the master

in the familiar "*du*" form; Berg (fig. 23) had to wait thirteen years! Both students virtually prostrated themselves at his feet, seeking his approval always, fearing his slightest pique as divine wrath: "Believe me, Mr. Schoenberg," Webern assured him in 1909, "this I always endeavor to do: to keep distance, to show respect, to take nothing for granted, to render honour" (Moldenhauer 107-8). Berg's letters to Schoenberg, as Donald Harris describes, were

> astonishingly servile. . . . [H]e was as intimidated by Schoenberg as he was in awe of him. He was rarely forthright. Almost always . . . his reasonings were circuitous, designed not to annoy or anger his master. . . . After all, one did not cross the master without danger of excommunication. . . . Berg hung on his every word, often would beg forgiveness when he felt, rightly or wrongly, that he had been mistaken, and never would question the wisdom of the elder without taking extreme precaution.[48]

Webern and Berg assumed this subservience eagerly because they believed wholeheartedly in Schoenberg's genius and that, as his student-disciples, they were uniquely privileged to partake of his ideas and inspiration. Donald Harris writes: "The idea that bound [Berg and Webern] together was their unwavering belief that Schoenberg's was the path to the future" (Brand xiv). While this belief soggily permeates virtually every self-abasing line of Berg's voluminous letters to Schoenberg, the more reserved Webern also opened himself to the Master with heartfelt candor. After they shared the deeply moving experience of attending Mahler's funeral—Mahler, who had been the revered trailblazer for all three—Webern wrote Schoenberg: "I will forever preserve in my heart your indescribably kind words to me after Mahler's burial. . . . The past few days are of immense significance to me: Mahler's death and the certainty that I possess your friendship forever. Gustav Mahler and you: there I see my course quite distinctly. I will not deviate. God's blessing on you" (24 May 1911; qtd. in Moldenhauer 144).

Accordingly, as Schoenberg's chosen lieutenants, Berg and Webern considered it their privilege and duty to spread his ideas and music in all ways possible. As Harris says of Berg: "Advocacy for Schoenberg's doctrines and beliefs is the single most important leitmotif in [their] correspondence. Almost everyone mentioned, however prominent in his or her own right, is seen as a believer or a detractor. Even Webern appears less as an individual than as a protagonist for Schoenberg's ideas" (Brand xii). Berg's 1912 letter to Schoenberg is typical:

> [T]here are bright prospects for next season [of the "Akademischer Verband" concerts, 1912-1913], which are almost certain to materialize, naturally only if you agree to it. This makes me all the happier, since my hopes of doing something for your cause, which is of course *our* cause, failed so miserably in the wretched Tonkünstlerverein, while here . . . we really have found a broad and willing forum. My principal goal is now above all to educate the audience systematically to your music. The quartet concert was only the beginning.[49] There will be ever more people who are both willing and understanding so

that soon the great circle of your *unconditional* supporters will enable
the performance and success of *each* of your existing as well as future
works. (23 April 1912, qtd. in Brand 86, Berg's emphasis)

Schoenberg felt understandably gratified by such fidelity (although he expressed
his appreciation sparingly): "Truly, I sensed [from your last letter] how devoted
you are to me and my words and that gives me an extraordinary good feeling"
(19 April 1912, qtd. in Brand 85).

The promotional and supportive efforts of Schoenberg's student-disciples
assumed all possible forms, including: arranging for concerts of his music, copy-
ing and proofreading his scores, writing out orchestral parts, writing reductions
and transcriptions, rehearsing orchestras and choruses, indexing *Theory of Har-
mony*, and so forth. Schoenberg even expected them to handle such nonmusical
chores as supervising the packing and shipping of his personal belongings from
Vienna to Berlin. Such duties demanded no small outlay of his disciples' time,
energy, and money. As Webern's biographer notes, "Webern's time and ener-
gies were so absorbed this winter [1911-1912] by his endeavors on Schoen-
berg's behalf that, paradoxically, [Webern's] Berlin sojourn [to visit Schoen-
berg], confidently expected to be a fertile time for composing, went by without
the birth of a single new work" (Moldenhauer 152).

Perhaps most striking of all these labors were his students' efforts to see
that Schoenberg was properly subsidized. When the Master's finances suffered
from lost teaching fees in his move from Vienna to Berlin in 1911, Webern or-
ganized Schoenberg's students and friends to raise money; they raised 1,000
kronen immediately and later sent to over a hundred potential donors a printed
appeal bearing endorsements of forty-eight signers, including such Viennese
luminaries as Gustav Klimt, Bruno Walter, Arthur Schnitzler, and Adolph Loos.
Two years later, Webern organized a more successful subscription.

These labors and benefits were not one-directional, however. Schoenberg
took considerable pains to find Webern a series of conductorships and a pub-
lisher in these years. (About Berg's professional future, he seemed less willing
to commit himself at the time.) To his publisher, Simrock, Schoenberg wrote:
"Webern is my pupil. He who penetrates more deeply will soon see that we are
dealing here with a really great, truly outstanding, independent talent who in
many respects surpasses my attainments and is clearly a fresh, original artist"
(qtd. in Moldenhauer 164). Similarly, Schoenberg promoted his students' com-
positions to the music directors of orchestras (for example, the Amsterdam Con-
certgubow) where he was conducting his own works. When Webern was inca-
pacitated by psychosomatic problems in 1913, Schoenberg arranged with
Alexander von Zemlinsky to get Webern a season's leave from the latter's con-
ducting position in Prague (though he had just been appointed) and urged We-
bern to see a specialist in nervous disorders. Webern did so, and his successful
therapy with Freud's disciple Alfred Adler led him to call Schoenberg "the
guardian angel" of his life (Moldenhauer 181).

Far more important than the practical level of mutual assistance, however,
was the intellectual synergy of the three composerss. That Berg and Webern

recognized the incomparable benefits they derived as Schoenberg's disciples is hardly surprising from the quotations above: they revered not only his compositions, but his theory and teaching. Here is Webern's revealing assessment of Schoenberg as teacher and mentor, from a collection of testimonials by Schoenberg's students, published by Berg and Webern in 1912:

> One might think that Schoenberg teaches his own style, and that he forces the pupil to adopt that style for himself. This is entirely false. Schoenberg teaches no style at all; he preaches the use neither of old artistic devices nor of new ones. [To do so,] [h]e says "does not give [the pupil] what is most important: the courage and the strength to confront things in such a way that everything he looks at becomes an exceptional case by virtue of the *way* he looks at it." It is this "most important" endowment . . . that the Schoenberg pupil receives. Before all else, Schoenberg demands that the pupil should . . . perform . . . exercises *out of a necessity for expression*. Consequently, he actually has to create, even from the most primitive beginnings of shaping a musical syntax. All of what Schoenberg then explains to the pupil, on the basis of the latter's work, results organically from it; . . . Thus, Schoenberg actually educates through the creative process. With the greatest energy he searches out the pupil's personality, seeking to deepen it, to help it break through. . . . This is an education in utter truthfulness with oneself. Besides the purely musical, it embraces also all other spheres of human life. Yes, truly, one learns more than rules of art with Schoenberg. To him whose heart stands open, the way to the good is shown here. (qtd. in Moldenhauer 77, my emphasis)

Despite Webern's emphasis on the student's freedom of thought under Schoenberg, however, the master's ideas inevitably permeated his students' views. Both Berg and Webern, for example, revered Schoenberg's *Theory of Harmony* (published in 1911); even twenty years later, the book's influence on Webern's thinking is evident. Compare Schoenberg's questioning in *Theory* of the necessity for cadences (i.e., for returning to, and thus establishing, the tonic center following a modulation) to Webern's explanation (in a 1932 lecture) of the breakdown of a central tonality about 1908:

> Schoenberg:
> Every chord that is set beside the principal tone has at least as much tendency to lead away from it [i.e., modulate] as to return to it [i.e., form a cadence]. And if . . . a work of art is to emerge we must have this movement-generating conflict. The tonality must be placed in danger of losing its sovereignty; the modulation's appetites for independence and the tendencies toward mutiny must be given opportunities to activate themselves.
>
> [T]hat one *can* create tonality, I consider possible. Only whether one *must* still work for it, indeed whether one *ought* to work for it any more at all, I doubt. (*Theory of Harmony* 151, 394 n.)

Webern:
[I]nstead of chords of sub-dominant, dominant, and tonic[,] one increasingly used substitutes for them and then altered even these—it led to the break-up of tonality. The substitutes became steadily more independent. It was possible to go into another tonality here and there. . . . *the necessity of returning to the main key disappeared*. . . . Where was one to go and *did one in fact have to return* to the relationships implied by traditional harmony?[50]

Similarly, their explanations of what should guide the composer are nearly identical:

Schoenberg:
Only the ear may take the lead, the ear, sensitivity to tone, the creative urge, the imagination, nothing else. . . .

[I]t was not first my deliberations that decided against [traditional aesthetics], it was rather my musical intuition. . . . My ear had said: yes; and the ear is, after all, a musician's whole understanding! . . .

The artist's creative activity is instinctive. . . . In composing I make decisions only according to feeling, according to the feeling for form. . . . Every chord I put down corresponds to a necessity, to a necessity of my urge to expression. (331, 410, 416, 417)

Webern:
Before all else, Schoenberg demands that the pupil should . . . perform . . . exercises out of a *necessity for expression*." ("Arnold Schoenberg," qtd. in Moldenhauer 77, my emphasis)

When we considered these things we felt: "We do not need these relationships any more, *our ear is satisfied without tonality.*" Naturally this was a fierce struggle. Inhibitions of the most frightful kind, the fear, "Is this at all possible?" had to be overcome. . . . All these events followed each other precipitately; they happened to us unselfconsciously and *intuitively.* . . . *It was for us a push that had to be made.* ("The Path to the New Music"; qtd. in Moldenhauer 118, my emphasis)

Thus, long after Webern had developed his own style, the imprint of Schoenberg's thought is clearly discernable on his former student's ideas.

VII. The Leader as Facilitator: The Salon Organizer

In [the salon's] convivial settings and in slightly more formal clubs, the avant-garde first discovered itself.
—Steven Watson, *Strange Bedfellows* 9

As noted in chapter 1, salons where artists and intellectuals gathered to socialize were a staple of the prewar modernist milieu. But by my criteria, the salon does not constitute a modernist group unless its membership remained sufficiently constant to enable member artists to influence each other's thinking and work or unless the salon itself produced creative work. The salon's organizer or host typically leads by facilitating encounters among artists and intellectuals. Given these criteria, only a few salons or studio discussion groups qualify: in Paris, Mercereau's salon, Le Fauconnier's studio group, and the Puteaux group had largely overlapping participants and have been discussed above. One of the most interesting salon groups of the period was Mabel Dodge's New York salon of 1913-1914.

Case Study: Mabel Dodge—"Getting the Right People Together"

In several respects, Mabel Dodge (fig. 24) was the perfect salon leader, "a creator of creators," as Marsden Hartley admiringly described her to Alfred Stieglitz (Watson 131). Like most salon organizers, she herself was a kind of nexus on the modernist map, linking various groups and artists through her wide-ranging friendships. During and after the Armory Show, her articles on Gertrude Stein[51] effectively linked Stein and herself as writer and interpreter, as well as associating literary and painterly Cubism, the Armory Show, and Stieglitz's productions. The same creative energies that leaders expended to develop their groups Dodge exerted to form circles of artists, intellectuals, and political activists. Lincoln Steffens finally encouraged her to direct her "gift" toward organizing regular evenings: "You have a certain faculty. It's a centralizing, magnetic, social faculty. You attract, stimulate, and soothe people, and men like to sit with you and talk to themselves. You make them think more fluently, and they feel enhanced" (qtd. in Luhan, *Movers and Shakers* 80-81).

Having established a prominent expatriate salon, the Villa Curonia, outside of Florence, for the past several years, Dodge sought the same for New York when she arrived in late 1912. As she recalls in her autobiography:

> When I came back from Europe last winter, it seemed to me there were so many people with things to say, and so few places to say them in. There seemed to be no centralization in New York, no meeting place for free exchange of ideas and talk. . . . So I thought I would try to get people together a little and see if it wouldn't increase understanding, if they would all talk among themselves and say what they thought. . . . The only spot I knew of outside my own apartment where one could find a kind of peaceful activity was with Stieglitz, at "291." There one did have that sense of a spiritual home that a cultural environment and background always gives one. (*Movers and Shakers* 83, 93)

Unlike Stein's salon in Paris, where attendance was unpredictable and discussions random, Dodge's evenings were structured around a discussion lasting about two hours, the topic selected and the discussion led by some of the most

exciting thinkers in New York. A journalist, identified only as "Mrs. Pearson," described her salons:

> [A] learned and eminent professor [probably A. A. Brill] . . . holding forth on Freud's theory of psycho-analysis. . . . Mr. Haywood of the I.W.W. . . . expounding to the uninitiated what the I.W.W. really stood for. Or Lincoln Steffens, or Walter Lippmann, would be talking about "Good Government"; a correspondent [John Reed] just back from Mexico, would be telling about the war, or a scientist from England would make eugenics a topic; or it might be feminism, or primitive life, or perhaps anarchism.[52]

Pearson then describes how the discussions proceeded:

> They didn't read speeches, mind you; they hadn't "got it up" beforehand; often [participants] came not knowing what was to be talked of. The principal speaker was always someone whose chief work and interest the subject was. He (or she) spoke "from the heart," and the others—writers, thinkers, artists, travelers, philosophers, politicians, and merely ordinary people—spoke in discussion, laid before the rest their views and experience and hammered the matter out.

As Pearson recognizes, Dodge herself was the linchpin necessary for the evenings to succeed:

> That it varied, as a rule, from the mildly interesting or frankly amusing to the intensely absorbing and wildly exciting; that out of it all men and women and ideas and "movements" seemed to find expression and coherence, was due largely to the fact that Mrs. Dodge seemed to know everybody worth knowing, not in the society way, but in the real way, and to get the right people together.

Significantly, Dodge herself maintained a low profile in order to let the discussion "decide" its own course: "I would sit in the background and silently smile with a look of understanding printed on my face. I never uttered a word during my Evenings beyond the remote 'How do you do' or the low 'Goodbye'" (*Movers and Shakers* 84). Steven Watson's evaluation of Dodge's gifts is less enchanted than journalist Pearson's, but no less laudatory: "Dodge lacked emotional stability, intellectual brilliance, incisive wit, and beauty, but her silent smile and intelligent eyes—what Carl Van Vechten called her 'perfect mask'— encouraged whoever was talking . . . to feel, as one of them put it, as if he had suddenly been made fluent in a foreign language" (131).

Dodge's salon moved beyond discussion and into political-artistic activism when it participated in all aspects of the Paterson Strike Pageant held at Madison Square Garden on 7 June 1913. This involvement grew naturally out of the salon's fusion of radical politics and modernist aesthetics, evidenced both in its discussion topics and core membership (prominent politicos like Big Bill Haywood of the I.W.W., radical journalists like John Reed, Hutchins Hapgood,

and Lincoln Steffens, as well as avant-garde artists like Robert Edmond Jones). The Pageant had multiple aims: to dramatize the plight of the striking workers of Paterson's silk factories; to energize the strikers themselves (who participated directly, marching to and from Madison Square Garden, playing "themselves" in the Pageant's six scenes and filling the auditorium with their families); to gain support for the strikers' cause; but also to bring their struggle provocatively into the heart of capitalist Manhattan. Its chief organizer, John Reed, worked directly with the strikers in planning their participation, but as Martin Green notes, "his main assistants were Greenwich Village friends like Hutchins Hapgood, Jessie Ashley, Alexander Berkman, Bobby Jones, John Sloan, and above all Mabel Dodge" (197). Dodge not only helped underwrite the Pageant's costs, but, as Reed's lover and enthusiastic supporter, claimed to buoy up its central organizer when his energy flagged: "I knew he couldn't have done it without me. I felt that I was behind him, pouring all the power of the universe through myself to him" (*Movers and Shakers* 205; qtd. in Green 199). However fanciful Dodge's boast and vaporous her political commitment, another salon member, Robert Edmond Jones, contributed significantly to both the Pageant's art and staging—the latter a fusion of avant-garde ideas and political *engagement* that merged symbolic ritual and open staging, facilitating audience participation. As a reviewer for *The Independent* enthused: "It is an unequalled device for clutching the emotion of an audience—this parade of the actors through the center of the crowd. . . . [and it was achieved] never with more effect than in this performance, where actors and audience were of one class and one hope" (qtd. in Green 204). Rarely have radical politics, avant-garde aesthetics, and social occasion met on such common ground, and Dodge's salon enabled this encounter.

VIII. Conclusion: The Other Side of Creation

From the case studies and examples above, it becomes clear that the qualities that enabled leaders to create, expand, and guide their groups—dynamism, vision, organizational skill, confidence, salesmanship, and devotion to artistic excellence—often had unsavory corollaries that repelled members and helped destroy the groups, almost as much as did external forces. The dynamic aggressiveness essential for any leader was virtually inseparable from arrogance and even megalomania. Leaders like Lewis and Pound, who delighted in offending their readers and editors and in causing a ruckus, could not always pin a high motive on their high jinks. Despite all his noble claims to resuscitate Western art, Pound's mission to "save the public's soul by punching its face"[53] stemmed as much from his joy of punching as from saving. John Gould Fletcher was one of many who noted "his only too apparent desire to infuriate people, and to gain notoriety by so doing" (*Life Is My Song* 72). Like Fletcher, group members, even those equally hungry for battle, eventually grew skeptical of such rabble-rousing leaders.

Still more alienating was the urge to control often lurking behind a leader's aesthetic idealism. As leaders like Kandinsky expanded their groups, they be-

came increasingly liable to this charge (and its corollary: wanting to be at the center), hence increasingly likely to repel peripheral members. In more extreme cases, pursuing a single aesthetic standard was inseparable from a totalitarian will to power. Thus, Pound: "A lot of people know damn well that if I got a grip on things there'd be no place for their kind of tosh and they naturally don't want me to get a grip."[54] Pound's comment also suggests a further stage of alienation between leader and group—defensiveness, paranoia, even a sense of martyr-dom—usually following a group's repudiation of their leader's initiatives. C. R. W. Nevinson felt Wyndham Lewis even nurtured these qualities: "It is said that he suffers from thinking he is unpopular, but this is not so. He is essentially his-trionic and enjoys playing a role; being misunderstood is one of his pleasures" (76).

The showmanship of a Marinetti or Walden could alienate even as it helped put their groups on the map. With some justification, group members imputed personal motives—a love of the limelight, a need to be the controlling center—to this pursuit of publicity. What fewer group members realized was that not just these shabbier motives but genuine artistic idealism could undermine the group by committing the leader to an idea rather than to a specific group of individu-als. These ambivalent qualities all combined to make the modernist group inher-ently unstable, enabling leaders to build and fissure it, promote its image and alienate its members simultaneously.

Chapter 3

Manifesto

The *imagistes* admitted that they were contemporaries of the Post
Impressionists and the Futurists; but they had nothing in common
with these schools. They had not published a manifesto. They were
not a revolutionary school.
 —F. S. Flint, *"Imagisme," Poetry* (March 1913)

I shall persuade you by all that I know about the art of making mani-
festos.
 —F. T. Marinetti, letter to Gino Severini, fall 1913

"On the morning of the opening day of the Indépendants [Salon] of 19[13], a
mysterious old man in a yellow topcoat was distributing a tract . . . approxi-
mately a page long, [which was] a passionate and very confused defense of 'or-
pheism' [sic]."[1] Apollinaire, who was there reviewing the show, was intrigued:
"An interesting document, typewritten, was distributed to most of the exhibitors
this morning. Its subject is orphism and it bears the signature 'Georges Me-
unier.' Who is Georges Meunier?"[2] Apollinaire had reason to wonder because
he himself had just announced a new group of painters "who for the first time
are exhibiting canvases that fall under the heading of aesthetic orphism."[3] What
was unusual about the incident was that Georges Meunier had no connection to
these painters or to Apollinaire. That he was issuing a manifesto he had probably
written himself, however, was not at all unusual: manifestos were everywhere in
1913.[4]

In the prewar tumult of modernist groups suddenly appearing, splitting,
merging, or reforming with a new name, a group's formal declaration—its mani-
festo—became its identity card, as important to its collective image as its crea-
tive productions. In fact, as several critics have noted, manifestos *became* an
avant-garde creation in the hands of a Marinetti or Apollinaire.[5]

Its importance to this period has long been recognized. In *The Futurist Mo-
ment*, Marjorie Perloff begins her chapter "The Manifesto as Art Form"—
probably the fullest treatment of how the Italian Futurists revolutionized the
genre—by identifying 1913 as "the height of the manifesto fever that swept
across Europe in the years preceding the First World War" (81). More recently,
Peter Nicholls, in tracing the trend back to Jean Moréas's announcement of his
école romane in 1891, describes a new sensibility underlying the manifesto:

"The intellectual climate, then, had suddenly changed [from the ennui of decadence]: the fashion was now for energetic and outspoken expressions of faith, and, above all, for manifestos. . . . [W]riters and intellectuals vied with each other to name the new tendency. Movements surfaced with a loud fanfare and then disappeared almost without a trace."[6] Manifestos did not significantly increase in the early 1900s, however, until 20 February 1909, a watershed of manifesto history, when Marinetti published the "The Founding and Manifesto of Futurism" in *Le Figaro*. Thereafter, manifestos proliferated rapidly and reached a peak in 1912-1913, as burgeoning groups (and sometimes individuals) published not only manifestos for themselves, but counter-manifesto rebuttals and manifesto parodies. For example, some manifestos published in Paris just in 1913 include:

> "Manifesto of Lust" by Valentine de Saint-Point, 11 January
> "Manifesto of Orphism" by Georges Meunier, 19 March
> "Manifeste des Cahiers de l'art moderne" by Pascal Forthuny, May
> "Technical Manifesto of Futurist Sculpture" by Umberto Boccioni, (republished) 20 June
> "Catalogue Preface for the First Exhibition of Futurist Sculpture," by Umberto Boccioni, 20 June
> "Manifesto of Poetic Simultanism" by Henri Martin Barzun, 27 June
> "L'Anti-tradition futuriste: manifeste synthèse" by Apollinaire, 29 June
> "Against Montmartre: Futurist Manifesto" by Félix Del Marle, 15 July
> "'Bombe éléphant carafe' manifesto" [parody of Apollinaire's above] by Merodack-Jeaneau, 7 August
> "General Introduction" by Morgan Russell and Stanton MacDonald-Wright to "Les Synchromistes S. Macdonald-Wright et Morgan Russell" [exhibition catalogue], 27 October
> "Individual Introduction" by Stanton MacDonald-Wright, 27 October
> "Individual Introduction" by Morgan Russell, 27 October
> "Poétique d'un idéal nouveau" (pamphlet) by Henri Martin Barzun
> Doctrine of "Paroxysme" by Nicholas Beauduin

"Manifesto fever" thus resulted from the rapid proliferation of modernist groups from 1909-1914; its contagion paralleled the extraordinary creative energy of this period, just as its aggressiveness echoed the daring of the period's artistic innovations. Critics alarmed by this energy and suspicious of the new groups found this medium for declaring the group's identity shallow, manipulative, and ephemeral—the epitome of self-promotion and publicity seeking. Futurism's "Foundation" Manifesto, for example, prompted one critic to compare it to the hawkings of "charlatans in the public square." "The Third Republic," he continues "will have seen born to it more literary manifestos than all the dominions and kingships before it; manifestos no sooner born than dead."[7] But if they died, new ones quickly replaced them, representing painters and composers as well as writers, and the fever raged on.

I. Defining the Genre

The few scholars who have studied the manifesto as a genre generally concur in defining it: Its mode is public; its length and prose style are typically compact, often limited to one-page fliers written in concise sentences; its voice is declamatory, hortatory, imperative, sometimes explanatory; and finally its purposes are to declare a group's position; "to convince the reader of a thesis"; to effect a "conversion,"[8] and sometimes to be "a call to arms."[9] As will be discussed below, the Italian Futurists did not so much overturn these qualities as to extend them radically to emphasize the manifesto's aggressiveness and, as Perloff puts it, to "aestheticize" it, making their manifestos eye-catching creations in their own right.

Using Welleck's and Warren's definition of a genre, Larry Peer usefully distinguishes between a manifesto's "outer and inner form": "The outer form of the manifesto is characterized by brevity and concision of expression that suits a public declaration. Its inner form is characterized by an attitude of assertion, a tone of declamation and explanation, and a purpose of conversion, drawing battle lines or, rarely, persuasion by conciliation" (2). While Peer concedes that manifestos "can have many forms because they have a looser set of conventions and [more] flexible rhetorical strategies" than does belletristic prose (4), he does not consider the generic problem that arises when a document fulfills the manifesto's "inner" purposes without at all resembling its stereotypical "outer form" or when it seems to overlap the outer form of other genres, for example, the essay, the poem (or book of poems), the pedagogical or philosophical book. The genre's metamorphic versatility, moreover, encompasses multiple purposes geared to several, quite different audiences. Each configuration of purpose and audience requires its own rhetorical strategies: the right tone, style, even form to arouse a particular reader. Because these purposes, audiences, and rhetorical strategies are so organically related, and because they reflect the group dynamics discussed in chapters 1 and 2, each factor needs close attention.

II. Multiple Audiences, Purposes, Rhetorical Strategies

Peer and others have suggested that a manifesto may have purposes beyond simply presenting a movement's principles, but when linked to the manifesto's differing potential audiences, these purposes are indeed various. Closest to home, the manifesto implicitly addresses the very group that authors it: as it publicly declares the group's existence—its collective identity, its aesthetic principles, its philosophy—the manifesto privately aims to strengthen the group's cohesion. As Perloff observes about the Italian Futurists' Foundation Manifesto, the "images do not point toward the self . . . [but] to the communal 'we' (the first word of the manifesto)" (*Futurist Moment* 87). Declarations of this collective identity aim particularly at the more uncertain and peripheral group members, to strengthen their bonds to the group and confirm their identity

as group members—a bolder identity, often, than what the artist might assert individually. Thus, virtually all group manifestos tacitly support what a Russian Cubo-Futurist manifesto concluded: "We are the new people of a new life."[10]

Not surprisingly, this group-building sometimes verged into fictions reflecting the group leader's ambitions far more than the group's reality. The most extreme example of these manipulative fictions was the manifesto entitled "Vital English Art," "coauthored" by Marinetti and the "English Futurist painter" Charles Nevinson.[11]

Case Study: The English-Futurist and Vorticist Manifesto Frauds

As noted in chapters 1 and 2, Marinetti strove unsuccessfully from late 1913 through early 1914 to recruit as Futurists a group of English painters whom Wyndham Lewis had led out of Roger Fry's Omega Workshops. In June 1914, Marinetti tried the rather desperate ploy of including these painters in a manifesto he published with painter Charles Nevinson, "Vital English Art." Appended to the manifesto's final demand are the last names of eight painters, in a statement whose cleverly ambiguous phrasing suggests that they coauthored this point ("we"), instead of being simply the referents of "pioneers and advance-forces": "6.—So we call upon the English public to support, defend, and glorify the genius of the great Futurist painters or pioneers and advance-forces of vital English Art—ATKINSON, BOMBERG, EPSTEIN, ETCHELLS, HAMILTON, NEVINSON, ROBERTS, WADSWORTH, WYNDHAM LEWIS" (*The Observer*, 7 June 1914). Since Marinetti's and Nevinson's names follow immediately, casual readers could easily assume that the English painters supported the entire manifesto. In fact, however, they had never been consulted or asked to have their names used.

This fraud provoked the eight, under Lewis's leadership, to publish an immediate denial in several London newspapers[12] and to break up a Futurist evening featuring Marinetti and Nevinson at the Doré Galleries (see chapter 4). More important, as Richard Cork points out:

> The outrage made them realize, once and for all, how urgently they needed to repel the Italian's advances; and Lewis, with his shrewd eye for political timing, knew at last that Marinetti's mistake provided him with a perfect opportunity. Now, surely, he could persuade his associates that they needed a fully-fledged movement of their own, and galvanize them into a concerted show of strength. (230)

Ironically (but not surprisingly considering how closely Lewis aped Marinetti's leadership tactics), Lewis soon pulled the same stunt of following the Vorticists' "Manifesto" in *BLAST* [no. 1, 43] with the phony "signatures" (in block letters) of eleven members. Again, Richard Cork:

> Few of the signatories . . . donated their names with any great seriousness or profound contemplation of Lewis's written testament. . . . [William] Roberts . . . later recalled . . . that "if anyone were to imagine we signed this Manifesto, pen in hand, in solemn assembly, they

would be making a big mistake. I, in fact, personally signed nothing. The first knowledge I had of a Vorticist Manifesto's existence was when Lewis . . . knocked at my door and placed in my hand this chubby, rosy, problem-child BLAST." (246, Roberts qtd. in Cork 247).

Frederick Etchells, another "group" member whose art appears in *BLAST*, even refused to have his name included among the manifesto's signatories because "I always thought Vorticism was a manufactured, faked movement" (qtd. in Cork 247). But manufactured or not, the movement, by the art politics of 1914, was real, for the Vorticists had indeed published not only a manifesto (albeit, a vague one, as will be discussed below), but two issues of an impressively irreverent journal, *BLAST*, containing several more manifestos. Ipso facto, the Vorticists were a group.

For interested and potentially sympathetic readers—and particularly for journalists who could publicize the group—the manifesto had to distinguish the authoring group from similar rivals and to assert the group's uniqueness. The closer a group seemed to a rival, the more vehemently it needed to declare itself distinctive and its rival misguided. For example, the Synchromists Morgan Russell and Stanton MacDonald-Wright had scarcely formed their nucleus group's identity[13] when Russell's submission to the 1913 Indépendants Salon was casually mislabeled by Apollinaire as "a vaguely Orphic painting."[14] Thus, at their all-important exhibition at the Bernheim-Jeune Gallery in October-November 1913, these Synchromists distinguished themselves forcefully in their catalog-manifestos from other groups and styles, particularly Orphism:

> We consider that orientation toward color is the only direction that painters can engage in for the moment. We shall speak neither of Cubists nor Futurists, finding their efforts superficial and of secondary interest. . . . In order to focus attention and to make clear by contrast the particular nature of our activity, let us first consider that young school of painting, Orphism. A superficial resemblance between the works of this school and a Synchromist canvas exhibited at the last Salon des Indépendants has led certain critics to confuse them: this was to take a tiger for a zebra, on the pretext that both have a striped skin. . . .
>
> In Orphism, we see the manifestation of analogous processes [to Impressionism], . . . color was spread thin over compositions that were powerless to evoke volume. . . . No doubt these Orphists excel at making a shade recede or stand out in relation to neighboring shades. But the technical observations they have been able to make on the subject do not amount to a treasure, and this sort of color perspective was already familiar to the Impressionists, who themselves had not invented it.
>
> Instead of forcing colors to serve no matter where, *we* assign them a place that conforms with their intimate nature, their natural propensity. ("General Introduction" to exhibition catalogue, October-November 1913; qtd. in Gail Levin, *Synchromism* 129, my emphasis)

The English Vorticists had even stronger reason to distance themselves from another group, the Italian Futurists, since the latter (as noted above) had attempted publicly to absorb them. Hardly surprising, then, was the raillery against Marinetti and Futurism in the Vorticist manifestos of their new journal, *BLAST*:

> AUTOMOBILISM (Marinetteism) bores us. We don't want to go about making a hullo-bulloo about motor cars anymore [sic] than about knives and forks, elephants or gas-pipes. . . . Wilde gushed twenty years ago about the beauty of machinery. . . .
> The futurist is a sensational and sentimental mixture of the aesthete of 1890 and the realist of 1870. ("Long Live the Vortex!" *BLAST*, no. 1)

For prospective converts and rival groups, alike, the manifesto's message is essentially the same: "We are at the center of avant-garde trends, the cutting edge of aesthetic innovation, the true path; all other groups are derivative or irrelevant." At the opening of their 1912 traveling exhibition at the Bernheim-Jeune Gallery in Paris—their true "coming out" into the European community—the Italian Futurists cheekily declared: "What we have attempted and accomplished while attracting around us a large number of skillful imitators and as many plagiarists without talent, has placed us at the head of the European movement in painting, by a road different from, yet, in a way, parallel with that followed by the Postimpressionists, Synthetists, and Cubists of France."[15] Perhaps taking their cue from the Italians, the Russian Cubo-Futurists declare at the beginning of their first manifesto: "*We* alone are the *face* of *our* Time. Through us the horn of time blows in the art of the word."[16]

But if this message is the same for friend or foe, its tone, development, and conclusion vary drastically with the reader. For potentially sympathetic artists—prospective converts—the tone is typically encouraging: the manifesto extends its hand in friendship; its message, stated or implied, is "Join us!" While this call for solidarity famously concludes the Communist Manifesto of 1848, Ernst Ludwig Kirchner's 1906 "Program für die Brücke" (which Perloff identifies as the first manifesto written by a visual artist) addresses it to young artists:

> With faith in evolution, in a new generation of creators and appreciators, we call together all youth. And as youths, who embody the future, we want to free our lives and limbs from the long-established older powers. Anyone who renders his creative drive directly and genuinely is one of us. (Rpt. in Rose-Carol Washton Long, *German Expressionism: Documents* 23)

Franz Marc had undoubtedly read Die Brücke's statement when he wrote in his prospectus for the Blaue Reiter: "Today art is moving in a direction of which our fathers would never even have dreamed. . . . There is an artistic tension all over Europe. Everywhere new artists are greeting each other; a look, a handshake is enough for them to understand each other!"[17]

For rival groups, the manifesto's tone is scornful, contemptuous, even pitying. Its message is: "You are history. Your aesthetics is misguided, antiquated. Give up!" In the Bernheim-Jeune Gallery, the Italian Futurists took aim at Paris's most radical style:

> [W]e declare ourselves to be absolutely opposed to [the Cubists'] art.
>
> They obstinately continue to paint objects motionless, frozen, and all the static aspects of Nature; they worship the traditionalism of Poussin, of Ingres, of Corot, aging and petrifying their art with an obstinate attachment to the past. . . .
>
> We, on the contrary, with points of view pertaining essentially to the future, seek for a style of motion, a thing which has never been attempted before. . . .
>
> It is indisputable that several of the aesthetic declarations of our French comrades display a sort of masked academism [e.g., the subject of the painting is insignificant]. . . .
>
> We declare, on the contrary, that there can be no modern painting without the starting point of an absolutely modern sensation. ("The Exhibitors to the Public," February 1912; rpt. in Chipp 294-95)

As radical artists broke away from older groups to form newer ones, the temptation was often irresistible to tweak the abandoned group in the new group's manifesto. Such was the case with Mikhail Larionov and Natalia Goncharova. Their "Rayists and Futurists: A Manifesto, 1913" combines messages of solidarity with potential allies and scorn for rival groups, particularly the Jack of Diamonds group, which they left at this time to form the Rayists:

> We, artists of art's future paths, stretch out our hand to the [Italian] futurists, in spite of all their mistakes, but express our utmost scorn for the so-called egofuturists and neofuturists, talentless, banal people, the same as the members of the Knave of Diamonds, Slap in the Face of Public Taste,[18] and Union of Youth groups. . . . We've had enough Knaves of Diamonds whose miserable art is screened by this title, enough slaps in the face given by the hand of a baby suffering from wretched old age, enough unions of old and young! We don't need to square vulgar accounts with public taste[19]—let those indulge in this[,] who on paper give a slap in the face, but who, in fact, stretch out their hands for alms. . . .
>
> We have no modesty—we declare this bluntly and frankly—we consider ourselves to be the creators of modern art. (Trans. in Bowlt, *Russian Art of the Avant-Garde* 88-89)

Finally, to those who could not be won over—the implacably hostile critics, an indifferent or derisive public—the modernist manifesto followed the infallible axioms that bad publicity is better than no publicity, and that slapping the critics and enraging the public *will* get a response and get the group attention. The tone of such provocations, of course, is hostile, belligerent, and mischievous. Partly, this hostility was intrinsic to the genre. As Larry Peer points out, its purpose of "drawing battle lines" derives directly from the etymology of "mani-

festo": "The word has similar roots in all the European languages: Latin 'mani-
festus' or 'manufestus' (*manus* 'hand' + *festus* 'hostile'. . .) indicates an attitude
of taking a stand and expecting a battle. . . . [A manifesto is] usually at least im-
plicitly hostile" (2). Nonetheless, by the 1910s, this hostility had become a cal-
culated strategy. What Marinetti said about the aesthetics of *parole-in-libertà*
applied in spades to his manifestos: "I do not want to suggest an idea or a sensa-
tion with passéist airs and graces [of Mallarmé's 'static ideal']. Instead *I want to
grasp them* [sic] *brutally and hurl them in the reader's face*."[20] In the Founda-
tion Manifesto, for example, he dramatizes the reader as an oppositional voice,
enabling Marinetti to rebut the enemy directly and heighten the dramatic energy
of his monologue:

> We are not exhausted Our heart is not in the least weary! For it
> has been nourished on fire, hatred, and speed! . . . You are aston-
> ished? It is because you do not even remember living! . . .
> Your objections? Enough! Enough! I know them! I quite un-
> derstand what our splendid and mendacious intelligence asserts. We
> are, it says, but the result and continuation of our ancestors.—
> Perhaps! Be it so! . . . What of that? But we will not listen! Beware
> of repeating such infamous words! Rather hold your head up!
> Erect on the pinnacle of the world, we once more hurl forth our
> defiance to the stars![21]

Taking their cue from Apollinaire as well as Marinetti, the English Vorti-
cists, mixed more humor into their diatribes that begin *BLAST* by fashioning a
manifesto-list of targets they wished to "BLAST" or "BLESS" (fig. 25),[22]
among them the English bourgeoisie and London weather:

BLAST First (from politeness) **ENGLAND**

CURSE ITS CLIMATE FOR ITS SINS AND INFECTIONS

DISMAL SYMBOL . . .

VICTORIAN VAMPIRE, the LONDON cloud sucks

the TOWN'S heart . . .

BLAST . . .

BOURGEOIS VICTORIAN VISTAS).

WRING THE NECK OF all sick inventions born in that progressive

white wake. (*BLAST*, no. 1, June 1914, 11, 18)

Less often, the manifesto's tone addressing the public assumes a more serene
confidence that the group's vision will ultimately prevail over public hostility.
Such confidence was especially evident in Franz Marc's otherwise belligerent

manifestos in the *Blaue Reiter Almanac*: "But maybe we will be right in the end. People will not *want* . . . [to accept these new spiritual treasures], but they will *have to*. For we know that our world of ideas is not a house of cards to be played in, but that it contains elements of a movement whose vibrations can be felt today throughout the world ("Spiritual Treasures" 59, Marc's emphasis).

The Russian Cubo-Futurists went Marc one better and managed to blend both confidence *and* hostility, à la Marinetti: "And if *for the time being* the filthy stigmas of Your "Common sense" and "good taste" are still present in our lines, these same lines *for the first time* already glimmer with the Summer Lightening of the New Coming Beauty of the Self-sufficient (self-centered) Word."[23]

III. Manifesto Content

A. Abstract Principles and Concrete Practices

The manifesto's many voices, audiences, and intentions do not alter its chief purpose: to declare the group's identity and present its aesthetic position and *programme*. While such statements range from nebulous generalizations about the group's philosophy to precise articulations of its aesthetics, some declaration of the group's values—what it stood for and especially what it opposed—is virtually the sine qua non of the manifesto.

Case Studies: Two Italian Futurist Manifestos

The Futurist manifestos alone span the entire range of specificity and narrative styles. The Foundation Manifesto, for example, begins with a lengthy narrative that humorously dramatizes the principles to follow. The young friends have been up all night in "frenzied writing" and "disputing beyond the extremes of logic." Now their leader—and the manifesto's sole author—declares it is time for action, not talk:

> "Let's go!" I said, "Let's go, friends! Let's go out. Mythology and the Mystic Ideal are finally overcome. We are about to witness the birth of the centaur and soon we shall see the first angels fly! . . . Let's take off! Behold the very first dawn on earth! There is nothing to equal the splendor of the sun's rose-colored sword as it duels for the first time in our thousand-year darkness!" (rpt. in Chipp 284)

The friends swoop into three conveniently waiting motorcars—"snorting beasts"—and off they go, putting rational discourse and the indoor life behind them ("The furious sweep of madness took us out of ourselves and hurled us through streets"), while the group leader exhorts: "'Let's break away from rationality as out of a horrible husk and throw ourselves like pride-spiced fruit into the immense distorted mouth of the wind! Let's give ourselves up to the unknown, not out of desperation but to plumb the deep pits of the absurd!'" (285). Comically, what they plumb is a factory drainage ditch, landing wheels up. But they are undaunted, even more energized than before, as they are soon "speeding

along once more on [the shark's] powerful fins." In this exalted state, "we de-
clare our primary intentions to all *living* men of the earth."

The principles that follow laud the values dramatized in the preceding nar-
rative: spontaneity, daring, love of speed and danger, energy, courage, audacity,
struggle, revolt, violent assaults on the unknown, and aggressive actions ("the
cuff, the blow," "War—the only true hygiene of the world"). The antitheses of
these qualities are to be scorned and opposed—thoughtful immobility, slumber,
moralism, feminism and "woman" (who, the speaker implies, fosters this passiv-
ity)—as well as the repositories of past thought and art: libraries and museums.

Driving motorcars at top speed, provoking fistfights, and bombing museums
may show artists how to live and what to value, but these "intentions" offer no
specifics on how artists might convert these values into practical aesthetics.[24]
The Futurist painters' first manifesto published a year later (February 1910)
does little better, roundly damning "slaves of past tradition," art critics, and the
values of imitation, harmony, and good taste, while praising originality, mad-
ness, and "victorious Science" (rpt. in Apollonio, *Futurist Manifestos*, 24-27).
Not until their "Technical Manifesto" a few months later do the painters present
specific principles that can be traced directly to their work:

> The gesture which we would reproduce on canvas shall no
> longer be a fixed *moment* in universal dynamism. It shall simply be
> the dynamic sensation itself (made eternal). . . .
>
> To paint a human figure you must not paint it: you must render
> the whole of its surrounding atmosphere.
>
> Space no longer exists: Thousands of miles divide us from
> the sun; yet the house in front of us fits into the solar disk.
>
> Who can still believe in the opacity of bodies, . . . ?
>
> The sixteen people around you in a rolling motor bus are in turn
> and at the same time one, ten, four, three; they are motionless and
> they change places;
>
> Our bodies penetrate the sofas upon which we sit, and the sofas
> penetrate our bodies. The motor bus rushes into the houses when it
> passes, and in their turn the houses throw themselves upon the motor
> bus and are blended with it.
>
> . . . [H]itherto . . . [p]ainters have shown us the objects and the
> people placed before us. We shall henceforward put the spectator in
> the center of the picture. (rpt. in Chipp 289-90)

Boccioni, the chief theorist among the painters, probably authored these ideas,[25]
and we can observe this inter-"penetration" of outer and inner in several of his
paintings, for example, *The Street Enters the House*, *The Forces of a Street*, and
Simultaneous Visions.

The manifestos offering the most detailed presentation of aesthetic prac-
tices came from the highly innovative Russian Cubo-Futurist poets, Aleksei
Kruchenykh and Velimir Khlebnikov, who in 1913 outlined, exemplified, and
discussed their poetics, which accorded individual words, syllables, and finally
letters increasingly abstract and self-referential functions in a poem.[26]
Kruchenykh's "Declaration of the Word as Such," for example, playfully jum-

bles the numbering of its eight declarations, but it concisely presents the Cubo-Futurists' pathbreaking idea of "transrational" language, *"zaumnyi iazyk"* or *"zaum"* for short, and thus deserves to be quoted at length:

(4) THOUGHT AND SPEECH CANNOT KEEP UP WITH THE EMOTIONS OF SOMEONE IN A STATE OF INSPIRATION, therefore the artist is free to express himself not only in the common language (concepts), but also in a personal one (the creator is an individual), as well as in a language which does not have any definite meaning (not frozen), a *transrational language.* Common language binds, free language allows for fuller expression. . . .
(5) WORDS DIE, THE WORLD IS ETERNALLY YOUNG. The artist has seen the world in a new way and like Adam, proceeds to give things his own names. The lily is beautiful, but the word "lily" has been soiled and "raped." Therefore, I call the lily, "euy"—the original purity is reestablished. (2) consonants render everyday reality, nationality, weight—vowels, the opposite: A UNIVERSAL LANGUAGE. Here is a poem exclusively of vowels:

o e a
i e e i
a e e E[27]

(3) a verse presents (unconsciously) several series of vowels and consonants. THESE SERIES CANNOT BE ALTERED. It is better to replace a word with one close in sound than with one close in meaning (bast-cast-ghast). If similar vowels and consonants were replaced by graphic lines, they would form patterns that could not be altered. . . . For this reason it is IMPOSSIBLE to translate from one language into another; one can only transliterate a poem into Latin letters and provide a word-for-word translation. . . . (1) A new verbal form creates a new content, and not vice versa. (6) INTRODUCING NEW WORDS, I bring about a new content WHERE EVERYTHING begins to slip (the conventions of time, space, etc. . . . (7) In art, there may be unresolved dissonances—"unpleasant to the ear"—because there is dissonance in our soul by which the former are resolved. Example: dyr bul shchyl, etc. (8) All this does not narrow art, but rather opens new horizons. (Rpt. in Lawton, 67-68)

Even Kruchenykh and Khlebnikov, however, were not above using their manifestos to slap their competitors: "the powdered ego-foppists" (the Ego-Futurists), the Mezzanine of Poetry (in *The Word as Such*), the Symbolists (who "are terribly afraid of not being understood by the readers . . . we, on the contrary, rejoice at that!"—"New Ways of the Word"), and finally the Italian Futurists:

The Italian "amateurish" Futurists, with their endless ra ta ta ra ta ta, are like Maeterlinck's heroes who think that "door" repeated a hundred times opens up to revelation.

These mechanical tricks—soulless, monotonous—lead to *the death of life and art.* . . .
In art there can be discordant sounds (dissonances), but there cannot be coarseness, cynicism, and impudence (which is what the Italian Futurists preach), because it is impossible to mix war and fighting with creative work.
(Kruchenykh, "New Ways of the Word"; rpt. in Lawton 76).

B. The Sacred "No": Accentuating the Negative

If even the most constructive manifestos, those presenting concrete proposals for a new aesthetics, could still denigrate other groups, it is scarcely surprising that most prewar manifestos couch their assertions in negatives and are far clearer about what (or whom) they oppose than about the principles they support.

Several factors contribute to this negativity. Modernism's embattled and marginalized status vis-à-vis a conservative public, as well as its intergroup rivalries, encouraged broadsides and jeremiads against "the enemy." By the 1910s, moreover, the idea was axiomatic that an avant-garde must first clear the ground by undermining the aesthetics of the prevailing order before it could construct a new aesthetics. Bakunin had stated in 1842 that "The urge for destruction is also a creative urge!" and Nietzsche echoed in his popular *Thus Spoke Zarathustra*: "Whoever must be a creator always annihilates."[28] Certainly, such declarations fell on receptive ears before as well as after the war. As Matei Calinescu asserts, for the avant-garde of the 1910s, "novelty was attained, more often than not, in the sheer process of the destruction of tradition" (117). Of course, the most "constructive" assertion of a new aesthetics can be deemed "negative" as it threatens the status quo, but modernist manifestos were often explicitly negative. The short, pithy paragraphs of typical manifesto form lend themselves far more readily to casual rejections of the old than to careful explications of the new; to merely listing practices, ideas, and groups to be opposed more than to explaining and justifying their successors. And as both Marinetti and Pound well knew, the declarative mode of such statements leaves little room for development and support: left by themselves, they become naked demands with an "in your face" air of being nonnegotiable, take it or leave it:

WE DECLARE:
 1. THAT ALL FORMS OF IMITATION MUST BE DESPISED, ALL FORMS OF ORIGINALITY GLORIFIED.
 2. THAT IT IS ESSENTIAL TO REBEL AGAINST THE TYRANNY OF THE TERMS "HARMONY" AND "GOOD TASTE" . . .
 3. THAT THE ART CRITICS ARE USELESS OR HARMFUL. . . .

WE FIGHT:
 1. AGAINST BITUMINOUS TINTS . . .

4. AGAINST THE NUDE IN PAINTING, AS NAU-
SEOUS AND AS TEDIOUS AS ADULTERY IN LITERA-
TURE. . . .
We demand for ten years, the total suppression of the nude in painting![29]

Finally, the manifesto's predominantly negative cast reflected a psychological fact of modernist group dynamics, namely: it was easier (and probably more fun) for group members to agree on what they opposed than on what they supported, especially when their targets were easily dismissable. Asserting constructive principles, conversely, required that group members not just agree (a difficult enough achievement with iconoclastic artists), but also express these principles in their own work. Such practical consensus could be achieved by only the most unified groups, like the Italian Futurists, by nucleus groups, or by nuclear cells within larger groups, for example, Kruchenykh, Khlebnikov, and Livshits within the Cubo-Futurists. Often, a group formed knowing only what it opposed. Determining what it espoused came later, and some groups (locale groups especially) never evolved constructive principles.

Case Study: Der neue Club and the "neues Pathos"

The poets who formed Der neue Club of Berlin in 1909 were, as Roy Allen describes, "united to a man ideologically by their mutual opposition to the prevailing social and cultural conditions ['apathy and decadence'] in the Wilhelmine era, and, because they aimed also to actively oppose these conditions now, they were anxious to recruit more supporters in their battle" (75, 82). What these poets promoted, however, was a rather vague emotive philosophy, drawn from Nietzsche and more directly from Stefan Zweig, who had titled it the "*neues Pathos.*"[30] For these poets—Kurt Hiller, Erwin Loewenson, Jakob van Hoddis, Georg Heym, and others—the *neues Pathos* represented a "synthesis of intellect and feeling" (Allen 85). The concept inspired several lectures at the club and both the title and orientation of the Neopathetisches Cabaret, which the members created to hold poetry recitals and lectures.[31]

Certainly, the *idea* of a new emotive sensibility was charismatic in Berlin at the time and spawned some similarly named movements. Ludwig Meidner's short-lived nucleus group of 1912, Die Pathetiker, derived its name from the Neopathetisches Cabaret and referred to "both the passionate aspect of Expressionist emotionalism and the compassion . . . evinced by these artists for their subjects" (Eliel 19). Meidner also coedited a periodical in 1913-1914, *Das neue Pathos*. Walden's *Der Sturm* emphasized the "instinctual life" in its first manifesto: the irrational's "darker forces" that society had repressed.[32] But how should the relation between intellect and this new "heightened emotion" (Loewenson) be configured? And how should this "synthesis" express itself practically in poetry? Loewenson was vague: "Our 'new pathos' was . . . a new form, which neither excluded the intellect nor found a place for it as we had learned as students, [i.e.,] only within the framework of theory and a complicated, historically well-founded doctrine" (qtd. in Allen 82).

That the Neue Club's members hoped to create a "regenerative movement" directed against societal apathy and decadence suggests that "heightened emotion" alone was to be the cure. Such a view directly parallels Nicholas Beauduin's "Paroxysme" movement in Paris.[33] But unlike Beauduin's call for unrestrained emotion, Loewenson's "heightened emotion" would still be "under the control of the intellect," according to Allen (82).

Such unresolved contradictions took their toll on the unity of Der neue Club. By early 1911, its cofounder, Kurt Hiller, came to feel that the club had shifted too heavily to the emotive under the influence of its star poet, Georg Heym. Hiller's split-off, along with two other members, soon followed. Perhaps because the club never resolved these theoretical issues, it issued no manifesto and evolved no clear aesthetics. As a locale group, it simply provided its member poets an agreeable setting and a sympathetic audience for readings given at the Neopathetisches Cabaret, and thus the opportunity to develop their own styles more fully and confidently.

Case Study: Pound's "A Few Don'ts by an Imagiste"

Probably the most negative of all manifestos was Ezra Pound's "A Few Don'ts by an Imagiste" (*Poetry*, March 1913), the companion piece to "Imagisme" (discussed below). Aiming specifically at "those beginning to write verses" (201), Pound adopts the exasperated voice of an editor fed up with reading bad poetry—no invention on his part! His "Don'ts," therefore, bludgeon neophytes with "Mosaic negatives"—"thou shalt not's" of poetic composition. Such proscriptions not only complement the vaguer, but more constructive rules in "Imagisme," but also aim to make the would-be poet an *Imagiste* by default.

Many of these prohibitions simply restate in negatives the constructive rules of "Imagisme":

"Imagisme"	"A Few Don'ts"
1. Direct treatment of the "thing," whether subjective or objective.	Go in fear of abstractions. Don't be descriptive; . . . [Shakespeare] presents.
2. To use absolutely no word that did not contribute to the presentation. (199)	Use no superfluous word, no adjective, which does not reveal something. If you are using a symmetrical form, don't put in what you want to say and then fill up the remaining vacuums with slush.
3. As regarding rhythm to compose in sequence of the musical phrase, not in sequence of a metronome. (199)	Don't chop your stuff into separate *iambs*. Don't make each line stop at the end, and then begin every next line with a heave. . . .

> Your rhythmic structure should not
> destroy the shape of your words,
> their natural sound, or their mean-
> ing. (204)

Pound's "Don'ts" also address a sore point that he considered particular to England: the dilettantish assumption that anyone could toss off a poem. As he wrote elsewhere, "It is impossible to talk about perfection without getting yourself much disliked. It is even more difficult in a capital where everybody's Aunt Lucy or Uncle George has written something or other."[34] His negatives attack this amateurism directly:

> Don't imagine that the art of poetry is any simpler than the art of music, or that you can please the expert before you have spent at least as much effort on the art of verse as the average piano teacher spends on the art of music. (202)

> Don't retell in mediocre verse what has already been done in good prose. Don't think any intelligent person is going to be deceived when you try to shirk all the difficulties of the unspeakably difficult art of good prose by chopping your composition into line lengths. (201-2)

In "teaching," Pound is really subverting the warmed-over Victorian poetics that still prevailed in 1913: prolixity, philosophizing (cf., Pound: "Don't be viewy"), use of abstractions, narrative description, fixed patterns of rhythm and structure, and images used as "ornaments" (à la Swinburne) rather than as "the speech itself." But if "A Few Don'ts" aimed to clear the ground of an outworn style and to throttle future poets into professional seriousness, it betrayed a problem common to most "negative" manifestos: it recommended precious few constructive practices new poets could adopt. Apart from offering such homilies as follow good models and learn your craft, these "Don'ts" essentially opened the way to free verse—without providing its novices a road map.[35]

Viewed more broadly, the prevailing negativism of prewar manifestos points as much to the beleaguered status of modernism itself before the war as to the needs of particular groups and leaders or to the manifesto's inherent nature. In a hostile artistic climate, "attack" became the essential modernist strategy, whether the target was an outmoded style, a complacent public, or a rival group.

IV. Manifesto Form: What Qualifies?

The manifestos quoted above show considerable variation in form and style, ranging from the bold declamations in terse, sentence-long paragraphs of the Italian Futurists and those groups they influenced (the English Vorticists, the Russian Cubo-Futurists and Rayists, and to some extent the Blaue Reiter) to long, explanatory paragraphs of the Mezzanine of Poetry and the American Synchromists; from one-page broadsides like the Russian Cubo-Futurists' "Go to

Hell!" to the article format of the Imagists' two manifestos in *Poetry*. As noted above, the manifesto's purpose, audience, and tone directly inform its style as part of a rhetorical strategy: paragraphs that seriously explicate the group's aesthetics tend toward length; those that airily dismiss rival groups are provocatively short, declamations and lists of demands shorter still. This stylistic variety poses problems in defining the manifesto's form, especially since its stereotypical form of short paragraphs, exclamations, and bold typography evolved during the "manifesto fever" of the prewar years, not earlier. If the form that Marinetti, Apollinaire, and others developed beginning around 1909 becomes *the* manifesto form, how should we classify those documents that preceded it or that simply do not conform to it?[36]

The generic problem does not end here, however, for, with a few exceptions, nearly all of the documents quoted above called themselves—or their authors considered them as—manifestos. What of documents that do not remotely resemble the manifesto's stereotypical form, texts their authors did not even conceive of as manifestos, but still function like one in asserting the group's identity or presenting its aesthetic principles? "Manifesto fever" was virulent enough in these years to infect such diverse media as pedagogical texts, prefaces to exhibition catalogues, articles, subscription prospectuses, and even poetry collections. If, as I believe, a document's function (and, secondarily, its purpose) takes precedence over its style and form, then should not these atypical works also receive manifesto status?

To address this problem, I would subdivide the genre into the "manifesto-proper" for documents that both look and act like manifestos, and the "quasi manifesto" for atypical documents that essentially *function* as a manifesto even as they maintain other, more primary identities.

A. The Manifesto-Proper

The typical features of the "manifesto-proper" have already been noted: a declamatory style of very short (usually one-sentence) paragraphs in the group's collective voice ("we"); a hostile, belligerent, often provocative tone; content often codified into lists (often lists of demands); a prevailing negativity in stressing what and whom the group opposes; and finally—Marinetti's and Apollinaire's chief innovation—a new "theatrical" typography that borrows from advertising such eye-catching—really, eye-assaulting—techniques as all-cap boldface headings (and for major headlines, large black block letters), numbered series, frequent exclamation marks, and aggressive, pithy subheads: "WE DECLARE:"; "WE FIGHT:"; "WE DEMAND."[37]

Case Study: The Vorticists' *BLAST*

The most extreme example of these qualities comes not from Marinetti's own pen, but from thirdhand imitators, the English Vorticists, in their journal, *BLAST*—tertiary, because they drew both their typography and the idea for lists of those to "BLAST" or "BLESS" directly from *"L'Anti-tradition futuriste"* of Apollinaire, who had, in turn, one-upped (and perhaps parodied) Marinetti with his boldfaced lists of those to receive a "ROSE" or "MERDE." Like their cover

featuring "BLAST" printed diagonally in huge block capitals on puce-colored paper, the Vorticists' initial manifestos, particularly the "BLAST" and "BLESS" lists (fig. 25), are a visual tour de force. In fact, compared to the nearly nonsensical prose, their meaning resides almost solely in their visual assault on the reader's eye:

<div align="center">

CURSE
the flabby sky that can manufacture no snow, but
can only drop the sea on us in a drizzle like a poem
by Mr. Robert Bridges.

</div>

Numerous manifestos that follow, replete with boldface type and multiple exclamation marks, continue these declarations at a shrill pitch. No reader can miss the youthful exuberance of this style or that it came from a modernist group self-consciously determined to make a splash.

Precisely what the Vorticists stood for and what their manifestos assert (besides their appearance) are far less certain. As noted above, the group essentially formed in reaction to Marinetti's crude effort to force them into the Futurist orbit and in acquiescence to Lewis's equally fraudulent efforts to organize and lead them. Even the principals could not agree on the meaning of the group's name and symbol, the vortex. Lewis used the term politically to describe the group's energized emergence in the London art world of 1914: "Long live the great art vortex sprung up in the centre of this town!" ("Long Live the Vortex!"). For Gaudier-Brzeska, it represented "sculptural energy" (but it also represented "will and consciousness" and a host of more fanciful associations in his manifesto "VORTEX. GAUDIER BRZESKA"). For Pound, it became a metaphor for the energized image: "The image is not an idea. It is a radiant node or cluster; it is . . . a VORTEX, from which, and through which, and into which, ideas are constantly rushing." Finally, the "Manifesto" that the Vorticist group "signed" in the June 1914 *BLAST* is a model of vacuity:

1. Beyond Action and Reaction we would establish ourselves.
2. We start from opposite statements of a chosen world. Set up violent structure of adolescent clearness between two extremes.
3. We discharge ourselves on both sides. . . .
6. We are Primitive Mercenaries in the Modern World.

<div align="right">

(*BLAST*, no. 1, June 1914, 31)

</div>

While the magazine contains prints of Vorticist art and important literary pieces by Lewis and Eliot (whose first published poems appear in the second issue), the manifestos are a case of style over substance: they shout in order to be shouting.

B. Quasi Manifestos

The Book-Manifesto: Schoenberg's *Theory of Harmony* and Kandinsky's *Concerning the Spiritual in Art*

Arnold Schoenberg's *Theory of Harmony* (published December 1911) nicely illustrates the generic issues discussed above. Weighing in at more than

four hundred densely packed pages that are footnoted and profusely illustrated with musical examples, this massive textbook on harmony certainly looks nothing like a manifesto. Its primary purpose, moreover, is pedagogical: to instruct students in the "handicraft of harmony," the conventions "necessary for complying with the major-minor system" (396, 48). Its tone is appropriately dry and "teacherly," and its style is discursive: Schoenberg analyzes, discusses, illustrates, repeats himself, and above all, seeks to persuade his student-reader. Easily nine-tenths of the book addresses these aims. [38]

Yet two major elements rescue this book from the dusty shelf of textbooks. First, interlaced with its dry, orderly presentation of harmonic combinations is a subversive subtext—commentaries in which Schoenberg switches hats from tacit supporter of the compositional conventions governing harmony and diatonic melody to intelligent skeptic who asks "whether they need be so"—questions, that is, their very authority (Carter xiv). Equally important, his questionings reflect the most recent compositional innovations (dating from about 1908) and current thinking of an avant-garde group comprised of Schoenberg and his two most advanced students, Alban Berg and Anton Webern. Arguably, then, the subversive subtext of *Theory of Harmony* served as the group's *post-facto* manifesto of pantonality.[39]

If student-readers of Schoenberg's textbook were disturbed to discover that in these discursive asides the author seemed to shake the very pillars of the major-minor system—central tonality as an organizing force, the traditional distinction between consonance and dissonance, and the existence of nonharmonic tones—Schoenberg's explanation seemed soothingly evolutionary rather than revolutionary: "nothing is definitive in culture; everything is only a preparation for a higher stage of development" (97). Thus, if tonality "is no natural law of music, eternally valid" (9), then the diatonic scale is "not . . . the ultimate goal of music, but rather a provisional stopping place" (25). This evolutionary view itself justifies studying the tonal system to understand both how it evolved and how it must be superseded: "Let the pupil learn the laws and effects of tonality just *as if* they still prevailed, but let him know . . . that the conditions leading to the dissolution of the system are inherent in the conditions upon which it is established" (29, my emphasis).

Elsewhere in the book, Schoenberg explains (and demonstrates) how such elements as tonal modulation and harmonic dissonance offer compositional possibilities that effectively undermine the structural hierarchies of the tonal system. His conclusions here are strikingly egalitarian: "every chord can be connected with every other" (241) and "any triad can follow any other triad" (12). Similarly, he erases the traditional distinction between consonance and dissonance by showing that dissonances are nothing more than "remote consonances" (21), thus enabling "any simultaneous combination of sounds, any progression" (70). The composer may simply "skip away from the dissonance" rather than carefully resolving it into a consonance (140)—a freedom Schoenberg called "the emancipation of the dissonance." Ultimately, without a "system" to judge admissibility, "any material can be suitable for art" (26).

All of these compositional freedoms shake the authority of the major-minor system of central tonality, and Schoenberg's late note delivers the coup de grâce: "that one *can* [still] create tonality, I consider possible. Only, whether one *must* still work for it, indeed whether one *ought* to work for it any more at all, I doubt" (394 n.).[40] Like most of the explicit manifestos of this period, Schoenberg's manifesto-like sections stress the negative in undermining the bases of the major-minor system and diatonic tonality, while offering few constructive practices to replace diatonic tonality. Thus, like Pound's "Don'ts," Schoenberg's negative emphasis leaves his readers with the unintended by inescapable conclusion that "everything is possible" in the art form—but, he adds tautologically, only "the master is free; . . . the pupil stays under restriction until he becomes free" (331).

This theoretical subversion of the major-minor system expressed a stage that not just Schoenberg, but also his two student-disciples, Alban Berg and Anton Webern, had already arrived at in their composing and frequent discussions of the past few years.[41] Throughout his book, Schoenberg uses the singular "I" to refer to his ideas and intentions. But his working relationship with Berg and Webern was so close in these years as to form a distinct group which music historians have subsequently labeled the Second Vienna School. As I discussed in chapter 2, the pedagogical nature of this group so elevated Schoenberg as *Der Meister* that it is hardly surprising that in *Theory of Harmony* he refers to Berg and Webern as his students, not colleagues. Yet much evidence suggests that their influence on Schoenberg's thinking was sufficient for us to consider the book's subversive ideas as the quasi manifesto of a group.

Schoenberg famously acknowledged his indebtedness to his student-collaborators in the opening sentence of his preface to the 1911 edition: "This book I have learned from my pupils" (1). His exploratory teaching methods, he explains, freely permitted errors by student and teacher alike that resulted in a mutual "searching" and "striving":

> I was compelled by my errors, which were quickly exposed, to examine my instructions anew and improve their formulation. . . . [As a result of this method, my students] do know what matters: *the search itself!* . . . that one searches for the sake of searching. That finding, which is indeed the goal, can easily put an end to striving. . . .
>
> The activity [of shaking up my students' preconceptions] comes back again to [the teacher]. In this sense also I have learned this book from my pupils. And I must take this opportunity to thank them. (1, 3)

Webern and Berg were enthralled with the book and overwhelmed by this generous acknowledgment of their intellectual stimulus. Webern responded: "You thank us?! Whatever I am, everything, everything is through you; I live only through you. That you could use us for practice was our limitless good fortune, a boundless blessing for us."[42] In Webern's view: "since Wagner, nothing like this [book] has been written in the German language. Perhaps not even since Schopenhauer" (qtd. in Moldenhauer 152). Berg, who indexed the book and

proofed the galleys, was unashamedly religious in his veneration of text and author: "[With the 'divine' forward and the dedication,] [t]his wonderful book has now received its final consecration: before entering the sanctuary one kneels devoutly and crosses oneself in profoundest humility. . . . And that we poor mortals may partake of it—that is our highest joy: For that, we thank you, beloved Herr Schoenberg."[43]

Finally, however, one looks beyond these mutual tributes to the relation between theory and practice, text and compositions. As Schoenberg acknowledges, the book's major innovative ideas reflect "that which the art has already achieved" (386). The text thus provides the formal, theoretical rationale for practices that Schoenberg and his disciple-collaborators had arrived at through "music intuition" (410) and discussion. As it both explains and justifies the group's aesthetic innovations, *Theory of Harmony* fulfills major functions of a manifesto.

In the same month that Schoenberg's *Theory of Harmony* appeared, December 1911, an even more influential book was published: Wassily Kandinsky's *Concerning the Spiritual in Art*.[44] Kandinsky's book was widely read and much discussed: excerpts from the manuscript were read aloud to the Congress of Russian Artists in St. Petersburg in December 1911, and the complete Russian edition appeared in 1912; Herwarth Walden published a chapter from it ("Language of Form and Color") in *Der Sturm* in 1912; and excerpts of it in English appeared in the first issue of *BLAST* in June 1914, the same year that witnessed the first complete English translation (Selz, *German* 213, 259). As Peter Selz summarizes: "It was immediately widely accepted in art and literary circles as one of the sources of the movement in art and aesthetics. It was also considered a manifesto of German expressionism and 'absolute painting'" (341 n.26).

By my criterion, too, the book qualifies as a manifesto: it expresses Kandinsky's deeply considered antimaterialist credo that modern (and future) painting must be guided by artists' "inner necessity"—their subjective and spiritual feelings, rather than by their concern for representing material forms or for technique as an end in itself. But because the book's individual authorship technically places it outside of my study of modernist groups and group productions, I will refer to its ideas only indirectly, as they inform the various manifestos of the group that Kandinsky and Franz Marc had by then organized: the Blaue Reiter.

Editions, Articles, Prefaces, Prospectuses, Private Letters as Manifestos: The *Blaue Reiter Almanac*

As noted above, Kandinsky and Marc created the *Blaue Reiter Almanac* to promulgate spiritual values in art that transcended boundaries of nation, culture, class, and age group. So conscious were they of their aesthetic mission that it informs virtually every aspect of their collaboration, from their correspondence to the published *Almanac*. Consider, for example, Kandinsky's letter of 19 June 1911, in which he first describes the project to Marc:

> Well, I have a new idea. . . . A kind of almanac (yearbook) with re-
> productions and articles . . . and a *chronicle*!! that is, reports on exhi-
> bitions reviewed by artists and artists alone. In the book the entire
> year must be reflected; and a link to the past as well as a ray to the fu-
> ture must give this mirror its full life. . . . We will put an Egyptian
> work beside a small Zeh, a Chinese work beside a Rousseau, a folk
> print beside a Picasso, and the like. Eventually we will attract poets
> and musicians. (Qtd. in Lankheit, *Almanac* 15-16)

Art historians have aptly called this the "birth certificate" of the Blaue Reiter
(Lankheit, "History" 16). Should we also consider it a quasi manifesto because it
expresses Kandinsky's plan? Should the entire *Almanac* be considered a single
manifesto because it embodies the Blaue Reiter*'s* aesthetic philosophy, or
should such status apply only to the "manifesto-like" articles in the *Almanac*,
such as the initial three by Franz Marc? And what status should we accord such
related documents as public announcements, unpublished and published pref-
aces to the first and second editions, and the "Foreword" for the unrealized sec-
ond volume—all of which expound the group's aesthetic philosophy and the
Almanac's plan?

Peer's criterion that the manifesto must be a public document, that is, pub-
lished (or intended to be) for public consumption (2), would rule out private
letters like Kandinsky's above, even if they clarify the aesthetic principles of
published manifestos.[45] Marc's subscription prospectus of mid-January 1912, on
the other hand, possesses several hallmarks of manifesto content and tone, even
though its one long paragraph lacks the Futurists' innovative form. Its voice is
declarative:

> *We know* that the basic ideas of what we feel and create today have
> existed before us, and *we are emphasizing* that in essence they are not
> new. But *we must proclaim* the fact that everywhere in Europe new
> forces are sprouting like a beautiful unexpected seed, and *we must
> point out* all the places where new things are originating. ("Der Blaue
> Reiter" in Lankheit 252, italics mine, underlining Marc's)

Beyond dual editorship, "We" evokes the strong "us-them" oppositional stance
that energizes the modernist manifesto—a recognition of allies and enemies and
a reaching out to the former in solidarity: "Today art is moving in a direction of
which our fathers would never even have dreamed. . . . There is an artistic ten-
sion all over Europe. Everywhere new artists are greeting each other; a look, a
handshake is enough for them to understand each other!" The modernist group's
typical claims of preeminence and centrality also echo in Marc's claim that
"[o]ut of the awareness of this secret connection of all new artistic production,
we developed the idea of the Blaue Reiter." Finally, the prospectus offers a little
of this group's core belief that the inner spirituality of art transcends the work's
medium, historical period, geographical origin, and the artist's sophistication:
"[The *Almanac*] reveals subtle connections with Gothic and primitive art, with
Africa and the vast Orient, and with the highly expressive, spontaneous folk and

children's art, and especially with the most recent musical movements in Europe and the new ideas from the theater of our time."

The unpublished preface to the first edition of the *Almanac*, "Almanac: *Der Blaue Reiter*," co-signed by Kandinsky and Marc, also deserves manifesto status as a document intending to present the Blaue Reiter*'s* philosophy to the public. Like the prospectus, it welcomes fellow artists, but goes even further in proposing to identify the opposition: art not rooted in inner necessity ("With all available means we want to try to unmask the hollowness of this deception. This is our second goal") and "unqualified art critics" whose "empty words . . . are building a wall in front of the public" (rpt. in Lankheit, *Almanac* 250-51).[46] Like the prospectus, the preface presents the group's optimistic belief that "[a] great era has begun . . . the epoch of great spirituality," its chief aim in the *Almanac* ("to reflect phenomena in the field of art that are directly connected with this change"), and even the principle by which the editors selected and organized the contents of the *Almanac*: "the reader will find works in our volumes that . . . show an *inner* relationship although they may appear unrelated on the surface." The question remains whether the entire *Almanac* itself should be considered a manifesto, or only particular pieces in it, such as Marc's three articles. Undoubtedly, the *Almanac* embodies the internationalist and ecumenical philosophy of its editors: it transcends boundaries separating historical periods, nations, classes, cultures (intermingling "high," "primitive," folk, and children's art), continental civilizations (including African, Oriental, and Western examples), and art forms (including musical scores, a music-theory essay, and an abstract theatre piece). What unifies this diversity also reflects the editors' philosophy: "Each contribution highlights signs of a spiritual renewal in its field" (Vezin 155).

As Annette and Luc Vezin point out, moreover, this expression of the editors' philosophy was shocking and subversive in its own right:

> For a public which had not yet accepted Fauvism and Cubism, the works reproduced in the *Almanac* probably remained completely incomprehensible. What is more, their juxtaposition with works from other cultures and generous space given to popular art forms must have completed the public's mystification, as would the desire to "bring down the barriers" which had hitherto existed between painting, music, theatre, dance and poetry. . . . [t]he reader was transported into an unexpected museum in which neither chronology nor relationship of style were respected. . . .
>
> By proclaiming the equivalence between a 20th-century painting and a sculpture from New Caledonia or a child's drawing, the editors . . . invented a new vision of the history of art. Henceforth artistic creations were no longer to be judged according to their fidelity to a certain idea of beauty or style, but according to the inner necessity which engendered them. (150-51)

Such direct challenges, the Vezins conclude, make the *Almanac* a "belligerent book, a weapon brandished against a reactionary concept of art of the kind that had led authorities to refuse gifts offered by Meier-Graefe and Tschudi" (155).

But subversive intent and belligerence of concept, although qualities typical of the modernist manifesto, do not by themselves make one; and works that embody an aesthetic philosophy in the way that, say, Boccioni's *The Street Enters the House* embodies the Futurists' aesthetic principle that exterior and interior realms interpenetrate each other in the artist's consciousness, are still, first and foremost, works of art.[47] Indeed, to claim that every work which embodies aesthetic principles becomes a manifesto of those principles opens a floodgate that virtually erases any distinction between artwork and manifesto. Only when the work itself *presents* (rather than represents) elements of an aesthetic philosophy, as in the case of Jules Romains's collection of poems, *La vie unanime* (discussed below), can it reasonably be said to serve double duty as artwork and manifesto.

Conversely, Franz Marc's three articles that begin the *Almanac*—"Spiritual Treasures," "The 'Savages' of Germany," and "Two Pictures"—are terse, aggressive and crackle with manifesto-like energy and messianic belief, as several critics have observed.[48] Like his prospectus, they present (in general terms) the Blaue Reiter's philosophical beliefs and aesthetics: that "genuine art" possesses an "inner life" of "spiritual expression" that "guarantees its truth" (*Blaue Reiter Almanac* 67); and that such innerness "heralds" a "new epoch" (69) of spiritual "renewal" (64), toward which young artists and their spiritually imbued works are the "pathfinders" (69).

In "Spiritual Treasures" and particularly in "The 'Savages' of Germany," Marc's writing adopts the aggressive language and divisive stance of the modernist manifesto. In his brief survey of modernist groups of German painters— Die Brücke, the Neue Secession in Berlin, and the NKV-Munich—who have "brought new, dangerous life to the country" (62), Marc conceives these "savages" in a "great struggle . . . against an old established power"—a battle the savages will win, of course, because "[n]ew ideas kill better than steel and destroy what was thought to be indestructible" (62, 61). Eschewing detachment, the author identifies himself clearly as one of the savages ("*we* fight") who welcomes the other fighters in solidarity: "the defiant freedom of this movement [the Neue Secession of Berlin] . . . we in Munich greet with a thousand cheers. . . . In the dark, without knowing them ["the many quiet powers in Germany struggling with the same high, distant goals" as the savages], we give them our hand" (62, 64).

At the same time, however, Marc is not above elevating *some* modernist groups—those that hew to the Blaue Reiter's cry for an art of inner spirituality—above those who mistakenly follow the formalist path of the French: "The most beautiful prismatic colors [of French Impressionists] and the celebrated cubism are now meaningless goals to these 'savages' [of Germany]. Their thinking has a different aim: To create out of their work *symbols* for their own time, symbols that belong on the altars of a future spiritual religion" (64).

The Italian Futurists may also receive an indirect slap: "Not all the official 'savages' in or out of Germany dream of this kind of art and of these high aims. All the worse for them. After easy successes they will perish from their own superficiality despite all their programs, cubist and otherwise" (64). But if Marc was alluding to the Futurists (whom he would publicly praise during their Berlin

exhibition of April 1912), he was not above learning from their manifesto style. For although his piece is technically still an article, its paragraphs, especially in the last half page, have acquired the edgy, single-sentence brevity of Futurist manifestos. Thus, in its combative language, its divisive stance, its confident assertions, and partly in its form, "The Savages of Europe" is virtually indistinguishable from the most avant-garde manifestos of its time.

The Disingenuous Manifesto: "Imagisme" (*Poetry*, March 1913)

If prosaic form does not disqualify an article from manifesto status, neither should its author's denials of intent. We have already analyzed the second of Imagism's dual manifestos in *Poetry*, "A Few Don'ts by an Imagiste," to illustrate the manifesto's pervasive negativism. The first of the pair, "*Imagisme*," is also noteworthy, however, this time for its coyness and disingenuousness, culminating a publicizing strategy Pound had begun the preceding summer. Understanding his methods in "Imagisme" thus requires a brief review of his strategy leading up to them.

As organizer, leader, even namer of *Les Imagistes* in 1912, Ezra Pound certainly intended to "boom" them, as he put it.[49] But for several reasons, he devised a coy, indirect strategy of veiled references to the Imagists coupled with teasing denials and demurrals. First, as I argue in the prologue, Pound was almost certainly inspired by Marinetti's brilliant promotional strategies, which Pound encountered during the Futurists' traveling exhibition in March 1912; indeed, the shared penchant of these two poet-leaders for acting as a group's impresario and publicist made it all the more necessary for Pound to find methods utterly different from Marinetti's to ensure for his group and himself a claim to originality. If Marinetti's approach was direct and unsubtle—dropping leaflets from Venice's central clock tower, assaulting audiences with his belligerent oral readings, provoking fistfights with his evenings—Pound was determined to be cagey and circuitous. Moreover, having just been appointed "foreign correspondent" to Harriet Monroe's new *Poetry* magazine in August 1912, a position that implied a certain critical disinterestedness, he probably did not wish to abuse—or at least *appear* to abuse—his access to the pages of this rare venue for new poetry by pushing his Imagist agenda too insistently.[50] Then, too, he understood the clever sales ploy of using reverse psychology to arouse his readers' curiosity.

Accordingly, Pound began making brief, elliptical references to the group beginning with the publication of his own collection of poems, *Ripostes*, in August 1912. Appending to the volume a tongue-in-cheek supplement, "Complete Poetical Works of T. E. Hulme," Pound adds a "Prefatory Note" which concludes: "As for the future, *Les Imagistes*, the descendent of the forgotten school of 1909, have that in their keeping" (*Personae* 266). In his monthly notes and intermittent articles for *Poetry*, the obscure references to *Imagisme* and *Les Imagistes* continue. The second issue (November 1912) features two poems by Richard Aldington, whom Pound identifies as "a young English poet, one of the '*Imagistes*,' a group of ardent Hellenists who are pursuing interesting experi-

ments in *vers libre*; trying to attain in English certain subtleties of cadence of the kind which Mallarmé and his followers have studied in French" (65).

Two issues later, poems appeared followed only by the poet's mysterious identification as *"H.D., 'Imagiste'"* (January 1913, 122). While the "editor" could shed no light on H.D.'s identity except to note she was "an American lady resident abroad" (135), Pound obviously could have (since he had invented this bit of mystification for Hilda Doolittle), but he chose not to.[51] In the same issue, however, he did mention the movement again in his lengthy survey of contemporary poetry, "Status Rerum": "The youngest school here that has the nerve to call itself a school is that of the *Imagistes*" (126). But, again, the note teases more than informs:

> Space forbids me to set forth the program of the *Imagistes* at length, but one of their watchwords is Precision, and they are in opposition to the numerous and unassembled writers who busy themselves with dull and interminable effusions, and who seem to think that a man can write a good long poem before he learns to write a good short one, or even before he learns to produce a good single line.

If Pound's aim was to arouse interest by this reverse psychology and by assuming a tantalizing "I-know-something-that-you-don't-know" manner, he seems to have succeeded, for the "Editor's Note" preceding the seminal Imagist manifestos in the March 1913 issue states: "In response to many requests for information regarding *Imagism* and the *Imagistes*, we publish this note by Mr. Flint, supplementing it with further exemplification by Mr. Pound" (198).[52] The two articles that follow intensify Pound's tactics of teasing denials, while surprising readers with perhaps more than they had expected: in fact, Imagism's complete manifesto and "how-not-to" guide to writing poetry.

"Imagisme" begins with a double deception: that F. S. Flint is the author and that his persona in the article is of an inquiring reporter responding to the curiosity that *Imagisme* has aroused by seeking out an *imagiste* in order to find out something "definite" about the movement. The latter facade—Flint was a poet close to Imagism's membership and ideas—is a standard journalistic gambit. But the deception of authorship (Pound ghostwrote nearly all of the article), although now well-known in the history of Imagism, again reveals Pound's clever duplicity in not wanting to appear a one-man publicity campaign for Imagism.

It is in this strategic context of indirect reference and duplicitous denials that Pound's identification of the Imagists should be read:

> The *imagistes* admitted that they were contemporaries of the Post Impressionists and the Futurists; but they had nothing in common with these schools. They had not published a manifesto. They were not a revolutionary school; their only endeavor was to write in accordance with the best tradition, as they found it in the best writers of all time. . . . They seemed to be absolutely intolerant of all poetry that was not written in such endeavor. (199)

The *imagistes* had, of course, *much* in common with the Futurists, beginning with the similarities of their poet-leaders. To be sure, they were not revolutionary in the past-hating way the Futurists were; but as I argue above, the three rules presented in "Imagisme" and especially the "Don'ts" that follow are indeed revolutionary as they effectively subvert late-Victorian poetics. The most curious of these denials is that "they had not published a manifesto" (thus they had "nothing in common with" the Futurists), when these two articles in every respect *are* the Imagists' manifesto.

Pound's reverse psychology of appearing to withhold or deny information continues in "Imagisme" itself: "They had a few rules, drawn up *for their own satisfaction only*. . . . They also had a certain 'Doctrine of the Image,' which they had not committed to writing; they said *it did not concern the public*, and would provoke useless discussion" (199, my emphasis). Obviously, once these rules are published, they can no longer exist "only" for the Imagists' own satisfaction. Conversely, the article does seem to withhold the "Doctrine of the Image"—unless we equate it with Pound's definition beginning "A Few Don'ts": "An 'Image' is that which presents an intellectual and emotional complex in an instant of time" (200). But why mention the "Doctrine" at all if "it did not concern the public and would provoke useless discussion" (199)? Pound's disingenuousness here could not be more obvious. In sum, "Imagisme" presents the Imagists as a secretive group, busily evolving their own style of poetry and caring not a fig for public exposure—even at the risk, the author(s) concede, of being charged with "*snobisme*."[53] Apart from presenting the movement's three rules, the manifesto's coyness scarcely prepares the reader for the bluntness and proscriptive specificity of its companion piece, Pound's "A Few Don'ts by an Imagiste." Rhetorically, the two manifestos thus complement each other—a kind of one-two punch, maximizing the impact of Imagism's debut. If "Imagisme" whets the reader's appetite for more information about the movement, the aggressive "Don'ts" surfeits that hunger.

Flint's pose in "Imagisme" as inquiring reporter suggests another way in which quasi manifestos can hide their partiality: when a text's author acts as a kind of double agent, ostensibly an objective critic, describing or evaluating the group's or style's achievement from outside, but covertly a *partisan*, promoting the group as a member. Maurice Raynal's articles about *La Section d'Or* in the group's exhibition catalogues and *Bulletin* are a good example. A writer and art critic, Raynal was, like his colleague Apollinaire, both a detached commentator on Paris's modernist groups and painters and an associate of the Puteaux group that held its major *Section d'Or* exhibition at the Galerie de la Boëtie in October 1912. Raynal's review-style article, "The *Section d'Or* Exhibition," like Apollinaire's front-page piece "Young Painters, Keep Calm!" appeared in the eightpage *Bulletin de La Section d'Or*. Apollinaire's title specifically and personally addresses the group's painters, while his text aggressively attacks its critics. By contrast, Raynal's article appears more detached and scholarly. Edward Fry describes his criticism as "at times . . . almost scientific, at a far remove from the lyrical prose of Salmon and Apollinaire. . . . [Raynal's] clearsighted articles pro-

vided a much needed counterbalance to the vague enthusiasm or condemnation of many contemporary critics" (93).

In "The *Section d'Or* Exhibition," for example, Raynal attempts to identify Cubism with "pure painting" (which he defines as "an art derived from a disinterested study of forms"), with conceptual art drawn from the "Primitives," and with a love of science and research (Fry 99). Yet these very qualities also express principles of the Puteaux group. And elsewhere in this article (and in an earlier version Raynal wrote for the show's opening in Rouen in June-July 1912), he clearly identifies himself as a group member and gives his prose the assertive and aggrandizing rhetoric of the manifesto-proper:

> [T]he twentieth century has seen the rise of a generation of artists who, possessing an exceptionally wide culture, have tried to renew the pictorial conceptions and styles of the past through their own knowledge in various fields and their affinities with the modern movement. . . . The painters and sculptors of *our* group have tried to free Painting and Sculpture from stagnation. . . . [54]

> [T]he *Section d'Or* Exhibition has grouped together for the first time with . . . completeness, all those artists who have ushered in the twentieth century with works clearly representative of the [century's] tastes, tendencies and ideas. ("The *Section d'Or* Exhibition"; rpt. in Fry 97)

Essentially, then, Raynal's "scientific" articles are as much manifestos of the Puteaux group as Apollinaire's militant call to arms: "Several young men—writers on art, painters, poets—have united to defend their plastic ideal, and that is ideal."[55]

Literature as Manifesto: Romains's *La vie unanime*

If pedagogical and philosophical books, articles in various guises and venues, even a prospectus can serve as quasi manifestos, what of artistic productions? Above, I argued that to maintain a semblance of generic clarity, artworks must do more than simply represent or embody aesthetic principles to be a quasi manifesto: they must state or present those principles directly. This criterion excludes all nonverbal media, but it does include a literary work such as Jules Romains's collection of poems, *La vie unanime* (March 1908). Although published just before the period studied in this book, it merits attention for its interesting blurring of boundaries between manifesto and work of art.

In the poems of *La vie*, Romains expresses a philosophy he had begun to evolve in 1905 among members of L'Abbaye de Créteil.[56] His first manifesto of Unanimism appeared as an article in the journal *Le Penseur* (April 1905), "*Les Sentiments unanimes et la Poésie*," which begins:

> At the present time, the life of civilized man has assumed a new character. Essential changes have given a different meaning to our existence. . . . The actual tendency of the people to mass together in the cities; the uninterrupted development of social relationships; ties

stronger and more binding established between men and their duties, their occupations, their common pleasures; an encroachment, even greater, of the public on the private, the collective on the individual: here are the facts that certain people deplore but that no one contests. (Qtd. in Perloff 84)

Romains conceived of these ties between city dwellers and the city's collective forces as "*unanimes.*" As Sherry Buckberrough explains: "His philosophy rested on the assumption that life was regulated by *unanimes*, or energy groups, which were every bit as real as the physical organism of the individual human being and deserved recognition as fluctuating but ever-present entities" (53).

Indeed, to "recognize" these energies—to capture them in a series of poems—became Romains's project for the next three years. "*Les Sentiments*" continues: "I strongly believe that the bonds of ['unanimous'] feeling between a man and his city, that the whole ethos, the large movements of consciousness, the colossal passions of human groups are capable of creating a profound lyricism or a superb epic cycle" (qtd. in Perloff 85).[57] That epic cycle became *La vie unanime*, which Romains published to much acclaim in 1908.[58] Its chief protagonist is neither the speaker, nor any single individual, but the city, whose collective forces and rhythms move through all:

> What is it that has thus transfigured the boulevard?
> The gait of the passers-by is scarcely physical
> These are no longer movements, they are rhythms
>
> Now the avenues . . .
> [With] their trees, their posts and their scattered houses
> Are full of passers-by . . .
> . . . their gestures form a single
> Movement which spreads . . .
> Nothing but a stream of force in which the rhythms are steeped.
> (*La vie unanime*, 1908 ed., 24, 92; trans. in Marianne Martin, "Futurism, Unanimism, and Apollinaire" 264)
>
> The eyes do not see separate forms
> . . . Each thing prolongs another. The metal
> Of the rails, the dazzling squares, the entrances
> To the houses, the passers-by, the horses, the carriages
> Join each other and join my body.
> We are indistinct
> (*La vie*, 239; trans. in Martin 261)

What distinguishes *La vie unanime* from, say, *Des Imagistes* (Pound's 1914 anthology of Imagist poems) and qualifies the former as a quasi manifesto is that while the poems in *Des Imagistes* enact (in varying ways and degrees) principles of the 1913 *Poetry* manifestos, Romains's poems state various aspects of his Unanimist credo. Several poems, for example, express variants of the theme that the speaker feels indistinguishable from and interpenetrated by the city's people, architecture, materials, and open spaces:

[I am] a joyous intersection of unanime rhythms, a condenser of universal energies

The passer-by below on the sidewalk
Scarcely moves and passes outside of me.

A crowd of intruders has invaded me and lives within me
Because I have lost the keys which lock my spirit

I slowly cease to be myself . . .
Jostled by the appearance of the street
I am completely drained of interior life.
My being diminishes and dissolves . . .
I am like a piece of sugar in your mouth
Greedy city. But I am not afraid of you;
. . . what joy
To melt in your immense body where one is warm.
> (*La vie*, 210, 31, 128, 133; trans. in Martin 261, 263; and in Nicholls
> 82)

Other poems envision the city itself as "moving" toward its energy sources in the sea and especially the sun:

Less and less divergent,
In spite of the walls, in spite of the structures,
The innumerable forces run together,
And how brusquely the total impulse
Sets all of the houses going
. . . toward the sunrise.
Among the chestnut trees the top of the avenue
Rotates the sun and I turn toward the sun
> (*La vie*, 134; trans. in Martin 262, 264)

Because each poem contributes only a small aspect of Romains's Unanimist vision, it cannot serve by itself as a Unanimist manifesto in the way that Marc's articles do in the *Blaue Reiter Almanac*.[59] Only taken collectively—a cognitive simulacrum of their theme—do the poems convey the Unanimist philosophy of this manifesto-book.

V. Conclusion

The quasi manifestos considered above obviously expand the manifesto genre; but, more important, they shift the balance between form and content toward content, specifically toward texts that present the principles of a group or movement. The document's outward appearance, its primary purpose and genre, even its author's stated intent are all secondary. Undoubtedly, Perloff is correct in showing how Marinetti, Apollinaire, and the Vorticists aestheticized the

manifesto's form and style through their typographical innovations, and how those visual innovations are inseparable from the modernist poetics of Marinetti's *parole-in-libertà* or Apollinaire's *calligrammes*. These stylistic innovations, moreover, spread quickly in the prewar period: Apollinaire adopts (or parodies) and exceeds Marinetti's style in June 1913; the Vorticists adopt and exceed Apollinaire's in June 1914; and groups like the Cubo-Futurists and Rayists in Moscow soon imitate the style's tamer aspects, for example, its one-sentence paragraphs and declamations.

Yet, any number of modernist groups of this period took time to spell out their principles in expository prose—the Mezzanine poets in Moscow, the Synchromists in Paris, *Die Aktion* and *Der Sturm* in Berlin are just a few examples—and neither these groups nor their aesthetic positions were any less radical than those of the Futurists and Vorticists. Indeed, if the implicit message of the visual innovators of manifesto form is that style *is* substance, then their manifestos can easily become intellectually vacuous—and the manifestos in the Vorticists' *BLAST* are certainly liable to this charge.

Moreover, Marinetti and the others did not invent an essential feature of the manifesto: its hostile, aggressive nature, which was, as Larry Peer observes, intrinsic to the name and nature of the genre. That Marinetti and the other great manifesto writers of the prewar years intensified this hostility speaks directly to the state of modernism then. Proliferating groups needed to identify and preserve themselves, emerge from the pack, and diminish their competitors; innovating groups, provoking ever greater public hostility, used the medium for preemptive strikes against skeptical readers and derisive viewers; groups bent on revolutionizing their society, like the *Die Aktion* writers, found manifestos an ideal medium of attack. But not the only medium. As the next chapter will show, attack and disruption were so pervasive in and intrinsic to this period that they spill over into virtually all forms of modernist—and audience—expression.

Mabel Dodge Luhan. Yale Collection of American Literature, The Beinecke Rare Book and Manuscript Library, Yale University.

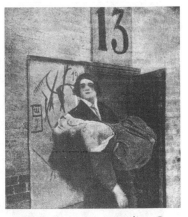

Larionov carrying Natalia Goncharova. Still from Cubo-Futurist film, *Drama in the Futurists' Cabaret No. 13*, 1914.

Mikhail Larionov painting his face, 1913.

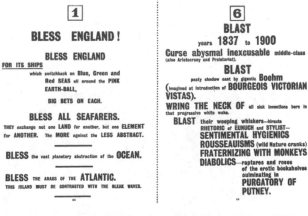

"BLAST" and "BLESS" lists from *BLAST*, no. 1, June 1914.

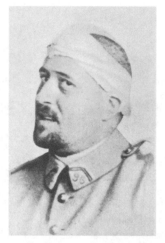

Guillaume Apollinaire after
head wound and trepanning.

Program from the "Skandal-
Konzert," 31 March 1913.

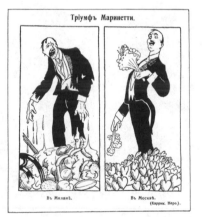

Karreek Naro, *The Triumph of
Marinetti in Milan and Moscow*, 1913.

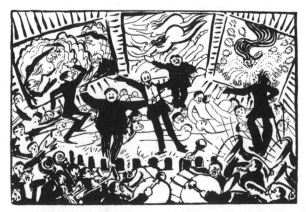

Umberto Boccioni, "A Futurist Evening," 1911. Ink drawing.

Chapter 4

Melee:
Group Performances, Hostile Responses

> [A]rticles, poems and polemics were no longer adequate. It was nec-
> essary to change methods completely, to go out into the streets, to
> launch assaults from theatres and to introduce the fisticuff into the ar-
> tistic battle.
> —F. T. Marinetti, "War: The World's Only Hygiene"
> (1915)

> [T]he months immediately preceding the declaration of war were full
> of sound and fury, and . . . all the artists and men of letters had gone
> into action before the bank-clerks were clapped into khaki. . . . Life
> was one big bloodless brawl, prior to the Great Bloodletting.
> —Wyndham Lewis, *Blasting and Bombardiering* 35

On the evening of 19 October 1913 at the Pink Lantern cabaret, the painters
Mikhail Larionov (fig. 26) and Natalia Goncharova (fig. 27), together with poets
Vladimir Mayakovsky and Konstantin Balmont, treated the audience to an eve-
ning's entertainment that was not soon forgotten in Moscow. As Anthony Parton
recounts:

> Larionov appeared with a painted face and insulted the audience by
> referring to them as "the jack-asses of the present day." Balmont
> added fuel to the fire by declaring: "Long live Larionov! Long live
> all the idiots who have sat in front of him!" . . . Mayakovsky de-
> claimed his insulting poem "Nate" ["Take This!"] while Goncharova
> struck an army officer. The audience went wild with anger [as a
> newspaper account describes the scene]:

> > To all the protests Larionov replied: "You're boors!"
> > The public bawled back at Larionov and his col-
> > leagues: "You're scoundrels!" The artist Natalia
> > Goncharova, one of the futurist ringleaders, assaulted
> > someone. The futurists shouted "asses" and "block-
> > heads" again and again. In the end the audience
> > wanted to thrash them. The feeling against the futur-

> ists ran so high that if the police had not intervened,
> everything would have ended in a bloody battle. (70-
> 71)

As Parton notes, the evening ended predictably and successfully: "Following the incident, the Pink Lantern was closed by the police, but this cannot have disappointed Larionov, Goncharova, or Mayakovsky, since the many reports in the Russian press provided maximum publicity for themselves and Russian futurism" (68, 71).

Sensational as it was, this melee was not in the least unusual for modernist groups before World War I. Across Europe and even in provincial America, these groups regularly provoked the public and often each other into uproars, fist fights, riots, and melees of all kinds in public presentations of their art and of their group's manifestos. Just six days before the Rayist evening described above, in fact, the rival Cubo-Futurists had organized publicity strolls of their own through Moscow with painted faces and with Mayakovsky (apparently playing both sides) "wearing a bright yellow shirt with wooden spoons in the button hole." At their sold out "recital" that night, Kruchenykh spilled hot tea on the front row of the audience and demanded to be booed off the stage; Mayakovsky insulted the audience and gave a nonsense lecture (instead of the one advertised). As Kruchenykh recalled: "We held our banner high, had fine fracases, shouted loudly, and were paid handsomely, up to fifty rubles an hour" (qtd. in Markov, *Russian Futurism*, 133-34, 138).

As these two evenings suggest, uproars at modernist events were not typically spontaneous expressions of the public's hostility to modernism, as they are usually portrayed. Often, the riots were intentionally planned and provoked by the groups themselves for publicity. Markov elaborates:

> [T]he numerous public appearances of Russian futurists in Moscow,
> St. Petersburg, and provincial cities [in 1913] aroused the interest of
> the reading audience, were reported by the newspapers with relish
> and gave rise to imitations and hoaxes. Most of these public appear-
> ances were organized by David Burliuk, who shrewdly understood
> that theory and poetic practice alone would not attract enough atten-
> tion. (132)

Sometimes, these melees resulted from fairly balanced battles between pro- and antimodernist forces, as in the case of the infamous première of *Le Sacre du Printemps*—fights that upstaged the work itself. And often the order of battle was not the public versus modernists but one modernist group against another. Clearly, these ruckuses followed inevitably from the nature of the modernist group itself: the bolder individual behavior and collective assertiveness it fostered, its internal ferment leading to rowdy split-offs, its competition with similar groups, its need to declare its principles in belligerent, provocative manifestos, and perhaps most important, its capacity to stage large-scale public events— exhibitions, concerts, evenings—that provided the occasion for confrontation.

Before examining more examples of these public melees, however, we should note both their range and essential qualities. A primary reason why artists formed groups in the first place was to create new opportunities for getting their work before the public, opportunities that they could not so easily realize as individuals: collective exhibitions for visual artists, concerts for composers, collective readings and recitals for poets, all promising public attention. Added to these group events were two particular to the time: the "blockbuster" international exhibition (the Armory Show, the Sonderbund exhibition, the First German Autumn Salon, the Target, the second *Blaue Reiter* exhibition) organized by ambitious art impresarios or small groups, and group evenings, a frothy mélange of manifesto-declarations, mini-performances, and recitations. "Performance art" it would be called today, but with a more violent edge: all activities of the evening were intended to provoke the audience.

The nature of the particular event largely determined the nature of the melee: who fought, how they expressed their hostility, how vulnerable the event was to disruption, and thus how likely the disrupters were to succeed. For example, modernism in all forms was subject to abusive newspaper reviews (albeit unevenly, as reviewers devoted far more attention to the more public and visceral experience of art exhibitions than they did to books of modernist poetry or to concerts of modern music).[1] Poets and novelists might fear censorship or book burnings, but except for public readings (discussed below) they did not have to encounter a hostile public face to face.

Painters and sculptors did. At the big, international exhibitions of visual art, for example, they had to endure not only insulting reviews, but public ridicule, and sometimes even physical abuse of the paintings. Kandinsky recalls that during the second NKV exhibition (1910),

> [t]he owner of the gallery complained that after the exhibition closed
> each day he had to wipe clean the canvases upon which the public
> had spat, . . . but [at least] they did not cut up the canvases, as hap-
> pened to me once in another city during my exhibition. . . . The times
> were difficult, but heroic. We painted our pictures. The public spat.
> ("Franz Marc"; in *Complete Writings on Art* 2: 794)

Much of the public's abuse of these exhibitions, however, appeared outside the galleries as scathing newspaper reviews and satirical cartoons. At least one could still view the paintings themselves, even if the exhibition rooms were crowded with excited and arguing partisans. In his memoirs, Albert Gleizes describes the intense reaction to the largely Cubist "*Salle 8*" of 1911 *Automne Salon* in Paris:

> The opening-day crowd quickly condenses into this square room and
> becomes a mob like the one at the Indépendants. People struggle at
> the doors to get in, they discuss and argue in front of the pictures;
> they are either for or against, they take sides, they say what they think
> at the tops of their voices, they interrupt one another, protest, lose
> their tempers, provoke contradictions; unbridled abuse comes up

against equally intemperate expressions of admiration; it is a tumult
of cries, shouts, bursts of laughter, protests. The artists, painters,
sculptors, musicians are there; some of the writers, poets, critics; and
that unholy Parisian opening-day mob, in which socialites, genuine
art-lovers and picture-dealers jostle one another, along with the
dairyman and the concierge who have been given an invitation by the
artist who is a customer of theirs or lives in their block. This extraor-
dinary flood of people was greater in this year 1911 than in previous
years, because the newspapers had announced that the "cubists"
(whose arrival six months earlier had been a surprise) would be tak-
ing part. (Rpt. in Fry, no. 48, 174-75)

Intergroup confrontations at these big exhibitions tended to be slight since
virtually all modernist groups could participate. The reverse generally applied to
small, one-group exhibitions like the Futurists' traveling exhibition. Since these
shows typically emphasized a group's exclusivity and were often accompanied
by belligerent manifestos and related events like Marinetti's public recitals, they
sometimes attracted a rival group's demonstration, but fairly little abuse from a
poorly informed or indifferent public that had not attended in the first place.
Public concerts at which new music was performed were the most vulnerable of
all art forms to abuse since only noise was required—hissing, catcalls, shouts for
silence—to disrupt the concert and prevent the works from being heard. Not
surprisingly, then, the biggest public melees of the time occurred at music con-
certs: the première of *Le Sacre du Printemps* in Paris (31 May 1913) and the
Schoenberg group's "*Skandalkonzert*" in Vienna two months earlier.

Unquestionably, the most volatile public event was the group's evening

because its explicit purpose was to provoke a fuss—often a fistfight,
or at least a public scandal; because the public . . . often attended for
precisely that reason; and because the artists themselves were present,
hence ready targets: [W]hen . . . Boccioni scornfully cries: "Lets
make an end of photographers, landscapers, lake-painters, mountain-
ists . . . ," the whole crowd of *plein air* Parthenopian painters roars
its protest. Russolo is beside himself. . . . The theater is in full revolt.
(Francesco Cangiullo, qtd. in R. W. Flint 24-25)

I. Large-scale, International Exhibitions

Any history of the visual arts in the prewar years will remark on the impressive
number of important, large-scale exhibitions in these years:

Table 4.1 Some Large-scale Art Exhibitions 1910-1914 [2]

Second Izdebsky Salon in Kiev, 1910
Second NKV exhibition in Munich, 1910
"Manet and the Post-Impressionists" exhibition in London, 1910
Die Neue Secession exhibitions (3) in Berlin, 1910-1912
Union of Youth exhibitions (4) in St. Petersburg, 1910-1914
Jack of Diamonds exhibitions (4) in Moscow, 1910-1914
Second Blue Rider exhibition in Munich, 1912
"The Donkey's Tail" exhibition in Moscow, 1912
Sonderbund International Art Exhibition in Cologne, 1912
Second Post-Impressionist exhibition in London, 1912
"La Section d'Or" exhibition in Paris, 1912
Armory Show in New York, 1913
"The Target" exhibition in Moscow, 1913
Fourth "Group of Plastic Artists" exhibition in Prague, 1913
"First German Autumn Salon" in Berlin, 1913
"No. 4—Exhibition of Paintings" in Moscow, 1914
Annual spring exhibitions of the Salon des Indépendants, Paris
Annual fall exhibition of the Salon d'Automne, Paris

While a few of these shows resulted from the tireless efforts of a single organizer (for example, Roger Fry's "Post-Impressionist" exhibitions in London, Herwarth Walden's First German Autumn Salon), most of them were necessarily group efforts, usually a special group formed for that very purpose and taking its name from the exhibition, for example, the Jack of Diamonds group. The daunting logistics and time required for finding and selecting hundreds of artworks, meeting with and corresponding with artists, and arranging the transportation, insurance, hanging, and publicity for the art virtually necessitated a division of labor among several organizers and explains why the greater resources of a group made these large shows possible. For example, the huge Armory Show was organized by the recently formed American Association of Painters and Sculptors (AAPS) in an astonishingly brief six months.[3] Following a hectic tour of Europe and England by Arthur Davies, Walt Kuhn, and Walter Pach to select the European art, the AAPS did not get down to the practical arrangements until December 1912! Milton Brown describes some of the tasks:

> European dealers and shippers were sending lists of works, announcing shipments ready to go when notified, and demanding guarantees on insurance; increasing numbers of European artists were asking or consenting to participate; and the Chicago Art Institute was beginning to dicker for the Exhibition. It was obvious that the Association needed an office and a staff to take care of details. (79-80)

> All sorts of things had to be considered—transformation of the Armory into an exhibition gallery; times of opening; admission charge;

printing of tickets; policing the Show; reception of guests; methods of hanging . . . printing the catalogue, posters, booklets, and post cards; advertising; handling the press; . . . invitations to the opening. . . . hiring guards, . . . [and] arranging for a band to play on opening night. (84)

The public response to these shows—as indeed with nearly all modernist presentations—tended toward polar opposites depending on the viewer: the avant-garde was enthralled, the general public scandalized. To young painters, composers, poets, and even to those, younger still, who only contemplated an artist's life, seeing the most daring contemporary work in so many different styles under one roof—work that showed (in Kandinsky's words) "that something is happening *everywhere*"—was often the decisive experience in their imaginative maturation: it changed them. Consider, for example, the response of a fledgling poet, William Carlos Williams, to the most infamous work of the Armory Show, Duchamp's *Nude Descending a Staircase*: "I do remember how I laughed out loud when first I saw it, happily, with relief" (*Autobiography* 136). "Relief" perhaps, because this work (and the epochal Armory Show itself) had dared to shatter the taboos of artistic propriety, and thus made it that much easier for others to dare. In 1913, Williams was still years away from his own innovative poetics, but he credited the Armory Show for penetrating the thick skin of American philistinism (in an odd, but, for a medical doctor, curiously appropriate metaphor of microbic infection): "There had been a break somewhere, we were streaming through, each thinking his own thoughts, driving his own designs toward his self's objectives. Whether the Armory Show in painting did it or whether that was also no more than a facet—the poetic line, the way the image was to lie on the page was [now] our immediate concern" (*Autobiography* 138).

Milton Brown generalizes Williams's response to American modernists. While slightly older painters like Marin, Weber, Dove, and Hartley (the Stieglitz group) had already broken their own ground and thus saw the Armory Show more as a "vindication" and "substantiation,"

[f]or a whole generation of artists the Armory Show was the introduction of modern art. . . . [and it] struck them all at once, as it did the public; but whereas the public saw the new art as an aberration, it was a revelation to artists. Standards of art that had been long accepted were undermined. Younger artists who had exhibited at the show, like Stuart Davis, . . . Andrew Dasburg, and others, like [Morton] Schamberg and [Charles] Sheeler, who had already taken tentative steps toward modernism, turned their backs on the past and began daring experiments. . . . The period immediately following the Armory Show saw a general and intensive experimentation in the new forms. (237)

To all of the major shows listed above, similar responses of revelation and inspiration can be found. And since most of these exhibitions were international in scope, they tended to foster cosmopolitanism in sympathetic artist-viewers.

To see powerful styles emerging from Moscow, Munich, and Milan, as well as from Paris, made it increasingly difficult to espouse nationalist priority in what had become a truly international movement. Unyielding nationalist painters like Carl Vinnen and Emil Nolde might sniff at the *Ausländers*;[4] Francophiles like Apollinaire might propagandize in their reviews for French preeminence; but the evidence to the contrary hung on the walls of the Sonderbund and Jack of Diamonds exhibitions.

"The Battle for Art"
 For the general public and the press, however, these major demonstrations of modernist painting were like an elephant suddenly appearing in their parlor: too big to be ignored, too powerful to be contained, too potentially disruptive to be laughed away. And, from the public's viewpoint, the shows made quite a mess. Whether it was the Armory Show in New York, the First German Autumn Salon in Berlin, the Post-Impressionist shows in London, the Donkey's Tail in Moscow, or even the yearly Autumn and Indépendants Salons in Paris, public responses[5] were very much the same: outrage, disdain, ridicule, moralizing over fallen standards, dire predictions of cultural demise, and, often, demands for artistic censorship and repression. The public's response to one of the first of these big shows, the second exhibition of the NKV-Munich in September 1910, has virtually all these qualities.
 The show itself was large, international (predominantly French), and as daringly au courant in painterly experimentation as a show of this size could be: Picasso sent his 1909 Cubist *Head of a Woman*, Braque his 1908 *L'Estaque*; Kandinsky himself showed his *Composition No. 2* and *Improvisation No. 12—The Rider*. The NKV's international membership and philosophy were well displayed: the Burliuk brothers from Moscow, the French Fauves (as well as Redon and Rouault), and the soon-to-be influential Cubist, Le Fauconnier, all showed. Munich had an established artistic reputation, even a large bohemian quarter, but it had never seen anything like this. Was it any wonder that the press howled? Wrote one reviewer:

> There are only two possible explanations for this absurd exhibition. Either the majority of the members and guests are hopelessly deranged, or they are shamelessly bluffing, pandering to our thirst for sensation which characterizes the modern age and exploiting a particular current of fashion. . . . Taken as a whole, their exhibition is sheer nonsense, but one also finds in it a synthesis of the shortcomings and futile mannerisms of the art of every known people and region, from primitive cannibals to Parisian neo-decadents.[6]

Besides "deranged" and "bluffer," Kandinsky could also add "morphia addict" to his depictions (Vezin 94). Elisabeth Macke recalls: "All Munich was in uproar, all the newspapers carried criticisms that were unbelievably mean-spirited and imperceptive. The expressions the critics used to belabour the poor painters would make you think the whole 'Union' was composed of escaped lunatics. We at least felt it was a great artistic experience" (qtd. in Gustav 14). Beneath

these outcries, more ominous tones lurked: xenophobia and censorship. Kandinsky: "The press demanded the immediate closure of this 'anarchist' exhibition . . . , made up of foreigners dangerous to the old Bavarian culture. They made it clear that the Russian artists especially were the most dangerous."[7] Xenophobia (not the fear of foreigners, but the cynical attribution of everything disturbing, thus detestable, in art to the State's adversaries) ran like a leitmotif in hostile reviews of the big exhibitions regardless of the city: German critics pinned the blame on the Russians and "Eastern Europeans"; conservative French critics bizarrely considered Cubism a German import (and even began denigrating its spelling by using a Germanic "K" once the war began).[8] But until the war made this intolerance patriotic, hence insuperable, it could be countered when modernists banded together to publish letters, petitions, and rebuttals. Such occurred when Kandinsky's paintings were attacked as "imbecilic" by a Hamburg newspaper in January 1913: artists, museum directors, art historians, and writers, including Apollinaire—fifty-six in all—published a collective protest, "In Support of Kandinsky," in the March 1913 issue of *Der Sturm* (Vezin 212).

The threat of state censorship was a more serious matter. Already in 1908, soldiers in Vienna had broken up Kokoschka's incendiary play, *Murderer: Hope of Women*, and a few years later in Austria Egon Schiele was arrested and imprisoned for exposing children to "obscenity" in his art. Modernist appeals to nationalism, here, did not mollify the censors: When Larionov and Goncharova, protesting against the supposed European domination of the second Jack of Diamonds exhibition, organized the all-Russian "Donkey's Tail" exhibition (March 1912), many works were nonetheless censured and confiscated (Barron 14). When a newspaper called Goncharova's religious paintings blasphemous, the public censor removed them from her huge St. Petersburg show in 1914. Still, over two thousand people attended the exhibition.

No locale was entirely free of this threat. Even Paris, which prided itself on its long-standing, official tolerance of disturbing new styles and movements, witnessed two attempts at state censorship during the *Automne Salon* of 1912, when a Parisian municipal councilman published in the *Mercure de France* (16 October) "An Open Letter to the Undersecretary for the Fine Arts" protesting against a government building (where the Salon was displayed) being used to exhibit Cubist painting. Several Parisian modernists objected, most notably Apollinaire who used the occasion to swipe at similar criticisms of the *Section d'Or* exhibition occurring at the same time. In his cover article, "Young Painters, Keep Calm!" for *The Section d'Or* review, he assumes a tone of long-suffering amusement:

> Some of these gentlemen [art critics], in order to add weight to their flightiness, have not hesitated to propose that their opinions be reinforced by penal sanctions against the artists whose works they dislike.
> These poor people are blinded by passion. Let us forgive them, for they know not what they say. It is in the name of nature that they are trying to crush the new painters. . . . And to those who would seek to deny a truth so manifest [i.e., that the Cubists are the "most serious and most interesting artists of our time"], we reply simply that if

these painters have no talent and if their art deserves no admiration, then those whose job it is to guide the taste of the public should not talk about them. . . .

Such a venomous spirit in our art critics, such violence, such lamentations, all prove the vitality of the new painters; their works will be admired for centuries to come, while the wretched detractors of contemporary French art will soon be forgotten. (Rpt. in *Apollinaire on Art* 252-53)

Once again, the modernists had rallied to have the last word.

Since Kandinsky and his NKV colleagues had planned their show to be bold and international, their shock at the intensity of the public's hostility and xenophobia is curious: What had they expected? Kandinsky recalls: "The press raged against the exhibition, the public railed, threatened, spat at the pictures. . . . We exhibitors could not understand this indignation. . . . We were only amazed that in Munich, the 'city of the arts,' nobody except [Hugo von] Tschudi [director of painting collections of Bavaria] had given us a word of sympathy" (Lankheit, *Almanac* 12-13).[9] While Kandinsky's "amazement" might genuinely reflect a painter who seemed to live more in the realm of his ideas than in the everyday world, it could well be considered "spurious," as Annette and Luc Vezin explain: "This display set up by foreigners in the capital of Bavaria holding up other foreigners as an example was, in itself, a challenge to Munich's chauvinists" (94). Moreover, the essential contours of this exhibition and the public's response describe what was already a familiar dialectic in prewar modernism:

1. The modernist group knowingly challenges the public with a highly provocative event.

2. The public takes the bait, responds predictably with outrage, abuse ("the artists are crazy, infantile"), suspicion ("It's all a hoax, a put-on"), xenophobia ("this Munich collection of East Europeans"); and threats of censorship.

3. Artists and supporters, in turn, often respond to the public's overreaction, typically with letters, petitions, or reviews of their own, sometimes with another provocation.

Examples of the public's outraged reactions are too well-known to need much documenting (and will appear throughout this chapter). But it is worth noting here some instances of the artists' awareness that their event would provoke the public or their desire to do so:

• Mikhail Larionov on the name "Donkey's Tail": "[It was] a challenge to the public. 'The Target' is also a challenge. The name symbolizes the public's attitude to us. The gibes and abuse of those who can't keep up with us and can't perceive the aims of

art with our eyes fly into us like arrows into a target." (qtd. in Parton 56)

- August Macke on the Sonderbund's purpose: "We contemplate a stupendous modern exhibition in response to the Vinnen business" (qtd. in Gustav 15).

- Macke on the first edition of the *Blaue Reiter Almanac*: "From a purely intellectual point of view, the journal seems to me at the moment like a flea leaping hippety-hop around on a mahogany table-top; it annoys everyone (people) and yet no one can catch it. God's blessing on it!" (letter to Marc; qtd. in Gustav 16)

- At the 1911 Indépendants, the Cubists were prepared to do battle:

 The cubist rooms . . . had the character of a collective demonstration, but with a difference from similar occasions in the past. Neither the impressionist exhibitions nor the Fauve exhibition of 1905 had aimed—any more than Cézanne had aimed—at creating a public scandal. What the 1911 Indépendants showed was that the new generation of painters no longer shrank from the "scandalousness" which had hitherto weighed on the avant-garde, and that in fact they courted it and sought to turn it to account. (Daix 76)

- In "Room 8" of 1911 *Automne Salon*, the crowd's tumult (described above) should have come as no surprise since the Cubists planned to have their paintings hung together to show their stylistic affinities;[10] thus concentrated, their work would have maximum impact. Recalls Albert Gleizes: "In spite of the lack of homogeneity the thing as a whole has a fine irreverent swagger. From these pictures there rises a wind of battle." ("Memoirs," qtd. in Fry 174)[11]

In this self-conscious and intentionally escalated series of blow and counterblow, artists' protestations of shock and dismay usually ring hollow, and the anecdotal image of the beleaguered modernist badly needs revision. The painters, composers, and poets whose groups presented these public events knew their work was provocative, knew the public's conservative tastes would be offended and outraged. But more than passively knowing, modernist groups eagerly joined the battle: fired the first shot, as it were, in staging the provocation. And when the public responded with abuse, artists did not hesitate to hit back: with print rebuttals, with verbal abuse, even with their fists.

We have already noted the petition defending Kandinsky against vitriolic newspaper attacks. Probably the best-known example of a modernist counterattack in print was in response to the petition (signed by 120 artists and critics) that the painter Carl Vinnen wrote and published in 1911, *Protest deutscher Künstler*, complaining that German art dealers and museum directors favored and purchased contemporary French art while ignoring German artists. In re-

sponse, German modernists (and many prominent painters who were not), museum directors, gallery owners, and prominent theorists like Wilhelm Worringer published a collection of articles entitled *The Battle for Art: The Answer to the "Protest of German Artists"* that thoroughly refuted Vinnen's charges.[12]

Modernist retaliations took more immediate forms, as well. During the contentious Paris *Automne Salon* of 1912, Apollinaire writes, "[a] minor incident occurred this morning, when a few cubist painters descended on one of our colleagues, [the critic] M. Vauxcelles, and insulted him roundly. But it was all confined to a lively exchange of words."[13] Lively enough for Vauxcelles to challenge the painters to a duel!

For the Italian Futurists, predictably, words were not enough. Stung by repeated criticisms of their work by the highly influential Florentine artist-critic Ardegno Soffici, writing for *La Voce* in 1911, the Futurists decided to pay him—and the entire editorial staff—a visit. As R. W. Flint narrates: "All were found at the literary café Giubbe Rosse on a quiet Sunday afternoon. Boccioni approached Soffici. "You are Mr. Soffici?" "Yes." "I'm Boccioni." A tremendous slap floored Soffici, who stood up and laid about Boccioni with a cane" (*Marinetti: Selected Writings* 23). Severini picks up the narrative from here:

> General commotion ensued, with tables and chairs overturned, broken glass, and plainclothes officers who carried everyone off to the police station. . . .
> Once the Futurists had evened the score, they went to the station to catch a train back to Milan. . . . But the Florentines from *La Voce*, despite having honorably defended themselves, were not satisfied, and they too hurried to the station. Just as the train was about to pull in, another fracas started up, and another brawl erupted that nearly prevented the Futurists from catching their train. They managed to board it somewhat bruised, but satisfied. (*Life of a Painter* 82-83)

The following autumn, 1912, following friendlier overtures from the Futurists, Soffici and Giovanni Papini joined the group, left *La Voce*, and started what quickly became the Futurists' own newspaper, *Lacerba*.

To be sure, a particularly vicious public response could leave artists temporarily stunned. One immediately thinks of that apocryphal carriage ride taken in silence by Stravinsky, Diaghilev, Nijinsky, and Cocteau following the debacle of the *Le Sacre* première—even if it never took place, it certainly could have, given the intensity of the riot, the exhaustion of the principals.[14] A similar but more private moment appears in the bitter emotions August Macke expressed to his patron, Bernhard Koehler, following the critics' howling over the First German Autumn Salon: "The worst thing, which really makes me see red, is that all our optimism goes for nothing, optimism that is so splendid and so well-justified; but these bastards just spit on it, boorish swine of newspaper hacks that they are."[15]

But such setbacks were temporary, for the artists who incurred them were, like Macke, unshakably optimistic about their avant-garde enterprise; if they faced an abusive, ignorant public, they could draw comfort from their comrades

in arms. When the crowd hissed the première of Schoenberg's *String Quartet No. 2* in December 1908, his student-colleague, Anton Webern, tried to buck him up:

> Nothing is more important than showing those pigs that we do not allow ourselves to be intimidated. The other day I had the impression that everything was lost again for years to come, and this was deadly. . . . Suddenly it is respectable to make noises and to hiss. The "high-class" part of the audience formed the opposition. . . . Well then, so youth is pro and the old men in the parquet contra. Those fellows can never do anything but come up with the past. . . . they should have finally comprehended that everything significant has such a fate; . . . that their colleagues in Beethoven's time disgraced themselves. (27 December 1908; qtd. in Moldenhauer 105)

As both "The Battle for Art" and the "punchup in Florence" suggest, this mutual support usually resulted in artists fighting back. Once again, the modernist group's dynamics affected all stages of this cycle. Its resources facilitated the staging of these provocative events; its collective concern for aesthetic innovation, expressed in its manifestos, strengthened the daring of member artists to experiment more boldly and to exhibit their innovative work; and its members' mutual support enabled them to absorb the public's blows and come back swinging.

II. Musical Melees: The "Skandalkonzert" in Vienna[16] and the Première of *Le Sacre du Printemps* in Paris

The two most infamous riots in prewar modernism, occurring almost two months apart (31 March and 29 May 1913), provide ample evidence that modernist battles with the public were seldom spontaneous and very much two-sided affairs, often anticipated and nearly always joined by the modernist artists themselves or by their partisans.

As noted above, musical concerts were especially vulnerable to disruption (as any patron can attest who has suffered an audience's coughs, whispers, or the agonizingly slow crinklings of lozenge wrappers). Well-meaning "shushers" or those admonishing the noisemakers only make things worse, adding more noise. Thus, a few determined disrupters can quickly turn a polite evening into a free-for-all. When composers conducted their own music, as Schoenberg often did, a hostile audience had additional incentive to misbehave. But if such composer-conductors had their hands full trying to keep the orchestra together, partisans sympathetic to new music readily took up their side.

Despite this vulnerability, major new compositions proliferated in the prewar years, matching the fecundity of the other arts. Table 4.2 lists some landmark premières:

Table 4.2 Some Major Premières: 1910-1914 (*hostile audience response)

Schoenberg, *Three Piano Pieces* (Op. 11) and *George-Lieder*, Vienna 1910
Stravinsky / Ballets Russes, *The Firebird*, Paris 1910
Scriabin, *Prometheus*, 1910
Stravinsky / Ballets Russes, *Petrouchka*, Paris 1911
*Debussy / Ballets Russes, *L'Après-midi d'un Faune*, Paris 1912
Schoenberg, *Pierrot Lunaire*, Berlin 1912; *Prague 1913
*Schoenberg, *Five Pieces for Orchestra*, London 1912
*"Skandalkonzert," Vienna 1913, including premières of Webern's *Six Pieces for Orchestra* (Op. 4) and two songs from Berg's *Altenberg Lieder*
Debussy / Ballets Russes, *Jeux*, Paris 1913
*Stravinsky / Ballets Russes, *Le Sacre du Printemps*, Paris 1913

Audience responses to new music were quirkily unpredictable, especially for the Schoenberg-Webern-Berg group. Why, for example, was the première of Schoenberg's *Second String Quartet* (1908) greeted with hostility in Berlin, when four years later it was cheered with bravos in Vienna? Conversely, why was the Berlin première of his *Pierrot Lunaire* (October 1912) a resounding success, but when given the following year in Prague by the same performers, *Pierrot* provoked "the greatest concert scandal which Prague has yet experienced" (qtd. in Stuckenschmidt 208). And why, only one month before the notorious "*Skandalkonzert,*" did Schoenberg have "an unmitigated success" in Vienna with the première of his newly orchestrated *Gurrelieder*? He received a laurel wreath from the conductor and "a fifteen-minute ovation from the Viennese public, an exceedingly rare occurrence for him" (Moldenhauer 169, Brand xv).

Despite this quirkiness, Vienna was so notoriously hostile to modernist compositions that Schoenberg felt compelled to leave his native city in September 1911 for Berlin, where he hoped to receive more support and a warmer response for his music. As Donald Harris observes, "[t]he Viennese musical establishment has always been essentially conservative and rigid. . . . a fact accepted by all who are familiar with the vicissitudes suffered by Mozart, Beethoven, Schubert, or Mahler" (Brand xiv). Vienna was also the city whose renowned Philharmonic snickered at Stravinsky's *Petrouchka* in 1912, referring to it as "*schmutzige Musik.*" Schoenberg's fate was no different; as he complained to Berg on separate occasions: "It just won't work. My works suffer and it's almost impossible for me to make a living in Vienna" and "in order to earn money I have [had] to do work that is beneath me and that is the cause for my having for *two years* now found no time to compose."[17]

If Vienna's lavish praise for the *Gurrelieder* in February 1913 gave no hint of the donnybrook to erupt over the *Skandalkonzert* in March, two facts should be noted. First, the *Gurrelieder* was stylistically from an earlier, far more lushly romantic and accessible period of Schoenberg's development, calling for

Mahler-like orchestral forces. Moreover, Schoenberg paid the city a compliment in choosing it for the première of this newly orchestrated version. By contrast, his (and his student-colleagues') works for the *Skandalkonzert* were far more difficult (fig. 28): Webern's *Six Pieces for Orchestra* (Op. 4) was virtually the antithesis of *Gurrelieder* in its aphoristic, pantonal motifs, crashing dissonances, and pointillistic orchestration—not exactly a light "opener." It was followed by Schoenberg's restlessly modulating, if still tonal first *Kammersymphonie* (Op. 9), which had "failed" in Vienna on its première (as a reviewer of the *Skandalkonzert* maliciously noted). Finally, Berg's *Two Orchestral Songs on Picture-Postcard Texts of Peter Altenberg* nearly brought the house down in protest. The only two works providing any relief for the audience—Zemlinsky's *Four Orchestral Songs on Poems of Maeterlinck* and Mahler's *Kindertotenlieder*—came from composers outside Schoenberg's group: the Zemlinsky briefly calmed the crowd; the *Kindertotenlieder* came too late: it was never performed. The second hint of trouble was more personal; as noted above, Vienna did not take kindly to the implied slap of Schoenberg's move to Berlin; this would be the first concert he would conduct in person since his move.[18]

In Paris, the situation was almost exactly reversed, but the outcome was the same. In this city famed for its tolerance of innovation, there were clear signs of a looming conflict between the increasingly daring ballets of Diaghilev's Ballets Russes and an increasingly disgruntled public in both Diaghilev's audience and the press that felt he had already gone too far.

The story of Diaghilev's brilliant success in bringing Russian ballet and opera to Paris in 1909 and in launching the Ballets Russes in 1911 is well-known. But beneath the image of successful impresario, Diaghilev was also an artistic revolutionary. In Modris Eksteins's depiction, he

> saw himself essentially as a pathfinder and liberator. Vitality, spontaneity, and change were celebrated. Anything was preferable to stultifying conformism, even moral disorder and confusion. . . . Social and moral absolutes were thrown overboard, and art, or the aesthetic sense, became the issue of extreme importance because it would lead to freedom. (59)

For an impresario whose livelihood depended on the box office, Diaghilev's social attitudes were radical indeed: "Social conscience did not motivate his thinking. Like Nietzsche, Diaghilev believed that autonomy of the artist and morality were mutually exclusive. . . . and like Gide, Rivière, and Proust, he believed that the artist, to achieve freedom of vision, must have no regard for morality" (59). If what mattered was the liberating moment that art alone could achieve spontaneously and convey subjectively, then "shock and provocation became important instruments of art. . . . [which] would excite, provoke, inspire. It would unlock experience" (60). Diaghilev himself put it baldly a few years later to a *New York Times* interviewer: "We were all revolutionists" (qtd. in Eksteins 74).

Transgressing sexual and aesthetic restrictions together became, in effect, Diaghilev's double subversion for achieving the liberating "experience" of art.

The première of *L'Après-midi d'un faune* on 29 May 1912 imposed this fusion on an audience expecting only flashing colors, lively melodies, athletic choreography: "[The] ballet . . . broke all the rules of traditional taste. The entire work was staged in profile in an attempt to reproduce the images of classical *bas-reliefs* and vase paintings. Movements, both walking and running, were almost entirely lateral, always heel to toe, followed by a pivot on both feet and a change of position of arms and head" (Eksteins 54-55). Brilliantly realizing the mythic remoteness of this story of fauns and nymphs, the staging also captured the strangeness of Debussy's music to ears acclimated to the soaring diatonic melodies and forceful, motific progressions of Western symphonic music. Although the music was already twenty years old in 1912, its delicate, evanescent shifts of tone color, motific repetitions, and delvings outside the diatonic scale (into whole-tone scale relationships, for example), combined to evoke an atmosphere of languorous stasis.

"Strangeness"—of story setting, choreography, and musical expression—became the disturbing unifier of *Faune*. What really upset viewers and critics, however, was not the strange and exotic (which was, after all, a major appeal of the Russian Ballet), but the all too familiar (and far too familiar for the stage): the faun's undisguised yet unfulfilled erotic desire for the nymph, which he finally relieves in an emulated masturbation so blatant that Stravinsky later claimed (dubiously) that Nijinsky (dancing the faun's part) had revealed his organ (*Memories and Comments* 36). Eksteins: "Nijinsky, dressed in leotards at a time when skin-tight costumes were still thought to be improper, provoked in the audience a collective salivation and swallowing as he descended, hips undulating, over the nymph's scarf, and quivered in simulated orgasm" (54). Scandal ensued:

> Gaston Calmette, editor of *Le Figaro*, refused to publish the review prepared by the regular dance correspondent . . . and instead penned a front-page article himself in which he denounced *Faune* as "neither a pretty pastoral nor a work of profound meaning. We are shown a lecherous faun, whose movements are filthy and bestial in their eroticism, and whose gestures are as crude as they are indecent." . . .
>
> Other members of the public were apparently also offended by *Faune*, and the final scene was modified slightly in subsequent performances. But the aesthetes were elated by the beauty of this "offense against good taste." (55)

Two weeks before the première of *Le Sacre*, on 15 May 1913, Diaghilev's forces struck again with *Jeux*, an insouciantly modern ballet set to Debussy's music, which again flouted the conventions of classical ballet. Two women and a man, dressed for tennis, ostensibly search for the ball while exploring amorous permutations. As Lynn Garafola writes: "Like *Faune*, *Jeux* turns on fantasies of seduction. The dancers flirt, embrace, pair off, change partners; they perform for one another, observe one other [sic]; caress themselves" (62). Anticipating *Le Sacre*, the dancers assume nonclassical poses with arms rounded and feet turned inward. Debussy's score, commissioned for this ballet, parallels the modern set-

ting, dress, and gesture with perky, slight motifs that sound offhand. Perpetually "busy," like tennis players batting a ball back and forth, the motifs seem to go nowhere. The piece builds to no climax; it just stops, as the dancers run offstage.

The audience greeted this "modern" ballet coolly: "a haphazard essay in affectation" Henry Quittard called it in *Le Figaro* (qtd. in Eksteins 33). The same reviewer later wrote that the ballet was making fun of the public (*Le Fi-garo*, 31 May 1913). With the scandalous memory of *Faune* still fresh and now this new affront, it seems reasonable to surmise that conservative critics and patrons greeted the rumors circulating Paris of a still more radical ballet to follow with cold resolve to endure no further insults. This audience, moreover, had changed markedly since Diaghilev's early successes in 1909-1911, as Lynn Garafola describes:

> By 1913 the noisy, untutored mob of fashionable and demimonde Paris had largely overshadowed the musically sophisticated community of Diaghilev's early seasons. That community had been one of connoisseurs bred in the habits of aristocracy. . . . Diaghilev's newly crystallizing public, by contrast, was one of consumers. The keynote of the connoisseur is disinterested appreciation of beauty and taste; that of the consumer "good value." (298)

The political context had changed too, paralleling the growing international tensions of the Agadir Crisis and the Balkan Wars: French politicians and editorial writers were increasingly complaining that artistic modernism was a foreign import (the same complaint made in the French Chamber of Deputies against "anti-national" Cubist art six months earlier); that Paris was increasingly dominated by foreign artists and gallery owners with German-Jewish surnames. Asked to name the great French artists of his time, Jean Cocteau quipped: Picasso, Stravinsky, Modigliani (qtd. in Eksteins 82). Even the new theatre where *Le Sacre* was to be performed, *Théâtre des Champs-Elysées*, was a bone of contention: critics complained that its severely modern style looked foreign. None of this boded well for a Russian troupe about to stage a radically innovative work—a ballet depicting ritual sacrifice in prehistoric Russia, with choreography, music, and set design all by Russians, and danced to what is arguably the most frenetically disturbing music ever composed in the twentieth century.

The storms unleashed by the Skandalkonzert and *Le Sacre* made them the most infamous—and most written about—premières of this period; their colorful details need no reiteration for their own sake. But a close examination of first-person and historical accounts of the events shows significant parallels between them that, in turn, suggest patterns to these large-scale modernist melees. First, neither riot occurred spontaneously as simply a conservative audience's revulsion against modernism. The tumult of 31 March in Vienna was, in the view of Hans and Rosaleen Moldenhauer, "provoked by an apparently organized clique of reactionaries who spread disquiet from the start" (171). Egon Wellesz, Schoenberg's pupil at the time and later his biographer, appears to confirm the

Moldenhauers when he states that "part of the public had clearly come looking for sensation and scandal" (paraphrased in Stuckenschmidt 187). Two separate newspaper accounts of the riot refer to "applauding and hissing factions of the audience" and "groups of disputants."[19] While these factions may have formed ad hoc, of course, Wellesz's recollection indicates that many *expected* this concert to be scandalous. Why, after all, would those Viennese already opposed to Schoenberg's music attend except for the pleasure of venting their accumulated hostility to Schoenberg personally (since he would be conducting), against his group (likely all to be present), and against the music itself?

The riot over *Le Sacre* was even more foreseeable; evidence of the impending upheaval came from all sides. As Modris Eksteins's study of the première proves, the ballet's collaborators (Diaghilev, Stravinsky, Roerich, Nijinsky, and even the conductor Monteux) all realized from the start the revolutionary explosiveness of their ideas. Stravinsky later claimed to be shocked by the première because the dress rehearsal had gone so smoothly: "Oddly enough [considering the uproar at the première], at the dress rehearsal, to which we had, as usual invited a number of actors, painters, musicians, writers, and the most cultured representatives of society, everything had gone off peacefully, and I was very far from expecting such an outburst."[20] But to conclude that all is well simply because "the most cultured representatives of society" behave themselves at a dress rehearsal to which they were specifically invited is strange logic indeed. It smacks of the same disingenuousness—whether from naiveté or willful blindness—that marked Kandinsky's shock over the scathing reviews of the second NKV-Munich exhibition. Moreover, Stravinsky's earlier caution to his mother ("Do not be afraid if they whistle at *Le Sacre*. That is in the order of things")[21] flatly contradicts his protestation of surprise. Nor was he alone. In January 1913, Nijinsky wrote to Stravinsky about the choreography he was designing: "Now I know what *Le Sacre du printemps* will be when everything is as we both want it: new, beautiful, and utterly different—but for the ordinary viewer a jolting and emotional experience." And the conductor Pierre Monteux referred to it in rehearsal as an "explosion."[22] Eksteins's conclusion seems incontrovertible: "There can be no doubt that a *scandale* of some sort was both intended and expected" (73).

Expected, also, by Paris, as word of this new ballet spread. The poet John Gould Fletcher, living then in Paris, recalls:

> [L]ong before *Le Sacre de Printemps* [sic] was set for production word went out that it was utterly revolutionary as regards both music and dancing, that it broke with every remaining convention of the old Italian ballet, that it represented a solstice festival and the sacrifice of a virgin in remote pagan Russia, that it went back behind recorded history into the realm of ethnology and primitive religion. All the students of the Latin Quarter were naturally anxious to see what the *Sacre de Printemps* was really going to be like. (*Life Is My Song* 65)

Thus, from the conservative critics and audience, already smarting from the Ballets Russes's previous affronts, to the Left Bank students, eager for more of

the same, to the ballet's collaborators themselves who knew what they were creating, the occasion shows intentionality on all sides. As Jean Cocteau later remarked: the audience played "the role that was written for it" (qtd. in Eksteins 34).

A second similarity between the upheavals of Vienna and Paris is that they were not one-sided assaults of a hostile audience. Rather, they resulted from a clash between "pro" and "contra" forces, both of which either came ready to do battle or chose sides on the moment. Indeed, so determined were both sides to fight each other that the music quickly became lost in the battle, an early casualty of the fight going on around it.

Fletcher notes, for example, how eagerly the Parisian students wanted to attend the première: "on the opening night they jammed the top balcony of the theatre, prepared to cheer Stravinsky and Nijinsky to the echo" (65). Gabriele Astruc recalls that "there were about fifty passionate fans of the Russians present, including . . . 'some radical Stravinskyites in soft caps.'" These caps, as Eksteins points out, were an intentional affront to the top-hatted opera patrons (33). That their wearers' aim was more to take on the social swells than to hear Stravinsky's ballet Jean Cocteau affirms: "they would applaud novelty at random simply to show their contempt for the people in the boxes" (33). Once the melee began, the "pro's" contributed their share of noise, not only to silence the contra's, but to put them down with a clever retort. Thus, in the many recollections of the evening, the catcalls of the "pro's" seem to stand out, as when Florent Schmitt cried out: "Down with the sluts of the Sixteenth!" or when Gabriele Astruc shouted to the whistlers: "Listen first! You can whistle afterward!" Whatever their motives, the devastating effect on the music of adding noise to noise was the same. As Stravinsky recalls: "These [negative] demonstrations, at first isolated, soon became general, provoking counter-demonstrations and very quickly developing into a terrific uproar" (*Autobiography* 47).

Essentially the same two-sided battle occurred in Vienna with at least one side, the contra's, intending to cause trouble from the outset. Two published eyewitness accounts and a detailed diary entry describe their effort.[23] The architect Richard Neutra wrote in his diary: "From the start, the people, that is some people, began to boo, laugh, and shout. . . . The rabble simply sensed that there was someone ready for easy slaughter, someone who was fair game" (qtd. in Moldenhauer 659 n. 9). Yet, almost immediately, those in the audience supporting Schoenberg counterdemonstrated; thus the unnamed Viennese reviewer refers to "a confrontation lasting several minutes between the applauding and hissing factions of the audience" following the first of Webern's *Six Pieces for Orchestra*. He continues: "After the second piece, a storm of laughter went through the hall. This was drowned out by thunderous applause from admirers of the tension-laden and provocative music" (Qtd. in Moldenhauer 171).

So it continued. Zemlinsky's *Four Songs* may have "calmed down those who were heated and eager for battle" (Stuckenschmidt 187), but after Schoenberg's *Chamber Symphony* the furious hissing and clapping returned, along with "the shrill tones from house keys and whistles" and "the first fisticuffs of the evening" (Moldenhauer 171). "In all directions people were now taking sides

with wild shouting and in the unnaturally long pause between the works the enemies formed up against each other" (Stuckenschmidt 185). Unlike Stravinsky, Schoenberg himself tried to intervene, turning from the podium to threaten disrupters with arrest; but this only poured fuel on the fire: laughter at Berg's songs quickly escalated into "wild invectives, face slappings, and challenges to duels" (Moldenhauer 172). Webern then yelled insults at the disrupters from his loge seat, apparently oblivious to his own disruptive act.

Even the reviewer from the *Boston Evening Transcript* caught the feeling of the "contra" faction, referring to Schoenberg's group as "Ultrists" and "musical cubists" (qtd. in Brand xv). Yet it is clear that *both* sides turned the evening into a free-for-all and that, precisely as in the riot over the première of *Le Sacre*, once the "contra's" had struck, the "pro's" seemed primarily interested in out-shouting, outclapping, or outinsulting them. Taking the contra's dare, of course, played right into their hands, ensuring that no one would hear the music (see cover illustration).[24]

The aftermath of the Vienna debacle, however, differed significantly from its counterpart in Paris, and indeed from similar melees in the other arts. For the riot killed both Schoenberg's enthusiasm for public confrontations and the very organization that facilitated the collision. As the editors note in *The Berg-Schoenberg Correspondence*, "[t]he Akademischer Verband never recovered from the after-effects of this scandal; its membership declined radically and the organization was disbanded in April 1914" (166 n. 1). When Schoenberg next designed an organization in Vienna for giving concerts of modern music, the *Verein für musikalische Privataüffuhrungen* in 1918, the emphasis was on *"Privat"*:

> The Viennese public would no longer figure in their considerations. The audience was invited through subscriptions and only those with membership passes could enter the concert hall. . . . [According to the *Verein*'s premises,] [t]he performances must not be touched by the corrupting influence of publicity. There must be neither applause nor expressions of disapproval. (Brand xvi)

By contrast, Diaghilev's enthusiasm for his role as avant-garde provocateur was only briefly diminished by the riot over *Le Sacre*, the ballet itself dropping out of his repertoire following its London performances that year. Indeed, as Lynn Garafola observes, he "moved the Ballets Russes to the forefront of the avant-garde" in the years 1914-1917, abandoning Russian exoticism for Futurist innovation and capping the change with *Parade* in 1917 (76-78).

III. Choreographed Conflict: The Evening

While the 1910-1914 period is best known for its big events—the international exhibitions, the premières and publications of modernist landmarks—arguably, the smaller-scaled evening best captures its zeitgeist. No other event so clearly belonged to the modernist group, so expressed a particular group's personality,

yet possessed qualities common to virtually all the modernist groups: self-dramatization, publicity seeking, and calculated violence. Here, modernist groups most directly engaged the public not just with their art, but with themselves as a kind of performance art of carefully choreographed challenge and conflict intended to provoke the audience to rage, to blows, to full-scale riot. The evening that could not at least spark a fistfight could be deemed a failure.[25]

As with its written corollary, the manifesto, the evening became a specialty of the Italian Futurists: in fact, they fused the two forms, declaiming manifestos as the evening's aggressive apex. Marinetti's genius for turning publicity into art achieved its fullest expression in this genre as he calculated its every aspect to achieve maximum aggression and thus attract maximum attention to his group. Even its locale was significant, as Caroline Tisdale and Angelo Bozzolla observe:

> [T]heatres of cities up and down Italy were the regular venues for these [evenings], since Marinetti realized that the theater was Italy's most popular form of entertainment and a far more effective way of reaching the masses than the bookshops and news kiosks. Once a Futurist Evening had been announced in a city it was awaited as an event to be experienced at all costs. (12)

Almost from the first of these evenings in 1910, the audience knew what to expect (from news accounts, word of mouth, or the portentous cordon of police around the theatre); they also knew their parts in the intended melee: accordingly, they brought rotten fruit and vegetables, whistles, noisemakers. Any subsequent protestations of shock or dismay from either side about the evening's violent outcome would thus be ludicrous; and in fact no such claims exist.

Once the crowd had entered the theater, as figure 29 shows, the Futurists assaulted their eyes, their ears, their emotions, and finally their persons:

> The Evening invariably began with Marinetti and his friends, protected from attack by the massive weight of the poet Armando Mazza, hurling insults at the host city and its illustrious men. The police rarely moved to protect the Futurists from their audience [and even joined the 3000 members of the attacking audience in Bologna]. . . . If the Evening continued . . . it might include a showing of Futurist paintings, the declamation of manifestos, the groaning and scraping of Russolo's Noise Intoners, gems of Futurist Variety Theatre, and more mutual insults. (Tisdale and Bozzolla 13)

Each element contributed its goad. The paintings that decades may have tamed for our eyes seemed "ultra-modern" to the *London Times* reviewer attending a Futurist performance at the Doré Galleries in 1914 (qtd. in Goldberg 20). Similarly, Russolo's "noise intoners"—which comprised "howlers, roarers, cracklers, whistlers, rubbers, buzzers, exploders, gurglers, and rustlers" (R. W. Flint 23)—looked like

weird funnel shaped instruments. . . . [What they produced] resembled the sounds heard in the rigging of a channel-steamer during a bad crossing, and it was perhaps unwise of the players—or should we call them the "noisicians"?—to proceed with their second piece . . . after the pathetic cries of "no more" which greeted them from all the excited quarters of the auditorium. (*London Times* review, qtd. in Goldberg 21)

The evening's manifestos, provocative in their own right, were not simply to be read aloud; when Marinetti delivered them, he drew on consummate powers of dramatic oratory to which several artists have attested (see below).[26] All this occurred over a background of live orchestral music (when Marinetti could gather the forces) composed by Balilla Pratella and described by R. W. Flint as "a sort of Gregorian notation minutely subdividing the octave 'enharmonically,' . . . [to produce] some of the earliest *musique concrète*, mimicking the sounds of a busy industrial city" (23).

Finally, the contribution of the evening's most important actor, prepared by all the foregoing: the audience, eager to insult, secretly eager to be insulted. "Interactive performance" scarcely captures the exchanges of insults, punches, slaps, and thrown fruit that the Futurists planned for, solicited, and received at each performance (fig. 30). The contretemps have been described many times; let us instead note a few features of this most contrived of all modernist melees. First, the Futurists gave as good as they got—probably better, in fact. Marinetti, an accomplished debater, could usually outinsult his hecklers, as several eye-witnesses confirm (for example, in Tisdale and Bozzolla 13; R. W. Flint 24-25); in fact, his relationship with audiences thrived on hostility (as will be shown presently). Boccioni was "an experienced fighter"[27] and his assault on Soffici in the infamous "punchup" in Florence shows that he liked a good scrap. And then there was that "massive" ally, Armando Mazza, whose fists left such "an unforgettable impression" in the Venice melee.

Like the factionalized melees that broke up the musical performances of Stravinsky and Schoenberg, the crowd would often divide between pro and contra forces:

Suddenly a storm broke in the orchestra seats, the room was beginning to divide in two: friends and enemies. The latter, inveighing against the Futurists in gusts of insult and profanity, fists shaking, faces twisted into masks. The others clapped insanely, "Viva Marinetti . . . Abbasso! . . . Viva! . . . Abbasso! . . . Idiots! . . . Cretins! Sons of whores!" The whole was crowned by a rain of vegetables: potatoes, tomatoes, chestnuts . . . an homage to Ceres.[28]

Marinetti confirms the presence of supporters when he recalls a Rome evening at which "we had a crowd of young defenders, which grew, fifty became a hundred, then five hundred, against a bigger crowd than Patti, Tamagno, or Caruso ever attracted" (R. W. Flint 26).

Another distinctive feature of these evenings was their intermingling of different arts to achieve a concerted effect. The daytime event the Futurists staged in Venice on 8 July 1910 offers a good example. It began with an act of pure performance: Marinetti and friends climbing to the top of the clock tower in Saint Mark's Square to drop what he claimed to be 800,000 copies of their brief manifesto "Against Past-Loving Venice" onto a crowd returning from the Lido.[29] Flint's version continues: Marinetti then "improvised" a "Speech to the Venetians" (fully written out in Flint's collection) and "provoked a terrible battle. The Futurists were hissed, the passéists were knocked around. The Futurist painters Boccioni, Russolo, and Carrà punctuated this speech with resounding slaps. The fists of Armando Mazza, a Futurist poet who was also an athlete, left an unforgettable impression" (55-56). Thus, a written manifesto becomes a performance event (the leafleting), which gives rise to an "improvised" speech counterpointed to physical aggression (the "resounding slaps") and response ("a terrible battle"). Writing that urges violence becomes theatre and speech intending to provoke it, then becomes violence itself—a perfect enactment of Futurist aesthetics of spontaneity, dynamism, and physical aggression.

Enter the police.

Where most brawls would now end in a joyless ride to the station house, the Futurist evening could enjoy its second and larger success in bad publicity. Tisdale and Bozzolla: "Ideally, the Evening would break up in a riot that would spread through the streets and bars of the city, to be followed by scandalized articles in the next day's press and maybe even a prosecution" (13-14). All the better, as RoseLee Goldberg asserts: "Arrests, convictions, a day or two in jail and free publicity in the next days followed many Futurist Evenings. But this was precisely the effect they aimed for" (16).

As performed by others, the evening still bears the Italian stamp of calculated outrage. Indeed, Benedict Livshits's description of such evenings among the Russian Futurist groups could just as easily have been set in Milan or Rome:

> [Russian] Futurist evenings of poetry reading and manifesto declamation became fashionable season events to which the respectable public flocked with a confessed feeling of condescending curiosity—after all, the performance smacked of the circus—and an unconfessed feeling of exciting, sinful transgression. An aura of scandal made the Futurism evenings irresistible. The proximity of those social outlaws on stage created the illusion of a daring adventure and of impending danger. . . . the public's fear was not totally unjustified. It was not unheard of for the Futurists to switch from verbal to physical violence, though such occurrences were more frequent in Italy. . . . the [Russian] public was occasionally subjected to physical abuse, judging from Kruchenykh's "spilling of hot tea on the audience."[30]

Paris, too, had its scandalous evenings, probably the best known being the "conference" on "Futurism and Lust" that Valentine de Saint-Point organized to be capped by her reading of her "Futurist Manifesto of Lust" (8 June 1912). Severini narrates:

That evening she was wearing an enormous hat, as wide as an um-
brella. Not only was it wide, but also tall, and covered with bright
plumes . . . a true edifice.

. . . [A]s usual it was an audience determined to enjoy itself, and
it did. The beautiful lecturer's topics were hot and spicy, as were the
interruptions and exclamations by the audience. Once [the manifesto
reading was] over, things began to take an ugly turn. . . . When [an in-
tentionally planted] "antagonist" . . . climbed to the stage to advocate
certain purposely chosen subjects, a real row broke out. The audience
raced onto the stage and our friends [including Marinetti] had to bat-
tle their way into the orchestra. Somehow I found myself in the first
row of boxes, from which I would have dropped directly down into
the orchestra by the shortest route possible, had it not been for the
timely intervention of [Arthur] Craven, a huge man and a boxer.
(105-6)

If the mecca of modernism was not immune to such cutting up (just as it was not
to the larger-scale melee of *Le Sacre*'s première), then the paradigm of the eve-
nings was truly European.

To gain publicity, an evening's organizers required—and enjoyed—the ea-
ger cooperation of the bourgeois press. Indeed, as many modernists have sepa-
rately observed, a symbiosis prevailed between modernist groups hungering for
publicity and newspapers eager to report their most outrageous acts to a reader-
ship that thrived on scandal. Before the war upstaged them, modernist groups
and leaders thus enjoyed the unexpected status of media stars. During his first
one-artist show in London (April 1913), Severini found that "[a]ll the newspa-
pers and magazines wrote about it and published my portraits and paintings. I
was interviewed like a prime minister" (*Life* 119). Anthony Parton describes
precisely the same phenomenon in Moscow: "Hardly a day went by without the
newspapers reporting the activities of Larionov and Goncharova and witty anec-
dotes about futurism (74). "In French newspapers," Kenneth Cornell tells us,
"not questions of style or manner of utterance but the manifestoes and the quar-
rels among the poets were considered good copy" (126).

Albert Gleizes's experience confirms this rapid stardom. After the scandal
of 1911 *Indépendants*, "[o]vernight we had become famous. Almost unknown
the night before, a hundred mouths hawked our names, not only in Paris, but in
the provinces, and in foreign countries." One consequence of this easy fame
worried Gleizes: "'isms' were soon going to multiply by the desires of artists
seeking more to attract attention to themselves than to realize serious works."
(*Souvenirs*, qtd. in Robbins 18). Although other artists shared Gleizes's concern,
for example, Gino Severini,[31] most modernist leaders clearly enjoyed this new-
found public attention, and no one enjoyed it more than Wyndham Lewis: "As
chef de bande of the Vorticists I cut a figure in London. . . . There were no poli-
tics then. . . . Instead there was the 'Vorticist Group.' I might have been at the
head of a social revolution, instead of merely being the prophet of a new fashion
in art" (*Blasting and Bombardiering* 32).

Thus, the public "scandals" of the large exhibitions and concerts, the riotous evenings, and the eager press coverage were all of a piece, all "show business" from the standpoint of modernist groups vying for attention and of a public eager for scandal. As Virginia Spate summarizes: "During the last years before the war, exhibitions and press comment multiplied; the Futurists added an element of competitive publicity, which so affected the art-world that [André] Salmon was led to criticize 'the deplorable intrusion of politics into art'"(55).[32] But as Spate also perceives, the very willingness of the public to be shocked itself may have intensified the groups' desire to shock:

> [There was] something new in the rapidity with which the public now absorbed its biannual artistic shocks [at the Paris *Salons*] and came back with a demand for more. Its capacity to absorb everything, and to reduce all art to a fashionable event, probably strengthened the provocative attitude of certain artists. . . . the attack on bourgeois convention and rationality became stronger in the last year before the war. (58)

IV. Public Readings, Debates, and Intergroup Warfare

The group rivalries described in chapter 1 produced numerous conflicts including battles for survival, as groups resisted being absorbed by others; for independence, as artists split off from one group to form a newer, more radical one; for preeminence in the field; and simply for public attention. Unlike the artist-public battles generated by large exhibitions, concerts, and evenings, intergroup battles typically occurred during small-scale events patronized largely by modernist groups and artists themselves: lectures and readings, often at the gallery housing a group's exhibition (such as Marinetti's readings at the Doré Galleries in London), or discussions, panels, conferences, and debates organized by artists themselves (for example, the debate Larionov and Goncharova organized during the Target Exhibition in 1913).

To be sure, not all these events produced antagonism, which depended on the composition and age of the audience, the type of reading or talk, and on the degree of group conflict in the locality. Outcomes tended toward polar opposites. Poetry readings, more often than not, attracted youthful audiences sympathetic to modernist innovation and eager to hear and support the poets' new work. This was especially true of readings by German Expressionist poets (as described in chapter 1). For groups and leaders that courted conflict and controversy, however, public readings could turn out quite differently. Marinetti's readings nearly always attracted a mixed audience of the genuinely curious, hostile competitors, and a press and public expecting to snicker or be scandalized. But this antagonism was precisely what Marinetti thrived on. His manifesto "The Pleasure of Being Booed" identifies it as an essential condition when the avant-garde confronts a bourgeois audience:

1. We Futurists, above all, teach authors to *despise the audience*, especially to despise [fashionable] first-night audiences. . . .

2. We especially teach *a horror of immediate success* that normally crowns dull and mediocre works. . . .

11. While waiting for this abolition [of clapping and whistling], we teach authors and actors *the pleasure of being booed.*

Not everything booed is beautiful or new. But everything applauded immediately is certainly no better than the average intelligence and is therefore *something mediocre, dull, regurgitated, or too well digested.*[33]

More than just "despising" his audience as bourgeois, Marinetti construed it sexually as the female recipient of his masculine aggression. In March 1916, when he announced a new type of "Dynamic and Synoptic Declamation," he recalls his earlier "passéist declamations" to an audience:

For too long now I have amused myself with seducing and moving [audiences] better and more reliably than all the other declaimers of Europe, insinuating into their obtuse brains the most astonishing images, caressing them with the most refined vocal sensations, with velvety softnesses and brutalities until, mastered by my look or entranced by my smile, they feel a feminine need to applaud something they neither understand nor love.

I have had enough experience of the femininity of crowds and the weakness of their collective virginity in the course of *forcing* free verse upon them.[34]

"Seducing" an audience by "forcing" one's art on its "collective virginity" rhetorically borders on rape, and Marinetti's descriptions of other performances show this same blurring of violent assault and seduction: "[Papini's speech] I then hurl from the footlights in fistfuls of manifestos. . . . I violently throw in your face the speech of my greatest friend . . . !" (qtd. in R. W. Flint 21). During a London reading, "My listeners, as they turned to follow me in all my evolutions [around the room], participated, their entire bodies inflamed with emotion, in the violent effects of the battle described by my words-in-freedom" (qtd. in Goldberg 20). Alternatively seduced and brutalized, "[t]he audience for the work becomes a target rather than a recipient—the Futurists speak of their plays as having been 'victoriously *imposed* on crowded theatres' (*Futurist Manifestos* 196)—and the public's complete understanding is neither solicited nor desired" (Peter Nicholls 91, my emphasis).[35]

Marinetti's London readings in November 1913 and the spring of 1914 (see fig. 5) demonstrate several aspects of this hostile seduction, but also show how intergroup rivalry affected the outcome. In his November visit, Marinetti was an appealing figure to the young artists who had followed Wyndham Lewis out of Roger Fry's Omega Workshops the preceding month and who now called them-

selves "the Rebel group." As Richard Cork shows, Lewis admired Marinetti's dynamic leadership at this time as a model for his own ambitions, and an even stronger Marinetti fan in the group, Christopher Nevinson, boldly invited him to London (98-99). For this grand imperialist of Futurism, the pickings seemed ripe indeed. Lectures, readings, and even a banquet for Marinetti hosted by the rebel group ensued. But Marinetti's path was by no means wide open. As Nevinson recounts in his memoirs, "most people had come [to the banquet] to laugh." But once Marinetti delivered his *parole-in-libertà* poem, "The Siege of Adrianople," complete with "various kinds of onomatopoeic noises and crashes in free verse . . . there were few who were not overwhelmed by the dynamic personality and declamatory gifts of the Italian propagandist" and by "his ideas and prodigious energy" (77-78). Others present corroborate Nevinson's sense of being "overwhelmed" even if, like Jacob Epstein, they did not especially like it: "Marinetti, when reciting his own poems, used an amount of energy that was astonishing, pouring with perspiration, and the veins swelling, almost to the bursting point, on his forehead. Altogether an unpleasant sight" (qtd. in Cork 100). Even Lewis, so quick to view others with suspicion, was impressed. As he recounts in *Blasting and Bombardiering* (33), "it was a matter for astonishment what Marinetti could do with his unaided voice. He certainly made an extraordinary amount of noise. A day of attack upon the Western Front with all the 'heavies' hammering together, right back to the horizon, was nothing to it."

When Marinetti returned to London in the spring of 1914, his declamatory gifts had not diminished, but his reception changed dramatically. In the interval, Lewis had some success in imbuing the "rebels" with a collective identity: they had exhibited together, even acquired their own art "Centre," patron, and (in Lewis's view, at least) leader. Thus, Marinetti's ambitions to recruit the painters into the Futurist orbit,[36] which had already succeeded with Nevinson, now appeared as undisguised aggression. As Richard Cork perceptively notes, however, the fledgling Vorticists (as they were soon to name themselves), were also driven to vilify Marinetti and Co. by their very similarity to the Italians, suffering what Harold Bloom later termed "the anxiety of influence": "Inevitably, the English rebels found it extremely difficult to establish themselves with an individual identity, and much of their posing and publicity-hunting was a simple matter of self-defence, a necessary counter-attack that would divorce them from the Futurist stereotype" (Cork 225). Thus, when Marinetti and Nevinson attempted their aborted "*putsch*" of the group in publishing the "Vital English Art" manifesto (7 June 1914), the Vorticists "counter-*putsched*" at Marinetti's and Nevinson's lectures on 12 June 1914 at the Doré Galleries. "*Putsch*" is Lewis's term, as is the narrative that follows:

> I assembled in Greek Street a determined band of miscellaneous anti-futurists. . . . After a hearty meal we shuffled bellicosely round to the Doré Gallery.
> Marinetti had entrenched himself upon a high lecture platform, and he put down a tremendous barrage in French as we entered. Gaudier went into action at once. . . . He was sniping him without in-

termission, standing up in his place in the audience all the while. The
remainder of our party maintained a confused uproar.
 The Italian intruder was worsted. (*Blasting and Bombardiering*
33)

Nevinson, too, was attacked: "I gave my first lecture on modern art at the Doré
Gallery and was fiercely heckled by Gaudier-Brzeska" (Nevinson 82). More
than heckled: "when Mr. Nevinson made a passionate outcry for motors, speed
and lightning, a Vorticist set off some fireworks in the centre doorway." Nevin-
son's speech fizzled "amid laughter and the shouting of names" (*Evening News*
review, qtd. in Cork 232).
 By this time, even the combative Marinetti was becoming hypersensitized
to group conflicts. A few days after the debacle at the Doré, when his and Rus-
solo's first *Intonarumori* concert at the Coliseum (15 June) was booed, he at-
tributed the failure to a "cabal." Nevinson makes clear, however, that the booing
resulted from the inadequacy of the Futurists' equipment in the huge auditorium
(83).

 Wherever rival groups encountered each other, fireworks were likely to
erupt. In Russia, where modernist groups restlessly formed, reformed, and vied
with each other, the sniping between them was particularly intense as former
allies confronted each other in public debates and conferences that commonly
accompanied large exhibitions. Such a debate occurred during the second Jack
of Diamonds exhibition in Moscow on 12 February 1912. The exhibition, which
had opened two weeks earlier, had already witnessed a major split-off among its
organizers: Larionov and Goncharova had walked out the preceding April, de-
nouncing the other organizers, particularly the Burliuk brothers, as conservative,
pseudo-innovators, "Cézanne-ists" and "decadent Munich followers" (Parton
39). Before the all-Russian counter-exhibition of these dissidents, the "Donkey's
Tail," could open in March, the February conference was held, sponsored by the
Jack of Diamonds group. The participation that night of defectors Larionov and
Goncharova already boded ill; and when David Burliuk finished a rambling lec-
ture (illustrated with lantern slides), "On Cubism and Other Directions," Gon-
charova threw the first punch by objecting to Burliuk's overly theoretical em-
phasis on abstraction in defining Cubism and to his failure to note her and
Larionov's new allegiance. The written version of her speech was a letter she
planned to publish in Moscow newspapers:

> For a long time I have been working in the manner of cubism, but I
> condemn without hesitation the position of the Knave of Diamonds,
> which has replaced creative activity with theorizing. The creative
> genius has never outstripped practice with theory. . . . Contrary to
> Burliuk, I maintain that at all times it has mattered and will matter
> what the artist depicts. (rpt. in Bowlt, *Art* 78)

Although Goncharova was initially laughed at by the pro-Jack of Diamonds au-
dience, her substantive statement received a better response than Larionov did

that evening when he tried to follow Goncharova with dithyrambs he had com-
posed to celebrate the upcoming "Donkey's Tail" exhibition. He was booed,
whistled at, and ultimately silenced with "shouts of 'Get outta here!'" (newspa-
per review, qtd. in Parton 39). The reviewer continues: "Through the noise, . . .
he yelled out incoherent statements about the conservatism of The Knave of
Diamonds[,] about the originality of the French artists and about the robbery of
Donkey's Tail members by The Knave of Diamonds. In exasperation he banged
his fist on the lectern and left the stage to the howls and whoops of the entire
hall" (qtd. in Parton 39).

Goncharova may have gotten in the last blow of this debate in the letter she
immediately published referring to "'the half-baked Cubism' of the Jack of
Diamonds" (Parton 39). But it was Larionov who went on the offensive in the
next such event, the public debate on 23 March 1913 marking the opening of the
"Target" exhibition that he and Goncharova had organized. A newspaper re-
viewer describes the "scandal" that ensued:

> Mr. Larionov, the presiding chairman, prevented one of the critics
> from speaking. The audience protested, surrounding the stage. Run-
> ning up, Larionov threw an electric light bulb into the audience, then
> the water decanter. Someone from the presidium hurled a chair into
> the audience and made off. . . . A genuine fight began. The police
> were called into the hall and the meeting was closed.

Perceptively, "[t]he press compared the Russian avant-garde with their Italian
contemporaries and began to refer to the artists as *futuristy* (futurists)" (Parton
58). As the evening at the Pink Lantern six months later shows, Larionov en-
joyed acting outrageously at these public confrontations, whether the antagonists
were fellow artists, critics, or the general public. Many more such public battles
between groups could be cited, for example, the series of confrontations various
members of Russian groups staged with Marinetti in January 1914; but the point
should be sufficiently clear that battles between modernist groups occupied a
sizable part of the public conflicts over art in the prewar years.

V. Micro-battles: Civil War within the Group

Besides battles with other groups, most groups experienced internal conflicts.
Usually, these divisions resulted in nothing more acrimonious than contentious
group meetings. But sometimes these brouhahas precipitated split-offs, such as
the NKV's meeting of 2 December 1911, where a majority rejected Kandin-
sky's *Composition Number 5* from its third exhibition—the final straw that
caused Kandinsky, Marc, and several others to leave the group.[37] Dissatisfied
group members typically preferred to vote with their feet. But often both sides
got in their licks, sometimes publicly. One member of the NKV's conservative
faction, Otto Fischer, attacked Kandinsky's views in the contemporary maga-
zine, *Das neue Bild*:

A picture is not only expression but also representation. It does not lend immediate expression to the soul; it expresses the soul within the object. A picture without an object is meaningless. Half object and half soul is sheer madness. The empty-headed dreamers and charlatans are on the wrong track. *The muddleheads talk of the spiritual*—the spirit does not muddle our thinking, but clarifies it. (qtd. in Zweite 34-35, my emphasis)

As Armin Zweite concludes: "Kandinsky could hardly have been expected to continue associating with artists whose views differed so radically from his own" (35)—and who insulted his art and aesthetics! In turn, Marc, the more combative member of the new splinter group, described the NKV sardonically in the *Blaue Reiter Almanac*: "Characteristic of the artists in the association was their strong emphasis on the *program*. Artists . . . competed among themselves as to who understood the new ideas best. Perhaps one heard the word 'synthesis' too often" (Lankheit, *Almanac* 64).

Ezra Pound tried a different tactic, ridicule, in an effort to discredit Amy Lowell and win back the Imagists she was recruiting to *her* Imagist anthology (see chapter 2). By the summer of 1914, no rapprochement between the leaders was possible: he had failed to convince Lowell to bankroll a magazine that would give Pound complete artistic control. Persuasion failing, he typically lost his temper "completely" (in Lowell's depiction) and accused her of being unwilling to support the arts.[38] For her part, Lowell dismissed the Vorticism Pound was then co-organizing as "a most silly movement" that Pound was shamefully using to keep his name before the public."[39] She drew this conclusion following a dinner she attended celebrating the publication of *BLAST*. Since Pound had invited her to join his raucous cohorts, who had, only a few weeks earlier, broken up Marinetti's and Nevinson's evening at the Doré Galleries, the surmise that he hoped to embarrass her at this dinner is thoroughly plausible (Watson 202). He failed. Undeterred, Pound tried again a week later at a dinner that Lowell threw for the very Imagists she hoped to recruit, to celebrate the Imagist anthology that *Pound* had gotten published!

One of the guests, John Gould Fletcher, recounts: "[t]he fact that Amy had definitely flung down a challenge to Ezra was known to most of us. I felt that the dinner might break up in some sort of quarrel, and like most of the others [present], knew that I had but little to say" (148-49). Pound, however, opted for ridicule, not accusation. The story has been told many times of his carrying a tin bathtub into the room to symbolize a new poetic school, "*Les Nagistes*," that Lowell had supposedly inaugurated with her poem "In a Garden," particularly in the lines, "Night, and the water, and you in your whiteness, bathing." The image of the corpulent Miss Lowell bathing her white body—would it even fit into this tub?—was what Pound obviously intended to call to mind. Again Fletcher:

Here everybody again laughed, but I for my part, felt that Pound had considerably overplayed his own intellectual arrogance. I anxiously eyed Miss Lowell. She did not appear in the least disturbed. Ezra, she said, must have his little joke, and she personally was glad of his in-

terruption, as it brought to an end the discussion between Gaudier and Aldington, which seemed to her to have little to do with poetry. . . . she was sure that, whether as "imagiste" or as Ezra's newly discovered "nagiste," the new movement in poetry would go on.

Ezra's squib had fizzled out, after all. Everyone felt, as I did, that we now owed homage to the gallant spirit of this woman who had brought us together, and who had maintained her position with unruffled dignity under the most difficult circumstances. (151)

Triumphant, Lowell proceeded to hold a series of intimate dinners to ensure the conversion of Aldington, H. D., F. S. Flint, Fletcher, and D. H. Lawrence to her leadership.

At the smallest scale, these hostilities come down to the pettiness of personal animosities, feuds, and jealousies, but they often symbolize larger differences as well. When Pound facetiously challenged Georgian poet Lascelles Abercrombie to a duel in 1914 because of the latter's "stupidity" (which Abercrombie immediately disproved by suggesting that, for weapons, they throw at each other unsold copies of their books of verse), Pound was obviously suggesting that Abercrombie and the Georgian group he belonged to were obsolete and must, like some ancient elders who can no longer keep up with the tribe, simply disappear. Precisely the same arrogance drove Wyndham Lewis to verbally assault the ubiquitous Ford Madox Hueffer. As the two were walking along with Pound (Hueffer recalls):

> D. Z. [Lewis] had grasped my arm as if he had been a police constable. Those walks were slightly tormenting. . . . Mr. D. Z. . . . more and more like a conspirator went on and on in a vitriolic murmur . . . [but not so as to be overheard by Pound]. Ezra would not have stood for it.
>
> D. Z. said:
>
> "*Tu sais, tu es foûtu! Foûtu!* Finished! Done for! Blasted in fact. Your generation has gone. What is the sense of you and Conrad and Impressionism. You stand for Impressionism. It is finished. *Foûtu*. Blasted too! This is the future. What does anyone want with your old-fashioned stuff? You try to make people believe that they are passing through an experience when they read you. You write these immense long stories, recounted by a doctor at table or a ship captain in an inn. You take ages to get these fellows in. In order to make your stuff seem convincing. Who wants to be convinced? Get a move on. Get out or get under.
>
> "This is the day of Cubism, Futurism, Vorticism. What people want is me, not you. They want to see me. A Vortex. To liven them up. You and Conrad had the idea of concealing yourself when you wrote. I display myself all over the page. In every word. I . . . I . . . I . . . The Vortex. Blast all the rest."
>
> Mr. D. Z. was perfectly right. . . . Impressionism *was* dead. The day of all those explosive sounds had come."[40]

One might easily conclude from these many types and instances of group conflict that the artistic milieu of the prewar period was especially vitriolic, hate filled, and harsh. In fact, the opposite was true: even during the most aggressive battles of the Italian Futurists or French Cubists, expressions of deep bitterness were few. Hatred (such as there was) was reserved for embodiments of aesthetic reaction—the "gigantic philistine" (Blass), "the old established power" (Marc), the old men in the parquet" (Webern), *passéism* (Marinetti), the smug bourgeoisie—and even these targets aroused in many modernists more the attitude of mischievous subversion than deadly enmity.

Overwhelmingly, the mood of these many battles was spirited optimism and exuberance. Some artists, like Marc and Kandinsky, fought for their confident belief in a new age of the spirit. Others, like Wyndham Lewis, dazzled by media attention, "mistook the agitation in the audience for the sign of an awakening of the emotions of artistic sensibility" (*Blasting and Bombardiering* 32). Most, like Marinetti and Burliuk, fought to establish their groups, their aesthetics, and themselves in the forefront of the avant-garde; and many, like Ezra Pound, fought for the art they believed in, but also simply because they were young, high-spirited, and loved a good scrap. To "save the public's soul by punching its face," after all, gave them the best of both worlds.

That these melees were joined by groups and artists eager for battle, that they resulted from a vigorous and turbulent artistic climate dominated by modernist groups eager to assert themselves, further undermines the image of the beleaguered modernist one-sidedly attacked by a hostile public and shows, instead, the combative exuberance, vigor, and optimism of prewar modernism. As Lewis put it so well in retrospect, "Life was one big bloodless brawl, prior to the Great Bloodletting" (35). It would take the real thing to shatter this milieu.

Epilogue

Fatal Symbiosis: Modernism and World War I

> That July-August [1914] issue was the end of the *Soirées*. Nowhere does one relive the fine fresh flourishing of twentieth-century art more intensely than in the pages of the new *Soirées de Paris*; nowhere does one have a keener sense of what "might have been" or feel more sickeningly the brutal stifling of it all when it had barely begun, the fatal descent of the curtain on 1 August 1914.
>
> —Francis Steegmuller, *Apollinaire: Poet among the Painters* 230

In 1909, Ezra Pound, standing on a chair in a London restaurant and assuming the persona of Betrans de Born, declaimed the following lines from his new poem, "Sestina: Altaforte":

> Damn it all! all this our South stinks peace. . . .
> There's no sound like to sword's swords opposing,
> No cry like the battle's rejoicing
> When our elbows and swords drip the crimson. . . .
> Hell grant soon we hear again the swords clash!
> Hell blot black for alway the thought "Peace"![1]

That same year, in Paris, Filippo Marinetti published the Foundation Manifesto of Futurism on the front page of *Le Figaro*, part of which declares: "We will glorify war—the world's only hygiene—militarism, patriotism, the destructive gesture of freedom-bringers. . . . Except in struggle, there is no more beauty. No work without an aggressive character can be a masterpiece. Poetry must be conceived as a violent attack on unknown forces" (*Selected Writings* 41-42).

In the following two years, 1910-1911, *Die Aktion* and *Der Sturm* introduced new and highly disturbing images of cataclysmic war and apocalypse in the poems of Jakob van Hoddis and Gottfried Benn, Georg Heym and Georg Trakl. Heym's "The War" (1911) images the disaster as an awakening monster:

> He that slept long has arisen,
> Arisen from deep vaults below.

He stands in the dusk, huge and unknown,
And crushes the moon to pulp in his black hand.[2]

By 1912-1913, motifs of cannons and marching soldiers, exploding shells and burning cities proliferated in modernist painting, regardless of whether the canvas was painted in London or Berlin, Paris or Milan. And in the same month as the assassination of Archduke Franz Ferdinand, the British composer Gustav Holst completed the first of his *Planets*: "Mars, the Bringer of War."

As anticipations of World War I, these images of war have been typically treated either as instances of naiveté (in glorifying a horror that artists could scarcely imagine) or as artistic prescience in sensing the blood that was already "in the air."[3] Yet such clichés oversimplify modernism's relation to World War I. For beyond merely anticipating or even welcoming a new war, avant-garde artists and modernist groups in particular drew upon war in its multiple meanings—war as metaphor and as actuality, war as language, as imagery, as models of both organizing and destructive power, and, most of all, as focused energy. One could almost say that the prewar groups *embodied* war in their raison d'être and might therefore have seemed well prepared to deal with the real thing in August 1914. In fact, however, they were especially vulnerable. For their relationship with war was essentially symbolic and symbiotic: As they drew energy from the idea of war, their own energies, in turn, were quickly sucked into the real war's immeasurably larger vortex. And as this juggernaut rolled through and over their lives, it mutilated the entire face of modernism, leaving a postwar artistic climate that would have been scarcely recognizable in 1914.

I. The Modernists' War

I have had this war inside me for a long time. That is why inwardly,
[the real war] means nothing to me.
 —Paul Klee, *Diaries*, 952

Like Paul Klee, modernist artists had been at war long before they were mobilized in August 1914. Their primary enemies were the forces of artistic reaction: hostile critics and newspapers, conservative academies, a smug, self-satisfied bourgeoisie, and even bourgeois culture itself. Secondarily, they battled each other in group conflicts. As chapter 4 has shown, several factors coalesced to intensify these oppositions and to make the prewar years especially combative. As modernist innovation in all of the arts accelerated, so did the public's reactions. Youthful artists relished these confrontations, enjoyed provoking them. The modernist groups they formed provided the perfect structure in which to express their provocations, offering collective security, encouraging daring, and facilitating the public events—exhibitions, concerts, readings—that became the flash points of conflict. Finally, as groups proliferated in these years and competed for survival and dominance, they attacked each other as vigorously as they did the public.

In drafting their manifestos, declaring their principles, even in describing their aesthetics, modernist groups inevitably drew on the vocabulary of war to depict their aggressiveness. Examples are legion:

> In this time of great struggle for a new art we fight like disorganized "savages" against the old established power. The battle seems to be unequal, but spiritual matters are never decided by numbers, only by the power of ideas. The dreaded weapons of the "savages" are their new ideas. New ideas kill better than steel and destroy what was thought to be indestructible. (Franz Marc, "The Savages of Germany" *Blaue Reiter Almanac* 61)

> We smash through the power and topple the thrones of the old reign. . . . on our heads the crowns of young messiahs we wear. (Ernst Lotz, qtd. in Cross, *Lost Voices* 5)

German Expressionists like those quoted above were especially prone to aggressive and messianic language since they saw themselves as both scourge and rejuvenator of Wilhelmine stagnation. Ernst Blass, for example, recalls his involvement with the young Berlin poets: "What I was engaged in . . . was a literary movement, a war on the gigantic philistine of those days [1910-1914]. . . . a spirited battle against the soullessness, the deadness, laziness, and meanness of the philistine world. . . . *We were definitely the opposition*" (qtd. in Raabe, *Era* 29-32, Blass's emphasis). Radical editors fueled this *Kulturkamph*. Alfred Kerr wanted to make *Pan* "a journal which will give a sound flogging to the contemporary middle class because of its baseness." And Franz Pfemfert, editor of *Die Aktion*, spoke of fighting a "merciless battle" against "the great [bourgeois] public" (qtd. in Allen 30, 183, 137). Even where this cultural perspective did not prevail, modernists across Europe still resorted to war language to portray their situation and intent. Albert Gleizes describes the impact of the Cubist School painters on the Paris Autumn Salon of 1911: "[The] ensemble had a fine provocative air about it. In those painters one sensed an air of battle" (qtd. in Coen xliv). And Arnold Schoenberg expressed his artistic combat in a nice aphorism: "peacetime . . . means wartime for me" (qtd. in Moldenhauer 215).

War imagery also provided a metaphorical vocabulary that artists drew on to express their particular aims and tactics. At times, indeed, the leaders of modernist groups sounded like imperialist politicians or generals deploying their troops. Guillaume Apollinaire wrote that his aim in composing his Calligrammes was to "annex new domains for poetry" (Gibson 191). Elsewhere, he declared that "young people, art critics, painters, and poets have formed an alliance in order to defend their artistic ideas" (qtd. in Steegmuller v-vii). Marinetti, in visiting the Russian Futurists in 1914, appeared (to two hostile poets) to "affect the pose of a general who had come to inspect one of his remote garrisons" (qtd. in Markov 150). Boccioni appealed for "an all-out campaign" against Italian provincialism and "cowardice" (qtd. in Coen xxxix), and Pound declared he was "busily engaged in a big campaign against the Georgian [poets]" (qtd. in Fletcher 72). Several group leaders—Kandinsky, Marinetti, Pound, Walden, and

Apollinaire—described their mission (or had it described by others) as creating a "united front" against the forces of reaction.[4] And just as Apollinaire portrayed himself among the vanguard "forever fighting at the frontiers of the limitless future," so Wassily Kandinsky described the first Blaue Reiter exhibition in Munich (December 1911) as having a "'front' comprised of a 'left' wing (the newly created 'abstract' side) and a 'right' wing (purely 'realistic')."[5]

Perhaps the most striking example of this linguistic appropriation came from the "enemy's" side: Alfred Capus's sardonic editorial on the front page of *Le Figaro* (2 June 1913) describes the riot at the première of *Le Sacre du Printemps* in the all-too-familiar political rhetoric of European brinkmanship. Although the Balkan War has just yielded a peace treaty, Capus writes,

> there remains nevertheless a number of international issues that still have to be settled. Among these I have no hesitation in placing in the front rank the question of the relationship of Paris with the Russian dancers, which has reached a point of tension where anything can happen. Already the other night there was a border incident whose gravity the government should not underestimate. (Qtd. in Eksteins 87)

The satire is virtually lost in the diplomatic echoes of a Europe moving ever closer to war: a "border incident" with a menacing foreign power, "a point of tension where anything can happen."

If, for the conservative press, these metaphors betray a leaden foreboding in 1913, for the fire-eaters of the avant-garde, war metaphors were energizing, and the more inflammatory the better. Thus, Ezra Pound declares in January 1914:

> The artist has at last been aroused to the fact that the war between him and the world is a war without truce. That his only remedy is slaughter. . . . He must live by craft and violence. His gods are violent gods. . . . Those artists, so called, whose work does not show this strife . . . are simply insensible. And being insensible they are not artists. . . . [The new] sculpture with its general combat, its emotional condemnation, gives us our strongest satisfaction. . . . The artist has been at peace with his oppressors for long enough. . . . We turn back, we artists, to the powers of the air, to the djinn who were our allies aforetime, to the spirits of our ancestors. It is by them that we have ruled and shall rule. . . . And the public will do well to resent these "new" kinds of art.[6]

The very extremity of this language shows how thoroughly it belonged to a realm where "slaughter" was entirely metaphorical—the "bloodless brawl."

For the Italian Futurists, however, violence was neither bloodless nor simply metaphorical; it was redemptive. Without question, they were the true warmongers among prewar modernists, making war and physical violence a centerpiece of their doctrine. As chapter 4 has shown, they created numerous occasions in Futurist evenings for "aggressive action . . . the punch and the slap," which their Foundation manifesto glorifies. While a few other groups imitated

the Italians' physical aggressiveness, notably the Rayists and Cubo-Futurists, most groups settled for verbal warfare—heckling critics and rival group members or, like Pound, spicing their manifestos and articles with violent imagery. The Cubo-Futurists entitled their anthology of December 1912 "A Slap in the Face of Public Taste."

II. Modernism and Prewar International Politics

Modernist bellicosity did not occur in a vacuum, of course; the war imagery and group battles mirrored in miniature the polarizing political situation of Europe beginning with the Agadir Crisis of 1910-1911.[7] Culminating five years of dispute between Germany and France over French control of Morocco, the crisis marked a turning point in European relations. Though war was averted, the gunboat diplomacy of Agadir resulted in a treaty in which both sides felt cheated. Its legacy of mutual bitterness, recriminations, and distrust sharply contrasted the relatively tranquil first years of the century. By 1912, Paris witnessed its first torchlight military parades in twenty years, and France soon extended the period of military service. The following year, Germany vastly increased the size of its peacetime army and, to pay for it, introduced a war tax. Italy, seeking to match French and Spanish gains in Morocco, attacked Tripoli in September 1911. As France strengthened its ties with Russia and England, Germany reaffirmed its Triple Alliance with Austria and Italy.

The Balkan wars marked the second major crisis before Sarajevo. The first Balkan war lasted scarcely the month of October 1912, as Serbia and several other small states successfully separated from Turkey. In late June 1913, the war renewed when Bulgaria fought other Balkan states over division of the land ceded by Turkey. Although technically outside the conflict, the European powers positioned themselves around it according to their current alliances and old grudges. Following the first Balkan war, Germany threatened to fight Russia, should Austria become involved (Gordon, *Expressionism* 152). Meanwhile, as Austria, with Germany's support, opposed Balkan independence and annexed Bosnia, Russia encouraged that rebellion, quietly supporting Serbia's provocative call for all ethnic minorities throughout the Hapsburg Empire to revolt.

Modernist groups both reflected and resisted this polarizing nationalism. The Italian Futurists, as noted elsewhere, proved a virtual microcosm of European nationalism, imperialism, and war fever. Their claims to being the vanguard of modernism were as much an assertion of *Italian* artistic renewal as they were group boasting.[8] And their efforts to absorb other groups, such as the London Vorticists, aped Europe's imperialist powers. In fact, Marinetti physically linked the two realms by shuttling back and forth between Italy's Libyan campaign and the Balkan wars, both of which he covered as a journalist, and the Futurist campaigns across Europe, which he planned and led.

Modernist opponents of the Italian Futurists were sometimes also driven by nationalist pride as well as by the need to preserve their own group's identity. Though obviously indebted to Futurist aesthetics and publicity techniques,

Larionov wanted his Rayism to be seen as "a distinctively Russian manifesta-
tion" of Futurism (Douglas 233).[9] The same intent applied to those Russian Fu-
turists who greeted Marinetti's 1914 visit with open hostility. Apollinaire, as we
have observed, betrayed a comparable nationalism in his one-sided claims for
French primacy in painting and sculpture; inevitably, his claims tangled with
those of the Italian Futurists over the invention of Simultaneism, for example.

More than counterbalancing these instances of artistic nationalism, how-
ever, were significant examples of modernist cosmopolitanism before August
1914. As shown throughout this study, the artistic climate of Europe itself was
international as artists crisscrossed the continent to visit each other's studios,
give lectures, read poems, stage performances and premières, hold one-artist
shows, and participate in major exhibitions. Those exhibitions, themselves—the
second NKV-Munich show, the Jack of Diamonds, the Sonderbund, the Armory
Show, the First German Autumn Salon—were exemplars of modernism's inter-
national character. Finally, modernist groups often had an international member-
ship, guided by leaders like Kandinsky who thought in terms of the West rather
than of nations.

Beyond their professional concerns, some artists worked to improve inter-
national understanding. Romaine Rolland and Paul Claudel, the latter a diplomat
as well as a playwright, fostered increased cultural exchanges between French
and German artists. The Alsatian-German poet and translator Ernst Stadler
worked with the French poet René Schickele for better relations between their
countries. But despite his international sympathies and the prospect of a univer-
sity appointment in Toronto, Stadler enlisted when war was declared and was
killed in October 1914. His enlistment and death sadly foreshadowed the larger
fate of modernism's international character, which also became an early casualty
of the war. Perhaps its last and bravest gesture in a belligerent country was
Franz Pfemfert's publication of an issue of *Die Aktion* in Berlin. Amid the in-
tense nationalism and war fever of 1915, the magazine featured poems by
Baudelaire and Mallarmé, essays by Bergson, Claudel, and Gide, art by Braque
and Picasso, and a dedication, in black edging, "TO THE POET CHARLES
PÉGUY VICTIM OF THE WAR" (Mehring, in Raabe, *Era* 110-11).

III. Prophetic Visions

Despite their internationalism, modernists were nonetheless susceptible to the
worsening political climate. Directly or peripherally, the European war scares
and preparations of 1911-1914 insinuate themselves into prewar art all across
Europe in images of violence and war.[10] In 1913 Jacques Villon paints *Marching
Soldiers* in Paris, while in Bavaria Franz Marc places the blue tunic and spiked
headgear of a German officer on a horseman in *St. Julian Hospitaler* and entitles
another painting *Wolves: Balkan War*. At the same time, Wassily Kandinsky
shows firing cannons obliterating hints of buildings and hills in his semi-abstract
Improvisation No. 30: Cannons. About the cannon imagery Kandinsky was eva-
sive, acknowledging that the war scares of 1913 may have informed it, but deny-

ing that through it he intended "to give a representation of war."[11] His ambivalence is hardly surprising since at the time he was struggling to free his paintings from the tyranny of figurative reference. Yet the cannons *are* central to this work; their diagonal blasts dominate the center and orient the other forms around themselves both spatially and thematically. Kandinsky subtitled his next *Improvisation* "Naval battle."

In Prague that same year, 1913, Bohumil Kubišta painted *Heavy Artillery in Action*, while in Berlin, at least three of Ludwig Meidner's apocalyptic canvases of 1911-1913—*Shelling of a City* (1913), *Horrors of War* (1911), and *Apocalyptic Landscape* (1913, Eliel no. 1)—trace their destructions specifically to war (the *Landscape* is illuminated by shells exploding over the city). Also in Berlin in 1913 was Marsden Hartley, a member of Stieglitz's circle who experienced Germany's intensifying militarization personally and professionally. He arrived, as Gail Scott writes, "in the midst of the festivities surrounding the marriage of the kaiser's daughter, one of the several massive spectacles celebrating what the kaiser declared to be a Hohenzollern year. The pageantry accompanying these events included banners, martial music, and cheering crowds" (44). These images appear directly in *The Warriors*. Hartley's affair with a German officer obviously intensified his sensitivity to this war environment; when the officer was killed at the start of the war, Hartley memorialized him in a number of powerful paintings comprised almost entirely of military insignia, for example, *Portrait of a German Officer*.

Across the Channel, several of Wyndham Lewis's prewar abstractions have martial motifs and titles: *Timon of Athens: Alcibiades* (1912-1913), *Plan of War* (1914), and *Slow Attack* (1914). As Richard Cork avers, the "combative character of . . . *Slow Attack*, *March*, and *Enemy of the Stars* foreshadowed the course of political events with uncanny accuracy" (268). Lewis himself was rather saddened by his unwitting clairvoyance: "it is somewhat depressing to consider how as an artist one is always holding the mirror up to politics without knowing it. . . . *Plan of War*, painted six months before the Great War 'broke out', . . . still depresses me. . . . With me war and art have been mixed up from the start. It [sic] is still" (*Blasting* 4).

True to their manifestos that glorified war as "the World's Only Hygiene," the Futurists incorporated its chaotic immediacy into their aesthetics and art. Specifically, Marinetti justified his "free-word" poetics of 1912-1913 through his experience observing the Libyan campaign and covering the Balkan wars as a journalist. The chaos and "swift pace" of war, he asserted, demanded a corresponding freedom of poetic syntax, grammar, and analogy.[12] The cover of his *ZANG TUMB TUMB* word drawings, dated "Adrianopoli Ottobre 1912," uses both onomatopoeia emulating artillery fire and visual spacing to suggest howitzer angles and shell trajectories. Marinetti would not perfect these multisensory, multidirectional depictions of battle until his 1915 masterpiece "Montagne+Vallate+StradeXJoffre"—an advance obviously inspired by the war itself.

Besides specific references to war, we should also consider more generalized images of violence and aggression. Several of Kandinsky's abstractions, such as *The Black Arc* (1912) and *Painting with Three Spots* (1914), show large

shapes looming menacingly over smaller ones; often one of these larger shapes sends out jagged, jabbing tubes suggesting attacking arms or stingers. As Peter Selz comments on *The Black Arc*,

> Kandinsky . . . creates a threatening image sheerly by means of line, plane, position, and color. Yet the painter has [also] created a mood. In his violent white world, swept by lines and shapes, the warm and cool colors conflict, the withdrawing and aggressive forms meet in battle. To speak of a premonition of war is too hasty in this case, and at any rate superfluous. This is more than an omen of a specific event—it is an expression of the violence of an entire era. (*German Expressionist Painting* 268)

Franz Marc expresses this violence even more directly. An abstraction he finished shortly before the war opposes two large "Fighting Forms": the red one's crescent swathes flail out aggressively while the black shape curves protectively inward. Marc's most disturbing image of violence, *Fate of the Animals*, in which jagged blood-red diagonals rip apart a forest while animals cower, bellow, and die, can be read in various ways. Donald Gordon sees in it "a destruction of the decadent and materialist world, a kind of post-Nietzschean 'war of spirits.'. . . [a] world of 'flaming suffering' [a phrase from the Hindu Vedas that Marc wrote on the back of the canvas], and simultaneously the creation of a more ideal and spiritual realm where flora and fauna have become transparent and dematerialized" (*Expressionism: Art and Idea* 47). Yet Marc himself, on seeing a postcard reproduction of the painting two years later, while he was at the front, wrote: "I was startled and astonished by its immediate effect on me. I saw it as an utterly strange work, a premonition of war that had something shocking about it. It is a curious picture, as if created in a trance."[13] Writing to his wife, he adds: "It is artistically logical to paint such pictures before wars, not as dumb reminiscences afterward" (Levine 77).

These readings are not mutually exclusive when we recall that Marc's apocalyptic vision, like Kandinsky's, was not nihilistic. Both painters saw a new world of the spirit emerging from the ashes of bourgeois materialism. Kandinsky writes in his 1913 *Reminiscences*: "Each art work arises technically just as the cosmos arose—through catastrophes, like the chaotic instrumental roar at the end of a symphony that is called the music of the spheres. . . . A great destruction with an objective effect is also a song of praise, complete and separate in its sound, just like a hymn to new creation which follows the destruction" (qtd. in Eliel 50).

This twining of apocalyptic forebodings and anticipations of cultural renewal was central to the Expressionists' sensibility and helps explain how even their most chilling images came from hopeful artists, inspirited by "the liberating lust of battle," as Ludwig Meidner put it.[14] The same paradoxical sensibility underlies modernist images of war and violence throughout Europe, regardless of the particular style or milieu, ambivalently signaling foreboding and hope, menace and promise, destruction and rebirth. Like the tiger in the limerick, war seemed a beast that could be ridden.

IV. "Eye-deep in Hell"

> I think the war is eating up all of everybody's subconscious energy.
> One does nothing but buy newspapers.
> —Ezra Pound to Harriet Monroe, 29 August 1914

When the war did come, modernists responded with the same naive enthusiasm as the general public. The surge of patriotism, the euphoria of being swept up in a great event (and now as part of the crowds they had formerly opposed), the release from a dull and complacent peacetime, and—for some—the hope that a corrupt, materialistic culture would finally crumble—all these emotions led them to welcome this new collective enterprise. Thomas Mann eloquently recalls:

> How the hearts of the poets burst at once into flame when war was declared! . . . in one way or another [we] had called it down upon us; for at the bottom of our hearts we had felt that the world, our world, could not go on as it was. We knew that world of peace well enough. . . . Was it not swarming with the vermin of the mind as if with maggots? Was it not surfeited with the rot of civilization? . . . How could the artist, the soldier in the artist, help thanking God for the collapse of a peace-time world of which he was sick, thoroughly sick. War! We felt its coming as a purification, a liberation, and an immense hope. This is what the poets spoke of, only of this. (qtd. in Dube, *Expressionists* 85)[15]

Only a few modernists demurred. Kandinsky had grave forebodings when war was declared, not least because he now had to leave Germany abruptly. He writes to Herwarth Walden on 2 August: "[N]ow we have it! Isn't it dreadful? It's as if I had been torn out of a dream. I have been living mentally in a time when such things are completely impossible. My delusion has been taken away from me. Mountains of corpses, horrible torments of various sorts, suppression of inner culture for an indefinite time" (qtd. in Shapiro 145). Yet, he could also look forward in a postwar world "to a great release of inner powers which will also make for the brotherhood of man. And so also a great flowering of art, which now can do nothing but lie in hidden corners" (qtd. in Dube, *Expressionists* 86). Paul Klee, however, went into the war under no such illusions; in 1915 he wrote in his diary: "There was about as much spirituality in it as dung on a heel" (qtd. in Shapiro 147).

The mock-wars artists had been fighting now seemed childish beside the real thing. As art critic Julius Meier-Graefe wrote that August: "The war bestows on us a gift. Since yesterday we are different. The fight over words and programs is over. We were tilting at windmills. . . . What we were missing was meaning—and that, brothers, the times now give us. . . . The war has given us unity. All parties are agreed on the goal. May art follow!" (qtd. in Gordon, *Expressionism* 153). Swollen with patriotism, writers like Thomas Hardy and H. G. Wells, who only months before had published antiwar poems and novels,

now urged young men to "Stand up and take the war / The Hun is at the gate" (Hardy, "Men Who March Away"). Modernist cosmopolitanism shriveled as the war closed borders and released a tidal wave of nationalism. From Switzerland the writer Emil Szittya complained: "[After the declaration] it is really astonishing how all the intellectuals in the countries at war, even the finest and most individualistic, became at one with the mass mentality [supporting the war]. There was something in the air that clouded the mind, robbed one of the will to breathe. People in the countries at war became absolutely horrible" (qtd. in Raabe, *Era* 153). With the war only a month old, Richard Aldington analyzed the debilitating effect of this "mass mentality" on poets:

> There seems now to be only one subject exercising everyone's mental and physical activities—the War. . . . The state of mind of the individual in a case like the present is undoubtedly influenced by the mob psychology. . . . This kind of social feeling does not produce art—for proof of this consult the war poems in the papers. The impulse is too vague, too general; the impulse of art is always clear and particular. The truth is that we are all too much engulfed in the "group psychology" to be artists. All our energy goes in outside effort, in anxieties and hopes, in combating the general fidgetiness.[16]

The war disrupted virtually everyone's life: artists put aside brushes and pens to volunteer or follow their mobilization orders; émigrés like Kandinsky suddenly found themselves living in an "enemy" country and hurriedly returned "home" or sought safe haven in a neutral country, as did more than a few nationals avoiding the war (see appendix 3). Groups that had been the lifeblood of prewar modernism disbanded, never to reform, their members in uniform, exiled, dead. Modernist journals folded: *Les Soirées de Paris*, the *Blaue Reiter Almanac*, eventually *BLAST*, *Lacerba*, *Pan*, and many others.[17] Francis Steegmuller's poignant eulogy applies to all these casualties:

> That July-August [1914] issue was the end of the *Soirées*. Nowhere does one relive the fine fresh flourishing of twentieth-century art more intensely than in the pages of the new *Soirées de Paris*; nowhere does one have a keener sense of what "might have been" or feel more sickeningly the brutal stifling of it all when it had barely begun, the fatal descent of the curtain on 1 August 1914. (*Apollinaire: Poet among the Painters* 230)

As Meier-Graefe had predicted, the artistic controversies that had seemed so vital before the war quickly faded. Modernist exhibitions were seldom held in the belligerent countries and failed to arouse controversy when they were. Albert Gleizes observed in 1915: "The present conflict throws into anarchy all the intellectual paths of the pre-war period, and the reasons are simple: the leaders are in the army and the generation of thirty-year-olds is sparse. . . . The past is finished."[18] Debates among French poetry groups were similarly stifled. Kenneth Cornell writes: "In August 1914 discussion of poetic and literary theory was

brought to an end. . . . The imbroglio of *'dramatisme,'* *'paroxysme,'* and *'néo-classicisme'* . . . was halted at a moment of great effervescence" (134).

On the other side of the lines, the situation was the same: "With the nation's energies fully devoted to the defence of the fatherland, artistic aspirations seemed to lose their significance. Each member of the Vienna circle was affected. From Altenberg, Kokoschka, and Loos to Schoenberg and his disciples, the only matter of importance now was the individual's role within the war effort" (Moldenhauer 211). Of the belligerents, the single major exception to this pattern was Russia, where returning émigrés like Kandinsky, Larionov, Goncharova, Tatlin, and El Lissitzky helped modernism thrive during the war years.

That their war work might also serve their art was not lost on some artists. Raymond Duchamp-Villon wrote in 1916: "Maybe this rest imposed on our artistic faculties will be a boon. . . . I have acquired a clearer and surer vision of the path already traced and the path yet to be traced" (qtd. in Shapiro 143). Fernand Léger, recalling the experience, was even surer of its benefits: "I was dazzled by the open breech of a 75-millimeter gun in the sunlight, by the magic of the light on the white metal. . . . Once I had bitten into that reality its objects did not leave me. [It] . . . taught me more for my plastic development than all the museums in the world" (qtd. in Shapiro 141). Apollinaire, too, saw something poetic in artillery: "[It is] as beautiful, as strong, as tender as one of my poems." In fact, his poems flourished during a service that he enjoyed—for a time.[19] Like Léger and Marinetti, the French sculptor Henri Gaudier-Brzeska also saw the mechanistic chaos and cacophony of combat as a modernist simulacrum. He wrote to Pound: "We have the finest futurist music Marinetti can dream of, big guns, small guns, bomb-throwers' reports" (qtd. in Pound, *Gaudier-Brzeska* 69). War's promises, however, proved treacherous: Duchamp-Villon, Apollinaire, and Gaudier would not live to see the peace.

The war's physical toll on modernist artists was immense: it killed or severely maimed scores of them, including some of the very best; it drove numerous others to nervous breakdowns and weakened still others to make them vulnerable to the 1918-1919 influenza epidemic, to pneumonia, or to a premature death from their war wounds (see appendix 3). Ezra Pound, now ruing his own poetic warmongering,[20] turned his modernist rage against a corrupt culture that sent promising young artists to their death:

> Died some, pro patria,
> non "dulce" not "et decor"
> walked eye-deep in hell
> believing in old men's lies, then unbelieving
> came home, home to a lie, . . .
>
> There died a myriad,
> And of the best, among them
> For an old bitch gone in the teeth,
> For a botched civilization (*Hugh Selwyn Mauberley*, IV-V)

As they boarded their troop trains, even some modernists eager for the war foresaw that things would never be the same. When Kandinsky, seeing Marc off for the front, hoped that "our separation would not be for long," Marc replied: "No, we will never see each other again." His prophetic words were echoed by Picasso, who saw Braque to his train. Although they were to meet again, their former intimacy was gone: "We never saw each other again" (qtd. in Rubin, *Picasso and Braque* 51).

Inevitably, the modernists' prewar mood of buoyant optimism and artistic aggression vanished amid the horrors of the real thing. The contrast between Max Beckmann's early enthusiasm and later disillusionment is typical:

> Outside there was the wonderfully grand noise of battle. I went out among crowds of wounded and exhausted soldiers coming from the battlefield, and heard this strangely awful, grand music. It is as though the gates to eternity are being torn asunder when such a great salvo rings above. Everything suggests space, distance, timelessness. I would like to, I could paint this noise. *Ach*, these broad and uncannily beautiful depths! Crowds of people and "soldiers" moved all the while toward the center of this melody, toward the decisive moment of their lives. (October 1914; qtd. in Shapiro 149-50)

> What would we poor men do if we didn't always create for ourselves ideas of fatherland, love, art, and religion, with which we can again and again cover up the black, dark hole a little. . . . I must digest it all inwardly, then I'll be free to work it up with almost timeless detachment. These black faces blossoming out of the grave and the silent dead coming toward me are mournful greetings of eternity and as such I will paint them later. (May 1915; qtd. in Shapiro 150)

Franz Marc's hope that the war would provide the "purifying fire" to clean out European decay and leave a "refined and hardened" culture gradually crumbled under the relentless grind of the killing.[21] On Christmas Eve 1914, he wrote his wife: "You would perhaps find me a little more silent, a little more melancholic [today]. . . . The cleverness and the bright thoughts are not the same as they were before." (qtd. in Levine 162). The following year, he wrote to August Macke's widow, Elizabeth, that the war was "the cruelest catch of men to which we have abandoned ourselves." And in a letter to his wife—one of the last before he too was "caught"—he reflected: "It is terrible to think of; and all for *nothing*, for a misunderstanding. . . . We must unlearn, rethink absolutely everything in order to come to terms with the monstrous psychology of this deed and not only to hate, revile, deride and bewail it, but to understand its origins and to form *counterthoughts*" (qtd. in Partsch 91, Marc's emphasis).

Oskar Kokoschka had once written to Franz Marc: "Let the apostles of the new German art take a leaf from your book [in your volunteering for service], and then they may gain some conception of a world which, by a natural outbreak of violence, we are trying to create" (qtd. in Dube 86). A year later, Kokoschka painted the trauma of his multiple woundings and loss of idealism into a 1915 self-portrait, *Knight Errant*. Amid an apocalyptic setting of darkness, flood,

devastation, and the angel of death, the artist lies in rigor-mortis-like stiffness, one arm awkwardly extended. Though his tunic is contemporary, his leg irons make him appear a knight, overweighted with armor, who has fallen from his charger and cannot right himself. The grotesque inadequacy of a chivalric conception of war in a modern inferno could not be clearer.

Even artists whose art thrived in a war setting, like Apollinaire, Léger, and Dix, often paid a huge price for this new inspiration. Apollinaire grew despondent after transferring into the infantry as a lieutenant:

> Nine days without washing, sleeping on the ground without straw, ground infested with vermin, not a drop of water except that used to vaporize the gas masks . . . It is fantastic what one can stand . . . One of the parapets of my trench is partly made of corpses . . . There are no head lice but swarms of body lice, pubic lice . . . No writer will ever be able to tell the simple horror of the trenches, the mysterious life that is led there. (qtd. in Steegmuller 249)

After he took a shell splinter in the head and underwent trepanning (fig. 31), Apollinaire's despondency and fatigue intensified. Though he continued to write, he was never to regain his former vitality, optimism, and exuberance before he succumbed to pneumonia on the day before the Armistice.

Noncombatant artists found it difficult to work in the feverish wartime environment. Some, like Matisse and Picasso, felt guilty being safe and doing something irrelevant to the war effort while their friends and sons (in Matisse's case) were fighting. Matisse writes in 1916: "I cannot say that [my recent painting] has not been a struggle—but it is not the real one, I know so well, and it's with a special respect that I think of the *poilu*." Two years later, the guilt had not lessened: "Every day I have to have worked all day long to accept the irresponsibility which puts the conscience to rest" (qtd. in Silver 30, 34). Picasso, according to William Rubin, "had changed a great deal during 1915-16. His loneliness and unhappiness in wartime Paris . . . were compounded by the death of his companion, Marcelle Humbert . . . and led to a profound morosity" (51). Juan Gris, who, like Picasso, suffered the isolation of being a foreign national in Paris, could not abide the xenophobic war fever:

> I can't understand . . . this urge to massacre, to exterminate, unless there's an absolute guarantee that it will end satisfactorily. . . . Ever since the war broke out, all the civilians I come in contact with have their minds warped by events. There's not one of them intact; all have broken down under the pressure of war. I am amazed by my own stupidity and inability to swim with the tide. My feet are anchored to pre-war times. (letter of 17 October 1916; qtd. in Shapiro 143)

More devastating still was the sense of meaninglessness that the Great War now gave to the ambitions of artist-veterans. Ernst Ludwig Kirchner was doubly a victim. The war he served in, which produced such harrowing images of muti-

lation and castration as *Self-Portrait as a Soldier* and which ultimately caused him a complete mental breakdown, now threatened to rob him of creative purpose as a civilian. As he wrote a friend: "The pressure of the war and the increasingly prevailing superficiality weigh more heavily than everything else. One feels that crisis is in the air. . . . Turgidly one vacillates, whether to work, where any work is surely to no purpose" (qtd. in Shapiro 152).

V. "And When We Came Back . . . It Was All Different"

Not merely individual modernists but modernism itself became a war casualty: it survived, but changed profoundly. As Kenneth Silver has documented in *Esprit de Corps*, the war provided the perfect opportunity for conservative opponents of modernism to counterattack. In a wartime climate of extreme nationalism and xenophobia, modernism's international character, elitism, and abstract experimentation proved easy targets.

French rightists deplored the nation's prewar state as "cosmopolitan, decadent, and demented"; one popular cartoon sequence depicted Marianne, the national symbol, enjoying "crazy paintings" and "barbarian ballets" (obviously an allusion to *Le Sacre du Printemps*), while nearby, "Germania" strengthened itself (Silver 13-22). Cubism (now spelled with a Germanic "K" in the hostile French press) and other modernist styles acquired the taint of a foreign conspiracy, foisted on a guileless public by foreign art dealers (for example, Kahnweiler, Uhde, and Weil): "[the Judeo-German Cartel] came to falsify French taste . . . [with] works stamped with German culture—Pointillist, Cubist, Futurist, etc." (Tony Tollet, 1915 lecture; qtd. in Silver 8).

Across the Rhine, the same political-aesthetic reaction occurred. The Expressionist poet Christian Schad complained from Zurich: "All the poetry and philosophy the Germans are so proud of had been transformed by Prussian discipline into the one watchword: 'God, Emperor and Fatherland'[;] the Officer was the ideal man and the War the supreme test: all that Man could look for in life was now restricted to subservience, the best qualities were crippled" (qtd. in Raabe, *Era* 161).

In England, too, modernism became equated with the enemy. The *London Times* called the Second Exhibition of the London Group "Junkerism in Art" and "Prussian in spirit" (Cork 269). And, as if to respond to Rémy de Gourmont's nostalgic recollection of the prewar years in 1915 ("How happy seem the times when we seriously discussed the future of Cubism, or the respective merits of free and regular verse!"), Francis Carco wrote that same year: "Do you remember—before the war—the diversity of views, opinions, tendencies, directions, theories in French pictorial art? The grossest extravagances became a daily spectacle—and amid this chaos we had to fight in order to declare that Cubism was no more than an error—and that experiment for experiment's sake was an idle preoccupation" (qtd. in Silver 146).

The new conservatism aimed not merely at particular styles but at the very spirit of prewar modernism: its expansive daring, its internationalism, its will to

uproot the very bases of traditional aesthetics: mimesis, tonality, regular rhyme and meter. Thus, Paul Dermée: "After a period of exuberance and force must follow a period of organization, of arrangement, of science—that is to say, a classic age" (*Nord-Sud*, 15 March 1917, qtd. in Silver 89). German and Austrian Expressionists, who had viewed their art as a cultural and not merely stylistic renaissance, generally resisted this new conservatism, but their own patriotism complicated the issue. Schoenberg, for example, withdrew his *Chamber Symphony* from a 1916 performance in Prague because "he did not want to excite aesthetic controversy now that the national emergency took priority over everything else[:] 'In peacetime—which means wartime for me—I am quite prepared to go back to being everyone's whipping boy'" (Moldenhauer 215).

French modernists were more susceptible to neoclassicism because its values were depicted as typically French. "Restraint," "balance," "order," and "moderation" were on the tongues of major artists who had, only a few years earlier, recognized no barriers as valid in art. Before the war, for example, Braque felt that emotion is "translated and transmuted" into art. By 1917, he could assert: "In art, progress consists not in extension but in the knowledge of its limits. . . . I love the rule which corrects emotion" (qtd. in Silver 105-6). Apollinaire expressed similar views the same year when in 1917 he claimed that the "new spirit" of poetry "tends toward austere expression, or rather toward containment, of feelings."[22] Delaunay went even further, declaring in 1916 that the newest art was "in reaction or rather in opposition to all the painting or artistic tendencies called Cubist-Futurist." A year later he referred to the prewar period of the Parisian avant-garde as an "epoch of poor painting, hysterical, convulsive, destructive. . . . [T]hese Futurist [and] Cubist hoaxes . . . [were] neither painting nor art" (qtd. in Silver 147-48). And Jean Cocteau, one of the collaborators of *Parade*, applied the new emphasis on limits even to modernism's penchant for shocking the bourgeoisie: "Between TASTE and VULGARITY, both unpleasant, there remains an *élan* and a sense of proportion: THE TACT OF UNDERSTANDING JUST HOW FAR YOU CAN GO TOO FAR" (qtd. in Silver 57, Cocteau's emphasis).

As Picasso returned to figurative portraiture during the war, Apollinaire's poetry similarly incorporated aspects of tradition following his brashly pictorial Calligrammes. Two months before his death he wrote Picasso: "What I am doing now will accord better with your present preoccupations. I am trying to renovate the poetic tone, but in the classic rhyme" (4 September 1918, qtd. in Silver 139). In England, at about the same time, the two leading modernist poets, Pound and Eliot, were doing likewise; Pound recalled: "at a particular date [1917] in a particular room, two authors . . . decided that the dilutation of *vers libre*, Amygism, Lee Masterism, general floppiness had gone too far and that some counter-current must be set going. . . . Remedy prescribed. . . . Rhyme and regular strophes."[23] In Stravinsky's postwar neoclassicism, in Ravel's *Le Tombeau de Couperin*, in the *Neue Sachlichkeit* of Germany, and even in Schoenberg's codification of "The Twelve Tone Method," one can see comparable movements of aesthetic contraction, of gravitation toward rules, boundedness, and older styles as an "orderly" framework for innovation.

The strained friendship between Picasso and Braque during and after the war perfectly dramatizes how resurgent nationalism affected the prewar modernists' widespread indifference to national boundaries and origins. As William Rubin notes: "We have Braque's word that these [national differences] 'didn't count for anything' in his prewar friendship with Picasso[:] 'Despite our very different temperaments, we were guided by a common idea.' But 'as was clear later, Picasso is Spanish, I am French; we know all the differences that implies'" (52). To be sure, modernist internationalism still flourished in neutral countries—Switzerland and America (until it entered the war)—but these countries were at the fringes of modernism as it had existed.

Not coincidentally, these same two countries, Switzerland especially, witnessed the most radical avant-garde movement of the war years, Dadaism. Yet Dada's anti-art nihilism shows just how much wartime modernism differed from its prewar counterpart. While it shared the latter's baiting of the bourgeoisie, Dada's shock value was in its own self-destructive nihilism. Nothing could be further from prewar modernism's high ambitions and optimistic battles for cultural rejuvenation than Dada's brittle laughter that proclaimed nothing, least of all art, worth saving. Juan Gris was not alone among the prewar modernists in his disgust at this change: "I am alarmed about what happens next in painting. I see our serious efforts being swallowed up in waves of Dadaism and Expressionism."[24]

Indeed, between Dada's nihilism and conservative neoclassicism, and in a Europe so utterly ravaged by the war that "cultural rejuvenation" itself was a Dada joke, there seemed little room and less reason for the prewar modernist *programme* to continue. It had become a casualty of the war it had so confidently anticipated and emulated. The German poet Jacob Picard's melancholic recollection of his particular group might speak for the entire prewar modernist movement: "And when we came back [from the war], those of us who had survived, it was all different and the *Argonauten* were past history" (qtd. in Raabe, *Era* 138).

Appendix 1

Time Line 1910-1914[1]

PARIS 1908

Hermann Minkowski publishes *Theories of Hyperspace*.
Jules Romains publishes *La vie unanime* (major publication of commune of poets, L'Abbaye de Créteil).

NOV 09-28: Galerie Kahnweiler: Georges Braque exhibits; Guillaume Apollinaire writes catalog introduction (Fry #3-5). Hostile critic Louis Vauxcelles writes Braque "reduces everything . . . to geometrical schemas, to cubes." (*Gil Blas*, 14 NOV).

PARIS 1909

Pablo Picasso consolidates multiple directions of 1907-1908 (after *Les Demoiselles*) into analytical Cubist style. (Braque slightly precedes him in his own consolidation of 1908.)
Robert Delaunay begins *Eiffel Tower* and *The City* series, both of which continue through 1911.

FEB 20: Filippo Marinetti publishes "The Founding and Manifesto of Futurism" in *Le Figaro*.

APR Marinetti's play *Le Roi Bombance* opens at Théâtre de l'Oeuvre (same theatre where Jarry's *Ubu Roi* had created riot on opening in 11 DEC 1896). Draws large crowds.

MAY 18: Théâtre du Châtelet: first season of Russian ballet brought by Serge Diaghilev and Georges Auric—huge success.
Prince Igor. Music by Borodin; sets and costumes by Roerich in bright colors and lavish features; choreography by Fokine; chief dancers: Bolm, Fedorova, Smirnova.
Le Pavillon D'Armide. Music by Tcherepnine, sets and costumes by Benois, choreography by Fokine; chief dancers: Karalli, Karsavina, Nijinsky.
Le Festin, *Les Sylphides*, and *Cléopâtre* also performed.
Dancers display vigorous, athletic style.

PARIS 1910

Claude Debussy composes *Trois ballades of Villon*.

Jules Romains publishes "Un être en marche" in *Mercure de France*.
Henri Martin Barzun publishes *La Terrestre Tragédie*, verse epic in 25 cantos: version for choric recital. First vol. published by L'Abbaye de Créteil, 1907
Apollinaire publishes *L'Hérésiarque et Cie.*, collection of short stories.
Péguy publishes "Notre jeunesse" (*Cahiers de la Quinzaine*, X, 11).
Marinetti publishes *Mafarka, le futuriste*.
Colette publishes *La Vagabonde*.
Romain Rolland publishes *Les amies*.
Rainer Maria Rilke publishes *The Notebooks of Malte Laurids Brigge*.
Georges Duhamel and Charles Vildrac publish *Notes sur la technique poétique*.
André Salmon founds review *Nouvelles de la République des Lettres*.

FEB 14—05 MAR: Galerie Bernheim Jeune: Matisse exhibits.

spring Braque introduces lettering into his Cubist paintings; Picasso does likewise in the fall.

MAR 18—01 MAY: Société des Artistes Indépendants Salon (hereafter: Indépendants Salon): Painters working in "post-Cézannian" style—Albert Gleizes (5 works), Jean Metzinger (6 works), Henri Le Fauconnier (4 works), Robert Delaunay (3 works), Fernand Léger (5 works)—impress critics and each other with shared stylistic interests. Apollinaire praises it as signifying "the rout of Impressionism." Vauxcelles calls them "ignorant geometers, reducing the human body . . . to pallid cubes"; *La Presse* complains of "geometric excesses."

APR 28—28 MAY: Galerie Berthe Weill: Group exhibition (includes Metzinger).

MAY Galerie Notre-Dame-des-Champs: Picasso exhibits Cubist (and proto-Cubist) paintings done in 1908-1909, including: *Bowl of Fruit with Wine Glass* and *Factory at Horta*.

18: "Technical Manifesto of Futurist Painting" published in *Comoedia* with satirical drawings by André Warnod.

JUN 04: Théâtre National de l'Opéra: Ballets Russes de Diaghilev (hereafter: Ballets Russes) begins its season with *Schéhérazade*. *Carnaval, Giselle, Les Orientales* also performed.

25: Ballets Russes première of *Firebird*; music: Stravinsky; choreography and libretto: Fokine; sets: Golovin; costumes: Golovin, Bakst; dancers: Karsavina, Fokine, V. Fokina.

SEP Painter Henri Rousseau ("le Douanier") dies.

OCT 01—08 NOV: Société du Salon d'Automne (hereafter: Automne Salon): Gleizes, Metzinger, Le Fauconnier, Delaunay hung close together, where their shared stylistic interests, now visible collectively, begin to coalesce into group sensibility. Critics now begin to treat these shared interests as a single style (although "Cubism" is not yet used as label). Metzinger's *Nude* is most purely Cubist work exhibited. Roger Allard's review uses "analytical" and "synthesis." Reviewer of *La Presse* describes their work as "geometrical follies." The group begins meeting regularly at Alexandre Mercereau's home, Le Fauconnier's studio, and the Closerie des Lilas over winter 1910-1911. With Roger de La Fresnaye, they plan their election to hanging committee of spring Indépendants exhibition so as to exhibit together.

Automne Salon sponsors lecture on Russian poetry (organized by Alexandre Mercereau); includes examples of modern verse in Russian and French translation.

NOV Metzinger publishes "Note sur la Peinture" in *Pan* (OCT-NOV issue): analyzes Cubist use of synthesis and simultaneity; praises Picasso and Braque for their "free, mobile perspective" and ability to depict "the successive and the simultaneous"; refers to the mathematician Maurice Princet's "deducing a whole geometry" from Picasso's perspective.

25: Apollinaire speaks of "the 4th dimension" in lecture at Exposition d'Art Contemporain.

DEC —JAN or FEB 1911: Galerie Vollard: Picasso exhibition.

PARIS 1911

Metzinger, Le Fauconnier, and Segonzac organize a studio, "La Palette," at which Russian painters Lentulov, Udaltsova, and later Popova work.

Debussy composes *Martyrdom of St. Sebastien*.
Erik Satie composes *Truly Flabby Preludes, 3 Pieces for Piano, En habit de cheval* for orchestra.
Florent Schmitt composes *The Tragedy of Salome* (2nd version).
Igor Stravinsky composes *Le Roi des étoiles, 2 Poems*.

Apollinaire publishes *Le Bestiarie ou Cortège d'Orphée*, with woodcuts by Dufy.
Roger Allard publishes book of poems illustrated by Gleizes.
Max Jacob publishes *La Côte* and first vol. of Saint Matorel trilogy, with etchings by Picasso.
Paul Fort publishes *L'Aventure éternelle* (French ballads).
Charles Péguy publishes *Le Mystère de la Charité de Jeanne d' Arc* and *Le Porche du Mystère de la Deuxième Vertu* (marks returns to regular verse).
Jean Giraudoux publishes *L'école des indifférents*.
Valéry Larbaud publishes *Fermina Marquez*.

Jules Romains publishes *The Death of Someone, The Power of Paris*, and verse drama *The Army of the City*.
André Gide publishes *Corydon*.
Romain Rolland publishes *Le Buisson Ardent* (penultimate volume of *Jean-Christophe*) and *Life of Tolstoy*.
Francois Mauriac publishes *Goodbye to Youth*.
Paul Claudel publishes *The Hostage*; his *The Tidings Brought to Mary* receives its première.

JAN Isadora Duncan dances to music of Gluck, Schumann, Wagner.

MAR 07: Romains publishes "A Call to Youth" in *Le Figaro*, which reaffirms principles of Unanimism.

 ca. 13: Maison des Etudiants: Marinetti lectures on Futurism; 14 MAR: in interview in *Les Temps*, he discusses Futurist exhibitionism as key tactic.

APR Apollinaire begins writing for *Mercure de France*; breaks with Unanimistes.

 21—13 JUN: Indépendants Salon: first major Cubist exhibition in salle 41 and salle 43 causes "international scandal" (Daix). Participants in salle 41: Le Fauconnier (*Abundance*, the most talked about work), Léger (*Nudes in the Forest*), Gleizes (2 works including *Woman with Phlox*), Delaunay (3 works including one from the *Eiffel Tower* series and *The City No. 2*), Metzinger (4 paintings including *Nude*), and Laurencin. Salle 43: La Fresnaye (*The Cuirassier*), Lhote, Dunoyer de Segonziac, Mare, Moreau, Marcoussis, Ozenfant. Mondrian also shows. Exhibition influences Duchamp brothers and Picabia. Apollinaire's review calls Metzinger's paintings "the only works here that can properly be called Cubist." Régis Gignoux of *Le Figaro* claims that Cubists "render all their subjects indiscriminately as cubes." "Cubism" becomes standard reference for variety of styles.

MAY 22: Théâtre du Châtelet: Ida Rubinstein company performs première of Debussy's *The Martyrdom of St. Sebastien: Mystery in 5 Acts of Gabriele d'Annunzio*. Choreography: Fokine; sets and costumes: Bakst.

JUN 13: Théâtre du Châtelet: Ballets Russes gives première of Stravinsky's *Petrouchka*; sets and costumes by Benois, choreography by Fokine, chief dancers: Nijinsky, Karsavina. Ballets Russes also performs *Le Spectre de la Rose, Narcisse, Sadko-Au Royaume Sous-Marin*, and *Swan Lake*.

JUL 06—15 OCT: Musée des Arts Décoratifs: Bakst exhibits.

SEP *Mona Lisa* theft and scandal implicate Apollinaire.

OCT Wassily Kandinsky writes Delaunay, praising Delaunay's art (which will be shown in the *Blaue Reiter Almanac*) and soliciting brief essay for the *Almanac*, thus beginning Delaunay's influential contacts with Germany.

Marinetti lectures on Futurism and publishes a collection of articles and manifestos as *Le Futurisme* (Paris: Sansot).

01—08 NOV: Automne Salon: 2nd major Cubist exhibition in salle 8 and 7. Salle 8 includes: Gleizes (*Portrait of Jacques Nayral, The Hunt*), Metzinger (*The Sonata, Tea Time*), Léger (*Study for 3 Portraits, Wedding*), Le Fauconnier and La Fresnaye—and Puteuax group, including: M. Duchamp (*The Sonata*), Jacques Villon (*Portrait of an Actor*), de Segonzac, Lhote, Moreau. Salle 7 ("room of the frenzied colorists") includes: Picabia and Kupka (*Planes by Colors*). Another public uproar, this one more prepared. Afterwards, painters from Mercereau-Le Fauconnier group and Normande group, along with several writers and critics begin meeting regularly at Jacques Villon's studio in Puteaux (hence, "Puteaux group").

ca. 11: Italian Futurists (Umberto Boccioni, Carlo Carrà, and possibly Luigi Russolo) arrive to plan February exhibition; Futurist Gino Severini introduces them to Braque, Picasso, Léger, Gleizes, Metzinger, Marcel Duchamp, and Gertrude Stein.

NOV Braque creates first of his paper sculptures and his first painting to use simulated wood graining, *Homage to J. S. Bach*.

20—16 DEC: Galerie d'art ancienne et d'art contemporain: "Exposition d'Art Contemporain" (group exhibition of Section d'Or painters): the Duchamp brothers, Gleizes, Léger, Picabia, Metzinger, etc.
25: Apollinaire lectures during exhibition on relevance of non-Euclidean geometry to contemporary painting, including the notion of a "4th dimension."

DEC —JAN 1912: Delaunay paints last of *City* series, *Windows on the City No. 4*.

PARIS 1912

Giorgio de Chirico paints *The Enigma of the Hour*.
Marcel Duchamp paints *Nude Descending a Staircase*.
Morgan Russell achieves total abstraction in his "Synchromies."
Constantin Brancusi begins "Bird in Flight" series.
Alexander Archipenko introduces new elements into sculpture: concavities, transparencies, modeling of space; sculpts *Médrano I* (his first 3-D construction).
Debussy composes the ballet *Khamma*, *Syrinx* (for flute), *Images*, finishes *Iberia*.
Satie composes *Truly Flabby Preludes for piano, Disagreeable Glimpses* (piano 4 hands), writes *Memoirs of an Amnesiac* (from 1912-1914 in *Journal of Musicians*).
Maurice Ravel composes *Mother Goose* ballet.

Jean Cocteau publishes *La Danse de Sophocle*.

Georges Duhamel publishes *Compagnons*; takes over poetry column of *Mercure de France*.

Rémy de Gourmont publishes *Divertissements*.

Max Jacob publishes *Burlesque Works and Mysteries of Saint Matorel* (2nd vol.)

Henri Martin Barzun publishes *Hymne des forces*, epic choral work, in *Mercure de France*; excerpted in *Poème et Drame*.

Maurice Barrès publishes *El Greco or The Secret of Toledo*.

Julien Benda publishes *The Ordination*.

Anatole France publishes *The Gods Are Thirsty*.

André Gide publishes *Isabelle*.

Romain Rolland publishes *La Nouvelle Journée* (concluding volume of *Jean Christophe*).

Francois Mauriac and André Lafon found *Les Cahiers*.

JAN Delaunay spends month in Laon, paints several views of Cathedral and town (e.g., *The Towers of Laon*).

FEB *Les Soirées de Paris*, founded by André Billy, René Depuy (Dalize), André Salmon, and André Tudesq, begins publishing. Managing editor: Dupuy; staff: Salmon, Billy, Max Jacob. Apollinaire publishes his poems and eventually his art reviews here. Reorganized NOV 1913 with new "co-directors": Guillaume Apollinaire, Serge Férat, Baroness Hélène d'Oettigen (the latter two using joint name: Jean Cérusse); new editor: Apollinaire. Altogether, *Soirées* runs 27 issues, ending JUL-AUG 1914.

05-24: Galerie Bernheim-Jeune: Italian Futurist painters' traveling exhibition, includes: Umberto Boccioni (10 works including *The Farewells* series, *The Street Enters the House*, and *The City Rises*); Carlo Carrà (11 works including *Funeral of the Anarchist Galli*); Gino Severini (8 works including *"Pan-Pan Dance at the Monico"*); and Luigi Russolo (6 works including *Memory of a Night*). Two manifestos accompany exhibition: the "Technical Manifesto of Futurist Painting" and "The Exhibitors to the Public" (written specifically for this exhibition). Marinetti and Valentine de Saint-Point lecture, Marinetti's causing uproar.
 Exhibition is major event, seen by most modernist painters in Paris. Apollinaire's reviews (*L'Intransigeant* 7 FEB, and *Le Petit Bleu* 9 FEB) condescend to Futurist claims of European leadership and repeatedly asserts primacy of French painting. Cf., Gustave Kahn: "a movement of such considerable novelty has scarcely been seen since the first pointillists' exhibitions" (*Mercure de France* 16 FEB 868). Most other critics hostile. Herwarth Walden sees show and immediately arranges its visit to Berlin after London.
25—24 MAR: Olivier Hourcade publishes in *L'Action* series of interviews with prominent writers (including Apollinaire, Marinetti, Rivière, Kahn) who attempt to explain Cubism to the public.

28—13 MAR: Galeries Barbazanges: Delaunay has first major show (with some works by Laurencin): 41 paintings including *Towers of Laon*; Maurice Princet writes catalog preface.

spring Picasso creates *Guitar*, first open-construction sculpture.

MAR Péguy publishes *Le Mystère des Saints Innocents.*

20—16 MAY: Indépendants Salon includes: Delaunay's *City of Paris*, Kupka's *Planes by Colors I-III*, works by Gris (3 paintings including *Homage to Picasso*), Gleizes, Metzinger, MacDonald-Wright, Kandinsky (*Improvisation 14*), Mondrian, Duchamp (but not *Nude Descending a Staircase,* which the Cubist hanging committee rejected), Lehmbruck, Brancusi, Zadkine, and Cubist sculpture by Archipenko. Apollinare: "Delaunay's painting (*City of Paris*) is by far the most important one of this Salon" (*L'Intransigeant*, 19 MAR). Hostile critic Louis Vauxcelles inveighs against "foreigners" who "have flocked [to Paris] . . . and in four months' time . . . have learned the latest recipes [for Cubism], which they apply even more extravagantly" (*Gil Blas*, 19 MAR). This review (strengthened by Picasso painting of "Kub" into a 1912 work, punning Cubism with German-made Kub bullion) begins to establish xenophobic notion that Cubism is foreign and subversive; hostile critics and newspapers gradually begin to refer to it as "Der Kubismus."

25: "Manifesto of Futurist Women," which rebuts Marinetti's antifeminism, signed by Valentine de Saint-Point.

APR Klee visits Paris, sees paintings of Picasso, Braque; meets Le Fauconnier and Delaunay. Corresponds often with Delaunay thereafter.
Delaunay begins his nearly abstract *Windows* series.

Apollinaire publishes "La Peinture nouvelle" in *Les Soirées de Paris* (early version of ch. 3 of *The Cubist Painters*), again relating math and the 4th dimension to modern painting.

(July?) Henri Martin Barzun publishes the manifesto *L'Ere du Drame: Essai de Synthèse Poétique Moderne*, 142 pp. (written in 1911), "a manifesto-book" (Mitchell) presenting Unanimist-influenced concept of simultaneity and "modern poetic synthesis" (Barzun). Signed by: Alexandre Mercereau, Sebastien Voirol, Georges Polti, Apollinaire, Gleizes, Albert Doyen, Fernand Divoire, Florian Parpentier, Louis Mandin, Theo Varlet, Pierre Jaudon, and Tancrede de Visan.

22: Ravel's ballet *Adélaïde ou le langage des fleurs* premières at Théâtre du Châtelet.

MAY Picasso creates first collage: *Still Life with Chair Caning.*

13—10 JUN: Théâtre du Châtelet: Ballets Russes season begins with *Le Dieu Bleu*: music by Reynaldo Hahn, libretto by Jean Cocteau, sets and costumes by Bakst, choreography by Fokine; chief dancers: Nijinsky, Karsavina. Other premières include *Thamar* (20 MAY) and *Daphnis and Chloe* (8 JUN).

29: Théâtre du Châtelet: Ballets Russes gives première of *L'Après-midi d'un Faune*; music: Debussy; libretto: after Mallarmé's poem; choreography: Ni-

jinksy; sets and costumes: Bakst; dancers: Nijinksy (faune), Nelidova. Severe choreography (dancers moving laterally, standing in profile to suggest images in classical bas-relief) and Nijinsky's simulated orgasm over the nymph's scarf cause scandal and scathing reviews including front-page denunciation of "filthy and bestial . . . eroticism" in *Le Figaro.*

summer Rouen: Société Normande de Peinture Moderne exhibition includes future Section d'Or group. Maurice Raynal writes catalog essay.

JUN (late): Salle Gaveau: Futurist Valentine de Saint-Point's "conference on lust" erupts in riot, fistfights.

JUL Braque and Picasso paint together at Sorgues, create early collages. Braque creates first *papiers collé* (*Fruit Dish and Glass*), in which he uses commercial paper printed with imitation oak-grain pattern. Braque also begins mixing sand in his paint. Picasso soon adopts both of these innovations.

fall Apollinaire writes "Zone."

 Delaunay completes two major essays, "Light," and "Note on the Construction of the Reality of Pure Painting."

SEP Picasso and Eva Gouel move from Montmartre to Left Bank (242 Boulevard Raspail).

OCT (before): Archipenko creates his first "sculpto-painting" assembly, *Médrano I.* Rejected by Automne Salon.

OCT 01—08 NOV: Automne Salon: 20+ "Cubist" painters exhibit including: Kupka (*Amorpha: Fugue in 2 Colors* and *Amorpha: Warm Chromatic*), Léger (*Woman in Blue*), Picabia (*Dances at the Spring, La Source*), Gleizes (*Man on a Balcony*), Metzinger (*Dancer in a Café*), Gris, Mondrian, Rivera. A "Cubist House" designed by André Mare (interior) and Duchamp-Villon (architecture and facade) also displayed. Boccioni exhibits 7 sculptures. Apollinaire writes: "The Cubists . . . are no longer being mocked as they were last year. Now they are arousing hatred."

 02: Franz Marc and August Macke visit Delaunay; both are strongly influenced by Delaunay's nearly abstract *Windows* series and may have seen beginnings of the completely abstract *Discs.*

 10-30: Galerie de la Boëtie: Salon de "La Section D'Or" (organized by the Puteaux Group): 31 artists with Russian Alexandra Exter, 180 works including: M. Duchamp (6 paintings including *Nude Descending a Staircase* and *King and Queen Surrounded by Swift Nudes,* which Vauxcelles called the most offensive of the new Cubist painting), Kupka (*Nocturne, The Language of Verticals,* and *Complexes*),[2] Léger (oil sketch of *Woman in Blue*), Picabia (13 paintings including *Dances at the Spring*), Gleizes (15 paintings including *Harvest Threshing*), Metzinger (12 paintings), Villon (4 paintings including *Young Woman*), Gris (12 paintings including *Man in a Café, The Washstand*—a col-

lage with a real mirror, and *Bottle of Sherry and Watch*), Archipenko (sculpture), Duchamp-Villon (first floor of *Maison Cubiste*). Delaunay, Picasso, Braque, Le Fauconnier not included in show. *Vernissage* lasts until midnight.

Reverdy produced *Bulletin de la Section d'Or* for the exhibition. Cover of same lists 19 writers and critics as "Collaborateurs" with articles by Raynal, Apollinaire, and others.

Apollinaire's review claims that "[t]he Cubists, whatever individual tendency they belong to, are . . . the most serious and most interesting artists of our time" (*Bulletin de la Section d'Or*, 9 OCT). Exhibition was "the last great manifestation of the French avant-garde [in painting] before the war" (Altshuler 36).

11: Apollinaire gives lecture to accompany show, "The Quartering of Cubism," referring to his division of Cubism into 4 categories: "Scientific," "Physical," "Orphic," and "Instinctive." His book, *The Cubist Painters* (MAR 1913), makes the same division.

14: Apollinaire publishes "The Beginnings of Cubism" (*Le Temps*).

16: A Parisian municipal councilman, Pierre Lampué publishes in *Mercure de France* "An Open Letter to the Undersecretary for the Fine Arts" (Léon Bérard) protesting against using public building (the Grand Palais, where Autumn Salon held) to show Cubists: "a band of renegades who behave in the art world as Apaches do in everyday life." (*Picasso and Braque* 407)

25: Delaunay (in open letter to the critic Vauxcelles) publicly repudiates Cubism and denies any role in creating the style.

NOV Apollinaire lives at Delaunay's studio for six weeks; discusses with Delaunay the aesthetics of Orphism; Apollinaire writes "Windows" inspired by Delaunay's paintings of the same title.

(ca.): Blaise Cendrars returns from U.S.A., meets the Delaunays and Apollinaire, impresses them with his recently printed "Les Pâques à New York" ("Easter in New York").

Salmon publishes *The Young French Painters*, including the chapter "Anecdotal History of Cubism."

Barzun founds and edits *Poème et Drame* "to expound the tenets and principles of synthesis presented in *L'Ere du Drame*." Runs 10 issues (to JUL 1914).

Manifesto, "The New Architecture," signed by André Vera, published in *l'Architecte* (SEP, OCT-NOV).

DEC Apollinaire publishes "Notes: Réalité, peinture pure" (based on Delaunay's "Note") in *Les Soirées de Paris*, DEC 1912 and *Der Sturm*, trans. Paul Klee, DEC 1912.

Socialist Deputy Jean-Louis Breton protests in Chamber of Deputies against "buildings belonging to the nation to be used for demonstrations of such an

unmistakably anti-artistic and anti-national character" (reflecting growing French xenophobia against modernism and Cubism in particular).
Gil Blas announces that the sculptor Archipenko has formally broken with Cubist group and repudiated its principles.

Péguy publishes *Tapisserie de Sainte Geneviève et de Jeanne d'Arc* (for 423rd anniversary of deliverance of Orleans).

27: Gleizes and Metzinger publish *Du Cubisme*, excerpted in *Poème et Drame*, March 1913.

PARIS 1913

Archipenko creates his *Sculpto-Paintings*.
Duchamp begins *Bride Stripped Bare . . .*, creates his first "ready-mades," e.g., *Bicycle Wheel*.
Sonia Delaunay creates her first "simultaneous dress," also designs "simultaneous" furniture, wallpaper, lamp shades, and book covers.
Léger paints abstract *Contrast of Forms, Geometric Elements*.
Picasso creates series of constructions with diverse materials.
Constantin Brancusi sculpts *Mlle. Pogany*.

Debussy composes *Second set of Preludes for piano, 3 Poems of Stephane Mallarmé* (which Ravel orchestrates).
Satie composes *The Snare of Medusa, Automatic Descriptions* (3 piano pieces), *Desiccated Embryos* (3 piano pieces), and numerous other piano pieces.
Russolo gives concert using his *intonarumori*.

Henri Martin Barzun publishes *The Revolution of Modern Polyrhythms, Three Simultaneous Poems, Poétique d'un idéal nouveau* (pamphlet).
Romains publishes *Odes et Prières, The Friends*; wins Grand Prize of French Literature.
Marcel Proust publishes *Swann's Way*.
Maurice Barrès publishes *La colline inspirée*.
Ricciotti Canudo publishes *Les transplantés*.
Colette publishes *The Backstage of the Music Hall, The Hindrance* (or *Chain*).
Anatole France publishes *The Revolt of the Angels*.
Alain-Fournier publishes *Le grand Meaulnes*.
Francois Mauriac publishes *Young Man in Chains*.
Claudel writes *Protée*, a "satirical drama."
Georges Duhamel publishes *Le Combat*.
Édouard Dujardin publishes *Martha and Mary*.
Mercereau edits and publishes *Anthologie des Poètes Nouveaux*; preface by Gustav Lanson.
Rémy de Gourmont publishes *Literary Promenades* [Writings 1904-1913].

Jacques Rivière publishes *The Adventure Novel* (theory).
Arthur Cravan starts review *Maintenant, a parody of the avant-garde review*.

JAN 11: "Manifesto of Lust" signed by Valentine de Saint-Point.
(ca. mid-): Delaunay and Apollinaire travel to Berlin for opening of Delaunay's exhibition at Der Sturm gallery.

17—01 FEB: Galerie Berthe Weill: "Exposition Gleizes, Metzinger, Léger" (paintings and drawings), including Metzinger's *Still Life (4th dimension)*.

FEB Blaise Cendrars and Sonia Delaunay create *La Prose du Transsibérien et la petite Jehanne de France*, their "simultaneous book." Vriesen: "the book . . . created an international sensation when it appeared and gave rise to literary controversies in newspapers and magazines in Paris and outside France. It was exhibited in Paris, New York, St. Petersburg, Moscow, Berlin, London, and elsewhere" (Hoog, *Robert Delaunay* 58).

Ricciotto Canudo begins publishing *Montjoie!*, a journal that mixed modernism with cultural nationalism (Mitchell 172). Runs to JUN 1914.

MAR 17: Apollinaire publishes *The Cubist Painters: Aesthetic Meditations* from earlier articles and reviews (1908-1912), now revised to reflect his analysis of Cubism (see 11 OCT 1912) and his new fascination with Delaunay's abstraction (which Apollinaire calls "Orphic Cubism").

18: Apollinaire writes article in *Montjoie!* on Orphism, crediting Delaunay with first use of "simultaneism" (See Milan: 1 APR 1913 for Futurist rebuttal in *Lacerba*.)

19—18 MAY: Indépendants Salon, including: Gleizes, Metzinger, Kupka (*Plans verticaux III, Le Solo d'un trait brun*), Picabia (*Procession*), Léger, Delaunay (*Cardiff Team*) and his group (including Bruce), Brancusi and Laurens (sculptures). Apollinaire's review names the new trend presented there as "orphism, pure painting, simultaneity." Apollinaire also writes: "From Cubism there emerges a new Cubism. The reign of Orpheus is beginning" (*Montjoie!* 29 MAR). In a separate review, he names Delaunay, Léger, Gleizes, Laurencin, Metzinger, and Bruce as "aesthetic orphists."

Delaunay moves to Chateau Louveniennes outside of Paris, where he works on his *Discs* and *Circular Forms*; over the summer he attracts small group interested in his color theories, including Patrick Bruce, Marc Chagall, Arthur Frost, Georges Yacouloff, Vladimir Rossiné, and Alice Bailly.

spring Vladimir Tatlin visits Picasso's studio, where the latter's open-constructions, e.g., *Guitar*, influence the reliefs and counter-reliefs Tatlin creates and exhibits in Moscow.

APR 02: Saint-Saëns, Debussy, D'Indy, Fauré, and Dukas participate in the inaugural concert of the Théâtre des Champs-Elysées in Paris.

14-19: Galerie Bernheim Jeune: Matisse exhibits.

20: Apollinaire publishes *Alcools, Poèmes 1898-1913* sans all punctuation; frontispiece: Picasso's portrait of Apollinaire; 34 etchings by Marcousis.

MAY "Manifeste des Cahiers de l'art moderne" signed by Pascal Forthuny.

Péguy publishes *La Tapisserie de Notre-Dame.*

15—12 JUN: Ballets Russes's season, includes: Florent Schmitt's *La Tragédie de Salomé* (12 JUN).

15: Théâtre des Champs-Elysées: BalletsRusses's première of Debussy's one-act ballet, *Jeux*, about a flirtatious tennis trio; modern dress costumes and decor: Bakst, anti-traditional choreography: Nijinsky. Cool reception from critics.

29: Théâtre des Champs-Elysées: première of *Le Sacre du Printemps*; music: Stravinsky, costumes and set: Roerich, "primitivist" choreography: Nijinsky. This landmark work in twentieth century music produces a major riot between pro- and anti-Stravinsky partisans that thoroughly drowned out the music. Numerous reviews, mostly hostile.

summer Gris, Picasso, Braque summer at Céret.

JUN 20—16 JUL: Galerie de la Boëtie: Boccioni's first sculpture exhibition; includes "Catalog Preface for First Exhibition of Futurist Sculpture" (published 11 APR 1912).

JUN 21: Lecture by Marinetti, who reads his "parole-in-libertá" manifesto, causing huge uproar. 27 JUN: lecture by Boccioni.

27: "Manifesto of Poetic Simultaneism," signed by Henri Martin Barzun, published in *Paris-Journal.*

29: Apollinaire publishes *l'Anti-tradition futuriste: manifeste synthèse* with collaboration of *Lacerba* and *Montjoie!* Published in Italian in *Lacerba* (1, no. 18), 15 SEP, 202-3.

JUL 15: "Against Montmartre: Futurist Manifesto," signed by the painter Félix Del Marle, published in *Comoedia.*

AUG 07: "Bombe éléphant carafe" manifesto (parody of Apollinaire's of 29 JUN), signed by the painter Merodack-Jeaneau in *Gil-Blas.*

SEP Barzun publishes excerpts from *Hymne des Forces. A choric drama in 3 mansions* (155 pp.) in *Poème et Drame.*

OCT 27—08 NOV: Galerie Bernheim-Jeune: "Les Synchromistes: Morgan Russell and S. MacDonald-Wright." "Manifesto of Synchromism" (signed by both) accompanies exhibition (which was formerly in Munich). Among the works are Wright's *Synchromy in Green*, Russell's *Synchromy in Deep Blue-Violet.*

NOV 15—05 JAN 1914: Automne Salon, includes: Kupka's *Localization of Mobile Graphics I and II*; Picabia's *Edtaonisl, Ecclesiastical,* and *Udnie*; works by Gleizes, Metzinger, and Rivera.
Apollinaire takes over editing of *Les Soirées de Paris.*

15: Apollinaire publishes photos of 4 Picasso constructions in *Les Soirées de Paris.*

DEC 20: Valentine de Saint-Point, author of "Futurist Manifesto of Lust," performs evening of dance and poetry at Comédie des Champs-Elysées. Music by Satie and Debussy accompany colored lights projected on large cloth sheets.

Péguy publishes *Tapisserie d'Ève.*

PARIS 1914

Gris meets Matisse at Collioure, paints large number of still lifes.
Gleizes paints *Portrait of Stravinsky,* abandons Cubism for abstraction.
Picasso continues constructions in mixed media, e.g., *Glass of Absinthe* (with spoon and sugar cube).

Debussy composes *6 Antique Épigraphes* (piano 4 hands).
Ravel composes *Trio for piano, violin, cello* (begun 1913), orchestrates Schumann's *Carnival,* begins *Le Tombeau de Couperin* (finished 1917 after interruption due to the war), *2 Hebrew Melodies.*
Satie composes numerous piano pieces, including *Sports et Divertissements, 3 Waltzes of disgusting affectation.*
Stravinsky composes *The Nightingale* (lyrical story in 3 acts): rev. as *Song of the Nightingale* in 1917; begins *Les Noces* (finished in 1917), *Untershale* (choirs for women's voices; finished 1917); *Pribaoutki* (4 songs for middle voices and 8 instruments); *3 Pieces for String Quartet.*

Duhamel publishes *Poets and Poetry* (1912-1913).
Charles Vildrac publishes *Book of Love.*
Gide publishes *The Caves of the Vatican.*
Rémy de Gourmont publishes *Letters of an Amazon.*
Jacob publishes 3rd vol. of Saint Matorel trilogy with etchings by Picasso.
Francois Mauriac publishes *The Stuff of Youth.*
Performance of several plays by Claudel: *L'Échange, The Tidings Brought to Mary, The Hostage.*

JAN 14: Jacob publishes *The Siege of Jerusalem,* with etchings by Picasso.

FEB 09: "Manifeste de l'Art cérébriste," signed by Ricciotto Canudo, published in *Le Figaro* and in JAN-FEB issue of *Montjoie!* Manifesto does not announce a movement or group, but "summarized views of an important part of the avant-garde" (Mitchell 172): lauded cerebral art that opposed sentimentalism; declared "the necessity of the new" an aesthetic category (Hulten).

MAR 01—30 APR: Indépendants Salon includes Orphist group (all doing big, color-
ful, circular or disc-like works): Delaunay (*Homage to Bleriot* and *Solar
Discs*), Sonia Delaunay (*Prismes éléctriques*), Bruce (*Movement, Colors*), Frost
(*Soleils 'Simultanés'*); also: Synchromists, Picabia, Gleizes, Metzinger, Mar-
coussis, Rivera, other Cubists.

spring Apollinaire receives Marinetti's *Zang Tumb Tumb*.

APR —JUN: Larionov publishes "Pictorial Rayism" in *Montjoie!*

 06—03 MAY: Galerie André Groult: Duchamp, Duchamp-Villon, Gleizes,
Villon, Metzinger exhibit drawings and watercolors, Duchamp-Villon shows
sculptures; catalog text by André Salmon.

 16: "Manifeste du spectre spontané," signed by Russian painter Georgi Yakou-
lov, poet Benedict Livshits, and composer Vincent Lourié, and introduced by
Apollinaire, published in *Le Mercure de France*.

 20—03 MAY: Galerie Levesque: La Fresnaye exhibits.

 20—30 JUN: Galerie Levesque: Lehmbruck exhibits.

MAY Larionov and Goncharova arrive to create sets for Ballets Russes's production
of *Le Coq d'Or* in Rayist[3] style, receive much attention.

 Galerie Berthe Weill: Diego Rivera exhibits.

 Raymond Duchamp-Villon publishes "L'Architecture et le Fer" in *Poème et
Drame*.

 13-27: Galerie Vildrac: André Lhote exhibits.

 14—JUN: Théâtre National de l'Opéra: Ballets Russes's season begins with
The Legend of Joseph. Libretto: Kessler and Hoffmanstahl, music: Richard
Strauss, sets: by Sert, costumes: Bakst, choreography: Fokine. Other ballets
performed: *Le Coq d'Or* (24 MAY) and *Midas* (2 JUN).

JUN Galerie Berthe Weill: Metzinger exhibits.

 Apollinaire publishes "Lettre-Océan" (his first calligramme) in *Les Soirées de
Paris*, where he also publishes "Simultanéisme-Librettisme" (article).
"Déclaration Montjoie" published in *Montjoie* (APR-MAY-JUN). Apollinaire
quarrels with Barzun over the principles and application of "simultaneism"
(published in *Paris Journal*). Cendrars mixes into it, too, as does Delaunay.

 17-30: Galerie Paul Guillaume: Larionov and Goncharova have major exhibi-
tion, attended by major Paris artists and critics; Apollinaire writes catalog pref-
ace.

 26: Isadora Duncan dances.

AUG　　Claudel's first edition of *Corona* destroyed at the outbreak of the war.
　　　　01: France and Germany both mobilize for war. War declared two days later.

BERLIN 1909

MAR　　"Der neue Club" founded by Kurt Hiller (as literary secession from the Free Academic Society of Berlin). Members: Hiller, Ernst Blass, Erwin Loewenson, Jakob van Hoddis, Erich Unger, John Wolfsohn, Wilhelm S. Ghuttmann (or Guttmann).

BERLIN 1910

　　　　—1911: Die Brücke painters move to Berlin.
　　　　Salon Cassirer: Kokoschka has first one-artist show.

　　　　Else Lasker-Schüler publishes *Die Wupper* (written 1909).
　　　　Christian Morgenstern publishes poems, *Einkehr*.
　　　　René Schickelé publishes poems, *White and Red*.
　　　　Heinrich Mann's one-act play, *Variété*, performed.
　　　　Carl Sternheim publishes play, *Don Juan*.
　　　　Hermann Hesse publishes novel, *Gertrud*.
　　　　Rainer Maria Rilke publishes *The Notebooks of Malte Laurids Brigge*.

　　　　Heinrich Mann publishes manifesto, "Spirit and Act."

JAN　　—FEB 1911: Franz Pfemfert edits Berlin weekly, *Der Democrat*.

MAR　　Paul Cassirer begins the arts revue *Pan* with Wilhelm Herzog; Cassirer leaves it NOV 1911, and Alfred Kerr edits it until 1915.

　　　　03: Herwarth Walden begins publishing *Der Sturm* in Berlin and Vienna simultaneously as a weekly. Circulation rises quickly, claimed to be 30,000.[4] Initially newspaper is devoted to literature and social criticism, later adds arts commentary. Authors include August Strindberg, Richard Dehmel, Max Brod, René Schickelé, Adolf Loos, Heinrich Mann, Frank Wedekind.

MAY　　Kokoschka joins *Der Sturm* as illustrator; his drawings soon begin appearing, likewise his play, *Mörder, Hoffnung der Frauen* (which police had closed in Vienna).

　　　　Schoenberg's *George-Lieder* (composed 1908-1909) performed.

　　　　10—JUN: Galerie Maximilian Macht: first Exhibition of Neue Secession organized by Max Pechstein includes 27 artists and 56 works; artists include: Heckel, Kirchner, and Schmidt-Rottluff (2 works each), Nolde, Mueller, Pechstein (4 works).

JUN 01: Neopathetisches Cabaret opens (runs until 3 APR 1912) as part of Der neue
 Club. Organized by Kurt Hiller, Georg Heym, H. E. Jacob, Erwin Loewenson,
 Ernst Blass, Jakob van Hoddis.

JUL Neopathetisches Cabaret: Georg Heym's first poetry recital.

OCT 01—DEC: Galerie Maximilian Macht: Neue Secession graphics exhibition;
 artists include Nolde and Brücke painters.

 31: Schoenberg's *Pelléas and Mélisande* performed.

BERLIN 1911

Der Sturm begins reproducing works by Nolde, Kandinsky, Marc, Pascin, and
Morgner, reflecting its growing emphasis on Expressionist art. Walden popu-
larizes the term "expressionism" in reviews and essays.
Berlin Secession includes paintings by Picasso.
Kirchner, Heckel, Schmidt-Rottluff move to Berlin, make contacts with *Der
Sturm*; (-1912): Kirchner and Pechstein operate MUIM Institut (Institute for
Modern Instruction in Painting).
Karl Vinnen, a German painter, publishes *A Protest of German Artists*, a col-
lection of essays by German artists that object to the purchase of French art by
German galleries and museums, allegedly hurting German art and artists. (See
Munich 1911 for rebuttal, "The Battle for Art.")

Johannes Becher publishes poems, *Der Ringende*.
Georg Heym publishes his first book of poems, *Der ewige Tag*.
Else Lasker-Schuler publishes *Meine Wunder*.
Christian Morgenstern publishes poems, *Ich und Du*.
Georg Kaiser publishes play, *Die jüdische Witwe*.
Carl Sternheim publishes satirical play, *Die Hose* (which is quickly censored),
and *Die Kassette*.
Gerhart Hauptmann publishes play, *The Rats*.
Fritz Von Unruh publishes play, *The Officers*.
Albert Ehrenstein publishes stories, *Tubutsch*.
René Schickele publishes novella, *Meine Freundin Lo*.

JAN 11: Jacob Van Hoddis publishes one of the first and most influential Expres-
 sionist poems, "World's End," in *Der Demokrat* (under Franz Pfemfert's edi-
 torship).

 Die Brücke artists begin appearing regularly in *Der Sturm*; Kirchner's wood-
 cuts begin appearing second half of 1911.

FEB —APR: Galerie Maximilian Macht: third Neue Secession exhibition includes
 Brücke painters and Nolde; introduces to Berlin works by Kandinsky, Marc,
 and Jawlensky.

20: First issue of *Die Aktion* appears with verse by Heym. Franz Pfemfert, editor; principle collaborators: Georg Heym, Jacob Von Hoddis, Kurt Hiller, Ernst Blass, Lugwig Rubiner, Hugo Ball, Johannes Becher, Gottfried Benn, Ivan Goll, Ferdinand Hardekopf, Alfred Lichtenstein.

MAY Berliner Secession exhibition: Picasso and Braque included.

JUL Agadir crisis: Germany sends gunboat and troops to Morocco to protect German interests; Kaiser affirms Germany's "place in the sun." London settlement of crisis avoids war, but leaves all parties dissatisfied.

SEP: Schoenberg moves to Berlin.

16: *Pan*, Berlin arts magazine, publishes appeal for financial support "for Arnold Sch." signed by Ferrucio Busoni, Artur Schnabel, Alfred Kerr (*Pan*'s editor and Berlin's leading drama critic), and others.

NOV Heym, Hardekopf, Rudolph Blümner give poetry recital at Neopathetisches Cabaret.

18—31 JAN 1912: Galerie Maximilian Macht: fourth Neue Secession exhibition includes: Kubišta and NKV-Munich: Le Fauconnier, Kandinsky (4 paintings including *Composition IV* and *Improvisation No. 18*), Marc, Jawlensky, Münter, Werefkin, Kanoldt, Erbslöh.

23: Der literarische Club Gnu: Max Brod gives poetry recital; gives another for Die Aktion (15 DEC 1911) at "Max-Brod-Abend," which also introduces work of Franz Werfel to Berlin.

DEC Die Brücke members quarrel with and leave Neue Secession.
Neopathetisches Cabaret: Hoddis, Einstein, Walden, Kurz give poetry recital.

BERLIN 1912

Brücke artists (Heckel, Kirchner) create primitivist sculptures of wood, polychrome.

Ballets Russes performs.
Schoenberg composes *Herzgewachse*, Op. 20.
Richard Strauss composes *Ariadne auf Naxos* and first version of *Bourgeois gentilhomme*.

Ernst Blass publishes *Die Strasse komme ich entlang geweht*.
Georg Heym's poems *Umbra Vitae* published posthumously.
Klabund (Alfred Henschke) publishes poems *Morgenrot! Klabund! Die Täge dämmern*.
Else Lasker-Schüler publishes poems, *Mein Herz*.
Rilke writes *Duino Elegies*.
Ernst Barlach publishes play, *Der tote Tag*, with 27 lithographs by author.

Gerhart Hauptmann publishes *Gabriel Schillings Flucht*, wins Nobel Prize for Literature.
Albert Ehrenstein publishes stories, *Der Selbstmord eines Katers*.
Carl Einstein serializes experimental novel, *Bebuquin* in *Die Aktion*.
(-1913) René Schickele serializes novel, *Der Fremde* in *Die Aktion*.

Heinrich Wölfflin publishes *The Problem of Styles in Painting*.
Wilhelm Worringer publishes *The Form Problem of the Gothic*.

Germany renews Triple Alliance with Austria and Italy.

JAN 16: Georg Heym drowns.

FEB 04: Première of Schoenberg's *6 Piano Pieces*, Op. 19. Other Schoenberg works performed: five early songs, the George Songs (Op. 15), an eight-hand, two-piano arrangement of the *5 Pieces for Orchestra*.

16: Schoenberg's *3 Pieces for Piano*, Op. 11, performed by Richard Buhlig.

MAR Galerie Maximilian Macht: Neue Secession's 5th exhibition (graphic art, sculpture) includes Kandinsky, Macke, Morgner, and Czech artists Bohumil Kubišta, Vincenc Beneš, Emil Filla, Bedrich Feigl.[5]

Gottfried Benn's *Morgue und andere Gedichte* (poems) published by Alfred Meyer (in *Lyrische Flugblätter* series); receives immediately widespread condemnation by press.

Der Sturm publishes German translations of "Technical Manifesto of Futurist Painting" and Futurist "Foundation" manifesto.

12—10 APR: Der Sturm gallery: first *Sturm* painting exhibition, "Expressionists" includes: first Blue Rider exhibition from Munich (with Marc's *Yellow Cow* and Kandinsky's *Composition 4*), some Fauve painters, Munch, Kokoschka, Klee, Kubin, Jawlensky, Werefkin, Pechstein, Braque.

APR Galerie Fritz Gurlitt: Die Brücke exhibits.

12—early MAY: Der Sturm gallery: Futurists traveling exhibition. Artists and works include: Boccioni (*Street Enters the House, The Laugh, Simultaneous Visions, Strengths of a Street*), Carrà, Russolo, Severini. Delaunay is shown with them: *The Tower, The City No. 1, The City No. 2*. *Der Sturm* publishes German translation "The Artists to the Public," which, along with previous Sturm translations, Marinetti distributes around the city. The show is huge sensation in drawing thousands of viewers and numerous artists. Panned by conservative critics, it is praised by German modernists. Marc writes a eulogy on Carrà, Severini, and Boccioni in *Der Sturm*: "We shall envy Italy her sons and shall hang their works in our galleries" (no. 132, OCT, p. 187). Macke writes: "Modern painting can bypass these ideas even less than [those of] Picasso (Vriesen, *August Macke* 109). Walden and patron Wolfgang Borchardt quietly replace Marinetti as show's impresarios.

MAY Meidner begins painting his apocalyptic cityscapes.

Der Sturm gallery: third exhibition features: French graphic art featuring Gauguin, Picasso, Gris, Herbin.

Reinhard Sorge publishes *Der Bettler* (*The Beggar*) (part of which appears in *Pan*). Play wins Kleist Prize, considered the "first full-fledged Expressionist play."

JUN —JUL: Der Sturm gallery exhibits "German Expressionists" including: Marc, Kandinsky, Block, Jawlensky, Münter, Werefkin—works that were either rejected by or withdrawn from the Cologne Sonderbund exhibition.

AUG (ca.) Der Sturm gallery "French Expressionists" including Braque, Vlaminck, Derain, Friesz, Herbin, Laurencin.

SEP Schoenberg publishes *Five Orchestra Pieces*, Op. 16 (completed APR 1912); première: London: 03 SEP 1912.

OCT Full score of Schoenberg's *Pelléas and Mélisande* published.

01: Alfred Meyer's new journal, *Die Bücherei Maiandros*, begins publication (continues to 1915).

02: Der Sturm gallery: first Kandinsky retrospective (paintings from 1901-1912); formerly in Munich; moves on to other German cities, Rotterdam. Kandinsky publishes essay accompanying exhibition catalog that responds to hostile criticism.

16: Première of Schoenberg's *Pierrot Lunaire* (completed JUL 1912), conducted by composer: major success despite negative reviews of critics.

NOV 02-15: Der Sturm gallery: Die Pathetiker group—Ludwig Meidner (leader) and Jakob Steinhardt. Group name taken from Das Neopathetisches Cabaret of Der neue Club. Group disbands after exhibition.

Marinetti's Futurist poetry collected and published in first German translation (*Futuristische Dichtungen*) by Alfred Meyer with foreword by Rudolf Kurtz.

DEC Apollinaire publishes in *Der Sturm* "Réalité: Peinture pure" (second part of his essay "The Beginning of Cubism" and drawn from Delaunay's "Note on the Construction of the Reality of Pure Painting").

(ca.): Alfred Lichtenstein's first collection of verse, *Die Dämmerung*, published by Alfred Meyer.

Der Sturm gallery: Neue Secession's 6th and last show includes Kandinsky, Kubišta, Marc, Morgner; show moves to Düsseldorf in JAN 1913.

BERLIN 1913

Le Fauconnier has important retrospective at Galerie Gurlitt.
Kirchner writes "Chronik der Brücke," but other group members reject it as a collective statement; group dissolves.

Schoenberg completes *Die Gluckliche Hand*, Op. 18 (begun 1909).
Max Reger composes *4 Portraits after Arnold Boecklin*.

Gottfried Benn publishes poems, *Schoene, neue Gedichte*.
Ivan Goll publishes poems, *The Panama Canal*.
Else Lasker-Schuler publishes *Hebrew Ballads*.
Ernst Lotz publishes poems, *Und schöne Raubtierflecken*.
Georg Trakl publishes *Poems*.
Paul Zech publishes poems, *The Black District*.
Thomas Mann publishes *Death in Venice*.
Georg Heym's stories, *Der Diels*, published posthumously.
August Stramm creates "the cry drama." Stramm begins publishing in *Der Sturm*. By the time of his death in 1915 he will publish 75 poems, 7 plays, and two short monologues. Plays include: *Sancta Susanna*, *Rudimentär*, *Die Haidebraut*, *Erwashen*, *Kräfte*, *Geschehen*, and *Die Unfruchtbaren*.
Georg Kaiser publishes play, *König Hahnrei*.
Kokoschka publishes *Plays and Paintings*.
Georg Kaiser publishes play, *From Morning to Midnight*.
Carl Sternheim publishes play, *Der Bürgher Schippel*.
Fritz Unruh publishes play, *Ludwig Ferdinand, Prince of Prussia*.

Robert Musil moves to Berlin from Vienna to edit monthly periodical, *Die Neue Rundschau*.
Max Brod edits anthology, *Arkadia*, with Kurt Wolf.
Das neue Pathos (revue) founded by Hans Ehrenbaum-Degele, Paul Zech, Ludwig Meidner, and Robert Schmidt.

JAN —FEB: Max Beckmann has major exhibition at Salon Cassirer (part of group show).

27—20 FEB: Der Sturm gallery: Delaunay has major exhibition (with Ardengo Soffici and Julie Baum). Delaunay's work includes: 13 of the *Windows* series, *The 3 Windows, the Tower, and the Ferris Wheel*, and *Simultaneous Contrasts*.[6] To accompany exhibition, Delaunay publishes album of 11 plates and Apollinaire's poem "The Windows." Exhibition moves to Cologne in FEB, Budapest in MAY.

Delaunay and Apollinaire attend the opening in Berlin. Both lecture at *Der Sturm* gallery (Apollinaire on "Modern Painting," 28? JAN); both drew "enthusiastic response" (Selz). Delaunay's article "Sur la lumière," translated by Klee, is published in *Der Sturm*. Delaunay's work profoundly influences Macke, Marc, and Klee, but Delaunay himself is likely influenced by Kandinsky's non-objective paintings. Apollinaire and Delaunay visit Macke in Bonn on return to Paris.

FEB Galerie Fritz Gurlitt: Max Pechstein exhibits.

Apollinaire's "The Modern Painters" (which proclaims Orphism and describes Picasso's collages) published in *Der Sturm*.

MAR Walden visits Paris (Delaunay especially) to select paintings for his large Autumn salon.

—APR: Der Sturm gallery: Marc retrospective. Shows by Klee, Hans Arp, Severini, and Archipenko follow.

spring Café Josty: Marinetti's 2nd lecture in Berlin (sponsored by Walden).

APR Der Sturm gallery: Moderner Bund exhibits including works by Klee.

JUN —AUG: Der Sturm gallery: Severini exhibits.

11: Franz Marc's woodcuts begin appearing in *Die Aktion*.

SEP Kandinsky publishes essay, "Painting as Pure Art," in *Der Sturm*.

Der Sturm gallery: Alexandre Archipenko exhibits; catalog essay by Apollinaire.

20—01 DEC: Der Sturm gallery: "Erster deutscher Herbstsalon" organized by Walden, Marc, Macke, Kandinsky, Klee, Delaunay: 366 paintings and sculptures, 85 artists—all but one (Rousseau with 22 works) living—including: Italian Futurists, Russians (Larionov, Goncharova, Burliuk brothers, Kulbin, Archipenko, Chagall), Dutch, Austrian, Swiss, Czech (Filla, Gutfreund, Procházka). Cubist School painters well represented (Gleizes, Léger, Metzinger, Marcoussis, Picabia), but Picasso or Braque missing. 22 works by Delaunay, including *Windows on the City, Circular Forms: Sun and Moon* (several versions), *Cardiff Team* (3rd version), his first "simultaneous" sculpture and other "simultaneous" objects; Sonia Delaunay and Blaise Cendrars (*La Prose du Transsibérien*), numerous Blue Rider works (including Kandinsky's nonobjective *White Edge* and Marc's *Tyrol, Animal Destinies, Tower of Blue Horses*), Macke, Arp, Ernst, Feininger, Chagall, Larionov (*Sea Beach and Woman*). Show severely criticized in the press. Selz: "the last of the significant international exhibitions of contemporary art held in Germany before World War I" (*German Expressionist Painting* 265). Delaunays, Chagall, Arp, Cendrars, Marc, Macke attend opening.

29: Cendrars speaks on "Today, the Spirit of the New Man."

OCT Galerie Fritz Gurlitt: Pechstein retrospective.

Der Sturm gallery: Prague "Group of Plastic Artists" (Filla, Čapek, Gutfreund, and Hofman) exhibit.

NOV Galerie Fritz Gurlitt: Kirchner and Matisse retrospective.

Der Sturm gallery: "Expressionists, Cubists, Futurists" (includes Czech Cubists, "Group of Plastic Artists").

DEC Marc paints first of his completely abstract *Small Compositions*.

Der Sturm gallery: Albert Bloch exhibits.

Der Sturm gallery publishes album of Kandinsky's works.

BERLIN 1914

Pechstein voyages to South Sea Islands.

Max Reger composes *Variations on a theme of Mozart*.

Johannes Becher publishes poems, *Verfall und Triumph*.
Albert Ehrenstein publishes *Die weisse Zeit*.
Ivan Goll publishes poems, *Films*.
Max Herrmann-Neisse publishes *Sie und die Stadt*.
Heym's *Marathon* is published posthumously.
Hans Johst publishes first book of poems.
Wilhelm Klemm publishes antiwar Expressionist poems in *Die Aktion*: *Battlefield Poetry*.
Else Lasker-Schüler publishes poems, *The Prince of Thebes*.
Christian Morgenstern publishes poems, *Wir fanden einen Pfad*.
René Schickele publishes poems, *Die Leibwache*.
Ernst Stadler publishes *Der Aufbruch*.
Alfred Wolfenstein publishes poems, *Die gottlosen Jahre*.
Paul Zech publishes book of poems, *The Iron Bridge*.
Hermann Hesse publishes *Rosshalde*.
Heinrich Mann publishes *The Vassal*.
Thomas Mann publishes *Tonio Kröger*.
René Schickele publishes novel, *Benkal, der Frauentröster*, and novella, *Trimpopp und Manasse*.
Walter Hasenclever publishes Expressionist play, *Der Sohn*.
Gerhart Hauptmann publishes play, *The Bow of Ulysses*.
Georg Kaiser publishes play, *The Burghers of Calais*.
Carl Sternheim publishes satirical plays, *Der Snob* and *Der Kandidat*.

JAN (ca.): Der Sturm gallery exhibits "Der Blaue Reiter"—the group's last joint exhibition—along with Werefkin, Heckel, Kirchner, and Pechstein.

Galerie Fritz Gurlitt: Otto Mueller exhibits.

FEB Der Sturm gallery: Jawlensky exhibits.

MAR 20—10 APR: Galerie Fritz Gurlitt: Adolph Erbslöh and Erich Heckel retrospective.

Neue Jugend, arts journal, appears; folds with 6th issue in DEC.

APR Stramm's poems first appear in *Der Sturm*.

Der Sturm gallery: Paul Klee exhibits.[7]

16—10 MAY: Galerie Fritz Gurlitt: Alexander Kanoldt, Karl Schmidt-Rottluff retrospective.

JUN Der Sturm gallery: Marc Chagall exhibits.

Neue Galerie: "Rheinische Expressionisten" exhibition.

AUG —OCT: Der Sturm gallery: Futurists exhibit (Boccioni, Carrà, Russolo, Severini).

Paul Cassirer begins new journal, *Kriegzeit* (runs till JAN 1916).

MUNICH 1909

JAN Neue Kunstlervereinigung (NKV) cofounded by Kandinsky (elected president) and Erbslöh; membership is multinational and includes sculptors, musicians, dancers, poets: Kandinsky, Marc, Jawlensky, Werefkin, Münter, Alfred Kubin, and others. Group's primary aesthetic principle: to find forms expressing *synthesis* of outer-world impressions and "events" from artist's inner world.

DEC 1-15: Moderne Galerie Thannhauser: first NKV exhibition (10 painters, 1 sculptor, 1 graphic artist) including: Kandinsky, Jawlensky, Werefkin, Münter, Kubin, Kanoldt, Erbslöh. "No similarity of style" (Selz). Poor critical reception, but aroused enough interest for German tour.

MUNICH 1910

Kandinsky paints his first completely abstract work, an untitled watercolor.
Kandinsky completes *Concerning the Spiritual in Art*.
Frank Wedekind publishes play, *Schloss Wetterstein*.

JAN Galerie Brackl: Marc has his first exhibition, meets publisher Reinhard Piper, who invites him to submit lithographs for his book, *The Animal in Art*. Through Macke, Marc acquires a patron, Bernard Koehler, who subsidizes Marc in exchange for more depictions of animals.

summer Exhibition of Islamic art.

SEP 1-14: Moderne Galerie Thannhauser: 2nd NKV exhibition with much larger international component including: Picasso (3 works inc. *Head of a Woman*),

Braque (*L'Estaque*), Le Fauconnier, Derain, David and Vladimir Burliuk, Rouault, Redon, etc. Kandinsky shows 4 paintings including *Composition No. 2, Improvisation No. 10.*[8] Participating artists permitted to write statements in catalog (anticipating mode of *Blaue Reiter Almanac*), e.g., Le Fauconnier's important "Das Kunstwerk." Public and press response extremely hostile: the public spat at the Kandinskys; Munich authorities considered closing show, especially with its emphasis on "foreign" artists. Only Hugo von Tschudi (director of painting collections of Bavaria) and an unknown Munich painter, Franz Marc, publicly supported the exhibition, Marc via a polemical letter which the NKV prints in a pamphlet as rebuttal to a savage review. Marc and Macke meet Kandinsky at this time.

MUNICH 1911

Kandinsky paints series of nonobjective works, e.g., *Compositions No. 4 and 5, Improvisation No. 22, Impression V, Troijka, Lyrisches.*
Marc paints *Yellow Cow, Red Horses.*
NKV polarizes into more conservative group, led by Adolf Erbslöh and Alexander Kanoldt, and more radical wing including Kandinsky (who resigns presidency) and Marc.
Kandinsky writes "On Stage Composition."
Campondonk comes under influence of Blue Rider painters, exhibits with them.
Klee joins with Marc, Macke, Kandinsky, Arp, Campendonk, and Münter.
Wedekind publishes play, *Franziska.*

A Protest of German Artists, organized by painter Carl Vinnen in 1911, prompts an immediate collective rebuttal from artists (including Kandinsky and Marc), art historians, museum directors, and art dealers, published as *The Battle for Art: Reply to the Protest of German Artists*. Part of Marc's essay declares: "Today a powerful wind is spreading the seeds of a new art across the whole of Europe" (Vezin 118).

JAN 01: Kandinsky and Marc attend concert of Schoenberg's works, incl. *2nd String Quartet, 3 Piano Pieces*, Op. 11, which inspires Kandinsky to write Schoenberg, exploring their common view of nonobjective art (expression of "inner processes, inner images"—Schoenberg). Marc (letter to Macke): "Can you conceive of music in which tonality is completely abolished? It kept reminding me of the great creation by Kandinsky which leaves not the slightest trace of tonality ... and of the leaping splashes in some of his works when I heard such music in which each intonation given is a kind of white linen screen stretched betw. the splashes of colors" (qtd. in Vezin 110). Concert also inspires Kandinsky's *Impression III—Concert.*

JUN 19: Kandinsky and Marc form Der Blaue Reiter; begin planning publication of an almanac; they start inviting other artists, like Delaunay, to participate.

Moderne Galerie Thannhauser: Klee exhibits work.

SEP 01: Kandinsky receives an Italian Futurist manifesto (apparently on music); sends letter to Marinetti.

 14: Kandinsky meets Schoenberg for first time (as Schoenberg is moving to Berlin), invites Schoenberg to participate in the Blaue Reiter exhibition.

 29: Kandinsky writes to Schoenberg's student-colleague, Alban Berg, inviting him to submit short composition for *Blaue Reiter Almanac*; Webern likewise.

DEC 02: Kandinsky and Marc break from NKV, whose jury rejected Kandinsky's *Composition No. 5: The Last Judgment* for 3rd NKV exhibition; Münter, Kubin, Thomas von Hartmann, and Henri Le Fauconnier support them.

 04: Moderne Galerie Thannhauser: third NKV exhibition. Painters include Erbslöh, Kanoldt, Jawlensky, Werefkin.

 18—03 JAN 1912: Moderne Galerie Thannhauser: "First exhibition of the Editors of the Blaue Reiter": 50 works by 14 artists invited by Kandinsky and Marc including: Kandinsky (*Composition No. 5, Improvisation No. 22, Impression II: Moscow*), Marc (*Blue Horses, Landscape and Deer, Cows (red, green, yellow, Yellow Cow*), Albert Bloch (6 paintings), Alfred Kubin, Delaunay (1 *Eiffel Tower, The City No. 2, The City [No. 1]*, 1 *St. Séverin*), Macke (*Girl Playing a Lute, Storm, Indians on Horseback*), Rousseau (3 works including *Street with Chickens*—first time his work shown in Germany), Schoenberg (1 landscape, 1 self-portrait, and 2 "visions"), D. and V. Burliuk, Heinrich Campendonk, Eugen Kahler, Gabriele Münter (6 paintings), J. B. Niestlé, Elizabeth Epstein. Exhibition moves on to Cologne (Gereons club, JAN), then Berlin (Der Sturm gallery, MAR-APR 1912), Hagen and Frankfurt.[9]

 (ca.) 25: Kandinsky publishes *Concerning the Spiritual in Art* (which bears a 1912 publication date). An abridged version is read to 2nd Russian Congress of Artists in St. Petersburg this same month. By 1914 it will go through 3 German editions, be translated into Russian and English, and selections will be printed in Stieglitz's *Camera Work* (JUL 1912) and the Vorticists' *BLAST* (no. 1, 1914).

MUNICH 1912

 NKV breaks up.

JAN 01: Marc travels to Berlin, meets Die Brücke painters and wants to include them in the next Blaue Reiter exhibition.

FEB 12—APR: Hans Golz gallery: "Second Exhibition of the Editors of the Blaue Reiter: Black-White." 315 items (graphic arts, drawings, and watercolors) from more international group of artists, who include: Kandinsky (12 watercolors), Marc (5 animal studies), Die Brücke group—Kirchner (31 drawings), Heckel (28 works), Nolde (17 pieces), Pechstein (38 works), Mueller (14 works)— Hans Arp, Paul Klee (17 works) and Der Moderne Bund (Swiss painters,

Wilhelm Gimmi, O. Lüthy, Walter Helbig), Wilhelm Morgner, Moriz Melzer, Georg Tappert (from Berlin's Neue Secession), Braque, Picasso (5 works dating back to 1902), La Fresnaye, Derain, Vlaminck, Malevich, Larionoff, Goncharova. Its internationalism rebuffs the much publicized Vinnen *Protest* (see 1911).

MAR? Marc publishes "The New Painting" in *Pan* magazine, states: "We seek and paint this inner, spiritual side of nature ['the things hidden behind the veil of appearances']. [The new painting was] no Parisian phenomenon [but] a European movement."

APR Klee travels to Paris, meets Cubist School painters and Delaunay.

MAY First edition of *The Blaue Reiter Almanac* published (144 pp.): 19 articles and essays, 144 reproductions of art of several countries and cultures: glass painting, Bavarian and Russian votive pictures, medieval art, Oriental art, Egyptian shadow-play figures, African masks, pre-Columbian art, Malayan, Easter Island and children's drawings. Reproductions of paintings by Blaue Reiter artists, Die Brücke, Kokoschka, Gauguin, Cézanne, van Gogh, Rousseau, Matisse, Picasso, Delaunay, Le Fauconnier, Rousseau (6 works). "Established connections among artists in all countries . . . and broke through periods and genres, searching solely for the inner spirit that motivated the result (Selz, *Art in a Turbulent Era* 84).

Also contained: Kandinsky's essay, "On the Question of Form"; Schoenberg's "The Relation to the Text"; lieder by Schoenberg, Webern, and Berg; 4 articles on modern music (one by Schoenberg) including an analysis of Scriabin's *Prometheus*, Kandinsky's *The Yellow Sound* (an abstract "script" encompassing drama, music, and painting). Selz: "essentially the book was a declaration of the artistic ideas of the young expressionist painters and musicians" (*GEP* 221). First edition of 1,500 sold out; 2nd edition of 6,000 published in 1914.

SEP Hans Goltz gallery: Kandinsky has major retrospective (1902-1912). Show travels to Berlin (Der Sturm gallery) in OCT, to Rotterdam in NOV.

 (late): Marc and Macke view Sonderbund Exhibition in Cologne (Marc praises to Kandinsky works by Munch, Heckel, Picasso, and especially Matisse).

OCT (ca. 01): Macke and Marc then travel to Paris, where they visit Delaunay's studio (2 OCT) and are deeply influenced by his work. On return trip, Marc helps hang the traveling Futurist exhibition at Gereons club in Cologne—his first direct contact with their work and another powerful influence. Marc's style becomes more angular, planar, and transparent, e.g., *Picture with Cattle*, *Tiger*, *In the Rain*.
 Goltz Gallery: Group Exhibition : 40 painters from Berlin, Munich, Paris.

NOV Golz Gallery: Futurists' traveling exhibition.

 4-30: Der Neue Kunstsalon: Nolde retrospective (49 works).

MUNICH 1913

Marc's work incorporates apocalyptic themes, continues mix of intersecting color planes and curves (e.g., *Stables*); paints *Fate of the Animals, The Tower of Blue Horses, The Poor Land of Tyrol, Tyrol*, the nearly abstract *Small Composition I*.
Kandinsky, Marc, Klee (and others) collaborate on Blaue Reiter project to illustrate a volume of the Bible, plan second edition of the *Almanac*.

Die Neue Kunst (review) founded by Johannes Becher (ends in 1914).
Revolution (review) founded by Hans Leynold, features poem by Hugo Ball, "Der Henker," which provokes seizure of first number.

FEB Moderne Galerie Thannhauser: major Picasso retrospective: 114 works from 1901-1912; show moves to Prague and Berlin.

MAR 16—04 APR: Hans Goltz gallery: Moderner Bund Schweiz exhibits; moves to Berlin (Der Sturm gallery) 26 APR.

APR Der neue Kunstsalon: Gabriele Münter exhibits.
 14-30: Hans Goltz gallery: Amiet, Giacometti exhibit.

JUN 01-30: Der neue Kunstsalon: "Synchromists" (Morgan Russell and Stanton Macdonald-Wright) hold their first exhibition, which then moves to Paris.

 25—12 JUL: Hans Goltz gallery: Egon Schiele exhibits.

AUG —SEP: Hans Goltz gallery: Group Exhibition: 60 painters including Braque, Picasso, Gleizes, Gris. André Salmon writes a catalog preface.

fall Kandinsky publishes *Klänge*: 38 hand-printed prose poems accompanied by 12 color and 44 black-and-white woodcuts.

MUNICH 1914

Kandinsky, Marc, Klee, and Hugo Ball plan Blaue Reiter book on the new theater, but abandon it when WWI begins.
Wedekind publishes play, *Simson oder Scham und Eifersucht*.

JAN Moderne Galerie Thannhauser: Kandinsky has one-artist show.

MAR Marc's work moves into complete abstraction, continues apocalyptic themes, e.g., *Fighting Forms, Broken Forms, Small Composition II*.

MAY 2nd edition of *Blue Rider Almanac* published with new prefaces by Marc and Kandinsky. Marc plans second volume, writes an introduction, but gets no further.

27: *Almanac* inspires Hugo Ball to plan similar avant-garde book, called *The New Theater*, with Kandinsky, M. Hartmann, Fokine, etc., to include architecture, scene paintings, music, figurines, etc. Ultimately, he hopes group will found an "International Society for Modern Art," supporting modernist creation in theater, painting, music, dance.

30—01 OCT: Galeriestrasse 26: New Munich Secession (which Klee helps found) holds first exhibition.

summer Hans Goltz gallery: group exhibition: 45 painters, 12 sculptors.

LONDON 1909

MAR 25: [new] Poets' Club founded by T. E. Hulme at Eiffel Tower restaurant as split-off from more conservative Poets' Club; members: F. S. Flint, Alan Upward, Edward Storer, F. W. Tancred, Florence Farr, Joseph Campbell. Ezra Pound joins following month, later refers to group as "the forgotten School of 1909."

APR Ezra Pound publishes *Personae* (Elkin Mathews); reviewed favorably by Edward Thomas in Ford Madox Hueffer's *English Review*.

 22: Pound reads "Sestina: Altaforte" at Poets' Club meeting; publishes it in *English Review* in JUN.

OCT Ezra Pound publishes *Exultations*.

LONDON 1910

John Masefield publishes *Ballads and Poems*.
Pound publishes *The Spirit of Romance, Provença*.
William Butler Yeats publishes *The Green Helmet and Other Poems*.

E. M. Forster publishes *Howards End*.
Henry James publishes *The Finer Grain* (5 stories).
Ford Madox Ford publishes *A Call* and *The Portrait* (novels), and *Songs of London* (poems).

APR Marinetti reads first Futurist manifesto at Lyceum Club.

JUN Pound publishes *The Spirit of Romance*.

 15—22 FEB 1911: Pound returns to United States.

AUG Douglas Goldring's review, *The Tramp*, publishes parts of Marinetti's 1909 manifesto, his "Against Past-Loving Venice," and a short story by Wyndham Lewis.

NOV Pound publishes *Provença* (first book of poems published in U.S.)

08—15 JAN 1911: Grafton Galleries: London's first major modernist exhibition: "Manet and the Post-Impressionists," organized by Roger Fry, includes: Picasso's Cubist *Portrait of Clovis Sagot*, Derain, Matisse, Redon, and large showings of Gauguin, Cézanne, and Van Gogh. Largely in response to this exhibition, Virginia Woolf wrote: "On or about December 1910 human nature changed. . . . All human relations shifted."

LONDON 1911

Rupert Brooke publishes *Poems*.

Joseph Conrad publishes *Under Western Eyes*.
D. H. Lawrence publishes *The White Peacock*.
Katherine Mansfield publishes *In a German Pension* (writings 1909-1911).
H. G. Wells publishes *The New Machiavelli, The Country of the Blind, The Door in the Wall*, and "The Contemporary Novel."
John Galsworthy publishes end of *The Forsythe Saga*.
Ford Madox Hueffer publishes *Ladies Whose Bright Eyes* (novel), *Ancient Lights* (reminiscences; aka *Memories and Impressions*); *The Critical Attitude* (criticism).

J. Middleton Murray and Katherine Mansfield publish magazine *Rhythm*, later renamed *Blue Review*, which includes drawing of the French expatriate sculptor Henri Gaudier-Brzeska.
F. S. Flint publishes influential article, "Contemporary French Poetry," in *The New Age*.

JUN Carfax Gallery: Camden Town Group's first exhibition, includes 2 works by Wyndham Lewis.

21—31 JUL: Ballets Russes performs.

JUL Pound publishes *Canzoni*.

AUG J. M. Murray publishes article on Picasso in *Rhythm*; 2 months later, he publishes another one on Picasso in *The New Age*. Murray also publishes article on Bergson's influence on English poetry: "Art and Philosophy" in *Rhythm* (summer 1911).

OCT Pound begins series of contributions to *The New Age*.

NOV Stafford Gallery: Gauguin and Cézanne exhibition.

16—09 DEC: Ballets Russes performs, including *Firebird*.

DEC Carfax Gallery: Camden Town Group's second exhibition, includes works by Duncan Grant, Lewis.

LONDON 1912

Lewis paints *The Vorticist* (watercolor).
"Friday Club" exhibition includes Frederick Etchells, Christopher Nevinson, Helen Saunders, and Edward Wadsworth.

Georgian Poetry published. Edited by Edward Marsh. Includes: Brooke, Abercrombie, Bottomley, Flecker, Drinkwater, Davies, Gibson, Masefield, Monro, Squire. Four more Georgian anthologies will appear through 1922.
Yeats publishes *Poems Written in Discouragement* and *The Cutting of an Agate*.
Pound publishes *The Sonnets and Ballads of Guido Calvalcanti.*
John Masefield publishes *The Window in the Bye Street*, wins Polignac Prize for *The Everlasting Mercy*.
Isaac Rosenberg publishes *Night and Day*.
Ford Madox Ford publishes *High Germany* (poems), *The Panel* (novel), *The New Humpty-Dumpty* (satirical novel).
Shaw publishes *Pygmalion*, finishes *Androcles and the Lion*.
Conrad publishes *The Secret Sharer*.
Lawrence publishes *The Trespasser*.

Poetry Review founded by Harold Monro; becomes *Poetry and Drama* in 1913; runs to 1914.
F. S. Flint publishes "Contemporary French Poetry," influential series of articles in *Poetry Review*.

MAR 01: Sackville Gallery: Futurist traveling exhibition opens (organized by Meyer-See). Catalog contains: "Technical Manifesto of Futurist Painting" and "From the Exhibitors to the Public." Exhibition draws large crowds and many reviews, most hostile; exception: Max Rothschild's in *Pall Mall Gazette*, 4 MAR, 8.

 19: Bechstein Hall: Marinetti lectures.
 (ca.) before Aug: Pound begins to organize Imagist movement.

APR 23: Stafford Gallery: Picasso exhibits.

JUN 12—01 Aug: Ballets Russes performs.

AUG Pound publishes *Ripostes*, which mentions "Les Imagistes" for the first time; refers to the group several times in *Poetry* from NOV through MAR.

SEP 03: Schoenberg's *5 Pieces for Orchestra* receives première at "Prom." Concert (Henry Wood conducting). Mostly negative response, but one open-minded review by Ernest Newman.

OCT 05—31 DEC: Grafton Galleries: Second Post-Impressionist Exhibition organized by Roger Fry; includes Picasso, Braque, Larionov, Goncharova. Charles Vildrac speaks on the Unanimist poets.[10]

DEC Carfax Gallery: 3rd exhibition of Camden Town Group; moves to Brighton, 16 DEC.

LONDON 1913

Cubist exhibition at Grafton Gallery.
Formation of London Group of Artists (Camden Town Group and "Cubists" like Lewis; Harold Gilman, president).
Lewis paints *Composition, Cactus, Timon of Athens*.

D. H. Lawrence publishes *Love Poems, and Others*.
J. G. Fletcher publishes several books of poems (*The Dominant City, Fire and Wine, Fool's Gold, The Book of Nature*, and *Visions of Evening*).
R. Tagore publishes *Gitanjali* (with introduction by Yeats).
Ford Madox Hueffer publishes *Collected Poems, The Young Lovell* (novel), *Mr. Flight* (novel), *A Ring for Nancy* (novel), and *The Desirable Alien* (with Violet Hunt, travel impressions).

Conrad publishes *Chance*.
Lawrence publishes *Sons and Lovers*.
Compton Mackenzie publishes volume 1 of *Sinister Street*.
H. G. Wells publishes *The Passionate Friends* and *The World Set Free*.

Shaw's *Pygmalion* receives première; Shaw writes *Great Catherine*.

JAN —FEB: David Bomberg, Christopher Nevinson, and Edward Wadsworth contribute to "Friday Club" exhibition.

FEB 04—07 MAR: Ballets Russes performs *Petrouchka, L'Après-midi d'un Faune, Le Dieu Bleu*.

MAR Pound publishes Imagist manifestos in *Poetry*: "Imagisme" (ostensibly authored by F. S. Flint) and "A Few Don'ts by an Imagiste."

 15-31: Grafton Group Exhibition at Alpine Club Gallery.

APR Roger Fry founds Omega Workshops with announcement in *Art Chronicle*: "a new movement in decorative art." Workshops officially open in JUL 1913.

 07: Marlborough Gallery: Gino Severini exhibits. Horace Samuel publishes essay "The Future of Futurism" in *The Fortnightly Review*.

JUN "An English Imagiste Manifesto," signed by E. G. Craig, published.

 Poetry and Drama republishes Imagist manifestos.

 Ballets Russes performs *Le Sacre du Printemps*.

13: *The New Freewoman: An Individualist Review* begins publishing, edited by Harriet Shaw Weaver and Dora Marsden. Continues for 13 issues until DEC 1913, when Pound persuades Weaver to change journal's title and focus away from feminism and toward modernism.

JUL —OCT: Amy Lowell arrives in London to meet with Pound, Imagists, and other poets.

AUG *The New Freewoman* republishes Imagist manifestos and contrasts Imagists with Georgians.

SEP *Poetry and Drama* devotes an entire issue to Futurism, including Marinetti's manifesto "Destruction of Syntax—Wireless Imagination—Words-in-Freedom."

(ca.): Poetry Bookshop: Marinetti speaks on "The Imagination without Strings and Words in Freedom." Harold Monro (proprietor of the Bookshop and editor of *Poetry and Drama*) declares himself a Futurist.

Pound publishes "The Approach to Paris" (on new French poetry) in *The New Age* (SEP-OCT).

OCT 05: Lewis, Etchells, Wadsworth, and Hamilton walk out of Fry's Omega Workshops and form "Rebel Group," invite Nevinson to join.

12—16 JAN 1914: Doré Galleries: third "Post-Impressionists and Futurists" exhibition, dominated by Italian Futurists, includes "Rebel Group" (with Epstein) and Picasso.

NOV 14-20: Marinetti gives Futurist evenings at several clubs and galleries, attended by Lewis, Aldington, Nevinson, Monro, etc. 18 NOV: Banquet for Marinetti given by Etchells, Hamilton, Wadsworth, Nevinson, and Lewis at Florence Restaurant, where Marinetti recites "Siege of Adrianople." Marinetti declaims same poem at Doré Galleries (gives 10 lectures in London between NOV 1913 and JUL 1914).

"The Variety Theater" (Futurist manifesto) published in the *Daily Mail.*

Pound acts as Yeats's secretary at the Stone Cottage, Sussex. Repeats service, winter of 1914-1915.

winter Gaudier-Brzeska and William Roberts affiliate with Omega Workshops.

DEC Pound refers to "the Vortex" in letter to William Carlos Williams.

Lewis begins planning *BLAST*.

Goupil Gallery: Jacob Epstein has first one-artist show. Hulme responds to negative criticism in his review in *The New Age*; Pound reviews show as "call to arms" in *The Egoist* (MAR 1914).

16—14 JAN 1914, Brighton: Public Art Galleries: Camden Town Group exhibition including "Cubist Room" (Lewis's Rebel group); Lewis writes separate text for "Cubist Room."

LONDON 1914

Rupert Brooke publishes sonnet cycle, *1914*.
John Gould Fletcher publishes several books of poems.
Robert Graves publishes his first book of poems.
Thomas Hardy publishes poems, *Satires of Circumstance*.
Weber publishes *Cubist Poems* (Elkin Mathews, publisher).
Yeats publishes *Responsibilities: poems and a play*.
Conrad publishes *Victory* and *Chance*.
Forster completes *Maurice*.
Joyce publishes *Dubliners*.
Lawrence publishes *The Prussian Officer and Other Stories*.
Mackenzie publishes vol. 2 of *Sinister Street*.
Virginia Woolf writes *The Voyage Out*.

JAN Alpine Club Gallery: Grafton Group's second exhibition, includes Gaudier-Brzeska and Roberts.

01: *The Egoist* (formerly *The New Freewoman*) begins, edited by Harriet Shaw Weaver. Runs until DEC 1919.

15: *The Egoist* begins serializing Joyce's *A Portrait of the Artist as a Young Man*.

17: Schoenberg conducts *5 Pieces for Orchestra* at Henry Wood Promenade Concert. Both Schoenberg and *Pieces* well received.

22: Hulme lectures on "Modern Art and Its Philosophy."

FEB Clive Bell publishes *Art*.

Modern German Art exhibition.

Bomberg and Nevinson contribute to Friday Club exhibition.

MAR Doré Galleries: Marinetti lectures, sponsored by Lewis's "Rebels Artists."

Rebel Art Centre opens.

Ballets Russes season begins.

Walter Sickert exchanges hostile articles with Lewis and Nevinson in *The New Age*.

—APR: Goupil Gallery: London Group's first exhibition, includes Lewis (5 works) and Bomberg.

APR *Des Imagistes* published by Harold Monro's Poetry Bookshop: first (and only) anthology of Imagist poems to be edited by Ezra Pound (see also: "New York: MAR 1914).

—MAY: Doré Galleries: Second Futurist Exhibition ("Exhibition of Works of the Italian Futurist Painters and Sculptors"): 73 paintings, including works by Giacomo Balla and Ardegno Soffici. Marinetti gives three evenings of "dynamic and synoptic declamation" at Doré including "Siege of Adrianople" with sound effects by himself and Nevinson.

15: *The Egoist* carries advertisement for *BLAST*.

MAY 07: *The New Age* publishes translation of Marinetti's manifesto "Geometric and Mechanical Splendor and the New Numerical Sensibility."

08—14 JUN: Whitechapel Art Gallery: "Twentieth Century Art."

JUN Allied Artists Association Salon includes Rebel Art Centre painters; show is reviewed by Gaudier-Brzeska in *The Egoist*.

Vorticism officially announced; Rebel Art Centre closes.

07: Marinetti and Nevinson publish "Futurist Manifesto: Vital English Art" in *The Observer*, *The Times*, and *The Daily-Mail*, falsely showing that the Rebel Artists (Lewis, Etchells, Wadsworth, etc.) had co-signed the manifesto. Marinetti and Nevinson also publish "Against English Art" (reprinted in *Lacerba* in JUL).

12: Marinetti and Nevinson lecture on Futurism at Doré Galleries, where they are heckled and lecture disrupted by Gaudier-Brzeska, Hulme, and Lewis.

14: Rebel Artists repudiate their alleged Futurist allegiance in open letter to *The Observer*.

15-22: Coliseum and Albert Hall: Marinetti gives 12 Futurist concerts ("The Art of Noises and the Grand Futurist Concert of Noises") with Russolo using 23 of Russolo's "Intonarumori." The first concert is booed by the crowd.

20: Publication of *BLAST* no. 1 (dated JUL 1914): manifestos by Vorticists (as Rebel Artists now call themselves), printed in striking block letters, include: "Manifesto of Vorticism" (signed by Pound, Lewis, Gaudier-Brzeska, Atkinson, Dismorr, Hamilton, Roberts, Saunders), "Vortex" (Pound), "Our Vortex" and "Long Live the Vortex" (Lewis), and "Vortex" (Gaudier-Brzeska). Poetry by Pound and Hueffer; fiction by Lewis (excerpts from *The Enemy of the Stars*); and a review of Kandinsky's *Concerning the Spiritual in Art* with long excerpts reprinted.

JUL Chenil Gallery: Bomberg has one-artist show; reviewed favorably by T. E. Hulme in *The New Age*.

 (late:) Amy Lowell arrives in London, refuses Pound's suggestion that she subsidize a new Imagist journal that he would edit. Following dinner in her honor (at which Pound fails to humiliate her), she succeeds in winning over nearly all of *Des Imagistes* participants, except Pound, to contribute to an Imagist anthology she would edit. Subsequently, *Some Imagist Poets* appears yearly from 1915-1917. Pound refers to movement as "Amygism."

AUG 03: When war declared, Hulme and Nevinson join up, as do all the other Vorticists eventually. Gaudier-Brzeska returns to France to join French army; killed in action at Neuville St. Vaast, 5 JUN 1915.

SEP Pound publishes "Vorticism" in *Fortnightly Review*.

 22: Pound meets T. S. Eliot for first time, begins promoting Eliot's poems ("The Love Song of J. Alfred Prufrock") to Harriet Monroe, editor of *Poetry*.

LONDON 1915

 Ford Madox Hueffer publishes *The Good Soldier*.

APR Pound publishes *Cathay*, translations of Chinese poems of Li Po from cribs of Ernest Fenellosa.

JUN 10: Doré Galleries: first Vorticist exhibition, includes: Lewis, Etchells, Gaudier-Brzeska, Wadsworth, Dismorr, and Sanders. Critical reviews are predictably hostile.

JUL Second and last issue of *BLAST* published; includes: first published poems by T. S. Eliot ("Preludes" and "Rhapsody on a Windy Night") and Pound's Vorticist poem "Dogmatic Statement on the Game and Play of Chess."

NOV Pound publishes *Catholic Anthology* (poems by Pound, Eliot, Yeats, Williams, and others).

VIENNA 1909

 Egon Schiele founds Neukunstgruppe. Group exhibits once at Pisko Gallery.

 Schoenberg composes *Erwartung*, Op. 17.

MAY —OCT: Secession's International Artshow includes Schiele (4 works), Kokoschka, Matisse, Gauguin, Van Gogh, Munch.

23: Schoenberg completes *5 Pieces for Orchestra*, Op. 16 (published SEP 1912).

JUL 04: Kokoschka's *Murderer Hope of Women* (written 1907) staged at outdoor theater, erupts in riot, halted by police.

VIENNA 1910

Berg composes *4 Songs*, Op. 2, and pantonal *String Quartet*, Op. 3.

Hofmannsthal publishes comedy, *Cristinas Heimreise*.

JAN 14: Première of Schoenberg's *3 Pieces for Piano*, Op. 11, and *15 Songs of Stefan George's "The Book of the Hanging Gardens."*

FEB 08: Première of Webern's *5 Pieces for String Quartet*, Op. 5 (composed 1909).

AUG Webern completes *Two Songs on Poems of Rilke* (for voice and 8 instruments), Op. 8.

SEP Schoenberg finishes *Harmonielehre* (*Theory of Harmony*, begun 1909).

OCT Hugo Heller's bookshops: Schoenberg exhibits paintings for the first time. (His String Quartets #1 and 2 are played at opening). Kandinsky later writes an homage to Schoenberg's painting, "The Pictures," published in 1912. By that year, Schoenberg, realizing his amateurism, stopped exhibiting with the Blaue Reiter.

VIENNA 1911

Kokoschka returns to Vienna, paints *Portrait of the Writer Rheinhardt*.

Schoenberg orchestrates *Guerrelieder* (composed in 1900).
Hofmannsthal publishes *Orange nocturne*, libretto for *Der Rosenkavalier*, and the allegory *Jederman*.

Robert Musil publishes collection of stories, *Vereinigungen*.
Stefan Zweig publishes *First Experience*.
Alfred Ehrenstein publishes play, *Tubütsch*.

FEB Oskar Kokoschka has major one-artist show (24 paintings), organized by the Hagenkünstlerbund.

APR 24: Première of Webern's *Four Pieces for Violin and Piano*, Op. 7 (composed 1910).

MAY 18: Mahler dies; Berg and Schoenberg attend funeral on 21st.

JUN *Der Merker* (biweekly Viennese cultural journal) devotes entire issue to Schoenberg with articles by others, chapter from *Harmonielehre*, and a Schoenberg song, Op. 2#4.

SEP Schoenberg moves to Berlin. He had been a private *Dozent* at the Academy of Music and Fine Art in Vienna since autumn 1910. His difficulty supporting himself in Vienna and getting his works performed in a climate hostile to innovation accounts for the move. (See Berlin for his subsequent works until the war).

17: *Die Zeit* (Vienna newspaper) responds to Schoenberg's move and the financial appeal on his behalf published in Berlin's *Pan*: "It would be interesting to know why Arnold Schönberg is fleeing Vienna. This city, which according to the appeal bears him a grudge, offered him a position at the Academy, has given him a publisher and many friends and students, and his works are repeatedly performed by outstanding Viennese musicians in Vienna and abroad" (Brand 15).

29: *Neues Wiener Journal* reprints the Berlin *Pan*'s appeal for Schoenberg, stating Schoenberg's decision was "understandable and certainly regrettable. But that doesn't give the gentlemen who signed the appeal in *Pan* the right to shake their heads over Vienna so piously" (Brand 22).

VIENNA 1912

Kokoschka paints *Double Portrait*.
Schiele exhibits in Vienna, Munich, and Cologne.

Berg composes *Five Songs for soprano (on post card texts by Peter Altenberg)*, Op. 4.
Ballets Russes performs in Vienna.
Hofmannsthal begins editorship of *Andreas*, writes libretto for first version of Strauss's *Ariadne auf Naxos*.

Kokoschka publishes play, *The Burning Bush* (originally entitled: *Spectacle*).
Zweig publishes play, *Das Haus am Meer*.

JAN —FEB: Galeric H.O. Miethke: "French Masters" exhibition.

APR 13: Neulengbach: Schiele imprisoned for three weeks while awaiting trial on charges of disseminating immoral drawings; sentenced to three more days.

DEC Futurist traveling exhibition.

VIENNA 1913

Schiele exhibits in Budapest, Cologne, Dresden, Munich, Paris, and Rome; one of his drawings appears in Pfemfert's *Die Aktion*.

Berg composes *4 Pieces for Clarinet and Piano*, Op. 5.
Zemlinsky writes *4 Poems* for voice and orchestra.

Georg Trakl publishes his first volume, *Gedichte*.
Zweig publishes *Der Varmandelte Komodiant*.

JAN —FEB: Galerie H.O. Miethke: "The New Art."

FEB 23: Première of Schoenberg's *Guerrelieder* is "unmitigated success": Schoen-
 berg received a fifteen-minute ovation from Viennese public.

MAR —APR: Galerie Arnot: French painters.

 31: Grosser Musikvereinsaal: "Skandalkonzert" of Akademischer Verband.
 Schoenberg conducts his *Chamber Symphony*, Op. 9; Zemlinsky's *4 Orchestral
 Songs*; premières of works by Berg (*Altenberg Lieder* #2, 4) and Webern (*Six
 Pieces for Large Orchestra*, Op. 6); and Mahler's *Kindertotenlieder* (not per-
 formed). Riot à la *Le Sacre* occurs: "a commotion such as has never occurred in
 a Vienna concert hall. Hisses, laughter, and applause made a bedlam. Between
 numbers little groups of disputants came within an inch of blows; one of the
 composers (Webern) shouted remarks and entered into the row; the conductor
 went on strike; an official boxed the ears of a man who had publicly assaulted
 him; the police commissioner ordered the hall cleared, and the concert was
 stopped before the final number. All because some 'Ultrists' or 'musical Cub-
 ists' insisted upon going a little further than even an advanced musical public
 would tolerate" (H.K.N., *Boston Evening Transcript*, 17 APR 1913).

JUL Webern completes *Six Bagatelles for String Quartet*, Op. 9.

OCT 06: Webern completes *Five Pieces for Orchestra*, Op. 10.

VIENNA 1914

Schiele exhibits in Rome, Brussels, Paris.

Schmidt writes *Notre-Dame*, opera after Victor Hugo.
Stefan George writes *Das Bundes des Sterns*.
Franz Werfel publishes play, *The Trojans*.

JAN Galerie Arnot: French painters.

FEB —MAR: Galerie H.O. Miethke: Picasso exhibits.

summer Webern completes final version of *Four Pieces for Violin and Piano*, Op. 7.

JUN Webern writes *3 Little Pieces for Cello and Piano*, Op.11.

SEP Berg completes *3 Pieces for Orchestra*, Op. 6 (dedicated to Schoenberg).

NOV (ca.) Schoenberg composes song for voice and orchestra on Ernest Dowson's poem "Seraphita" (trans. Stefan George) that anticipates serial "method" he would develop in the early 1920s. ("Seraphita" becomes first of *4 Songs with Orchestra* (Op. 22, 1916.)

DEC 31—31 JAN 1915: Galerie Arnot: Egon Schiele exhibits.

MILAN (and Italy) 1910

Marinetti publishes novel, *Mafarka, la Futurista* in Italian and French (first edition: 1909).
Gabriele d'Annunzio publishes *Forse che si, forse che no.*
Luigi Pirandello's plays, *Sicilian Lemons* and *The Vice* are performed.

JAN 12: Trieste: Teatro Rosetti: first Futurist Evening (includes Marinetti and Armando Mazza); Foundation Manifesto read.

FEB 11: "Manifesto of Futurist Painters" pamphlet published in *Poesia,* signed by Balla, Boccioni, Carrà, Russolo, Severini, Romani, and Bonzagni.

 14: Milan: Futurist Evening at Teatro Lirico.

MAR 08: Turin: Teatro Chiarella: Futurists' first major public demonstration: Futurist Evening ends in riot: "the Battle of Turin." Boccioni reads "Manifesto of Futurist Painters."[11]

 19—04 APR: Milan: Famiglia Artistica exhibition: Milan Futurist painters (Boccioni, Bonzagni, Carrà, Russolo) first exhibit together.[12]

APR 11: "Technical Manifesto of Futurist Painting" published in *Poesia,* signed by Balla, Boccioni, Carrà, Russolo, and Severini.

 20: Naples: Mercadante Theater: Futurist Evening, at which Boccioni declaims "Technical Manifesto of Futurist Painters," ends in riot.

 27: "Against Passéist Venice" signed by Atomare, Boccioni, Bonzagni, Buzzi, Carrà, Cavacchioli, Folgore, Gorrieri, Marinetti, Mazza, Palazzeschi, Russolo, and Severini.

MAY "Against the Professors," signed by Marinetti; "Multifaceted Men and the Reign of the Machine," signed by Marinetti.

 Florence: Ardegno Soffici writes first article in *La Voce* against Futurism.

JUN "Against Florence and Rome: Purulent Sores of Our Peninsula," signed by Marinetti.

 "Against Love and Parlementarism," signed by Marinetti.

"Against Spanish Passéism," signed by Marinetti, translated and published in Madrid's *Prometeo*.

26: Naples: Marinetti gives talk: "The Heroic City, the Abolition of the Police and the School of Courage: Discourse on the Necessity of Violence."

JUL 08: Venice: Futurists drop 800,000 copies (according to R. W. Flint) of "Against Passéist Venice" from top of Venice clock tower. During and after Marinetti's speech that follows, slaps and fistfights occurred.

OCT Boccioni's first one-artist exhibition at *Ca'Pesaro*.

08: Milan: Marinetti tried for obscenity in *Mafarka, the Futurist* (one of three such trials); Futurist demonstration in court. Marinetti given suspended sentence of two-and-a-half months.

11: "Dramatists' Manifesto" signed by Marinetti.

DEC 20-21: Milan: Famiglia Artistica exhibition: Milan Futurist painters exhibit together.

MILAN (and Italy) 1911

Boccioni paints *The Street Enters the House, Simultaneous Visions, States of Mind*; sculpts *Development of a Bottle in Space*.
Carrà paints *Funeral of the Anarchist Galli, Jolts of the Cab*.
Russolo paints *Dynamism of an Automobile, The Revolt, Music*.
Severini paints series of *Dancers, The Boulevard*.

Marinetti's French anthology of Futurist poems, *Destruction*, is translated into Italian. Marinetti publishes a collection of articles and manifestos as *Le Futurisme* (Paris: Sansot); in Italy they appear together in *War: The World's Only Hygiene*, 1915.
D'Annunzio writes libretto in French for Debussy's *Martyrdom of St. Sebastien*.

Papini founds the revue *L'Anima* with Giovanni Amendola.
Rome: Ballets Russes performs.

JAN 11: "Manifesto of Futurist Musicians," signed by Balilla Pratella.

11: "Manifesto of Futurist Dramatists."

MAR 11? (or 29): "Futurist Music. Technical Manifesto," signed by Pratella.

APR 30: Milan: Ricordi Pavilion: "Esposizione d'arte libera": Futurist exhibition of painting (ca. 50 paintings) aimed at working class, includes Boccioni, Carrà, Russolo. Boccioni's *Laughter* defaced.

MAY 29: Rome: Boccioni lectures on Futurist dynamism, force lines, and simultane-
ity, inspires the Bragaglia brothers (Anton and Arturo) to experiment in
"photodynamics," e.g., *The Bow*.

JUN 22-: "Punchup in Florence": Soffici publishes violently critical article, "Liberal
Art and Futurist Painting" in *La Voce*, prompting Milan Futurists to travel to
Florence soon after and assault him and other *La Voce* writers at a café until
police intervene. Fight renews later at railroad station.

SEP Italy attacks Tripoli, causing war with Turkey.

OCT 11: "Italian Tripoli: Second Political Manifesto," signed by Marinetti.

(ca. 11): On urging of Severini, Boccioni, and Carrà (and Russolo?)[i] travel to
Paris, see paintings of and meet Picasso, the Cubist School painters, also Apol-
linaire, to prepare for their major exhibition in Paris (FEB 1912). Cubism af-
fects their styles significantly, especially Carrà's and Boccioni's (who paints
more planar versions of his three *States of Mind*). Marinetti speaks at Maison
des Etudiants.

(late): Marinetti observes Italian campaign in Libya, writes "The Battle of
Tripoli (26 OCT 1911)" and the political novel in free verse, *The Pope's Mono-
plane*, from the trenches (both published 1912).

MILAN (and Italy) 1912

Balla paints *Dynamism of a Dog on a Leash, Iridescent Interpenetrations*.
Boccioni paints *Spiral Construction; Matter*, sculpts *Development of a Bottle in
Space*.
Carrà paints *Simultaneity, Women on a Balcony, The Galleria of Milan*.
Russolo paints *Solidity of Fog*.
Severini paints *The Pan-Pan Dance at the Monico, Dynamic Hieroglyph of the
bal Tabarin*.
Soffici adopts Cubist style.

Marinetti edits anthology, *I Poeti futuristi*, published in Milan; publishes short
plays, *Anti-Neutrality* and *Simultaneity*.
Pirandello publishes *The Doctor's Discovery*.
D'Annunzio publishes *Meropa* and *Contemplation of Death* (4 essays on death
of Pascoli).

FEB 05: Futurist exhibition opens in Paris (see: Paris). For the exhibition Boccioni
writes "The Exhibitors to the Public," a manifesto giving most detailed presen-
tation yet of Futurist aesthetics.

APR 11: Boccioni's "Technical Manifesto of Futurist Sculpture 1912" published as
leaflet by *Poesia*.

MAY 11: "Technical Manifesto of Literature" signed by Marinetti, proclaims "words in freedom" ("parole in libertà") and the "wireless imagination" via a "chain of analogies" (fusions) of substantives. (Revised and retitled; see: 11 MAY 1913).

JUL Balla makes the first of two trips to Düsseldorf (the other is in NOV 1912), where he begins a series of completely abstract works entitled *Iridescent Interpenetrations*.

 (ca.): Anton Bragaglia begins writing *Futurist Photodynamism*.

AUG 11: "Response to Objections against 'Technical Manifesto of Futurist Literature,'" signed by Marinetti. This "Supplement" to the Technical Manifesto was the first work to present example of "Parole in Libertà."

fall Soffici and Papini ally themselves with Futurism, make their new journal, *Lacerba*, a Futurist medium.

OCT Marinetti, as war correspondent covering the Balkan War, writes "Zang Tumb Tuumm: Adrianopoli ottobre 1912" (published 1914 as "Futurist Edition of *Poesia*").

MILAN (and Italy) 1913

Balla paints *Speed of an Automobile, Swallows in Flight*.
Boccioni paints *Dynamism of a Cyclist, Unique Forms of Continuity in Space*; creates several sculptures.
Carrà paints Cubist *Simultaneità*.
Russolo paints *Dynamism (automobile)*; publishes "Intonarumori futuristi."
Severini begins *Sea=Dancer* and *Spherical Expansion of Light*.

Futurists publish at least 16 manifestos, e.g., Tavolato writes "Against Sexual Ethics."
Del Marle writes "Futurist Manifesto against Montmartre." Soffici writes "Cubism and Beyond."
Papini publishes *Pragmatism*.

JAN 01: Florence: Papini and Soffici publish first issue of Futurist review, *Lacerba*.

 11: Valentine de Saint-Point writes "Futurist Manifesto of Lust."

FEB 21—21 MAR: Rome: Teatro Costanzi: exhibition of Futurist painters, including Soffici. Pratella performs *Musica Futurista per Orchestra* at exhibition. "[T]heir first fully representative exhibition in Italy" (Marianne Martin 123).

 21 FEB: At Futurist Evening, Papini reads his "Against Rome and Against B. Croce"; Boccioni lectures.

MAR 09: Rome: Second Futurist Evening at Teatro Costanzi produces riot.

11: Russolo publishes manifesto "The Art of Noises" in *Poesia*; republished as booklet 1 JUL 1913.

APR 01: Boccioni publishes in *Lacerba* "The Futurists Plagiarized in France" as rebuttal to Apollinaire's claim in *L 'Intransigeant* that Delaunay was first to use "simultaneism" (see Paris, 18 MAR 1913).

MAY 11: "Destruction of Syntax—Imagination without Strings—Words in Freedom 1913" signed by Marinetti; published in *Lacerba*, 15 JUN. Manifesto is a more detailed and more radical version of "Technical Manifesto of Literature."

 18—15 JUN: Rotterdam: Rotterdamsche Kunstring: "Italian Futurist Painters and Sculptors" exhibition opens.

summer Bragaglia's *Futurist Photodynamism* is published. Examples are exhibited at the Sala Pichetti in Rome.

JUN Milan: "The Futurist Intonorumori" signed by Russolo.

 02: Modena: Russolo demonstrates intonorumori (noise intoners) at Teatro Stocchi.

JUL 18: "Destruction of the 'quadrature'" signed by Pratella.

AUG 11: Carrà writes "The Painting of Sounds, Noises, and Smells" (published 01 SEP in *Lacerba).*

 11: Milan: Casa Rossa: first public performance of *intonorumori.*

SEP 15: Apollinaire's "L'antitradition futuriste" published in *Lacerba*. While some critics take it as a parody of Futurist manifestos, others see it as a rapprochement between Apollinaire and the Italian Futurists.

 29: "The Variety Theater: Manifesto of the Music Hall," signed by Marinetti; published in *Lacerba*, 1 OCT 1913, in London *Daily Mail*, 21 NOV 1913, and in the Paris *Comoedia,* 09 JAN 1914.

OCT 11: "Futurist Political Program" signed by Marinetti, Boccioni, Carrà, Russolo; published in *Lacerba*, 15 OCT.

NOV 30—JAN 1914: Florence: Gonnelli Gallery: major Futurist group show, sponsored by *Lacerba*, causes "great uproar" (Severini 137); includes: Boccioni (11 works), Carrà (14), Soffici (18), Severini (10), Balla (4).

 15: "After Free Verse: Words in Liberty" (supplement to Manifesto of MAY 1913), signed by Marinetti.

DEC 06: Rome: Galleria Permanente d'Arte Futurista (part of Sprovieri Gallery): Boccioni exhibits sculpture (from Paris exhibition) and drawings.

12: "Against Passéist Florence," signed by Papini.

12: Florence: Teatro Verdi: Futurist Evening joining Milanese and Florentine Futurists provokes riot.

29: Florence: "Anti-Dolour," signed by Palazzeschi.

MILAN (and Italy) 1914

Boccioni, after approaching abstraction in *Horse+Rider+Building*, returns to more Cubist-inspired painting, e.g., *Spiraling Construction*.
Carrà under influence of Cubism does papier collé (e.g., *Festa patriottica*); and collage (*Pursuit*).
Severini completes abstraction *Spherical Expansion of Light*.
Balla paints *Mercury Passing in Front of the Sun*.

Russolo gives Intonarumori concert in Milan.

Marinetti publishes *Zang Tumb Tumb*, visual-spatial poems which apply his "words-in-freedom" aesthetics.

Numerous manifestos published, including: "The Past Does Not Exist Anymore" (Papini); "My Futurism" (Papini).

JAN (ca.) 25—FEB: Marinetti travels to Russia, urges Larionov, Goncharova, Mayakovsky, Malevich, Tatlin to organize their own groups, incorporate Futurist art-politics and aesthetics; receives mixed response: a few, like Igor Severyanin receptive, but several (e.g., Khlebnikov, Larionov) quite hostile.

01: "Synthetic Lyricism and the Physical Sensation of Light," signed by Futurist poet Luciano Folgore.

11: "Down with the Tango and Parsifal," signed by Marinetti.

15: "Against Sadness" signed by Palazzeschi in *Lacerba*.

FEB Growing tension between Florentine Futurists (Soffici and Papini, joined by Carrà and Severini) and Boccioni and Marinetti results in a major split.

Boccioni publishes *Futurist Painting—Sculpture (Plastic Dynamism)*. Carrà and Severini are offended by what they feel is undue credit that Boccioni gives himself in the book.

—MAR: Rome: Sprovieri Gallery: "Futurist Painters' Exposition" (major show).

01: "Pure Lyricism in the Futurist Sensibility," signed by Auro d'Alba.

11: "Dynamic and Synoptic Declamation" signed by Marinetti.

18: "Geometric Splendor and the Mechanics of Numerical Sensibility," signed by Marinetti.[14]

29—5 APR: Rome: Galleria Futurista: Francesco Cangiullo's *Piedigrotta* (a "parole-in-libertà" drama) performed by Marinetti, Balla, and Cangiullo, accompanied by Futurist paintings.

APR —MAY: Rome: Sprovieri Gallery: "Expositionze Libera Futurista Internationale." Only Balla of the original group participates. Also: Archipenko, Exter, Rozanova, Kulbin, Larionov, Goncharova.

MAY Milan: "New Tendencies" group—9 artists, 62 works, including: Sant'Elia and Leonardo Dedreville.

20—10 JUN: Naples: Futurist group show (from Rome) organized by Roman art dealer, Giuseppe Sprovieri.

JUL 11: "Manifesto of Futurist Architecture," signed by Sant'Elia; published 01 AUG 1914 in *Lacerba*.

AUG When war breaks out, Futurists stage several Interventionist demonstrations.

14: Paris: d'Annunzio's poem *À la Résurrection latine* published in *Le Figaro*. d'Annunzio agitates for Italian intervention into the war.

SEP 11: "Anti-Neutralist Clothing. Futurist Manifesto" signed by Balla and Cangiullo, clothing designed by Balla. The other Futurist painters create pro-war works in the months following.

15-16: Milan: Teatro dal Verme and Piazza del Duomo: Boccioni, Marinetti, Russolo participate in anti-neutrality rallies, are arrested and imprisoned for a few days.

20: "Futurist Synthesis of War" signed by Boccioni, Carrà, Piatti, Russolo.

MILAN (and Italy) 1915

Soffici, Papini, and Palazzeschi break from Marinetti and publish "Futurism and Marinettism."
Marinetti publishes *War, the World's Only Hygiene*, manifesto comprised of poems.

JAN 11: "The Futurist Synthetic Theatre" signed by Corra, Marinetti, Settimelli.

MAR 11: "The Futurist Reconstruction of the Universe" signed by Balla and Despero.

APR 11: Balla, Boccioni, Carrà, Marinetti, Russolo, Sant'Elia join battalion of volunteer cyclists after Italy enters war.

MOSCOW and ST. PETERSBURG 1908 [15]

Moscow: Shchukin collection (open to public) features Matisse's Fauvist works and Picasso's 1908 paintings incorporating African masks. Morozov collection features Impressionist and Post-Impressionist works.

Moscow: "Golden Fleece" exhibitions (organized by Mikhail Larionov) feature French Post-Impressionists, Fauves, and Russian avant-garde.

MOSCOW and ST. PETERSBURG 1909

Italian Futurist "Foundation" Manifesto translated in St. Petersburg newspaper soon after it appears in *Le Figaro*.

DEC: Moscow: Third Golden Fleece exhibition displays new primitivist style of Larionov and Goncharova and "lubki" (peasant woodcuts).

MOSCOW and ST. PETERSBURG 1910

Vladimir Tatlin expelled from Moscow Institute of Painting, Sculpture, and Architecture.

Ivan Bunin publishes *The Village*.
Maxim Gorki publishes *The Life of Matvie Koshemyakin*.

FEB St. Petersburg: *Apollon* magazine publishes article on Italian Futurists as "new literary school."

St. Petersburg: Velimir Khlebnikov publishes transrational poem: "Incantation by Laughter" in *The Studio of the Impressionists* (edited by Nicholai Kulbin).

MAR (o.s.) St. Petersburg: first exhibition of "Union of Youth" (group formed in FEB). Works are mainly Primitivist, e.g., Larionov's *Walk in a Provincial Town* (1907) and Goncharova's *Potato Planting* (1909), and neo-Symbolist (e.g., Filanov).

St. Petersburg: exhibition of "Triangle" group (Elena Guro, Mikhail Matyushin, Alexandra Exter, Burliuk brothers, Pavel Filonov) organized by Nicolai Kulbin.[16]

24: Moscow: Society of Free Aesthetics: Goncharova has her first exhibition. It receives extremely hostile reviews (e.g., her work is "completely decadent and indecent," "exceeding all pornography of dirty postcards"). Exhibition is sequestered by police, 3 paintings confiscated, Goncharova charged with "offense against public morality," but later acquitted. Larionov writes on her behalf (Parton 31).

APR (2nd half): St. Petersburg: Burliuk brothers (David, Nikolai, Vladimir) and Vasily Kamensky publish *A Trap for Judges* (*Sadok sudei*): an almanac of poetry printed on back of wallpaper, including poetry by Khlebnikov, D. and N. Burliuk, Kamensky, E. Guro, and lesser-knowns. Represents beginning of Russian futurism, and although "the book was meant to be 'a shocker' and . . . 'a bombshell' its radicalism can hardly be felt now" (Markov 9, 26). Received notice by two leading critics.
Moscow: publication of last number of Symbolist magazine *Golden Fleece*.

MAY 02—07 JUN: St. Petersburg: Izdebsky Salon (begun in Odessa, DEC 1909) opens with contemporary works from Europe and Russia.

JUL —AUG: St. Petersburg: *Apollon* publishes Italian Futurist "Technical Manifesto of Painting" and Mikhail Kuzmin's article on the Italian Futurist literary contributors to *Poesia*.

DEC —JAN 1911 (o.s.): Moscow: first "Jack of Diamonds" exhibition—major show of European and Russian modernism, organized by Larionov and Aristarkh Lentulov; represents collaboration of several small avant-garde groups. Includes works by Larionov (primitivist *Soldiers* on which he scrawled "vulgar graffiti"), Goncharova, Malevich, and Lentulov; from Germany: Kandinsky (4 *Improvisations*), Jawlensky, Heckel, Kirchner, Macke, Marc, Münter. Parisian painters (works selected by A. Mercereau) include: Picasso, Gleizes, Metzinger, Lhote, Le Fauconnier. Exhibition elicits heated public reactions.
Jack of Diamonds society continues holding yearly exhibitions until 1917.

Moscow: Moscow Salon: first exhibition includes: Goncharova, Larionov, Malevich. Subsequent exhibitions continue until 1918.

"Manifesto of the Defense of New Art" signed by D. Burliuk.

Izdebsky's Salon 2 includes: Kandinsky (several *Improvisations*, 3 *Compositions*), Larionov (*Soldiers in a Café* and others), Tatlin, and Goncharova. Kandinsky's essay, "Content and Form," and his translation of Schoenberg's "On Parallel Octaves and Fifths" appear in catalog.

MOSCOW and ST. PETERSBURG 1911

Goncharova paints *Electricity*, tending to abstraction.
Moscow: Art and Literary Circle: Tatlin designs innovative set and costumes for *Tsar Maximilian and His Unruly Son, Adolf.*

Scriabin composes piano sonatas nos. 6 and 7.

JAN (o.s.) St. Petersburg: "World of Art" exhibition.

MAR 02: Moscow: Première of Scriabin's *Prometheus: Poem of Fire*, Op. 60 for orchestra and piano with color organ (for projecting colors on screen simultaneous with tones).

spring (o.s.) Moscow: "World of Art" exhibition includes works by Goncharova, Yakulov.

 (o.s.) St. Petersburg: Union of Youth's second exhibition, includes works by Malevich, Tatlin, Goncharova, Rozanova, and Larionov.

OCT St. Petersburg: Igor Severianin founds group, Ego-Futurists, with C. C. Fofanov, George Ivanov, and Graal-Arelsky; they publish brochure, *Prolog Ego-Futurizm* and (in NOV) their first manifesto.
 Henri Matisse, accompanied by his patron Sergei Shchukin, travels to Russia.

NOV 28 (n.s.): Moscow: "World of Art" exhibition includes: Larionov, Goncharova, Burliuk brothers.

DEC Burliuk brother and Benedict Livshits form Hylaea group. Poets Velimir Khlebnikov, Vladimir Mayakovsky, and Aleksei Kruchenykh soon join.

 Moscow: Tatlin organizes teaching studio called "The Tower," which draws Liubov Popova, Nadezhda Udaltsova as students.

 St. Petersburg: The Guild of Poets (1911-1914) founded by neoclassical Acmeist group (members: N. Goumilev, A. Akhmatova, S. Gorodetzky, O. Mandelstamm, M. Kousmine, G. Ivanov). *Apollon* publishes their manifesto.
 Moscow Art Theater stages Gordon Craig's *Hamlet* with spare, geometric sets and props; attended by Burliuk and Mayakovsky.

 St. Petersburg: Alexandra Exter, painter, returns from Paris with photos of Picasso's latest Cubist paintings.

 St. Petersburg: first All-Russian Congress of Artists opens, at which sections of Kandinsky's *Concerning the Spiritual in Art* read by Nikolai Kulbin, who develops his own color theory.

 08 (o.s.): Moscow: Society of Free Aesthetics: Larionov has 1-day exhibition of over 100 works, including *Resting Soldier*.

 17—23 JAN 1912 (n.s.): St. Petersburg: third Union of Youth exhibition. Includes: Larionov's *Head of a Soldier* (1912), Tatlin's *Fishmonger* (1911), Malevich's *Taking in the Harvest*, works by Matyushin, Rozanova, and Ivan Puni.

MOSCOW and ST. PETERSBURG 1912

 Malevich paints *The Harvest, The Knife Grinder*, vacations in Paris.

 Scriabin composes *Poème nocturne for piano*, Op. 34, *2 poems, 3 etudes* for piano, *2 preludes* for piano.

 Igor Severyanin begins Ego-Futurist review, *The Herald*.
 Gorki begins cycle of stories, *Through Russia*.

Bunin publishes *A Beautiful Life* and *Dry Valley.*
Gleizes's and Metzinger's *Du Cubisme* is translated into Russian; likewise,
Marinetti's writings.

early St. Petersburg: L'Institut Français: Centennial Exhibition: French Painting
 1812-1912.

JAN 25—MAR (o.s.): Moscow: Second Jack of Diamonds Society exhibition: Ma-
 tisse, Picasso, Léger, Derain, Braque, Picasso, Le Fauconnier, Van Dongen,
 Delaunay, Gleizes, Le Fauconnier, Friesz, Kandinsky, Heckel, Kirchner,
 Macke, Marc, Münter, Picasso, Léger. Organized primarily by Burliuk broth-
 ers.
 Larionov and Goncharova split with Burliuks during planning for the show;
 denounce Burliuks as conservative, pseudo-innovators and "decadent Munich
 followers"; and form "Donkey's Tail" group to organize counter-exhibition
 (see MAR 1912).

JAN? —FEB (o.s.): St. Petersburg: "World of Art" exhibition.

FEB Goncharova and Larionov exhibit at Blaue Reiter's second exhibition, then
 break with Munich.

 12: Polytechnic Museum: Jack of Diamonds group holds public debate, at
 which David Burliuk gives illustrated lecture, "On Cubism and Other Direc-
 tions in Painting." Goncharova publicly dissociates herself from Burliuk and
 "half-baked non-Cubism of the Jack of Diamonds" and declares herself mem-
 ber of the Donkey's Tail group (see Bowlt 77-78). Larionov attempts to read
 paean to the Donkey's Tail, but is booed down.

 25: Polytechnic Museum: second public discussion organized by Jack of Dia-
 monds group (Larionov's splinter group does not attend). D. Burliuk gives talk,
 "The Evolution of the Concept of Beauty," and deprecates Italian Futurism.

MAR 24—21 APR (n.s.): Moscow: "Donkey's Tail" exhibition: all-Russian show,
 organized by Larionov: 307 works, including: Malevich (23 works), Tatlin
 (13 his first major exhibition), Larionov (58 works, primarily in his "primitiv-
 ist" style but also proto-Rayist paintings: *Study of a Woman* and *Head of a Sol-
 dier*), Goncharova (36 works), and some Union of Youth painters. 10,000 visi-
 tors view the exhibition. Public reaction: "immense ridicule and outrage. . . .
 many works censured and confiscated" including several by Goncharova on re-
 ligious themes that authorities considered blasphemous in that environment
 (Barron). "Larionov was widely caricatured in press and the 'leftist' art of the
 Donkey's Tail held up for public scorn" (Parton 42).

APR St. Petersburg: publication of first issue of *The Union of Youth* magazine con-
 tains Vladimir Markov's essay, "The Principles of the New Art."

JUN St. Petersburg: in second issue of *Union of Youth*, translations of essays by Le
 Fauconnier ("Das Kunstwerk" from 2nd NKV-Munich exhibition), Italian Fu-
 turists' "The Exhibitors to the Public" and "Technical Manifesto of Futurist

Painting," "Catalog Preface for First Exhibition of Futurist Sculpture," and completion of Markov's essay.

"Luchism," Larionov's first Rayist manifesto, dated and published as brochure.

David Burliuk returns from trip to Europe (Paris, Milan, Rome, Munich, where he saw Futurist traveling exhibition); brought back lantern slides of Futurist paintings and their manifestos.

AUG Moscow: Alexei Kruchenykh publishes first Russian Futurist poems, *Old-time Love*, hand-printed with deliberate misprints and substitution of exclamation marks for periods and commas; illustrated with abstract "ornament" by Larionov.

Moscow: Kruchenykh and Khlebnikov publish book-length poem, *A Game in Hell*, with 16 illustrations by Goncharova; revised edition with illustrations by Malevich and Rozanova published ca. DEC 1913.

OCT Moscow: Pavel Ivanov's newspaper article (under pseudonym V. Mak) gives first formal discussion of Rayism, which he treats as "entirely Russian creation with a completely new technical method" (Parton 44).

St. Petersburg: Russian Museum: Kulbin has retrospective exhibition (1907-1912).

Anna Akhmatova, Nikolai Gumiliev, and Osip Mandelstamm found an Acmeist review.

NOV 20: D. Burliuk speaks on Cubism at Union of Youth debate. Mayakovsky discusses analogous ways of constructing a work in verbal and visual media. Alexandr Benois publishes hostile reaction to Burliuk's talk, "Cubism or Ridiculism."

DEC (o.s.): World of Art exhibition, includes Larionov's Rayist painting, *Glass*. Exhibition travels to St. Petersburg, Kiev; 2nd issue of *World of Art* published.

Moscow: "Contemporary Painting" exhibition includes Tatlin, Malevich.

Kruchenykh and Khlebnikov publish *World Backwards*, a collection of poems and prose (one piece—"A Voyage Across the Whole World"—written without punctuation with overlapping sentences); illustrated by Larionov, Goncharova, Tatlin and Rogovin in semi-abstract style.

04—10 JAN 1913: Moscow:[17] Fourth exhibition of Union of Youth including: Larionov's first work in a fully Rayist style (*Rayist Sausage and Mackerel*), the Burliuk brothers, and Malevich (*Portrait of Ivan Klyun*).

22: Moscow: Hylaea group (soon to become Cubo-Futurists) publishes collection, *A Slap in the Face of Public Taste*, printed on wrapping paper and covered with coarse sackcloth; with manifesto (same title) signed by Burliuk, Ma-

yakovsky, Khlebnikov, and Kruchenykh. Manifesto proclaims idea of "self-sufficient word" ("cornerstone of Cubo-Futurist theory"—Lawton 13). Benedict Livschitz, N. Burliuk, and Kandinsky (*Sounds*) all contribute to *Slap*, which also contains poems (2 by Mayakovsky), prose pieces, and articles, including D. Burliuk's "Cubism (Surface—Plane)." Manifesto's goal was "to outrage readers' sensibilities," but "suffered from certain lack of clarity . . . [and] failed to define its concrete and positive aims." *Slap* received much attention and public ridicule (Barooshian 18).

MOSCOW and ST. PETERSBURG 1913

St. Petersburg: Burliuk publishes pamphlet-manifesto "The Benois Brawlers and Modern Art of Russia."

Gorki publishes *My Childhood*.

Scriabin composes piano sonatas nos. 8-10.

JAN —FEB (o.s.): St. Petersburg: "World of Art" exhibition.

Moscow: exhibition of contemporary French art includes Léger's *Women in Blue*, works by Gris, Metzinger.

Moscow: Kruchenykh publishes small book of poems, *Pomade* (some composed with E. Lunev), illustrated by Larionov. Book contains the first of his poems with "words [that] do not have a definite meaning" (Kruchenykh), i.e., the transrational language of *zaum*. Larionov's primitivist drawings also tinged with Rayism.

FEB Moscow: Kruchenykh publishes *Hermits*, comprising two long poems including "A Hermit Woman," illustrated by Goncharova, and *Half-Alive*, a book of primitivist verse depicting war and violence, illustrated by Larionov.

Moscow: Hylaea group publishes leaflet version of "A Slap in the Face of Public Taste" (different content from manifesto of same name of DEC 1912).

St. Petersburg: Hylaea group (with Guro and Matyushin) publishes *A Trap for Judges II*, including the group's second manifesto (untitled), poetry by Mayakovsky, Livshits, Khlebnikov, and D. and N. Burliuk, illustrated by Guro, Matyushin, Larionov, Goncharova, and D. and V. Burliuk.

St. Petersburg: Troytsky Theater: Union of Youth sponsors two evenings of lectures on new styles in painting and literature. The first evening features D. Burliuk's "Painterly Counterpoint" and Larionov's "Rayism." Their joint appearance marks shaky rapprochement between their groups.

Moscow: Publication of *The Jack of Diamonds*, collection of essays on modern art by Le Fauconnier, Apollinaire, Ivan Aksenov.

24: Moscow: Jack of Diamonds group holds public forum: speeches by D. Burliuk, Mayakovsky, and Aksenov. Jack of Diamonds also publishes collection of articles and reproductions.

spring *Union of Youth* magazine publishes translations of Gleizes's and Metzinger's *Du Cubisme* and Signac's *From Delacroix to Neo-Impressionism*.

MAR St. Petersburg: Union of Youth sponsors Malevich lecturing on Cubo-Futurism.

St. Petersburg: 3rd issue of *Union of Youth* announces union of this group with Hylaea group, publishes poems by D. and N. Burliuk, Livshits, Khlebnikov, and Kruchenykh. Also contains article by Olga Rozanova, "The Bases of the New Creation and the Reasons Why It Is Misunderstood," a rebuttal to Alexandre Benois's article "Cubism or Ridiculism."

02-30: St. Petersburg: Exhibition of Apolitical Painters.

03—02 APR (n.s.): Moscow: third Jack of Diamonds Exhibition, includes Picasso and Braque.

APR 06 (ca., n.s.): Moscow: public debate on contemporary art and theatre, organized by Larionov and Goncharova, to mark opening of "The Target" exhibition. Ilya Zdanevich speaks on Italian Futurist manifestos, Larionov on Rayism, Goncharova and Shevchenko on Russian national art being more Eastern than Western. Evening ends in uproar, primarily provoked by Larionov, closed by police.

06-20 (n.s.): Moscow: "The Target" exhibition organized by Larionov, Goncharova, and others. Artists include: Larionov (14 works including Rayist *Glass*, *Rayist Sausage and Mackerel*, and *The Farm* triptych), Goncharova (26 works, 6 of them Rayist), Malevich (*Knifegrinder*). One goal of exhibition: to present work of artists not associated with any definite trend or group, e.g., students, naive painters.[ii]

06-20 (n.s.): Moscow: "Exhibition of Original Icon Paintings and *Lubki*," organized by Larionov (marks waning of his primitivist style).

Moscow: Khlebnikov, D. and N. Burliuk, and Mayakovksy publish poetry collection, *Service-Book (or "Missal") of The Three*; illustrated by V. and N. Burliuk and Vladimir Tatlin.

MAY Mayakovsky publishes small volume of poems, *Ya (Me)*, illustrated by Chekrygin and Zhegin.

summer Moscow: Russian Futurists parade with painted faces.
 Kruchenykh publishes "Declaration of the Word as Such" as pamphlet: "laid-foundation for theory of transrational language" (Lawton).
 P. P. Muratov founding of *Sofiia*, a journal of art and literature.

JUN Alexandr Shevchenko publishes *Neo-Primitivism: Its Theory, Possibility, and Realization* and *Principles of Cubism and Other Contemporary Trends in Painting.*

St. Petersburg: Kruchenykh and Khlebnikov publish *A Forestly Rapid*, illustrated by Rozanova, Kulbin, and Kruchenykh. Kruchenykh also publishes *Let's G-r-r-rumble*, illustrated by Malevich and Rozanova, and the booklet *Explodity*, illustrated by Malevich and Kulbin.

JUL First All-Russian Congress of Singers of the Future (Poet-futurists) held at Matyushin's dacha in Finland; there, Matyushin (painter-musician), Malevich and Kruchenykh (poet) plan opera, *Victory over the Sun.*

Publication of the miscellany *The Donkey's Tail and Target*, which includes: Larionov's "Rayist Painting" (Bowlt 91-100), and Larionov's and Goncharova's "Rayonists and Futurists: A Manifesto, 1913" signed by these two, Ivan Larionov, Timofei Bogomazov, Kirill Zdanevich, Mikhail Le-Dantiyu, Vyacheslav Levkievsky, Sergei Romanovitch, Vladimir Obolensky, Moritz Fabri, and Alexandr Shevchenko. Its declarations are both philosophical (e.g., elevating Eastern and national art over Western) and technical ("spatial forms arising from intersection of reflected rays"). Khlebnikov publishes *Madame Lénine* (2-act playlet) in *Donkey's Tail* miscellany.

Zdanevich publishes first monographs on Goncharova and Larionov.

Moscow: Konstantin Bolshakov publishes long poem, *Le Futur*, with illustrations of prostitutes by Larionov and Goncharova. Police suppress it as pornography.

AUG Moscow: Cubo-Futurists (formerly Hylaea) publish *The Croaked Moon*, an anthology with an essay by Livshits, "Liberation of the Word," and poetry by Larionov, Kruchenykh, Mayakovsky, Khlebnikov, D. and V. Burliuk; illustrated by D. and V. Burliuk.

Moscow: Goncharova has major one-artist show (768 works), which moves to St. Petersburg in 1914.

SEP St. Petersburg: Kruchenykh, Khlebinkov, and Guro (posthumously) publish poems and prose entitled *The Three*. Kruchenykh's essay "New Ways of the Word," here uses *"zaum"* ("transrational," "trans-sense," or "translogical") for the first time. Illustrated by Malevich; published by Matyushin.

Larionov, Goncharova, Burliuk bros., Kulbin participate in German Autumn Salon in Berlin.
Moscow: The Mezzanine's first manifesto, "Throwing Down the Gauntlet to the Cubo-Futurists" (signed: M. Rossiyansky) is published in *Vernissage.*

OCT Kruchenykh and Khlebnikov publish *The Word as Such*, a fifteen-page booklet of manifesto-prose and poetry, illustrated by Malevich and Rozanova. *Zaum*

here described as "chopped words, half-words, and their whimsical, intricate combinations (Markov 130).[19]

06: Moscow: Bolshakov's play, *Jig of the Streets*, performed (accompanying Goncharova's retrospective). Hero performed by 3 different actors in different settings *simultaneously*. Larionov designs these simultaneous sets.

(ca.) 12—NOV (n.s.): Moscow: Painters' Salon: Goncharova has major retrospective: 770 works from 1910-1913. Goncharova writes "Preface" to exhibition catalog, which attacks Western culture, praises Eastern. Zdanevich lectures on "Everythingism."

13: Moscow: Cubo-Futurists hold much-publicized "Evening" where they give nonsense poems and lectures. Kruchenykh spills hot tea onto front row of audience, but fails to provoke riot.

19: Moscow: Larionov, Goncharova. and Mayakovsky stage similar Evening in Pink Lantern cabaret. This one does result in near-riot after Goncharova strikes an officer. Police intervene and close cabaret.

28: St. Petersburg: Painters' Bureau of Dobichna: "Permanent Exhibition of Contemporary Paintings."

NOV (o.s.): St. Petersburg: "World of Art" exhibition.

Schevchenko publishes *Neo-Primitivism: Its Theory, Its Potentials, Its Achievements.*

05: "Manifesto of Totalism" signed by Ilya Zdanevitch.

05 (n.s.): St. Petersburg: Painters' Bureau of Dobichna: Graphic Arts Exhibition.

23—23 JAN 1914 (n.s.): St. Petersburg: 5th Union of Youth exhibition "marked climactic point in the development toward abstraction" (Bowlt), inc. Malevich's series *Transrational Realism*, Rozanova's *Dissonance*, Tatlin's *Compositional Analysis*, Matyushin's *Red Ringing*, Filanov's *Half a Picture.*

DEC? (o.s.) Moscow: "World of Art" exhibition includes new works by Larionov and Goncharova.

DEC Debussy conducts concerts in Moscow and St. Petersburg.

Russian Futurist tour of D. Burliuk, V. Mayakovsky, and V. Kamensky, who give evenings of poetry and lectures on the new art in 17 cities throughout Russia.

St. Petersburg: Stray Dog Cabaret: Alexandr Smirnov lectures on simultaneism and Delaunay, and exhibits Sonia Delaunay's and Cendrar's *La Prose du Transsibérien.*

Larionov and Zdanevich publish "Why We Paint Ourselves: A Futurist Manifesto" in *Argus* magazine.

Andrei Biely's publishes novel, *Petersburg*.

02 (o.s.): St. Petersburg: Luna Park: première of *Vladimir Mayakovsky: A Tragedy*, a 2-act play produced and directed by, and starring, Mayakovsky. Sponsored by Union of Youth. Décor (Filonov, Shkolnik, Rozanova) "barely connected with Mayakovsky's text" (Bowlt, *Russian Modernism* 179). Play presents poet as prophet-like figure superior to, but sympathetic toward, the people. Action carried by grotesque abstractions of people or by chorus-like groups. Great personal success for Mayakovsky, establishes his success in literary circles (Markov 143-46).

03 (o.s.): St. Petersburg: Luna Park: première of collaborative opera, *Victory over the Sun*; text by Mayakovsky and Kruchenykh, music by Mikhail Matyushin, sets by Malevich, whose curtain design (square within a square) shows first instance of abstract Suprematist style. Opera effects a "complete breakup of concepts and words . . . decor and harmony" (Bowlt, *Russian Modernism* 177, 179-80). Theme: Futurist strongmen upset conventional artistic and historical values by challenging and conquering the sun. Language is often unintelligible; music relies heavily on atonal techniques: chromatics, consecutive fifths, melisma, out-of-tune piano, chorus sings flat. Audience reaction: some hisses, some shook their fists and shouted, but most were "good-natured" in laughing (Markov 147). The two Luna Park plays were called "First Futurists' Spectacles in the World."

10: St. Petersburg: "First Evening of the Everythingists" (organized by Larionov, Goncharova, Zdanevich, Le-Dantyu, Levkievsky, Romanovich, and others).

MOSCOW and ST. PETERSBURG 1914

Letters of Credit and Declarations of Russian Futurists, collective anthology published in form of a parchment.

Marinetti's *Futurism* (collection of essays) published in Russian (see PARIS, OCT 1911). Critic G. Tastevin publishes several of Marinetti's manifestos, Saint-Point's "Futurist Manifesto of Lust," and his own essay on Futurism.

JAN St. Petersburg: Goncharova's one-artist show moves here from Moscow.

Moscow: Ego-Futurist Igor-Severyanin allies himself with Cubo-Futurists (briefly). They now call themselves collectively "Russian Futurists" and publish *The Milk of Mares* with poetry by Severyanin, D. Burliuk (trying to emulate Italian Futurist typography), Khlebnikov (and a fragment of his letter reflecting his increasing Russian nationalism and pan-Slavism).

Larionov, Goncharova, and film director Vladimir Kasyanov make a short film, *A Drama in the Futurists' Cabaret No. 13*, depicting Futurist dance of death, murder, burial, suicide, accompanied by Futurist music.

St. Petersburg and Moscow: Publication of *Futurists: Roaring Parnassus. First Revue of Russian Futurists.* Collective anthology assembling poets of various groups: Cubo-Futurists (D. and N. Burliuk, Kamensky, Kruchenykh, Mayakovsky, Khlebnikov, B. Livshitz, P. N. Filonov, Olga Rozanova; numerous poems by David Burliuk under the general title: "A Milker of Exhausted Toads"); Ego-Futurism (Igor-Severyanin); "The Mezzanine of Poetry" (Riurik Ivnev, Vadim Shershenevitch); and individually: Nicholai Aseev and Boris Pasternak. Anthology contains Cubo-Futurists' most belligerent manifesto: "Go to Hell!" (which attacks other poets by name and declares: "All Futurists are united only by our group . . . [which has] rejected our accidental labels Ego and Cubo"). Anthology is immediately seized because of Filonov's illustrations and doesn't receive public reading.

"We and the West," a manifesto that favorably compares Russian art to European, signed by Georgi Yakoulov, B. Livshits, A. Lourié.

FEB (o.s.): Moscow: The Jack of Diamonds 4th exhibition. Malevitch shows : *Portrait of Matyushin*, *Woman in a Tram* (Cubist works), *Suprematist Composition*. Show also includes Picasso, Braque, Exter, Lentulov, Popova, and Udaltsova.

08—13 FEB (n.s.): Moscow: Second Exhibition in "Contemporary Painting" series.

26: Invited by Nicolai Kulbin, Marinetti arrives to give series of lectures and receptions in Moscow (27-28 JAN) and St. Petersburg (1, 4 FEB) and to meet Russian Futurist groups, hoping to form a "united front" with them (Markov 155).

27-28: Moscow: Marinetti lectures on consecutive evenings. Press response generally favorable, but Larionov publishes hostile letter urging that Marinetti be greeted with rotten eggs for betraying Futurist ideals, which leads to lengthy exchange of pro and con newspaper letters by Russian Futurists.

FEB 01: St. Petersburg: Kalashnikov Exchange: Marinetti's gives lecture-recitation. 04: repeat performance. During a private dinner in his honor, he engages in lively debate with Livshits over the comparative merits of the two types of Futurism.
13: Moscow: Literary-Artistic Circle: Marinetti's last lecture and discussion (to be given solely in French) taken as insult disrupted by D. Burliuk, Mayakovsky, and Kamensky. Marinetti leaves Russia disappointed.

spring Moscow: Publication of second edition of *The Croaked Moon* with several additions. Published "not only to demonstrate a strengthened, 'unified' movement in Russia, but also to . . . [highlight] previous achievements." Anthology

"marked end of the . . . flowering of prerevolutionary Russian futurism" (Markov 179).

MAR Moscow: Publication of *The First Journal of the Russian Futurists*: "last large-scale attempt to unite all Russian futurists under the same cover" (Markov 172); includes a "ferro-concrete" poem by Kamensky.

APR (o.s.): Moscow: "No. 4—Exhibition of Paintings: Futurists, Rayists, Primitivists," major exhibition organized by Larionov and Goncharova. Like Donkey's Tail exhibition, emphasizes Russian art and primitivist origins. Includes: Kamensky's "ferro-concrete" poetry, works by Larionov (16, including *Sea Beach* and *Sunny Day*), Goncharova (19 paintings).

 Moscow: Publication of *Vladimir Mayakovsky: A Tragedy.*

 —03 MAY (n.s.): St. Petersburg: Goncharova exhibits at Painters' Bureau of Dobichina (249 works). Newspaper calls her religious paintings blasphemous, and public censor removes them; exhibition draws over 2,000 people and many newspaper reviews.

MAY Larionov and Goncharova travel to Paris to work as set designers for the Ballets Russes production of *Le Coq d'or*. Sets receive wide attention.

 10-15: Moscow: Tatlin opens his studio for "First Exhibit of Painterly Reliefs."[20]

NOV Kandinsky returns to Russia, as do numerous other Russian artists and writers after AUG, when the war begins.

 Publication of Goncharova's album of lithographs, *Mystical Images of War.*

MOSCOW and ST. PETERSBURG 1915

MAR 03: St. Petersburg: "First Futurist Exhibition of Pictures: Tramway V."

DEC 19—19 JAN 1916 (n.s.): Petrograd: "The Last Futurist Exhibition of Pictures: 0-10" organized by Ivan Puni: major debut of Malevich's Suprematist works (including *Black Square on a White Background* and *Red Square on a White Background*) and Tatlin's reliefs.

 Malevich publishes *From Cubism to Suprematism: The New Painterly Realism* (first edition sold at 0-10 exhibition). 2nd edition published JAN 1916, 3rd ed. in NOV 1916.

NEW YORK 1908

JAN Alfred Stieglitz's Photo-Secession Galleries at 291 Fifth Ave. (hereafter referred to as 291) hold its first exhibitions of modern art: Rodin's drawings. The Matisse exhibition (APR), the first in the U.S., draws over 4,000 viewers and gains the Galleries much notoriety.

 Stieglitz's magazine, *Camera Work*, adds articles on arts and art criticism.

FEB Macbeth Galleries: Exhibition of "The Eight" (known also as "the Ashcan School"): Robert Henri, John Sloan, George Lucs, William Glackens, Arthur B. Davies, Everett Shinn, Ernest Lawson, Maurice Prendergast. Exhibition gains much notoriety and introduces a new realism into American painting that parallels the same in recent fiction (literary naturalism).

NEW YORK 1909

MAR 30—17 APR: 291: John Marin's U.S. debut and first one-artist show: 24 watercolors; Alfred Maurer's U.S. debut: 15 oil sketches.

MAY 08-18: 291: Marsden Hartley has his first one-artist show: 33 oils.

summer Stieglitz tours Paris for 3 weeks with Edward Steichen.

JUL 30: Gertrude Stein publishes *Three Lives* (Grafton Press).

DEC 20—14 JAN 1910: 291: Toulouse-Lautrec's first U.S. exhibition: lithographs.

NEW YORK 1910

 William Dean Howells publishes *Imaginary Interviews* and *My Mark Twain*.
Jack London publishes *Revolution and Other Essays*.
E. A. Robinson publishes *The Town Down the River*.
Hamlin Garland publishes *Other Main-Traveled Roads*.
Edith Wharton publishes *Tales of Men and Ghosts*.

FEB 07-25: 291: Marin exhibits watercolors, pastels, etchings.

 27—20 MAR: 291: Matisse exhibits drawings and photographs of paintings.

MAR 21—15 APR: 291: "Younger American Painters in Paris": Arthur Dove and Max Weber (their U.S. debuts), Hartley, Marin, Maurer, Edward Steichen, Arthur Carles, Lawrence Fellows, G. Putnam Brinley.

APR 01: 29 W. 35th St.: "Independent Artists" Exhibition (organized by Robert Henri and Rockwell Kent and modeled on the unjuried Salon des Indépen-

dants). Includes: "The Eight," and George Bellows, Stuart Davis, Edward Hopper, and Rockewell Kent. 2,500 people attend opening.

MAY Gelett Burgess publishes "The Wild Men of Paris" in *The Architectural Record*, which includes interviews with Braque and Picasso, and photos of Braque's drawing, *Three Nudes*, and Picasso's *Les Demoiselles d'Avignon*.

NOV 18—08 DEC: 291: Exhibition of Manet, Cézanne, Renoir, Toulouse-Lautrec, Rodin, and Rousseau.

 22: Ezra Pound publishes his first book of poetry in America: *Provença*.

NEW YORK 1911

 Isadora Duncan dances with New York Metropolitan Opera and New York Symphony Orchestra.

 Theodore Dreiser publishes *Jennie Gerhardt*; his *Sister Carrie* is reissued.
Jack London publishes *South Sea Tales, When God Laughs and Other Stories*.
Edith Wharton publishes *Ethan Frome*.

JAN 11-31: 291: Max Weber has his only one-artist show at 291: 32 works (oils, watercolors, charcoals, and crayon drawings).

FEB 02-22: 291: Marin exhibits watercolors.

MAR 01-25: 291: Cézanne's first one-artist show in U.S.: 20 watercolors.

MAR 28—25 APR: 291: Picasso has his first one-artist show in U.S.: 83 drawings and watercolors (1905-1910). Marius De Zayas writes accompanying article on Picasso in *Camera Work*.

DEC 19: First meeting of Association of American Painters and Sculptors (AAPS), organized to hold exhibitions of best contemporary European and American art. Founders: Walt Kuhn, Elmer MacRae, Jerome Myers, and Henry Fitch Taylor. 27 FEB 1912: Arthur B. Davies elected president. Their efforts will produce the Armory Show (see New York: 17 FEB 1913).

NEW YORK 1912

 Gaston Lachaise begins his *Standing Woman* series of sculptures.

 Robinson Jeffers publishes poems, *Flagons and Apples*.
Vachel Lindsay publishes poems, *Rhymes to be Traded for Bread*.
Amy Lowell publishes poems, *A Dome of Many-Coloured Glass*.
Edgar Lee Masters publishes poems, *Songs and Sonnets*.
Elinor Wylie publishes poems, *Incidental Numbers*.
Dreiser publishes *The Financier*.

James Weldon Johnson publishes *The Autobiography of an Ex-Colored Man.*
London publishes *Smoke Bellew.*
Wharton publishes *The Reef.*

FEB 07-26: 291: Marsden Hartley exhibits paintings and drawings.

 27—12 MAR: 291: Dove has his first one-artist show: drawings and 10 pastels.

MAR 14—06 APR: 291: Matisse has his first sculpture show: 12 sculptures and 12
 drawings.

JUL *Camera Work* publishes extracts from Kandinsky's *Concerning the Spiritual in
 Art.*

AUG *Camera Work* devotes issue to modern art; includes Stein's "portraits" of Pi-
 casso and Matisse, her first creative writing to appear in a periodical.

DEC *Masses* publishes its first issue, Max Eastman editor. John Reed joins staff.
 15—14 JAN 1913: 291: Abraham Walkowitz has his first one-artist show:
 drawings and watercolors.

NEW YORK 1913

Joseph Stella paints *The Battle of Lights: Coney Island.*

Donald Evans publishes *Sonnets from the Pantagonian* (including Stein's
"Portrait of Mabel Dodge").
Robert Frost publishes his first book of poems, *A Boy's Will.*
William Carlos Williams publishes his first book of poems, *The Tempers.*
Witter Bynner publishes poems, *Tiger.*
Paul Lawrence Dunbar publishes *Complete Poems.*
Willa Cather publishes *O Pioneers!*
Ellen Glasgow publishes *Virginia.*
Wharton publishes *The Custom of the Country.*

Ives publishes *Holidays Symphony.*

Cass Gilbert designs Woolworth Building, then the world's tallest building at
55 stories. Construction begins.

Arthur Jerome Eddy publishes *Cubists and Post-Impressionism*, first study of
modern art published in America.
W. H. Wright becomes editor of *Smart Set*, publishes modern European writ-
ers.

JAN 20—15 FEB: 291: Marin exhibits watercolors at 291 (his 4th exhibition there).

 20: Picabia and his wife arrive from France to attend Armory Show.

FEB 17—15 MAR: 25th St. Armory: "International Exhibition of Modern Art," popularly known as "Armory Show" (held by Association of American Painters and Sculptors): ca. 1,300 works, includes such French styles and painters as the Nabis, Impressionists, Cézanne, Fauves, and Cubists. Picasso, Braque, Léger, Delaunay, Gleizes, La Fresnaye, Duchamp, Villon, Duchamp-Villon, Matisse, Picabia, Kandinsky, Kirchner, are all represented. Sculptors Rodin, Brancusi, Archipenko included. No Russian, Czech, or Italian Futurist works shown; very few German (only Kirchner, Kandinsky, Lehmbruck). The Show, which receives enormous popular attention (newspaper reviews, satirical cartoons, etc.) and draws ca. 88,000 viewers (plus another 212,000 in Chicago and Boston), is commonly credited with introducing modernist European art to the American general public.

 Arts and Decoration devotes special issue to Armory Show, including Mabel Dodge's article on Gertrude Stein, "Speculations or Post-impressions in Prose."

 24—15 MAR: 291: Stieglitz has his first and only one-artist exhibition of photographs.

MAR 17—05 APR: 291: Picabia has his first one-artist show in the U.S.: 16 New York "studies."

JUN *Camera Work* devotes special issue to Armory Show, including Gertrude Stein's abstract "Portrait of Mabel Dodge at the Villa Curonia," followed by Dodge's "Speculations" about Stein's writing and its significance for modern art. These exposures of Stein's avant-garde writing (see also AUG 1912), and Dodge's articles about her, establish her image in America as poetic equivalent of Cubist painting.

 07: Paterson Strike Pageant staged at Madison Square Garden; sets designed by Robert Edmond Jones, painted under direction of John Sloan, organized by John Reed and Mabel Dodge. 1,147 strikers and supporters march up Fifth Ave. to participate.

NOV 19—03 FEB 1914: 291: Walkowitz exhibits drawings, pastels, and watercolors.

NEW YORK 1914

 Conrad Aiken publishes poems, *Earth Triumphant and Other Tales in Verse.*
 Frost publishes book of poems, *North of Boston.*
 The Single Hound by Emily Dickinson published posthumously.
 Vachel Lindsay publishes *The Congo and Other Poems.*

 Dreiser publishes *The Titan.*
 Frank Norris publishes *Vandover and the Brute.*
 Booth Tarkington publishes *Penrod.*

Eugene O'Neill publishes *Thirst and Other One-Act Plays*.

JAN 12—12 FEB: 291: Marsden Hartley exhibits paintings from New York, Paris, and Berlin.

MAR 02: *Des Imagistes* (edited by Pound, text from *The Glebe*) published by Albert and Charles Boni at Washington Square Bookshop. (See also London: APR 1914.)

 12—01 APR: 291: Brancusi has his first one-artist show: sculptures.

APR 29: Robert Henri's colleagues pull out of AAPS, crippling the organization.

JUN Stein's *Tender Buttons* published by Donald Evans's Claire Marie Press.

SEP Amy Lowell publishes *Sword Blades and Poppy Seeds*, her first Imagist collection.

OCT Daniel Gallery: Charles Demuth has his first one-artist show.

NOV 03—08 DEC: 291: "African Savage Art" (18 sculptures): America's first major exhibition of "primitive" art.

DEC 09—11 JAN 1915: 291: exhibition of Picasso and Braque (charcoals and oils) and Mexican art.

OTHER CITIES 1909

Dresden: Première of Richard Strauss's *Elektra*, libretto by Hoffmansthal.

FEB —MAR: *Prague*: Mánes Union of Artists holds first exhibition, including Vincenc Beneš, Emil Filla, Dubin. Kubišta writes negative review. "The Eight," an artists group formed in 1907, dissolves.

MAR 05: *Chicago*: Francis Hackett begins *Friday Literary Review* (eight-page tabloid, part of *Chicago Evening Post*): Floyd Dell becomes his assistant; JUL 1911: Dell becomes editor and central figure in creating the "Chicago Renaissance."

DEC 17: *Odessa*: Vladimir Izdebsky organizes huge art exhibition (800 works). Participating artists are Russian (including Kandinsky, Jawlensky, Goncharova, Exter) and European (including Matisse, Braque, Rousseau, Gleizes, Metzinger, Laurencin, Le Fauconnier, Redon, Balla, Münter). Show travels to Kiev (25 FEB—27 MAR) and St. Petersburg (2 MAY—7 JUN), and Riga (25 JUN—20 JUL).

OTHER CITIES 1910

Brussels: Maeterlinck publishes *The Blue Bird* and *The Tragedy of Macbeth*.

Budapest: Bartok composes *Two Pictures for Orchestra*. Première of his *String Quartet No. 1*.

Cambridge MA (USA): T. S. Eliot, a graduate student in philosophy at Harvard, writes part of the "Preludes" and "The Love Song of J. Alfred Prufrock" (both completed in Europe, 1910-1911).

Dublin: Padraic Colum publishes *Thomas Muskerry*.
J. M. Synge's *Deirdre of the Sorrows* performed.
Yeats's *The Green Helmet* performed.

Prague: Emil Filla publishes "On the Virtues of Neo-Primitivism," causing much debate.
Max Brod publishes *Tagebuch in Versen*.

FEB —MAR: *Prague*: "Les Indépendants" exhibit, co-organized by Kubišta, including many Fauves, Braque (but not Picasso); Derain's *Bathing* collectively purchased through subscriptions. Kubišta paints his first Cubo-Expressionist works.

APR —MAY: *Budapest*: Gallery Müvészház: Picasso shows 4 works, including *Woman with a Mandolin*, at group exhibition.

JUL 16—09 OCT: *Düsseldorf*: Sonderbund exhibition includes Picasso and Braque.

SEP *Dresden*: Galerie Arnold: Die Brücke exhibits.

NOV *Buffalo NY*: Albright Gallery: "International Exhibition of Pictorial Photography" (held by the Photo-Secession). Exhibition presents photography as a fine art.

DEC *Odessa*: Second Izdebsky Salon: 440 works, including works by Kandinksy (53), the Burliuks, Larionov, Goncharova, Tatlin, and many European modernists. Catalog essays by Kandinsky ("Content and Form") and Schoenberg (excerpts from *Theory of Harmony*).

OTHER CITIES 1911

Brussels: Maeterlinck receives Nobel Prize.
Verhaeren publishes *Les Plaines, Les Heures du soir*.

Budapest: Bartok and Kodály form "New Hungarian Music Association."
Bartok composes *Two Orchestral Portraits* and "Allegro Barbaro" for piano.

Dublin: *The Irish Review* founded by Padraic Colum, James Stephens, Thomas MacDonagh—primary magazine of Irish Renaissance.

Helsinki: Sibelius composes *4th Symphony*.

Lucerne: Hans Arp cofounds *Der Moderne Bund*, a primarily Swiss group of modernist painters, which holds exhibition.

Prague: Franz Werfel publishes his first Expressionist work, *Der Welt Freund*. Max Brod publishes *Jüdinner*.
"Group of Plastic Artists" organized (former Mánes members, including Vincenc Beneš, Josef Čapek, Emil Filla, Antonín Procházka, Ladislav Šima, and Vaclav Špála, sculptor Otto Gutfreund, writers Karel Čapek, František Langer, and others). Group publishes journal, *Arts Monthly*.

Saint Louis: Scott Joplin composes *Treemonishia*, a ragtime opera. First concert performance: 1915.

Spring Green WI: Frank Lloyd Wright builds his Taliesin home.

MAY 20—02 JUL: *Düsseldorf*: Sonderbund Exhibition.

JUN *Brussels*: Société des Artistes Indépendants exhibition features Cubist School painters Delaunay, Gleizes, Le Fauconnier, Léger, Segonzac, etc. Apollinaire refers to them as "Cubists" in his preface to their catalog.

OCT 06—05 NOV: *Amsterdam*: Moderne Kunstring exhibition, includes Picasso (9 works), Braque.

OTHER CITIES 1912

Bucharest: Simbolul group (Trisatan Tzara, Marcel Janco, Jules Janco, Poldi Chapier, Ion Vinea) forms around magazine, *Simbolul*.
Bartok writes *4 Old Hungarian Folk Songs* for male choir; *4 Pieces for Orchestra*.

Dublin: James Stephens, of the Movement of Poetic Revolutionaries, publishes *The Hill of Vision*.
Yeats's *The Hour Glass* (new version) performed.

Prague: Josef Gočár and Pavel Janák create Prague Art Workshop to produce Cubist furniture.
Franz Werfel publishes poems, *Der Weltfreund*.
Max Brod publishes *Arnold Beer*.
Franz Kafka writes "The Judgment," begins work on *Amerika* and "The Metamorphosis."

Stockholm: Strindberg dies.

Zurich: Der Moderne Bund holds second exhibition.

JAN —FEB: *Prague*: "Skupina" (or Group of Plastic Artists) holds its first exhibition of Czech artists.

23-31: *Cologne*: Gereons Club: Der Blaue Reiter's first exhibition (from Munich).

FEB *Budapest*: Gallery Müvészház: Picasso and Braque exhibit.

Prague: Schoenberg's disciples (Berg, Webern, Königer, Linke, Polnauer) present him with first printed copy of their collected literary tribute to him, *Arnold Schoenberg*.

17, 24: *Cologne*: Webern publishes two-part article on Schoenberg in *Rheinische Musik- und Theaterzeitung*.

29: *Prague*: Performance of Schoenberg's *Pelléas und Mélisande* receives hostile response from audience.

MAY 20—JUN: *Brussels*: Galerie Georges Giroux: Italian Futurists' traveling exhibition. Valentine de Saint-Point lectures.

25–30 SEP: *Cologne*: Sonderbund International Art Exhibition. Over 500 paintings shown from Post-Impressionists onwards, including a 125-painting Van Gogh retrospective. Paul Klee, Ernst Ludwig Kirchner, Erich Heckel, Karl Schmidt-Rottluff, Larionov, Picasso, Braque, Beneš, Filla, Kubišta, Procházka, and many others participate. Franz Marc, dissatisfied with jury's selections, retracts his paintings and publishes article critical of the jury system.

JUN 15—15 JUL: *Rouen*: Salon de Juin: preliminary version of "Section d'Or" exhibition in OCT. See: Paris: OCT 1912.

JUL 07-31: *Zurich*: Kunsthaus Zurich: Moderner Bund exhibition, includes two of Delaunay's *Windows* series.

AUG *The Hague*: Kunstzaal Biesing: Italian Futurists' traveling exhibition.

Weimar: Grossherzogliches Museum: Max Beckmann exhibits paintings.

—SEP: *Hamburg*: Galerie Commeter: Die Brücke exhibits.

SEP *Rotterdam:* Gallery Biesing: Italian Futurists' traveling exhibition.

—OCT: *Prague*: "Group of Plastic Artists" exhibition includes: Picasso, Braque, Friesz, Derain, Die Brücke artists.

23: *Chicago*: Harriet Monroe begins publishing *Poetry*, with Alice Corbin Henderson as associate editor, Ezra Pound as foreign correspondent. *Poetry*

becomes the first and most prominent poetry magazine in America willing to publish modernist poets.

OCT First Balkan War begins between Turkey and an alliance of Serbia, Bulgaria, Montenegro, and Greece. Turkey loses and cedes control of Balkans.

Amsterdam: Gallery de Roos: Italian Futurists' traveling exhibition.

Cologne: Gereons Club: Italian Futurists' traveling exhibition.

NOV 06-07: *Amsterdam*: Moderne Kunstring 2: exhibition includes Picasso (12 works), Braque (6 works), Gris, Gleizes, Léger, Marcoussis, Metzinger, Villon.

DEC *Hagen*: Museum Folkwang: Le Fauconnier, Archipenko exhibit. Introduction by Apollinaire.

OTHER CITIES 1913

Brussels: Maeterlinck publishes *Marie-Magdalene*.

Dublin: Thomas MacDonagh publishes *Lyrical Poems*.
Kathleen Tynan, of Movement of Poetic Revolutionaries, publishes *Irish Poems*.

Leipzig: Erik Schwabach (and later René Schickele) found and edit *Die weissen Blätter*—an example of "activist" branch of Expressionism (Weisstein 33); journal is moved to Switzerland during war.

Prague: Werfel publishes *The Temptation* and *We Are*.
Brod publishes *Weiber Wirtshaft*.
Kafka publishes "The Heater" (first chapter of *Amerika*).

JAN *Chicago*: *Poetry* publishes poems by "H.D. 'Imagiste.'" Two months later, it publishes the Imagist manifestos, officially launching the movement.

FEB *Budapest*: National Salon: Futurist and Expressionist exhibition.

Düsseldorf: Leonhard Tietz: Neue Secession Berlin exhibits.

MAR 24—15 APR: *Chicago*: Art Institute: Armory Show (American section scaled down). Show attracts many more viewers than in New York (ca. 200,000) and much critical abuse.

30—30 JUN: *Florence*: Society of Fine Arts: International Exhibition, includes Gleizes.

APR —MAY: *Budapest*: Exhibition of Modern Art, includes Picasso, Metzinger, Delaunay, Gleizes, Le Fauconnier, Goncharova, Burliuk brothers.

—JUN: *Prague*: Group of Plastic Artists' third Prague exhibition includes Cubists (Picasso, Braque, Derain, Gris), Soffici, and Plasticist group; organized by Alexandre Mercereau, well received. "Group" also exhibits at First German Autumn Salon, Golzst's "Neue Kunst" salon in Munich, Der Sturm Gallery in Berlin in 1913.

28—18 MAY: *Boston*: Copley Hall: Armory Show (with only European art). Show attracts far fewer visitors than in New York and Chicago (ca. 13,000).

MAY *Milwaukee WI*: Gimbels Department Store: exhibition of Cubist painting.

18—15 JUN: *Rotterdam*: Rotterdamsche Kunstkring: "Italian Futurist Painters and Sculptors."

JUN Balkan War resumes with Bulgaria opposing Greece, Serbia, Romania, and Turkey over division of the land ceded by Turkey in OCT 1912. Bulgaria is defeated, and a major European war is avoided, but settlement intensifies Serbian hostility toward Austria-Hungary.

summer *Grantwood-Ridgefield NJ*: Alfred Kreymborg rents cabin with painter and photographer Man Ray and painter Samuel Halpert (beginning of an artists' community).

JUL —AUG: *Bonn*: Friedrich Cohen Gallery: "Rhineland Expressionists" (first exhibition). 16 artists, including August Macke, Max Ernst, Heinrich Campendonk. Exhibition is "great success" (Gustav).

SEP *Ridgefield NJ*: Kreymborg begins publishing *The Glebe* (which runs 10 issues until NOV 1914). Entire 5th issue devoted to "Des Imagistes" and becomes text of the first Imagist anthology (see: New York, MAR 1914).

NOV —JAN 1914: Brighton (England): Public Art Galleries: "Exhibition of English Post-Impressionism, Cubists, and Others" includes "The Cubist Room" featuring works by Wyndham Lewis and his "Rebel" group.

DEC *Prague*: Havel Gallery: Italian Futurist painters exhibit.
 S. K. Neumann publishes Czech Futurist manifesto, "Open Windows" (in response to manifesto by Felix Del Marle "Contre Montmartre").

OTHER CITIES 1914

Budapest: Bartok begins *The Wooden Prince* (finished 1916).

Cologne: "Werkbund" exhibition.

Dublin: James Joyce publishes *Dubliners*.

New York: Henry Cowell composes *String Quartet*.
Isadora Duncan tours U.S.

JAN *Dresden*: Galerie Ernst Arnold: "The New Painters: Expressionistische Ausstellung" (46 artists).

 30—15 FEB: *Cologne*: Kandinsky retrospective (from Der Sturm gallery) moves to Barmen, Aachen (through late MAR).

FEB —MAR: *Helsinki*: Blue Rider Exhibition; texts by Marc and Kandinsky. Moves to Trondheim (APR-MAY), Göteborg (JUN-JUL).

 —MAR: *Prague*: Mánes Society and Alexandre Mercereau organize major exhibition of Picasso and French Cubists, especially "La Section d'Or" group, also includes: Archipenko, Delaunay, Brancusi, Kubišta, J. Čapek. Mercereau lectures at exhibition.

 —MAR: *Prague*: Group of Plastic Artists hold 4th Prague exhibition with many of same painters seen at Mánes-Mercereau exhibition.

MAR *Chicago*: Margaret Anderson begins publishing *The Little Review*, a major "little magazine" in the U.S. devoted to avant-garde writing; moves magazine to California in late 1916; to New York, JAN 1917; thence to Paris in early 1923. Jane Heap assumes editorship in 1924, returning the magazine to New York.

APR 07: Klee, Macke, Louis Moilliet travel to Tunisia, paint many watercolors.

MAY *Düsseldorf*: Flechtheim Gallery: Rhineland Expressionists exhibit. Show then moves to Berlin.

JUN 28: *Sarajevo*: Archduke Francis Ferdinand of Austria-Hungary and his wife are assassinated by a Serbian nationalist. The German Kaiser assures Austrian Emperor Franz Joseph of Germany's unconditional support of Austria; France probably does likewise for Russia. When Serbia fails to satisfy all demands of Austria-Hungary's ultimatum, the latter mobilizes its army and declares war on Serbia (30 JUL). Austria-Hungary's mobilization, in turn, prompts Russia's (30 JUL), which, in turn, spurs Germany's mobilization and declaration of war against Russia and France (1, 3 AUG). When Germany violates Belgian neutrality, England declares war on Germany (3 AUG).

DEC 01: *Boston*: Amy Lowell gives her first public poetry reading at a benefit for Belgium. "400 applaud" (Watson).

OTHER CITIES 1915

JUL *Ridgefield NJ*: Kreymborg begins publishing *Others* (which runs in 26 issues until JUL 1919).

SEP *San Francisco*: "San Francisco Panama-Pacific International Exhibition": Italian Futurists' first American exhibition, also their last group exhibition.

Appendix 2

Modernist Groups 1910-1914: A Listing

Paris
Cubist School groups
Picasso and Braque
Orphists
Ballets Russes
Montjoie! circle / Cerebristes

Unanimists
Simultaneists
Paroxystes
Dramatistes
Fantaistes

Berlin
Der Sturm
Der neue Club
Die Pathetiker
Pan
Neue Secession
Meyer circle

Die Aktion
Neopathetisches Cabaret
Das neue Pathos
Der literarishes Club Gnu
Die Brücke
Salon Cassirer

Munich
Neue kunstlervereignigung (NKV)-Munich

Der Blaue Reiter

Vienna
2nd Vienna School
Akademisches Verband
Neukunstgruppe

London
Imagists
Vorticists

Milan
Italian Futurists

Moscow and St. Petersburg
Union of Youth
Donkey's Tail
Hylaea / Cubo-Futurists
Centrifuge
Triangle

Jack of Diamonds
Rayists
Ego-Futurists
Mezzanine

Prague
Osma or The Eight
Skupina or Group of Plastic Artists

Mánes Union of Artists
Arconauts

New York City and environs
Stieglitz's "291" group
Association of American Painters and Sculptors
Mabel Dodge salon

Camera Work
Synchromists
The Glebe

Paris[1]

Cubist School (locale groups) 1910-1914
comprised of:

a. Henri Le Faconnier's studio (locale group) winter 1910-1911

Center
Henri Le Fauconnier, painter

Regular visitors (all painters unless noted)

Albert Gleizes	Jean Metzinger
Roger de La Fresnaye	Robert and Sonia Delaunay
Fernand Léger	Jules Romains, poet

b. Alexandre Mercereau's salon (locale group) 1908-1911

Center
Alexandre Mercereau: writer, impresario, "the central electric of European letters" (Marinetti); former member of Abbaye de Crèteil group and several poetry groups, co-edited (with Paul Fort) *Vers et Prose*, primarily a Symbolist magazine.

Regular visitors
same painters as those visiting Le Fauconnier's studio
writers associated with Abbaye de Créteil group:

Jules Romains	Henri Martin Barzun
René Arcos	
later: artists Roger de La Fresnaye	Alexandr Archipenko

c. Closerie des Lilas café (locale group: Tuesday evenings)

Center
Paul Fort, ed. of *Vers et Prose*

Regular patrons
painters listed in a. and b.
writers (directly related to Cubism):

Guillaume Apollinaire	Roger Allard
Alexandre Mercereau	André Salmon

d. Albert Gleizes's salon (locale group: Courbevoie: Mondays) ca. 1910-1914

Center
Albert Gleizes, painter

Regular visitors
visitors drawn from groups a, b, and Puteaux groups

e. Société Normande de Peinture Moderne (exhibition group)

Members

Marcel Duchamp	Raymond Duchamp-Villon
Jacques Villon	Francis Picabia

All of the groups above coalesce into:

Puteaux Group (salon-locale group: Sunday afternoons) April 1911-1914

Creators
Jacques Villon (group meets at his studio in Puteaux)

Marcel Duchamp	Raymond Duchamp-Villon
Francis Picabia	

Regular visitors
painters and sculptors:

Alexandr Archipenko	Robert and Sonia Delaunay
Albert Gleizes	Juan Gris
František Kupka	Roger de La Fresnaye
Marie Laurencin	Henri Le Fauconnier
Fernand Léger	André Lhote
André Mare	Jean Metzinger
Georges Ribemont-Dessaignes	Henri Valensi

Walter Pach, painter, Armory Show organizer

writers / critics:

Guillaume Apollinaire	Roger Allard
Maurice Raynal	André Salmon

Alfred Princet, mathematical theorist and insurance actuary

Major Exhibitions / History

OCT	1910	Paris Automne Salon: Gleizes, Metzinger, Le Fauconnier hung close together, recognize their common interest in Post-Cézannian planar form. Over winter 1910-1911, group begins meeting regularly at Le Fauconnier's studio, Mercereau's apartment, and at Closerie des Lilas. With Roger de la Fresnaye they plan to exhibit together for Spring Indépendants by controlling the voting for the Indépendants' hanging committee.
APR	1911	At Indépendants Salon, the above painters, plus Delaunay, Léger, Lhote, Segonziac, Moreau, Marcoussis, Ozenfant all exhibit Cubistic or Cubist-inspired works in *salle 41* and *salle 43*. Show creates scandal, influences Duchamp brothers and Picabia. Apollinaire reviews show, calls Metzinger only real Cubist of the group.

JUN 1911 Brussels Society of Independent Artists: Several painters of *salle 41* and *43* exhibit; Apollinaire writes catalog introduction.

OCT 1911 At Automne Salon, second major Cubist exhibition; merger of Mercereau group and Puteaux group (Duchamps, Picabia, Kupka) in *salle 8*. "[P]ublic outrage was greater" [than at the spring 1911 Indépendants]" (Altshuler 27).

Both groups, plus Archipenko, Léger, and sometimes Gris, Laurencin, Apollinaire, and others begin meeting at Villon's studio in Puteaux to discuss common interests, plan Section d'Or exhibition.

Gleizes, Metzinger, Le Fauconnier, Mercereau, and Jacques Nayral announce new review of plastic arts (unrealized).

NOV 1911 Galerie d'Art Ancien et d'Art Contemporain: group exhibition of future Section d'Or painters: the Duchamps, Gleizes, Léger, Metzinger, etc. Apollinaire lectures on 4th dimension in contemporary painting.

before MAR 1912 Indépendants Salon (with hanging committee members from Puteaux group), rejects Duchamp's *Nude Descending a Staircase*, leading to his estrangement from the group.

MAR 1912 At Indépendants Salon, works include: Delaunay's *City of Paris*, Kupka's *Planes by Colors I-III*, Gris's *Homage to Picasso*, works by Gleizes and Metzinger. Cubist sculpture by Archipenko, Gleizes, Duchamp, Lehmbruck, Brancusi, Zadkine.

JUN 1912 Salmon announces plans for Section d'Or exhibition in *Gil Blas*.

OCT 1912 At Automne Salon 20+ "Cubist" painters show works; Parisian municipal councilor publishes open letter in *Mercure de France* protesting against public buildings used to show Cubist art.

10 OCT 1912 *Salon de "La Section D'Or"* at Galerie de la Boëtie (the major exhibition organized by Puteaux group): 31 artists, 180 works, periodical produced by Reverdy, *Bulletin de la Section d'Or*, with essays by Apollinaire, Raynal. Apollinaire lectures at exhibition: "The Quartering of Cubism."

JAN 1913 *Poème et Drame* announces formation of new group, "Les Artistes de Passy," which holds a few meetings and "Rue Tronchet Exhibition."

Major Publications

OCT 1912 *Bulletin de la Section d'Or*
DEC 1912 *Du Cubisme* (Gleizes and Metzinger)
MAR 1913 *The Cubist Painters: Aesthetic Meditations* (Apollinaire) includes articles on Cubist School painters.

Picasso and Braque (nucleus group) 1908-1914

Members
Pablo Picasso
Georges Braque

Nature of Relationship
Braque: "Before long [winter 1908], Picasso and I had daily exchanges; we discussed and tested each other's ideas as they came to us, and we compared our respective works."

Picasso: "Almost every evening, either I went to Braque's studio or Braque came to mine. Each of us had to see what the other had done during the day."

When on vacation and away from Braque, Picasso writes: "I miss you. What's happened to our walks and our [exchanges of] feelings? I can't write [about] our discussions [on] art" (letter of 30 MAY 1912). When the two vacation together in Sorgues, Picasso writes to Kahnweiler: "Braque and I have taken so many walks and talked so much about art that time has passed quickly" (letter of 11 AUG 1912, Rubin, *Picasso and Braque: Pioneering Cubism* 358, 395, 401).

Major Achievement: Their Codevelopment of Analytical and Synthetic Cubism

SEP 1908	One of Braque's submissions to the Automne Salon's jury (*Houses at L'Estaque*, painted that summer) is described by Matisse as "a painting made of small cubes." Braque later withdraws this painting from his submission. Matisse's description, together with Vauxcelles's (below) are generally thought to have named the new style.
09 NOV 1908	Reviewing Braque's exhibition at Galerie Kahnweiler, hostile critic Louis Vauxcelles writes that Braque "reduces everything . . . to geometrical schemas, to cubes." (*Gil Blas*, 14 NOV).
winter 1908	"Close dialogue" between Picasso and Braque begins (Rubin 357).
spring-summer 1909	With *Woman in an Armchair* and the several landscapes completed at Horta de Ebro, Picasso consolidates the several directions he explored simultaneously after *Les Demoiselles d'Avignon* into Cubist style (later called "analytical Cubism").
fall 1909	Braque paints *Violin and Palette* and other works in which a trompe l'oeil nail intensifies visual ambiguity of Cubist form (playing off illusory 3-D space against the flatter Cubist faceting).
spring 1910	Braque paints first oval Cubist work, *Woman with a Mandolin*. Picasso does likewise and paints several Cubist portraits (Wilhelm Uhde, as well as Vollard and Kahnweiler by late autumn).
AUG 1911	Close collaboration betw. Picasso and Braque at Céret. Both start incl. titles of local newspaper, "*Indépendants*."
JAN 1912	Braque uses stenciled letters in *Le Portugaise* and simulated wood graining in *Homage to J.S. Bach*.
MAY 1912	Picasso makes first collage, *Still Life with Chair Caning*; Picasso also simulates wood graining with steel comb in *Souvenir du Havre*.
SEP 1912	Braque creates first *papier collé*, *Fruit Dish and Glass*, in which he uses commercial paper printed with imitation oak-grain pattern; also begins mixing sand in his paint.
OCT 1912	Picasso experiments with sand in painting.
OCT 1913	Picasso creates several assemblages, incl. some made of cardboard.
spring 1913	Picasso makes bronzes incl. *Absinth Glass*.

Exhibitions

fall 1908	Automne Salon: Braque exhibits.
09 NOV 1908	Galerie Kahnweiler: Braque exhibits, incl. *Houses at L'Estaque*. Apollinaire writes catalog introduction (Fry #3-5).
21 DEC 1908	Notre-Dame-des-Champs gallery: Picasso exhibits 3 paintings, Braque 6.
25 MAR 1909	Indépendants Salon: Braque exhibits, incl. *Harbor and Landscape*.
01 SEP 1909	Galerie Kahnweiler: Braque exhibits in group show.

MAY	1910	Notre-Dame-des-Champs: Picasso exhibits.
SEP	1910	Munich: Thannhauser gallery: Braque and Picasso jointly exhibit.
28 MAR	1911	New York: 291 Gallery: Picasso exhibits 83 drawings and watercolors at Stieglitz's, his first show in America.
01 MAY	1911	Berlin: 22nd Secession Exhibition: Picasso and Braque show 4 and 2 works, respectively.
05 OCT	1912	London: Second Post-Impressionist Exhibition: Braque sends 4 works (incl. *Violin: Mozart/Kublick*), Picasso 13 paintings, 3 drawings.
06 OCT	1912	Amsterdam: *Moderne Kunst Kring 2* exhibition: Braque sends 6 works, Picasso 12.
17 FEB	1913	New York: Armory Show: Braque exhibits 3 works, Picasso sends 7 paintings and a bronze sculpture.
late FEB	1913	Munich: Thannhauser Galerie holds first Picasso retrospective in Germany: 76 paintings, 37 watercolors from 1901-1912.
10 JUN	1913	Picasso does etchings for Max Jacob's book *Siege de Jérusalem* (published 14 JAN 1914).
09 DEC	1914	New York: 291 Gallery exhibits Picasso and Braque.

Orphism (nucleus group) 1913-1914

Creator
Robert Delaunay

Publicist
Guillaume Apollinaire

Members
writers:

Apollinaire	Blaise Cendrars

painters:

Patrick Bruce	Arthur Frost
Sonia Delaunay	Vladimir Rossiné
Alice Bailly (Swiss)	Georges Yakoulov (leaves January 1914)

Associates

Marc Chagall	Alexander Archipenko

Major Exhibitions

28 MAR	1912	Paris: Delaunay has first major show: 41 paintings incl. *Towers of Laon*; Maurice Princet writes catalog preface.
mid-JAN	1913	Berlin: Der Sturm exhibition (Delaunay): 19 paintings incl. 12 *Windows*.
20 SEP	1913	Berlin: First German Autumn Salon: Delaunay shows 22 works incl. first *Circular Forms*.
01 MAR	1914	Paris: Indépendants Salon: the "Orphists" exhibit together.

Publications, Lectures, Forums

summer	1912	"Light," and "Note on the Construction of the Reality of Pure Painting" (Delaunay).
10 OCT	1912	"The Quartering of Cubism" (Apollinaire): lecture given at "Section d'Or" exhibition; links Delaunay to "Orphic Cubism."
ca. NOV	1912	"Windows" (Apollinaire) written while Apollinaire lived with the Delaunays and in response to Delaunay's *Windows* series.
DEC	1912	"Notes: Réalité, peinture pure" (Apollinaire's revision of Delaunay's notes) in *Les Soirées de Paris* and *Der Sturm*, trans. Paul Klee.
late JAN	1913	Delaunay and Apollinaire give lectures at Der Sturm Gallery accompanying Delaunay's exhibition.
FEB	1913	"On Light" published in *Der Sturm*, trans. by Klee.
		"La Prose du Transsibérien" (Sonia Delaunay and Blaise Cendrars).
17 MAR	1913	*The Cubist Painters: Aesthetic Meditations* (Apollinaire) repeats the "Orphic Cubism" category.
18 MAR	1913	In *Montjoie!* Apollinaire credits Delaunay with first use of "simultaneism," provoking angry rebuttal from Futurists.
		"The Salon des Indépendants on the Quai d'Orsay" (Apollinaire): review names Delaunay, Léger, Gleizes, Laurencin, Metzinger, and Bruce as "aesthetic orphists"; in separate review, he names the new trend presented there as "orphism, pure painting, simultaneity."
19 MAR	1913	"Manifesto of Orphism" (Georges Meunier) distributed at Spring Independents, unrelated to Delaunay's group.
29 MAY	1913	In *Montjoie!* Apollinaire writes: "From Cubism there emerges a new Cubism. The reign of Orpheus is beginning."

Other History

early	1913	Orphist circle coalesces around Delaunays, incl.: Apollinaire, Cendrars, Chagall, Bruce, Frost, Yacouloff, Rossiné, and Bailly.
APR	1913	Delaunays move to Chateau Louveciennes outside Paris, where he works on *Discs* and *Circular Forms* series. Others of the group visit regularly.
JAN	1914	Georges Yakoulov leaves group and returns to Russia, accuses Delaunay of plagiarizing his ideas about simultaneism; joins B. Livshits and A. Lourié in writing anti-Western manifesto.

Unanimists (nucleus group) 1905-ca. 1910

Founder (and chief proponent)
Jules Romains

Associates (identified by Romains, though some later resisted being grouped):

*Georges Duhamel	*Charles Vildrac
*Henri Martin Barzun	*Alexandre Mercereau
*René Arcos	Luc Durtain
Georges Chennevière	

*resident of L'Abbaye de Créteil (1906-1908), commune of writers and artists that published books of poems incl. Romains's *La vie unanime* and later published their poetry primarily in Barzun's *Vers et Prose*.

Manifestos

APR 1905 "Les Sentiments unanimes et la poésie" (Romains) in *Le Penseur*:
 founding article-manifesto.

MAR 1908 *La vie unanime* (Romains, Abbaye Press), book of poems, written
 between 1904-1907, that embody Unanimist aesthetics and world-
 view.

History

SEP 1905 "Sur la poésie actuelle" in *La Revue des poètes* criticizes Symbolism
 for "artificiality."

autumn 1906 Abbaye de Créteil commune created; Romains becomes frequent
 visitor, "lay member" (Robbins).

APR 1907 Abbaye Press publishes first book: *La Terrestre Tragédie* (Barzun),
 "a verse epic in 25 cantos."

autumn 1907 Duhamel, Vildrac leave Abbaye, associate closely with Romains.

 1908 *La tragédie des espaces* (Arcos) and *Gens de La et d'Ailleurs* (Mer-
 cereau) published by Abbaye Press, both reflecting Unanimist themes
 incl. "simultaneity of modern life" (Robbins).

early 1908 Abbaye folds, but Unanimism continues through influence of Ro-
 mains and *La vie unanime*.

 1908 Romains publishes "À propos e l'unanimisme" in *Grand Revue*, vol.
 50.

Aesthetics and Philosophy

Life is regulated by "unanimes," or energy groups that fluctuate but are ever present. The
modern city is one such group, which Unanimist poets treat as "the protagonist, fully
humanized into states of mind and states of emotion" (Buckberrough, *Robert Delaunay:
The Discovery of Simultaneity* 53). Thus, the poems show a kinaesthetic interaction be-
tween individual and larger energy groups that affects both. Abbaye group was also in-
terested in "speed, technology, simultaneity, and vast physical scope of modern life"
(Buckberrough 54). Cf., Futurism; according to Buckberrough, Marinetti, a frequent
Abbaye visitor, integrated Romains's philosophies into his own (54). Cf., also, Delaunay,
who attended Mercereau's *soirées* beginning in 1910.

Unanimism opposed the poetry of *individual* emotion and confession (neo-
Romantics, Symbolists), hermetically isolating the individual from society; conversely,
its emphasis on the personified social context gave "personal emotion and experience . . .
[a] collective significance" (Cornell, *The Post-Symbolist Period*). E.g., Arcos and Vildrac
both favored the theme of the crowd.

Selected Publications of Members

 1907 Vildrac, *Images et mirages* (L'Abbaye press)
 1908 Durtain, *Pégase*
 1909 Romains, "La poésie immédiate" in *Vers et prose*, vol. 19
 1909 Duhamel, "L'homme en tête" in *Vers et Prose*
 1910 Duhamel and Vildrac, *Notes sur la technique poétique*
 1910 Romains, "Un être en marche," in *Mercure de France*
 1910 Duhamel, "Selon ma loi" (poems) in *Figuière*
 1910 Arcos, "Ce qui naît" in *Figuière*
 1910 Chennevière, "Le Printemps" in *Figuière*

1911 Romains, "Puissances de Paris" and "Mort de Quelqu'un" in *Figuière*
1911 Romains, *L'Armée dans la ville* (drama)
1912 Vildrac, *Livre d'amour*, ed. *Nouvelle Revue Francais*
1913 Romains, "Odes et Prières" in *Mercure de France*
1913 Duhamel, "Les poètes et la poésie" in *Mercure de France*
1913 Arcos, "L'Ile perdue," in *Mercure de France*

Simultaneists and Dramatistes (nucleus groups) 1912-ca. 1914

Founder
Henri Martin Barzun

Adherents
Fernand Divoire
Sébastien Voirol

Associates (manifesto signers)

Guillaume Apollinaire	Albert Doyen
Alexandre Mercereau	Albert Gleizes
Pierre Joudon	Louis Mandin
Florian Parmentier	Georges Polti
Tancrede de Visan	Theo Varlet

Major Manifestos and Articles

JUL[2] 1912 *L'Ere du Drame: Essai de Synthèse Poétique Moderne* (Barzun): "a manifesto-book" (Mitchell) of 142 pp. presenting Unanimist-influenced concept of simultaneity and "modern poetic synthesis" (signed: Barzun et al. above)

1913 *Poétique d'un idéal nouveau* (Barzun): pamphlet

1913 "The Revolution of Modern Polyrhythms"

MAY 1913 "technical manifesto of the new literary art: 'Voix, Rhythmes, et Chants Simultanés Experiment in *L'Ere du Drame*'" (Barzun)

27 JUN 1913 "Manifesto of Poetic Simultaneism [Simultanéisme]" (Barzun, in *Paris-Journal*)

1913? "L'Esthétique dramatique" (Barzun)

1913? "Du Symbole au drame" (Barzun)

Major Publications

APR 1907 *La Terrestre Tragédie* (Barzun): "a verse epic in 25 cantos"; Version for Choric recital, 1910

1912 *Hymne des forces* (Barzun): a choric drama in 3 "mansions"; character types (hero, poet, prophet) speak with supporting hymns and choruses in epic form (Cornell 130). 155 pp. (*Mercure de France*).

MAR[3] 1912 *Poème et Drame* (Barzun, founder and ed.): runs 10 issues (to JUL 1914) "to expound the tenets and principles of synthesis presented in *L'Ere du Drame*" (Boyd Carter).

L'Orphéide, Universel Poème (Barzun): "An epic journey in 7 episodes (12 choruses encompassing the 4 seasons)" (Barzun)

Aesthetics
Synthesis, simultaneous presence of individual and universal forces; conflict betw. these elements gives poetry its dramatic quality. Barzun advocates (in *Poétique d'un idéal nouveau*) "le chant simultané et polyrythmique," i.e., simultaneous presentation of collective and individual levels, effecting a "polyphonic" poetry (akin to music) that should replace "monodic" verse. In Barzun's poems (published in *Poème et Drame*) choruses are typographically aligned like opera librettos. Critics questioned how genuinely simultaneous voices would be possible without cacophony (Cornell 125).

Barzun (and Apollinaire in his *Calligrammes*) experimented with typographical techniques to realize these simultaneous perceptions of different phrases. These experiments also influenced Blaise Cendrars.

In his Berlin lecture of JAN 1913, Apollinaire ambiguously mentioned "dramatism" as a movement to which he subscribed, with Barzun, Mercereau, and Polti (*Apollinaire on Art* 268).

Paroxystes (nucleus group) 1913-1914

Founder
Nicholas Beauduin, poet and editor[4]

Adherent
Georges Turpin, poet

Manifestos

	1913	In *Sur les Tendances présentes de la littérature française* (Gaston Picard) and in condensed form in
16 JAN	1914	*Mercure de France* (article)
15 AUG	1914	"The New Poetry of France" (Beauduin, in *The Egoist*, trans. Richard Aldington)

Publications

	1908-1912	*Les Rubriques nouvelles* (Beauduin, ed.), little magazine which published Beauduin's books of poems
MAR[5]	1913	*La Vie des lettres* (Beauduin, ed.), little magazine, official organ of Paroxysme, attracted important modernist poets

Aesthetics
Stressed "enthusiasm," dynamic action, an unreflective immersion into life, the "machine man," and the tumultuous present. Opposed skepticism, analysis, pure reason, "egotistic irony," the detached solipsism of "personal sensation, in which the earlier symbolists were delighted" ("The New Poetry of France" 314), philosophies (e.g., "art for art's sake") that separate art from life, and "antique" literature.

Paroxysme, thus represented a "synthesis" of Futurism and Unanimism—"Art . . . is . . . a perpetual dynamism. We . . . find it . . . in palpitating multitudes, those immense reservoirs of joyous energies" ("New Poetry" 314)—with an intentional nod to the Neue Pathos: the lyricism of contemporary life "will be powerfully instinctive. . . . it will bring 'a new pathos'" (315). Beauduin also preached a reconciliation of art and science and a dynamic relation between the two.

Fantaistes (medium-locale group)

Members (staff of *Soirées de Paris*, Cubist allies)
André Salmon Max Jacob
André Billy

Dynamistes (nucleus group) 1913

Founders
Henri Guilbaux
A. M. Gozzes

Aesthetics
"strength, spontaneity, and free play of the imagination, having no truck with the intellect" (*Oxford Companion to French Literature*)—very close to Paroxysme.

Synthétistes (nucleus group)

Aesthetics
"poetry of synthesis, of small details assembled to make a panoramic whole" (*Oxford Companion to French Literature*)—similar to Integralistes.

Integralistes (nucleus group) ca. 1902 - ?

Founder
Adolphe Lacuzon

Member
Nicholas Beauduin

Montjoie! Circle / Cerebristes (medium-locale group: Mondays evenings)
JAN-JUN 1914

Founder
Riccioti Canudo, editor of *Montjoie!*

Associates
writers / critics:
Guillaume Apollinaire Alexandre Mercereau
Henri Martin Barzun Roger Allard
Blaise Cendrars

composers:
Igor Stravinsky Eric Satie
Alfredo Cassella

painters, sculptors:
Robert Delaunay
Marc Chagall
Raymond Duchamp-Villon
Albert Gleizes
Natalia Goncharova

Fernand Léger
Jacques Villon
Morgan Russell
Mikhail Larionov
Roger de la Fresnaye

designer:
Léon Bakst

Manifestos

09 FEB 1914 "Le Manifeste Cerebriste" (Canudo) in *Le Figaro* and *Montjoie!*
(Jan-Feb); did not announce a movement or group, but "summarized
views of an important part of the avant-garde" (Mitchell 172).

APR-JUN 1914 "Our Aesthetics: Concerning Stravinsky's [*Song of the*] *Nightingale*"
in *Montjoie!*

Publications

FEB 1913
–JUN 1914 *Montjoie!* (little magazine, Canudo, ed.)

Performances

ca. early 1913 "La Prose du Transsibérien . . ." (Cendrars-S. Delaunay):
first presentation

Ballets Russes (performance group) 1910-1929

Founder, Organizer, and Impresario
Serge Diaghilev

Major Composers for the Ballet
Claude Debussy
Nikolai Rimsky-Korsakov
Maurice Ravel

Igor Stravinsky
Reynaldo Hahn

Chief Choreographers
Michel Fokine (for *Firebird, Le Dieu Bleu, Petrouchka, Daphnis and Chloé*)
Vaslav Nijinksy (for *L'Après-Midi d'un Faune, Jeux, Le Sacre du Printemps*)

Designers
Léon Bakst (for *Le Dieu Bleu, Daphnis and Chloe, L'Après-Midi d'un Faune, Jeux*)
Alexandre Benois (for *Petrouchka)*
Nicholas Roerich (for *Le Sacre du Printemps*)

Principal Dancers
Vaslav Nijinsky
Vera Folkina
Lydia Nelidova

Tamara Karsavina
Michel Fokine
Ronislava Nijinska

Enrico Cecchetti Adolph Bolm
Maria Piltz Anna Pavlova

Major Premières

I. Ballets Russes (with Gabriel Astruc, Diaghilev organizes first Russian ballet in Paris)
18 MAY 1909 *Prince Igor* (Paris: Théâtre du Châtelet)
 music: Borodin; sets / costumes: Roerich (using bright, provocative
 colors and lavish features); choreography: Fokine; principal danc-
 ers—Nijinksy, Pavlova, Karsavina—employed vigorous, athletic
 style. Major success.
 Le Festin (Paris: Théâtre du Châtelet)
 music: Glauzunov, Glinka et al.; sets: K. Korovin; choreography:
 Fokine et al.; costumes: Bakst, Benois et al.; principal dancers: Nijin-
 sky, Fokina, Karsavina.
04 JUN 1910 *Schéhérezade* (Paris: Théâtre National de l'Opéra)
 music: Rimsky-Korskov; libretto: Bakst, Benois, Fokine; sets / cos-
 tumes: Bakst; choreography: Fokine; principal dancers: Nijinsky, Ida
 Rubinstein
25 JUN 1910 *Firebird* (Paris: Théâtre National de l'Opéra)
 music: Stravinsky; choreography: Fokine; libretto: Fokine; sets: A.
 Golovin; costumes: Golovin, Bakst; principal dancers: Karsavina,
 Fokine, Fokina
 Les Orientales (Paris: Théâtre National de l'Opéra)
 music: Arensky, Borodin, Glazunov, Grieg (orchestrated: Stravin-
 sky); sets: Korovin; costumes: Korovin, Bakst; choreography:
 Fokine; principal dancers: Nijinsky et al.

II. Ballets Russes de Diaghilev
19 APR 1911 *Le Spectre de la Rose* (Monte Carlo)
 music: Weber (orch. Berlioz); libretto: J.-L. Vaudoyer (after poem by
 T. Gautier); choreography: Fokine; sets / costumes: Bakst; principal
 dancers: Nijinsky, Karsavina
13 JUN 1911 *Petrouchka* (Paris: Théâtre du Châtelet)
 music: Stravinsky; choreography: Fokine; sets / costumes: Benois;
 libretto: Stravinsky, Benois; principal dancers: Nijinsky, Karsavina
13 MAY 1912 *Le Dieu Bleu* (Paris: Théâtre du Châtelet)
 music: Reyaldo Hahn; libretto: Jean Cocteau; choreography: Fokine;
 sets / costumes: Bakst; principal dancers: Nijinsky, Karsavina, B. Ni-
 jinska, Lydia Nelidova
20 MAY 1912 *Thamar* (Paris: Théâtre du Châtelet)
 music: Balakirev; libretto: Bakst; choreography: Fokine; sets / cos-
 tumes: Bakst; principal dancer: Karsavina
29 MAY 1912 *L'Après-midi d'un Faune* (Paris: Théâtre du Châtelet)
 music: Debussy; libretto: poem by Mallarmé; choreography:
 Nijinksy; sets / costumes: Bakst; dancers: Nijinksy, Nelidova. Cre-
 ated scandal with antique style and Nijinksy as faune simulating or-
 gasm over nymph's scarf.

08 JUN 1912 *Daphnis and Chloe* (Paris: Théâtre du Châtelet)
 music: Ravel; libretto: Fokine; sets / costumes: Bakst; choreography:
 Fokine; dancers: Nijinksy, Karsavina
15 MAY 1913 *Jeux* (Théâtre de Champs-Elysées)
 music: Debussy; libretto: Fokine; sets / costumes: Bakst; choreogra-
 phy: Nijinsky; principal dancers: Nijinksy, Karsavina. Dancers in
 modern dress; cool reception.
29 MAY 1913 *Le Sacre du Printemps* (Théâtre de Champs-Elysées)
 music: Stravinsky; libretto: Stravinsky, Roerich; sets / costumes:
 Roerich; choreography: Nijinsky; dancers: Piltz, Vorontzov. Pro-
 voked huge riot on opening night between pro- and anti-Stravinsky
 partisans.
12 JUN 1913 *La Tragédie de Salomé* (Théâtre de Champs-Elysées)
 music: Florent Schmitt; sets / costumes: Soudeikine; choreography:
 B. Romanov; principal dancer: Karsavina
14 MAY 1914 *Legend of Joseph* (Paris: Théâtre National de l'Opéra)
 music: R. Strauss; libretto: Hofmannsthal, Kessler; sets: Sert; cos-
 tumes: Bakst; choreography: Fokine; principal dancers: Fokina,
 Kuznesova, Massine et al.
24 MAY 1914 *Le Coq d'Or* (Paris: Théâtre National de l'Opéra)
 music: Rimsky-Korsakov; sets / costumes: Goncharova; choreogra-
 phy: Fokine; principal dancers: Karsavina, Bolm
summers 1911 Balles Russes tours Europe and London each summer with huge
-1913 success.

Berlin

Der Sturm (medium-locale group) first phase: MAR 1910-1914

Founder, Editor, and Impresario
Herwarth Walden (formerly editor of *Der Neue Weg*; fired JAN 1910 for incl. avant-
garde writers)

Working Associate
Oskar Kokoschka, contributor of art and poetry, MAR 1910–spring 1911, editor for Aus-
tria-Hungary, OCT 1910–SEP 1911

Circle (meeting at Café des Westens, 1910-1912; at Café Josty and Sturm gallery, 1913-
1924)
Gottfried Benn, poet (from 1913) Rudolf Blümner, actor and poet
Alfred Döblin, writer and poet Albert Ehrenstein, Viennese writer
Salomo Friedlaender, writer Peter Scheerbart, writer
August Stramm, poet (1913-1915) William Wauer, sculptor, painter
Else Lasker-Schüler, poet (Walden's first wife), until 1911
Nell Walden, poet and painter (Walden's second wife)

Associates and Contributors

Ernst Blass, writer and poet Theodor Däubler, poet
Carl Einstein, writer Alfred Kerr, critic, editor of *Pan*
Rudolf Kurtz, writer Walter Mehring, writer
Alfred Richard Meyer, publisher Peter Scher, Munich writer
René Schickele, poet, writer, editor

Manifesto

MAR-APR 1910 "Programmatisches" (Kurtz): vigorously opposed bourgoisie's em-
 phasis on intellect and classicism: "Intellectualism can only be sub-
 dued by a noisy emphasis on the instincts, the dark forces. . . . With
 our most provocative measures, we will flout every manifestation of
 this culture" (vol. 1, nos. 2-3; qtd. in Allen 104).

Major Publication: *Der Sturm* (newspaper)

MAR	1910	*Der Sturm* begins publishing in Berlin and Vienna, quickly reaches very high circulation.
MAY	1910	Kokoschka's drawings begin appearing.
JAN	1911	Die Brücke artists' work begins appearing (Pechstein, Heckel, Schmidt-Rottluff, Mueller, Nolde).
after MAY 1911		Kirchner's woodcuts begin appearing.
1911-1912		Works by Kandinsky, Marc, Pascin, and Morgner begin to appear.
MAR	1912	Futurists publish Foundation Manifesto, "Technical Manifesto of Painting" and "The Exhibitors to the Public" (preceding their exhibition: see below).
DEC	1912	"Reálité: Peinture pure" (Apollinaire, trans. Paul Klee)
FEB	1913	"On Light" (Delaunay, trans. Paul Klee)
FEB	1913	"Modern Painting" (Apollinaire)—these three essays accompany their talks and Delaunay's paintings at Der Sturm gallery).
SEP	1913	"Painting as Pure Art" (Kandinksy)
29 SEP	1913	"Today, the Spirit of the New Man," lecture (Cendrars)
late	1913	Expressionist woodcuts by artists above completely replace earlier art nouveau style.
late	1913	*Sancta Susanna*, play (Stramm)
APR	1914	Stramm's poetry begins appearing.

Focus in first phase (1910-1914)

"In the first two years . . . essays on broad cultural and philosophical themes are liberally
mixed with literature, art criticism and theory"; but, by APR 1912, the journal's interests
narrow to literature and the arts, and by the following year, focus increasingly on Expres-
sionist art and criticism (Allen 106).

Readings, Recitals

Sponsored sporadically at Sturm Gallery, often read by Blümner.

Major Exhibition Openings at Der Sturm Gallery: 1912-1914

12 MAR	1912	"Expressionists" includes first Blaue Reiter Exhibition (modified).
12 APR	1912	Italian Futurists traveling exhibition
MAY	1912	"French Graphic Arts" (includes Picasso)
ca. AUG	1912	"French Expressionists" (includes Braque)

OCT	1912	Kandinsky Retrospective (from Munich)
02 NOV	1912	Die Pathetiker group (Meidner, Janthur, Steinhardt)
mid-JAN	1913	Delaunay, A. Soffici, J. Baum: Delaunay and Apollinaire lecture, read poetry
JUL	1913	Severini exhibits
20 SEP	1913	"Erster deutscher Herbstsalon": major international exhibition with 366 works, ca. 85 artists
ca. JAN	1914	Last Blaue Reiter exhibition includes some Die Brücke artists
APR	1914	Klee and Chagall exhibit
10 AUG	1914	Italian Futurists exhibit

Die Aktion (medium-locale group) FEB 1911-1932

Founder, Publisher, and Editor
Franz Pfemfert

Initial Circle

*Carl Einstein, novelist	*Kurt Hiller, writer (leaves in 1913)
*Jakob van Hoddis, poet	*Max Oppenheimer ("Mopp"), painter
Alexandra Ramm (Mrs. Pfemfert)	*Ludwig Rubiner, writer
*Anselm Ruest, writer	

Collaborators (poets unless otherwise noted)

Hugo Ball, writer	Johannes Becher
Gottfried Benn	Ernst Blass
Paul Boldt	Ivan Goll, writer
Ferdinand Hardekopf, writer	Henriettte Hardenberg
*Georg Heym	Franz Jung, writer
Oskar Kanehl	Hugo Kersten, writer
Gustav Landauer, writer	Alfred Lichtenstein
Grete Meisel-Hess	Claire Otto
Maria Ramm (Alexandra's sister)	Richard Oehring, writer
Karl Otten, novelist	Carl Sternheim, dramatist
Hellmut Wetzel	Alfred Wolfenstein

Less regular members, occasional guests, and contributors

Franz Blei, writer	Max Brod (from Prague), poet and writer
*Salomo Friedlaender, writer	Walter Hasenclever, poet and writer
Else Lasker-Schüler	Heinrich Mann, novelist
Otto Gross, psychoanalyst	Peter Scher, ed. *Simplicissimus*
René Schickele, poet and novelist	

*contributed to Pfemfert's *Der Democrat* (JAN 1910–FEB 1911)

20 FEB	1911	First issue contains poems by Heym.
11 JUN	1913	First woodcuts by Franz Marc appear.
16 MAY	1914	Senna Hoy memorial

Some Major Recitals and Evenings

| 22 MAR | 1911 | Paul-Scheerbart-Abend |

15 DEC 1911 Max-Brod-Abend (also reading of Franz Werfel's poetry)

Focus
Overall, much more political than *Der Sturm* with emphasis on leftist-anarchist politics: "almost a lone island of political commitment in the main current of Expressionism" (Allen 129). By 1912, more balance between literature and politics, incl. Expressionist poets listed above. Serialized novels by Einstein (*Bebuquin*) and Schickele (*Der Fremde*) in 1912. 1912-1914 featured Expressionist drawings and prints, woodcuts in 1914 (Mopp, Marc).

Der neue Club (locale group: Fledermauszimmer restaurant) MAR 1909–ca. 1912

Founders
Kurt Hiller Jakob van Hoddis

First Leader
Kurt Hiller (left with Blass, Wassermann JAN 1911 to form "Der literarische Club Gnu")

Initial Circle
Erwin Loewenson Robert Majut
John Wolfsohn Erich Unger (became leader when Hiller left)

Members joining soon after
Ernst Blass Arthur Drey
David Baumgardt (left early 1911) Ernst Engert
Wilhelm S. Guttmann Georg Heym (from MAR 1910)
Robert Jentzsch (left early 1911) Friedrich Koffka
Friedrich Schulze-Maizier Armin Wassermann

Associates
Heinrich Eduard Jacob Rudolf Kurtz
Armin Wegner

Major Performances: see neopathetisches Cabaret

Philosophical Orientation
Like *Der Sturm*, opposed bourgeoisie's repressive emphasis on rational intellect and strongly supported Stephan Zweig's "neue pathos": "a synthesis of intellect and feeling" (Allen). Also echoed Nietzsche's call for a Dionysian counterbalance to the Apollonian. Apocalyptic theme especially strong in Hoddis. Lyrical poetry becomes the chief medium to embody these themes.

Das neopathetisches Cabaret (performance-locale group of Der neue Club)
JUN 1910–APR 1912

Organizers and participants (all poets except Schoenberg)
Ernst Blass Georg Heym (until his death on 16 JAN 1912)
Jakob van Hoddis H. E. Jacob

Else Lasker-Schuler Erwin Loewenson
Ferdinand Hardekopf Kurt Hiller
Robert Jentzsch Erich Unger
Arnold Schoenberg, composer

Performances: 9 evenings, incl.:
 1910 First poetry recital by Heym
NOV 1911 Poetry recital by Heym, Hardekopf, Blümner, etc.
DEC 1911 Poetry recital by Hoddis, Einstein, Walden, Kurz
The recitals, which included music, often drew audiences of several hundred.

Die Pathetiker (nucleus group) summer 1912-NOV 1912

Organizer
Ludwig Meidner, painter

Members
Richard Janthur, painter
Jakob Steinhardt, painter, member of Lasker-Shüler circle at Café des Westens

Exhibition
02 Nov 1912 Der Sturm Gallery

Philosophical Orientation
Echoes apocalyptic themes of poetry at neopathetiches Cabaret, which influenced
Meidner Group. Dispanded after exhibition.

Meidner studio (locale group: Wednesday evenings) late 1912–spring 1914

Center
Ludwig Meidner, painter and poet (moves to Dresden, spring 1914)

Participants
Johannes Becher, poet George Grosz, painter
Walter Hasenclever, poet and writer Max Herrmann-Neisse, poet
Jakob van Hoddis, poet

Das neue Pathos (medium-locale group)[iii] 1913–1914

Editors
Hans Ehrenbaum-Degele Ludwig Meidner
Robert Schmidt Paul Zech

Die neue Secession (exhibition group) 1910–1912

Organizers and Leaders
Max Pechstein Emil Nolde
(after paintings of both were rejected by Berlin Secession)

Members include:
Die Brücke painters:
 Erich Heckel Ernst Ludwig Kirchner
 Max Pechstein Karl Schmidt-Rotluff
(They leave collectively DEC 1911, causing Neue Secession to fold soon after.)

Exhibitions
MAY	1910	First exhibition includes Nolde, Die Brücke artists (and others rejected by Berlin Secession).
01 OCT	1910	Second exhibition: graphics, includes Nolde, Die Brücke.
FEB	1911	Third exhibition introduces Kandinsky, Marc, Jawlensky.
18 NOV	1911	Fourth exhibition includes NKV-Munich, Kubišta.
MAR[7]	1912	Fifth exhibition: graphic art, sculpture

Die Brücke (full-fledged group) 1905–1913

I. Dresden Period (1905–ca. 1910)

Core Members
Ernst Ludwig Kirchner, spokesman and de facto leader
Fritz Bleyl (left 1909) Erich Heckel
Karl Schmidt-Rottluff

Expanded Membership
Emil Nolde (1906-07) Max Pechstein (1906-1912)*
Axel Gallén-Kallela (Finnish, 1906-?)
Cuno Amiet (Swiss, 1906-?)
* "expelled" 1912 for exhibiting separately in Berlin Secession

Aesthetics
Rejected finished and correct formalism of the academies; flat, linear, and abstract decoration of Jugendstil Impressionists' use of color as ocular sensation. Emphasized immediate, intuitive, subjective response to nature.

Character
Core-group painters lived and worked communally: "signatures often omitted, pictures painted by one were cut in wood by another." (Selz)

Manifesto
"Manifesto of Künstlergruppe Brücke" (woodcut by Kirchner) 1906

Exhibitions

	1906	(in lamp shade factory)
winter	1906	graphics (included Kandinsky)
fall	1907	Salon Richter: created "violent rejection" (Selz)
SEP	1910	Galerie Arnold; travels to Weimar

Portfolios: annually 1906-1912

II. Berlin Period (ca. 1910-1913)

1908 Pechstein moves to Berlin; other members follow over next 3 years.

Exhibitions

MAY	1910	Neue Secession (see above)
OCT	1910	Neue Secession
FEB	1911	Neue Secession (Brücke formally withdraws from N.S.: DEC)
APR	1911	Galerie Fritz Gurlitt
APR	1912	Galerie Fritz Gurlitt

Graphics in *Der Sturm*:
Pechstein: 21 JAN 1911 frontispiece
Kirchner: 11 May 1911 and many thereafter

Pedagogy

fall 1911 Kirchner and Pechstein found MUIM Institute to give courses in painting, graphics, sculpture, glass and metal, etc.; venture fails by summer 1912.

Writings

1913 "Chronik der Brücke": Kirchner's history of group, accompanied by woodcuts and photographs, was to be 1913 Portfolio. Repudiated by other members, resulting in breakup of group.

Der literarische Club Gnu (performance-locale group) JAN 1911-1914

Organized cabaret evenings to rival Neopathetisches Cabaret.

Founders

*Kurt Hiller Ernst Blass (breaks with Hiller in mid-1913)
*Armin Wassermann *Walter Hasenclever
* split off from Die neue Club

Performances

NOV	1911	Readings by Blümner, Lichtenstein, Rubiner, Max Brod from Prague (introducing Franz Werfel's poetry to Berlin)
	1911	Hoddis reads "Weltende"; Heym reads "Das Krieg."
	1912-1913	ca. 5 recitals

The Meyer Circle (medium group) 1912-1914

Center
Alfred Richard Meyer, publisher and editor (Verlag A. R. Meyer)

Associates (all poets unless noted)

Gottfried Benn	Otto Buek, writer-translator
Fritz Max Cahén	Paul Erkens
Else Hadwiger, writer-translator	Oskar Kanehl
Rudolf Kurtz	Rudolf Leonhardt
Feliz Lorenz	Ernst Wilhelm Lotz
René Schickele	

Affiliates

Ernst Stadler, from Strasbourg	Apollinaire, from Paris

Major Publications
1. *Lyrische Flugblätter* (1907-1915, 1919-1924): small, unbound, soft-cover volumes (8-16 pp. each), mostly of lyric poetry, incl.:

MAR	1912	*Morgue und andere Gedichte* (Gottfried Benn)
late	1912	*Die Dämmerung* (Alfred Lichtenstein), first volume
NOV	1912	*Futuristische Dichtungen* (F.T. Marinetti, ed., with title page portrait by Carrà, foreword by Kurtz on Futurist theory)
NOV	1913	"Zone" (Apollinaire), trans. Cahén. Apollinaire's first poetic appearance in German translation
	1912-1914	Expressionistic woodcuts by Meidner, Artur Segal, Max Beckmann used as covers.
	1913-1914	Volumes by Zech, Benn, Lasker-Schüler, Scher, Lotz, Döblin, Heym, Goll, and others

2. *Die Bücherei Maiandros* (OCT 1912 - JAN 1915)
Journal featuring literature primarily by the Meyer circle with woodcuts by Meidner, Zech, and Beckmann

Editor
Alfred Meyer

Assistants

Heinrich Lautensack, Munich poet	Anselm Ruest

Recitals
Primarily readings by Meyer group and associates

Other History

1911	Meyer won over to Expressionist poetry by Hoddis's "Weltende."
1911	Meyer publishes his own poems in *Der Sturm* and *Die Aktion*.

Pan (medium group: weekly arts journal) March 1910-1915

Founder
Paul Cassirer, art dealer

Editors
Paul Cassirer, leaves 1912 Wilhelm Herzog, coeditor 1910-1911
Alfred Kerr, literary contributor and critic (1910-1911), later replaces Cassirer as editor
(1912-APR 1915)

Focus
Journal had regular sections devoted to the arts and critcism, plus essays on politics, so-
cial, and moral themes. Endorsed "Expressionist aesthetic of 'littérature engagée' to pro-
voke reader's response" (Allen).

Major Publications in *Pan* include:

| | 1912 | *Der tote Tag* (Ernst Barlach): play published with 27 original lithos by playwright-artist. |
| Mar | 1912 | New editor, Kerr, emphasizes Expressionist literature even more than Cassirer had, publishing H. E. Jacob, H. Essig, L. Frank, and R. Sorge (section from *Der Bettler*). |

Other History

| | 1911 | Kerr publishes letter ridiculing police chief, Traugott Jagow, prompting Jagow to ban *Pan* and prosecute its editors (ending in ac-quittal). Publications led to Cassirer's resignation. |

Salon Cassirer (locale group) 1902-1933
Gathering place for artists; sponsored Ernst Barlach, Jules Pascin. Locale for readings,
some sponsored by Der Neue Club, Der Sturm, Die Aktion, and Meyer circle.

Exhibitions

| JUN | 1910 | Kokoschka's first one-artist show. |
| | 1913 | Beckmann has large one-artist show. |

Munich

NKV-Munich Neue kunstlervereignigung (exhibition group) 1909-1912

Organizers
Wassily Kandinsky (first chairman) Adolph Erbslöh
Alexei von Jawlensky

Members incl. sculptors, musicians, dancers, poets
Alexei von Jawlensky Marianne Werefkin
Garbriele Münter Alfred Kubin
Alexender Kanoldt Otto Fischer

Paul Baum	Karl Hofer
Vladimir von Bechtejeff	Moissey Kogan
Erna Bossi	Alexander Sacharoff (dancer)

Associates

Henri Le Fauconnier (1910)	Thomas von Hartmann, composer
Pierre Girieud (1910)	

Exhibitions

01 DEC 1909 — Munich: includes Kandinsky, Jawlensky, Werefkin, Münter, Kubin, Alex. Kanoldt, Erbslöh. Kandinsky was "the center" but the exhibitors showed "no similarity of style" (Selz).

01 SEP 1910 — Munich: one of the first major international exhibitions emphasizing modernism. Includes Cubist works by Picasso and Braque, works by Le Fauconnier, Derain, the Burliuks, Rouault, Redon, Van Dongen, Vlaminck. Kandinsky shows *Composition No. 2, Improvisation No. 12—The Rider*. Participating artists permitted to write catalog statements (anticipating *Blaue Reiter Almanac*). Kandinsky shocked by hostility and xenophobia of public and press responses; receives supportive letter from then unknown Franz Marc.

04 DEC 1911 — 3rd exhibition (follows Kandinsky-led walkout and overlaps with first Blaue Reiter exhibition); includes: Erbslöh, Kanoldt, Jawlensky, Werefkin, but sans Kandinsky, Marc, Münter, Kubin, von Hartmann, Le Fauconnier.

Manifestos and Articles

DEC 1909 "Foreword" to NKV exhibition catalog (Kandinsky)

Aesthetics and Philosophy

Art should be a synthesis of outer-world impressions and "events" from artist's inner world: search for forms to express this interaction. Exhibitions should emphasize new developments regardless of nationality (Kandinsky).

History

JAN	1909	Cofounded by Kankinsky and Erbslöh
JAN	1911	Polarizes into liberals (Kandinsky and Marc) and conservatives (Erbslöh, Kanoldt) over group's support of abstraction in exhibited paintings (primarily Kandinsky's).
JUN	1911	Kandinsky and Marc form Blaue Reiter, plan exhibition and almanac.
DEC	1911	Kandinsky and Marc formally break from NKV, joined by Münter, Kubin, von Hartmann, and Le Fauconnier.

Der Blaue Reiter (nucleus group) June 1911-August 1914

Founders and Organizers

Wassily Kandinsky	Franz Marc

Close Collaborator

August Macke

Associates (contributors to the *Blaue Reiter Almanac*)

Hans Arp

Heinrich Campondonck

Henri Le Fauconnier

Paul Klee

Gabriele Münter

Burliuk bros. (for exhibitions)

Robert Delaunay

Thomas von Hartmann

Alfred Kubin

Arnold Schoenberg

Major Exhibitions

18 DEC 1911 Munich: "First Exhibition of the Editors of the Blaue Reiter": 50 works, 14 artists, invited by Kandinsky and Marc

12 FEB 1912 Munich: Second exhibition, "Black and White": 300+ graphics, watercolors, drawings by international group. Exhibition moves to Cologne and Berlin.

early 1914 Berlin: Sturm gallery: "Der Blaue Reiter" includes Klee, Werefkina, and some Die Brücke artists

Major Manifestos and Statements

19 JUN 1911 Kandinsky's letters to Franz Marc stating idea and principles for the

01 SEP 1911 *Blaue Reiter Almanac* and exhibition.

ca. OCT 1911 "Preface" (Kandinsky and Marc, unpublished) for the *Almanac*.

DEC 1911 *Concerning the Spiritual in Art* (Kandinsky) [1912 publication date]

MAY 1912 "Spiritual Treasures," "Two Pictures," "The 'Savages' of Germany" (Marc), "The Relation to the Text" (Schoenberg), and "On the Question of Form" (Kandinsky)—all in the *Blaue Reiter Almanac*

FEB 1914 "Foreword to the Planned Second Volume of the *Blaue Reiter*" (Franz Marc)

MAR 1914 "Preface to the Second Edition" (Kandinsky)

MAR 1914 "Preface to the Second Edition" (Marc)

Publications

May 1912 *Blaue Reiter Almanac* (ed. Kandinsky and Marc), 1st edition: 19 articles and essays, 144 reproductions of art from several cultures and countries, incl. creative works by Kandinsky (*The Yellow Sound: A Stage Composition*), Schoenberg (*Hertzgewächse*), Berg, and Webern. First edition of 1,500 sold out; 2nd edition of 6,000 (with new prefaces by Kandinsky and Marc) published in 1914.

Revolution (medium-locale group: Café Stefanie) 1913

Editors

Hans Leybold

*Hugo Ball *Richard Huelsenbeck

*later became Berlin Dadaists

Little magazine lasted only 3 months (5 issues). First issue impounded by police.

Vienna

Second Vienna School (pedagogical group) ca. 1904-1914

Organizer and Pedagogue
Arnold Schoenberg

Student-Disciples
Alban Berg
Anton von Webern

Other Student-Disciples of Arnold Schoenberg

Karl Horwitz	Erwin Stein
Paul Stefan	Egon Wellesz
Heinrich Jalowetz	

Major Works: Schoenberg

14 JAN	1910	Première of *3 Piano Pieces*, Op. 11 (finished 1909)
3 SEP	1912	London: première of *5 Pieces for Orchestra*, Op. 16 (finished 1909)
	1913	*Erwartung*, Op. 17
FEB	1912	Berlin: première of *6 Little Klavierpieces*, Op. 19 (finished 1911)
MAY	1912	*Herzgewächse*, Op. 20, published: *Blue Rider Almanac* (finished 1911)
	1912	Berlin: première of *Pierrot Lunaire*, Op. 21 (finished 1912)
	1913	*Die Glückliche Hand*, Op. 18
	1914	*4 Melodies for Voice and Orchestra*, Op. 22

Major Works: Berg

31 MAR	1913	Première (of two songs): *Altenberg Lieder: 5 Orchestral Songs on Picture-Postcard Texts by Peter Altenberg*, Op. 4 (finished 1912)
	1913	*4 Pieces for Clarinet and Piano*, Op. 5
	1913-1914	*3 Orchestral Pieces*, Op. 6

Major Works: Webern

8 FEB	1910	Première of *Five Movements for Strings*, Op. 5 (finished 1909)
	1910	*Two Songs on Poems by Rilke (for Voice and 8 Instruments)*, Op. 8
24 APR	1911	Première of *4 Pieces for Violin and Piano*, Op. 7 (finished 1910)
31 MAR	1913	Première of *6 Pieces for Orchestra*, Op. 6 (finished 1909)
	1913	*6 Bagatelles for String Quartet*, Op. 9
	1913	*5 Pieces for Chamber Orchestra*, Op. 10
	1914	*3 Small Pieces for Cello and Piano*, Op. 11

Major Publications

DEC	1911	Schoenberg, *Harmonielehre (Theory of Harmony)* (written 1909–SEP 1910)
MAY	1912	Schoenberg, "The Relationship to the Text" (Schoenberg) in *Blaue Reiter Almanac*

Neukunstgruppe (exhibition group) 1909-1910

Founder
Egon Schiele

Members

Anton Faistauer	Karl Massmann
Anton Peschka	Franz Wiegel
Karl Zakovse	and others

Manifesto Stance
"The new artist is and must at all costs be himself; he must be a creator; he must build the foundation himself without reference to the past, to tradition. Then he is an artist." (republished in *Die Aktion*, 1914)

Exhibition
1909 Pisco Gallery

London

Poets' Club (locale group) March 1909-ca. 1910
"Forgotten School of 1909"—Pound

Leader
T. E. Hulme

Members

F. S. Flint	Ezra Pound
Alan Upward	Edward Storer
F. W. Tancred	Joseph Campbell
Florence Farr	

Significance: Antecedent of 1912 Imagists. Experimented with haiku and free verse forms.

Imagists / Les Imagistes (nucleus group) spring 1912-1917

Founder
Ezra Pound

Leader and Impresario
*Ezra Pound, spring 1912-1914
*Amy Lowell, summer 1914-1917

Central Members

*H. D. (Hildegarde Doolittle)	*Richard Aldington

Associates (from Imagist anthologies)

Skipwith Cannell John Cournos
John Gould Fletcher *F. S. Flint
Ford Madox Hueffer *T. E. Hulme
James Joyce D. H. Lawrence
Marianne Moore Alan Upward
*William Carlos Williams
*applied Imagist principles in poetry

Major Manifestos

MAR 1913 "Imagisme" (Flint, ghostwritten by Pound) in *Poetry*
MAR 1913 "A Few Don'ts by an Imagiste" (Pound) in *Poetry*
 1915 "Preface" to *Some Imagist Poets* (Lowell)
 1916 *Gaudier-Brzeska: A Memoir* [passim] (Pound)

Major Publications

MAR 1914 *Des Imagistes* (ed. Pound)
 1915-1917 *Some Imagist Poets* (yearly anthology, ed. Lowell)

Histories by group members

28 JAN 1915 "Affirmations: As for Imagism" (Pound)
01 MAY 1915 "History of Imagism" (Flint)

Omega Workshops (locale group: artists' workshop) APR 1913-1914

Founder
Roger Fry

Members

David Bomberg *Frederick Etchells
Duncan Grant *Cuthbert Hamilton
Nina Hamnett *William Roberts
Wyndham Lewis (led members' walkout on 05 OCT 1913 that ended the Workshops)
*joined Lewis in forming Rebel Group (see Vorticism history below)

Aesthetics
Devoted to decorative arts in the tradition of William Morris's Arts and Crafts movement.

Vorticists (nucleus group) spring 1914-summer 1915
formerly: "Rebel Group" fall 1913-spring 1914

Founder
Wyndham Lewis, painter and writer

Central Members

Frederick Etchells, painter Henri Gaudier-Brzeska, sculptor
Ezra Pound, poet William Roberts, painter

Edward Wadsworth, painter

Associates and Manifesto Signers

Richard Aldington, poet Malcolm Arbuthnot, painter
Lawrence Atkinson, painter Jessie Dismorr, painter
Jacob Epstein, sculptor Cuthbert Hamilton, painter
Helen Saunders, painter Alvin Langdon Coburn, photographer

Major Publications

20 JUN 1914 *BLAST: Review of the Great English Vortex*, no. 1, ed. Lewis
02 JUL 1915 *BLAST*, no. 2, ed. Lewis; includes first published poems by T. S.
 Eliot ("Preludes," "Rhapsody on a Windy Night")

Major Manifestos and Statements

15 JUN 1914 "Futurism" *New Age* (Aldington, Bomberg, Etchells, Wadsworth,
 Pound, Atkinson, Gaudier-Brzeska, Hamilton, Roberts, Lewis): Vor-
 ticists' repudiation of Futurists' "Vital English Art" manifesto.
20 JUN 1914 [in *BLAST*, no. 1]:
 "Long Live the Vortex!"
 "Manifesto" (Aldington, Arbuthnot, Atkinson, Gaudier-Brzeska,
 Dismorr, Hamilton, Pound, Roberts, Sanders, Wadsworth, Lewis)
 "Vortex. Pound" (Pound)
 "Vortex. Gaudier Brzeska" (Gaudier-Brzeska)
SEP 1914 "Vorticism" (Pound) in *Fortnightly Review*
02 JUL 1915 [in *BLAST* no. 2]:
 "Editorial" [Lewis]
 "Vortex (written from the Trenches)" (Gaudier-Brzeska)
 "Vortex 'Be Thyself'" (Lewis)
 "Blasts and Blesses"
JUL 1915 "Preface" to catalog for Vorticist exhibition (Lewis)

Major Exhibitions

OCT 1913 London: Rebel group included in third "Post-Impressionist and Fu-
 turist Exhibition."
16 DEC 1913 Brighton: Group exhibits (as "Cubist Room") in "Camden Town
 Group and Others" exhibition.
MAR 1914 London: group included in London Group's first exhibition.
JUN 1914 London: group members included in AAA salon exhibition.
MAR 1915 London: group members exhibit in London Group's second
 exhibition.
10 JUN 1915 London: "First Vorticist Exhibition"

Other Events

05 OCT 1913 Lewis leads secession from Fry's Omega Workshop (incl.
 Wadsworth, Etchells, Hamilton) to form "Rebel group"; invites
 Nevinson to join.
18 NOV 1913 Nevinson invites Marinetti to London; Rebel group holds banquet
 honoring Marinetti.
MAR 1914 Rebel Art Centre opens.
 Marinetti lectures at Doré Galleries, sponsored by "Rebels."

APR	1914	*The Egoist* carries ads for *BLAST*.
JUN	1914	Vorticism officially announced; Rebel Art Centre closes.
07 JUN	1914	Marinetti, Nevinson publish "Vital English Art" as English-Futurist manifesto, listing Lewis et al. as signatories.
12 JUN	1914	Lewis et al. heckle Marinetti and Nevinson during their Evening at Doré Galleries.
14 JUN	1914	Lewis et al. repudiate manifesto "Vital English Art" and Futurism in several London papers.

Milan

Italian Futurists (full-fledged group) FEB 1909-1915; 1919-1930s

Leader-Impresario
Filippo Marinetti
Members:[8] painters, sculptors, photographers, architects

Umberto Boccioni	Carlo Carrà
Gino Severini (joins by May 1910)	Luigi Russolo
Giacomo Balla (joins by May 1910)	

Ardegno Soffici, ed. of *Lacerba* (1912-1914)
Antonio Sant'Elia, architect
Romolo Romani, Aroldo Bonzagni (briefly members in 1910)

Members: poets

Libero Altomare	Paolo Buzzi
Francesco Cangiullo	Enrico Cavacchioli
Auro D'Alba	Luciano Folgore
Corrado Govoni	Giovanni Papini, ed. of *Lacerba* (1912-1914)

Members: composers

Francesco Balilla Pratella	Luigi Russolo

Foreign Members or Associates

Félix Del Marle, French painter	C. W. Nevinson, English painter
Valentine de Saint-Point, French writer	Mina Loy, English poet and painter

"Second Generation" Futurists

Anton Bragaglia, photographer, theatre and film director	
Bruno Corra, novelist and playwright	Fortunato Despero, painter, sculptor, poet
Enrico Prampolini, painter, sculptor	Emilio Settimelli, writer and editor
Mario Sironi, painter	

Major Manifestos (more than 50 published between 1909-1914)

| 11 FEB | 1909 | Foundation Manifesto (Marinetti, in *Le Figaro*) |
| 11 FEB | 1910 | Manifesto of Futurist Painters (Balla, Boccioni, Carrà, Russolo, Severini, Romani, Bonzagni) |

11 APR	1910	Technical Manifesto of Painting (Boccioni, Carrà, Russolo, Balla, Severini)
11 JAN	1911	Manifesto of Futurist Musicians (Pratella)
11 JAN	1911	Manifesto of Futurist Dramatists (Marinetti)
11 MAR	1911	Technical Manifesto of Futurist Music (Pratella)
05 FEB	1912	The Exhibitors to the Public (Boccioni, Carrà, Russolo, Balla, Severini)
25 MAR	1912	Manifesto of Futurist Women (Saint-Point)
11 APR	1912	Technical Manifesto of Sculpture (Boccioni)
11 MAY	1912	Technical Manifesto of Literature (Marinetti)
11 JAN	1913	Futurist Manifesto of Lust (Saint-Point)
11 MAR	1913	The Art of Noises (Russolo)
11 MAY	1913	"L'Immaginazione senza fili e le parole in libertà" (Marinetti)
JUN	1913	"The Futurist Intonorumori" (Russolo)
29 JUN	1913	"L'Anti-tradition futuriste" (Apollinaire)
11 AUG	1913	"The Painting of Sounds, Noises, and Smells" (Carrà)
29 SEP	1913	"The Variety Theater: Manifesto of the Music Hall" (Marinetti)
11 OCT	1913	"Futurist Political Programme" (Boccioni, Carrà, Russolo, Marinetti)
15 NOV	1913	"After Free Verse: Words in Liberty" (Marinetti): supplement to Manifesto of MAY 1913
11 MAR	1914	"Dynamic and Synoptic Declamation" (Marinetti)
01 AUG	1914	"Manifesto of Futurist Architecture" (Sant'Elia)
11 SEP	1914	"Anti-Neutralist Clothing. Futurist Manifesto" (Balla and Cangiullo)
20 SEP	1914	"Futurist Synthesis of War" (Boccioni, Carrà, Piatti, Russolo)
11 JAN	1915	"The Futurist Synthetic Theatre" (Corra, Marinetti, Settimelli)

Exhibitions of Painting and Sculpture

19 MAR	1910	Milan: Futurist painters' first exhibition
OCT	1910	Boccioni's first one-artist exhibition at *Ca'Pesaro*
20 DEC	1910	Milan: Futurist painters' second exhibition
30 APR	1911	Milan: Futurist "free art" exhibition of painting (ca. 50 works)
05 FEB	1912	Paris: Traveling exhibition of Futurist painting. Moves to London, 1 March; to Berlin, 12 April; to Brussels, 20 May. Exhibition (divided or in toto) then moves to The Hague, August; Rotterdam, September; Amsterdam and Cologne, October; Munich and Karlsruhe, November; Vienna, December; possibly also: Hamburg, Zürich, Prague, Budapest
21 FEB	1913	Rome: major Futurist exhibition (incl. Soffici)
07 APR	1913	London: Severini's first one-artist show; moves to Berlin (summer)
18 MAY	1913	Rotterdam: "Italian Futurist Painters and Sculptors"
20 JUN	1913	Paris: Boccioni's first sculpture exhibition
20 SEP	1913	Berlin: Futurists participate in "Erster deutscher Herbstsalon"
12 OCT	1913	London: "Post Impressionists and Futurists" exhibition
NOV	1913	Berlin: Futurists participate in multiple group show at Sturm gallery
NOV	1913	Florence: major Futurist group show, sponsored by *Lacerba*
DEC	1913	Rome: Boccioni's sculpture exhibited
	1914	Russolo gives concerts of noises ("Intonarumori") in Milan and London (June 1914)
FEB	1914	Rome: "Futurist Painters Exposition" at Spovieri Gallery
APR	1914	Rome: "First Free Futurist Exhibition" at Spovieri Gallery

APR	1914	London: second Futurist exhibition (incl. sculpture) at Doré Galleries
20 MAY	1914	Naples: group show
AUG	1914	Berlin: Futurist exhibition at Sturm gallery
SEP	1915	San Francisco: last exhibition of original Futurist painters

Major Publications

	1910	*Mafarka, the Futurist* (Marinetti): novel, in Italian and French
	1911	*Destruction* (Marinetti): Futurist poems in French; translated into Italian
	1911	*Le Futurisme* (Marinetti): Futurist articles; in Italy they appear together in *War: The World's Only Hygiene*, 1915
	1912	*The Pope's Monoplane* (Marinetti): political novel in free verse
	1912	"The Battle of Tripoli" (Marinetti): early poem applying "parole in libertà" techniques. (Both works composed OCT 1911 while Marinetti is in trenches observing battle.)
	1912	*I Poeti futuristi* (Marinetti, ed.): anthology
	1912	*Anti-Neutrality* and *Simultaneity* (Marinetti): short plays
JAN	1913	*Lacerba* begins publishing.
summer	1913	*Futurist Photodynamism* (Bragaglia): examples exhibited in Rome
	1914	"Zang Tumb Tumb" (Marinetti) as "Futurist Edition of *Poesia*": poems applying his "words-in-freedom" style
APR	1914	*Futurist Painting–Sculpture (Plastic Dynamism)* (Boccioni): book
	1915	"Montagne+Vallate+StradeXJoffre" (Marinetti) best-known example of "parole in libertà" poem

Futurist Evenings, Readings, Riots

spring	1909	Turin: Marinetti declaims Foundation Manifesto; his play *Les Poupées électriques* performed
12 JAN	1910	Trieste: first Futurist evening; Foundation Manifesto read.
14 FEB	1910	Milan: Futurist Evening
08 MAR	1910	Turin: Futurist evening ending in fight and riot ("Battle of Turin").
20 APR	1910	Naples: Futurist evening ends in riot.
26 JUN	1910	Naples: Marinetti gives talk: "The Heroic City, the Abolition of the Police and the School of Courage: Discourse on the Necessity of Violence."
08 JUL	1910	Venice: Futurists drop 800,000 copies [re: R. W. Flint] of "Against Passéist Venice" from top of Venice clock tower. During and after Marinetti's speech following leafleting, slaps and fistfights occur.
JUN	1911	Florence: Milanese Futurists violently attack Soffici and Papini ("Punch-up in Florence").
FEB	1912	Paris: Marinetti lectures accompanying Futurist traveling exhibition.
MAR	1912	London: Marinetti lectures accompanying exhibition.
APR	1912	Berlin: Marinetti lectures accompanying exhibition.
FEB	1913	Rome: Futurist Evening
spring	1913	Berlin: Marinetti lectures, sponsored by Herwarth Walden.
JUN	1913	Paris: Marinetti and Boccioni lecture accompanying Boccioni's first sculpture exhibition.
NOV	1913	London: Marinetti gives several lectures and poetry readings; has dinner in his honor; tries to recruit English "Rebel" painters to Futurist movement.

NOV	1913	Florence: Futurist Evening accompanying group exhibition, ends in fight.
JAN	1914	Moscow / St. Petersburg: Marinetti lectures, meets and debates with Russian Futurist groups.
29 MAR	1914	Rome: *Piedigrotta* (Francesco Cangiullo), performance of "parole-in-libertà" drama by Marinetti, Balla, and Cangiullo
late APR	1914	London: Marinetti reads "Siege of Adrianople" with sound effects by himself and C.W. Nevinson.
05 MAY	1914	London: Marinetti and C.W. Nevinson lecture.
12 JUN	1914	London: Marinetti and C.W. Nevinson lecture; heckled and disrupted by English Vorticists (Lewis, Gaudier-Brzeska) and T. E. Hulme.
15 JUN	1914	London: Marinetti and Russolo give series of "Intonarumori" concerts.
15 SEP	1914	Milan: first Futurist anti-neutrality demonstration
16 SEP	1914	Milan: second anti-neutrality demonstration; Marinneti, Boccioni, Russolo arrested and imprisoned for a few days.
winter	1914	Florence: Futurist Evening results in riot.

Moscow and St. Petersburg[9]

Union of Youth (exhibition group) fall 1909–DEC 1913

Organized exhibitions, lectures, and debates; "attempted to unite talents of young writers, painters, musicians, and critics under . . . single cultural organization." Sponsored visits by foreign artists, e.g., Marinetti in 1914. "[S]oon became synonymous with artistic extremism, sensation, and capricious experiment" (Bowlt, *Russian Modernism* 166). Published members' books and its own journal.

Founders
Elena Guro, writer and painter, wife of
Mikhail Matyushin, writer and painter
Olga Rozanova, painter

Financed by
Levky Zheverzheyev, businessman and collector

Members

Vladimir Markov	Vladimir Tatlin (in early 1913)
Nikolai Kulbin	"Hylaea" group (at beginning of 1913)

Exhibitions
MAR	1910 [o.s.]	St. Petersburg
spring	1911 [o.s.]	St. Petersburg
17 DEC	1912 [n.s.]	St. Petersburg
04 DEC	1912	Moscow
23 NOV	1913 [n.s.]	St. Petersburg

Performances
DEC 1913 St. Petersburg: sponsored *Vladimir Mayakovsky: A Tragedy* and *Victory over the Sun.*

Lectures, Forums
DEC 1911 St. Petersburg: all-Russian Congress of Artists:
 Kulbin read translated excerpts of *Concerning the Spiritual in Art*,
 presents his own color theory.
NOV 1912 D. Burliuk, Mayakovsky lecture.
 1913 (2 evenings): D. Burliuk speaks on "Painterly Counterpoint,"
 Larionov on Rayism.

Publications: *Union of Youth magazine*
APR 1912 First issue has translation of Italian Futurists' "The Exhibitors to the
 Public."
JUN 1912 Second issue has translations of Le Fauconnier's catalog statement
 from 2nd NKV-M exhibition of 1910, Italian Futurist "Technical
 Manifesto of Painting."
spring 1913 Issue includes translations from Gleizes and Metizinger's *Du Cubisme* and Signac's *From Delacroix to Neo-Impressionism.*
 1915 Matyushin publishes Malevich's *From Cubism to Suprematism.*

Triangle (exhibition group) 1909-ca. 1910

Founder
Nikolai Kulbin

Members
Elena Guro Mikhail Matyushin
David Burliuk (from "The Wreath of Stephanos")
Vladimir Burliuk (from "The Wreath of Stephanos")

Exhibition
MAR 1910 St. Petersburg: first exhibition (includes all members)

Aesthetics: Impressionism

Jack of Diamonds (exhibition group) 1910-1918

Founders
Mikhail Larionov (leaves in JAN 1912 to form Donkey's Tail group)
Natalia Goncharova (leaves in JAN 1912 to form Donkey's Tail group)
Aristarkh Lentulov

Impresarios / Organizers
David and Vladimir Burliuk (for 2nd exhibition)

Members

Robert Falk Petr Konchalovsky
Aleksandr Kuprin Ilya Mashkov
Vasilii Rozhdestvensky

Major Exhibitions

DEC 1910 [o.s.] Moscow
05 JAN 1912 [o.s.] Moscow
03 MAR 1913 [n.s.] Moscow
JAN 1914 [o.s.] Moscow

Lectures, Forums

12 FEB 1912 at which Larionov and Goncharova disaffiliate
25 FEB 1912
24 FEB 1913

Publications

FEB 1913 Moscow: *The Jack of Diamonds*, collection of essays on modern art
 by Le Fauconnier, Apollinaire, Aksenov

The Donkey's Tail (exhibition group) 1911-1912

Created to counter Jack of Diamonds's second exhibition with its European emphasis. Exhibition to be all-Russian and emphasize "primitivism," Russian roots. Name taken from famous Montmartre hoax of painting done by donkey's tail.

Founders

Mikhail Larionov
Natalia Goncharova

Associates

Kasimir Malevich
Vladimir Tatlin (who also stays involved in Jack of Diamonds group)

Exhibitions

17 DEC 1911 [n.s.] St. Petersburg (with Union of Youth)
24 MAR 1912 [n.s.] Moscow

Rayists (nucleus group) 1912-1914[10]

Founders

*Mikhail Larionov
*Natalie Gontcharova

Close Associate

*Ilya Zdanevich, poet, propagandist for Italian Futurism

Associates (signers of Rayist Manifestos)

Ivan. Larionov T. Bogomazov

Kiryll Zdanevich *Michel Le-Dantyu
*Vladimir Levkievski *Sergei Romanovich
Vladimir Obolenski Morits Fabri
Alexandr Shevchenko
* organizers of first "Everythingist" evening

Organizers of Target Exhibition:
Anisimov, Bart, Bobrov, Chagall, Goncharova, M. and I. Larionov, Le-Dantyu, Malevich, Rogovin, Sagaydachny, Shevchenko, Skuie, Yastrzhembsky, and Zdanevich.
MAR 1913 Movement officially announced during Target Exhibition.
DEC 1913 Founders change their name to "Everythingists."

Major Exhibitions
24 MAR 1912 [n.s.] Moscow: "Donkey's Tail" Exhibition
04 DEC 1912 Moscow?: 4th Union of Youth Exhibition
06 APR 1913 [n.s.] Moscow: "The Target" Exhibition
MAR 1914 [o.s.] Moscow: "No. 4 - Exhibition of Paintings: Futurists, Rayists, Primitivists"

Manifestos and Articles
JUN 1912 "Luchism" (Larionov) brochure
OCT 1912 First public discussion of Rayism in Pavel Ivanov's newspaper article (under pseudonym V. Mak); treated as "entirely Russian creation with completely new technical method" (Parton 44).
JUL 1913 "Rayonnists and Futurists: A Manifesto" (authors: M. Larionov, N. Goncharova; additional signers: I. Larionov, T. Bogomazov, K. Zdanevich, M. Le-Dantyu, V. Levkievsky, S. Romanovitch, V. Obolensky, M. Fabri, and A. Shevchenko); accompanies Target Exhibition of MAR 1913. Group is also called "futurepeople" ("budushchniki"), Larionov's neologism to distinguish it from Burliuk's "people of the future" ("budetlyane") coined by Khlebnikov.
JUL 1913 "Rayist Painting" (Larionov), largely a reprint of "Luchism" but refers to "Pneumo-rayism, or concentrated rayonism" as "next stage of development." Published together in *The Donkey's Tail and The Target* (Moscow).
DEC 1913 "Why We Paint Ourselves: A Futurist Manifesto" (Larionov and Zhanevich), includes praise (à la Italian Futurism) for "frenzied city of arc lamps," "screech of the trolley," etc.
spring 1914 "Pictorial Rayonism" (Larionov) in *Montjoie!* (April-May-June issue) to accompany Larionov-Goncharova Parisian exhibition

Hylaea / Cubo-Futurism (full-fledged group) late 1911-1913
[Russian "Gileya" was the ancient Greek name for Buliuk's region on Black Sea; "Hylaea" thus intended to connote primitivism (Markov 35). Khlebnikov sometimes called the group "Budetlyane"="men of the future."]
late 1913: name changed to Cubo-Futurism (-1914)

Founders
Burliuk brothers: David (poet and painter), Nikolai (poet), and Vladimir (painter)

Benedict Livshits (poet)

Impresario
David Burliuk

Members: poets

Velimir Khlebnikov	Vasily Kamensky
Vladimir Mayakovsky	Aleksei Kruchenykh (all joined in 1911)

Igor Serveryanin (briefly, in early 1914)

Associates: painters

Mikhail Larionov	Natalia Goncharova

(both later split with Burliuk to form Rayists, JAN-FEB 1912; briefly reunited in 1914 to make film)

Kasimir Malevich	Olga Rozanova

Major Manifestos

12 DEC 1912 "Slap in the Face of Public Taste" (D. Burliuk, Kruchenykh, Mayakovsky, Khlebnikov); published in almanac of same name, includes first published reference to "self-sufficient word." Leaflet version with different content appears FEB 1913.

FEB 1913 St. Petersburg: untitled manifesto in *A Trap for Judges, II* (D. Burliuk, Guro, N. Burliuk, Mayakovsky, Nizen, Khlebnikov, Livshits, Kruchenykh); includes more detailed program of word-oriented poetry.

summer 1913 "Declaration of the Word as Such" (Kruchenykh): leaflet

SEP 1913 "New Ways of the Word" (Kruchenykh); published in *The Three*; contains first reference to *zaum* (transreason) and to transrational language (*zaumnyi iazyk*), which author defines as "irrational."

OCT 1913 "*The Word as Such*" (Kruchenykh and Khlebnikov), fifteen-page booklet (manifesto and verse)

JAN 1914 "Go to Hell!" (D. Burliuk, Kruchenykh, Livshits, Mayakovsky, Severyanin, Khlebnikov) published in *Roaring Parnassus*

early JAN 1914 "We and the West" (Yakoukov, Livschitz, Lourie)

Major Publications and Performances

FEB 1910 *The Studio of Impressionists* (includes Khlebnikov's "Incantation by Laughter," which becomes his most famous transrational poem)

APR 1910 *A Trap for Judges*, almanac of poetry by Kamensky, Khlebnikov, D. and N. Burliuk, Guro, etc.

DEC 1912 *World Backwards*, poetry by Kruchenykh and Khlebnikov, illus. by Larionov, Goncharova, Tatlin

FEB 1913 *A Trap for Judges II* (2nd almanac)

MAR 1913 *The Missal of the Three*, poetry by the Burliuks, Mayakovsky, Khlebnikov; illus. by V. and N. Burliuk, Vladimir Tatlin

AUG 1913 *Futurists. 'Hylaea.' The Croaked Moon* poetry anthology

SEP 1913 *The Three*, poetry by Kruchenykh, Khlebnikov, Guro (posthumously); illus. by Malevich; published by Matyushin

02 DEC	1913	*Vladimir Mayakovsky: A Tragedy*, written, directed by, and starring Mayakovsky; produced by Union of Youth
03 DEC	1913	*Victory over the Sun*, opera with score by Matyushin, text by Kruchenykh and Mayakovsky; "Prologue" by Khlebnikov, sets by Malevich, whose curtain design anticipates Suprematist style; produced by Union of Youth
JAN	1914	*A Drama in the Futurists' Cabaret No. 13*: the Cubo-Futurists' only futurist film, created by Goncharova and Larionov, includes Mayakovsky, Burliuk brothers, Shershenevich, and Lavrenev (Markov 147)
early	1914	*The Milk of Mares*, anthology includes Ego-Futurist Igor Severyanin, typographical poetry by Burliuk, poems and letter fragment of Khlebnikov
JAN	1914	*Futurists: Roaring Parnassus. First Revue of Russian Futurists*, art by Filonov, Rozanova, Ivan Puni; collective anthology bringing together various groups as "Russian Futurists"; contains Cubo-Futurists' most belligerent manifesto: "Go to Hell"; one-half is devoted to poems by Burliuk under the general title: "A Milker of Exhausted Toads." Police confiscate revue for "pornography" of Filonov's drawings
11 FEB	1914	"Shared Aspects of Italian and Russian Futurism" (Livshits and Lourié): lecture in response to Marinetti's visit
MAR	1914	*The First Journal of the Russian Futurists* (Moscow): continues "united front" effort; includes "ferro-concrete poem by Kamensky
spring	1914	*The Croaked Moon* 2nd ed.; "marked end of the . . . flowering of prerevolutionary Russian futurism" (Markov). Livshits and Khlebnikov both leave group.

Evenings

late	1913	Demonstrations in Moscow with painted faces, wild clothing; first evenings and public readings to sold-out theatres
DEC	1913	Traveling readings and evenings given by D. Burliuk, Mayakovsky, Kamensky, and briefly Severyanin. Created great notoriety for Russian Futurists.

Aesthetic philosophy re: poetry
"Poetry is not unlike a painting in that it is constructed of words which possess a self-contained reality. Poetry is not so much constructed of ideas as of words whose compositon and arrangement are designed to evoke its content or 'idea.' The poet is thus a verbal engineer, as it were." (Barooshian 17)

Ego-Futurists (nucleus group) St. Petersburg, October 1911-1914

Founder
Igor Severyanin (later quarrels with Olimpov and leaves OCT 1912, briefly joins Cubo-Futurists Burliuk and Mayakovsky in JAN 1914)

Chief Publicist and Organizer
Ivan Ignatyev: joined after JAN 1912, published *Petersburg Herald* (forum for Ego Futurist works), Ego Press; commits suicide JAN 1914

Members ("Rectorate of Ego-Poetry")
C. C. Fofanov (pseud. of Constantine Olimpov)
George Ivanov Grael-Arelsky (pseudo. of Stefan Petrov)

Reformed by Ivan Ignatyev (pseud. of I. Kazansky) in 1913:
Pavel Shirokov Vasilii (Vasilisk) Gnedov
Dimitri Kriuchkov

Major Manifestos and Publications
OCT 1911 *Prologue Ego-Futurism* (I. Severyanin) booklet-poem giving foundation of Ego-Futurist aesthetics; uses "Futurism" as Russian group title for 1st time
NOV 1911 manifesto
JAN 1912 "The Tables" (C. M. Fofanov and Mirra Lokhvitskaya)
 1913 "Ego-Futurism" (I. V. Ignatyev) sixteen-page booklet

Major Publications
fall 1912 *Eagles over the Abyss*: 3rd almanac (6 pp.)

Aesthetics (Lawton 20 ff.)
• a boundless individualism
• intuitivism, madness, pseudomysticism
• lyricism
• technological reality of present requires new poetic rhythm and new orchestration of sounds
• programmatically opposed Cubo-Futurists and their emphasis on transrational poetry

The Mezzanine of Poetry (nucleus group) Moscow, summer-ca. DEC 1913

Founder
Vadim Shershenevich (pseudonym of Georgii Gaer)

Members
Lev Zak (aka Khrisanf, M. M. Rossiyansky), artist, poet, theorist
Konstantin Bolshakov Riurik Ivnev
Sergei Tretyakov

Major Manifestos
SEP 1913 "Throwing Down the Gauntlet to the Cubo-Futurists" (M. Rossiyansky)
26 ARP 1914 "A Declaration about the Futurist Theatre" (Shershenevich)

Major Publications

	1913	*Vernissage* (ed. Zak) first almanac-journal
OCT	1913	*A Feast during the Plague*, 2nd almanac
NOV-DEC 1913		*Crematorium of Common Sense*, 3rd and final almanac

Aesthetics (Lawton 25-27, 3 n. 6)

1. "considered almost a Moscow branch of Ego-Futurists": shared emphasis on intuition, but rejected latter's emphasis on mysticism and metaphysics
2. opposed Cubo-Futurists' emphasis on transrational language; felt essence of the word is combination of its "sensible" properties—color, smell, palpability—that evoke "the image" or "word-image"
3. had closest ties of any Russian group to Marinetti: Shershenevich studied Marinetti's manifestos and adopted his ideas on the "word-image" almost literally

Acmeists (nucleus group of poets) 1912-1921

Founders
Sergei Gorodetzki
Nikolai Gumilev

Members
Anna Akmatova (pseud. of Gorenko) Osip Mandelstamm
Mikhail Lozinski Georgii Ivanov

Manifesto

	1913	"The Heritage of Symbolism and Acmeism" (Gumilev)

Publications

1909-1917	*Apollon*, originally a Symbolist magazine, prints Acmeist manifestos and poems.
1912	Acmeist review begun.

Events

1911	Gumilev founds the Poets' Guild as a forum for Acmeists.

Centrifuge (nucleus group) early 1914-1917

Leader
Sergei Bobrov

Members
Boris Pasternak Nikolai Aseyev
Ivan Aksyonov Ilya Zdanevich

Publications

spring	1914	*Brachiopod* (first Centrifuge almanac)

Manifestos

spring 1914 "Charter" (Aseyev, Bobrov, Zdanevich, and Pasternak); published in *Brachiopod*; "nothing more than a polemic against Cubo-Futurists and Shershenevich" (Lawton 31). "Turbopaean" ("manifesto in verse" in *Brachiopod*); image of turbine to convey poetic transcendence.

Prague

"Osma" or The Eight (exhibition group) 1907-1909.

Members

Bedrich Feigl	Emil Filla
Max Horb	Otakar Kubín
Bohumil Kubišta	Willy Nowak
Emil Pittermann	Antonín Procházka

Exhibitions

APR 1907 First exhibition: show received critical praise only from Max Brod.
JUN 1908 Second exhibition: negative critical response

Group later joined Mánes Union.

Mánes Union of Fine Artists (exhibition group) 1909-1914
(Association of Secessionist Plastic Artists)

Major Exhibitions

FEB 1909 Exhibition for sculptor Emile-Antoine Bourdelle
 1909 29th exhibition of Mánes, incl. V. Beneš, E. Filla, Dubin
 1909 Exhibition of Emile Bernard's work
FEB 1910 "Les Indépendants" exhibit
 1914 Alexandre Mercereau organizes a major exhibition of French painters

Publication: *Free Directions* magazine

Other History

 1911 Secession of 15 painters, architects, and theoreticians from Mánes to form more radical "Group of Plastic Artists"

"Skupina" or Group of Plastic Artists (exhibition group) 1911-1914

Members

painters: Vincenc Beneš	Josef Čapek
Emil Filla	Antonín Procházka
Ladislav Šima	Václav Špála

sculptor: Otto Gutfreund

writers:
Karel Čapek František Langer
Vilém Dvořák Jan Thon

architects and designers:
Josef Gočár Pavel Janák
Josef Chochol Vlastislav Hofman

art historian and critic: Václav Štech

Journal
Arts Monthly: "the focus of radical ideology until WWI" (Wittlich 24)

Exhibitions

OCT	1911	Following encouraging visit by Berlin *Brücke* painters, Kubišta exhibits with Berlin Neue Secession and listed as member of *Die Brücke*.
JAN	1912	Group's first Prague exhibition at Municipal House (where their subsequent Prague exhibitions are held).
MAR	1912	Kubišta, Filla, Feigl exhibit at Neue Sezession in Berlin.
MAY	1912	Beneš, Filla, Kubišta, Nowak, Procházka participate in Cologne Sunderbund exhibition.
SEP	1912	Group's 2nd exposition includes: Filla group, Picasso, Braque, Friesz, Derain, Die Brücke artists.
APR	1913	Group exhibits in Munich (Golz salon), incl.: Beneš, Filla, Gočár, Gutfreund, Procházka.
MAY	1913	Group's 3rd Prague exhibition includes Picasso, Braque, Derain, Gris, Soffici, Plasticist group, folk, exotic, and ancient art; received well.
fall	1913	Group exhibits in First German Autumn Salon, Berlin.
OCT	1913	Filla, Čapek, Gutfreund, and Hofman exhibit at Sturm Gallery.
FEB	1914	Group's 4th Prague exhibition (coincides w/ Mánes-Mercereau exhibition) includes: Munch, Braque, Derain, Gris, Picasso, Filla, and Gutfreund.

"Group" becomes "most important proponent of [Picasso-Braque] Cubism in Central Europe." (Andel and Greene 210)

Other History

late 1912	Painters Čapek, Špála, and Šima; writer Čapek; designer Brunner; architects Hofman and Chochol feel Picasso-Braque influence needs to be broadened to include Futurism, Orphism, and Puteaux Cubists. They split off from Group and return to Mánes Union. Čapek, becomes leader of "opposition" that organizes "Modern Art" exhibition of 1914.
	Art historian Vincenc Kramár, working through "Group," begins large collection of Cubist works.

Arconauts* (locale group: Cafe Arco) 1909-1914
*named by Karl Kraus

Participants
Franz Werfel Egon Erwin Kisch
Johannes Urzidil

Associates
Max Brod Franz Kafka

New York (and environs)

291 Group (medium-locale group: "Little Galleries of the Photo-Secession" 291 5th Ave.) ca. 1909-1917[11]

Founder and Leader
Alfred Stieglitz, ed. *Camera Work: Journal of the Photo-Secession*

Member-painters
Arthur Dove Marsden Hartley
John Marin Alfred Maurer
Georgia O'Keeffe (beginning 1915) Abraham Walkowitz (ca. 1911-1913)
Max Weber (-1911)

Major Exhibitions

JAN	1908	Rodin: drawings: first exhibition in U.S.
APR	1908	Matisse: drawings, lithographs, watercolors, etchings: first exhibition of Matisse's art in U.S., gains 291 much notoriety (ca. 4,000 viewers according to Stieglitz)
MAR	1909	John Marin: watercolors, Alfred Maurer: oils: Marin's first exhibition, Maurer's first exhibition in U.S.
MAY	1909	Marsden Harley: oils: his first one-artist exhibition
MAR	1910	"Younger American Painters": major exhibition of American modernist painters: Arthur Dove and Max Weber (1st appearances), Hartley, Marin, Maurer, Edward Steichen, Arthur Carles, Lawrence Fellows, G. Putnam Brinley
NOV	1910	Manet, Cézanne, Renoir, Toulouse-Lautrec (lithographs), Rodin (drawings), Henri Rousseau (paintings and drawings)
JAN	1911	Max Weber: paintings and drawings: his first and only one-artist show at 291
MAR	1911	Cézanne: 20 watercolors: first one-artist show in U.S.
MAR	1911	Picasso: 83 drawings and watercolors: first exhibition in U.S.
FEB	1912	Dove: paintings and 10 pastels: first one-artist show
MAR	1912	Matisse: sculpture (exhibited first time anywhere) and drawings
DEC	1912	Abraham Walkowitz: drawings and watercolors: first one-artist show
FEB	1913	Stieglitz: photographs: his first and only one-artist show at 291
MAR	1913	Picabia: 16 "studies" of NYC: his 1st one-man show in America

JAN	1914	Hartley: paintings done in NYC, Paris, and Berlin
MAR	1914	Brancusi: sculpture: 1st one-artist show anywhere
NOV	1914	"African Savage Art": America's 1st major exhibition of "primitive" art: 18 sculptures
DEC	1914	Picasso and Braque: paintings; Mexican art

Other History

NOV	1905	Little Galleries of the Photo-Secession (291) founded at 291 5th Ave.
JAN	1907	Photo-Secession Galleries holds first nonphoto exhibition.
	1910	Photo-Secession Galleries become known as "291."

Camera Work (medium group) ca. 1903-1917

Founder, Publisher, Editor
Alfred Stieglitz

Patron
Agnes Ernst Meyer (beginning 1908)

Staff Artists and Photographers
Paul Haviland (beginning 1908) Agnes Ernst Meyer
Marius de Zayas (beginning 1909) Edward Steichen

Writers and Critics
Charles Caffin Benjamin De Casseres
Alfred Kreymborg Sadakichi Hartmann
Dallet Fuguet, editor Joseph Turner Keiley, editor
John Kerfoot, editor J. Nilsen Lauvrik

History

JAN	1903	*Camera Work* begins publishing, Stieglitz editor.
	1908	*Camera Work* adds articles on arts and criticism.
JAN	1909	*Camera Work* announces new purpose of both the magazine and 291 gallery: to "champion modern tendencies" in all the arts.
APR	1910	*Camera Work* elaborates the group's new philosophy: "The Photo-Secession can now be said to stand for those artists who seceded from the photographic attitude toward representation of form" (Stieglitz, qtd. in Watson 71).
summer	1909	Stieglitz tours Paris for 3 weeks with Edward Steichen, visits the Steins; his tastes change toward modernism during trip.
ca.	1909	de Zayas replaces Steichen as Steiglitz's chief lieutenant.
	1910	Haviland becomes *Camera Work*'s associate editor.
	1910	"International Exhibition of Pictorial Photography" arranged by Photo-Secession at Albright Gallery, Buffalo: Photo-Secession's last formal exhibition.
JUL	1912	*Camera Work* publishes extracts from Kandinsky's *Concerning the Spiritual in Art*.
AUG	1912	*Camera Work* devotes issue to modern art; incl. Stein's "Portraits" of Picasso and Matisse, her first writings to appear in a periodical.

JUN	1913	*Camera Work* publishes Stein's "Portrait of Mabel Dodge at the Villa Curonia" and "Speculations" by Mabel Dodge (on Stein's style). These 2 exposures of Stein's writing, linked to the Armory Show, did much to establish her image in America as poetic equivalent of Cubist painting.
	1914	*Camera Work* devotes special issue to readers' evaluations of 291's importance. 68 responses published.
SEP	1914	Edward Steichen arrives from Paris, takes active role in running and rejuvenating 291 and expanding scope of both gallery and magazine.
	1915	*291* Magazine begins publishing.
	1917	291 Galleries and *Camera Work* terminated.

Synchromism (American expatriate nucleus group) 1913-1916

Founders and Members
Morgan Russell Stanton MacDonald-Wright

Publicist
Willard Huntington Wright

Exhibitions

18 MAR	1913	Indépendants Salon: Russell's work called vaguely Orphist in review by Apollinaire.
01 JUN	1913	Munich: "Der Synchromisten Morgan Russell, S. Macdonald-Wright"
27 OCT	1913	Paris: "Les Synchromistes S. Macdonald-Wright et Morgan Russell": "the single most important exhibition containing non-figurative art in Paris before the war" (Spate 51)
02 MAR	1914	Carroll Galleries, New York City
13 MAR	1916	New York: "Forum Exhibition of Modern American Painters"

Manifestos / Exhibition Catalog Statements

JUN	1913	"In Explanation of Synchromism" (Russell and MacDonald-Wright): for Munich exhibition
OCT	1913	"General Introduction" (Russell and MacDonald-Wright): for Paris exhibition
		"Individual Introduction" (MacDonald-Wright): for Paris exhibition
		"Individual Introduction" (Russell): for Paris exhibition
MAR	1914	"Foreword" (Willard Huntington Wright): for Carroll Galleries exhibition, NYC
		"Introduction" (Russell and MacDonald-Wright): for Carroll Galleries exhibition

Association of American Painters and Sculptors (exhibition group)
1911-1914

Organizers
Walt Kuhn Elmer MacRae
Jerome Myers Henry Fitch Taylor

Charter Members
Karl Anderson D. Putnam Brinley
Gutzon Borglum Arthur B. Davies, first president
Leon Dabo James E. Fraser
William J. Glackens Walt Kuhn
Ernest Lawson Jonas Lie
George B. Luks John Mowbray-Clarke
Jerome Myers Henry Fitch Taylor
Allen Tucker J. Alden Weir

Subsequent Members:
painters:
George Bellows Bryson Burroughs
Guy Pène du Bois Edward Kramer
Frank Nankivell Bruce Porter
Maurice Prendergast John Sloan

sculptors:
Jo Davidson Sherry Fry
Mahonri Young

Purpose
"Exhibiting the works of progressive and live painters, both American and foreign" especially work neglected "by current shows."

Exhibition
17 FEB 1913 "International Exhibition of Modern Art" ("The Armory Show")
 Organizers: Arthur Davies, Walter Pach, Walt Kuhn

History
SEP 1912 Davies receives catalog of Sonderbund Exhibition, writes Walt Kuhn
 of his wish to mount a similar show; Kuhn immediately leaves for
 Cologne.
30 SEP 1912 Kuhn visits Sonderbund, selects many works for Armory Show; then
 travels to The Hague, Amsterdam, Berlin, Munich, and Paris to scout
 work for Show.
06 NOV 1912 Davies meets Kuhn and Pach in Paris for 10 days to select works for
 Show.
17 FEB 1913 —15 MAR: Armory Show, displayed ca. 1,300 works (one-third by
 foreign artists). About 88,000 see the show in NYC; ca. 300,000 see
 it altogether (incl. Chicago and Boston).
13 MAR 1913 *Arts and Decoration* devotes special issue to show (sold at the Show
 as "full introduction" to the exhibition). Magazine includes Mabel

Dodge's article on Gertrude Stein, "Post-impressions in Prose," argu-
ing that Stein was "the only woman in the world who has put the
spirit of post-impressionism into prose" and that Dodge was "the
only woman in America who fully understands [Stein's prose]" (Alt-
shuler 72).

24 MAR 1913 —15 APR: Exhibition appears in Chicago, attracts ca. 200,000 view-
ers and much critical abuse.

28 APR 1913 —18 May: Exhibition moves to Boston, attracts smallest crowd of
three cities, ca. 13,000.

JUN 1913 Stieglitz runs special issue of *Camera Work* devoted to Armory
Show, incl. Gertrude Stein's "Portrait of Mabel Dodge at the Villa
Curonia" followed by Dodge's explanation of Stein's writing and its
significance for modern art.

summer 1913 Following the Exhibition, AAPS becomes moribund, mounting no
new exhibitions. Breaks up in 1916, partly a victim of the interest in
modernist painting that it helped create by sponsoring the Armory
Show.

Mabel Dodge's Salon (locale group: 23 5th Ave., NYC) JAN 1913-summer 1914

Organizer
Mabel Dodge

Members: (2 basic groups)
aesthetes:

Andrew Dasburg	Marsden Hartley
the Picabias	Carl Van Vechten

politicos (socialists, anarchists, IWW members, etc.):

Max Eastman	Emma Goldman
Big Bill Haywood	Walter Lippmann
John Reed	Mary Heaton Vorse

Philosophy (loosely followed)
Belief in the intersection of artistic and political revolution; life as visceral excitement;
anti-analytical: "identification with intuitives: children, pagans, mystics, and outcasts";
emphasis more on personal "liberation" (via Freud) than on social or group liberation.

History

JAN 1913 Dodge begins evenings at her apartment, 23 5th Ave. Most prominent
groups: aesthetes, Greenwich Village rebels, and political radicals,
e.g., Big Bill Haywood, Jack Reed.

APR 1913 When Paterson Strike begins, Haywood and Reed participate, get
arrested; Dodge, Haywood, Reed (and others) plan a Pageant to
dramatize strike to New Yorkers.

07 JUN 1913 Paterson Strike Pageant staged at Madison Square Garden. 1,147
strikers and supporters march up 5th Ave. to participate.

DEC 1913 A. A. Brill introduces psychoanalysis at an evening. Possibly the first
time Freud is introduced to Village.

The Glebe (medium-locale group: Ridgefield, NJ) SEP 1913–NOV 1914

Founder and Editor
Alfred Kreymborg, poet

Members
Samuel Halpert, artist
May Ray, artist and photographer

History

SEP 1913 Kreymborg begins publishing *The Glebe*, which runs 10 issues.

FEB 1914 Fifth issue entirely devoted to Imagist poetry submitted by Pound; entitled "Des Imagistes," it becomes text for first Imagist anthology.

Appendix 3

Modernist Casualties of World War I[1]

How much is lost for all of us; it is like a murder.
—Franz Marc, on learning of August Macke's death

Killed in action

Kurt Adler, German poet (1892-1916)
Peter Baum, German novelist and poet (1869-1916)
Rudolf Börsch, German writer (1895-1915)
Hans Ehrenbaum-Degele, German poet (1889-1915)
Gerrit Engelke, German poet and writer (1890-1918)
Walter Ferl, German poet (1892-1915)
Eugen Fischer, German writer (1891-1915)
Georg Hecht, German poet (1885-1915)
Paul Heller, Austrian writer (?-1916)
Hugo Hinz, German poet (1894-1914?)
Robert Jentzsch, German poet (1890-1918)
Alfred Lichtenstein, German poet and novelist (1889-1914)
Ernst Wilhelm Lotz, German poet (1890-1914)
August Macke, German painter (1887-1914)
Franz Marc, German painter (1880-1916)
Albert Michel, German writer and poet (1895-1915)
Wilhelm Morgner, German painter (1891-1917)
Franz Nölken, German painter (?-1918)
Walter Rosam, German painter (1883-1916)
Wilhelm Runge, German poet (1894-1918)
Gustav Sack, German poet and novelist (1885-1916)
Reinhard Johannes Sorge, German poet and playwright (1892-1916)
Ernst Stadler, German poet (1883-1914)
Hermann Stenner, German painter (1891-1914)
August Stramm, German poet and dramatist (1874-1915)
Kurt Striepe, German writer (?-1917)
Albert Weisgerber, German painter (1878-1915)
Robert Zellermayer, German writer (?-1917)

Giosué Borsi, Italian poet (1888-1915)
Carlo Erba, Italian Futurist painter (1884-1917)
Nino Oxilia, Italian film director, playwright, and poet (1888-1918)
Antonio Sant'Elia, Italian Futurist architect (1888-1916)
Ugo Tommei, Italian Futurist artist

Alain-Fournier, French novelist (1886-1914)
Robert Besnard, French painter (1881-1914)
Henri Doucet, French artist (1883-1915)
René Dupuy (pseud. Dalize), French poet (1879-1917)
Henri Gaudier-Brzeska, French sculptor (1891-1915)
Léo Latil, French poet (1890-1915)
Olivier-Hourcade, French poet (1892-1914)
Charles Péguy, French poet (1873-1914)
Ernest Psichari, French writer (1883-1914)
Roger Vincent, French writer (1886-1915)

George Butterworth, English composer (1885-1916)
T. E. Hulme, English poet and theorist (1883-1917)
H. H. Munro ("Saki"), English short-story writer (1870-1916)
Wilfred Owen, English poet (1893-1918)
Isaac Rosenberg, English poet and painter (1890-1918)
Edward Thomas, English poet and writer (1878-1917)

Georges Antoine, Belgian composer (1892-1918)
Vladimir Burliuk, Russian painter (1886-1917)
Franz Janowitz, Bohemian poet (1892-1917)
Aladár Rado, Hungarian composer (1882-1914)

Died from war wounds or war-related causes

Guillaume Apollinaire, French poet and journalist (1880-1918; died of pneumonia,
 severely weakened by head wound and trepanning)
Umberto Boccioni, Italian painter (1882-1916; died from fall from his horse)
Hans Bolz, German painter (1887-1918; died of exhaustion)
Rupert Brooke, English poet (1887-1915; died of uremic poisoning while en route to
 Dardenelles)
Raymond Duchamp-Villon, French painter and sculptor (1876-1918; died of typhoid
 contracted in trenches)
Roger de la Fresnaye, French painter (1885-1925; died of pneumonia, severely weakened
 by lung hemorrhages in war)
Enrique Granados, Spanish composer (1867-1916; drowned after torpedo attack on
 English ship)
Franz Henseler, German painter (1883-1918; died of exhaustion and insanity)
Alfred Heymel, German poet and publisher (1878-1914; died of illness contracted at
 front)
Hans Leybold, German poet (1894-1914; suicide at the front)
Wilhelm Lehmbruck, German sculptor (1881-1919; suicide from depression partly
 caused by his war work as hospital orderly and self-exile to Switzerland)
Alexandre Mercereau, French writer, closely connected with French painters and poets
 (1884-1945; severely wounded, never fully recovered)
Otto Mueller, German painter (1874-1930; died of lung disease caused by two lung
 hemorrhages in war)
Georg Trakl, Austrian poet (1887-1914; drug overdose [accident or suicide unknown]
 while in military hospital)

Died from influenza epidemic, 1918-1919

Gustav Klimt, Austrian painter (1862-1918)
Bohumil Kubišta, Czech painter (1884-1918)
Tadeusz Nalepinski, Polish poet, novelist, and playwright (1885-1918)
Morton Schamburg, American painter (1882-1918)
Egon Schiele, Austrian painter (1890-1918)

Severely wounded

Georges Braque, French painter (head wound, trepanned)
Blaise Cendrars, Swiss poet (arm amputated)
Otto Dix, German painter (wounded three times)
Othon Friesz, French painter
Ernest Hemingway, American novelist (wounded in leg)
Oskar Kokoschka, Austrian painter (shot in head, bayonetted in lung)
František Kupka, Czech painter (awarded Legion of Honor by French)
Mikhail Larionov, Russian painter (concussion)
Fernand Léger, French painter (gassed)
Filippo Marinetti, Italian poet (leg wounds)
Luigi Russolo, Italian painter and composer (head wound, trepanned)
Ardegno Soffici, Italian painter (head wounds)
Josef Sudek, Czech photographer (arm amputated)
Laurence Stallings, American playwright (wounded in leg, which is later amputated)
Jakob Steinhardt, German poet and painter
Wtadystaw Strzeminski, Russian painter
Georgy Yakulov, Russian painter

Suffered nervous or physical breakdown during or just after war

Max Beckmann, German painter
Alban Berg, Austrian composer (physical breakdown)
Oskar Graf, German novelist (mental breakdown)
Ivor Gurney, English composer (complete mental breakdown)
Erich Heckel, German painter (painting impaired for a time after war)
David Jones, English poet and artist (mental breakdown)
Ernst Ludwig Kirchner, German painter (physical and mental breakdown)
Oskar Kokoschka (shell shock)
Karl Schmidt-Rottluff, German painter (painting impaired for a few years after war)
Arnold Schoenberg, Austrian composer (physical breakdown)
Georg Trakl, German poet (after treating casualties as medic)

Foreign national returning to native country

Natan Altman, Russian graphic designer (from Paris)
Zhenia Bogoslavskaya, Russian artist (from Paris)
Marc Chagall, Russian painter (from Paris)

Giorgio de Chirico, Italian painter (from Paris)
Natalia Goncharova, Russian painter (from Paris)
Wassily Kandinsky, Russian painter (from Bavaria after stays in Switzerland and
 Sweden)
El Lissitzky, Russian painter (from Darmstadt)
Max Pechstein, German painter (from Palau Islands)
Elie Nadelman, American sculptor (from Paris)
Liubov Popova, Russian painter (from Paris)
Ivan Puni, Russian artist (from Paris)
Nadezhda Udaltsova, Russian painter (from Paris)

Foreign national moving to neutral country

Alexei Von Jawlensky, Russian painter (Switzerland from Munich)
Daniel-Henry Kahnweiler, German art dealer (Switzerland from Paris)
Marie Laurencin, French painter married to a German (Spain from Paris)
Wilhelm Uhde, German art dealer (Switzerland? from Paris)
Marianne Werefkina, Russian painter (Switzerland from Germany)

Citizen moving to neutral country

Alexander Archipenko, Russian painter and sculptor (Switzerland)
Hugo Ball, German writer (Switzerland)
Robert and Sonia Delaunay, French painters (Spain and Portugal)
Marcel Duchamp , French painter (USA)
Albert Gleizes, French painter (USA)
Richard Huelsenbeck, German writer (Switzerland)
Ernst Ludwig Kirchner, German painter (Switzerland after military service)
Else Lasker-Schüler, German poet (Switzerland)
Wilhelm Lehmbruck, German sculptor (Switzerland)
Gabriele Münter, German painter (Switzerland, Sweden, Denmark)
Max Oppenheimer, Austrian painter (Switzerland)
Julius Pascin, Bulgarian painter (London, USA)
Francis Picabia, French painter (USA and Spain)
Hans Richter, German painter and filmmaker (Switzerland)
Romain Rolland, French novelist (Switzerland)
Christian Schad, German painter (Switzerland)
Igor Stravinsky, Russian composer (Switzerland)
Tristan Tzara, Romanian poet (Switzerland)
Edgar Varèse, French composer (USA after military service)

Imprisoned during war

E. E. Cummings, American poet and painter (briefly imprisoned by French, 1917)
Lyonel Feininger, German-American painter (interned by Germans, 1917-1918)
Otto Gutfreund, Czech sculptor (interned 3 years by French Foreign Legion for
 insubordination)

Karl Hofer, German painter (interned as enemy alien in France until 1917)
László Moholy-Nagy, Hungarian artist (wounded and POW of Russians)
Max Pechstein, German painter (interned in New Guinea)
Jacques Riviere, French writer (POW of Germans)
Heinrich Vogeler, German painter (incarcerated by Germans)

Notes

Introduction

1. For simplicity's sake, I shall use "artist" throughout this book to refer to one working in any medium, not just in the visual arts.

2. Ezra Pound, from *Hugh Selwyn Mauberley* (I, l. 13), describing his protagonist's (and his own) fidelity to artistic craftsmanship.

3. Closest to the interdisciplinary range of my study are: Marjorie Perloff's *The Futurist Moment: Avant-Garde, Avant-Guerre*, Roy Allen's *Literary Life in German Expressionism and the Berlin Circles*, Charles Russell's *Poets, Prophets, & Revolutionaries: The Literary Avant-Garde from Rimbaud through Postmodernism*, Renato Poggioli's *Theory of the Avant-Garde*, Stephen Kern's *The Culture of Time and Space*, and Christopher Butler's *Early Modernism: Literature, Music and Painting in Europe 1900-1916*. Roger Shattuck's excellent older study, *The Banquet Years*, also spans several arts in France 1885-1915 to get at essential qualities of modernism. Except for Poggioli's, however, none of these studies anatomizes the modernist group per se; and Poggioli's brief discussion is tangential to his theoretical construct of the avant-garde.

4. Although the Symbolist heyday of the mid-1880s to early 1890s rivals this period in the proliferation of groups, small reviews, and café meeting places, groups forming in the prewar years were so numerous as to attract widespread critical concern, especially if, following the Futurists' example, they promoted themselves with an aggressiveness heretofore unseen. Combined with the profoundly disturbing art these groups were producing (and also with the accelerated pace of the times), the rise of these prewar groups was deeply unsettling to the artistic and critical communities.

5. Alphonse Séché, *Le Désarroi de la Conscience Française* (February 1914); qtd. in Barzun, *Orpheus: Modern Culture and the 1913 Renaissance* 62.

6. Georges Batault, "Ecoles littéraires," *Arlequin* (December 1909): 35; qtd. in Jeffrey Weiss, *The Popular Culture of Modern Art: Picasso, Duchamp, and Avant-Gardism* 55.

7. "Les Arts plastiques—Futurisme, Simultanéisme et autres Métachories," *Les Ecrits français* (05 February 1914), 255; qtd. in Weiss 60. Weiss studies in detail these intersections—particularly the ambiguity and critical uncertainty resulting from their manipulations as avant-garde *blague*, mystification, and *réclame*—in chapter 2 of *The Popular Culture of Modern Art*.

8. Scholarship on the Cubist School painters in the 1980s began to redress this imbalance, notably in Daniel Robbins's work on Albert Gleizes and Jean Metzinger. His 1985 article "Jean Metzinger: At the Center of Cubism" (in Joann Moser, *Jean Metzinger in Retrospect* 9-23) criticizes earlier historians' tilt toward Picasso and Braque. Since then a number of monographs on Cubist School painters have appeared to redress this imbalance.

9. *Souvenirs—le Cubisme 1908-1914* (1957); qtd. in Edward Fry, *Cubism* 175.

10. See, for example, Marjorie Perloff's excellent analysis of the Italian Futurist Manifestos in *The Futurist Moment*, chapter 3.

11. "Apollinaire's Great Wheel," in *The Innocent Eye: On Modernist Literature and the Arts* 240.

12. Some historians locate the end of the prewar era in December 1914, or even 1915, when it became clear that the war would be protracted and bloody. But as I show in the

epilogue, the world changed virtually overnight for artists after 1 August 1914, once they were mobilized (or were abruptly forced to leave their resident countries). By September, heavy casualties on the Western Front had claimed such major artists as August Macke Charles Péguy, and Ernst Stadler (see appendix 3).

13. Jeffrey Weiss identifies the starting point with the Futurist's "Foundation" Manifesto, which "does indeed correspond the beginning of a new rush of schools and esthetic pronouncements in both art and literature . . . and may actually have influenced a new spirit of aggressive collaboration" (54). But other artists and critics, for example, Stephen Spender and Graham Hough, bracket the years 1910-1914 as being "a period of enhanced intensity" (qtd. in Bradbury and McFarlane, 32).

14. As William Rubin notes, beginning in 1909, "the two painters maintained an absolute public silence concerning their art"; and "[t]hereafter, with rare exceptions, the work of the two pioneer Cubists could be seen publicly in Paris only in very limited numbers, and sporadically at that, in the installations at Kahnweiler's little gallery" (*Picasso and Braque: Pioneering Cubism* 41, 42).

15. Peter Bürger, *Theory of the Avant-Garde*, passim; Charles Russell, *Poets, Prophets, and Revolutionaries: The Literary Avant-garde from Rimbaud through Postmodernism*, preface, chapter 1.

16. Some scholars interpret even Futurist warmongering in an aesthetic context. Their enthusiasm for war, Marianne Martin asserts, "was above all an aspect of their desire for an active and courageous creative life. It was through art and artistic activity that the new values were to be discovered for society" (*Futurist Art and Theory* 186). Anna Lawton asserts that "although [Italian] Futurism's political connotations cannot be denied, for Marinetti war was primarily an aesthetic category" ("Main Lines of Convergence," in *Russian Futurism through Its Manifestoes* 9). While it is true that the group had agitated vigorously for Italy's invasion of Tripoli in 1911, Martin concludes that "actual politics played only a minor part of [Futurism's] functions before the autumn of 1913" when the Futurists published their "Political Program" (186).

17. Meidner recalled the hot summer of 1912, when he created many of his apocalyptic paintings: "It was a strange and omen-laden time for me as none other ever was. I was very poor but not at all unhappy; I was charged with energy, full of mighty plans; I had faith in a magnificent future" (qtd. in Roters, "The Painter's Nights," in Eliel 63). To be sure, Meidner's memoirs could be contradictory, as when he recalled the same period in 1918 with hindsight tinged by the war: "We were confused, high-strung and irritable. We were driven to the breaking point by the approach of world catastrophe" (qtd. in Miesel, *Voices* 182).

18. In Berlin, Roy Allen notes, the number of Expressionist journals doubled in 1912, and readings and recitals sponsored by various groups increased noticeably (57). Judith Zilczer traces a similar jump in the number of modernist exhibitions held in New York that year: 22, up from 13 in 1911.

19. Kandinsky and Marc, "*Almanac: Der Blaue Reiter*," unpublished typescript preface to the *Blaue Reiter Almanac*, October 1911; rpt. in Lankheit, *Almanac* 250-51. The editors had recently defended these views in the Vinnen controversy (described below in chapter 4).

20. Although Vezin states that Delaunay exhibited three paintings, other historians, for example, Buckberrough (85), claim that he submitted five works (four paintings and a drawing), including *The City No. 2 (study)*. This work was identified in the *Blaue Reiter Almanac* as *The Window on the City*, and Delaunay's titling has caused no little confusion. The *City* painting shown in the first Blue Rider exhibition and in the *Almanac* belong to a series of four painted in summer or fall 1911. But early in 1912, Delaunay began a far more abstract series, *The Windows*, and, to complicate matters supremely, he

entitled some of these *The Windows on the City*. Selz displays a plate from the *Windows* series as being shown in the first *Blaue Reiter* exhibition (*German* 211), even though Delaunay didn't begin the series until April 1912.

21. Paul Klee translated for Walden both of these talks—Delaunay's "On Light" and Apollinaire's "Modern Painting"—as well as Apollinaire's "Reality, Pure Painting."

22. He was by no means alone, however, with mystics like Scriabin, Kupka, and Yeats, as well as Theosophists like Mondrian, all working then.

23. Robert Wohl notes that the German Youth Movement of this period reflects this same desire for a new spirituality in everyday life (*The Generation of 1914* 42-43).

24. As Roland Stromberg demonstrates, Marc's sense of the war's cleansing purpose was thoroughly typical of his time: "The commonest images aroused by the shock of August were the cleansing fire or flood, or 'the blacksmith that will pound the world into new shapes' (Ernst Jünger)" (11). Alban Berg, for example, "agreed with Igor Stravinsky and with Scriabin, who saw the war as sent to 'shake the souls of people' and 'prepare them for spiritual things'" (2). Berg writes his wife: "Yes the war has to continue. The muck-heap has been growing for decades" (qtd. in Stromberg 199 n. 4). Where artists and intellectuals disagreed sharply, however, was what "muck-heap"—and the spiritual world that would replace it—represented.

25. "The Young People of Today," in *L'Opinion*, 1912, ed. by Henri Massis (using pseudonym: Agathon) and Alfred de Tarde, in Robert Wohl, *The Generation of 1914*, 8-9, 14-15. Romaine Rolland's presence in Stromberg's list is anomalous. His *Jean Christophe* novels were enormously popular, but Rolland himself was decidedly internationalist in outlook and worked to strengthen cultural ties to Germany.

26. Henri Bergson represents an important exception to this generalization, since the appeal of his antimaterialist philosophy transcended modernist and antimodernist divisions.

Prologue: The Futurist Traveling Exhibition of 1912

1. *Le Désarroi de la Conscience française* 28; qtd. in Jeffrey Weiss, *The Popular Culture of Modern Art* 61.

2. Interview with Joseph Bois, "Au Jour le Jour—Le futurisme et son prophète," *Le Temps*, 14 March 1911, 2; rpt. in Weiss 61, 273.

3. Trans. in John Golding, "The Futurist Past," *New York Review of Books*, 14 August 1986, 16; qtd. in Weiss 95.

4. Alexandre Chignac, "Les Tendences de la Littérature présente," *La Société nouvelle* (May 1912): 183; qtd. in Weiss 95-96.

5. André Arnyvelde, "Séance de boxe futuriste," *Gil Blas*, 16 February 1912, 1; paraphrased in Weiss 61.

6. "Les Futuristes," *Paris-Journal*, 6 February 1912; qtd. in d'Harnoncourt 17-18. In *Futurism and the International Avant-Garde*, Ann d'Harnoncourt suggests that Salmon was parodying the Futurist intent (stated in "The Exhibitors to the Public") to place the viewer in the center of the picture. Nevertheless, the large crowds and numerous reviews that the exhibition attracted, as well as its influence on French painters (discussed below), attest to the Futurists' impact. d'Harnoncourt estimates that "there were probably few avant-garde artists in Paris who did not visit the . . . exhibition" (17).

7. Allard, "Les Arts plastiques—Futurisme, Simultanéisme et autres Métachories," *Les Ecrits français*, 5 February 1914, 255; qtd. in Weiss 60.

8. "Orphisme, Orphéisme, or Orphéonisme," *Gil Blas*, 20 March 1913; qtd. in Spate 55.

9. "Art News: The Futurists" *Le Petit Bleu*, 9 February 1912; rpt. in *Apollinaire on Art* 202.

10. *Mercure de France*, 16 February 1912, 868; qtd. in Martin 120-21, 121 n. 1.

11. "Futurism, Unanimism, and Apollinaire," *Art Journal* 28, no. 3 (spring 1969): 267-68. Among other critics sharing Martin's thesis is Virginia Spate: "[T]he Futurists' challenge seems to have made the future Orphists reconsider their means to expression and strengthen the abstract structure of their paintings. Indeed, it was in the months immediately succeeding the Futurist exhibition that the Orphists made a decisive move toward non-figurative painting" (35). Spate specifically identifies Futurist influences on Kupka, Delaunay, and Marcel Duchamp (23, 29, 32).

12. Although Duchamp later dismissed any import that meeting Boccioni and seeing the Futurist paintings may have had for his own ideas at the time, their divergences from Futurist dynamism may have encouraged him all the more to pursue his own approach to movement, convinced, as Sarane Alexandrian observes, "that he was doing something different" (26). More directly, Futurist writings may have encouraged Duchamp's interest in applying such technical devices as chronophotographs and cinematic techniques to painting (Spate 23, 29).

13. "Contemporary Achievements in Painting," 1914; rpt. in *Functions of Painting* 1.

14. Gino Severini identifies this impresario (giving no first name) as a dealer in antiques and "pseudo-antique paintings" (*Life of a Painter* 106).

15. Marianne Martin writes that the Futurists declined because the Armory Show organizers could not meet their conditions (*Futurist Art* 121). Yet their primary condition—a separate exhibition area so as to maintain the integrity of the group—*was* met (Brown 79). Boccioni's letter to Carrà (ca. November 1912, qtd. in Coen liv, lii) reveals that the Futurists also wanted their own *entrance* to their exhibition area—a stipulation the Armory Show organizers could meet only with difficulty, given that the entire show was to be held in one large hall subdivided by moveable partitions. This seemingly excessive demand reveals just how sensitive the Futurists had become by November about seeing their work muddled with that of other, potentially rival painters and styles (as it had been by Walden and Borshardt over the past few months—see n. 18 below). Boccioni's letter also gives the other major reason for the Futurists' demurral: the New York exhibition would conflict with a major exhibition in Rome (spring 1913) in which they planned to participate, and with an Amsterdam exhibition (April 1913) for which they had already contracted.

16. Although Ester Coen writes that the "traveling shows" that Walden organized "were seen from July to October" (xxvi), it seems likelier that Walden and Borchardt took over the exhibitions no later than the end of the Brussels showing (late May), where the original exhibition was presented intact, and continued them through November. On 15 November 1912, Marinetti writes Walden: "We are very angry with you for not letting us know about the various exhibitions of Futurist painting you have organized with Dr. Borchardt. It would have been useful to do so, in the interest of those exhibitions themselves" (qtd. in Coen liv).

17. Art historians provide various locales for these exhibitions, but a complete itinerary has never been established, nor even whether the exhibition remained intact, or, more likely, became "a series of traveling shows" (Coen xxvi). Donald Gordon's comprehensive catalogue lists exhibitions in Holland (The Hague: Gallery Biesing, August 1912; Rotterdam: Gallery Oldenzeel, September; Amsterdam: Gallery de Roos, October). Several sources confirm the Cologne showing in October which was attended by August Macke and Franz Marc (Menseure 48-49, 95; Partsch 95; Eliel 33); Menseure states the exhibition was held at the Rheinische Kunstsalon Feldmann, but several other sources identify it at the Gereon Club. Eliel lists openings at Munich (Golz Gallery,

November) and Karlsruhe, while Coen also mentions Munich and adds Hamburg and Prague. Martin cites exhibitions in Zürich, Budapest, and Vienna (the last dated by Gordon as December 1912).

18. In the letter cited above (n. 15), Boccioni complains to Carrà that Borchardt "for purposes of outright speculation, with paintings bought at half price, is moving ahead of us and despoiling all the most important cities in the world. Our triumphal entry into all the capitals is completely compromised! . . . If Marinetti wants well-staged entries (and he is right) he ought to see to them himself" (qtd. in Coen lii, liv). Marinetti's complaint to Walden about his "jumbling" Futurists and "Expressionists" pertained to both the hangings (Walden featured some Delaunays in the Berlin showing) and to Walden's lectures (letter of 15 November 1912; qtd. in Coen liv-lv).

19. Marinetti's "Technical Manifesto of Literature" appeared 11 May 1912. Among its radical poetics are: the destruction of syntax, abolition of adjectives, adverbs, punctuation, and the speaker's voice (the "I"), and emphasis on infinitives and juxtapositions of nouns to create a "chain of analogies" (Marinetti, *Selected Writings* 84-89).

20. Qtd. in Cork, 28, 300 nn. 11-13.

21. Literary historians disagree about the precise date when Pound approached Doolittle and Aldington about starting the movement—or rather, as Aldington recalls, when Pound *informed* them that they were *Imagistes* (Jones 17). Pound's own recollection, in his 1918 "Retrospect," was "the spring or early summer of 1912." Noel Stock, Pound's most comprehensive biographer, thinks April, before Pound left for a three-month holiday—that is, in the month following Marinetti's lecture and the Futurist exhibition in London. Humphrey Carpenter, another Pound biographer, dates this group formation as autumn 1912, after Pound had become "foreign correspondent" for *Poetry* magazine (187).

22. Probably an earlier version of Marinetti's "Technical Manifesto of Literature," published the following month.

23. In his correspondence, Marc's opinions of Futurism were more mixed, but the style clearly grew on him. After seeing Walden's reproductions of Futurist paintings in the Berlin showing, Marc wrote Kandinsky: "I cannot get over the strange conflict between my estimation of their ideas, most of which I find brilliant and *fruitful*, and my view of the pictures, which strike me as, without a doubt, utterly mediocre." But several months later, on seeing the paintings in Munich, Marc wrote Macke: "[Their] effect is magnificent, far, far more impressive than in Cologne [where Marc had helped Macke hang the Futurist exhibition]" (qtd. in Zweite, n.p.).

Also informing this change in Marc's style was Robert Delaunay's distinctive blending of dynamic fracture and semi-abstraction. Several Delaunay paintings—*The Tower*, *The City No. 1*, and *The City No. 2*—were included in the Berlin exhibition, and Marc later visited Delaunay's studio in October 1912.

24. Beyond emulating Marinetti's confrontational style, the Cubo-Futurists (as Anna Lawton has demonstrated) shared a number of Marinetti's attitudes: about the technology of speed and the modern city; about war as a metaphor for the writer's condition in bourgeois society; about the importance of the artist's intuition; about the necessity of the ugly in modern literature, and, most important, about language as an autonomous entity, free of subservience to conventional reference ("Main Lines of Convergence," chapter 1, passim). Significantly, the two relevant Cubo-Futurist manifestos here, "A Slap in the Face of Public Taste" and Kruchenykh's "Declaration of the Word as Such," followed by several months their Italian Futurist counterparts (i.e., Marinetti's "Technical Manifesto of Literature," "*parole-in-libertà*," and "*l'immaginazione-senza-fili*").

25. The feud Apollinaire waged with the Futurists over who first used the word "simultaneism" resulted in a heated exchange of articles in the spring of 1913 and ended in Apollinaire's publication on 31 May of "L'Anti-tradition Futuriste." While some critics feel that Apollinaire's manifesto parodied the Futurists—a "hoax," André Salmon called it—others feel that his own growing fascination with visual typography made him more an ally of Marinetti's own radically pictorial poetics (Perloff 97-98). Either way, his debt to Marinetti is self-evident.

Chapter 1: The Modernist Group

1. Except, of course, at the minimum end of the scale: a *one*-artist movement, by definition, cannot be a group, thus disqualifying a number of such movements, particularly in French poetry.

2. Dora Vallier, "Braque, la peinture et nous," *Cahiers d'art* 29, no. 1 (October 1954): 14; qtd. in Rubin, *Picasso and Braque: Pioneering Cubism* 47.

3. André Verdet, "Recontre dans l'atelier parisien," *Entretiens, notes et écrits sur la peinture: Braque, Léger, Picasso* 21; qtd. in Rubin 47.

4. Françoise Gilot and Carlton Lake, *Life with Picasso* 76; qtd. in Rubin 47.

5. Vallier, 14; qtd. in Rubin 47.

6. Sonia Delaunay recalled: "Cendrars gave me the poem and I made an improvisation, an impression of the poem next to the poem itself. Not an illustration of the poem" (qtd. in Arthur Cohen 15).

7. Walter Arensberg's salon in New York would definitely qualify, given its fairly fixed membership, the members' narrower focus on modernist art and theory, and the traceable influence of its Dadaist and mechanomorphic ideas on such member poets as Williams and Stevens. But beginning as it does in 1915 with Duchamp's arrival in America, the salon falls outside the time boundaries of this study.

While some studies of this period list Stieglitz's 291 Gallery as a salon (for example, Robert Crunden in *American Salons*), I classify its membership differently. The gallery was a medium or venue where a discernable group (the painters whom Stieglitz regularly exhibited and supported) met and shared a loosely related set of aesthetic views and professional goals (even as they developed their own styles), with the tireless Stieglitz as their intellectual and entrepreneurial center.

8. Regarding Chicago, Crunden writes:

> Chicago did have a brief outburst of activity that many participants and their chroniclers have called a "renaissance," and those involved usually knew each other and shared tastes in literature. Most of this activity was in no definable way modernist: it was often surprisingly conservative in its sense of form. . . . What Chicago did for modernist impulses was give them room to grow and opportunities to appear in print. . . . [as well as opportunities] for certain themes of modernism to emerge: above all that of free sexual expression and its relationships to psychotherapy and the unconscious. (102-3)

9. Inevitably, categorizing on a broad scale is somewhat arbitrary. Criteria for determining the categories themselves sometimes overlap; for example, several media groups, like *Die Aktion*, were also locale groups, with artists meeting at the same place (typically, a café or someone's studio) to work *and* socialize. Likewise a group's characteristics and purposes might qualify it for two categories simultaneously. For example, the Donkey's

Tail was a nucleus group comprised of Larionov and Goncharova, but its chief purpose was to organize a counter-exhibition of the same name, thus placing it in the "Exhibition" column.

10. In his *Chronik der Brücke* of 1913, Kirchner wrote: "In order to keep their endeavors pure the members of 'Brücke' resigned from membership in the '*Neue Sezession.*' They exchanged promises to exhibit only jointly in the '*Sezession.*' . . . Pechstein broke the confidence of the group by becoming a member of the '*Sezession*' [and exhibiting alone] and was expelled from Brücke" (rpt. in Selz *German* 321). Pechstein claimed he withdrew "because of Kirchner's too personal judgments about the group" (*German* 140). In any case, Pechstein's departure accompanied the group's gradual disintegration.

11. *Franz Marc im Urteil Seiner Zeit*; qtd. in Lankheit, ed., *The Blaue Reiter Almanac* 15. Kandinsky developed this view in another statement: "We were not trying to create an exclusive movement with specific aims, but simply to juxtapose various manifestations of the new art on an international basis" (*Kunstblatt* [1930]; qtd. in Grohmann 67). Scholars like Marc Rosenthal agree: "the 'group' was never more than a loose alliance" (*Franz Marc* 23).

In my study, however, a two-person "nucleus" constitutes a group when its productions reflect a shared philosophy or aesthetics—and such was certainly true of the *Blaue Reiter*. As Klaus Lankheit states: "[The *Blaue Reiter* exhibitions and book] were based on the same convictions and carried out according to the same principles. Chronologically, as well, the two undertakings ran parallel. Thus it is not without good reason that the name *Blaue Reiter* is still applied to both book and exhibitions" (*The Blaue Reiter Almanac* 15). Moreover, Kandinsky's disclaimers were retrospective by at least sixteen years; the *Blaue Reiter*'s founders were not so worried about being branded a group at the time.

12. Klaus Lankheit concurs: "As most of the artists were being exhibited at the Thannhauser and Goltz galleries were also collaborating on the almanac, the name could now be applied to a larger circle of like-minded artists. But the *Blaue Reiter*—in its two forms—was ultimately the very personal achievement of two congenial individuals" (*Almanac* 15).

13. As I have argued in "Subversive Pedagogies: Schoenberg's *Theory of Harmony* and Pound's 'A Few Don'ts by an Imagiste,'" Renato Poggioli's depiction of schools in his *Theory of the Avant-Garde* as upholders of "traditional poetics and rhetoric, normative and didactic simply by nature" (24) does not adequately describe those "schools" led by aesthetic revolutionaries like Schoenberg and Pound, who used pedagogy as an important tool in promoting their subversive theories.

14. Hereafter, Stieglitz's gallery will be identified simply as the "291 Gallery," its casual name deriving from its address: 291 Fifth Avenue.

The newspapers mentioned here acquired a distinct circle of artist-contributors, who gathered together regularly, often to share editing and printing tasks, and thus loosely developed the collective identity that qualifies them by my criteria as a group. Little magazines and journals, such as *Poetry* and *The New Age*, obviously contributed greatly to prewar modernism; but unless they gathered around them a distinct circle of artists, I have not considered them a modernist group.

15. The first issue of *Die Aktion* declared that the journal will be politically leftist and favor "newer trends" in literature" (qtd. in Allen 141).

16. See Michael Hamburger, *Contraries: Studies in German Literature* 275-76; Levine 209; and see especially Johannes Becher's recollection of this poem's impact on himself and other young Expressionist poets (qtd. in Eliel 22).

17. Allen 75-85 *passim*. "*Neues pathos*" comes from an essay by Stephan Zweig. The urge to shake a smug, Wilhelmine bourgeoisie out of its materialistic complacency and rejuvenate its decadent culture with Dionysiac frenzy (à la Nietzsche) can be found

throughout the Expressionist movement, ranging from the paintings of Nolde, Kirchner, and Meidner, to the music of Schoenberg, to the expressed philosophy of *Die Aktion, Der Sturm,* and the *Blaue Reiter.*

18. Erwin Loewenson, *Georg Heym order Vom Geist des Schicksals* 62-63; qtd. in Allen 80.

19. See Linda Henderson's *The Fourth Dimension and Non-Euclidean Geometry in Modern Art,* chapters 2-3.

20. In his review of the 1911 Automne Salon, Apollinaire's reference to the painters of *salle 8* as a "school" was not pejorative: the term was intended to distinguish their Cubism—and Picasso's—from "a systematic doctrine" ("The Cubists," *L'Intransigeant,* 10 October 1911; rpt. in *Apollinaire on Art* 183). But subsequently, "the Cubist school" acquired a condescending connotation in numerous art histories oriented toward the Picasso-Braque wing of Cubism. (See Daniel Robbins, "Jean Metzinger: At the Center of Cubism," in Joann Moser, *Jean Metzinger in Retrospect* 9-23.

21. Georges Ribemont-Dessaignes, *Déjà Jadis*; qtd. in Fauchereau 17.

22. Other projects planned by members of these groups include a review of the plastic arts (unrealized) and formation of a new group, the *Artistes de Passy,* which did hold some meetings—further evidence, Golding concludes, "of the continual emphasis on communal activity" (29). Many of the Puteaux group also met at Gleizes's studio in Courbevoie on Mondays.

23. When the hanging committee (comprising several of the Puteaux group) for the 1912 Indépendants Salon—an exhibition supposedly unjuried—rejected Duchamp's *Nude Descending a Staircase,* Duchamp recalled later that the decision "helped liberate me completely from the past. . . . I said, 'All right, since it's like that, there's no question of joining a group—I'm going to count on no one but myself, alone" (qtd. in Cabanne, *Dialogues with Marcel Duchamp* (NY 1987: 31; rpt. in Weiss 113).

24. Arguably, only Gleizes's and Metzinger's paintings were so similar as to belong to a single style. That the entire group has been lumped under the amorphous catchall, "Cubist School," derives not from their style, but from their common intellectual and painterly *interest* in Cubism, from their joint discussions of these interests, from their painterly responses to Cubism, and from their desire to exhibit together and thus be recognized publicly as *the* Cubists.

25. "Union of Youth" in *Russian Modernism* 186-87.

26. The performance group the *Ballets Russes* will be discussed in relation to Diaghilev as its leader in chapter 2.

27. New studies showing modernism's inextricable connections to mainstream art worlds are welcome modifications of the pattern I have described, but they don't change the essentially marginalized and oppositional status of prewar modernism.

28. Letter of 2 May 1910, Henri's emphasis; qtd. in Levin 16.

29. "Patria Mia," *New Age* 11 (17 October 1912): 588; qtd. in Watson 8.

30. "*Le Cubisme et tradition,*" *Montjoie!* (25 February 1913): 20; qtd. in Weiss 58.

31. "Why I am a Futurist," *Lacerba* 1 (December 1913): 268.

32. Virginia Spate, *Orphism: The Evolution of Non-figurative Painting in Paris 1910-1914,* appendix A, 367-69. After sifting through various opinions for and against, Spate offers a qualified "yes."

33. One source of confusion over the question of Kupka's participation was that his name does not appear on the catalog, although at least one eyewitness, Nicholas Beauduin, remembers his work on display. Spate and others plausibly hypothesize that he must have decided to join the exhibition at the last minute, after the programs were printed—another sign of his ambivalence about being part of the group.

34. Apollinaire's lecture was not preserved; however, both Beauduin and Kupka himself (writing in the 1920s) claim that Apollinaire referred to at least one of Kupka's paintings at the Section d'Or exhibition as Orphist. Spate concludes that the evidence is insufficient to prove that Kupka was included in the talk, but feels that he was.

35. Letter to Arthur Roessler; qtd. in Allison Greene, "Czech Modernism: 1900-1920," in *Czech Modernism: 1900-1945*, 38.

36. Beauduin also states that Apollinaire had planned to write on Kupka and Delaunay (who receives very brief mention in *The Cubist Painters*) in a separate book. Spate believes that Delaunay (who then exerted considerable influence over Apollinaire, as well as providing his living quarters) "scotched the project, for he was anxious to appropriate Orphism to himself" (369).

37. Dates are based on scholarly monographs on Kupka (Fauchereau 17) and Delaunay (Hoog 62). But as these scholars concede, both painters were prone to misdate—and in Delaunay's case, intentionally backdate—their work, making issues of precedence and imitation even stickier.

38. Marc, letter to his brother, 3 December 1911; qtd. in Lankheit, "A History of the Almanac," *The Blaue Reiter Almanac* 14.

39. Letter to Marc, 14 May 1912; qtd. in Lankheit, *Almanac* 29.

40. Kandinsky's version of the *Blaue Reiter*'s demise in his "Recollections" of 1930 was sentimental in omitting his own reluctance to continue on (or rather, in converting reluctance to intent) and in attributing the group's end entirely to the war and Marc's death: "My immediate plans for the next volume of the *Blaue Reiter* were to put art and science next to one another: origins, realization through various work processes, purpose. . . . But then came the war, which swept even these modest plans away" (*Complete Writings on Art*, 2: 748).

What Kandinsky may not have known at the time was that even Marc, now at the front, had second thoughts about the whole enterprise. He wrote his wife on 13 April 1915: "With Kandinsky I shall always have a kind of human friendship, in spite of everything; but honestly: I can no longer believe in a collaboration." Two weeks earlier, he took an even more extreme stance in his "Aphorisms": He declared the *Blaue Reiter* a "complete failure" (Ida Rigby, "Franz Marc's Wartime Letters from the Front," in *Franz Marc: 1880-1916*, 60).

41. 27 March 1915; qtd. in Rigby 59-60.

42. As perceptive modernists also recognized, daring to scandalize the public could also earn its grudging respect. Hermann Bahr, for example, advised Viennese Secessionists in the 1890s: "One must know how to make oneself hated. The Viennese respects only those people whom he despises. . . . The Viennese painters will have to show whether or not they know how to be agitators. This is the meaning of our Secession" (qtd. in Martin, *Futurist Art and Theory* 44 n. 1).

43. Poggioli calls this stance "activism": "the tendency of certain individuals, parties, or groups to act without heeding plans or programs . . . for the mere sake of doing something, or of changing the sociopolitical system in whatever way they can" (27).

44. "The Prejudice of Novelty in Modern Art"; qtd. and paraphrased in Weiss 58.

45. The Kerr-*Pan*-Jagow affair resulted from Berlin's chief of police Traugott von Jagow's banning and impounding in 1910 of several issues of *Pan* (published and edited by art dealer Paul Cassirer) and retaliation against Jagow by the magazine's chief literary contributor, Alfred Kerr. To circumvent Jagow's banning of Carl Sternheim's play, *Die Hose* in 1911, Jagow was invited to attend a dress rehearsal, where he was so charmed by the company of Paul Cassirer's actress-wife Tilla Durieux (obviously, playing one of her best roles) that he not only permitted the performance, but even wrote Durieux a private note attempting to continue their "conversation." While Cassirer put a quick end to

Jagow's overtures and considered the matter closed, Kerr (who had already taken some swipes at Jagow's censorship in *Pan*) saw a chance to humiliate the police chief publicly and thus published and ridiculed the note in the magazine's next issue. Cassirer, obviously embarrassed, disavowed Kerr's article. Another attack and disavowal followed in the magazine's next issue. Cassirer, now alienated from Kerr, was so disgusted by the affair that he sold the magazine the following year, whereupon the new owners made Kerr editor.

Modernist editors quickly took sides in the affair and used it to settle scores. Karl Kraus criticized Kerr in *Die Fackel*, prompting Franz Pfemfert to defend Kerr and attack Kraus in *Die Aktion*. Walden then mocked *Die Aktion*'s position in *Der Sturm*, leading to Pfemfert's retaliation and several further exchanges in their journals (Allen 185, 354 nn. 88, 124).

In retrospect, the feud between Walden and Pfemfert seems inevitable, given their newspapers' competition for preeminence among Berlin's modernists and their contrasting emphases. The Kerr-*Pan*-Jagow affair only provided the spark.

46. The Berlin Expressionists had as many split-offs and rivalries as modernist groups elsewhere, but fewer pitched battles among themselves. Seldom did these groups attempt to disrupt each other's events, for example. Hostilities were limited to nasty swipes in modernist newspapers, as between Pfemfert and Walden, or resignations, as when Paul Cassirer left *Pan* after the Kerr-Jagow affair of 1911. Rival groups simply coexisted (often, like *Der Sturm* and *Die Aktion*, sharing members) or ignored each other, patronizing separate cafés.

Perhaps this avoidance was one explanation in itself: Compared to Moscow and St. Petersburg, Berlin had few large-scale conferences and debates for modernist groups, which often became the scene of many intergroup melees. Berlin also had no fire-eating, young group leaders like Marinetti, Pound, Lewis, Burliuk, and Larionov, eager for confrontations with the public and other groups. Its major leaders tended to be somewhat older impresarios building groups around their enterprises: newspaper editors (Walden and Pfemfert), gallery owners (Cassirer), and publishers (Meyers)—no less courageous and innovative than a Pound or Larionov, but less given to disruptive antics for the fun of it.

Finally, the Expressionist groups felt more allied than modernist groups elsewhere in sharing the view that their real opponent was not each other but the hide-bound, materialistic culture of Germany and Austria that desperately needed a complete overhaul.

47. And being central to prewar modernism, these intergroup battles cannot simply be attributed to an external factor, such as the "general mood of unease created by the ever-present threat of war," as Virginia Spate argues (55). The war scares certainly provided war imagery, both verbal and visual, as the epilogue asserts. But the competitive and aesthetic factors described above provide, in my view, a more compelling explanation of intergroup conflict.

48. John Bowlt considers this "intricate complex of groups and subgroups" as "[o]ne of the distinctive features of post-1910 Russian art" (*Russian Art of the Avant-Garde* xxx). Similarly, Roy Allen demonstrates that as Berlin emerged in 1910 as a center of Expressionist art, not only did the number of modernist groups increase significantly, but also their collective projects: the number of journals alone doubled in 1912-1913 and poetry recitals, exhibitions, etc. increased markedly (56-57).

49. In 1912, the poet and literary historian Florian-Parmentier listed thirty-five separate literary "isms" and groups in Paris from 1885 to 1912, "all competing 'for the minds' of our generation" (Barzun 61; for the list itself, see appendix 2, n. 1). Virginia Spate summarizes: "The Parisian context seems to have favoured the growth of a multitude of small groups of artists and writers which formed, absorbed, divided, and re-formed. They

were never exclusive and were linked by innumerable personal ties and, although they were often locked in bitter controversy, they tended to share fundamental ideas about 'the new reality'" (9).

50. The Automne Salon of 1912 provoked two political protests—one by a Parisian municipal councilman writing to the Undersecretary of Fine Arts, the second by a Socialist Deputy in the Chamber of Deputies—against public buildings being used "for demonstrations of such an unmistakably anti-artistic and anti-national character" (i.e., showing Cubist painting) (qtd. in *Picasso and Braque* 412). Nothing came of either protest.

Responding to the riot over the première of *Le Sacre du Printemps*, the reviewer in *Mercure de France* likened the situation to a grave "border incident" in a climate "which has reached a point of tension where anything can happen" (see prologue and chapter 4 for further discussion).

51. In Germany, Austria, and Russia, the police had the power to censor performances and impound publications (for example, see n. 45 above). During Natalia Goncharova's well-attended 1914 exhibition in St. Petersburg, for example, a newspaper called her religious paintings blasphemous and the public censor removed them.

52. As he was moving to Berlin, Schoenberg admitted to Berg, "You know I've always wanted to [leave Vienna]. My works suffer and it's almost impossible for me to make a living in Vienna. But since there may well be such an opportunity for me in Berlin, I must take advantage of it!" (letter of 19 September 1911; rpt. in Brand 12). As chapter 4 will show, the Viennese took revenge on Schoenberg's move.

53. Letter to Arthur Roessler, 10 March 1897; qtd. in Fauchereau 9.

54. Roy Allen explains Berlin's appeal differently by citing some elements of infrastructure attributed above to Paris: the most important Expressionist journals, *Der Sturm* and *Die Aktion*, located there, likewise, the publishing houses most sympathetic to the young poets; and finally, the "circles" of young artists meeting in cafés were more "active, stable, influential and cohesive" than in other Expressionist centers (54-55). These reasons, however, beg the question of Berlin's emergence as an Expressionist center, since the appearance of the journals, publishers, and "circles," themselves, marked the beginnings of the movement. Why did they coalesce in Berlin?

Peter Jelavich's explanation is more compelling: "[Artists] delighted in the dynamism and frenzy of the metropolis. . . . For all its barbaric harshness . . . Berlin exuded a forceful and fascinating vitality. The chaotic city and its citizens seemed to teeter on the verge of an apocalyptic outburst of energy" ("Berlin's Path to Modernity," in *Art in Berlin: 1815-1989*, 28).

55. While precise comparative statistics do not exist, a conservative estimate would have the number of modernist groups from 1910-1914 doubling over their 1905-1909 numbers.

56. As Robert Craft notes in *Memories and Comments*, Stravinsky completed *Le Sacre* in the fall of 1912.

Chapter 2: Leaders

1. Creating a group was certainly not the most efficient means of promulgating one's aesthetic theories, however, since it took so much time. Publishing a manifesto in a newspaper was simpler. Not surprisingly, several movements in this period began this way, including the most famous, Italian Futurism. Some movements, like Henri-Martin Barzun's Simultanéisme and Dramatisme, scarcely existed outside these manifestos.

2. In 1908, Burliuk helped organize art exhibitions with Nikolai Kulbin and Alexander Benois. The following year, he formed a circle of artists—Elena Guro,

Mikhail Matyushin (Guro's husband), Vasily Kamensky, Velimir Khlebnikov—which produced a poetry collection, *A Trap for Judges*, in 1910. In January 1912, Burliuk organized the second Jack of Diamonds exhibition with painting from modernists across Europe (Barooshian 68).

3. The same charge was frequently leveled at Marinetti. Rudolf Leonhard said of the "General of the Futurists":

> [H]e was no poet, no artist. He was an ambassador; one who concealed [his lack of artistry] . . . by the din he created, one who had no other credentials than the signature on other people's pictures, no other *agrément* than our indiscriminate interest in the Café Josty; and it is now obvious that he was no organizer, but an entrepreneur ("Marinetti in Berlin 1913," qtd. in *Era of German Expressionism* 116).

But cf. Papini's contrasting view (n. 23 below).

4. "Nouvelles Ecoles et Nouveaux '. . . ismes,'" *Les Tablettes* (July-September 1912): 29; qtd. in Weiss, 97, 287. Weiss asserts that this victimization scenario was "a recurring critical perception" of these years (98).

5. "Les Salon des Indépendents" (1913); qtd. in Weiss 98.

6. Kandinsky, *Franz Marc im Urteil Seiner Zeit*; qtd. in Lankheit, *Almanac* 15.

7. The French name would also indirectly link the group to the nationality Pound thought most advanced in poetry at that time, particularly in the free verse principles of Charles Vildrac and Georges Duhamel in "Notes sur la technique poétique" (1910), which directly influenced Pound's ideas and to which he refers in his Imagist manifestos.

8. Letter to Glenn Hughes, 26 September 1927; in *Ezra Pound: Selected Letters* 213.

9. Letter of 3 July 1915; rpt. in *The Imagist Revolution*, n.p.

10. Lowell's promise to obtain a more prominent publisher in America—Houghton, Mifflin, and Company—to bring out several yearly anthologies was equally alluring.

11. Lankheit, "Franz Marc—The Man and His Work," in *Franz Marc: Watercolors, Drawings, and Writings* 16.

12. Ca. October 1911; qtd. in Grohmann 70.

13. "Reminiscences," *Complete Writings*, 1: 381. Cf., Grohmann's view (67-68) that Kandinsky at the time was not trying to propagandize in his views or found a party.

14. "The Blaue Reiter (Recollection)" (1930); rpt. in *Complete Writings*, 2: 745-46.

15. Kandinsky, letter to Marc, 1 September 1911; qtd. in Lankheit, *Almanac* 16-17.

16. The artists were also alike in exploring the interstices of their arts: Schoenberg was painting seriously then and considering the possibilities of tone colors as an organizing principle for melody (*Klangfarbenmelodie*) in his pedagogical text, *Theory of Harmony*. Kandinsky was attempting to link particular colors to musical tones and emotive states in *his* book, *Concerning the Spiritual in Art*. As a further coincidence, their books—each a seminal influence in its field—came out within a few weeks of each other in December 1911 (although *Concerning the Spiritual in Art* bears a 1912 publication date); and both books had been composed a few years earlier and had difficulty in finding a publisher. The authors exchanged and eagerly read each other's volumes.

17. Soon after the concert, Kandinsky wrote in his first letter to Schoenberg:

> [W]hat we are striving for and our whole manner of thought and feeling have so much in common that I feel completely justified in expressing my empathy.

In your works, you have realized what I, albeit in uncertain form, have so greatly longed for in music . . . the independent life of the individual voices in your compositions, is exactly what I am trying to find in my paintings. . . .

I am certain that our own modern harmony is not to be found in the "geometric" way, but rather in the anti-geometric, antilogical way. And this way is that of "dissonances in *art*,["] in painting, therefore, just as in music. And "today's" dissonance in painting and music is merely the consonance of "tomorrow." . . .

It has given me immense joy to find that you have the same ideas (18 January 1911; rpt. in Hahl-Koch, 21)

18. Macke felt ill-used by the *Blaue Reiter*'s organizers because he himself had organized the exhibition's appearance in Cologne, where one of his own paintings had been excluded!

19. "Great spiritual" probably refers to a sentence in Kandinsky's and Marc's unpublished preface to the *Almanac*, ca. October 1911, which Macke (who was working with them at the time in Munich) had surely read: "We are standing at the threshold of one of the greatest epochs that mankind has ever experienced, the epoch of Great Spirituality" (rpt. in *German Expressionism: Documents* 45).

20. Macke's repudiation of Kandinsky's spirituality is remarkably close to Delaunay's own (see introduction). The two probably discussed the matter when Delaunay and Apollinaire visited Macke in Bonn, January 1913, following Delaunay's opening at *Der Strum* gallery.

21. E. Harms, "Paul Klee as I Remember Him," *College Art Journal* (Winter 1972-1973): 178; qtd. in Beeke Sell Tower, *Klee and Kandinsky in Munich and at the Bauhaus* 38.

22. The most notable exception to Futurist dominance was the painter Giorgio de Chirico.

23. Initially, Papini denied that Marinetti did attempt to impose this aesthetic consistency: "Marinetti is a man of talent and an innovative poet . . . but he is neither the Pope nor an office boss. He acknowledges what he owes to others and lets everyone think and act according to his own wishes, but is ready with all kinds of undertaking" ("Why I Am a Futurist," *Lacerba*, December 1913, 268.

24. *Blasting and Bombardiering* 34-35. No doubt, Lewis has shaded his recollection to make himself look good and Marinetti a near buffoon ("Yes. But what's it matter"). Even so, it captures qualities of both men (Lewis's cold self-possession, Marinetti's passionately rigid ideology) that others confirm.

25. Although Metzinger's name was omitted from Apollinaire's categorical lists, it is clear both from his prominent positioning among the "New painters" and from Apollinaire's remarks elsewhere in the book that Apollinaire intended to include him in the "Scientific" category. For Kupka's absence from the "Orphic Cubist" group, see chapter 1, 47-49.

26. Delaunay's view, however, is jaundiced by his falling out with Apollinaire over the simultaneity battle that he (Delaunay) was fighting with the Futurists. Apollinaire had changed sides and supported the Futurists' claim to primacy in inventing the idea.

27. Vriesen cites the military language in Apollinaire's essay in the *Section d'Or* catalogue: "Some young people, art critics, painters, and poets, *have formed an alliance* in order *to defend* their artistic ideas—that is in itself an ideal" (qtd. in Vriesen 53, my emphasis).

28. For example, his review of the 1913 Indépendants proclaiming that "[f]rom cubism there emerges a new cubism. The reign of Orpheus is beginning" (*Montjoie!* 29 March 1913; in *Apollinaire on Art* 293, 500 n. 28).

29. "The Salon des Indépendants," *L'Intransigeant*, 2 March 1914; rpt. in *Apollinaire on Art* 355-56.

30. *L'Intransigeant*, 28 February 1914; in *Apollinaire on Art* 355. Spate notes that following the publication of *The Cubist Painters*, Apollinaire "devoted his critical energies mainly to literary polemic" and that "after early 1913, he more or less abandoned Orphism" (81). By 1914, his presence in the art world was clearly diminished. His review of the Indépendants that year brought him both a snide undercutting from the editors of *L'Intransigeant* and outraged and insulting letters to the editor from a painter, Henry Ottman, who felt wronged by the review. *L'Intransigeant* printed all the letters (*Apollinaire on Art* 503-6). Apollinaire then resigned from the newspaper and challenged Ottman to a duel. As a final insult, Ottman's second was to be the painter Apollinaire had worked so hard to promote before their quarrel, Delaunay. The duel was finally averted with Ottman's apology.

31. According to Richard Cork, "the rebels considered that they were making all the important stylistic innovations, while Fry was getting the credit for their daring. He was unbearable in their eyes, a leech and a crafty exploiter of other people's talent" (*Vorticism and Abstract Art in the First Machine Age* 94). As Cork also notes, aesthetic ideology played a major role: the rebels held "an irreconcilably opposed view of art" from Fry's (93).

32. Compare the almost identical view of another famous gallery owner and agent, Daniel-Henry Kahnweiler, on publicizing "his" painters, Picasso, Braque, and Gris. To a reporter for the magazine *Je sais tout!* Kahnweiler was rather stiff: "I prefer that your magazine not speak of my painters. I don't want them ridiculed. My painters, who are even more my friends, are sincere, convinced *chercheurs*, in a word, artists. They are not those *saltimbanques* who pass their time stirring-up the crowd" (Jacques de Gashons, *"La Peinture d'après-demain,"* Je sais tout! 15 April 1912, 349-56; qtd. in Weiss 94).

33. "A Different One"; in Frank, *America and Alfred Stieglitz* 122.

34. *"Programmatisches"* (1910), vol. 1, nos. 2-3; excerpted and paraphrased in Allen 104.

35. Walden could not only "smell out" major talent, he could promote it skillfully. The poets he published in *Der Sturm*, many of whom formed the Sturm circle, read like a who's who of German Expressionism: Benn, Döblin, Ehrenstein, Blass, Lasker-Schüler, Stramm (a special find), etc. The visual artists whose woodcuts appeared in the newspaper are equally impressive: Kokoschka, Kirchner and other members of *Die Brücke*, Marc, Kandinsky, etc.

What really shows Walden's uncanny ability to identify and attract first-rate modernists, however, were the groups and artists he exhibited at the Sturm Galerie beginning in 1912: the first Blaue Reiter exhibition, the Futurists, Picasso and Braque, Kandinsky, Marc, Ensor, and Meidner (to name only the list for 1912).

36. "Testimony against Gertrude Stein," *transition* 40, special supplement, 1934-1935.

37. Kokoschka writes in *My Life*: "During that year I lived and worked with Walden we had only the bare necessities of life; during the week we survived almost exclusively on biscuits and tea, and on Sundays we went to one of the new Aschinger popular restaurants, where for a few groschen one could eat meatballs and as much bread as one dared. . . . [H]e had nothing except for his small subsidy from Karl Kraus, and neither he nor I owned a thing" (60).

38. About this fusion Modris Eksteins writes:

[A] sexual tension pervaded the whole experience of the Ballets Russes, among performers, managers, hangers-on, and audience. Some of the ballet themes were openly erotic, even sadomasochistic, as in *Cléopatre* and *Schéhérazade*: in both, young slaves pay for sexual pleasures with their lives. In others the sexuality was veiled. In *Petrouchka* the puppet dies frustrated in his love for a cruel doll. Nijinsky was to claim later in his diary, written six years after the first performance, that *Jeux*, with its cast of one man and two girls, was Diaghilev's way of presenting, without danger of outright censure, his own fantasy, apparently often stated to Nijinsky, of making love to two men. . . . Nijinsky with his physical prowess and his mental audacity, with his combination of innocence and daring, . . . [gave an] erotic thrill [to] Parisians. (63-64)

Only when erotic suggestion became blatantly sexual, however, as in Nijinsky's masturbatory conclusion to *L'après-midi d'un Faune* did scandal ensue (see chapter 4).

39. Garafola argues that Diaghilev's "disenchantment" with Nijinsky as choreographer began as early as the summer of 1913—well before he learned of Nijinsky's surprise marriage (73). In fact, if Diaghilev listened to Stravinsky's bitter complaints (and why would he not?) that Nijinsky simply did not know music well enough to choreograph dancers, Diaghilev's disapproval would date from 29 May 1913. By the same token, we might assume an earlier date than Nijinsky's marriage announcement for Diaghilev's first inklings that his affair with Nijinsky was ending.

40. This retrenchment to the known and reliable was only temporary, however, and, in Garafola's view, Diaghilev's truly avant-garde years were still ahead of him, in the 1914-1917 period, culminating in *Parade* (76).

41. William Carlos Williams, Pound's friend from college days, referred to Pound's "painful self-consciousness" in public (*The Autobiography of William Carlos Williams* 58). Many others have noted that Pound's exaggerated posturing, often in the persona of the rough-hewn American Westerner, was obviously intended to mask his social discomfort.

42. For example, from 1912 (when he began assuming these poetry editorships) through 1914, Pound averaged 46 articles a year, in addition to his correspondence and publication of several volumes of poetry.

43. As with Kandinsky, such selflessness was never pure, however, and as Pound abandoned groups in the late teens and became more selective about those he promoted, he did not hesitate to include himself in the select coterie. From a letter to Margaret Anderson (editor of the *Little Review*), ca. January 1917:

I want an "official organ" (vile phrase). . . . a place where I and T.S. Eliot can appear once a month (or once an "issue") and where Joyce can appear when he likes, and where Wyndham Lewis can appear if he comes back from the war.

DEFINITELY a place for our regular appearance and where our friends and readers (what few of 'em there are), can look with assurance of finding us. . . . I must have a steady place for my best stuff (apart from original poetry, which must go to *Poetry*). (*Selected Letters* 106-7)

44. *A Poet's Life* 266, 268. Interestingly, Monroe omits all reference to her frequent disagreements with Pound, such as his refusal to accede to her wishes that Eliot change the ending of "Prufrock."

45. Pound was easily scorned once his services were no longer essential. Although he had helped Aldington become *The Egoist*'s deputy editor and even secretly subsidized the position, Aldington ungratefully kept Pound out of the magazine and later called him "a small but persistent volcano in the dim levels of London literary society" (*Life for Life's Sake* 105). Once Pound's contacts with literary magazines started shutting down in the late teens, his literary influence plummeted in London and America, until he moved to Paris in 1920.

46. Other pedagogical groups led by modernists existed, of course, for example, Matisse's class in the years following 1905. But because their essential function *was* pedagogical, that is, they did not evolve a single style and present it publicly, they will not be considered, likewise Schoenberg's relations with his other students.

47. As Harriet Monroe observed: "Ezra Pound was born to be a great teacher. The American universities which, at this time of his developing strength [ca. 1912-1914], failed, one and all, to install him as the head of an English department, missed a dynamic influence which would have been felt wherever English writing is taught" (*A Poet's Life*, 268).

48. Introduction, *The Berg-Schoenberg Correspondence*, ed. Juliane Brand, Christopher Hailey, and Donald Harris, xiii-xiv (hereafter referred to in the text as "Brand").

49. Berg refers here to a highly successful quartet concert of 16 April 1912, sponsored by the newly formed Akademischer Verband, at which the Rosé Quartet performed Schoenberg's string sextet (*Verklarkte Nacht*) and his D-minor string quartet to "[n]ot a single sign of opposition!" (Berg, letter to Schoenberg, 16 April 1912; qtd. in Brand 85).

50. "The Path to the New Music" (1932 lecture); qtd. in Moldenhauer 117-18, my emphasis.

51. Dodge's articles on Stein appeared in *Arts and Decoration* (March 1913) and in Stieglitz's *Camera Work* (June 1913), alongside of Stein's "Portrait of Mabel Dodge at the Villa Curonia."

52. Mrs. Pearson, "'The Printed Page Will Soon Be Superseded by the Spoken Word,' Declares Mrs. Mabel Dodge, Who Has Been Holding a New York 'Salon' for Free Speech," no newspaper title; qtd. in *Movers and Shakers* 82-83.

53. Letter to Harriet Monroe, December 1913; in *Selected Letters* 13.

54. Letter to Milton Bronner, early 1916; qtd. in Stock, 190-91.

Chapter 3: Manifesto

1. André Salmon, *Action*, no. 10 (November 1921): 12-13; qtd. in *Apollinaire on Art*, 499 n. 12.

2. *L'Intransigeant*, 19 March 1913; rpt. in *Apollinaire on Art* 283.

3. *L'Intransigeant*, 18 March 1913; rpt. in *Apollinaire on Art* 282.

4. Jeffrey Weiss persuasively asserts that this manifesto was a joke, a "pastiche of Marinetti's manifesto voice" (84).

5. Marjorie Perloff asserts in a chapter on modernist, and particularly Futurist, manifestos: "The novelty of Italian Futurist manifestos . . . is . . . their understanding that the group pronouncement, sufficiently aestheticized, can, in the eyes of the mass audience, all but take the place of the promised art work" (*The Futurist Moment* 85). See also n. 36.

6. Nicholls 76. I would identify the beginning of the manifesto vogue a bit earlier, however, with the Symbolists' manifesto of 1886 (also authored by Moréas), since Symbolism was unquestionably a modernist style.

7. Paul Acker, "Manifestes Littéraires," *Gil Blas* (12 March 1909): 1; qtd. in Weiss 55, 269.

8. Larry H. Peer, *The Romantic Manifesto: An Anthology*.

9. James M. Hutchisson, *Paper Wars: The Literary Manifesto in America* 4.

10. Qtd. in Lawton, *Russian Futurism through Its Manifestoes* 54.

11. *London Observer*, 7 June 1914. Since Marinetti probably wrote nearly all of the manifesto, the co-signatures themselves were a deception to make the enterprise look like a joint English-Italian effort. Cf., Pound's similar ploy in ghost-writing "Imagisme" (discussed below).

12. The letter stated in part: "We, the undersigned, whose ideals were mentioned or implied, or who might by the opinions of others be implicated, beg to dissociate ourselves from the 'Futurist' manifesto which appeared in the pages of THE OBSERVER of Sunday, June 7." The letter was published in *The Observer* (14 June), *The New Weekly*, and *The Egoist* (Richard Cork, *Vorticism and Abstract*, vol. 1, 227-30, 232-33, and 310 n. 61).

13. In *Synchromism and American Color Abstraction*, Gail Levin does not precisely date the group's formation, but notes that Russell had first used "Synchromisme" in his notebooks in October 1912 (20). Between that date and their first exhibition as a group in Munich (June 1913), the group formed.

14. "Through the *Salon des Indépendants*" *Montjoie!* 18 March 1913; rpt. in *Apollinaire on Art* 293.

15. "The Exhibitors to the Public"; rpt. in Chipp, *Theories of Modern Art* 294.

16. Qtd. in Lawton 51, authors' emphasis. Cf., Franz Marc's identical ambitions for the Blaue Reiter ("The Editors of the Blaue Reiter will now be the starting point for new exhibitions. . . . We will try to become the center of the modern movement"—letter to his brother, 3 December 1911; qtd. in Lankheit, *Almanac*, 14) and Ezra Pound's for *Poetry*: "We must be *the voice* not only for the U.S. but internationally" (letter to Harriet Monroe, 24 September 1912; in *Selected Letters* 10, Pound's emphasis).

17. Qtd. in Lankheit, *Almanac* 252. Compare the similar theme in an unused preface to the first edition of the *Almanac*: "We are therefore asking those artists who feel inwardly related to our goals, to turn to us as *brethren*" (October 1911; rpt. in Lankheit, *Almanac* 251, authors' emphasis).

18. "Slap . . ." was the first manifesto issued by the Hylaea group of painters and poets, who later renamed themselves the Cubo-Futurists.

19. Larionov here alludes to the aims of the Jack of Diamonds exhibition group, which tried to accommodate conflicting styles and aesthetic preferences among the modernist groups in selecting art for their exhibitions.

20. "Destruction of Syntax—Imagination without Strings—Words in Freedom 1913," in *Futurist Manifestos*, ed. Apollonio, 105, my emphasis.

21. Rpt. in Chipp, *Theories of Modern Art* 288. Chipp notes that this translation, made under Marinetti's direction, was reprinted in the catalogue for the Futurists' traveling exhibition in London.

22. These lists (published in the first issue of *BLAST*, June 1914) virtually plagiarize Apollinaire's lists of those to receive either a "Rose" or "Merde" in his widely read "*l'Anti-tradition futuriste: manifeste synthèse*" of June 1913.

23. "Slap in the Face of Public Taste"; qtd. in Lawton 52, authors' capitals and emphasis.

24. Marianne Martin contends that Marinetti's "broad recommendations" in this manifesto "did not provide many clues for the Futurist artists, who in the early spring of 1910 were searching for an appropriate painting theory of their own." By contrast, "[Jules] Romains's approach to reality, as described in . . . *La vie unanime* [discussed further on in this chapter] seems . . . to have provided the crucial source that enabled the artists to verbalize their aims" ("Futurism, Unanimism, and Apollinaire," *Art Journal* 28, no. 3 [spring 1969]: 260).

25. Marianne Martin plausibly attributes their origins to Jules Romains's *La vie unanime*: "I am a joyous intersection of unanime rhythms, a condenser of universal energies. . . . the entrances / To the houses, the passers-by, the horses, the carriages / Join each other and join my body. / We are indistinct" (qtd. in Martin, "Futurism, Unanimism, and Apollinaire" 260-61).

26. See Anna Lawton, ed., *Russian Futurism through Its Manifestoes* 55-81.

27. Lawton notes that, according to Vladimir Markov (*Manifesty*), "[t]hese are the vowels from the beginning of the prayer "Our Father.""

28. Nietzsche 171. Walter Kaufmann, the editor, calls *Zarathustra* "by far Nietzsche's most popular book" (103), and it certainly seemed to have been for modernists in 1910-1914. In *Expressionism: Art and Idea*, Donald Gordon notes its influence on the *Brücke* painters, who took their name from Nietzsche's declaration in the prologue ("What is great in man is that he is a bridge and not an end"). Gordon also points out the Nietzschean idea of creative destruction in Kandinsky's 1913 *Reminiscences* (for example, "A great destruction . . . is also a song of praise"). "What Nietzsche sowed," Gordon writes, "the Expressionists reaped" (14-15, 2).

"Annihilation" was only a first step, however, since Nietzsche also writes in the same section of *Zarathustra*: "For the game of creation, my brothers, a sacred "Yes" is needed: the spirit now wills his own will" (qtd. in Nietzsche 139). This view, too, accurately anticipates the sensibility of prewar modernism, which (as I argue in my introduction) was far removed from the pervasive nihilism that infected artists during and shortly after the war.

29. "Futurist Painting: Technical Manifesto," 11 April 1910; rpt. in Chipp 292-93.

30. Zweig wrote:

> It seems that our age is again preparing to return to this primordial, intimate contact between poet and listener, our age which is again originating a *new pathos*. . . . Today, as before, it seems that the lyric poet will have the right to become, if not the spiritual leader of his age, then at least the tamer and arouser of its passions, the rhapsodist, the challenger, the inspirer, the igniter of the sacred flame—in short, to become energy. (Qtd. in Eliel 19)

31. The definition comes from member Erwin Loewenson (qtd. in Allen 84-85), who also asserted that the poets reading at the club should manifest this synthesis in their work.

32. Rudolf Kurtz, "Programmatisches," *Der Sturm* 1 (1910): 2-3; qtd. in Allen 103-4.

33. Beauduin, in fact, predicted specifically "a new pathos" when he stated in a 1914 manifesto that the violent and kinetic "rhythm of modern life" will create a "lyricism [that] will be powerfully instinctive" ("The New Poetry of France," trans. Richard Aldington, *The Egoist*, August 1914, 315). Since, in the same article, he also speaks the language of Futurism and Unanimism, he seems to be trying to connect his movement, Paroxysm, with other emotive movements of his day.

34. Qtd. by Wyndham Lewis (no source given) in C. K. Stead, *The New Poetic: Yeats to Eliot* 53. Lewis himself described these amateurs as "a cloud of locusts, from the Victorian Age . . . choking professional talent—drawing all the applause to themselves, . . . because they were such awfully nice people (and the critics were not looking for artistic perfection, but social *niceness*)" (Stead 54).

35. In the years following the Imagist manifestos, Pound complained repeatedly that *vers libre* poets had misconstrued his manifestos, especially his advice against composing to a metronome; hence, they produced poetry marked by "looseness [and] lack of rhythmical construction and intensity" ("Correspondence," *Poetry*, March 1916, 323). Although his later statements between 1914-1917 called for a flexible and organic relation between rhythm and the individual "creative emotion" that generates it, this relation was not clearly expressed in the manifestos themselves. If subsequent poets misunderstood what the manifestos advocated, Pound's vagueness was the culprit. See Milton Cohen, "Subversive Pedagogies: Schoenberg's *Theory of Harmony* and Pound's 'A Few Don'ts by an Imagiste," *Mosaic* 49-65.

36. Precisely here, Marjorie Perloff's excellent discussion of the manifesto encounters the same problem. Her chapter analyzes how the Futurists, Apollinaire, and the Dadaists radically changed manifesto form and style, ca. 1910-1918. While acknowledging that numerous earlier documents deserve "manifesto" status, for example, Romains's "*Les Sentiments unanimes et la poésie*" of 1905 and *Die Brücke*'s "Program" of 1906, she cannot grant them full status, because they do not resemble the form and style Marinetti et al. subsequently developed: "[N]either in *The Germ* nor in its successors . . . do the manifestos and critical essays claim to be more than texts of mediation, designed to lead the audience to the proper view of a given artist or movement. The novelty of Italian Futurist manifestos, in this context, is their brash refusal to remain in the expository or critical corner. . . . [but to become instead] aestheticized" (*Futurist Moment* 85). The manifesto form she analyzes, therefore, I shall call the "manifesto-proper."

37. Perloff 94-95.

38. As an index of how easily the book's innocuously pedagogical purpose could be taken at face value, the first (and for decades the only) English translation by Robert D. W. Adams (New York: Philosophical Library, 1948) omitted all of Schoenberg's parenthetical commentary, which, as I shall show below, changes this pedagogy into a very different text. Fortunately, Roy E. Carter's complete translation and annotation in 1978 corrected this problem. Although Carter used Schoenberg's third, revised edition of 1921, he indicates any significant divergences from the first edition of 1911.

39. Schoenberg began writing the text in late 1909, the same year he composed his *Three Piano Pieces* (Op. 11), *Erwartung* (Op. 17), and *Five Pieces for Orchestra* (Op. 16)—major works of his pantonal period. His *Three Piano Pieces*, in fact, is often identified as his first composition in which "the new non-tonal chromaticism is completely dominant" (Salzman 33). That same year, Anton Webern completed *Five Movements for Strings* and *Six Movements for Orchestra*, both employing a pantonal style. Schoenberg completed *Theory of Harmony* in September 1910, then put it aside for lack of a publisher (Stuckenschmidt 134).

40. Reinforcing this demolition of the diatonic scale, Schoenberg concludes his book by reviewing, briefly and almost teasingly, alternative tonal and harmonic structures: the chromatic scale, the whole tone scale, quartal harmonies, "a new epoch of polyphonic style," and, last and most provocatively, *klangfarbenmelodie*, or melodies constructed of individual tone colors (387 ff.).

41. Webern certainly had adopted these ideas, as evidenced by his *Five Pieces for Strings* (Op. 5) of 1909. Berg, although maturing later as a composer, was thoroughly conversant with the assumptions of pantonal composition, having proofread and indexed

Theory of Harmony for Schoenberg, as well as carefully studying his other compositions of the period (as evidenced by his letters to Schoenberg in Brand).

42. Letter of 19 August 1911; qtd. in Moldenhauer 146.

43. Letter to Schoenberg, 3 August 1911; qtd. in Brand 6-7. Berg must have been especially awed that Schoenberg quoted a phrase from one of Berg's compositions as an example of quartal harmony (Schoenberg 420, Brand 23 n. 4).

44. The book's 1912 publication date was postdated by its publisher, R. Piper.

45. Thus, for example, the ideas on poetry that Robert Frost described in private letters to friends in 1913 would not deserve the status of "poetic manifesto" that William Pritchard gives it (*Frost: A Literary Life Reconsidered* 75-77) because Frost did not published these ideas and because they seem too desultory and unsystematic to qualify as a manifesto.

46. According to Lankheit, the paragraph containing the latter target, art critics, was deleted from a later version of this preface (250 n. 1).

47. In fact, a stronger case can be made for considering the *Blue Rider Almanac* as itself a work of art, crafted and shaped by the shared philosophy of its editors, rather than as a manifesto.

48. Marjorie Perloff refers to "Spiritual Treasures" as Marc's "opening manifesto" (*Futurist Moment* 93), and Mark Rosenthal says of "The 'Savages' of Germany": "[t]he missionary zeal of Marc's call to arms indicates the degree to which the [Blaue Reiter] movement was as much social as artistic" (*Franz Marc* 24).

49. He stated to Glenn Hughes in 1927 that his object in creating *Imagisme* was to "launch H.D. and Aldington before either had enough stuff for a volume. Also to establish a critical demarcation" (*Selected Letters* 213).

50. In maintaining this appearance, Pound succeeded admirably. When Harriet Monroe awarded him a *Poetry* prize in January 1914, she described her "high appreciation not only of Mr. Pound's poetry, but also of his disinterested and valuable service as foreign correspondent of the magazine" (*Poetry* January 1914, 52).

51. Pound appeared to keep Harriet Monroe almost as much in the dark as her readers about Imagism and H. D. In August 1912, he labeled, without explaining, one of the first of his own poems that he sent her as "Imagiste." As Noel Stock observes: "Harriet Monroe had no way of knowing what this meant since the new movement existed hardly at all outside Pound's own mind, but it was a beginning and no doubt served to arouse her curiosity" (119-20). In his correspondence to Monroe in October-November 1912, he refers several times to "H. D." and even instructs Monroe that the poet should be identified only as "H. D. *imagiste*," adding mysteriously: "It is requested that no biographical note appear." Pound kept Monroe in the dark until March 1913 when he gave her Doolittle's address in Rome. (I am indebted to Dr. Tim Redman for facts drawn from the Pound-Monroe unpublished correspondence.)

According to Aldington, both he and "H. D." found Pound's exotic name for her "ridiculous," but they were too dependent on his promotional support to protest (*Life* 135).

52. Pound succeeded, that is, if the note was genuinely Harriet Monroe's. She *was* the magazine's editor and signed her comments this way; and for Pound, as "foreign correspondent" to use "editor" would seem both too ambiguous and cheeky for Monroe to permit.

But the way that the "Editor's Note" provides the perfect gambit for F. S. Flint's "response" does seem rather too neat. Did Pound provide this note to Monroe and encourage her to append it to the articles? If so, it becomes another of his fictions (along with the authorship of "Imagisme"); and "many requests" then becomes simply another tactic—creating a "bandwagon" illusion—for generating interest in the movement.

53. Pound's intentional mystification here recalls a frequent complaint of critics that each modernist group depends on "an elaborate *a priori* system" that it conceals from the public" (see Weiss 74). In fact, however, most groups were eager to present their *programme*—if they had one—in their published manifestos and exhibition statements.

54. *Salon de juin: Troisième exposition de la Société normande de Peinture Moderne*, catalogue, Rouen, 15 June-15 July 1912, 9-11; rpt. in Fry, *Cubism* 91-93, my emphasis.

55. "Young Painters, Keep Calm!"; qtd. in *Apollinaire on Art* 252. Willard Huntington Wright's articles and especially his book on modernism, *Modern Painting: Its Tendency and Meaning* (1915), are another example of critical partiality turning a supposedly objective study into a quasi manifesto. In the book, Wright ruined what might have been a superb analysis of Cézanne's legacy with obvious propaganda for Synchromism, whose cofounder, Stanton Macdonald-Wright, was Willard's brother.

56. Although not a member of the Abbaye commune himself, Romains was such a frequent and influential visitor that he was considered an associate. The Abbaye's members were much influenced by his Unanimist philosophy: they published *La vie unanime* (the best-known work of the Abbaye press) and were later grouped by critics as Unanimists, whether they desired the affiliation or not.

57. In envisioning a modern epic that shifts the "center" of spiritual power away from the individual's subjectivity and toward these collective urban forces, Romains, I believe, attempts to supplant not only decadent interiority (as Peter Nicholls argues in *Modernisms* 83), but also Whitman's romantic identification with the energies of a burgeoning nation in *Leaves of Grass*, particularly his absorption of these energies into himself. In Romains's poems, the self is more absorbed by *unanimes* than vice versa:

> I scorn my heart and my personal thoughts
> The city's dream is more beautiful than mine. . . .
> I disappear. And the charming life of everyone
> Drives me out of my body, possessing every fibre.
>
> I slowly cease to be myself. . .
> Jostled by the appearances of the street
> I am completely drained of interior life.
> My being diminishes and dissolves. . .
> Greedy city,
> I am like sugar in your mouth.

(*La vie unanime* 132-33; trans. in Peter Nicholls, *Modernisms* 81-82)

58. According to Sherry Buckberrough, "[T]he book was warmly received and inspired ten or twelve pages of commentary in the *Mercure de France*" (*Robert Delaunay: The Discovery of Simultaneity*, 336 n. 18). Marianne Martin argues convincingly that Romains's *La vie unanime* directly influenced Marinetti's "Foundation" Manifesto of Futurism, which appeared the following year: "both statements, full of youthfully buoyant spirits and distrustful of the past as an artistic source, stressed . . . the concept of the artist as creative seer and guide to the future . . . and the necessity to recover a pure, untrammeled sensibility to express the novel values and experience of the changing world" ("Unanimism, Futurism, and Apollinaire" 260). She goes on to show how Romains's philosophy informed the ideas of the Futurist painters and Apollinaire. Buckberrough adds Delaunay to the list of the influenced, via the intermediary of the writer Alexandre Mercereau, one of the cofounders of the Abbaye group and later organizer of his own soirée in 1910 (54).

59. In this regard, Marianne Martin's depiction of Romains's concluding poem, "*Nous*," as a "manifesto-like poem" (261) may indeed be valid regarding the poem's declarative style and voice; but the poem by itself does not provide enough of Unanimism's philosophy to qualify, in my view, as a quasi manifesto.

Chapter 4: Melee

1. Modernist poetry was certainly not neglected, however. When *Des Imagistes* first appeared, for example, it came "at once under fire from apparently the whole American fleet of critics. . . . Columnists parodied the poems, or reproduced them (without payment) accompanied by derisive remarks" (Aldington, *Life* 138). The London edition did little better with critics: "except for the ultra-conservative *Morning Post*, which gave us a column of praise, all the newspapers, particularly the 'liberal' ones, were against us" (Aldington 148).

Kreymborg, who published the American edition in *Glebe*, recalls: "Vituperation and ridicule joined in denouncing the [Imagist] group in general and Pound in particular. Nowhere was his [Kreymborg's] name held up to greater derision than in the columns of the New York press and the chambers of The Poetry Society" (*Troubadour* 203).

2. Recognizing that any fixed criterion here is arbitrary, I shall define "large-scale" as exhibitions including over 100 works.

3. Figuring from the time Arthur Davies sent Walt Kuhn the catalogue of the Sonderbund Exhibition (ca. September 1912) to the opening on 17 February 1913.

4. Emil Nolde was "always a strong believer in theories of racial superiority and the need for a national German art revival. . . . he also decried cubist and constructivist paintings as being of Jewish origin, because he disliked them" (Selz, *German* 123-24).

Carl Vinnen organized a petition in 1911, "Protest deutscher Künstler," which had complained about German museums buying French painting allegedly at the expense of German artists (discussed further on in this chapter).

5. "Public" here and throughout the chapter excludes professional artists and those sympathetic critics who published in the little modernist magazines and newspapers that were favorably predisposed toward modernism.

6. *Münchner Neueste Nachrichten*, 10 September 1910; qtd. in Zweite 28. The reviewer's use of "synthesis" intentionally mocked the NKV's fondness for this word in their manifestos to describe their aesthetic ideas. In an elided passage of the review, the reviewer notes the group's use of the word.

7. "Franz Marc" [1936]; rpt. in *Wassily Kandinsky: Complete Writings on Art*, 2: 793-94.

8. Picasso unwittingly strengthened this jab by including the letters "KUB" in his *Landscape with Posters* (July 1912). His pun on Cubism was drawn from an advertisement for a German-named bouillon cube.

9. "Nobody" else except Franz Marc, then still unknown to the Munich avant-garde, who responded to the public's hostility in a published letter: "Has the imagination become so philistinized today, so constipated, as to have broken down completely?" (qtd. in Grohmann 65).

10. Cubists Roger La Fresnaye and Raymond Duchamp-Villon, members of the Salon's hanging committee, persuaded the jury to include the Cubists and to show their paintings together. In "Room 8" appeared paintings of Albert Gleizes, Jean Metzinger, Fernand Léger, Henri Le Fauconnier, Roger de La Fresnaye, Marcel Duchamp, Jacques Villon, Dunoyer de Segonzac, André Lhote, and Luc Albert Moreau. Next door, in

"Room 7," the "room of the frenzied colorists," were hung paintings by Francis Picabia and František Kupka.

11. About the earlier scandal at the 1911 *Indépendants*, Gleizes is a bit contradictory, even disingenuous. In his *Souvenirs*, he claimed that the public uproar was a surprise and that the painters' desire to exhibit together "did not in any way indicate an intention to stir up the crowds" (qtd. in Robbins 16). This disclaimer seems to contradict the "contentious excitement" the Cubists hoped to create by being grouped together: "This idea of grouping by [stylistic] tendencies could only serve the interests of *all* the young painters and give back to the salon its contentious excitement, which was the spirit of its founders" (*Souvenirs*, in Robbins 17, Gleizes's emphasis).

12. *Im Kamph um die Kunst: Die Antwort auf den "Protest deutscher Künstler"* (1911). Franz Marc participated actively in gathering contributions, including ones from Kandinsky (untitled), Macke, and himself ("German and French Art"). Worringer's essay was reprinted in *Der Sturm* (August 1911).

13. Apollinaire, "The Opening [of the *Automne Salon*]," *L'Intransigeant*, 1 October 1912; qtd. in *Apollinaire on Art* 248. Vauxcelles was quick to respond—in public:

> Please do me the honor of believing that it is not in my character to allow myself to be insulted "roundly" without responding to the offense. I did in fact inform the two ill-bred young men that the incident would be resolved in the customary way on the dueling ground. At that, they immediately retracted, prevented no doubt by their cubist principles from engaging in a fight. (letter to *L'Intransigeant*, 3 October 1912; qtd. in editer's note, *Apollinaire on Art* 495)

14. Jean Cocteau's account of the carriage ride was denied by Stravinsky (Eksteins 39).

15. Letter of October 1913; qtd. in Gustav Vriesen, *August Macke* 19.

16. More formally, "*Orchester-Konzert of the Academischer Verband für Literatur und Musik in Vien*," 31 March 1913.

17. Letters of 19 September and 31 October 1911; in Brand 12, 38, Schoenberg's emphasis. If neglectful, official Vienna was not indifferent. Shortly after Schoenberg left, the prominent newspaper *Die Zeit* published an article entitled "Arnold Schoenberg's Emigration Plans" in which, like a scorned suitor, it complained: "It would be interesting to know why Arnold Schönberg is fleeing Vienna. This city, which according to the appeal [a fund-raising drive for Schoenberg published in Berlin's *Pan*] bears him a grudge, offered him a position at the Academy, has given him a publisher and many friends and students, and his works are repeatedly performed by outstanding Viennese musicians in Vienna and abroad" ("*Auswanderungpläne Arnold Schönberg*," 17 September 1911; qtd. in Brand 15 n.8).

18. That Schoenberg was featuring his students' works on this program may also have been construed as a slap. Certainly, leading off with Webern's *Six Pieces* was not calculated to win the audience.

19. "Tumult in Large Musikverein Hall," rpt. in Moldenhauer 171-72; H.K.N., no title, *Boston Evening Transcript*, 17 April 1913; rpt. in Brand xv.

20. Stravinsky, *An Autobiography* 47. Some music historians have uncritically accepted his claim, for example, Eric Walter White, *Igor Stravinsky: The Composer and His Works* 213.

21. Qtd. in Robert Craft, "Stravinsky's Russian Letters," *New York Review of Books*, 21 February 1974, 18.

22. Nijinsky and Monteux qtd. in Robert Craft, "Le Sacre and Pierre Monteux: An Unknown Debt," *New York Review of Books*, 3 April 1975, 33.

23. The most detailed account, "Tumult in the Large Musikverein Hall," comes from an unnamed newspaper reviewer, rpt. in *Musikblätter des Anbruch* 6 (August-September 1924), 321-23; trans. and rpt. in toto in Moldenhauer (131-32), and (in a different trans.) excerpted in Stuckenschmidt (185-86).

Moldenhauer also prints the lengthy diary entry of Richard Neutra describing the event (659 n. 9). Finally, a reviewer identified only as H.K.N. reviewed the concert for the *Boston Evening Transcript* (17 April 1913); qtd. in Brand xv.

24. The same pattern of planned demonstrations and battling factions can also be seen in the melee greeting Schoenberg's *Pierrot Lunaire* in Prague:

> Now a storm began between the holders of different opinions, during which the last notes of the composition went unheard. Not only the excited young people, but also the musically educated part of the public were on the side of those who applauded after the last poems. The opposition was also prepared. They blew whistles, and the door key came into its uncultivated rights as an instrument of criticism. Cries of "Pfui" tried to drown the loud Bravos, and the battle between the parties went on uninterruptedly until the lights were put out and the tumult gave way to silence. (Stuckenschmidt 209)

25. Thus, critics who view the "art" and performance of these evenings as dichotomous—for example, "how much of the activity was 'political' propaganda for the movement and how much of it was art[?]" (Kirby 18)—miss what was most aesthetically innovative about these evenings: that they turned publicity-seeking performance into an art form. As Perloff asserts, the Futurists aestheticized politics (84).

26. This delivery technique should not be confused with a far more machinelike and impersonal style that Marinetti called "declamation" and codified in a 1916 manifesto, "Dynamic and Synoptic Declamation" (R. W. Flint 142-47). Surely, its stipulations such as "Completely dehumanize [your] voice, systematically doing away with every modulation or nuance" and "Gesticulate geometrically" would not create the spellbinding power attested to by his listeners in 1912-1914.

27. Marinetti's estimate, quoted in R. W. Flint 23.

28. Francesco Cangiullo's description of a Futurist evening in Naples; qtd. in R. W. Flint 24.

29. R. W. Flint reprints Marinetti's version without questioning the dubious figure. Another version (Tisdale and Bozzolla 12) identifies the crowd as coming out of mass at Saint Mark's just as Marinetti & Co. greet them with a trumpet, loudspeaker, and a "stream of abuse for the churchy, passéist stink of Venice, together with a blast of publicity for the Futurists."

30. Benedict Livshits, *The One and a Half-Eyed Archer* 151; qtd. in Lawton, *Russian Futurism through Its Manifestoes* 16 n. 29.

31. In his autobiography, Severini expressed exactly the same concern as Gleizes: "I was sure that all the publicity and the use Marinetti made of it, tended more and more to distract my friends from the main object of their aspirations" (93).

32. "Orphisme, Orphéisme, ou Orphéonisme," *Gil Blas*, 20 March 1913; qtd. in Spate 55.

33. From "War, the World's Only Hygiene" (1911-1915), Marinetti's emphasis; rpt. in R. W. Flint 113-15.

34. "Dynamic and Synoptic Declamation," 11 March 1916; in R. W. Flint 143, my emphasis.

35. Through performance, therefore, Marinetti reintroduces the very theme that the Futurists repudiated in their manifestos—"amore"—only now it has been acceptably transformed by Futurist values of violence and machismo into conquest and domination and aestheticized into performance.

36. Nevinson recounts how, during his earlier trip, Marinetti had to be dissuaded from trying to "present us to Europe [as Futurists] and be our continental guide" (*Paint and Prejudice* 57).

37. This walkout had been a long time coming. Early in 1911, Kandinsky resigned as president of the NKV over differences with other members. Sharp quarrels were soon to follow over the acceptable degree of abstraction in a painting, the group polarizing into radical and conservative factions, led by Kandinsky and Adolph Erbslöh respectively. By June 1911, as we have seen, Kandinsky was planning the *Blaue Reiter* exhibition and almanac with Marc, and two months later, Marc could predict to August Macke: "I foresee clearly that the next jury meeting (in late fall) will bring about a horrible argument that then or the next time will result in a split or in the resignation of one of the two factions; the question is, which of the two will *survive*" (10 August 1911; qtd. in Lankheit, *Almanac* 13). As Marc had predicted, the split occurred over selection for the third exhibition. Erbslöh, the new president, asked members to send "only works that were 'as comprehensible as possible'" (qtd. in Vezin 13). Kandinsky forced the issue by submitting *Composition 5*, which the hanging committee rejected, providing the *causus belli*.

38. Letter to Harriet Monroe; qtd. in Stock 165.

39. Letter to Harriet Monroe, 20 July 1914; qtd. in Watson 202.

40. *Return to Yesterday* 400. Although Ford's penchant for exaggerating should be considered here, Lewis's arrogant behavior squares with his own and others' accounts.

Epilogue: Modernism and World War I

1. *Personae: The Shorter Poems of Ezra Pound*, rev. ed. by Lea Baechler and A. Walton Litz 26.

2. Trans. in *Modern German Lyric Verse*, ed. William Rose.

3. Regarding the artists' prescience before World War I, see Francis Haskell, "Art & the Apocalypse," *New York Review of Books*, 15 July 1993, 25-29.

4. Examples:

> In the [Kandinsky-authored] circular which announced its existence, the [NKV-Munich] . . . set itself the goal of "addressing the public with a united front." (qtd. in Vezin 84)

> By his insistence that poets should stick together, help one another, and present a united front to the Philistine world, Ezra taught literary London a lesson which, unfortunately it refused to learn. (Douglas Goldring, *South Lodge* 48)

> New "isms" were springing up everywhere. . . . [E]ach laid claim to consideration as a definitive creative statement and carried on a running battle with all the others. Walden, in *Der Sturm*, managed to hold these factions together, with enormous difficulty [until the Nazis

and Communists ended the "spiritual disquiet" of the younger generation]. (Oskar Kokoschka, *My Life* 66)

[In grouping both Cubist and non-Cubist painters together in *The Cubist Painters*, Apollinaire wanted] to create a solid front against the continuing attacks from the press and from the general public. All artists who strove for the new were to be united under the flag of Cubism. (Gustav Vriesen, *Robert Delaunay* 53)

5. Qtd. in Steegmuller, introduction to *Alcools*, v-vii; Kandinsky quoted in Lankheit, *Almanac* 14.

6. "The New Sculpture," *The Egoist*, 16 February 1914, 67-68; rpt. in *Ezra Pound and the Visual Arts* 180-82. Pound's personal battles were no less warlike and more obviously tinged with megalomania, as when he assures the editors of *Poetry* in 1914: "I can annihilate anyone who gets in front of us. Simply I've got the artillery . . . to take on the whole lot" (quoted in Watson 307).

7. Evidence of this high energy speaks for itself in the astonishing outpouring of works and styles in the years just preceding the war. Nevertheless, a number of modernist artists recalled the eerie parallel between prewar political tensions and modernist energy. Stephan Zweig, for example, writes: "Marvelous was this tonic wave of [artistic] power which beat against our hearts from all the shores of Europe. But there was danger too in the very thing that brought joy, although we did not perceive it." Citing the accelerating instances of international tension, he continues: "The surplus energy had finally to discharge itself and the vanes showed the directions from which the clouds were already approaching Europe. It was not yet panic, but there was a constantly swelling unrest; we sensed a slight discomfort whenever a rattle of shots came from the Balkans. Would war really come upon us without our knowing why and wherefore?" (*The World of Yesterday*, 196-98).

8. Futurist painter Carlo Carrà spoke for the group when he wrote to Ardengo Soffici: "We must have faith and courage in ourselves as artists and Italians. To reject nationalism would mean to subject ourselves to the nationalism of others" (qtd. in Martin, *Futurist Art* 132). By 1913, Marinetti was even willing to abandon the anarchistic freedom so central to Futurism's ideology when he published in a Futurist political manifesto: "The word ITALY must prevail over the word FREEDOM" (qtd. in Martin 187).

9. Douglas refers specifically to Larionov's ambiguously titled manifesto, "Rayists and Futurists: A Manifesto," 1913.

10. Frederick Levine persuasively argues that the war imagery of Expressionist painters like Meidner and Marc belongs to their broader struggle against Wilhelmine culture (*The Apocalyptic Vision* 101). But war images were equally prevalent in art from countries little affected by Expressionism, for example, England and France.

11. Letter to Arthur Jerome Eddy, rpt. in Eddy, *Cubists and Post-Impressionism* 126.

12. "Destruction of Syntax-Imagination without Strings-Words-in-Freedom 1913"; rpt. in Apollonio 95-106.

13. Letter to Bernhard Koehler, March 1915; qtd. in Levine 77.

14. Meidner, himself, recollects this period of his dark, apocalyptic landscapes with contradictory sentiments:

We were confused, high-strung and irritable. We were driven to the breaking point by the approach of world catastrophe. (1918, quoted in Miesel, *Voices* 182)

> [Summer 1912] was a strange and omen-laden time for me as none other ever was. I was very poor but not at all unhappy. I was charged with energy, full of mighty plans; I had faith in a magnificent future." (1964, quoted in Eberhard Roters, "The Painter's Nights," in Eliel 63, 69)

15. Theda Shapiro argues that French modernists greeted the war less enthusiastically than did their German counterparts (138, 144); certainly, the French entered it with fewer expectations because few of them shared the Germanic belief that a corrupt social order needed a thorough overhaul. The Swiss poet Blaise Cendrars, fighting for the French, was one of the few to express this Germanic hope when he wrote en route to the front that "[t]his war is a painful delivery, needed to give birth to freedom. It fits me like a glove" (qtd. in Altshuler 41). The simile was to prove a ghastly irony: he would soon have one less hand on which to wear the glove.

16. "Notes on the Present Situation," *The Egoist*, 1 September 1914, 326.

17. Of sixteen German Expressionist journals extant in August 1914, only five survived the first year of the war and all underwent rigorous censorship. The literary circles surrounding these journals likewise disbanded or suffered drastically altered memberships (Allen 33-34). The same held true for Paris: "General mobilization . . . meant suspension of almost all publications, leaving a discontinuity . . . and for several years a sense of void" (Cornell 134).

18. *Le Mot*, 1 May 1915; quoted in Silver 48.

19. Quoted in Miesel, "Paul Cassirer's *Kriegszeit*" 156, n. 3. S. I. Lockerbie notes,

> the vast poetic output . . . of the fifteen months between [Apollinaire's enlistment and his wounding] . . . testifies to the stimulating effect of events on his imagination. . . . [In his poems] the ominous associations of war are sublimated in a release of energy, prompted by a situation with an unusual appeal to the poet's imagination and stimulating him to a unique appreciation of life, given greater force by its context. (introduction, Guillaume Apollinaire, *Calligrammes* 14, 16)

20. After the war, Pound said of "Sestina: Altaforte": "Technically, it is one of my best, though a poem on such a theme could never be very important" (qtd. in Noel Stock, *The Life of Ezra Pound* 68).

21. "In War's Purifying Fire" (1915); qtd. in Miesel, *Voices* 161-65.

22. "The New Spirit and the Poets," lecture (November 1917); trans. Steegmuller, *Apollinaire: Poet among the Painters* 278.

23. "Harold Monro" (1933); rpt. in *Ezra Pound: Polite Essays* 14.

24. Letter of 2 December 1919; qtd. in Silver 310.

Appendix 1: Time Line 1910-1914

1. The following guidelines apply to this time line:

 A. Years included before 1910 and after 1914 list only a few major events and are not intended to be comprehensive.

B. Ordinarily, an event is listed where it occurred, not in artist's home city (if different). For example, although Schoenberg was born in Vienna and considered himself Viennese, those works composed after he moves to Berlin in SEP 1911 are listed under Berlin.

C. Where historians disagree about dates, I have used the one that is best corroborated by other data or sources or that seems most plausible. Only where alternative dates seem equally likely do I indicate such in an endnote. For example, Donald Gordon's ordinarily reliable two-volume catalog of *Modern Art Exhibitions* lists Delaunay's Berlin show at *Der Sturm* gallery as beginning in February 1913. Since we know that Apollinaire and Delaunay attended the opening in mid-January, I would not note this discrepancy.

D. A music composition will ordinarily be listed by date of its première (if within the 1910-1914 period), otherwise by date of publication (if within this period), or finally, by date of completion.

E. To conserve space, major publications will usually be listed in a time line city (rather than actual place of publication, if different).

2. Whether Kupka exhibited these works has been questioned. I share Virginia Spate's tentative conclusion that he did.

3. Throughout the time line, I shall use "Rayist" rather than "Rayonist."

4. Disputed by M.S. Jones xix.

5. According to Peter Selz, this exhibition occurred in APR 1912.

6. Donald Gordon states this exhibition began in FEB 1913 (*Modern Art Exhibitions: 1900-1916*).

7. According to Donald Gordon (*Modern Art Exhibitions: 1900-1916*), Otakar Kubin exhibited at this time at *Der Sturm Gallery*, continuing through May.

8. Selz suggests the painting was *Improvisation No. 12—The Rider*.

9. According to Bruce Altshuler, this exhibition began on 19 DEC; according to Roethel, on 15 DECEMBER

10. According to Richard Cork, this exhibition ran until JAN 1913.

11. According to Marjorie Perloff, this Futurist evening occurred on 18 MAR 1910.

12. According to Giovanni Lista, this exhibition began 18 MAR 1910.

13. Whether Russolo accompanied Carrà and Boccioni is not certain (Marianne Martin 110 n. 2).

14. According to Magdalena Dabrowski (*Contrasts of Form*), this manifesto first appeared in *Lacerba* on 15 MAR 1914.

15. As Altshuler points out, "Artists traveled regularly between St. Petersburg and Moscow, and their group activities formed a single, though multiform and conflict-ridden, advanced culture" (80). Dating follows Gordon's *Modern Art Exhibitions*; o.s. refers to old style calendar, n.s. to new style.

16. According to Vladimir Markov, this exhibition began in FEB 1910.

17. Dabrowski gives the locale as St. Petersburg.

18. According to the old style calendar, this exhibition ran from 24 MAR to 07 APRIL Anthony Parton states that it started on 23 MAR.

19. According to Markov, this work appeared in SEP 1913.

20. According to Dabrowski (*Contrasts of Form*), this exhibition ended on 14 MAY 1914.

Appendix 2: Modernist Groups

1. Prewar Paris was rife with literary movements that often consisted of just one member, the founder, and a print venue such as a journal. In 1912, the literary historian (and group participant himself) Florian-Parmentier listed upwards of thirty-five such groups then (or recently) active. Only a few of these groups contributed significantly to the various strands of French modernism; many were indifferent to modernism and some, indeed, existed to oppose modernist innovation. Those not in the "Listing" above include:

"Ism" or Movement	Begun	Founder or Contemporaneous Leader
Le Symbolisme (and Neo-Symbolism)	1886	Paul Verlaine et al.
Le Vers-Librisme	1887	Gustav Kahn
Le Primitivisme	1909	Touny-Lys, Marc Dhano, and George Gaudion
Le Subjectivisme	1909	Han Ryner
Le Sincérisme	1909	Louis Nazzi
L'Intensisme	1910	Charles de Saint-Cyr
L'Ecole Spiritualiste	1910	Edouard Schuré
Les Renaissances		
Le Floralisme ou l'Ecole de la Grâce	1911	Lucien Rolmer
L'Impérialisme	-1913	Ernest Sellière
L'Effrénéisme		Albert Londres
Le Bonisme	1912	Edmond Thiaudière
Le Druidisme		Max Jacob
Le Plurisme	1912	Adrien Mithouard
Le Pluralisme		J. H. Rosny, Arthur Cravan
Le Totalisme		Emile Henriot
Le Patriartisme	1912	F. Jean-Desthieux
Le Démocratisme et Prolétarisme	1913	Charles Bourcier, Marcel Martinet
Le Philoprésentatanéisme		Lenzi
Le Vivantisme		Gauthiers-Villars
Le Sérénisme		Louis Estève
La Closerie des Lilas		Paul Fort
Les Argonautes	1908	Camille Le Mercier d'Erm
Les Loups		A. Belval-Delahaye
Le Conseil Central		
[pour la défense des Littéreteurs libres]	1912	Roinard, Ryner, St.-Pol Roux, Polti, Mercereau, Voirol, et al.
La Lingue Celtique	1909	Française Pauliat
La Gauche Libéerale	1912	Fernand Divoire
La Biche	1913	(cafe group drawn from other groups)

2. Published April 1912 according to Barzun.

3. Barzun dates the first issue as November.

4. Florian-Parmentier identifies Paroxysme's founding as 1893, its founder Emile Verhaeren (see n. 1 above). By the years 1910-1914, however, Beauduin was clearly recognized as its leader.

5. April according to Bonner Mitchell.

6. This journal inspired by Stefan Zweig's essay of same title.

7. According to Peter Selz, this exhibition began in APR.

8. Marinetti used the Futurist label freely as a strategm for making his group seem more formidable and thus applied it to dozens of writers and artists. Those listed here have signed Futurist manifestos or participated in Futurist events.

9. Dates are in o.s.=old calendar or n.s.=new calendar.

10. Scholars disagree on when Rayist style began. Anthony Parton cites first proto-Rayist works, for example, *Study of a Woman*, shown at Donkey's Tail exhibition (MAR 1912), and Larionov's first published theory of Rayism (OCT 1912). Bowlt dates "Luchism" essay JUN 1912. Charlotte Douglas and Magdalena Dabrowski put likeliest date as late 1912, when Larionov paints *Rayist Interior* and *Rayist Sausage and Mackerel*— *after* he saw reproductions of Futurist traveling exhibition (233).

11. Although Stieglitz opened the Gallery in 1905, he did not begin to show the work of American modernists—and thus draw them loosely together as a group—until 1909.

Appendix 3: Modernist Casualities of World War I

1. "Modernist" here includes those working in a modernist style, affiliated with a modernist group, or contributing to a modernist journal.

Bibliography

I. Visual Arts

Alexandrian, Sarane. *Marcel Duchamp*. Trans. Alice Sachs. New York: Crown Publishers, 1977.

Altshuler, Bruce. *The Avant-Garde in Exhibition: New Art in the 20th Century*. New York: Harry N. Abrams, Inc., 1994.

Andel, Jaroslav, et al. *Czech Modernism, 1900-1945*. Houston TX: Houston Museum of Fine Arts, 1980.

————, and Alison De Lima Greene. "Czech Modernism: 1900-1920." In *Czech Modernism: 1900-1945*, 35-53.

Apollinaire, Guillaume. *Apollinaire on Art: Essays and Reviews, 1902-1918*. The Documents of 20th Century Art. Edited by Leroy C. Breunig. Trans. Susan Suleiman. New York: Viking Press, 1972.

The Avant-Garde in Russia, 1910-1930: New Perspectives. Exhibition catalog, Los Angeles County Museum of Art. Edited by Stephanie Barron and Maurice Tuchman. Cambridge MA: MIT Press, 1980.

Barron, Stephanie. "The Russian Avant-Garde: A View from the West." In *The Avant-Garde in Russia, 1910-1930*, 12-18.

Bowlt, John E. *Russian Art of the Avant-Garde: Theory and Criticism*. Rev. and enlarged ed. New York: Thames and Hudson, 1988.

————. "The Russian Avant-Garde." Introduction to Exhibition catalog, *A New Spirit: Explorations in Early 20th Century Russian Art*. New York: Barry Friedman Ltd., 1987.

————. "The 'Union of Youth.'" In Gigian and Tjalsma, *Russian Modernism: Culture and the Avant-Garde, 1900-1930*, 165-88.

Brown, Milton W. *The Story of the Armory Show*. New York: Abbeville, 1988.

Buckberrough, Sherry A. *Robert Delaunay: The Discovery of Simultaneity*. Ann Arbor MI: UMI Research Press, 1982.

Chipp, Herschel B. *Theories of Modern Art: A Source Book by Artists and Critics*. Berkeley: University of California Press, 1968.

Coen, Ester. *Umberto Boccioni*. New York: The Museum of Modern Art, 1988.

Cohen, Arthur A. "The Delaunays, Apollinaire and Cendrars" (text of lecture). New York: The Cooper Union School of Art and Architecture, 1972.

Cohen, Milton A. "Fatal Symbiosis: Modernism and World War One." *War, Literature and the Arts* 7, no. 3 (spring-summer 1996): 1-46.

————. "The Futurist Exhibition of 1912: A Model of Prewar Modernism." *European Studies Journal* 12, no. 2 (fall 1995): 1-31.

Cooper, Douglas. *The Cubist Epoch*. New York: Phaidon Publishers Inc., 1971.

Cork, Richard. *Vorticism and Abstract Art in the First Machine Age.* Vol. 1, London: Gordon Fraser, 1976.

Czech Modernism: 1900-1945. Museum of Fine Arts, Houston. Houston: Bulfinch Press, 1989.

Dabrowski, Magdalena. *Contrasts of Form: Geometric Abstraction, 1910-1980.* New York: Museum of Modern Art, 1985.

———. "The Formation and Development of Rayonism." *Art Journal* 34 (spring 1975): 200-207.

———. "The Plastic Revolution: New Concepts of Form, Content, Space, and Materials in the Russian Avant-Garde." In *The Avant-Garde in Russia, 1910-1930,* 28-33.

Daix, Pierre. *Cubists and Cubism.* Geneva: Editions d'Art Albert Skira S.A., 1982.

Douglas, Charlotte. "The New Russian Art and Italian Futurism." *Art Journal* 34 (spring 1975): 229-39.

Dube, Wolf-Dieter. *Expressionism.* Trans. Mary Whittall. New York: Praeger, 1972.

———. *Expressionists and Expressionism.* Geneva: Skira, 1983.

Düchting, Hajo. *Wassily Kandinsky, 1886-1944: A Revolution in Painting.* Cologne: Bendict Tachen Verlag, 1991.

Eddy, Arthur Jerome. *Cubists and Post-Impressionism.* Chicago: 1914.

Eliel, Carol. *The Apocalyptic Landscapes of Ludwig Meidner.* Exhibition catalog, Los Angeles County Museum of Art. Munich: Prestel-Verlag, 1989.

Expressionism and Modern German Painting from the Thyssen-Bornemisza Collection. Exhibition catalog. Lugano: Fondazione Thyssen-Bornemisza, 1989.

Fauchereau, Serge. *Kupka.* New York: Rizzoli, 1987.

Fry, Edward, ed. with introduction. *Cubism.* Trans. from French and German, Jonathan Griffin. New York: Oxford University Press, 1966.

Golding, John. *Cubism: A History and Analysis, 1907-1914.* Boston: Harper & Row, 1968.

Goodrich, Lloyd. *Pioneers of Modern Art in America: The Decade of the Armory Show, 1910-1920.* New York: Whitney Museum, Frederick Praeger, 1963.

Gordon, Donald E. *Ernst Ludwig Kirchner: A Retrospective Exhibition.* Boston: Boston Museum of Fine Arts, 1968.

———. *Expressionism: Art and Idea.* New Haven CT: Yale University Press, 1987.

———. Vol. 1 of *Modern Art Exhibitions: 1900-1916; selected catalogue documentation.* 2 vols. Munich: Prestel-Verlag, 1974.

Gray, Camilla. *The Russian Experiment in Art, 1863-1922.* Rev. and enlarged ed. by Marian Burleigh-Motley. London: Thames and Hudson, 1962.

Grohmann, Will. *Kandinsky: Life and Work.* New York: Harry Abrams, 1958.

Gustav, Jürgen. *August Macke.* Trans. Jennifer Barnes. Thornbury, UK: Artline Editions, 1990.

d'Harnoncourt, Anne. *Futurism and the International Avant-Garde*. Philadelphia: Philadelphia Museum of Art, 1980.

Haskell, Francis. "Art & the Apocalypse." *New York Review of Books*, 15 July 1993, 25-29.

Haxthausen, Charles W. "Images of Berlin in the Art of the Secession and Expressionism." In *Art in Berlin: 1815-1989*. Exhibition Catalog. Atlanta: High Museum of Art, 1989, 61-82.

Henderson, Linda D. *The Fourth Dimension and Non-Euclidian Geometry in Modern Art*. Princeton NJ: Princeton University Press, 1983.

Hoog, Michel. *Robert Delaunay*. Trans. Alice Sachs. New York: Crown Publishers, 1976.

Jelavich, Peter. "Berlin's Path to Modernity." In *Art in Berlin: 1815-1989*. Exhibition Catalog. Atlanta GA: High Museum of Art, 1989, 13-40.

Kandinsky, Wassily. "The First Exhibition of the Editors of the *Blaue Reiter*." In *Kandinsky: Complete Writings on Art*, vol. 1, 109-11.

———. *Kandinsky: Complete Writings on Art*, vol. 1 (1901-1921), vol. 2 (1922-1943). Edited by Kenneth Lindsay and Peter Vergo. Boston: G. K. Hall, 1982.

———. "Second Exhibition of the Editors of the *Blaue Reiter*." In *Kandinsky: Complete Writings on Art*, vol. 1, 227-28.

——— and Franz Marc, eds. *The Blaue Reiter Almanac*. Reedited with introduction by Klaus Lankheit. New York: Da Capo Press, 1974.

Lamac, Miroslav. "Czech Cubism: Points of Departure and Resolution." In *Czech Modernism: 1900-1945*, 55-63.

Lankheit, Klaus. "Franz Marc—The Man and His Work." In *Franz Marc: Watercolors, Drawings, Writings*. Text and notes by Klaus Lankheit. New York: Harry N. Abrams, Inc., 1960.

———. "A History of the Almanac." In *The Blaue Reiter Almanac*. Ed. Klaus Lankheit. New York: Da Capo Press, 1974, 11-48.

Levin, Gail. *Synchromism and American Color Abstraction, 1910-1925*. New York: George Braziller, 1978.

Levine, Frederick S. *The Apocalyptic Vision: The Art of Franz Marc as German Expressionism*. New York: Harper & Row, 1979.

Lista, Giovanni. *Futurism*. Paris: Editions Pierre Terrail, 2001.

Long, Rose-Carol Washton, ed. with annotations. *German Expressionism: Documents from the End of the Wilhelmine Empire to the Rise of National Socialism*. New York: G.K. Hall, 1993.

Marc, Franz, "The Savages of Germany." In *The Blaue Reiter Almanac*. Reedited by Klaus Lankheit, 61-64.

———. "Spiritual Treasures." In *The Blaue Reiter Almanac*, 55-60.

Martin, Marianne W. *Futurist Art and Theory, 1909-1915*. New York: Hacker Art Books, 1978.

———. "Unanimism, Futurism, and Apollinaire." *Art Journal* 28, no. 3 (spring 1969): 258-68.

Meidner, Ludwig. "An Introduction to Painting Big Cities." In *Kunst und Künstler* 12 (1914). Quoted and trans. in Carol Eliel 35-36 and Charles Haxthausen 68.

Meseure, Anna. *August Macke*. Cologne: Taschen Verlag, 1991.

Miesel, Victor H. "Paul Cassirer's *Kriegszeit* and *Bildermann* and Some German Expressionist Reactions to World War I." *Michigan Germanic Studies* 2 (fall 1976): 148-68.

Milner, John. *Vladimir Tatlin and the Russian Avant-Garde*. New Haven CT: Yale University Press, 1983.

Morgan, Ann Lee. *Arthur Dove: Life and Work, with a Catalogue Raisonné*. Newark: University of Delaware Press, 1984.

Néret, Gilles. *F. Léger*. Trans. Susan Resnick. New York: BDD Books, 1993.

Norman, Dorothy. *Alfred Stieglitz: An American Seer*. New York: Random House, 1973.

Parton, Anthony. *Mikhail Larionov and the Russian Avant-Garde*. Princeton NJ: Princeton University Press, 1993.

Partsch, Susanna. *Franz Marc: 1880-1916*. Cologne: Benedikt Taschen Verlag, 1991.

Rigby, Ida Katherine. "Franz Marc's Wartime Letters from the Front." In *Franz Marc: 1880-1916*. Edited by Mark Rosenthal, 55-62.

Robbins, Daniel. "Jean Metzinger: At the Center of Cubism." In Joann Moser, *Jean Metzinger in Retrospect*. Iowa City: University of Iowa Museum of Art, 1985, 9-23.

Roethal, Hans, in collaboration with Jean K. Benjamin. *Kandinsky*. New York: Hudson Hills Press, 1979.

Rose, Barbara. *American Art since 1900*. Rev. and expanded ed. New York: Praeger, 1975.

Rosenthal, Mark. *Franz Marc* Munich: Prestel-Verlag, 1989.

———. *Franz Marc: 1880-1916*. Exhibition catalog. Berkeley: University Art Museum, Berkeley, 1980.

Roters, Eberhard. "The Painter's Nights." In Carol Eliel, *The Apocalyptic Landscapes of Ludwig Meidner*, 63-90.

Rubin, William. *Dada, Surrealism, and Their Heritage*. New York: Museum of Modern Art, 1968.

———. "Picasso and Braque: An Introduction." In *Picasso and Braque: Pioneering Cubism*. New York: Museum of Modern Art, 1989, 15-69.

Schwarz, Arturo. *The Complete Works of Marcel Duchamp*. New York: Harry N. Abrams Inc., 1970.

Scott, Gail R. *Marsden Hartley*. New York: Abbeville Press, 1988.

Selz, Peter. *Art in a Turbulent Era*. Ann Arbor MI: UMI Research Press, 1985.

———. *German Expressionist Painting*. Berkeley: University of California Press, 1957.

Shapiro, Theda. *Painters and Politics: The European Avant-Garde and Society, 1900-1925*. New York: Elsevier, 1976.

Silver, Kenneth. *Esprit de Corps: The Art of the Parisian Avant-Garde and the First World War, 1914-1925.* Princeton NJ: Princeton University Press, 1989.

Spate, Virginia. *Orphism: The Evolution of Non-figurative Painting in Paris, 1910-1914.* Oxford: Clarendon Press, 1979.

Steiner, Reinhard. *Egon Schiele, 1890-1918: The Midnight Soul of the Artist.* Cologne: Benedickt Taschen Verlag, 1991.

Taylor, Joshua. *Futurism.* New York: Museum of Modern Art, 1961.

Tower, Beeke Sell. *Klee and Kandinsky in Munich and at the Bauhaus.* Ann Arbor MI: UMI Research Press, 1981.

Vergo, Peter. *Art in Vienna 1898-1918: Klimpt, Kokoschka, Schiele and Their Contemporaries.* Ithaca NY: Cornell University Press, 1975.

Vezin, Annette, and Luc Vezin. *Kandinsky and Der Blaue Reiter.* Paris: Pierre Terrail, 1992.

Vriesen, Gustav. *August Macke.* Stuttgart: W. Lohlhammer, 1953.

———, and Max Imdahl. *Robert Delaunay: Light and Color.* New York: Harry Abrams, Inc., 1967.

Weiss, Jeffrey S. *The Popular Culture of Modern Art: Picasso, Duchamp, and Avant-gardism.* New Haven CT: Yale University Press, 1994.

Wittlich, Petr. "Czech Cubism." In *Czech Cubism: Architecture, Furniture, and Decorative Arts, 1910-1925.* Edited by Alexander von Vegesack. New York: Princeton Architectural Press, 1992.

Zilczer, Judith. "Aesthetic Struggle in America, 1913-1918: Abstract Art and Theory in the Stieglitz Circle." (Ph.D. diss. University of Delaware, 1975). Ann Arbor MI: UMI, 1979.

Zweite, Armin. *The Blue Rider in the Lembachhaus, Munich.* Munich: Prestel-Verlag, 1989.

II. Literature

Aldington, Richard. "Notes on the Present Situation." *The Egoist,* 1 September 1914, 326.

Allen, Roy F. *Literary Life in German Expressionism and the Berlin Circles.* Ann Arbor MI: UMI Research Press, 1983.

Apollinaire, Guillaume. *Alcools.* Trans. Anne Hyde Greet with a foreword by Warren Ramsey. Berkeley: University of California Press, 1965.

———. *Calligrammes: Poems of Peace and War, 1913-1916.* Trans. Anne Hyde Greet with an introduction by S. I. Lockerbie. Berkeley: University of California Press, 1980.

Barooshian, Vahan D. *Russian Cubo-Futurism, 1910-1930: A Study in Avant-Gardism.* The Hague: Mouton, 1974.

Bergonzi, Bernard. *Heroes' Twilight: A Study of the Literature of the Great War.* 2nd ed. London: Macmillan, 1980.

Breunig, L. C., ed. *The Cubist Poets in Paris: An Anthology.* Lincoln: University of Nebraska Press, 1995.

Brown, Edward J. "Mayakovsky's Futurist Period." In Gigian and Tjalsma, *Russian Modernism: Culture and the Avant-Garde, 1900-1930*, 107-31.

Carpenter, Humphrey. *A Serious Character: The Life of Ezra Pound*. Boston: Houghton Mifflin, 1988.

Closs, August, ed. *Twentieth-Century German Literature*. New York: Barnes & Noble, 1969.

Cornell, Kenneth. *The Post-Symbolist Period: French Poetic Currents, 1900-1920*. New Haven CT: Yale University Press, 1958.

Erlich, Victor. *Modernism and Revolution: Russian Literature in Transition*. Cambridge MA: Harvard University Press, 1994.

Gibson, Robert. *Modern French Poets on Poetry*. Cambridge: Cambridge University Press, 1961.

Gigian, George, and H. W. Tjalsma, eds. *Russian Modernism: Culture and the Avant-Garde, 1900-1930*. Ithaca NY: Cornell University Press, 1976.

Gordon, Mel, ed. *Expressionistic Texts*. New York: PAJ Publications, 1986.

Grimm, Reinhold, and Henry Schmidt. "Foreign Influences on German Expressionist Poetry." In *Expressionism as an International Literary Phenomenon: 21 Essays and a Bibliography*. Edited by Ulrich Weisstein. Paris: Didier, 1973.

Hamburger, Michael. *Contraries: Studies in German Literature*. New York: Dutton, 1970.

————, ed. and trans. *German Poetry, 1910-1975*. New York: Urizen Books, 1976.

————. *A Proliferation of Prophets: Essays on German Writers from Nietzsche to Brecht*. New York: St. Martin's Press, 1984.

————, and Christopher Middleton, ed. and trans. *Modern German Poetry, 1910-1960*. London: Macgibbon & Kee, 1962.

Hone, Joseph. *W. B. Yeats: 1865-1939*. New York: Macmillan, 1943.

Hughes, Glenn, "Introduction." *Imagist Anthology: 1930*. London: Chatto & Windus, 1930.

The Imagist Revolution: 1908-1918. Exhibition "keepsake" (including selected Pound-Flint correspondence). Austin: University of Texas at Austin, 1992.

Jones, Peter, ed. *Imagist Poetry*. London: Penguin Books, 1981.

Lawton, Anna. "Main Lines of Convergence between Russian and Italian Futurism: V. Šeršenevic and F. T. Marinetti." (Ph.D. diss.) Ann Arbor MI: UMI, 1979.

Mackworth, Cecily. *Guillaume Apollinaire and the Cubist Life*. New York: Horizon Press, 1963.

Markov, Vladimir. *Russian Futurism: A History*. Berkeley: University of California Press, 1968.

Mellow, James R. *Charmed Circle: Gertrude Stein and Company*. New York: Houghton Mifflin, 1974.

Modern German Lyric Verse. Ed. William Rose.

Oxford Companion to French Literature. Edited by. Sir Paul Harvey and J. F. Heseltine. Oxford: Clarendon Press, 1959.

Oxford Companion to German Literature. Edited by Henry and Mary Garland. Oxford: Clarendon Press, 1978.

Pound, Ezra. *ABC of Reading*. 1934. New York: New Directions, 1960.

——. *Ezra Pound: Selected Letters 1907-1941*. Ed. D. D. Paige. New York: New Directions, 1971.

——. *Gaudier-Brzeska: A Memoir*. 1916. New York: New Directions, 1970.

——. "Harold Monro." 1933. In *Ezra Pound: Polite Essays*. Plainview NY: Books for Libraries, 1966, 14.

——. "The New Sculpture." *The Egoist*, 16 February 1914, 67-68. In *Ezra Pound and the Visual Arts*. Ed. with introduction by Harriet Zinnes, 180-82.

——. *Personae: the Shorter Poems of Ezra Pound*. Rev. ed. by Lea Baechler and A. Walton Litz. New York: New Directions, 1990.

——. "A Retrospect." 1918. In *Literary Essays of Ezra Pound*. Edited with introduction by T. S. Eliot. New York: New Directions, 1968, 3-14.

Pritchard, William H. *Frost: A Literary Life Reconsidered*. New York: Oxford University Press, 1984.

Shattuck, Roger. "Apollinaire's Great Wheel." In *The Innocent Eye: On Modernist Literature and the Arts*. New York: Farrar Straus Giroux, 1984, 240-62.

Stead, C. K. *The New Poetic: Yeats to Eliot*. Philadelphia: University of Pennsylvania Press, 1987.

Steegmuller, Francis. *Apollinaire: Poet among the Painters*. New York: Penguin, 1986.

——. Introduction to *Alcools: Poems, 1898-1913* by Guillaume Apollinaire. Garden City NY: Doubleday, 1964.

Stock, Noel. *The Life of Ezra Pound*. San Francisco: North Point Press, 1982.

Welleck, René. "Russian Formalism." In Gigian and Tjalsma, *Russian Modernism: Culture and the Avant-Garde, 1900-1930*, 31-48.

Williams, William Carlos. *The Autobiography of William Carlos Williams*. New York: New Directions, 1967.

Woolf, Virginia. "Mr Bennett and Mrs Brown." 1924. Reprinted in vol. 1, *Collected Essays*. London: Harcourt, Brace & World, 1967, 321.

III. Music

Brand, Juliane, Christopher Hailey, and Donald Harris, eds. *The Berg-Schoenberg Correspondence: Selected Letters*. New York: Norton, 1987.

Craft, Robert. "Le Sacre and Pierre Monteaux: An Unknown Debt." *New York Review of Books*, 3 April 1975, 33.

——. "Stravinsky's Russian Letters." *New York Review of Books*, 21 February 1974, 18.

Garafola, Lynn, *Diaghilev's Ballets Russes*. New York: Oxford University Press, 1989.

Moldenhauer, Hans, and Rosaleen Moldenhauer. *Anton Von Webern: A Chronicle of His Life and Work*. New York: Knopf, 1979.

Norton-Grove Concise Encyclopedia of Music. Edited by Stanley Sadie. New York: Norton, 1988.

Salzman, Eric. *Twentieth-Century Music: An Introduction*. Englewood Cliffs NJ: Prentice Hall, 1967.

Schoenberg, Arnold. *Theory of Harmony*. 3rd ed. 1922. Trans. and introduction, Roy E. Carter. Berkeley: University of California Press, 1978.

————. *Style and Idea: Selected Writings of Arnold Schoenberg*. Edited by Leonard Stein. Trans. Leo Black. New York: St. Martin's Press, 1975.

Stravinsky, Igor. *An Autobiography*. New York: Norton, 1962.

————. *Memories and Commentaries*. Berkeley: University of California Press, 1981.

————, and Robert Craft. *Conversations with Igor Stravinsky*. Berkeley: University of California Press, 1980.

Stuckenschmidt, H. H. *Schoenberg: His Life, World, and Work*. Trans. Humphrey Searle. New York: Schirmer Books, 1977.

White, Eric Walter. *Stravinsky: The Composer and His Works*. 2nd ed. Berkeley: University of California Press, 1979.

IV. Aesthetics and Theories of the Avant-Garde and Modernism

Bradbury, Malcolm, and James McFarlane. *Modernism: 1890-1930*. London: Penguin, 1976.

Bürger, Peter. *Theory of the Avant-Garde*. Trans. Michael Shaw. Minneapolis: University of Minnesota Press, 1984.

Goldberg, RoseLee. *Performance Art: From Futurism to the Present*. Rev. and enlarged ed. New York: H. N. Abrams, 1988.

Huyssen, Andreas. *After the Great Divide: Modernism, Mass Culture, Postmodernism*. Bloomington: Indiana University Press, 1986.

Kandinsky, Wassily. *Concerning the Spiritual in Art*. Trans. Francis Golffing, Michael Harrison, and Ferdinand Ostertag. New York: Wittenborn, Schultz, 1947.

————. "On the Question of Form." In *The Blaue Reiter Almanac*. Edited by Klaus Lankheit. New York: Da Capo Press, 1974, 147-87.

————. "On Stage Composition." In *The Blaue Reiter Almanac*, 190-206.

Karl, Frederick R. *Modern and Modernism: The Sovereignty of the Artist, 1885-1925*. New York: Atheneum, 1985.

Léger, Fernand. *Functions of Painting*. Edited and introduction by Edward F. Fry. Trans. Alexandra Anderson. New York: Viking Press, 1973.

Nietzsche, Friedrich. *Thus Spoke Zarathustra: A Book for All and None*. Trans. Walter Kaufmann. In *The Portable Nietzsche*. Edited by Walter Kaufmann. New York: Penguin, 1982.

Poggioli, Renato. *Theory of the Avant-Garde*. Trans. Gerald Fitzgerald. Cambridge MA: Belnap Press of Harvard University Press, 1968.

Russell, Charles. *Poets, Prophets, and Revolutionaries: The Literary Avant-garde from Rimbaud through Postmodernism*. New York: Oxford University Press, 1985.

Shattuck, Roger. *The Banquet Years: The Origins of the Avant-Garde in France, 1885-World War I*. New York: Vintage, 1968.

V. Histories of the Period

Butler, Christopher. *Early Modernism: Literature, Music, and Painting in Europe, 1900-1916*. Oxford: Clarendon Press, 1994.

Cronin, Vincent. *Paris on the Eve, 1900-1914*. New York: St. Martin's Press, 1991.

Crunden, Robert. *American Salons: Encounters with European Modernism, 1885-1917*. New York: Oxford, 1993.

Eksteins, Modris. *Rites of Spring: The Great War and the Birth of the Modern Age*. Boston: Houghton Mifflin, 1989.

Green, Martin. *New York 1913: The Armory Show and the Paterson Strike Pageant*. New York: Scribner, 1988.

Horne, Alistair. *The Price of Glory: Verdun 1916*. New York: St. Martin's Press, 1963.

Nicholls, Peter. *Modernisms: A Literary Guide*. Berkeley: University of California Press, 1995.

Stromberg, Roland. *Redemption by War: The Intellectuals and 1914*. Lawrence: The Regents Press of Kansas, 1982.

Symons, Julian. *Makers of the New: The Revolution in Literature, 1912-1939*. New York: Random House, 1987.

Watson, Steven. *Strange Bedfellows: The First American Avant-Garde*. New York: Abbeville Press Publishers, 1991.

Wohl, Robert. *The Generation of 1914*. Cambridge MA: Harvard University Press, 1979.

VI. Memoirs, Diaries, and Letters

Aldington, Richard. *Life for Life's Sake: A Book of Reminiscences*. New York: Viking, 1941.

Anderson, Margaret. *My Thirty Years' War: An Autobiography*. 1930. Reprinted Westport CT: Greenwood Press, 1971.

Becher, Johannes R. "On Jakob van Hoddis." Rpt. in Raabe, *The Era of German Expressionism* 43-48.

Blass, Ernst, "The Old Café des Westens." Rpt. in Raabe, *The Era of German Expressionism* 27-34.

Duchamp, Marcel. Interview with J. J. Sweeney. 1946. Quoted in *The Complete Works of Marcel Duchamp* by Arturo Schwarz. New York: Abrams, 1970.

Ezra Pound and Dorothy Shakespear. Their Letters: 1909-1914. Edited by Omar Pound and A. Walton Litz. New York: New Directions, 1984.

Fletcher, John Gould. *Life Is My Song: The Autobiography of John Gould Fletcher.* New York: Farrar & Rinehart, 1937.

Ford, Ford Madox. *Return to Yesterday.* New York: Liveright, 1932.

Frank, Waldo, Lewis Mumford et al. *America and Alfred Stieglitz: A Collective Portrait.* 1934. Reprinted New York: Farrar, Straus, & Giroux, 1975.

Gleizes, Albert. *Souvenirs, le cubism 1908-1914.* 1957. In *Cubism* by Roger Fry, 172-75.

Goldring, Douglas. *South Lodge: Reminiscences of Violent Hunt, Ford Madox Ford and the English Review Circle.* London: Constable & Co. Ltd., 1943.

Hapgood, Hutchins. *A Victorian in the Modern World.* 1939. Reprinted, Seattle: University of Washington Press, 1972.

Jacob, Heinrich. "Prewar Writing and the Atmosphere in Berlin." Rpt. in Raabe, *The Era of German Expressionism* 17-21.

Kandinsky, Wassily. "The *Blaue Reiter* (Recollections)." 1930. In *Kandinsky: Complete Writings on Art*, vol. 2, 744-48.

———. "Franz Marc." 1936. In *Kandinsky: Complete Writings on Art*, vol. 2, 793-97.

———. "Reminiscences." In *Kandinsky, 1901-1913.* Berlin: Verlag Der Sturm, 1913. In *Kandinsky: Complete Writings on Art*, vol. 1, 355-82.

Klee, Paul. *The Diaries of Paul Klee: 1898-1918.* Edited with introduction by Felix Klee. Berkeley: University of California Press, 1964.

Kokoschka, Oskar. *My Life.* Trans. David Britt. New York: Macmillan, 1974.

Kreymborg, Alfred. *Troubadour: An Autobiography.* New York: Liveright Inc., Publishers, 1925.

Lewis, Wyndham. *Blasting and Bombardiering.* 1937. Reprinted, New York: Riverrun Press, 1982.

———. *Rude Assignment: An Intellectual Autobiography.* Edited by Toby Foshay. Santa Barbara CA: Black Sparrow Press, 1984.

Lowe, Sue Davidson. *Stieglitz: A Memoir / Biography.* New York: Farrar Straus Giroux, 1983.

Luhan, Mabel Dodge. *Movers and Shakers.* Vol. 3 of *Intimate Memories.* New York: Harcourt, Brace & Co., 1936.

Marc, Franz. *Letters from the War.* New edition by Klaus Lankheit and Uwe Steffen. Trans. Liselotte Dieckmann. New York: Peter Lang, 1992.

Mehring, Walter. "Berlin Avant-Garde." Rpt. in Raabe, *The Era of German Expressionism* 109-14.

Miesel, Victor H., ed. *Voices of German Expressionism.* Engelwood Cliffs NJ: Prentice Hall, 1970.

Monroe, Harriet. *A Poet's Life: Seventy Years in a Changing World.* 1938. Reprinted, New York: AMS Press, 1969.

Nevinson, C. R. W. *Paint and Prejudice.* New York: Harcourt, Brace, & Co., 1938.

Oskar Kokoschka: Letters, 1905-1976. Selected by Olda Kokoschka and Alfred Marnau. London: Thames and Hudson, 1992.

Otten, Karl. "Summer without Autumn. Memorial to August Macke and the Rhineland Expressionists." Rpt. in Raabe, *The Era of German Expressionism* 139-44.

Papini, Giovanni. "Why I Am a Futurist." *Lacerba* 1 (December 1913): 268. Quoted in *Futurism and the International Avant-Garde* by Anne d'Harnoncourt. Philadelphia: Philadelphia Museum of Art, 1980, 4.

Picard, Jacob. "Ernst Blass, His Associates in Heidelberg and *Die Argonauten*. Rpt. in Raabe, *The Era of German Expressionism* 131-38.

Raabe, Paul, ed. with annotation. *The Era of German Expressionism*. Trans. J. M. Ritchie. Woodstock NY: Overlook Press, 1974.

Schad, Christian. "Zurich / Geneva: Dada." Rpt. in Raabe, *The Era of German Expressionism* 161-66.

Severini, Gino. *The Life of a Painter*. Trans. Jennifer Franchina. Princeton NJ: Princeton University Press, 1995.

Stein, Gertrude. *The Autobiography of Alice B. Toklas*. In *Selected Writings of Gertrude Stein*. Edited with introduction and notes by Carl Van Vechten. New York: Random-Vintage, 1972.

Szitta, Emil. "The Artists in Zurich during the War." Rpt. in Raabe, *The Era of German Expressionism* 153-60.

Zweig, Stephan. *The World of Yesterday: An Autobiography*. Lincoln: University of Nebraska Press, 1964.

VII. Interdisciplinary Studies

Barzun, Henri Martin. *Orpheus: Modern Culture and the 1913 Renaissance*. New York: privately printed, 1956. Commemorative edition, 1960.

Briot-Guerry, Liliane. *L'Année 1913: Les formes esthétiques de l'oeuvre d'art à la veille de la première guerre mondiale*. Vols. 1-2. Paris: Éditions Klincksieck, 1971.

Cross, Tim. *The Lost Voices of World War I: An International Anthology of Writers, Poets and Playwrights*. Iowa City: University of Iowa Press, 1988.

Dijkstra, Bram. *Cubism, Stieglitz, and the Early Poetry of William Carlos Williams*. Princeton NJ: Princeton University Press, 1969.

Dreier, Katherine S. *Burliuk*. New York: Société Anonyme, Inc. and *Color and Rhyme*, 1944.

Ferrall, Charles. "'Melodramas of Modernity': The Interaction of Vorticism and Futurism before the Great War." *University of Toronto Quarterly* 63, no. 2 (winter 1993/1994): 347-68.

Hahl-Koch, Jelena, ed. *Arnold Schoenberg-Wassily Kandinsky: Letters, Pictures, and Documents*. Trans. John C. Crawford. London: Faber and Faber, 1984.

Hulten, Pontus, ed. *Futurism and Futurisms*. New York: Abbeville Press, 1986.

Jones, M. S. *Der Sturm: A Focus of Expression*. Columbia SC: Camden House, 1984.

Kandinsky, Wassily. *The Yellow Sound.* In *The Blaue Reiter Almanac.* New York: Da Capo Press, 1974.

Kirby, Michael, and Victoria Nes Kirby. *Futurist Performance.* New York: PAJ Publications, 1986.

Lista, Giovanni. *Futurism.* Trans. Charles Lynn Clark. New York: Universe Books, 1986.

Perloff, Marjorie. *The Futurist Moment: Avant-Garde, Avant Guerre, and the Language of Rupture.* Chicago: University of Chicago Press, 1986.

Rye, Jane. *Futurism.* London: Studio Vista, 1972.

Schorske, Carl E. *Fin-de-Siècle Vienna: Politics and Culture.* New York: Vintage, 1981.

Schvey, Henry I. *Oskar Kokoschka: The Painter as Playwright.* Detroit: Wayne State University Press, 1982.

Shevin-Coetzee, Marilyn, and Frans Coetzee. *World War I and European Society: A Sourcebook.* Lexington MA: D. C. Heath, 1995.

Tisdale, Caroline, and Angelo Bozzolla. *Futurism.* New York: Oxford University Press 1978.

Weisstein, Ulrich, ed. *Expressionism as an International Literary Phenomenon: 21 Essays and a Bibliography.* Paris: Didier, 1973.

Willet, John. *Expressionism.* New York: McGraw-Hill, 1970.

VIII. Manifestos and Group Manifestations

Aldington, Richard, et al. "[Vorticist] Manifestos I and II." In *BLAST*, no. 1, June 1914, 10-43.

———, et al. [Vorticist] letter to *The Observer*, 14 June 1914.

Apollinaire, Guillaume. "l'Anti-traditione futuriste: manifesto synthese." *Monjoie!* June 1913.

———. *The Cubist Painters: Aesthetic Meditations.* March 1913. Trans. Lionel Abel. In Chipp, *Theories of Modern Art*, 221-48.

———. "Reality, Pure Painting." Late 1912. Reprinted *Apollinaire on Art*, 262-65.

Apollonio, Umbro, ed. with introduction. *Futurist Manifestos.* Trans. Robert Brain et al. Documents of 20th-Century Art. New York: Viking Press, 1970.

Aseyev, Nikolai, Sergei Bobrov et al. "Charter" [Centrifuge manifesto]. 1914. In Lawton, ed., *Russian Futurism through Its Manifestoes*, 161-63.

Barzun, Henri Martin. "Manifesto of Poetic Simultaneism [Simultanéisme]." June 1913. Quoted in *Orpheus: Modern Culture and the 1913 Renaissance.*

Beauduin, Nicholas. "The New Poetry of France" [Paroxysme]. Trans. Richard Aldington. *The Egoist*, 15 August 1914, 313-16.

BLAST: Review of the Great English Vortex. Edited by Wyndham Lewis, vols. 1-2 (June 1914, July 1915).

Boccioni, Umberto, Carlo Carrà et al. "Manifesto of Futurist Painters." 11 February 1910. In Apollonio, *Futurist Manifestos* 24-27.

————. "The Exhibitors to the Public." Sackville Gallery catalog, March 1912. In Chipp, *Theories of Modern* Art, 294-98.

————. "Futurist Painting: Technical Manifesto." 11 April 1910. In Chipp, *Theories of Modern Art*, 289-93.

Burliuk, David, Alexander Kruchenykh et al. "Slap in the Face of Public Taste." December 1912. In *Russian Futurism through Its Manifestoes*, 51-52.

————, Elena Guro et al. [Untitled manifesto.] *A Trap for Judges*, 2 February 1913. In *Russian Futurism through Its Manifestoes*, 53-54.

Burliuk, Nikolai, with David Burliuk. "Poetic Principles." February 1914. In *Russian Futurism through Its Manifestoes*, 82-86.

Canudo, Ricciotto. "L'art Cerebriste." February 1914. In *Les Manifestes littéraires de la belle époque 1886-1914*, by Bonner Mitchell, ed., 173-76.

Cohen, Milton A. "Subversive Pedagogies: Schoenberg's *Theory of Harmony* and Pound's 'A Few Don'ts by an Imagiste.'" *Mosaic* 21, no. 1 (winter 1988): 49-65.

Delaunay, Robert. "Notes on the Construction of the Reality of Pure Painting." August 1912. In Sherry Buckberrough, *Robert Delaunay: The Discovery of Simultaneity*, 247-48.

————. "Light." Late 1912. In Sherry Buckberrough, *Robert Delaunay: The Discovery of Simultaneity*, 247-48.

Flint, F. S. "Imagisme." *Poetry*, March 1913, 198-200.

Flint, R. W. Introduction. *Marinetti: Selected Writings*. Edited by R. W. Flint. Trans. R. W. Flint and Arthur Coppotelli. New York: Farrar, Straus, and Giroux, 1971.

Florian-Parmentier. *La Littérature et l'Epoque*, vol. 1 of *Histoire de la Littérature Française, de 1885 à nos jours*. Paris: Figuière, 1912.

Gaudier-Brzeska, Henri. "Vortex Gaudier Brzeska." *BLAST*, no. 1, June 1914, 155-58.

————. "Vortex (Written from the Trenches)" *BLAST*, no. 2, July 1915, 33-34.

Goncharova, Natalia. "Cubism." February 1912. In *Russian Art of the Avant Garde: Theory and Criticism*, 77-78.

Graal-Arelsky. "Egopoetry in Poetry." October? 1911. In *Russian Futurism through Its Manifestoes*, 110-11.

Hutchisson, James M. *Paper Wars: The Literary Manifesto in America*. (Ph.D. diss., University of Delaware). Ann Arbor MI: UMC, 1987.

Ignatyev, I. V. "Ego-Futurism." 1913. In *Russian Futurism through Its Manifestoes*, 118-29.

Kruchenykh, A[leksei]. "Declaration of the Word as Such," summer 1913; rpt. in *Russian Futurism through Its Manifestoes*, 67-68.

————. "New Ways of the Word (the language of the future, death to Symbolism)." September 1913. In *Russian Futurism through Its Manifestoes*, 69-77.

————. Untitled excerpt from *Explodity*. June 1913. In *Russian Futurism through Its Manifestoes*, 65-66.

————, and V[elimir] Khlebnikov. "The Letter as Such." 1913. In *Russian Futurism through Its Manifestoes*, 63-64.

————, and Velimir Khlebnikov. Untitled and unpublished manifesto [later published as "The Word as Such," 1933]. 1913. In *Russian Futurism through Its Manifestoes*, 55-56.

————, and Velimir Khlebnikov. Untitled manifesto [from *The Word as Such*]. October 1913. In *Russian Futurism through Its Manifestoes*, 57-62.

Larionov, Mikhail. "Luchism" [titled "Rayist Painting" by Bowlt]. June 1912. In *Russian Art of the Avant-Garde: Theory and Criticism*, 91-100.

————. "Pictorial Rayism." Spring 1914. In *Russian Art of the Avant-Garde: Theory and Criticism*, 100-102.

————, and Natalia Goncharova. "Rayists and Futurists: A Manifesto." July 1913. In *Russian Art of the Avant-Garde: Theory and Criticism*, 87-91.

Lawton, Anna, ed. with introduction. *Russian Futurism through Its Manifestoes, 1912-1928*. Trans. Anna Lawton and Herbert Eagle. Afterword by Herbert Eagle. Ithaca NY: Cornell University Press, 1988.

Lewis, Wyndham. "Wyndham Lewis Vortex No. 1. Art Vortex," *BLAST*, no. 2, July 1915, 91.

Livshits, Benedict. "The Liberation of the Word." August 1913. In *Russian Futurism through Its Manifestoes*, 78-81.

Macdonald-Wright, Stanton. "Individual Introduction" [for Paris exhibition]. October-November 1913. In Gail Levin, *Synchromism and American Color Abstraction, 1910-1925*, 130.

Malevich, Kasimir. "From Cubism to Suprematism" [manifesto-brochure accompanying "0-10" Exhibition]. December 1915. In *Russian Art of the Avant-Garde: Theory and Criticism*, 116-35.

Marinetti, F. T. "The Birth of a Futurist Aesthetic." *War, the World's Only Hygiene*. In Flint, *Marinetti: Selected Writings*, 80-83.

————. "Destruction of Syntax—Imagination without Strings—Words in Freedom." 11 May 1913. In Apollonio, *Futurist Manifestos*, 95-106.

————. "The Foundation and Manifesto of Futurism." 20 February 1909. In Chipp, *Theories of Modern Art*, 284-89.

————. "Let's Murder the Moonshine." April 1909. In Flint, *Marinetti: Selected Writings*, 45-54.

————. "The Pleasure of Being Booed." *War, the World's Only Hygiene*. In Flint, *Marinetti: Selected Writings*, 113-15.

————. "Technical Manifesto of Futurist Literature." 11 May 1912. In Flint, *Marinetti: Selected Writings*, 84-89.

————. "The Variety Theater." 29 September 1913. In Flint, *Marinetti: Selected Writings*, 116-22.

————, Emilo Settimelli, et al. "Futurist Synthetic Theater." 11 January 1915, 18 February 1915. In Flint, *Marinetti: Selected Writings*, 123-29.

————, and C. R. W. Nevinson. "Vital English Art. Futurist Manifesto." *The Observer*, 7 June 1914.

Mitchell, Bonner, ed. *Les Manifestes littéraires de la belle époque, 1886-1914: Anthologie critique*. Paris: Editions Seghers, 1966.

Peer, Larry H. *The Romantic Manifesto: An Anthology*. Vol. 23 of American Studies Series III (Comparative Literature). New York: Peter Lang, 1988.

Pound, Ezra. "A Few Don'ts by an Imagiste." *Poetry*, March 1913, 200-206.

———. "Vortex Pound." *BLAST*, no. 1, June 1914, 153-54.

Raynal, Maurice. "The *Section d'Or* Exhibition." *La Section d'Or* [pamphlet-review accompanying exhibition of same name]. 9 October 1912. In *Cubism* by Edward Fry, ed., 97-100.

Romains, Jules. *"Les Sentiments unanimes et la Poésie."* April 1905.

———. *La vie unanime* [poems]. Abbaye de Creteil, June 1908.

Rossiyansky, M. "Throwing Down the Gauntlet to the Cubo-Futurists." September 1913. In Lawton, *Russian Futurism through Its Manifestoes*, 137-39.

Russell, Morgan. "Individual Introduction" [for Paris exhibition]. October-November 1913. In Levin, *Synchromism and American Color Abstraction*, 130-31.

———, and Stanton MacDonald-Wright. "In Explanation of Synchromism." June 1913. In Levin, *Synchromism and American Color Abstraction*, 128-29.

———, and Stanton MacDonald-Wright. "General Introduction" [for Paris exhibition, October-November 1913]. In Levin, *Synchromism and American Color Abstraction*, 129-30.

Zdanevich, Ilya, and Mikhail Larionov. "Why We Paint Ourselves: A Futurist Manifesto." December 1913. In Bowlt, *Russian Art of the Avant-Garde: Theory and Criticism*, 79-83.

Index

About the Author

Milton Cohen is Associate Professor of Literary Studies at The University of Texas at Dallas. He has published *PoetandPainter: The Aesthetics of E. E. Cummings's Early Work* and articles on American and European modernists. His study of Hemingway's first version of *In Our Time* is forthcoming.